JOSEF HOFFMANN

The Architectural Work

1. Stoclet House, Brussels, view from the west

Eduard F. Sekler

JOSEF HOFFMANN

THE ARCHITECTURAL WORK

Monograph and Catalogue
of Works

Translated by the author
Catalogue translated by John Maass

Princeton University Press
Princeton, New Jersey

Copyright © 1985 by Princeton University Press

Published by Princeton University Press, 41 William Street,
Princeton, New Jersey 08540
In the United Kingdom: Princeton University
Press, Guildford, Surrey

All Rights Reserved

Library of Congress Cataloging in Publication Data will
be found on the last printed page of this book.
ISBN 0-691-06572-1

This book has been composed in Linotron Aldus type

Clothbound editions of Princeton University Press books
are printed on acid-free paper, and binding materials are chosen
for strength and durability. Paperbacks, although satisfactory
for personal collections, are not usually suitable
for library rebinding.

Printed in the United States of America by Princeton
University Press, Princeton, New Jersey

Contents

UXORI MANIBUSQUE PARENTUM
D.D.D. AUCTOR

Foreword

Though he designed everything from book decorations to bentwood furniture and from dresses to jewelry, Josef Hoffmann always considered himself first and foremost an architect. Yet the whole extent of his architectural oeuvre was never surveyed in depth, and several of his works, in fact, fell into complete oblivion. Therefore, if one wanted to render long overdue justice to Hoffmann's achievement, one first had to provide a full documentation of his architecture.

In order to appreciate and understand works of architecture, one must, as we all know, experience them in three dimensions, which means one must visit them. With many of Hoffmann's buildings this, alas, is no longer possible; with others it is difficult. In either case, description, supported by illustrations, has to substitute for the lost or inaccessible original. Even with existing buildings, description of impressions and observations must form the basis for analysis, interpretation, and evaluation.

In the present volume, descriptions, as far as possible, have been grouped together in the catalogue raisonné that forms the second part of the book. This separates what can be verified unequivocally from what are interpretative and evaluative statements, but it also demands an effort of cooperation; the reader has to be willing to supplement the arguments of the text in the first part by cross-references to descriptions and illustrations in the second part.

Every effort has been made to assure that the catalogue raisonné is complete. It is likely, however, in view of both Hoffmann's fecundity as a designer and the particular historic conditions surrounding his activity and its later recording, that a number of additional, so far unpublished, designs may yet come to light. Even since the appearance of the German edition of this book in 1982 some hitherto overlooked works were brought to the attention of the author. They have been briefly recorded in the last entry of the catalogue.

Wherever possible, illustrations have been selected to enable the reader to make comparisons between design drawing and executed work. In addition, to facilitate comparisons of size, all ground plans of important buildings have been redrawn for this book to the same scale. Thus it becomes evident, for example, that one of the smaller villas would easily fit inside the central hall of the Stoclet House.

In many instances the attempt has been made to view the genesis of a design from the point of view of the designer, as it were, and to stress those factors that might have been the most important for Hoffmann.

In this connection, the author came to the realization that in the 1982 edition, he had not stressed sufficiently two significant influences on Hoffmann: Piranesi and Japan. Even if Hoffmann had not sketched Piranesi's work in Rome (fig. 10), his designs for such imaginary monumental buildings as those in Cats. 18/3 and 18/4, together with his persistent predilection for visual ambiguity and inversions of the classical canon, should be evidence enough for his debt to the Venetian master. His first teacher at the Academy, Hasenauer, after all, on more than one occasion had aimed at achieving Piranesian effects along the Viennese Ringstraße.

The influence of Japan—briefly mentioned in the text in connection with the Japanese exhibitions in Vienna around 1900—is, of course, typical for the historical situation at the beginning of Hoffmann's career. *Japonisme* was a strong ingredient in both the British aesthetic movement and the international Art Nouveau; Japanese objects were readily available for inspection in Vienna ever since they had been acquired by the Austrian authorities after the 1873 World's Fair; Gustav Klimt, Berta Zuckerkandl (cat. 196), and Friedrich Victor Spitzer (cat. 63) all collected Japanese woodcuts, textiles, or objects. It would have been surprising, therefore, had Hoffmann not turned to Japan as a source of inspiration.

Hoffmann's works of architecture obviously should not be seen as isolated phenomena but must be considered in the historical context of their period of origin—embedded in a complex network of conditions and influences. This, however, does not fully explain the process of their design, for the essential and unique characteristic of Hoffmann's creations, their aesthetic quality, transcends all explanation and interpretation.

A book about Hoffmann is, in the last resort, a coming to terms with the question of aesthetic quality. Hoffmann has left no theoretical formulations of great significance, he published no brilliant polemical essays, and he developed no new concepts about the social tasks of

architecture and architects. All this others could do better. What he could do, with the absolute assurance of instinct, was to produce strong, beautiful forms in designs that stand out everywhere and at all times because of the unique character and clear legibility of their gestalt. Hoffmann, then, is not in need of an apologist; his works can speak for themselves.

In the following chapters Hoffmann's works are discussed together with the circumstances of their genesis as factually as possible and roughly in historical sequence. In this manner, it is hoped, the reader will be able to form his own opinion about Hoffmann's oeuvre. If he approaches it in an entirely open and unprejudiced way, and with the leisure necessary to truly contemplate it, it is likely that a message will come across that Hoffmann himself once summed up in the words, "I concede everything practical and necessary, but, I think, we also always have the duty to give joy. This joy . . . is the main asset of our existence."

With the research for this book extending over a period of more than two decades, the debt of gratitude for help and encouragement from many quarters became truly vast. The work could never have been completed without the generous financial support from the Edgar J. Kaufmann Charitable Foundation, Pittsburgh, the Austrian *Bundesministerium für Wissenschaft und Forschung* under Minister Dr. Herta Firnberg, and the Harvard Graduate Society. There were more than one hundred individuals and institutions who kindly provided information or access to buildings, drawings and documents; their names are gratefully recorded in the preface to the German edition. Here it must suffice to single out the late widow of the architect, Karla Hoffmann, and his daughter-in-law, Ann M. Hoffmann, for their steadfast, invaluable assistance, and Mme. Jacques Stoclet with members of her family for their courteous hospitality and great kindness in providing the loan of color photographs specially taken for this book. In addition, the author would like to extend his appreciation to the following, who were either not mentioned in the German edition or who came forth with assistance after 1982: Dennis DeWitt and Eleanor M. DeWitt, Mitzi Gallia, Dr. Josef Kaltenböck, Mr. and Mrs. Charles Kessler, Terence Lane, Dipl. Ing. Bruno Maldoner, James May, John Maass, Dr. Wilfried Posch, Dipl. Ing. Ernst Prink, Dr. W. G. Rizzi, David Ryan, Professor Johannes Spalt, Dipl. Ing. Günther Tischler, Benjamin Weese, the staff of the Frances Loeb Library and the Library of the Fogg Art Museum, Harvard University, and all those members of the staff of Princeton University Press who competently saw this book through the press. Finally, without the patient support of my wife Mary Patricia there would have been no English version of the book.

Eduard F. Sekler
Cambridge, Massachusetts
June 1984

PUBLISHER'S NOTE

The proposal to publish a translation of Eduard F. Sekler's *Josef Hoffmann* was brought to our Press in 1978 by Christine Ivusic, our Fine Arts Editor. She was extremely enthusiastic about the book, and her enthusiasm was borne out by the public reception of the German edition. As editor she cared deeply about the book, but unfortunately she did not live to see it published. She died on January 5, 1985.

Editorial responsibility for the book was taken over by Tam Curry, who has seen it through the final stages. We chose to use the format and negatives from the German edition, which complicated the design; our designer was Susan Bishop.

Production was at first the responsibility of Joseph Evanchik and later of Kenneth Merritt. The type was set by many hands, using a Penta-Linotron system, under the supervision of Philip Leclerc. The proofreading was done under the care of Betty Brewer, and the page make-up was done by Robert A. Rosner. Stanley Cooper supervised the printing and binding. The physical book is the result of the skill and workmanship of these people and their colleagues.

Of course the book truly belongs to its author, for whom it represents the work of half a lifetime. But to the extent that we at the Press can claim a part of it, we wish it to be dedicated to the memory of Christine Ivusic.

I. Years of Upbringing and Education

The wedding of Josef Franz Karl Hoffmann and Leopoldine Tuppy on 24 July 1866 took place under rather unusual circumstances: just as the bride and bridegroom arrived in front of the small church of Priesenitz (Přízřenice), Moravia, where the ceremony was to occur, shots rang out nearby. The parson tried to flee and had to be compelled by force to remain to perform the wedding. It was then discovered that the shots had been meant as a salute to the newly married couple and had been fired by occupying Prussian soldiers recently quartered in the region. The Austrian defeat at Königgrätz (Hradec-Kŕalové)—that turning point of Central European history—had occurred just three weeks before.

Ninety years later, on 7 May 1956, Josef Hoffmann, the son of that couple, died, one year after an equally significant turning point: after two world wars and long years of occupation, Austria, or what remained of it, had just regained its independence. The pertinent state treaty had been signed in the Belvedere in Vienna, a building visible from the windows of Hoffmann's apartment on the Rennweg, across from the Baroque gardens in which he used to go for walks. Between 1866 and 1956, Austria, and Europe, had changed profoundly, yet the extent to which the full spiritual, social, and technological significance of this transformation could be grasped by those whom, like Hoffmann, it affected directly, remains open to question.

The family of Josef Hoffmann lived in southwest Moravia, in Pirnitz (Brtnice), a little town of some 3,000 inhabitants near Iglau (Jihlava), approximately 80 km from Brünn (Brno) and 200 km from Vienna. In Moravia the impact of the Industrial Revolution was felt earlier and more strongly than in many other parts of the Monarchy, and some of the most successful early industrial enterprises flourished around Brünn, a city that between 1875 and 1900 experienced an increase in population of more than 50 percent, to a total of approximately 118,000 inhabitants. The nearby villages, however, remained traditionally agricultural, and peasant folkways survived for a long time with very typical customs, costumes, folk art, and folk music—all of high quality.

For Josef Hoffmann, as for many of his contemporaries who grew up under similar conditions, his descent from a German-speaking family that settled in Moravia became an important factor in later life; not only did he preserve a strong emotional attachment to his birthplace—for example, he drew a view of Pirnitz for the catalogue of the fifth Secession exhibition (fig. 2)—but in his private and professional life he gained much from contacts with acquaintances and friends from the same or adjacent parts of the old Monarchy, including clients who shared this background. It has often been pointed out that the cultural and economic life of the Monarchy owed much to the talent and energy of young people who came to Vienna from Bohemia and Moravia. Hoffmann's career, like that of several other important architects of his generation, must be seen in this context; Adolf Loos came from Brünn (Brno), Joseph Maria Olbrich from Troppau (Opava), and Leopold Bauer from Jägerndorf (Krnov).

Hoffmann seems to have attached much importance to the environment and the experiences of his early youth, since he described them in great detail in reminiscences he set down in his old age.[1] In this he resembles other great architects: in their autobiographies Louis Sullivan and Frank Lloyd Wright also dwelled more on their youth than on later years. Hoffmann came from hospitable surroundings and a patriarchal structure in which the order of society and family seemed unshakable. Something of it still resonates in the words he wrote in 1926

2. Josef Hoffmann, view of Pirnitz, Vignette

3. Josef Hoffmann's family home in Pirnitz

to his only son, Wolfgang, who had emigrated to the United States one year earlier:[2] ". . . don't forget that you are the last scion of an after all honorable and known family. . . . I hope I have not brought disgrace to our name and I absolutely hope the same from you."

The Hoffmanns had acquired possessions and reputation in the service of the princes of Collalto, whose castle, imposing in its size and prominent hillside position, clearly expressed the historically given hierarchy in Pirnitz. One member of the Collalto family in the late eighteenth century had started a textile manufacture that included a shop for the hand printing of cotton. As his collaborator, Franz Hoffmann, the first of his name to settle in Pirnitz, was so successful that he was able to lay the foundations for the family fortune. Two generations later Hoffmann's father was already co-owner of the cotton manufacture, landowner, owner of several houses, and, as mayor of Pirnitz, a dignitary among the comparatively few German-speaking inhabitants of the small town.

Hoffmann's family lived in a fine eighteenth-century house, formerly the postmaster's residence, facing the main square (fig. 3). Under a large shingled mansard roof the building displayed a well-proportioned facade decorated by pilasters, and it contained a series of spacious rooms, some of which were vaulted. Next to a courtyard and garden there was ample provision for stabling and storage.

Here on 15 December 1870, Josef Franz Maria Hoffmann was born. At his birth his mother, daughter of a landed proprietor, was twenty-four, his father thirty-five. He was the third of six children, two of whom died in early childhood leaving three sisters. In later years

his sisters recorded their own recollections of family life supplementing Hoffmann's reminiscences.[3] Though somewhat transfigured by retrospect, they convey plausibly enough something of the atmosphere in which Hoffmann spent his childhood:

"We children, four in number . . . adored our parents. Papa for us was a person held in respect—even though he was nothing but kindness and never had a bad word for us—we were afraid of him. . . . The darling of the parents and actually of the whole house was our little brother Josef, called Pepo. . . . He was a handsome, serious boy with great dreamy eyes, always eager for activity."

Next follows a passage that, one suspects, may have been colored by the writer's awareness of the boy's later career: ". . . not an hour in the day passed when, with his blocks or with pencil in hand, he did not construct fantastic buildings, or cut out from paper quite strangely beautiful things. Paper, pencil, and scissors were his tools, from which he was inseparable."

Hoffmann later actually liked to cut out forms in colored paper when he designed glasses and pottery, but his memoirs fail to mention any youthful cutouts. What he does mention is playing the violin in the circle of his family, where music making was a favorite pastime, and venturing with the grown-ups into the fields and meadows where he came "to know intimately the horses, cows, and other creatures in yard and stable, and to join in the activities everywhere." The children also played with the old wooden blocks from the cotton hand-printing shop.

L. W. Rochowanski, who knew Hoffmann well through years of personal contact, was convinced[4] that as a youth he received strong impulses from his native surroundings, including the Collalto castle with its Renaissance loggia, rooms rich in artistic decoration, and an old park, as well as the surrounding idyllic countryside with its fertile fields and meadows. The flourishing local tradition of folklore and folk art certainly would also have contributed toward enriching his stock of visual experiences. Hoffmann specifically remembered how on market days the little town would fill up with peasants in local costumes and with ambulant merchants, among them numerous potters. He once depicted such a market scene in one of his sketchbooks (fig. 4), and even in later years he still delighted to stay in a room in his father's house filled with decorations painted by a talented coachman who was fond of children. A life-long admiration and affection for the restrained harmonies of Biedermeier art and design—Hoffmann often commented on it and at

one time collected Biedermeier portraits—may also have had its roots in the atmosphere of the parental home where, it appears, as far as attitudes and appearances were concerned, a good deal of Biedermeier tradition was still alive, even at the end of the nineteenth century.

Though it is impossible to establish precisely the later effects of that early social and family environment, undoubtedly they were important factors in the formation of Hoffmann's personality. His position in the family as the pampered but also responsibility-laden sole heir and brother of three sisters, his privileged social position as the mayor's son, determining his relation to peasants and servants on the one hand and to the world of high aristocracy represented by the Collalto family, whom he frequently visited, on the other—all this must have contributed to Hoffmann's particular character traits. These comprised as much a quality of social ease and charm when dealing with others as an inclination toward shyness and reticence, but above all a vacillation between under- and over-estimation of his own worth.

In this connection Hoffmann's traumatic experience at the humanistic Gymnasium (secondary school) probably deserves special consideration. It began when at the age of nine he was transferred from the German private school he had attended thus far to the Gymnasium at Iglau (Jihlava), where at that time young Adolf Loos was also a student. Hoffmann's father, intending that his son study jurisprudence for government service, where a career seemed assured "with the aid of relatives who were Privy Councillors [Hofräte]," placed his son as a boarder with a severe landlady. But such plans for the future were thoroughly frustrated by Hoffmann's inability to submit to the uncongenial discipline in unfamiliar surroundings or to overcome an apparently congenital weakness of memory that made learning by heart, as it was so extensively practiced at the time, a torture for him. This failing gave him a good deal of trouble in later years as well.

"I felt intimidated and abandoned in every way," he later recalled, describing how the fifth year at the Gymnasium finally became an insuperable obstacle. Having had to repeat once, he failed a second time: ". . . a shame and an agony which embittered my young life [so] that until this day a certain feeling of inferiority [(Minderheitsgefühl [sic])] never left me." In his despair he found only one friend who stood by him—the son of the local building contractor; together they visited building sites where they were permitted to lend a hand. At that time, Hoffmann later remarked, building, "with all its mysterious possibilities," stimulated his imagination and

4. Josef Hoffmann, market day in Pirnitz, pencil

captivated him "by its purposeful, clearly directed activity." He had discovered a calling.

After "some struggles" he was permitted to register in the department of building of the State Technical School (Staatsgewerbeschule) at Brünn in 1897, and from then on matters improved; at this highly esteemed and by no means easy school—it was also frequented by Adolf Loos from 1888 till 1889—he soon distinguished himself as a student. Moreover, wealthy, art-loving relatives of his mother occasionally invited Hoffmann into their home; they also permitted him the use of their private box in the city theater. However, in his memoirs Hoffmann hints that despite all his success at the Technical School he was not taken quite seriously because of his failure at the Gymnasium.

The Technical School had a mechanical-technological section and another for building, entirely geared to the needs of later master builders and building technicians. Besides courses in mathematics, physics, chemistry, and history, there was specialized instruction in matters relating to architecture. Under the heading "Theory of Styles" a pupil of Theophil Hansen taught the fundamentals of ancient architecture, with pride of place given to Greek architecture. Instruction in building design and the "doctrine of forms" (Formenlehre) was given by Germano Wanderley, who was also the head of the school's section for building. He was a capable architect of ample building experience and the author of a book on rural service buildings. Like Otto Wagner, he had studied at the Berlin Academy of Building with Carl Ferdinand Busse, Schinkel's former assistant, and thus he served as a direct personal link to a great tradition. The design

projects at the school began with small buildings and ended with multistory constructions that had to be worked out fully in technical detail. Instruction at the school was supplemented by mandatory building practice during the summer months, and by regular visits to the richly instructive collections of the Moravian Museum of Arts and Crafts. Hoffmann's schoolmate Aloys Ludwig[5] remembered that he was very diligent and a good comrade, who in mathematics "just managed." He sat next to Leopold Bauer, a "highly gifted devil of a fellow," who occasionally provided information and assistance.

After graduation in 1891 Hoffmann went to Würzburg, Germany, for additional building practice at the military office of works, where he was employed in the construction of brick barracks. He enjoyed the "wondrous Baroque town," and the money he earned enabled him to invite his sisters for a visit as his guests. When the year of practice was over, he applied for admission at the Academy of Fine Arts in Vienna.

The difference between Vienna, imperial city and capital of an empire of some twenty-four million people, and the small provincial capitals of Brünn and Würzburg where Hoffmann had lived up to that time, at first must have impressed him profoundly. The city was in the midst of a process of continuous, dramatic growth. Between 1870 and 1890 the population had increased by 59.2 percent and in 1900 it reached 1,648,335. Building activity was enormous and the monumental buildings along the Ringstraße were eloquent testimony to a prosperity expressed by the fact that in the very year Hoffmann arrived in Vienna, the gold standard was adopted for the currency. Yet at the same time there were continuously growing social and political problems and flagrant differences in income and living conditions for the various strata of society.[6]

Hoffmann began at the Academy in October 1892, the same month in which the institution celebrated its bicentenary in a ceremony which was attended by the Emperor himself. The main address was given by the head of the Academy at that time, Karl Freiherr von Hasenauer, one of the two professors of architecture; then at the height of his fame as an architect, he was intimately connected with some of the most grandiose buildings along the Ringstraße.[7] It was in Hasenauer's class (Spezialschule für Architektur, as it was called) that Hoffmann was accepted as one of a comparatively small and very select group: in 1892 a total of twenty-four new students was admitted to both existing classes of architecture at the Academy.

Only applicants who had graduated from the Institute of Technology (Technische Hochschule) or had equivalent preparation were eligible to apply, and once accepted they were given a great deal of freedom to develop artistically, working independently on projects which only received occasional criticism but had to be submitted to the head of the school at the end of the term. In addition, at given points in time, they were permitted to compete for a series of prizes; most coveted among these was the great State Traveling Fellowship that corresponded to the Prix de Rome of the Ecole des Beaux-Arts in Paris. During his period of study, Hoffmann was awarded every prize the Academy then offered. Hasenauer himself was much too busy, with his monumental buildings and his duties as Rector of the Academy, to devote a great deal of time to his students. Instead he left the day-to-day conduct of his class in the hands of a trusted but rather insignificant older assistant, Bruno Gruber. When Hasenauer died in January 1894, Gruber became the provisional head of the architectural school but he left after one term when Otto Wagner was appointed as Hasenauer's successor. In a certificate of 22 July 1894, Gruber attested to Hoffmann's laudable diligence, continuous effort, and especially rich talent as displayed in the student projects he had designed: a villa, a castle, an apartment house, and a palace.

Hoffmann later recalled his experience in Hasenauer's class in the following words:[8] "The study of architecture at the Academy a quarter of a century ago took the form of a master, at that time always one of the most famous architects, having [the students] work out building projects, so-called building-programs, during three years in the following way: a country residence in the first year, a city residence in the second year, and in the third year some kind of public building. . . . Work was carried out in the following manner: every day an assistant discussed the plans with the individual students, and the professor now and then looked at the results. . . . To arouse any interest, to pose any problem was not their concern. . . . One had the project and was permitted to work. There was no question of guidance or an instruction in any relevant manner. One studied the projects of one's predecessors and made something similar.

"The atmosphere was entirely uninteresting and inartistic. All we had [to go on] was . . . the study in the library which we did on our own initiative. Under Wagner matters really improved. This artist at least knew how to instill enthusiasm into his school . . . there was a real life and search for form."

If Hasenauer, who died 4 January 1894, can be called a master of the grandiloquent gesture, his successor Otto

Wagner, though also working in a tradition of grand composition, was a man of entirely different character, artistic temperament, and architectural intention. He combined a growing orientation toward the future with a rationalism that came from Semper and French architectural theory; this was summed up in his Semperian motto *Artis sola domina necessitas*,[9] which he had used on his competition plan for the extension of Vienna and which he mentioned expressly in his inaugural lecture at the Academy.[10]

In this lecture Wagner outlined his future program of instruction and stated: "The point of departure of every artistic creation must be the need, the capacity, the means and the qualities of 'our' time. . . . Our conditions of life, our constructions must be expressed fully and entirely . . . the realism of our time must penetrate the work of art."

He then proceeded to describe projects he envisaged for students in each year: for the first year a rental apartment building, for the second year a public building, and for the third year,[11] "the solution of a task which in life probably will never come to you but which, as you design it, will contribute to fan the divine spark of imagination which must glow inside you, into a bright flame. In Paris at the Ecole des Beaux-Arts every year such exotic assignments are tried. . . . I should like to add that . . . I would leave it to . . . [your] choice to select that imaginative creation which best suits . . . natural inclination."

Josef Hoffmann selected as his program an Island of Peace, a kind of forerunner of the Hague Palace of Peace, the palace of the League of Nations, or the United Nations building—a project of gigantic dimensions to which he affixed the motto *Forum orbis, insula pacis* (Cat. 2) (figs. 5, 6). His design was so successful that in Hoffmann's final certificate of 23 July 1895 (Appendix 1), Otto Wagner explicitly described it as a masterwork, and in addition, Hoffmann was awarded a State Traveling Fellowship, colloquially referred to as the Rome Prize. This prize required the recipient to study abroad for one academic year and then to submit evidence of work done during the period. In honor of the departing winners of the Rome Prize an official banquet was given to which Hoffmann's father was also invited. He did not live to see most of his son's later successes and honors since he died in 1903, three years before his wife.

Hoffmann's choice for a topic, an international congress palace as an Island of Peace, may be understood as a political gesture. At the end of the nineteenth century, pacifism and the idea of an international court of arbi-tration were highly topical concerns. In 1905 the planning of a palace of peace for The Hague was actually begun: Otto Wagner participated in the international design competition for this palace; Hoffmann did not.

The Island of Peace project represented something like a grandiose swansong of the historicism characteristic of the Ringstraße period: it proved that the young architect had completely mastered the formal language and method of design appropriate to these circumstances. His complicated but not confusing composition would have done honor to every winner of the Prix de Rome at the Ecole des Beaux-Arts and it certainly owes something to the published designs of these prize winners. But, more closely at hand, models were also to be found in Otto Wagner's oeuvre. In scale, fusion of landscape and architecture, as well as in the employment of a high-domed construction as a dominant compositional feature, Wagner's ideal project, *Artibus* for an art precinct probably was as influential for Hoffmann as was Wagner's competition project for a parliament at Budapest[12] (fig. 7).

Hoffmann always stressed how much he owed to Otto Wagner's teaching, and his great admiration for Wagner never diminished. Thus in 1909 he gave an impassioned speech in support of Wagner's design for a museum at the Karlsplatz in Vienna (Appendix 5) and in doing so he described, among other things, why he saw him as a true innovator:[13] "Wagner abandons pure formalism, i.e. he does not think of his buildings as a combination of traditional forms but tries to explain, i.e. to crystallize the construction and the purpose . . . by the usual means of expression."

In 1928, ten years after Wagner's death, Hoffmann once more expressed words of genuine thanks to him:[14] "We who had the good fortune to stand by his side, who appreciated him as the revered master and guide, frequently also friend, thank him above all for all the stimulating and awakening forces.

"He understood how to encourage us and to support our hope. He had the gift of gladly bringing out all dormant abilities, of promoting and leading. He was truly a great and important teacher."

This fits well with Robert Oerley's characterization of Wagner's teaching:[15] "His activity as a teacher was a success chiefly because he was capable of rousing the young to very intensive work and to a colossal volition. . . . One thing every student has learned: to carry every assignment to its ultimate conclusion, to study it in every sense and to elaborate it with the greatest precision, always with the desire to seek and invent something still better."

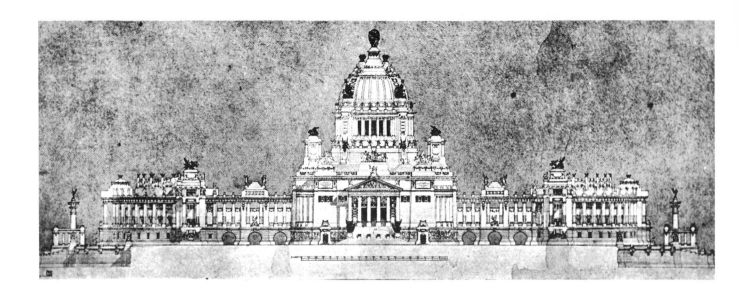

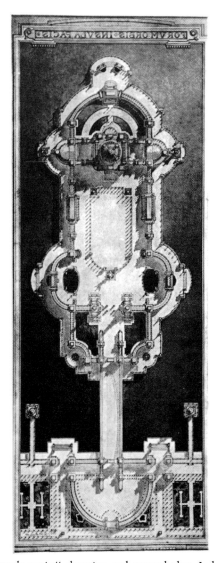

5, 6. *"Forum orbis, insula pacis,"* elevation and ground plan, India ink, pencil, watercolor

Student work at the Academy often related closely to Wagner's own topical projects. He made it a rule to be freely available for review and criticism of student projects every work day between nine and half-past nine in the morning when on occasion he might also discuss recent publications and exhibitions of interest.[16] Wagner often invited the most talented graduates to become collaborators in his private office, which was located next door to the students' drafting room; most of them, however, preferred to work at home. Since students from all three years were placed in the same large room, contacts were easily made and in this way beginners were able to learn much from those in the upper classes and from Wagner's young employees. They would also meet with students from other classes in the Academy, at least when sharing in joint festivities and when dining together in one of several nearby restaurants. The afternoon "daily coffee in the 'Heinrichshof' " provided more contact with Wagner and the possibility of "informing oneself about all artistic problems" of the day.

Among the young professional colleagues with whom Hoffmann came into contact through the Academy and Wagner's office, many were soon to shape architectural history in the Monarchy during the early years of the twentieth century: Leopold Bauer, who, like Aloys Ludwig, had been at school with Hoffmann in Brünn; Jan Kotěra, a native of Brünn, who later became a professor in Prague; Josef Plečnik and Max Fabiani, who designed some of the most remarkable buildings that were built in Vienna around 1900; the talented Joseph Urban, who made a name as a most versatile exhibition designer before he went to the United States; Friedrich Kick, a native of Prague, who eventually taught there at the German Institute of Technology; and finally the lesser-known Franz Krásný, who later collaborated with Hoffmann (see Chapter III). But to none of these were Hoffmann's relations as close as to Joseph Maria Olbrich, who came from Troppau in Austro-Silesia, a province adjoining Hoffmann's native Moravia. Olbrich was three years older than Hoffmann and was already working in Wagner's office while the younger man was still a student and much admired Olbrich's impressive, spirited draftsmanship. Both seem to have felt they had much in common; when they were unable to see each other because one of them was traveling, they wrote long letters full of shared hopes, ambitions, and ideals, with such revealing passages as the following:[17] ". . . remain faithful to the work! There after all the highest satisfaction is to be found; I think the two of us are of a fairly similar kind . . ." (1894).

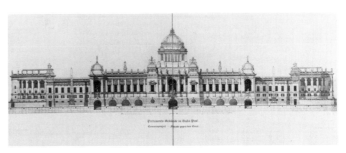

7. Otto Wagner, competition project for the Parliament in Budapest, 1882, elevation

Hoffmann later remembered his friend in the following words: "Olbrich, a man full of sparkling ideas and, perhaps, a romanticism that was too great, was a colossal worker and indefatigable doer. He was obsessed by [Richard] Wagner's music and would have loved to build Walhalla. Fantasizing with him was too beautiful. No task was too great for him, and [there was] nothing he did not at least try to draw.

"We loved his eminent capability and enjoyed his company as the first fully and totally artistic presence. His merry laughter at all philistinism and his powerful conviction, combined with a truly charming personality, refreshed us and spurred us on to advance. His influence was absolute, although each of us at that time already was striving for something else" (Appendix 7).

Both Hoffmann and Olbrich were members of a small convivial debating group of young artists who called themselves the Siebener Club. They held regular meetings on Saturday evenings in a restaurant where a special room was available to them, and in an adjacent coffeehouse. Discussions dealt with topical problems in the world of the arts and, according to Max Fabiani, at one period they were also devoted exclusively to architecture; this helped to clarify thoughts that found their way directly into Otto Wagner's manifesto *Moderne Architektur* of 1895.[18]

It seems that during the comparatively short period of its existence the Siebener Club fulfilled a function that similar small and shortlived avant-garde groups were to fulfill frequently in the later history of twentieth-century architecture. They all provided a congenial setting for the development and testing of new ideas among young, still unknown, or little known, designers and artists. Usually the groups dissolved when their members began to be successful in the outside world.

The prevailing atmosphere of the Siebener Club seems to have been characterized by a mixture of youthful joie

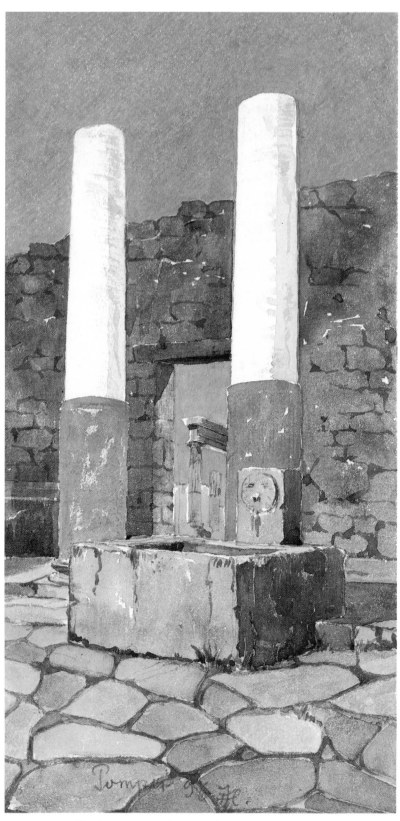

8. Pompeii, public fountain, pencil, watercolors

de vivre and avant-garde fervor. Members of the club frequently sent each other self-made picture postcards with drawings and watercolors, sometimes enriched by improvised humorous verses like those on the view of an alpine chalet which Hoffmann received from Leo Kainradl, later the editor of Munich's *Fliegende Blätter*, who wrote to him from Carinthia.[19]

Among the members of the club two painters soon were to play special roles in Hoffmann's early career: Max Kurzweil for whom he designed the interior arrangement and furniture of his first studio, and Koloman Moser. Moser not only had Hoffmann design his studio furniture and later his house (see Chapters II, III), but he also became Hoffmann's colleague at the Vienna School of Arts and Crafts and, eventually, a co-founder of the Wiener Werkstätte. According to Hoffmann,[20] Moser was "the driving element of this small group. . . . He was not content with anything and knew . . . how to interest and inspire us for every kind of Fine Art. . . ." "Painter Moser . . . thanks to his activity as an illustrator already knew more about the outside [art world] and henceforth gained the greatest influence over us. His talent for two-dimensional artistic design and every kind of arts and crafts invention appeared fabulous to us. He knew how to promote and stimulate everywhere. He excelled not only by his great imagination but equally by his practical and organizational abilities."

The regular architect members of the club were Hoffmann, Olbrich, and Friedrich Pilz, while Friedrich Kick, Jan Kotěra, Max Fabiani, and Joseph Urban came only as occasional visitors. Urban made himself unpleasantly conspicuous, according to Olbrich,[21] "by offensive expressions." With the exception of Urban, who had graduated from the Academy prior to Wagner's appointment, all the members had close relations to Otto Wagner and, at one time or another between 1893 and 1898, had gone to Italy for an extended tour of study. "The journey to Italy in the course of the life of an architect is the culminating point toward which he already looks longingly as a boy and youth, and which, after he has been there, still casts a lustre over his entire later life."[22] When these words were written to introduce a travel guide for young architects in 1838, the meaning of the journey to Italy for an architectural traveler was very different from what it was half a century later for a man of Josef Hoffmann's generation; yet he would still have understood and probably shared the enthusiasm of the earlier statement, for even another half-century later, in 1954, Alvar Aalto expressed a similar feeling when he wrote:[23] "In my spirit there is always a journey to Italy.

. . . Maybe a voyage of this kind is a *'conditio sine qua non'* for my work as an architect." The journey to Italy for architects and artists from Central and Northern Europe for a long time has had an emotional significance which transcended that of a simple tour of professional study; crossing the Alps into Italy easily turned into an experience of liberation, a step in the direction of artistic self-definition, and a widening of the artistic and human horizon.

When Hoffmann and Olbrich began their journeys of study, it had become habitual to include in one's itinerary countries other than Italy. Otto Wagner's opinion in this matter we know from his advice to Aloys Ludwig,[24] who had indicated that he wanted to tour Italy: "Don't look so long at the old trash, rather go to Paris and look around there." He was alluding, above all, to the great projects done at the Ecole des Beaux-Arts. While Hoffmann seems to have visited Western Europe only later in his career, others like Kick, Fabiani, and Olbrich from the outset included parts of Western Europe in their great tours of study; occasionally they also included extensions in other directions such as North Africa, and—like young Le Corbusier later on—the Balkans and Turkey.

Olbrich's previous travels probably influenced Hoffmann's choices of what to study on his own route, for he regularly exchanged letters with his friend while the latter was in Italy during part of 1894; there was even a plan to spend a month together with him and Kick in Naples some time in the spring of 1895. Olbrich had greatly enjoyed his days in the south of Italy but in Rome he was despondent and disappointed to such a degree that he wrote to Hoffmann:[25] "It is true Rome teaches what is great and mighty, but what for our time appears the highest to me—I did not find even in germ."

While in Olbrich's case written comments have survived that indicate in what manner he found something of value for modern design in certain buildings from classical antiquity and in anonymous vernacular architecture, no comparable letters have turned up from Hoffmann. All we have to work with if we wish to describe his interests and architectural attitude are two brief published articles (Cats. 4, 6), scanty autobiographical remarks, and the internal evidence his surviving travel sketches (Cat. 6) provide. Unfortunately, we cannot even be certain that these are a complete record since Hoffmann lost many drawings at the end of the Second World War. It seems odd, for example, that no drawings of Paestum have come to light, although there are a number of sketches from nearby Pompeii (fig. 8) and from the general area around Naples. Yet not only Olbrich wrote

9. Group of rural buildings, pencil

in glowing terms about Paestum; Hoffmann himself later remembered: "The confrontation with the first historic temple was, to be sure, an even more significant experience. The strong short columns with the widely projecting capitals that almost touched each other . . . the self-evident triangular form of the tympanon . . . had their exciting, stimulating effect." Elsewhere he wrote (Appendix 7): "I saw the Doric temple and suddenly it fell from my eyes like scales why I did not like the stuff learned at school. There we learned only the proportions of the average of fifty temples and their columns and their entablatures. Here I saw columns with capitals almost as wide as the height of the column [sic], and I was simply transfixed with admiration. Now I knew that what mattered above all was the proportion [?] and that even the most accurate application of the individual forms of architecture meant nothing at all."

Hoffmann set out from home in the autumn of 1895 and on the second of November sent a postcard to the Siebener Club on which he depicted the Batzenhäusel in Bozen (Bolzano), a country inn, and explained that he was en route to Verona. A humorous verse was also included[26] and the card was co-signed by Friedrich Kick

and Friedrich Pilz. In Bozen, Hoffmann also sketched, among other things, two Neoclassical street fountains which became the first in a series of studies dealing with street or garden fountains in Italy. Since there are sketches from Trient (Trento) and Verona, one can assume that Hoffmann, like so many famous travelers before him, entered Italy on the classical route from Innsbruck across the Brenner; he also followed a well-established pattern when he next turned to Vicenza and Venice. In Vicenza he sketched Palladio's Villa Rotonda, in Venice several interiors of San Marco and some typical views showing canals, bridges, and campanili. There are also a few drawings from Florence and one from Ancona.

By Christmas, Hoffmann had reached Rome[27] where at that time accommodations for scholarship holders from the Monarchy were provided in a tower of the Palazzo Venezia, then the seat of the Austro-Hungarian Embassy. The rooms "were kept in order by an old woman from Bohemia." The young architect wrote about Rome: "At first all impressions were overpowering, especially since the remains of architectural monuments from Antiquity had a shattering effect on me, an unemancipated architectural neophyte," and "I was desperate. All of-

18

10. Motif in the forecourt of the church of Santa Maria del Priorato on the Aventine, Rome, pencil, gray wash

11. Baroque portal, pencil, India ink

12. Roman city wall, pencil and watercolors

ficial, art-scholarly architecture failed to interest me. I was looking for new impulses at any price. Library studies and the perpetual learning of certain styles and architectural forms had spoiled me, had robbed me of the entire delight of seeing for the first time, and had dulled me to the true beauties of this divine land.''

Of Hoffmann's approximately two hundred known surviving sketches, roughly one-third deal with historic monumental architecture and its details and construction; one-third with fountains, mausolea, sculptures, objects in museums, and painterly subjects; the final third with vernacular architecture (fig. 9), urbanistic views, and gardens. Add to this the fact that more than a quarter of all the sketches are of antiquities, and it becomes clear that for Hoffmann the monumental architecture of the Renaissance and the Baroque played a very small role as a potential model for eclectic reuse, and that the Middle Ages were strongly neglected. This lack of interest in medieval architecture, typical of Hoffmann's Central European training, distinguished him fundamentally from his British contemporaries, chief among them Mackintosh, whose travel sketchbook includes several renderings of Italian medieval architecture.

Among the architectural views and details Hoffmann sketched, there are three separate studies, one of them a rather elaborate drawing with washes, of Piranesi's work at the forecourt of Santa Maria del Priorato on the Aventine in Rome (fig. 10). That he was particularly attracted by these very idiosyncratic and picturesque motifs is striking. He also drew some elaborate gateways, entrances to villas or palaces (fig. 11), and the usual details of cornices, frames, swags, and cartouches which at that time were still considered part of an architect's formal stock in trade. A number of drawings dealt with utilitarian or constructionally interesting buildings such as bridges, city gates and walls (fig. 12), fountains, and Roman vault constructions, reminding us that both Wanderley, his teacher at the Brünn Technical School, and Wagner, at the Academy, had stressed the importance of sound construction as a basis of architecture. In all of Hoffmann's drawings, however, the technique of representation and selection of view is such that a certain pictorial and even decorative appeal is never entirely neglected.

Most of the drawings Hoffmann brought back from Italy have the character of genuine travel sketches,

13. Studies after a picture, pencil

14. Motifs from the Via Appia, Rome, pencil

charming in their spontaneity or immediacy and the apparently effortless yet extremely precise handling of line and hatching, which sensitively achieves both the strongest and the most delicate effects. Some sheets, however, such as the elaborate perspectives of Baroque portals (fig. 11), obviously were carefully worked out and inked at the drawing board at home, and in some cases, though not many, washes, watercolors and colored crayons were skillfully used. At times one can sense the draftsman's pleasure not only in a motif and in the clarifying effects of the Mediterranean light on forms but also in his own skill in using the drawing as an effective tool of observation and discovery. As records and instruments of self-education and visual enrichment during a formative period in a young architect's life, these sketches recall Le Corbusier's comments in connection with his own travel sketches:[28] "When one travels and works with visual things—architecture, painting, or sculpture—one uses one's eyes and *draws*, so as to fix deep down in one's experience what is seen . . . all this means first to look, and then to observe, and finally perhaps to discover." Hoffmann's drawings, however, carry distinctly fewer written comments than those of Le Corbusier.

The great number of sculptures and objects Hoffmann sketched indicates an interest that goes beyond purely architectural concerns, as do some subjects of purely pictorial character including a copy after a painting (fig. 13). Most of the objects and sculptures were drawn in the museums of Rome, Naples, and Palermo and are from antiquity, as are the monuments and mausolea that Hoff-

mann sketched along the Via Appia (fig. 14). But as he went for excursions outside Rome, along the ancient Roman roads such as the Via Nomentana or the Via Salaria, or into the hills at Tivoli and Frascati (fig. 15), Hoffmann seems to have enjoyed nothing so much as the charm of parks and gardens with their old cypress trees, fountains, herms and other sculptures, and the play of light and shade on the ground, as well as the ever-changing irregular groupings of simple vernacular buildings such as farmhouses, barns, and stables (fig. 9). These and the anonymous architecture that made up the urban groupings, with their narrow roads and unexpected vistas, attracted him not only in Rome but also further south where he drew in Amalfi, Capua, Caserta, Naples, Pompeii, Pozzuoli, and above all in Capri (figs. 8, 16-18).

As he explained in his reminiscences (Appendix 7): "Finally I fled into the Campagn [*sic*] and refreshed myself at the simple peasant buildings. . . . There, for the first time, it became clear to me what matters in architecture. . . .

". . . probably it had to happen spontaneously that the simple yet specially characteristic Italian way of building . . . in the countryside and beyond official great architecture . . . would touch me deeply, because it had more to say to our effort to arrive at form by doing justice to purpose and material. . . .

"In my sketchbooks I had instinctively portrayed just these buildings . . . and in spring I took to the road for Pompeii and Sicily. . . . Then indeed every small town

en route was rich in suggestions of that self-evident, natural manner of building, and for me a revelation and confirmation. . . .

"I had experienced happy days, even feasts . . . and in Capri and Anacapri equally had been able to collect innumerable impressions of the unpretentious, natural way of building."

Hoffmann's especially enthusiastic reaction to Capri was entirely in keeping with a tradition that embraced several generations of artists before him. The island with its beautiful scenery and the remains of the palace of Tiberius redolent with classical associations had long been one of the highlights in an architect's trip to southern Italy. Weinbrenner visited it in 1794 and recalled it as "most unforgettable," because of the people he met, the scenery and the "romantic . . . little country houses."[29] Schinkel was twice in Capri, in 1804 and 1824, and was impressed by the local architecture, of which he made several sketches. In a letter to his cousin he praised "the prettiest little houses that in beautiful picturesque form and neatness surpass anything I have ever seen of rural complexes. . . . Simplicity, honesty and concord here live together closely united, I shall never forget my stay among these people."[30] Such comments clearly indicate that for him and other visitors the vernacular architecture of Capri was attractive for two reasons.

On the one hand was the purely visual charm of freely-arranged, simple white volumes which combined most picturesquely with pergolas and the surrounding vegetation. On the other hand was the strong sentimental appeal of the moral and other associations these forms evoked; one could delight in the vision of an uncontaminated country life in the manner of a paradise long since lost anywhere else, and in addition one could recall interesting theories in connection with these buildings, such as Semper's variations on the venerable theme of the simple hut as the origin of all architecture.[31]

The visual appeal had, of course, been long recorded in landscape painting, and certain picturesque building types came into architectural usage by way of a landscape architecture that was modeled on paintings.[32] A tradition of interest in anonymous Italian architecture[33] had existed already among architects in Central and Western Europe for approximately a century before Hoffmann too began to study these modest yet charming buildings. It seems very likely that in doing so he was at least encouraged, if not altogether influenced, by this tradition.

As far as the nonvisual, emotional appeal was concerned, it is obvious that the associations which these

15. Villa Falconieri, Frascati, cypresses on the water, pencil

buildings elicited through their evocation of simple, bucolic, morally admirable life can be traced back to the eighteenth century and Rousseau. But by the time the generation of Hoffmann and Olbrich looked at vernacular architecture, more topical reasons for social and moral interpretation were at hand. With the rise of ethnic na-

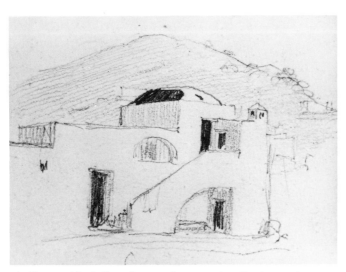

16. House with shallow dome and open stairs, Capri, pencil

tionalism in the multinational Austro-Hungarian monarchy, folk art and folkways had assumed a new, particularly future-oriented, meaning; after their discovery as traditions closely related to the roots of national grandeur by the Romantic poets and philosophers, they soon became highly relevant elements in the process of deliberately building up national consciousness and ethnic sensibilities.

In this sense, Ruskin's feelings[34] about the relation between such vernacular buildings as the Italian and Swiss cottages and the corresponding qualities of national character could be as much appreciated as the often-repeated admonitions of William Morris about "popular art, the foundation on which all art stands" (1881).[35] Morris here expressed the same thought that Eitelberger, the Austrian art historian and reformer of applied art, formulated in 1876:[36] "Nothing is more admirable than the folk in its artistic activity, a greater artist than any individual which ever existed." Eitelberger in turn had been a teacher of Camillo Sitte, who himself had strong feelings about the importance of national character and its relation to the arts and architecture,[37] and who was director of the State Technical School in Vienna when Olbrich studied there.

Of Capri, Olbrich wrote:[38] "Architecture here has not even achieved the complete fulfillment of the 'necessary,' much less embellished the necessary. Yet it is also good to cast a glance into the time when man demanded nothing from the 'art' of building except protection against the elements. Here the first traces of the carefree oriental way of building can be found." It is not surprising that

in this frame of mind Olbrich continued his journey to Tunisia and sketched anonymous architecture in North Africa.[39]

Hoffmann drew no less than eight views of Capri (figs. 16, 17), and used six of them to illustrate an article (Appendix 2) which, in 1897, appeared in *Der Architekt*. This was the second in a series of essays, the first of which had been entitled "Architektonisches aus der österreichischen Riviera" ("Architectural Matters from the Austrian Riviera").[40] A promised third article never appeared.

The first article dealt with Istrian vernacular architecture around Abbazia (Opatja, Yugoslavia), illustrated examples from Voloska and Lovrana, and included a sketch of Hoffmann's for a villa in the same area (Cat. 4). The brief text stressed how "situation and habits of life determine man's manner of building" and insisted that, "those architectural scenes . . . are free from overcivilized artistic connoisseurship, and yet in their original naturalness are of such great charm that it is well worth the trouble to occupy oneself a little with these children of naive, popular art." It is interesting to note in passing that in the same year, 1895, in which Hoffmann's sketches appeared in *Der Architekt*, sketches from Lovrana and near Abbazia were published in *The Studio*.

Hoffmann's second article, "Architektonisches von der Insel Capri" ("Architectural Matters from the Island of Capri"), demonstrates wherein, at the outset of his professional career, he saw the current problems of architecture. In this connection the subtitle of his essay, "Ein Beitrag für malerische Architekturempfindungen" ("A Contribution for Picturesque Architectural Sentiments"), indicates an approach that is much concerned with the purely visual qualities of architecture; this fits well with the interest in painterly aspects of architecture that Hoffmann had revealed in many sketches and with the fact that during the next years some of his work was to be as a graphic artist, or closely related to painting.

Having briefly mentioned the beautiful location and scenery of Capri, Hoffmann continued: ". . . the remarkable friendliness and contented serenity of its inhabitants and, what particularly charmed me, the still almost entirely pure, vernacular manner of building, render it dear and unforgettable to everyone. . . . The example of folk-art, as it actually exists here in these simple country houses, exerts a great effect on every unprejudiced mind and lets us feel more and more how much we miss this at home. . . . The example of Capri and of some other places . . . however, should not lead to the imitation of this way of building, but should only serve to

awaken in us a homely concept of housing, which consists not in decorating over the bad skeleton of a building with ridiculous ornaments of cast cement produced in the factory, nor in forced-on architecture of the Swiss or gable house type, but in a simple grouping, suited to the individual, full of understanding and sentiment, of uniform natural color and, where wealth permits it, with some sculpture—preferably less but from the hand of a real artist. . . . England in this is far ahead of us, but its taste, mostly indebted to medieval forms, ought not to be equally guiding for us; rather we ought to recognize England's interest in arts and crafts, and thus in the arts in general, and try to awaken it in our own context, but [we ought] to attempt time and again to search in our own being for our art forms, and finally to cast away forcefully the obstructive barriers of outdated style-mongering.''

The somewhat surprising association of Capri with the English Arts and Crafts movement shows that for Hoffmann this brief essay was in the nature of a programmatic manifesto; its statements about villas and country houses assumed all the more significance, since roughly two years later his first major commissions dealt with precisely this building type.

The longer one studies the travel sketches, the environment from which they sprang, and their meaning, the clearer it becomes why for Hoffmann and other architects of his generation anonymous Mediterranean architecture became so important. These vernacular buildings were not only attractive visually, but they also stood for a number of principles which appeared particularly relevant at this moment in history. On the one hand the buildings were understood as reflections of untroubled social conditions, as Hoffmann's remarks indicate when he speaks about the "remarkable friendliness and serenity" of the inhabitants and the absence of speculation. On the other hand they demonstrated a direct relationship between need and design response which was the very antithesis of the relationship that followed from the formalistic design method of historicizing stylistic eclecticism based on imitation. The architectural forms of these vernacular buildings were believed to owe nothing to the historic styles of "high art" and accordingly appeared acceptable as sources of inspiration, especially since they were supposed to be an inspiration in matters of principle, not of form.

It obviously is important to understand the vast difference in meaning that for the architects of this period separated "imitating" from "being inspired by" something. While with the avant-garde imitation was entirely

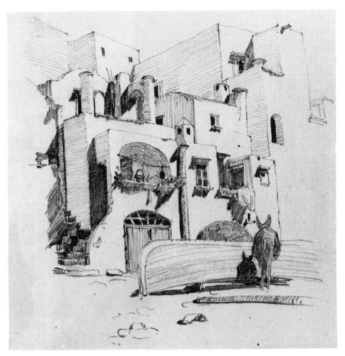

17. View of houses on Capri, pencil; preliminary drawing for an illustration in *Der Architekt*

18. House in Pozzuoli and sketch for a villa inspired by it, pencil

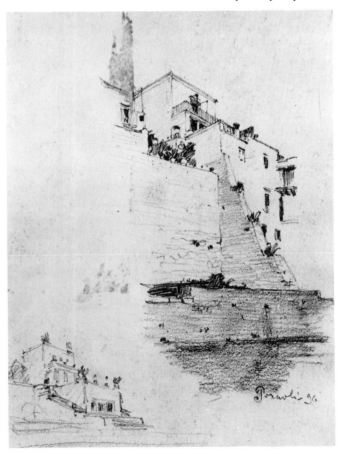

despised because of the lack of creative originality it implied, seeking inspiration from various sources seemed permissible—with the sources coming from further and further afield as more knowledge about cultures remote in time and place became more readily available: from Mycenaean-Minoan sources to the Far East, and from Ur of the Chaldaeans to the riches of pre-Columbian Indian culture.

It is not surprising that although he warned against imitation at the end of his article, Hoffmann was as little averse as Olbrich to accepting some rather direct inspiration from Mediterranean motifs. This is evident not only in the villa design he published together with his article of 1895 (Cat. 4) but also in a sketch from Pozzuoli of 1896 (fig. 18) which on the same sheet shows a flat-roofed, terraced vernacular building and underneath the direct transposition of this prototype into a modern villa. The young architect obviously felt in such a case that it was all right to accept the underlying principles of arrangement and such basic features as terraces and loggias from folk architecture, as long as they were used for a building that responded to identical conditions, and no stylistic copying of historic forms was involved.

Other designs by Hoffmann, "which the author brought back from his tour of study in Italy," were published in *Der Architekt* (Cat. 7), in *Ver Sacrum* I, and in the catalogue of the first Secession exhibition of 1898 (Cat. 18). These are less indebted to vernacular prototypes than to the studies of garden architecture, pavilions, and mausolea that the architect had done in Italy. Some of these drawings border on the fantastic and there is a peculiar sensuous quality about them, brought about by a number of devices such as graphic allusions to the atmosphere of a Mediterranean garden with its colors and scents and the incorporation into architecture of anthropomorphic forms that owe much to Hoffmann's studies of garden herms and fountain sculpture in Italy.

Several other pupils of Otto Wagner later published Italian designs, chief among them Emil Hoppe, whose extremely bold sketches at times strikingly anticipated the futurism of Sant' Elia,[41] and Wunibald Deininger who designed several villas. One of these, for Capri, was included, with two photographs of actual houses from the island, among the positive examples which Josef August Lux illustrated in his book *Das Moderne Landhaus* (Vienna, 1903). In 1904, Lux, with Hoffmann's support, began editing the periodical *Hohe Warte*, which among other things was much concerned with vernacular architecture and folk art. The editors obviously hoped to create a sound basis for a new movement in this manner, one that could take the place of the Secession style that was now defunct. Yet only a few years earlier Hoffmann had been instrumental in creating that style, when after his return from Italy he began to build a career in Vienna—at first as a designer in the office of Otto Wagner who at that time was engaged in work for the Vienna Metropolitan Railroad system. Hoffmann was entrusted with handling the bridge with granite obelisks at Gumpendorf, the Lobkowitz bridge station (today, Meidling Hauptstraße), and several other stations.[42]

II. Artistic Beginnings and Models

If a young Viennese architect of Josef Hoffmann's generation wanted to emerge with a distinctive artistic profile, coming to terms creatively with the outstanding achievement of Otto Wagner was an essential precondition. Wagner treated Hoffmann as a favorite disciple whom, like Olbrich, he would have liked as a son-in-law,[1] and whom later he even proposed as his own successor at the Academy. Yet, according to a comment made by his pupil Ernst Lichtblau,[2] Wagner also "was afraid of him." This statement can be interpreted in various ways, but perhaps its meaning becomes clearest if one compares two designs by Hoffmann and Wagner done at the same time and for the same program: the pavilion for the city of Vienna for the Emperor Jubilee Exhibition of 1898 (figs. 19, 20). The younger architect in this case obviously was closer to the European avant-garde of the moment than was his former teacher.

Both architects resorted to a tripartite symmetrical facade, with a higher central projection framed by two broad piers with decorative crowning elements. The solution thus belongs to the same typological group as Olbrich's early designs for the building of the Vienna Secession,[3] Hoffmann's studies for an exhibition pavilion *Artibus* (Cat. 18), and various executed pavilions of the Jubilee exhibition.[4]

Wagner treated his pavilion[5] not unlike some of the stations he had designed for the Vienna Metropolitan Railroad system. He articulated the building tectonically by stressing the horizontal and vertical lines without recourse to arcuated forms. The total impression tends to be severe and, compared to Hoffmann's design, even somewhat dry. Though Hoffmann treated the broad pylonlike piers with grooves in Wagner's manner, he showed overall much less interest in tectonic articulation, that is, in making visible artistically the relationship between load and support. Neither the central projection nor the side wings have a horizontal upper termination, and the segmental arch above the central projection is conceived in a most nonstructural manner. It meets the lateral piers without articulation or recognizable abutment, and instead of a keystone it has a decorative armorial motif which by means of freely-curving leaf forms merges with the upper half of the arch as if to suggest organic plant growth. Decorative vegetal forms play an important role

elsewhere too in the rich artistic treatment of the facade. In the presentation drawing the renderings of two trees, richly varied in their painterly effect, with tops stylized within a square outline, are elements which in their effect are as important as the architecture itself. The whole makes a more restless, decorative, and richer impression than Wagner's design[6] and clearly shows Hoffmann's eagerness to accept the most recent inspirations from Western Europe—in this case the integration of stylized leaf forms into the design.

Comparable arrangements of stylized leaves and blossoms, often—like the trees in the pavilion design—within an approximately square outline, are found not only in numerous drawings by Hoffmann for facades, furniture, and graphic patterns (Cats. 13, 18/IV, 30-34, 45, 46) but also in designs by Olbrich, such as the Secession building with its stylized laurel trees in stucco. Otto Wagner at the same period utilized similar forms as lateral borders for the facades of the apartment house in Vienna IV, Linke Wienzeile 38, completed in 1899. That the young Charles-Edouard Jeanneret (Le Corbusier) designed similar stylized plants[7] a few years later in the school of arts and crafts at La Chaux-de-Fonds is proof of the ubiquity of such motifs. Clearly their origin is to be found in the English Arts and Crafts movement, and Hoffmann may well have known the designs with stylized trees by Charles H. Townsend which, beginning in 1894, were published in *The Studio*.[8]

It cannot be established whether Hoffmann's stylized tree tops and umbels of blossoms had an allegorical or symbolic meaning, but considering the importance of symbolism in contemporaneous painting it seems very likely in some cases—for example, when stylized laurel leaves are used in the graphic decoration for the book *Viribus Unitis*, or when Eve is made to sit under apple tree capitals in the design for a Hall of Knowledge (Cat. 18/IV). Generally speaking, the use of such motifs suggests an incorporation of nature into architecture. (For example, the illusionistic wall paintings in the vestibule of Labrouste's library of Ste. Geneviève in Paris project a perpetual grove of trees onto the walls of the building.) For Hoffmann, however, the natural forms are unequivocally subject through strict geometrization to the formal intention of the architect. He prefers geometric forms

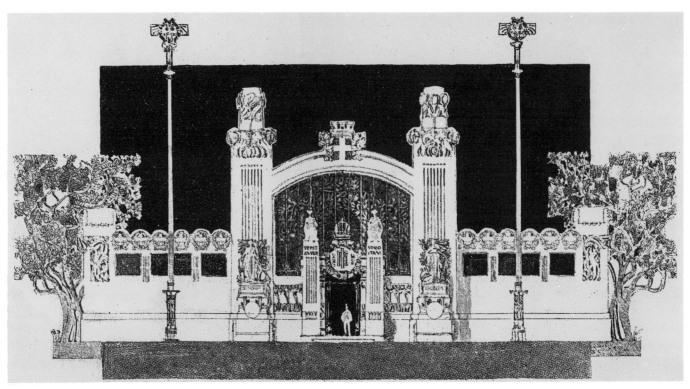

19. Exhibition pavilion of the City of Vienna for the Jubilee Exhibition 1898, competition design by Josef Hoffmann, facade

20. Exhibition pavilion of the City of Vienna for the Jubilee Exhibition 1898, design by Otto Wagner

even when he works with living plant material, as his utilization of spherically-cropped little trees in numerous designs shows.

In the interior of the exhibition pavilion (Cat. 11), both Hoffmann and Olbrich for the first time turned completely toward models from Western European Art Nouveau, with which at this time they became familiar through many exhibitions and illustrated articles in periodicals.[9] Whether one thinks of the interiors of Bing's shop *L'Art Nouveau* in Paris, the rooms at the 1897 Dresden exhibition and the Colonial exhibition at Tervueren, Brussels, or of the designs by Hankar and Horta, Serrurier-Bovy, Van de Velde and Sauvage, in every case one discovers possible models for the elements that characterize the pavilion designs by Hoffmann and Olbrich for the Jubilee exhibition—large three-quarter arches, stylized plant forms, and the fusion of built-in furniture with ascending wooden struts.

These and related elements were important constituents of the "Moderne," the new direction in architecture which Wagner welcomed and promoted. He had become personally acquainted with the new Belgian trend during seaside vacations in Ostende, and elements of it occur, in part, in his own works. However, owing to his rationalist and classicist fundamental attitude, what he took over became disciplined and changed in such a manner that the Viennese "Moderne" cannot be mistaken for Western European Art Nouveau. Where Horta and Guimard found inspiration in the world of medieval forms seen through the eyes of Viollet-le-Duc, for Wagner the world of classical forms, seen through the eyes of Semper, remained decisive.

As far as Hoffmann was concerned, a turning toward the forms of Art Nouveau beyond what Wagner was willing to accept offered the possibility for taking the first dramatic step away from too close a tie to his teacher. He had been invited to work for his admired master, and while this was a most gratifying corroboration of his own worth, it did nothing toward solving the most crucial problem in every beginning architect's career: that of becoming visible as an autonomous artistic personality to a public of potential clients. Hoffmann was eager to make a name for himself through independent artistic work, and with this goal in mind he intensively utilized such free time as the work in Wagner's office left him. In this he was able to turn his proven graphic talent to good advantage.

During his last student year, he had drawn vignettes and perspectives for *Der Architekt*, and in the following two years he continued to provide various decorative

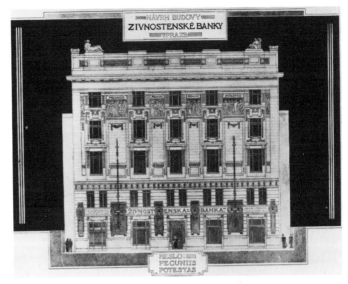

21. Competition design for new building of the Trades Bank in Prague, facade (Josef Hoffmann and Franz Krásný)

drawings, among them two vignettes (Cat. 9) that most likely can be considered symbolic self-representations: they show the head of a youth, with a wooden triangle of the kind used in architectural drafting, and with a peacock feather, that essence of the aesthetic experience.

The connection to a professional journal provided an easy opportunity for Hoffmann to publish not only his graphic art but also his essays, sketches of existing buildings, and above all designs. Indeed, a competition design by Hoffmann and Franz Krásný for a bank building in Prague (Cat. 10) (fig. 21) was illustrated even though it had not won an award. Krásný studied in Otto Wagner's class in the same year as Hoffmann and in addition came from the same part of the Monarchy as his colleague. However, he was five years older and possessed greater practical experience in building. In 1895 he was awarded the Pein Prize of the Academy, and several of his projects were published in *Der Architekt*. He was also active as a building contractor and as such carried out the first houses Hoffmann did at the Hohe Warte (Cats. 52-54, 63).[10]

It is not surprising that the competition project for the Prague bank, dated from the beginning of 1897, shows Hoffmann still in the wake of Otto Wagner. From his teacher's project for the Länderbank in Vienna (1883-1884),[11] he adopted the device of a centralized space as a vestibule mediating the transition between the obliquely angled wings of the building. The only difference was that where Wagner had a circular rotunda, Hoffmann envisaged an oval room. The treatment of the facade

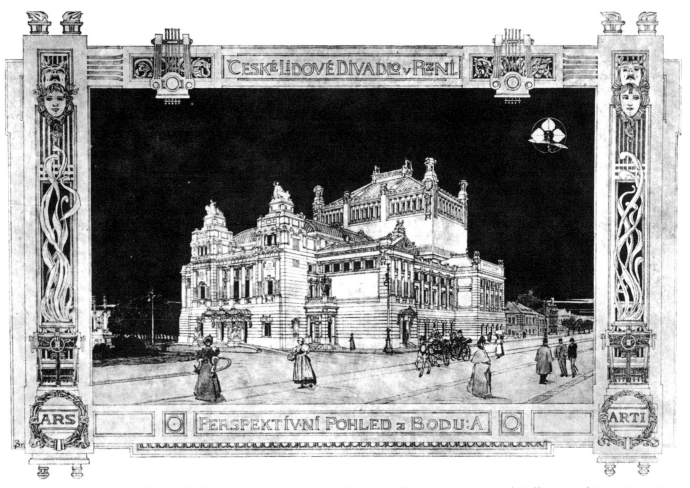

22. Competition design for the new building of the Czech People's Theater in Pilsen, perspective (Josef Hoffmann and Franz Krásný)

adopts the typical articulation of Wagner's apartment houses: a high, two-storied, grooved socle terminating in a fully-developed intermediary cornice supports the multistoried main body of the building, which is crowned by a widely overhanging entablature with mutules on the soffit of the cornice and topped by a tall balustrade. In addition, Hoffmann's design, like the nearly contemporaneous elevated stations of the Metropolitan Railroad system, treats the facade as a surface with several layers. Elements of the facade are planar and in part display an atectonic treatment while at the same time they are made to interlock and fuse in such a way that visual ambiguity results. The composition is held together by an extremely simple geometrical scheme of proportions: except for the low lateral strips, it is inscribed in a square whose side is identical in length to the total height of the building from street level to the highest point of the crowning sculptures; a third of this height is allotted to the socle story. Compared to the facade solutions submitted by others, including Wagner's pupils Jan Kotěra

and Adolf von Infeld, the design by Hoffmann and Krásný shows a better feeling for rhythm and contrast as a means of achieving effect, and a greater radicalism in its striving for general simplicity and avoidance of direct borrowing from historical sources.

Unlike this bank design, a second competition project from approximately the same period—it was submitted roughly four months earlier—had no direct models in Wagner's oeuvre. This was a design for a theater building, the Bohemian Volkstheater for Pilsen (Cat. 8) (fig. 22). Wagner's influence can be detected nevertheless, both in the rationalism of the total treatment and in the reticent severity of the facade with its marquee in visible glass iron construction. A comparison with a theater design[12] Olbrich had done three years earlier for Hasenauer at the Academy illustrates the difference between the older manner, which strove primarily for decorative effects, and the rationalism of Wagner's pupils Hoffmann and Krásný.

Their project shows that they had familiarized them-

28

selves with all the problems of theater planning as they were discussed in the relevant technical literature of the period—chief among them the problem of maximum fire safety. Hans-Christoph Hoffmann[13] has compared the layout of their auditorium with that of the Deutsche Volkstheater in Vienna and has pointed to the works of Heinrich Seeling as models for the general disposition of the plan. Not only had Seeling planned numerous theaters with a staircase arrangement he had invented but he was also the author of the section on theater building in the *Baukunde des Architekten* that had appeared in Berlin in 1895.

It is probably indicative of the way Hoffmann was influenced by the Western European avant-garde that following these projects he did not participate in any competitions for monumental buildings or urban apartment houses but turned his attention to individual houses and above all to the decorative arts, furniture, and interiors. Particularly useful to him in this connection was his association with the newly founded Secession, the Vereinigung bildender Künstler Österreichs, which in its general assembly of 21 July 1897[14] unanimously elected him a member, two months after he, together with other Secessionists, had canceled his membership in the Künstlerhaus. At that time the Künstlerhaus stood for tradition and academic routine while the Secession set itself the goal of educating the public to appreciate the art of the avant-garde.

The Secession began its activities at a moment of important artistic as well as political change. Not only was there a demonstrative turn toward the radically new in the arts, but the appointment of Lueger as mayor of Vienna, against the wishes of the Emperor, marked a new political chapter as well. Lueger took office only a few weeks before the Secession was founded. It was the mayor himself who, together with the city councilor Dr. Mayreder, won approval for the permit to construct the new Secession building by obtaining "a majority for the project that cut across both factions."[15]

The role of "house architect" of the new association fell to the founding member Olbrich. The framework of harmonious cooperation, however, was sufficiently broad in scope to permit the artistic deployment of his friend Hoffmann. Hoffmann was assigned the special task of arranging the rooms for the Secessionist periodical *Ver Sacrum*. Accordingly, for the first exhibition he designed the *Ver Sacrum* room (Cat. 14), intended to propagandize the new journal, and for the second exhibition (the first one in the new building of the Secession) he designed the editorial room (Cat. 16). For the fifth exhibition,

toward the end of 1899, he once more designed a *Ver Sacrum* room (Cat. 27).

The *Ver Sacrum* rooms of 1898, the *Viribus Unitis* room in the Jubilee exhibition of the same year (Cat. 15), and the contemporaneous studio furniture for Kolo Moser (Cat. 17) indicate the manner in which Hoffmann had learned the lessons of Western European Art Nouveau and the English Arts and Crafts movement. He strove throughout to create unified rooms wherein the walls, ceiling, and furniture functioned together, and he worked with strong effects of color and material such as, in the manner of Baillie Scott, contrasting shiny copper mountings with wood stained blue or green. He also employed patterned draperies of English inspiration and stenciled wall paintings of the kind Frank Brangwyn had designed for the facade of Bing's shop *L'Art Nouveau*.[16] The flat boardlike elements from which he constructed his furniture are sawed in various, always curving, forms which include stylized plant and animal shapes as well as references to classicist palmette ornaments and abstract geometric linear patterns. Forms borrowed from palmettes are among the features that most distinguish Hoffmann's Secessionist ornamentation from the decorative treatment of other Art Nouveau artists. His artistic choices for these designs were a matter not just of visual effect but also of principle, especially in the use of techniques appropriate to the nature of the material. This artistic honesty dictated, for example, that one type of wood could not be stained the color of another kind of wood in order to falsify its appearance. Hoffmann once explained that "staining serves to achieve colors that do not occur in natural wood, and therefore do not copy any. Thus gray, blue, and green are proper above all. . . . We have to present everything as it really is" (Appendix 7). Presumably the shock effect of the unusual coloration that occurred as a by-product of a faithful adherence to such principles was not unwelcome.

In the text accompanying a published selection of works by Hoffmann from this early period, Adolf Loos wrote:[17] "I find it difficult to write about Josef Hoffmann because I stand in strongest opposition to that direction represented by young artists not only in Vienna. For me tradition is everything, the free activity of imagination for me only secondary. But here we are dealing with an artist who with the aid of his overflowing imagination succeeds . . . in attacking all traditions." Thus Loos displays a critical but not unfriendly attitude toward Hoffmann. This is compatible with the fact that in July 1898 *Ver Sacrum*, with Hoffmann on the editorial committee, published an article by Loos about "our young archi-

23. Designs for interiors

tects," accompanied by design sketches of Hoffmann's. By contrast Hoffmann was not willing to accept his articulate, widely-traveled colleague from Brünn as his equal for design work in the ambience of the Secession. When Loos offered to furnish an interior he was turned down,[18] and this together with purely personal motives must have been one reason for his later animosity toward Hoffmann, which in Vienna became a proverbial legend wreathed by anecdotes.

Hoffmann's numerous published sketches (Cats. 18, 19) (fig. 23) are even more telling evidence of his "overflowing imagination" than the works that were actually carried out and therefore had to be amenable to fast and comparatively inexpensive execution. Some of these drawings show Hoffmann still entirely under the spell of the same architectural monumentality that had informed his Rome Prize project. Thus the Hall of Knowledge which was published in *Ver Sacrum* (Cat. 18) might have been an interior from the Palace of Peace. The symbolism of a seated Eve under apple tree columns might however also be interpreted in relation to Hoffmann's private life. For him, the erotic seems to have

been as closely connected to artistic potency as it was for Gustav Klimt. The large *mascherone* above the tree tops in the Hall of Knowledge suggests an architectural anthropomorphism that occurred elsewhere in Hoffmann's designs from this period. It seems to be related to the biomorphism that finds its most striking expression in three sketches for the entry of a house (Cat. 18) (fig. 24) that were illustrated in *Ver Sacrum*.

In these designs, Hoffmann abandoned two-dimensionality in the use of curved forms in favor of spatially-modeled curvatures that enabled him to achieve a dramatic fusion of form and space: his canopy, vaulted in the form of a thin shell, unfolds like one of Loie Fuller's billowing silk scarves. It is not surprising that these sketches more than any others attracted the attention of both contemporary and later writers about Art Nouveau and invited comparison with creations by Horta, Guimard, and Gaudi. In Hoffmann's architecture, however, the sketches remained without direct sequel, even though the year 1899 offered ample opportunities for the execution of his ideas.

The beginning of the year brought significant success

with the positive critical reception of the design for the third exhibition of the Secession (Cat. 22) that had been entrusted to Hoffmann alone. His effective presentation of Klinger's *Christus im Olymp,* in particular, demonstrated his ability to employ bold contrasts of brightness, color, and spatial treatment in order to display the work of art to advantage. In learning how to do this he must have profited greatly from his close contact with painters. Klinger himself was very pleased with the arrangement of the exhibition and Max Schmidt in his Klinger monograph (Leipzig, 1899) describes an ideal presentation of the picture that leads one immediately to think of Hoffmann's creation: "one should think of this work at the end of a long, solemn room . . . the path to it enclosed by laurel trees . . ." (p. 130).

In the third exhibition, as well as in the fourth which opened two months later, Hoffmann also took advantage of the opportunity to exhibit furniture of his own design: in the third exhibition, a cabinet and the "cartlike" chairs from Moser's studio, and in the fourth exhibition a total of six pieces which he placed in the decorative arts room he had arranged. In addition, the furnishings of the secretariat were his work. He also designed the Gray Hall (Cat. 25), with its curving wooden latticework in forms that are typical of the high point of Hoffmann's curvilinear Secessionist phase. In addition to many unexecuted designs (fig. 23), this phase subsequently included halls for the fifth exhibition (Cat. 26) and the room for the Vienna School of Arts and Crafts at the Paris World's Fair (Cat. 38).

If one considers the importance of the early Secession exhibitions for Viennese cultural life, it becomes clear that Hoffmann had found the ideal opportunity to introduce himself to a circle of potential clients who were art lovers, progressive minded, and in possession of ample financial means—in short, those patrons from the ranks of the liberal *haute bourgeoisie* to whose support and acquisitions the Secession owed its very existence. It was actually from this circle that in 1899 the first commissions came to Hoffmann, among them two very different projects which deserve special mention.

One was the arrangement of a shop in Vienna which was likely to make the architect the talk of the town: the city branch of the Apollo soap and candle factory at Vienna I, Am Hof 3 (Cat. 31) (fig. 25), whose owner, the patron of the arts Felix Fischer, was also one of Olbrich's first clients. The other project was the adaptation and interior design of a small, inaccessible hunting lodge, far from Vienna, the Bergerhöhe in Hohenberg, Lower Austria (Cat. 32), formerly a peasant house—a

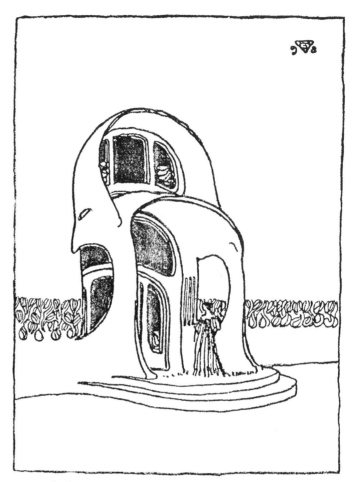

24. Study for entrance to a house with strongly modeled forms

work which would have remained completely unknown had the commission not come from Paul Wittgenstein, a member of one of the most important families of industrialists in Austria. The shop has since been destroyed, but the lodge interior still exists.

The permit for the remodeling of the Apollo shop was issued on 6 June 1899, and Hoffmann's friend Krásný was the building contractor. The shop front, with its iron arch in the guise of a floral composition (Cat. 31), anticipates in an amazing fashion a motif destined to become world famous through Guimard's Parisian Métro stations.[19] For Vienna at that time it represented a unique, novel, and striking solution; in propaganda value it vied with the shop interior, which had been carefully composed for a maximum effect of prestige.

The Apollo shop invites comparison to the contemporaneous law office of Dr. Brix (Cat. 30), because both modify motifs that typologically belong to another realm. In the law office a niche that is enclosed by a quasi-

31

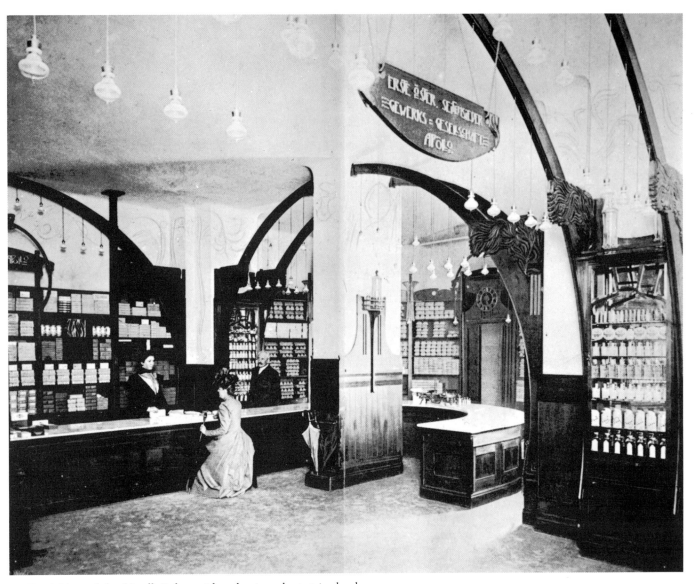

25. Furnishings of the "Apollo" shop with arches in walnut stained red

triumphal arch and closed by a curtain houses not an altar or a statue, but the safe. Similarly in the Apollo shop, artistic means that had their origin in entirely different functional contexts were pressed into service for the sale of commodities. In addition to richly-crafted wall brackets, there is a stained glass window, an organ-like composition (made of candles) and a rich, festive illumination produced by electric lamps freely suspended from the ceiling. As in so many designs from this period, wooden three-quarter arches provide the main motif. They represent a form that has been stripped of its original structural and tectonic significance. Although as linear elements they are very effective visually, they are

no longer unequivocally legible architecturally. Obviously they no longer perform the constructional function of true arches, but they still span the space like the arches of a metal bridge and therefore have a dynamic effect. These dynamics are so strong that the effect even includes the apparent perforation of a solid masonry pier. The lower portions of some of these arches become the sides of built-in showcases. This increases their ambiguity and makes them typical representatives of something that occurs time and again in Hoffmann's oeuvre: a design element that may be read in different contexts and interpreted in more than one way.

Thus in the facade design for the pavilion of the city

of Vienna (Cat. 11), discussed above, the semicircular curves which form the upper conclusion of the side wings may be read either as parts of a crenelated crowning feature made up of segments of arches, or as parts of circular heraldic escutcheons. The facade design for houses in the Kärntnerstraße, on the Donnergasse corner (Cat. 13), provides a triaxial triumphal arch between the buildings. Its two external "piers" are not freestanding but are embedded into the adjoining facades in such a manner that they serve at the same time as bounding elements for the socle of these facades. Accordingly, they may be seen either as parts of the triumphal arch or of the facades, and there is no indication that one interpretation is more correct than the other. The catalogue cover Hoffmann designed for the tenth Secession exhibition in 1901 (fig. 26) is indicative of his inclination to exploit such ambiguities: the design is based on an ambiguous figure-ground composition developed from the figure 10, which at first appears to be a purely ornamental form. Kolo Moser, Hoffmann's close friend, designed numerous patterns[20] based on comparable ambiguous figure-ground compositions and thus anticipated what a half-century later Konrad Escher was to exploit successfully in many works.

In a short essay in 1897 on the vernacular architecture of Capri (Appendix 2), Hoffmann stated: "It is to be hoped that with us, too, sometime the hour will strike when the wallpaper, the ceiling painting, as well as furniture and utensils will be ordered not from the dealer but from the artist." Two years later, his wish found fulfillment in the Bergerhöhe adaptation commissioned by Paul Wittgenstein. Here Hoffmann found the opportunity to design not only a set of furniture as he had for Kolo Moser's studio but an entire, albeit small, interior. He took full advantage of the chance to create something which corresponded to the Secessionist ideal. Hermann Bahr had expressed that ideal in the spring of 1898:[21] ". . . a room . . . should express something of the soul; everything in a room must be like an instrument in an orchestra, the architect is the conductor, the whole should produce a symphony. . . .

"Above the door a verse would be written: the verse of my being, and what this verse is in words, so should all colors and lines have to be, and again every chair, every wallpaper, every lamp, always the same verse. In such a house I would see my soul as in a mirror everywhere."

The "verse" the client had written above the entrance of his house at the Bergerhöhe (fig. 27) is a quotation from Luther—"the house of peace in stillness"—and it

26. Catalogue cover for the 10th Secession Exhibition, 1901

conveys very clearly the mood he wanted in his surroundings. Paul Wittgenstein was not only an industrialist; he also had serious literary and artistic interests. Among his friends he counted painters from the circle of the Secession such as Bacher, König, and Lenz, and he was not without talent as a draftsman and painter himself. Unfortunately, in his last will he ordered the destruction of his entire oeuvre. During his lifetime he remained faithful to Hoffmann as a client. He commissioned him to design an evangelical church in St. Aegyd (Cat. 74) (fig. 70) and to furnish his apartment in Vienna (Cat. 203). In addition, he enjoyed spending a good deal of time in the house Hoffmann had designed for his wife's sister, Helene Hochstetter (Cat. 111), and with her he finally shared the simple, Spartan last place of rest (Cat. 163), also designed by Hoffmann.

At the Bergerhöhe house a rustic simplicity appropriate to its setting prevails in the treatment of the exterior (fig. 27). The handling of the interior, however, with its spatial, formal, and coloristic richness corresponds to a style of life that is not at all rustic and to a striving for modernity without compromise. Such an

27. House on the Bergerhöhe remodeled by Hoffmann, entrance

amalgamation of elements belonging to a conscious regional tradition, with others inspired by the international avant-garde, corresponds to the cultural and societal situation that influenced the majority of Hoffmann's clients in the period before World War I. Anglophilia and an enthusiasm for popular art and peasant customs were completely compatible in this context.

At the Bergerhöhe, just as in Moser's studio and in the Apollo shop, the large arch motif derives from Belgian Art Nouveau, while England seems to have contributed the idea of a window seat, the drapery and other fabrics,[22] as well as the manner in which the writing desk has been given a simple form. The total result, however, with its carefully coordinated forms, colors, and textures is not simply a compilation of elements but is a meaningful and coherent composition. Its constituent parts are treated differently according to their function: in the living room (fig. 28), for example, the wall is covered by simple wainscoting stained in a cold greenish hue that harmonizes with the tiled stove; in contrast, the bedroom walls above a richly detailed dado are covered by a fabric in warm hues of red and yellow. Moreover, in keeping with the more intimate scale and character of this room, the decorative treatment of carved elements in wood is richer and more minute than in the living room. Yet the contrasts never destroy the coherence of the whole; instead they introduce animating tensions. In the same sense, the swing and counterswing of the large arch forms can be experienced either as thrusting or withdrawing.

34

Two monograms mark the work: the P W of the client inside the *sopraporta* of the entrance door and the J H of the young architect in one corner of the wainscoting.

In addition to the works that have already been discussed, Hoffmann began a number of others in 1899 that were completed only in 1900. Among these the prestigious commission to design a contribution to the Paris Universal Exposition of 1900 was destined to have many positive consequences. Artistically and otherwise, 1899 was a decisive year in Hoffmann's career. In the spring he was invited by Felician Baron von Myrbach, the newly appointed director of the Vienna School of Arts and Crafts, to become a professor at that institute, which at the time was in a state of reorganization. It was an honor that Olbrich did not share although his name had also been proposed. Subsequently, in the fall of that year Olbrich accepted an invitation to Darmstadt, leaving the field in Vienna wide open for Hoffmann, whose friend he remained despite these events. The appointment of Hoffmann as well as that of Kolo Moser and Alfred Roller was part of a grandly conceived reform of education and training in the decorative arts, which included the appointment of a new director to the Austrian Museum for Art and Industry, Arthur von Scala. However, after a short period, he shifted his department in a direction entirely different from that of the school, which led to difficulties for everyone concerned.

In order to realize what the appointment as professor meant for Hoffmann, it must be remembered that he was then only twenty-nine years of age and four years out of school. In addition to a guaranteed regular income, he now had the support—not to be underestimated in the Viennese setting—of "k. k." (kaiserlich königlich [imperial royal]) position and title. But there were also nonmaterial advantages which must have been as important as the practical ones. Hoffmann was now able to share ideas and work in what, at least for the first years, was an ideal community of artistically likeminded members of the Secession (Myrbach, Moser, Roller). He was also in a position to follow the model of Wagner's school and to carry out experimental work with talented students. In the following years, student work from Hoffmann's class began to appear in the pages of professional periodicals, and graduates from these first years later played an important role in Austrian architecture. Hoffmann's own employees were chiefly recruited from among his pupils, just as his artistic collaborators—sculptors, ceramicists, and decorative artists—came mainly from among the teachers or graduates of the School of Arts and Crafts.

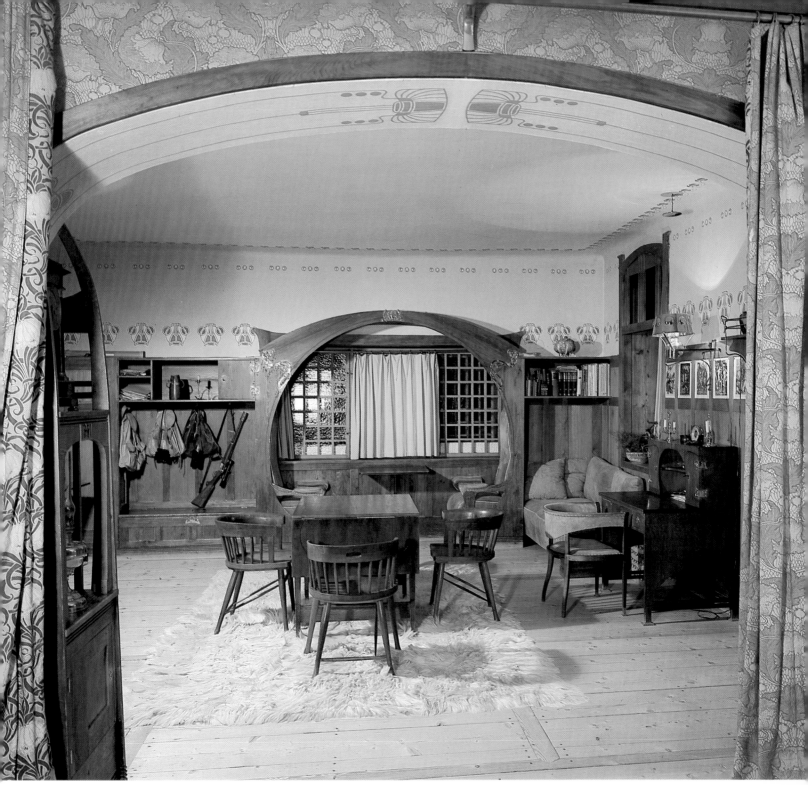

28. House on the Bergerhöhe, view from the bedroom into the living room

In view of his proven record as a designer of exhibitions for the Secession, the newly appointed professor was the obvious choice when the time came to commission someone to design the room of the Vienna School of Arts and Crafts at the Paris Universal Exposition of 1900 (Cat. 38), a task that for various reasons possessed special importance. For one thing, it meant presenting before an international forum the first results of the Monarchy's latest reform movement in education for arts and crafts; moreover, in Paris one was on particularly critical ground and faced an unusually sophisticated public.

Hoffmann seems to have conceived the room as a symbolic grove of the muses, as is indicated by the pictorial representation that fills one wall. He intelligently avoided overloading the space with examples of student work in the arts and crafts. This facilitated the viewing of the bounding wall surfaces themselves. Together with the ceiling they were decorated with patterns of lines that maintained the dynamism of vegetal forms while being geometrized and abstracted to a large degree—"in the manner of the School of Glasgow," as a contemporary critic felt moved to remark.[23] Graphic works of small format could be viewed separately in a small entry room, which proves again how much care Hoffmann took in each case to show works of art in a setting that would display them to their best advantage.

This feature also impressed several critics in the rooms for the Secession that Hoffmann designed in the *Grand Palais* (Cat. 39). There the treatment of the walls, basically avoiding strong curves and striking forms, was conceived entirely as an enlarged framing for the pictures whose character also determined the wall coverings. The room for larger, monumental, paintings, with dark, highly polished woodwork, and the decoration of the wall surfaces, strove for a more solemn mood than the room for watercolors, with its undecorated walls and the matte transparent glaze on applied maple. "One can say without hesitation that no section of the art exhibition has been arranged with more taste or a sharper sense for the value of the works on display than that of Austria," wrote the French critic Gabriel Mourey, and he recommended it as an example to French exhibition organizers. His countryman Arsène Alexandre was equally full of praise, and commented: "The Secession sought to give a lesson in elegance to the whole world . . . and in this was completely successful." No less an authority than the Belgian painter Fernand Khnopff quoted this passage in a laudatory report on Hoffmann and his achievements in Paris.[24] Hoffmann's success with these rooms and

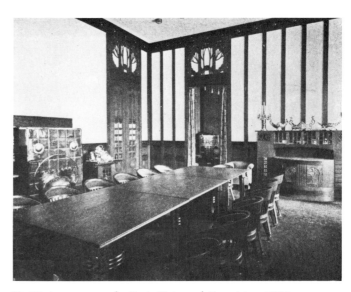

29. Dining room at the Paris Universal Exposition, 1900, executed by W. Hollmann in oak stained gray green, upholstery in yellow leather, stove of yellow tiles

several others he had designed for Viennese cabinet-making firms (Cats. 37, 40) (fig. 29) was recognized officially by the Cross of the Knight of the Order of Francis Joseph, which was awarded to him on 15 March 1901.

The reticence that characterizes the design for the Secession rooms in Paris cannot be explained by Hoffmann's sensitivity to the needs of the works of art alone; it also indicates a fundamental change of style in his oeuvre. This change begins to be recognizable as early as 1900 and is characterized by a turning away from the abundance of curves found in the early Secession style. In this connection, two architectural sketches (Cat. 43) published in *Ver Sacrum* in March 1900 are particularly remarkable. They are illustrations for Alfred Lichtwark's essay *Palastfenster und Flügelthür*, representing a hall and a tall window seat (fig. 30). Hoffmann, in a later autobiographical statement (Appendix 7), points specifically to Lichtwark's publications as one of the influences that brought about a change in his thinking. The straight-lined, simple character of the Lichtwark illustrations had its exact parallel in the formal treatment of the eighth exhibition of the Secession (Cat. 47).

During the preparation of this exhibition, Hoffmann wrote a letter which perhaps was never mailed but which has survived in its original handwritten draft in the Secession archives. No addressee is given, but the contents suggest that it might have been intended for Bing's gallery *L'Art Nouveau*. For our purposes, the passages of greatest interest clarify Hoffmann's new attitude to-

ward the curves of Art Nouveau. He obviously was criticizing a drawing that had been sent to him and that in all likelihood was by Van de Velde's own hand. This would explain why soon afterward, in a review of the Düsseldorf exhibition, the Belgian artist decried "the spoiled inventiveness of the Viennese." Hoffmann condemned the design that had been transmitted to him in the following words:[25]

". . . to me the design appears flawed and incapable of execution in every way. I am eager to show something exemplary to the public and therefore I have to tell you this. The reasons also. I absolutely cannot admit a sin against the wood fiber. Disregarding the extremely festive lines—kindly regard the manner in which the curves are touched tangentially by the straight planes—the gentleman who did this design doesn't have a clue about construction. This is precisely what we ourselves dread like poison as false Secession. The above design could be carried out correctly only in bentwood. . . .

"Further, please regard the showcases, what kind of bent glass is desired. It is astonishing that somebody could invent such a thing.

"You will forgive me if I ask you to spare us this misfortune and rather have the arrangement designed by us instead. I promise you to do this better and certainly more effectively. Your works shall definitely profit. We know our native techniques better and therefore work more easily.

"I would not dream of having your design sawed out of ordinary wood like some jig-saw work. . . .

"You must not take my forthrightness amiss, it can only affect your architect, who perhaps believed that he had to stage something in some hinterland.

"Heaven be thanked the time of false curves is already past with us, and we above all fully respect every material. You must not judge our arts and crafts in the light of the Paris exhibition where the better things were not to be found."

The slogan of a "false Secession" probably comes from Hermann Bahr, the ideologist of the Secessionists, who in an article of November 1899 described how in a short period the whole of Vienna had become Secessionist but unfortunately in the sense of a misunderstood, vulgarized Secession: "What today we call Secession, what we see on all roads, what has become a loud fashion, is a false Secession; that, the first, the genuine, the true [Secession] must dissociate itself from it if it is not to perish miserably."[26]

According to Bahr the renewed turn toward a construction true to materials was owed to "the Americans":

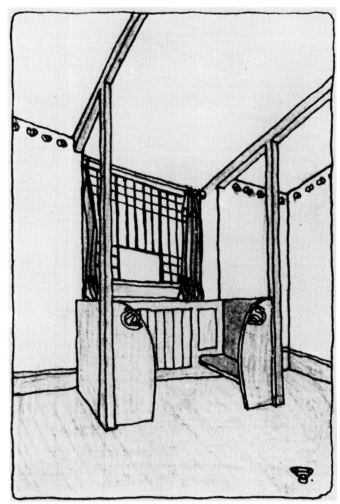

30. "High window bench," illustration for Alfred Lichtwark, *Palastfenster und Flügelthür*

"From them we learn to listen to the will of the material."[27] But for Hoffmann a return to the doctrines of Otto Wagner would have been the more obvious response to his concern about the superficial imitation and commercialization of the new style that could be observed everywhere and, in addition, to the apparent impossibility of sustaining for any length of time the formal overstatement and unrest of Secessionism. Moreover, Hoffmann's rebellion against the curves of Art Nouveau and his turning toward simpler forms must be seen in the historic context of the more general turning away from Jugendstil that in Germany began around 1900 and went hand in hand with a revival of classicist ideals.[28]

It was in this spirit of a stylistic change of direction that Hoffmann developed an interest in C. R. Ashbee and his simple furniture, and in a letter of 20 April 1900, requested the director of the School of Arts and Crafts[29]

"to visit in London the Guild of Handicraft in Essex House [where] . . . Aschbee [sic] works." Hoffmann solicited contributions for the fall exhibition of the Secession from Ashbee who accepted the invitation and sent several pieces, among them a writing cabinet that was placed in the middle of the central hall (Cat. 47). His furniture had a heavy simplicity, "as if it came from a foursquare planet that is inhabited by square-built peasants . . . essentially it is English Biedermeier, simple, sound, ponderous."[30]

Hoffmann's admiring interest in the most recent developments in architecture and the arts and crafts of Great Britain is easily explained: numerous newly founded illustrated periodicals together with *The Studio* provided ample information about British developments. Moreover the whole revival of Austrian arts and crafts, including the founding of the Austrian Museum for Art and Industry and its School of Arts and Crafts, had been directly inspired by English models. The energetic new director of the museum, Hofrat von Scala, had returned from an extended stay in England full of genuine admiration for the British lifestyle and domestic furniture. At the beginning of his tenure, when he organized an exhibition of English models as a source of inspiration for Austrian craftsmen, he met with general approbation. The young artists believed that in him they had found an ally for their plans of reform; ultimately, however, it became clear that in the last resort he wished to promote not the "Moderne" but historicism once more, thus working against the progressive tendencies of the School of Arts and Crafts and the Secession.[31] It is against this background that one must see the polemics of Hoffmann's essay "Simple Furniture" (Appendix 4) and the eighth exhibition of the Secession (Cat. 47) which was entirely dedicated to modern arts and crafts. Here, in addition to Ashbee's creations, work by Charles Rennie Mackintosh and his wife, Margaret, was prominently displayed.[32]

Hoffmann may have been familiar with the work of the Scottish artists from articles in *The Studio* XXII, 1897, and *Dekorative Kunst* III, 1898/1899. Perhaps he also saw the pieces of furniture by Mackintosh in Munich which were in the possession of H. Bruckmann, the publisher of *Dekorative Kunst*. Hoffmann must have been in contact with Bruckmann since the periodical often published his own work. At any rate, what Hoffmann knew of the Scotsman was so interesting to him that he dispatched his friend and later business partner Fritz Wärndorfer to Glasgow in order to establish a direct connection with artistic circles there. This was accom-

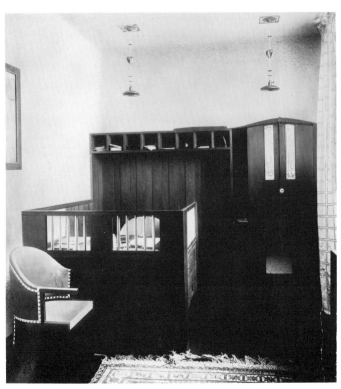

31. House for Dr. Hugo Henneberg, study. The desk was designed by Hoffmann to match the furniture by Mackintosh next to it.

32. C. R. Mackintosh, design for a bed, India ink and watercolors, 1900(?)

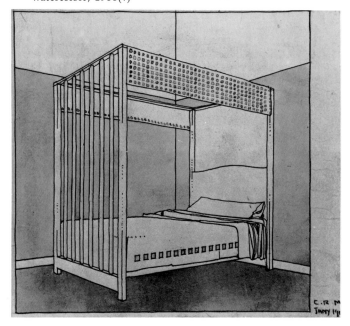

plished in the middle of 1900 as part of the preparations for the eighth Secession exhibition. Wärndorfer in this case was an ideal go-between because he had the closest possible links with Britain,[33] through education, personal inclination, and owing to trade connections of his family who were in the textile business.

Charles Rennie and Margaret Mackintosh contributed a sensational tea room to the eighth exhibition. They also came to Vienna personally where, after a triumphal reception, they were so successful that ten years later an Austrian visitor to England could still report:[34] "Mackintosh is said to consider his Viennese journey the high point of his life!" An enthusiastic reviewer said of the tea room in the eighth exhibition:[35] "The inner truth of these works . . . has an overwhelming effect. The severity, purity, simplicity, and ardor of this construction makes one recognize the contrast between the design, charged with life, of an atmosphere, and that artificial platitude which now bores [sic] us for years in certain supposedly modern productions."

For Hoffmann the confrontation with Mackintosh represented a confirmation and a challenge at the same time. He must have been very impressed by the work and by the personality of his Scottish colleague at that time, for henceforth he continued to watch his career with friendly interest. Late in 1902 during his stay in Britain with Myrbach, Hoffmann even traveled to Glasgow from London in order to visit Mackintosh personally;[36] earlier in the same year he had assisted with the installation of the music room Mackintosh had designed for Wärndorfer.

Since Wärndorfer had commissioned a dining room (Cat. 70) (fig. 63) from Hoffmann at approximately the same time, works of the two architects were realized side by side. On another occasion (Cat. 54), Hoffmann had the opportunity to design an interior (fig. 31) around an existing piece of furniture by Mackintosh; the comparison implied by the ensuing juxtaposition is instructive and shows a significant difference in personal style.[37] In the formal aspects of the pieces under discussion, both Mackintosh and Hoffmann are more reticent than contemporaneous Belgian and German Art Nouveau artists, and both work with the natural planarity of their material—wooden boards. But while Hoffmann in his work stresses straight lines, right angles, and undecorated plainness, Mackintosh provides subtle curves, delicately carved enrichments, and decorative insets, so that the total effect is more complex and elegant.

Hoffmann therefore in this case is stylistically much closer to Ashbee than to Mackintosh. This is not sur-

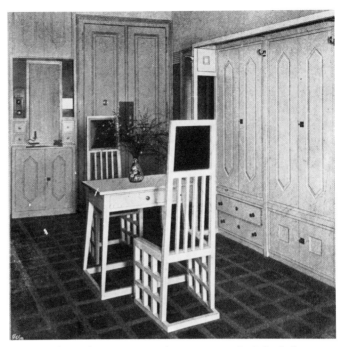

33. Furnishings for Dr. Hans Salzer (Cat. 67), high-back chairs in the anteroom

34. Designs for high-back chairs, probably for the furnishings of the Flöge fashion salon (Cat. 89)

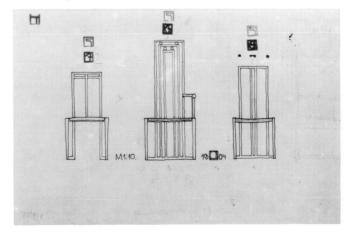

39

prising in view of his proven interest in Ashbee and the Guild of Handicraft; the connection had been noticed by a contemporary critic who wrote,[38] "But the younger modernists . . . visibly have absorbed also something of the race Ashbee-Voysey-Newton," and who praised the sound common sense of Ashbee, "who, as it were, finds the square root of all things." Ashbee and the other artists of the Arts and Crafts movement at this time were well known in Central Europe; about Mackintosh one had as yet heard little, as is borne out by a perusal of the art periodicals of the period 1898 to 1900. Moreover, the constructional directness of Ashbee's furniture must have appealed to Hoffmann's Wagner-trained rationalism. He was equally attracted by the Englishman's metalwork and jewelry which anticipated a direction his own creative endeavors were soon going to take, and he even bought a salt cellar by Ashbee in the Secession exhibition,[39] while Kolo Moser acquired a chair by Mackintosh. This accords well with a remark in Hoffmann's reminiscences about Mackintosh, about whom he wrote,[40] "The friendship with Mekintosch [sic] permitted us to recognize the strange charm of certain colors and dreamy moods and above all also affected Moser." Thomas Howarth, the pioneer of Mackintosh research, some time ago summed up the results of his investigations into the Hoffmann-Mackintosh relationship in the following way:[41] "For long it has been assumed that Hoffmann modeled his work on that of Mackintosh, but all evidence examined by the author would indicate this was not so." Broadly speaking, Howarth's conclusion has not been disproved. At the time late in 1900 when Hoffmann admired the Scottish room in Vienna, his personal style in furniture design was already so clearly formed that one would only be justified in speaking of a genuine influence from Mackintosh if the work of the Viennese artist had shown a clearly recognizable change in the direction of the formal language of the Scotsman. This however is not the case.

Nevertheless, it is undeniable that the high artistic quality of the Scottish work and the intensity of stylistic expression that came across in it did not fail to make a strong impression on Hoffmann. Even if he did not change his own style fundamentally, some of his pieces bear a marked similarity to Mackintosh's work: for example, the chairs with straight backrests in the anteroom of the Salzer apartment (Cat. 67) (fig. 33) and in the Flöge fashion studio (Cat. 89) (fig. 34), as well as the armchair for Gustav Klimt (Cat. 96), all strikingly recall typical chairs by Mackintosh. Comparable similarities have rightly been pointed out in connection with designs for cutlery.

The artistic impact seems to have been entirely mutual between Hoffmann and Mackintosh, since in the wake of Hoffmann's most severely geometric purism, around 1903, the furniture style of the Scottish artist also changed: square or rectangular forms often composed of straight parallel elements took the place of the earlier characteristic long-drawn curves. There is even a Mackintosh drawing for a four-poster bed of uncertain date (1900?) (fig. 32),[42] which surprisingly resembles designs by Hoffmann. In 1905 the critic Ludwig Hevesi explicitly mentioned the influence of Hoffmann and Moser abroad when he wrote,[43] "Great autonomous artists like the Mackintosh group in Glasgow . . . already occasionally work in this local [i.e., Viennese] manner."

The client who commissioned Hoffmann to incorporate an existing cabinet by Mackintosh into a new study was Dr. Hugo Henneberg. His house formed part of a small group of suburban residences—called a colony of villas at the time—at the Hohe Warte, which Hoffmann began to design at the time he was preparing the eighth exhibition of the Secession. These villas mark a turning point in his career, for they gave him his first opportunity to carry out a larger building commission on Viennese soil and to show how he envisaged shaping the environment according to the ideals of the "Moderne."

III. British Models and the Path toward Simplicity and Unity

The idea of living together in the "caves of the Bi-samberg,"[1] suggested by some enthusiastic Secessionists, was hardly to be taken seriously, but it indicates that the concept of communal life had its place in the total reform program of these young artists. In this, as in so much else, they were indebted to the nineteenth century when, in reaction to the incipient industrial society, artists sought salvation in groups and brotherhoods that experimented with communal life in rural surroundings. The avant-garde, inspired by the example of England, also strove to replace the densely built-up urban tenements with individual residences in garden suburbs, so as to create the framework for a way of life that would be artistically shaped in every detail. The ideal was formulated by Olbrich on the opening of the first Secession exhibition in 1898:[2] "We must build a city, an entire city! Everything else means nothing! The government should give us a field, in Hietzing or at the Hohe Warte, and there we want to show what we are capable of; in the entire settlement and to the last detail, everything dominated by the same spirit."

Olbrich was the obvious first choice when Carl Moll and Kolo Moser decided to implement the idea of an artists' colony, and to this end they were able to secure the cooperation of two well-to-do art lovers and photographers—Victor Spitzer and Hugo Henneberg. Both had close ties to the Secession where, as at the Hagenbund and elsewhere, they exhibited.

Spitzer had already demonstrated his artistically progressive attitude when he commissioned Olbrich to design the furniture for his apartment in town. Henneberg, whose works were published in *Ver Sacrum* on several occasions, was active in art photography as well as printmaking. He collected Japanese woodcuts, followed international art activities with intense interest, and in 1888 undertook a study tour through the United States. He had his wife's portrait painted by Klimt and was among the subscribers to the deluxe edition of the German periodical *Pan*, with its wealth of original graphic art. In many ways Henneberg can be considered a typical representative of that stratum of society which supported the Secession and later the Wiener Werkstätte and from which Hoffmann's most important clients were to come. Not infrequently the art-loving women in these families played an important role in deciding questions of interior design and architecture. The financial independence of the *haute bourgeoisie* enabled this group to devote themselves entirely to an ideal of self-realization through cultural refinement. The arts were indispensable for achieving that avant-gardist exclusivity which could engender spiritual superiority—whether toward the Philistine *petite bourgeoisie* or toward the traditionalist old nobility. With the decline of the Monarchy, this stratum of the liberal *haute bourgeoisie* largely disappeared. Their lifestyle was in some cases preserved or handed on to the next generation, who consequently possessed similar ambitions but in most cases lacked the means for their realization. Henneberg himself died in 1918.

Suitable building sites for the artists' colony were found in a section of Döbling which was just beginning to be parceled. It combined all the amenities of a fine rural situation, including a view of the Viennese woods, with the practical advantage of being comparatively easy to reach. Olbrich began the planning, but got only so far as thinking about the siting of the houses and preparing a folder for the reception of the project drawings when his new tasks in Darmstadt precluded his proceeding further with the design. Moll, who here, as on other projects, was the main organizer, finally informed him angrily that they had decided to transfer the commission to Hoffmann. Olbrich welcomed this change, as he expressed in a letter of 26 May 1900:[3] "I know Hoffmann will build splendid houses for you. With pleasure I give you my studies of the utilization of the site and the arrangement. . . . Good luck for the place of friendship."

By October, Hoffmann already submitted plans for approval to the building authority, even though he can only have started design work around the middle of the year and was also occupied with preparations for the eighth Secession exhibition and other tasks. During the first half of the year he had been able to finish designs for two rural residences which, as far as size and construction problems were concerned, were good preparation for the work at the Hohe Warte. They had been commissioned by Karl Wittgenstein, brother of Hoffmann's Bergerhöhe client and a patron of the Secession.[4]

Wittgenstein owned extensive forests near Hohenberg, Lower Austria, and for their administration he required a forestry office and accommodations for forestry personnel. For this purpose he had Hoffmann design two

35. Entrance to the forestry office of the Wittgenstein Forestry Administration in Hohenberg, Lower Austria (in 1966)

36. Detail of the staircase of the residence for forestry personnel of the Wittgenstein Forestry Administration, Hohenberg, Lower Austria

37. View in the staircase of the forestry office of the Wittgenstein Forestry Administration in Hohenberg, Lower Austria

houses (Cats. 45, 46) (figs. 35-37), one with offices and apartments, the other with apartments only. These buildings were fundamentally simple, rural residences and were thus ideal for a young architect who, in the wake of the English Arts and Crafts movement, shared with many artists of his generation the conviction that anonymous rural buildings were an important source for recovering the health of architecture. The architectural solution for two rural residences might easily have been banal, but Hoffmann avoided this danger by strongly contrasting the two buildings in his treatment. The office building stands with its long side parallel to the street and has a hipped roof; the apartment building has a saddle roof and stands with its short side along the street. In addition, where the facade of the office building is completely stuccoed, the other building displays visible wood framing in the upper story. In the uppermost zone of the facade, both buildings have stucco decoration with leaf forms stylized in the manner of those envisaged in the designs for the houses in the Donnergasse (Cat. 13)

and for the Jubilee Pavilion of the city of Vienna (Cat. 11). For the rest, Hoffmann's design efforts were concentrated at the entrances and in the staircases.

In particular, the centrally-placed entrance of the office building (fig. 35) was treated quite willfully in Secessionist forms. The original design had combined the three-quarter arch, so characteristic of Hoffmann's early work, with two flanking piers and a semicircular canopy; but ultimately, probably at the request of the client, who was concerned with practicality, it was executed with a tentlike roof covering reaching far down. This could be fabricated more easily and provided better protection from the weather. The volutelike buttresses that also serve as staircase parapets at the foot of the two entrance piers might be recognized as distant relatives of the buttressing volutes at Otto Wagner's Nußdorf watergate completed in 1898. In contrast to the rest of the building, the entrance pavilion does not in the least give a rural-vernacular impression. For the local population, the impression of something unusual must have been strengthened

43

by the fact that all visible woodwork on the exterior of the house was painted blue and the upper termination of the rough-cast socle was not straight-lined but undulating. Thus, while in form and dimension the volumes of the buildings fitted effortlessly into the surroundings, the treatment of formal details bespoke the stylistic intention of the architect who was under the spell of the "Moderne" just arrived in Vienna.

By the end of the nineteenth century, the use of visible half-timbering for a picturesque effect in the construction of villas and country residences could boast a respectable tradition in Austria. For example, *Der Architekt*, founded in 1895, displayed on the first plate of its first issue a picturesque double villa in half-timber construction (fig. 38) designed by none other than Camillo Sitte. But an essential difference exists between Hoffmann's residential building in Hohenberg and Sitte's design, as well as many other contemporary examples of half-timbering. Sitte shows a genuine half-timber construction which includes diagonal bracing. Hoffmann has only horizontal and vertical timbers set into the stuccoed walls of the upper portion of the house. A similar effect was achieved by Olbrich in a preliminary sketch for the Christiansen house in Darmstadt[5] and by Max Fabiani in a villa in Vienna-Speising[6]—evidence enough that we are dealing with a motif that was very popular at the time. Its origin is not difficult to discover since it occurs in numerous approximately contemporaneous British country residences. There, following the example of Norman Shaw, it is favored as a means of achieving, together with other devices, a particularly picturesque total effect. In these examples, as with Hoffmann, the half-timbering is frequently restricted to the upper zones of the facades, while the lower portions remain plain. Good examples for this type of treatment are found in several designs by Baillie Scott and in a house, "Rowantreehill," Kilmalcolm by J. Salmon and Son, which was illustrated in *Dekorative Kunst*[7] in 1900 (fig. 39). Hoffmann must have found this treatment very appealing since he used it not only at Hohenberg but also in the first four villas of the artists' colony at the Hohe Warte (Cats. 52-54, 63) (figs. 40-54). Interestingly, there is also a facade design for the Moll-Moser house without half-timbering. In addition to the visible wooden members of the upper floors, we have another indication of a direct link to British models: the thin metal brackets under the flat wooden gutters. Similar metal supports under the eaves are particularly characteristic of designs by Charles Annesley Voysey.[8]

Since the villas were commissioned by Kolo Moser,

38. Camillo Sitte, design for a half-timbered double villa

39. J. Salmon and Son, "Rowantreehill" in Kilmalcolm, 1900, general view of the house

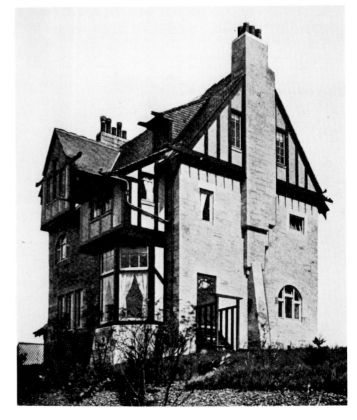

40. Double house for Carl Moll and Kolo Moser, garden facade shortly after completion

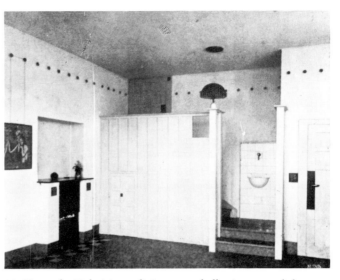

41. House for Kolo Moser, living room/hall, view toward the stairs

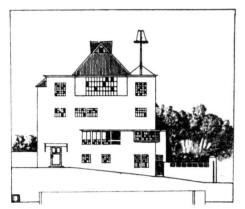 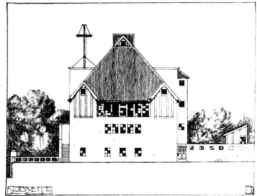

42. House for Dr. Hugo Henneberg, preliminary design, north and south facades

Carl Moll, Hugo Henneberg, and Victor Spitzer—people who were Hoffmann's friends through the Secession—he had the opportunity to realize houses that corresponded to a shared ideal. It was a matter of achieving a unity of exterior and interior, or in Hoffmann's words,[9] "a house the exterior of which would . . . have to reveal its interior." In the service of this ideal he employed all the architectural means at his disposal; among these the color and texture of the surfaces, the lively modeling of the volumes, and the spatial articulation and formal detailing played an important role. The buildings are clearly related to each other in their external treatment and are not conceived as isolated individual villas but as parts of a total composition.

The one possible exception to this unified impression is the Henneberg house (figs. 42, 43), where the willfulness of the roof treatment threatens to disrupt the overall coherence. While the south facade with its half-timbered gables clearly related to the other villas in the colony, the north and east facades seemed to belong to an entirely different family of forms: here the overall impression is determined by cubical elements with flat roofs and widely cantilevered cornice slabs. One is reminded of the Mediterranean villas of Hoffmann's Italian period, of the formal language taught by Otto Wagner, and last but not least of Olbrich's Christiansen house in Darmstadt, for which there is a preliminary design[10] that, with a round bay window at one corner and a central hall, shows a certain similarity to Hoffmann's project for Hugo Henneberg. This does not necessarily prove a

mutual dependence, since after all Olbrich and Hoffmann shared the same background of Mediterranean influences and Wagner's teachings. At any rate, the Henneberg house announces a new formal direction in Hoffmann's creative activity for which there are also parallels in his designs for furniture and interiors.

The clash of two essentially incompatible worlds of form at the Henneberg house makes visible a conflict of ideas with which Hoffmann had yet to come to terms. The flat roofs, the columnar loggia, and much else belong to the world of Mediterranean classicism. The tall, angular half-timbered gables, however, come from the world of the English Arts and Crafts movement, where such forms had a meaning that was generally understood. The recall of elements from medieval vernacular dwellings was undertaken not simply out of romantic inclination but also from moral conviction. If one believed Ruskin and Morris—and Hoffmann, like so many of his contemporaries, was prepared to do so—an architecture derived from medieval models was morally far superior to other forms of architecture available in the late nineteenth century, and above all to neoclassical architecture. According to the teachings of Ruskin and Morris, such an architecture was more honest, more appropriate to the climate and habits of life of the non-Mediterranean countries of Europe, and, in its return to old traditions of craftsmanship, was a saving antidote against the soulless monotony of machine-age mass production. All this may appear untenable and ridiculous today, but around 1900 it carried the power of conviction and it must have created a genuine dilemma for a young architect who, like Hoffmann, had been educated in the language of classical form. His answer was not a rejection of what he learned from Hasenauer and Wagner but an attempt to reconcile the two worlds. Accordingly, in the same building he closely connected the neoclassical flat roof with its widely overhanging cornice and the steep Nordic roof in a composition intended to be coherent.

Some years later when the Arts and Crafts movement had lost its impetus and much of its moral force and when in England itself former adherents of the Arts and Crafts movement moved in the direction of classicism,[11] Hoffmann also brought the classical element to the fore more strongly in his work, and at times it even held undisputed sway. But he never lost his predilection for combining in the same work both the principles of classical composition, such as axiality and bilateral symmetry, and the picturesque, asymmetrical grouping that was a legacy of the Arts and Crafts movement.

Since we know the original state of the early Hohe Warte buildings primarily from black and white photographs, it is difficult to visualize how colorful they must have appeared originally (fig. 43), with their painted woodwork, ceramic insets, brilliant red roof tiles, and manifold color effects in the interior—though large areas of white or light stucco always ensured that the overall impression did not become too restless. Some of the interiors recorded by Carl Moll in his paintings (fig. 44) still convey the most faithful impression of these rooms. They were meant to provide the setting for a way of life that was shaped both by a claim to artistic self-realization and by what were recognized as the binding norms of a society that still had a clear hierarchical structure.

This social context explains the vertical articulation of all four houses into three zones, with the service rooms and servants' quarters on the lowest floor (or occasionally in the attic), a hall with adjoining dining room on the main floor, and the largely self-sufficient studio floor under the roof. The Vienna Woods are consciously included in the composition, and in front of each studio is a terrace with a view of the landscape facing Kahlen- and Leopoldsberg. Access to the hall is gained by way of a richly articulated sequence of preparatory spaces, which begin at the garden gate and include staircase solutions (fig. 45) so complicated that without exception they fell victim to the wishes of later owners for greater simplicity. The halls themselves (fig. 52) from which partly-open stairs lead to the upper floor, are conceived as complicated spatial compositions. Formal accents such as open fireplaces, seats built into niches, and upholstered furniture in richly contrasting forms and colors, together with the manner in which light is manipulated, create a strong and, in each case, uniquely characteristic impression. Hevesi[12] in a different context stressed the great degree to which Hoffmann accommodated his designs to the wishes of his clients in a unique way.

The hall designs illustrate this point. The Moser and Moll halls are like ordinary rooms in height and dimension except for the staircases that begin at one end. By contrast the halls of Henneberg and Spitzer are large rooms of greater height than the spaces that surround them, and in shaping them Hoffmann largely managed to free himself from possible British prototypes. The staircase in the hall of the Moser house (fig. 41) tempts one to accept Stephen T. Madsens' suggestion that Mackintosh was the source of inspiration, although one might also think of Voysey. One looks in vain for equally convincing models for the hall in the Henneberg house (Cat. 54); here Hoffmann already manifested full originality and also eschewed any reference to curvilinear

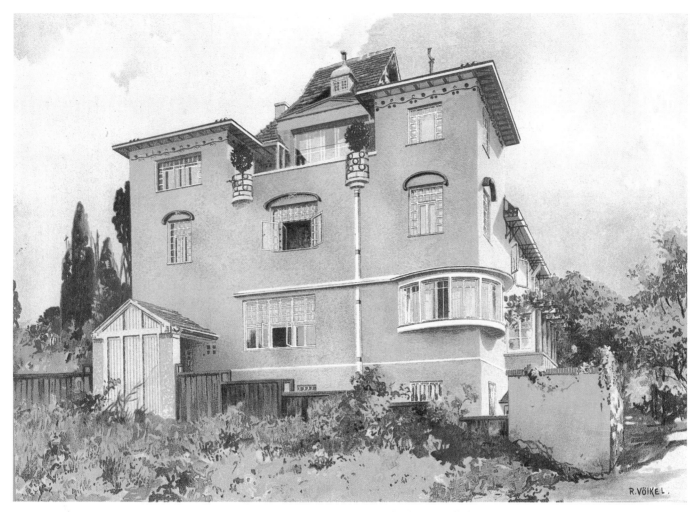

43. House for Dr. Hugo Henneberg shortly after completion, after a watercolor by R. Völkel

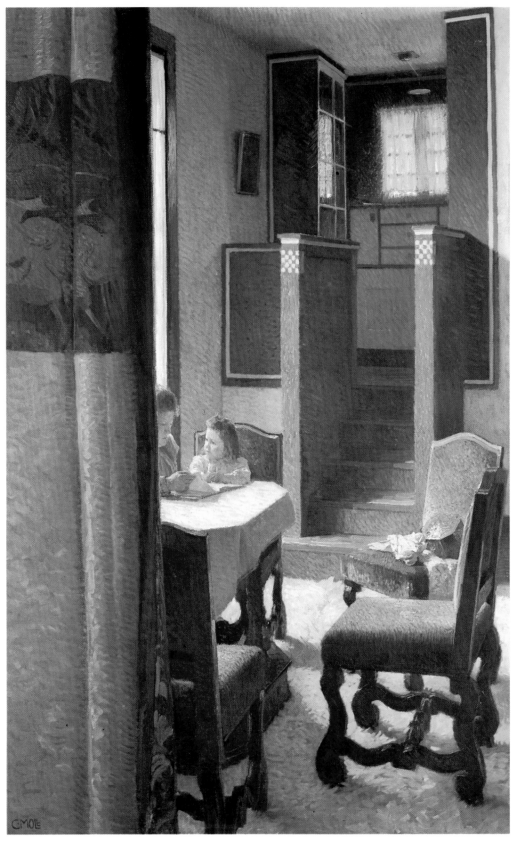

44. Corner in the salon of the Moll House, after a painting by Carl Moll. The chairs are not by Hoffmann.

Secessionism. Since the building of the house was entered in the land register in July of 1901, one can assume that the interiors were finished in the spring of 1902 at the latest, perhaps approximately at the same time that the certificate of occupancy was issued for the neighboring Spitzer house.

What makes the hall in the Henneberg house so unique is the fact that it extends through the depth of the house in a manner which enables light to penetrate the space from two sides and on different levels; this makes the room particularly changeable. The experience of space or depth is enhanced and dramatized in many ways: in plan, by a subdivision of space, giving particular importance to the area around the fireplace where a portrait by Klimt of the mistress of the house was displayed; and in elevation, by the creation of various vistas and, above all, on the gallery level, by the piers (fig. 46). One becomes particularly aware of the extension of the room in depth when one looks past the lateral surfaces of the piers illuminated by raking light, toward the source of the light—the gallery windows—behind them and when one sees the leafy silhouette of the plants growing in boxes built into the parapet of the gallery. In a similar manner an arrangement of slender piers enhances the experience of space in the photo studio (fig. 48). Room dividers like these which facilitate the perception of depth occur again and again after this time in Hoffmann's rooms. At the Henneberg house the windowlike opening in the masonry pier between two flights of the secondary stair (fig. 47) creates a similar effect: it is due to this space-creating gesture that this staircase, with its strong contrast of light and dark and its large surfaces of stucco, leaves such a lasting—one is tempted to say, monumental—impression. From the beginning of Hoffmann's career, a markedly three-dimensional manner of composition is characteristic. He was not satisfied with simply joining together spatial units of equal height, but liked to link and interlock units of different heights. Adolf Loos, speaking later of his own comparable solutions, dubbed them his "space-plan."

While the total impression made by the exterior of the Henneberg house suffers from the architect's being carried away with joining different motifs, the general disposition of the house for Dr. Spitzer, approximately half a year later, was much more tranquil and unified. In this building the compositional elements of all the facades belong to the same family and are deployed more sparingly, though not less effectively, as at the Henneberg house. This is particularly striking in the almost windowless garden facade (figs. 50, 51) where the overall

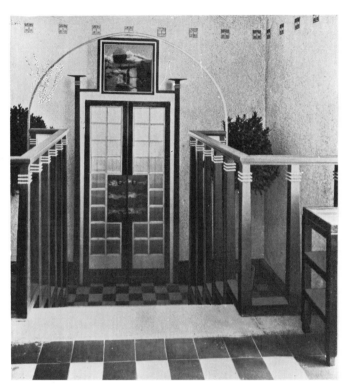

45. House for Dr. Hugo Henneberg, view from vestibule to entrance door

46. House for Dr. Hugo Henneberg, detail of the hall-gallery

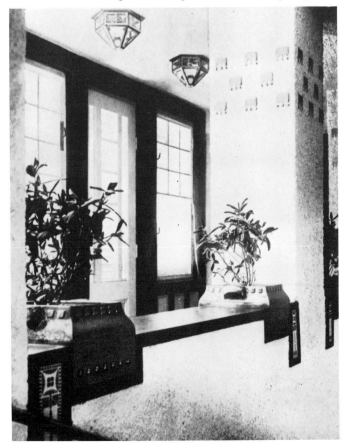

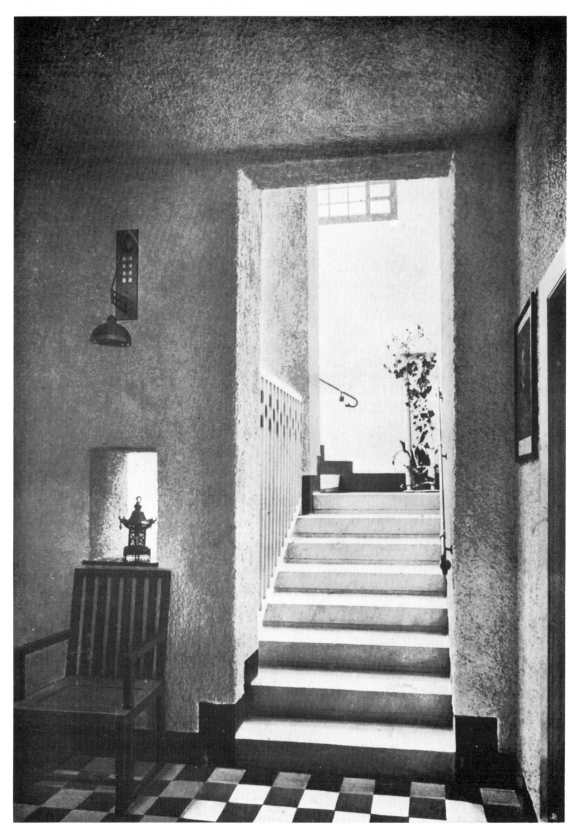

47. House for Dr. Hugo Henneberg, secondary staircase

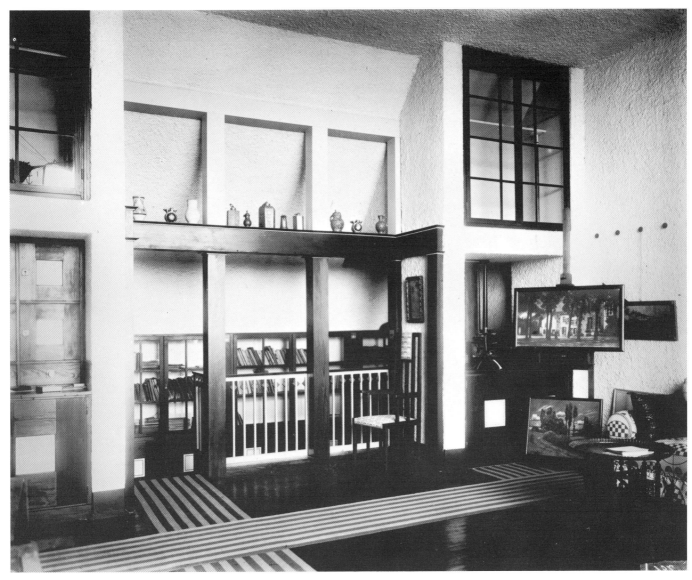

48. House for Dr. Hugo Henneberg, photographic studio

effect is achieved mainly through modeling of the built volume and the contrast between the uninterrupted wall surfaces and the large, dark, arched opening of the veranda. Here, by limiting himself to a few strong elements, the architect displays an assurance that can be observed in the treatment of the interiors as well (figs. 52, 53). In none of his earlier designs, except perhaps the Henneberg bedroom (fig. 54), had Hoffmann achieved such perfect unification as in the study for Dr. Spitzer (fig. 53), where built-in and movable furniture in cubical forms[13] appear monumental. Perhaps the awareness that his rooms in the Spitzer house would be seen with those designed by Olbrich spurred Hoffmann to create particularly strong designs which by their very simplicity would stand in successful contrast to Olbrich's exuberance. Hevesi[14] made the following comments: "Now for Vienna this is an art-historically interesting contrast. The room of Olbrich's imagination that embraces forms and colors in an Epicurean manner, and the rooms of the severe logician of taste, Hoffmann, who with few effects achieves much, and this in a particular, personal manner."

A similar striving for simplicity in house design characterizes Hoffmann's ideal design for a country residence published in *Ver Sacrum* (Cat. 55). Like Olbrich's Hermann Bahr house, this building has ties to vernacular architecture, thus repeating a leitmotif with which we are familiar from Hoffmann's earlier works and from his writings.

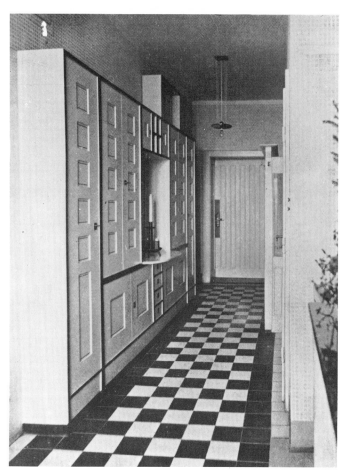

49. House for Dr. Friedrich V. Spitzer, pantry on the second floor, painted white and blue

50. House for Dr. Friedrich V. Spitzer, submitted elevation of garden facade

The increasing simplification and tightening of the formal treatment in these buildings was not something accidental and unique but a deliberate change of direction; this is borne out by the fact that Hoffmann's next two residential buildings, both dating in 1903, show the same tendency. These were the so-called Gewerkschaftshotel of the Poldihütte (Cat. 77) (fig. 56), which was part of the Wittgenstein steelworks in Kladno, and the Knips summer residence at Lake Millstatt (Cat. 78) (figs. 57-59).

The plan of the Gewerkschaftshotel is closely related to that of the Hohe Warte houses, but it might be argued that its purpose as a utilitarian building within an industrial complex determined the simplicity of its treatment. However, no such reasons can be adduced in connection with the Knips summer residence. As the contemporaneous interior of the Knips apartment in Vienna (Cat. 79) proves, a rich, even luxurious, treatment would have been perfectly feasible. Indeed, this apartment, with intarsia, a barrel vault in stucco, and a black

marble fireplace with silver-plated metal fittings and a showcase (fig. 55), already belongs to a group of interiors that marks a transition to a new phase in Hoffmann's work. It is a phase in which the aim once again is greater decorative richness, at times even anticipating the effects of the Art Deco style of the 1920s. It begins, approximately, with rooms for Max Biach (Cat. 69) and reaches its climax in the luxurious dining rooms for Fritz Wärndorfer (Cat. 70) and Editha Mautner-Markhof (Cat. 83). By contrast, the Knips summer residence was stunningly simple, perhaps to underline the informal character of country life.

According to Hoffmann's original intention, it would have been even simpler with a flat or barely inclined roof. The effect would have been that of purely cubic forms, and as far as formal typology is concerned, the main elevation with its projecting veranda would have somewhat anticipated the Purkersdorf Sanatorium (Cat. 84) in miniature. When the Knips summer residence was actually built, it received a saddle roof. The gable ends

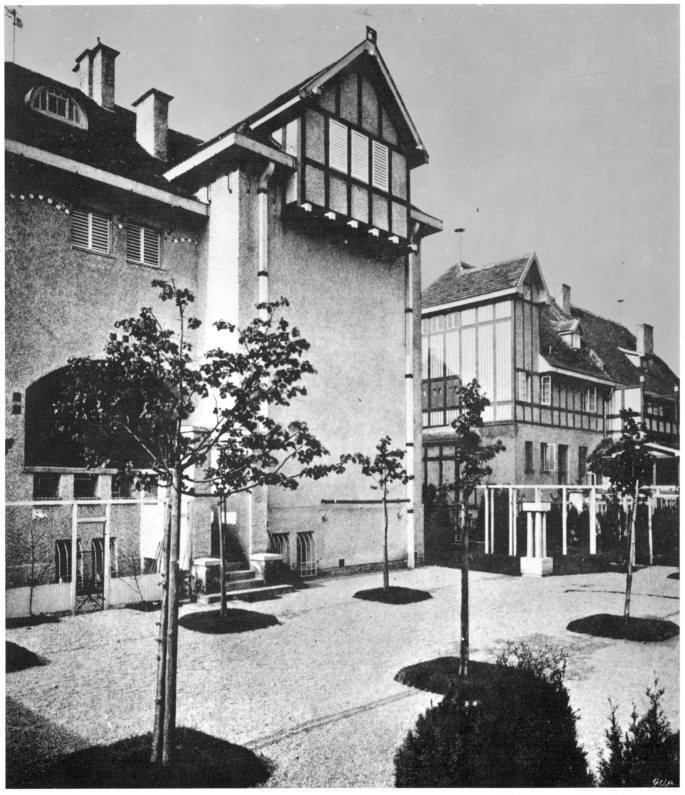

51. House for Dr. Friedrich V. Spitzer, garden facade shortly after completion. The Moll/Moser double house is visible in the background.

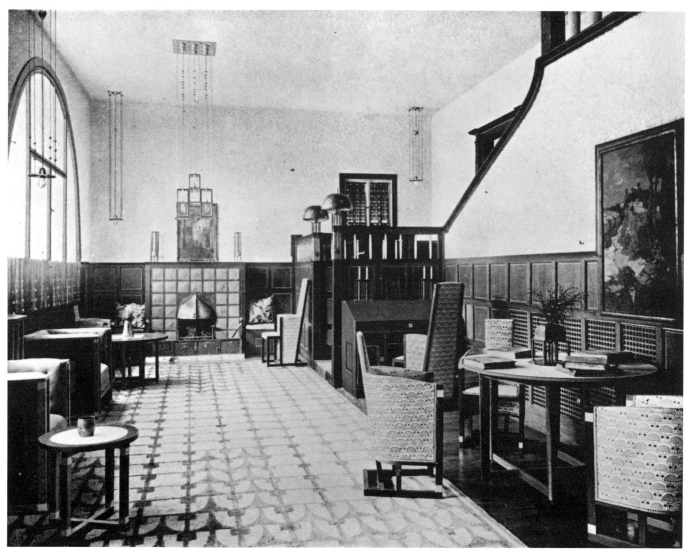

52. House for Dr. Friedrich V. Spitzer, hall

displayed multiple framing in several lightly recessed steps, a motif which occurs here for the first time on a large scale in an architectural context. Initially used by Hoffmann in the design of interiors and furniture, it remained one of his favorite motifs for some time—together with various kinds of repeated staggering and stepping back (Cats. 80, 81). This indicates that he submitted even decorative enrichment to a puristically severe limitation, i.e., the repetition of the simplest formal gestures such as framing, covering, or stacking. The motif of multiple framing immediately appealed to his contemporaries. Even Otto Wagner applied it to the blind doors of the transepts at his Steinhof church, despite the fact that the design drawings had indicated a different

solution. Later, Mackintosh adopted the motif in his design for a theater at Chelsea.

During the years 1901 and 1902, Hoffmann obviously went through a stage in his development in which he was drawn to the greatest possible simplicity and unity in his work. This was not only a result of external influences but was also a consistent consequence of design concepts he had worked out himself. In retrospect, he said of this attitude that he had been particularly interested "in the square as such and in the use of black and white . . . because these clear elements never appeared in earlier styles."[15] At the time, however, when this purist phase began, he attempted to explain his motivation not in terms of such formal interests but rather

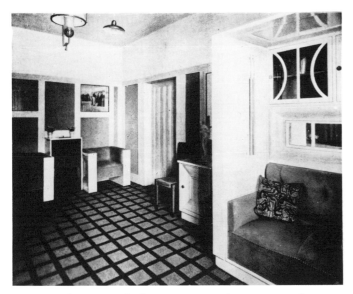

53. House for Dr. Friedrich V. Spitzer, study, view toward fireplace, woodwork painted white

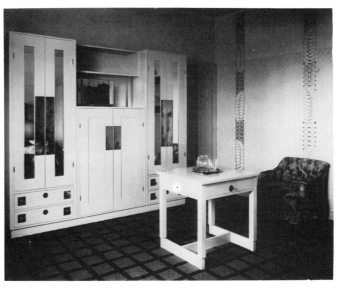

54. House for Dr. Hugo Henneberg, bedroom, painted bluish light gray, with brass mountings

on the basis of certain principles. This was done in the framework of a manifestolike, programmatic text accompanying the publication of numerous ideal designs for furniture in *Das Interieur*, II, 1901 (Appendix 4). These pieces, described as "simple furniture" (Cat. 57), without exception had forms based on simple geometric constructions. Influences from English models are unmistakable; frequently, one finds slender uprights with flat, widely-protruding, thin plinths as upper conclusions, in the manner of Arthur Mackmurdo and George Walton. In later furniture, Hoffmann also employed a motif that may have come from M. H. Baillie Scott: the connection of chair legs into a sledlike frame by means of horizontal runners on the floor.

In the accompanying text, Hoffmann deplores—no doubt with reference to Hofrat von Scala—the prevailing tendency to return to the historicizing, eclectic imitation of form, and he blames museums for showing the wrong objects: ". . . have you ever seen a beautiful machine in a museum of arts and crafts?" But he also criticizes the avant-garde: "the 'Moderne' also suffers from intolerable faults . . . on the one hand, the individual artists . . . often believe they have to establish a precedent, i.e., insofar as they consider worthy of imitation their personal manner of expression, and not the eternal laws of beauty. . . . On the other hand, most of them are intent on squeezing themselves into some trend." By contrast, Hoffmann demanded a consideration of purpose and material and absolutely honest thinking. It was en-

55. Knips apartment, black marble fireplace, silvered metal parts

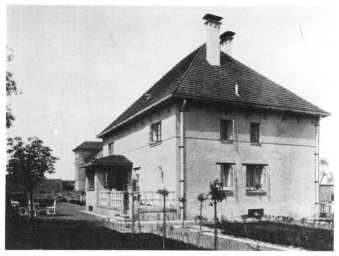

56. "Gewerkschafts"-hotel of the Poldihütte, garden view

57. Knips Country House, Seeboden, design sketch for the garden facade

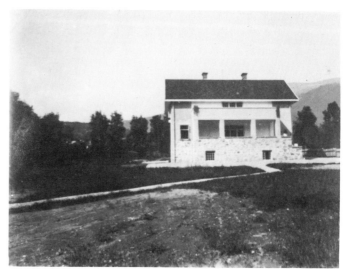

58. Knips Country House, Seeboden, garden side shortly after completion, 1903

59. Knips Country House, Seeboden, in the late 1960s, before demolition

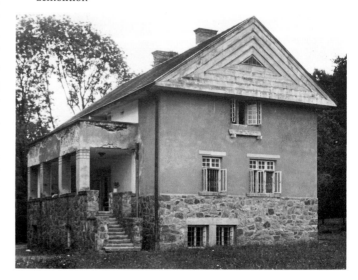

tirely in this spirit that he instructed his pupils: "Purpose alone is the source of the motifs. Main support [is] absolute honesty and simplicity in conception and execution." Among the technical errors to be avoided Hoffmann singled out the violation of wood against which he had already protested during the preparation for the eighth Secession exhibition: "One does not respect the straight fibers of the wood and makes curves on top of curves, which rarely can be joined to the necessary straight surfaces of furniture."

Above all, in Hoffmann's opinion, the basic attitude of the designer had to be changed, "for most designing artists do not lack talent so much as character and the necessary firmness. By this I mean indulgence toward the whims and false sentiments of himself and of his client, the creation of mood in rooms for daily life, and false pathos in places where we should long for naturalness. The perpetual exhibition business also has spoiled much because we have begun to take things into our houses that were intended for a thousand eyes. Therefore the insufferable changes in style and color. I believe a house should stand as a perfect whole." The first four houses at the Hohe Warte clearly show Hoffmann on the road toward this ideal goal.

The years 1901 and 1902, in addition to the completion of the Hohe Warte houses, brought a wealth of other tasks, in both interior and exhibition design. The amount of work was so great that Hoffmann not only had to employ several collaborators in his office in the School of Arts and Crafts, but occasionally, as with the interior design for Max Biach or for the Gewerkschaftshotel Pol-

dihütte, passed on the design of whole rooms to Franz Messner, a talented pupil.

By 1902, Hoffmann was already able to count on a group of graduates who had attended his special class for three years and in doing so had acquired a familiarity with the easily recognizable characteristics of his new style: the predilection for the square and other simple forms, the preference for wood in the shape of boards, and the repetition of linear, decorative motifs that were either abstracted from natural forms or developed solely from geometry. Some students from Hoffmann's class, who, incidentally, joined graduates from Moser's class in an association called Wiener Kunst im Hause, succeeded in designing pieces of furniture that amazingly resembled those of their teacher. But generally it became apparent that the imitation of Hoffmann's stylistic characteristics was no guarantee that the application would be performed with the same intuitive feeling for good proportion, effective contrast, and elegant decoration that was typical of Hoffmann's work in those years. Moreover, perhaps in response to the personality or wishes of the client, Hoffmann in most cases also gave a special character to his interiors: if one compares different interiors it becomes apparent that despite whatever they may have in common stylistically, it is usually impossible to exchange important pieces of furniture from one apartment to another without creating a noticeable disharmony.

Thus the study in walnut for young Helene Hochstetter (Cat. 60) with its understated linear ornamentation conveys an entirely different mood from that in polished mahogany with brass mountings but without ornament designed for Magda Mautner-Markhof (Cat. 68), who was approximately the same age. Three anterooms for different clients—Dr. Hugo Koller (Cat. 61), Gustav Pollak (Cat. 62) (fig. 61), and Dr. Hans Salzer (Cat. 67) (fig. 33)—are comparable in severity, use of straight lines, and preference for square forms as well as in the typology of their pieces of furniture, but they differ in detailing and coloration. The round extension tables in the Pollak and Salzer dining rooms (fig. 60) also belong together typologically, but again their detailing is very different, and viewing them one begins to understand one of the secrets of Hoffmann's enormous capacity for turning out designs. He approached every new task not only with great imagination but also with a very clear typological conception, a well-defined stylistic sense, and a comprehensive knowledge of the potential effects to be achieved by means of various materials. A detailed study of his bedrooms would be

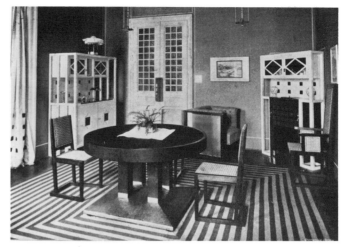

60. Apartment for Dr. Hans Salzer, dining room, buffet and fireplace unit with brown insets, extension table with red fabric

61. Apartment for Gustav Pollak, anteroom in white and grayish blue

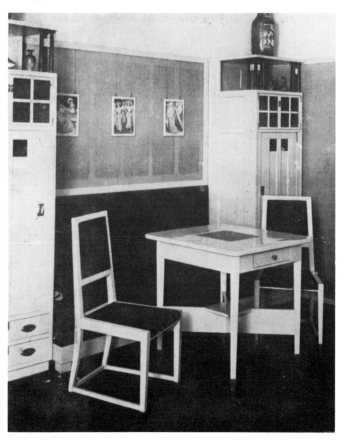

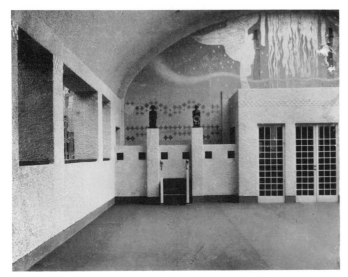

62. 14th Secession Exhibition, view toward the entrance wall of the central hall

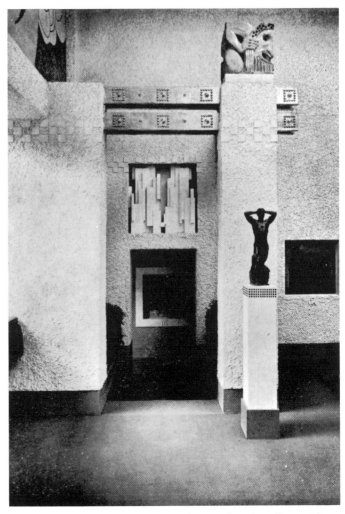

63. 14th Secession Exhibition, exit from right side gallery with Hoffmann's *sopraporta* relief

64. Abstract two-dimensional design with overlapping rectangles; student work by A. Untersberger from the School of Arts and Crafts, 1899

particularly instructive, from Henneberg and Salzer to Biach and the later examples, with the bentwood bedroom for J. & J. Kohn (Cat. 59) as an interesting special case.

As for exhibition design, the fourteenth Secession exhibition (Cat. 64) (figs. 62, 63, 65), which opened on 15 April 1902, marked the high point of Hoffmann's puristic phase. It was devoted to the display of Max Klinger's polychrome statue of Beethoven, and Hoffmann was responsible for the overall artistic direction and the design of all the rooms except one. Marian Bisanz-Prakken[16] has convincingly established what the content of the exhibition, i.e., Klinger's statue, meant to contemporaries and how it could become an obviously fruitful source of inspiration for the artists of the Vienna Secession. When Gustav Mahler conducted his arrangement for wind instruments of motifs from the last movement of Beethoven's Ninth Symphony[17] in the exhibition's left lateral gallery which Klimt had frescoed, it appeared as if for a brief moment the ideal of creating a *Gesamtkunstwerk* had been achieved; and this, moreover, in the service of an idea that was of intense personal significance for the artists of the Secession: the heroizing of the artist in his role as redeemer of mankind.

Josef Hoffmann may not have known in detail the thoughts of Richard Wagner and Friedrich Nietzsche on this heroic ideal, but from the general atmosphere of Otto Wagner's class and from discussions in the Secession he must have been familiar with the general mood, and he was therefore in a position to create an appropriate

65. 14th Secession Exhibition, Hoffmann's *sopraporta* relief of cut plaster in the right side gallery, 1902

architectural framework for it. It was, in his own words, necessary to create "the character of monumentality," and the path he selected was that of the most elementary simplicity. This trend certainly owed something to his acquaintance with Japanese art—in 1900 there had been a Japanese exhibition in the Secession; in 1901, a Hokusai exhibition in the Austrian Museum of Art and Industry; and during the following years, his designs often included Japanese references.

Contemporary critics noted with admiration the quasi-sacred character of Hoffmann's spatial composition; it was compared to a temple and described as being modern and archaic at the same time. One critic, however, Karl Kraus,[18] condemned the exhibition arrangements and enlisted the aid of a quotation from Martin Spahn who had angrily exclaimed, "How could he [Klinger] permit a work . . . to be taken by the Vienna Secession into the

colorful theater and 'Über'-cabaret that the gentlemen had deemed necessary to daub on its behalf!" "Klinger leaves his Beethoven to the Viennese Jews. . . ." With this spiteful remark, Kraus explained, only the *"goût juif"* of the Secessionists can have been meant.

Eighty years later it is not difficult to recognize that these remarks were conditioned by prejudices Kraus harbored against the Secession and particularly against Klimt. Even if one remains aware that the positive judgments of those who defended the Secession were also strongly conditioned, it cannot be denied that in this case the apologists came closer to the truth. Klinger himself was highly satisfied with the general arrangement, which indicates that once more Hoffmann had proven to the highest degree his ability, tested on other occasions, to adapt an environment sympathetically to the work of art exhibited. In his three-aisled arrangement, the statue by

59

Klinger reigns supreme; all other works relate to it thematically and formally, and they are arranged so as to preclude competition and disturbing contrast. All the works visible in the same room as the Klinger sculpture have mainly a decorative effect, while the great cycle by Klimt—next to Klinger's the strongest work in the exhibition—is shown in a neighboring gallery where its visibility from the main hall is very limited.

Yet it was obviously not enough to subordinate the other works and to use neutral white as the basic color in all the rooms to avoid a detraction from Klinger's polychromy, for these were only negative measures. Hoffmann's main artistic problem consisted rather in finding a formal language and iconography for his architecture that would do justice to the exhibition's spiritual theme. His solution (fig. 62) was to create an architectural interior with piers and vaults while at the same time suggesting a landscape that through paintings on the walls was made to carry transcendental implications. The front wall, with piers crowned by sculptures, and the pairs of piers between the main hall and the lateral galleries, are treated in a formal language that, like the white stucco, recalls Mediterranean buildings. The decorative plaques set into the walls give the effect of windows through which one can look into a garden populated by fabulous creatures. In the same spirit, the two great paintings in the main hall that illustrate the times of the day are set back somewhat behind the surface of the stucco, as if beyond the wall one was viewing a mythical landscape belonging as much to the world of antiquity as the sculpture of Beethoven itself.

To project the natural landscape, as it were, into the architecture was an approach Hoffmann had already used, for example in the Hall of Knowledge (Cat. 18) with its apple tree capitals, in the Grove of the Muses of the Paris Universal Exposition (Cat. 38), and on the many inner and outer walls that were decorated with little trees or treetops. In later years, too, this conception still found occasional expression (cf. Cats. 445, 484, 491). At the Beethoven exhibition, various motifs taken from garden architecture play an important role. There are fountain niches in the main hall, and the descents from the side galleries to the main hall even use living plant material in their composition (fig. 63): they are handled like garden pergolas through which one walks as one descends to the door openings. The essence of the total architecture is crystallized, in the truest sense of the word, in the *sopraporta* of these doors (fig. 65). It was no coincidence that Hoffmann reserved the treatment of these surfaces for himself instead of delegating it to one of the other

Secession artists, as he had done with all other decorative insets in the walls. He must have been well aware of the significance of this place as the point of transition from the realm of preparation to that of the main experience, and accordingly one may assume with some justification that here he created a work that embodied the essence of his artistic ideals at the time. The work took the form, revolutionary for 1902, of an abstract composition made up from freely juxtaposed, three-dimensionally grouped rectangular forms.

This design appears less amazing when seen in the context of the tendency toward planar and crystalline abstractions that had existed in Central and Western European art since approximately 1900. In that year Hermann Obrist, who had started his career as a natural scientist, created a completely abstract, cubical capital[19] that in its basic approach seems related to Hoffmann's *sopraporta*. But already in 1899 abstract surface patterns made up of overlapping rectangles (fig. 64)[20] had been designed in the Vienna School of Arts and Crafts. And in Switzerland Charles L'Eplattenier steered his pupils at the School of Arts and Crafts in La Chaux-de-Fonds in a similar direction when he charged them to study crystallike rock formations from which they were to derive abstract decorative motifs. L'Eplattenier's pupil Charles-Edouard Jeanneret (Le Corbusier) even participated in an international exhibition with such a pattern engraved on the case of a pocket watch.[21] In France the architect and theorist Henri Provensal prophesied a crystalline architecture which would assume the leadership of the arts.[22]

Hoffmann's own creative development during the first years of the twentieth century therefore coincided with a general turn toward the abstract geometry of cubic and crystalline forms and away from the exaggerations of historicizing eclecticism and the exuberant curves of Art Nouveau with their links to organic nature. Similar directions in Hoffmann's work and in that of major contemporaries including Frank Lloyd Wright can therefore be explained without having to assume a direct mutual influence. At any rate the historiography of art has so far taken too little notice of the fact that the *sopraporta* reliefs by Hoffmann can be compared to formal solutions that not until more than a decade later became common in Neo-Plasticism and Constructivism.

For Hoffmann the employment of essentially undecorated cubic forms and abstract geometric motifs remained but one among several possible modes of design, an option never entirely forgotten that might become effective, if the occasion arose, as a corrective to a super-

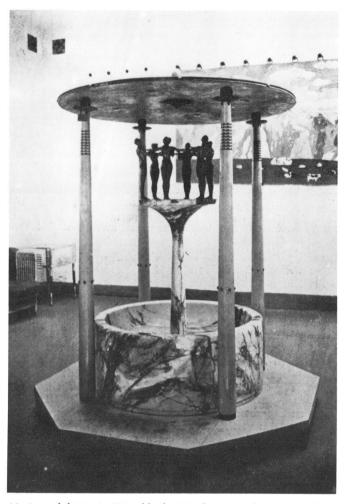

66. Art exhibition in Düsseldorf 1902, decorative fountain with slim columns, sculptures by Richard Luksch

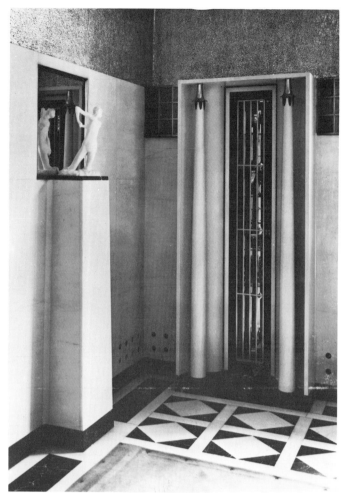

67. Furnishings for Fritz Wärndorfer, dining room, wall unit, detail with slim columns

abundance of formal motifs. His next exhibition design, the rooms of the Vienna Secession (Cat. 65) at the great Düsseldorf art exhibition, already attests to his mastery of a considerably less puritan formal language. Here he used small, slender, inlaid columns as parts of door surrounds, inlaid armchairs, and a decorative fountain of precious materials, probably inspired by Minne (Cat. 66) (fig. 66). These columns recall both the typical, small elongated columns of Biedermeier furniture and, in their nonclassical form and proportion, columnar forms from pre-Classical antiquity. During the following years, Hoffmann used such columns in a series of interiors (Biach, Cat. 69; Knips, Cat. 79; and Wärndorfer, Cat. 70) (figs. 67, 68). In his struggle to overcome the eclectic historicism of the Ringstraße, Hoffmann thus resorted not only to elementary geometrical forms and their multiple repetition and framing, but also to forms that could be considered elementary in character because they de-

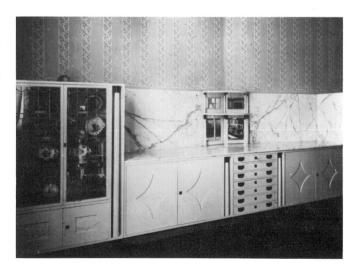

68. Furnishings for Max Biach, dining room, wall unit with buffet, detail with slim columns

rived from the earliest high cultures. The Minoan and Mycenaean forms belonged to this group; at that time they had only just been discovered, and Klimt was also very interested in them.[23] Going beyond the late nineteenth century interest in Japanese art, the period around 1900 went further afield in its search for new forms and explored early and exotic high cultures. For example, the Dutch journal *Bouw en Sier Kunst*, appearing in Amsterdam from 1898 onward, presented in its first volume, illustrations from Egypt, Assyria, Japan, Java, and Persia. Interestingly enough, the periodical in the service of this exoticism employed a graphic treatment in which configurations of small squares play an important role.[24] Earlier suggestions and indications regarding exotic forms and patterns had already been available in the great standard works of art history such as Perrot and Chipiez and in the nineteenth-century collections of motifs, above all in the *Grammar of Ornament* by Owen Jones and in Racinet's comparable collection of plates.

Hoffmann resorted to these elementary forms again in the dining room he designed for Fritz Wärndorfer (Cat. 70) (fig. 67).[25] Here slender columns decorated with metal cappings contribute to the restrained splendor of the room. They were placed in door jambs that had an S-shaped profile not unlike cyma recta molding; this constituted an additional enrichment but perhaps also a return to borrowed classical forms, proving that Hoffmann was always willing to enlarge and alter his stock of motifs. Yet we notice in this same Wärndorfer room a discipline of restraint that goes back to the purism of the fourteenth Secession exhibition.

Wärndorfer, a young industrialist from a very well-to-do family of textile magnates, recently married to a beautiful and equally well-to-do woman, was an enthusiastic art collector and supporter of the Secession. By education, personal inclination, and through trade connections of his family, he had the closest possible links with Britain. He loved to associate with artists and, after a short time, became a personal friend of Kolo Moser and Josef Hoffmann, who had met him "on the scaffolding of the Secession building."[26] Both artists have left descriptions—varying in detail but tallying in their main outlines—of that momentous event which was to have such a profound effect on Hoffmann's life and on the artistic life of Vienna: the founding of the Wiener Werkstätte. Financed by Wärndorfer, it was incorporated in May 1903 as the Produktiv-Genossenschaft von Kunsthandwerkern Ges. M. b. H (Cooperative Association of Art Workers for Production, Ltd.). Having been briefly located in a former apartment in Vienna IV, Heumühl-

gasse 6, the enterprise eventually had its seat at Neustiftgasse 32-34, where an existing new building was adapted for its purposes (Cat. 81), with accommodations added later in a block of flats Otto Wagner built in 1912 at Döblergasse 4.

According to Hoffmann's reminiscences,[27] the founding of the Wiener Werkstätte came about in the following manner: "We were sitting at noon in the Cafe Heinrichshof with Otto Wagner, Kolo Moser, some friends, and with Fritz Wärndorfer. Moser and I grumbled loudly about the condition of art in Vienna. Nothing wanted to go forward. All over Europe, conscience stirred; to us in Vienna everything seemed mouldering and rotting. Everywhere workshops came into existence that made it their duty to be done with eternal imitations of styles and to try to find new forms corresponding to our time. . . . We talked ourselves more and more deeply into reproaches for the obtuseness of the times and all that was impossible [to do]. Finally one of the gentlemen whom we knew only superficially, and who had just returned to Vienna from an extended stay in London, said that it surely would not cost [the amount of] a house if we wanted to try something of the kind."

As it happened it was finally to cost the entire Wärndorfer fortune, but for the time being the enthusiasm with which the main actors tackled the new task was enormous. During the first, happiest years of its existence the Werkstätte included an architectural office that was under Hoffmann's direction. A good deal of his creative energy, however, was expended not on architecture but on arts and crafts designs. This is hardly regrettable, in view of the beautiful objects that resulted, but at the same time one cannot help wondering how much more he might have achieved in architecture had there not been the additional commitment to the Werkstätte. The question is less relevant at the beginning than during the last years of the Werkstätte, when ideological attacks and financial difficulties irritated Hoffmann to a degree that must have been detrimental to his creative capacities. Wärndorfer, impoverished and embittered, emigrated to the United States before the First World War, in the vain hope of acquiring a new fortune there.[28] But an extensive exchange of letters between him and Hoffmann proves that their old friendship revived in the postwar years.

Kolo Moser maintained in his recollections[29] that an early suggestion for founding the Wiener Werkstätte came from Julius Maier-Graefe. Yet there can be no doubt that, at least for Hoffmann, the English model was decisive, above all the Guild of Handicraft of Charles

Robert Ashbee,[30] who was better known in Vienna than other representatives of the English Arts and Crafts movement because of his participation in the eighth Secession exhibition and his repeated mention[31] in *Kunst und Kunsthandwerk*, the important periodical sponsored by the Austrian Museum of Art and Industry.

In April 1900, Hoffmann had recommended that the director of the School of Arts and Crafts visit Ashbee in London. Finally in December 1902 he himself went to Great Britain with Myrbach on a tour of study. Their route took them through Brussels, London, Glasgow, Edinburgh, Berlin, and Dresden.[32] In London, Hermann Muthesius took care of the Austrian guests. This can be gathered from a farewell letter which he wrote from his quarters in The Priory, Hammersmith:[33] "Permit me to give you some of my writings as you embark on your further journey. You have yourselves brought this affliction upon yourselves by your esteem of my last little essay. . . . I also add the book that you tried unsuccessfully to obtain in the South Kensington Museum." The "last little essay" probably referred to *Stilarchitektur und Baukunst*. The work appeared in 1902 and a copy existed in Hoffmann's library. Muthesius' demand for objectivity so impressed Otto Wagner that he changed the title of his own programmatic *Moderne Architektur* to *Die Baukunst unserer Zeit*, as he explained in the preface to the fourth edition. We therefore may assume that the arguments of Muthesius had an equally considerable influence on Hoffmann. Certainly, he and Myrbach could not have had a better guide to English architecture than Muthesius. As far as time permitted they would have been shown all the more important buildings of the most recent past, as well as the pertinent workshops, museums, and institutions of education. Thus Hoffmann could have acquired firsthand information about the goals and methods of the English Arts and Crafts movement.

Considering its well-known commitment to the ideal of improving the worker's lot by offering spiritually satisfying and financially rewarding cooperative work—something Ashbee's Guild of Handicraft actually demonstrated successfully for a number of years—one must ask how far Hoffmann shared not only the artistic but also the social goals of the Arts and Crafts movement. There are indications that especially at the beginning of his career he did share these goals—even if one does not read political symbolism into his Palace of Peace (Cat. 2), where "as a landmark of the entire complex, glowing red globes" were envisaged. Along with Kolo Moser and Alfred Roller, he had assisted in furnishing the Vienna

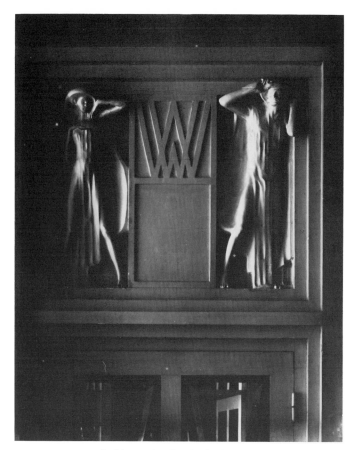

69. *Sopraporta* relief by Richard Luksch above the entrance to the Wiener Werkstätte

settlement house,[34] and he also had the students in his special class participate in a competition for inexpensive living rooms for workers' dwellings.[35] In the program of work for the Wiener Werkstätte, it is expressly stated: "We consider it our most noble duty to regain for the workers a joy in work and an existence worthy of a human being." There is also no lack of later statements by Hoffmann about the dignity and cultural significance of work and workers. Yet on the whole he was more interested in questions of art and creation of form than in social and political issues. He very soon expressed a fear that in artistic concerns "it is absolutely no longer possible to convert the masses," and he concluded, "but then it is all the more our duty to make happy those few who turn to us." In theory he thus arrived at the same elitist conclusion as William Morris did in his practice, but with the difference that Hoffmann seems to have accepted the fact without dismay while Morris complained in angry frustration that he passed his life "ministering to the swinish luxury of the rich."[36]

70. Evangelical Church in St. Aegyd am Neuwald, Lower Austria

The small evangelical church in St. Aegyd (Cat. 74) (fig. 70) was a work toward which Hoffmann may have felt a special moral obligation quite in the sense of the arts and crafts tradition. The man who had commissioned this design, his client from the Bergerhöhe, Paul Wittgenstein, wrote to him after the completion:[37] "I'm so glad that your building, which is as beautiful as it is practical, came to stand on that spot. This satisfaction: to see your artistic ideas realized, for you unfortunately will be all you have from this building for, as I hear, your stated honorarium is so low that it can hardly cover the expenses." The exterior of this little church may have been inspired by Baillie Scott's community hall at Onchan that had been illustrated in *Dekorative Kunst V*, 1900, 46. There is at any rate a complete correspondence to the ideals of the Arts and Crafts movement in the rustic but dignified simplicity, in the references to medieval tradition with the open roof truss dominating the interior of the church, and in the loving care with which the building has been sited in the landscape. Yet Hoffmann certainly designed the church before his journey to Great Britain, since construction had already begun in the fall of 1902.

Some months before Hoffmann traveled to Glasgow, his friend Wärndorfer visited there with his wife. Picture postcards mailed to Hoffmann prove that they went to see the White House by Baillie Scott and the Ferry Inn at Rosenieth by Edwin Lutyens. At that time work for the music room Mackintosh had designed for Wärndorfer was far advanced, for he wrote to Hoffmann about it at Düsseldorf[38] and implored him to go to Vienna as soon as possible in order to clarify some problems that had arisen in connection with the plans sent by Mackintosh. Wärndorfer reported his vast amusement at certain remarks Hoffmann's pupil Wilhelm Schmidt, who was employed in these works, made when he was faced with the plans. According to Wärndorfer he exclaimed: "You see this is quite wrong as far as the material; we solve this in an entirely different manner, but Mackintosh has so much taste . . . jolly, very jolly, you know, this door can turn out [to be] very jolly,—and only because so little is on it . . . oh, the cabinet makers will be annoyed."

These comments by an engaged eyewitness are of obvious interest because they illuminate both fundamental differences of conception between Mackintosh and Hoffmann and at the same time show what Hoffmann, and therefore his students, admired in Mackintosh.

A comparison of the two contiguous rooms the architects designed for Wärndorfer yields the same result as the earlier comparison between the furniture by Hoffmann and Mackintosh in the Henneberg House. Hoffmann's dining room remains predominantly rectilinear and comparatively undecorated. He stresses the definition of space by means of planar elements and subjects the overall composition to the strict geometric discipline of square, rectangle, and rhomb. In its coloristic restriction to white, silver, and black, his room is downright ascetic. Mackintosh on the other hand blurs the definition of space with stronger modeling of the spatial boundaries. He provides more decoration and creates a wealth of subtle effects in both color (frieze of figures) and form, with curves from the realm of organic growth playing an important role. Obviously, two fundamentally different artistic conceptions and temperaments confront each other, yet the artists were able to share a mutual respect and admiration because they were united by an identical goal: the complete aesthetization of the human environment.

Hoffmann and Wärndorfer remained in contact with Mackintosh throughout 1903 when Peter Behrens too paid a visit to England and Scotland,[39] and in 1904 the Scottish couple was even invited to exhibit at the Secession once more. They also came to Vienna for the completion of the wall decoration in Wärndorfer's music room. Later, however, the connection was interrupted, and in 1908 Eduard Wimmer, who had been sent to England by Hoffmann, wrote,[40] "I regret . . . not to have received a reply regarding the inquiry at Mackintosh's."

On 17 March 1903, Wärndorfer reported to Hoffmann that he had written to Mackintosh[41] "in strictest discretion about our project for a metal workshop" and that he had received the following interesting reply: "I have the greatest conceivable sympathy for your 'youngest' idea and consider it simply splendid. . . . Moser is completely right in his intention to carry out nothing but commissioned works for the time being.—If one wants to achieve artistic success with your programme (and artistic success must be your first thought) every object you pass from your hand must carry an outspoken mark of individuality, beauty, and the most exact execution. From the very outset your aim must be that every object which you produce is made for a certain purpose and place. Later, once your hands and your position have been strengthened by the high quality of your product and by financial successes, then you can emerge boldly into the full light of the world, attack the factory trade on its own ground, and you can achieve the greatest work of this century: namely the production of useful objects in magnificent form and at such a price that they

71. View from entrance into the special exhibition of the Wiener Werkstätte in the Hohenzollern-Kunstgewerbehaus, Berlin

between Hoffmann and Moser followed before early in 1907 the latter withdrew from the Werkstätte, irritated by its administrative and financial problems. "His marriage alienated him from us and from himself,"[42] Carl Moll later wrote about Moser, his former neighbor and good friend. The actual rupture came when Wärndorfer, behind Moser's back, attempted to obtain funds for the Wiener Werkstätte from Moser's wife.

Having completed the interiors of the Wiener Werkstätte (Cat. 81), including the sales display, Hoffmann and Moser arranged an exhibition in the fall of 1904 at the Hohenzollern-Kunstgewerbehaus H. Hirschwald in Berlin (Cat. 87) (fig. 71). This probably represented the high point of their joint creative activity. The treatment of the walls in rough white stucco recalls the fourteenth Secession exhibition, but there is the additional articulation of very thin dark wooden strips which create an impression reminiscent of Japanese interiors, as Giulia Veronesi has pointed out. A barrel vault in stucco, not unlike that in the Knips apartment (Cat. 79), is evidence that Hoffmann at this time was eager to deal with the shape of rooms not only through their outline in plan but equally through the modeling of their spatial volume. In order to achieve the fullest effect of the space itself, only a few objects were placed in it, and the majority of exhibited arts and crafts objects were arranged in built-in showcases that helped at the same time to articulate the wall surfaces. Abstract dip paintings of the kind employed in the Knips summer residence, figurines in black and white by Moser that were strongly stylized toward abstraction, and plants in containers and stands of punched metal painted white, typical of the Wiener Werkstätte, all combined in a strong overall effect that was enhanced by sophisticated lighting. As in the Wärndorfer dining room, the built-in showcases were also made to serve as luminous strips in the wall surface. The generous yet severe overall disposition permitted the artists to be subtle, playful, and precious in details and exhibits without running the risk of appearing exaggerated or kitschy. They achieved the perfect balance of contrasts which characterizes masterworks. In view of this design, and, in addition, the furniture for the Stoneborough apartment (Cat. 97) and the Berlin showroom for Jacob and Josef Kohn (Cat. 110a), it becomes understandable why Kolo Moser wrote in his reminiscences:[43] ". . . we had our first successes, however, not in Vienna but abroad, particularly in Berlin where we triumphed earliest." The restrained elegance of this exhibition was matched at the same time in the fashion studio of the Flöge sisters (Cat. 89) in Vienna.

lie within the buying range of the poorest, and in such quantities that the ordinary man on the street is forced to buy them, because he does not get anything else, and because soon he will not want to buy anything else. . . .

"Yes—the plan that Hoffmann and Moser have designed is great and splendidly thought through, and if you have the means for it, you are not taking any risk and all I can say is: *begin today!*—If I were in Vienna, I would assist with a great, strong shovel!

"The enterprises that were placed on the same basis in England, all have succeeded. Ashbee, as far as I know, is occupied continuously and lucratively."

Another letter from Wärndorfer even illustrates a signet for the Wiener Werkstätte that Mackintosh had designed for his Viennese friends. However, they understandably preferred to utilize a design of their own—the two interlocking Ws (fig. 69) that were to become so well known throughout the world during the next three decades.

Four years of friendly, often very close, collaboration

72. Purkersdorf Sanatorium, design perspective, India ink with traces of graphite

Hoffmann showed his versatility by also designing for the same Hohenzollern-Kunstgewerbehaus the sales exhibition of the ceramics department (Cat. 88). Because it displayed so many vessels, this exhibition turned out to be much more restless than the Wiener Werkstätte sales exhibition, for which the pieces had been carefully selected. For the entrance side, Hoffmann adopted a solution that illustrates one of his characteristic methods of design: the creation of visual ambiguity, as discussed earlier. In this case the segmental pediment atop the entrance is supported on its right by pairs of slender columns which thus become framing elements. At the same time, they also serve as the left boundary of the low display wall next to the entrance, and as such they are provided with a symmetrical correspondence on the right of that wall where small columns carry a smaller segmental pediment. In this manner the optical tension of ambiguity is achieved because it is impossible to discern clearly whether the columns next to the entrance belong to the opening or to the wall as compositional elements. Such ambiguities can be discovered repeatedly in Hoffmann's designs.

Thanks to the strong and easily remembered impression Hoffmann's style made, it is not surprising that its influence can be followed beyond the borders of Vienna. This fact was already noted by Hevesi,[44] and examples can be found in Switzerland[45] and Germany, even at times in the work of Peter Behrens.[46]

One of the most enthusiastic reviews of the fourteenth Secession exhibition had come from the pen of Berta Zuckerkandl.[47] As an art critic, she had never missed an opportunity to promote and defend the Secession, and she wrote one of the first extensive appreciations of Hoffmann.[48] It was therefore natural that she should recommend the architect, who later furnished her own apartment (Cat. 196), to her husband's brother Viktor Zuckerkandl, the director of the Westend Sanatorium at Purkersdorf near Vienna, when he decided to supplement the existing buildings with new construction (Cat. 84) (figs. 72-81).

The Sanatorium was intended for physical therapy, baths, and the treatment of nervous conditions and convalescence for a range of well-to-do patients, and it was meant to satisfy the highest possible demands of comfort and luxury. Hevesi, for example, expressly noted[49] "the ladies in grand toilette" on their way to the dining hall. Accordingly, the entire second floor contained, aside from the large dining room, chiefly rooms for social contact and amusement (fig. 79), while the rooms for treatment and service were arranged on the ground floor and in the basement. During the planning stage, the client seems to have exerted great influence, for the design exists in a number of versions (figs. 73-75) that differ in the order and size of the treatment rooms.

The most significant change was the decision to build a flat-roofed, three-story building instead of the smaller two-story construction with hipped roof that had been envisaged originally. The decision may have been brought

73. Purkersdorf Sanatorium, preliminary drawing, ground floor plan with the entrance hall on the left

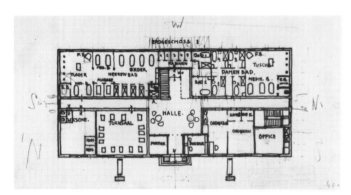

74. Purkersdorf Sanatorium, design drawing, ground floor plan

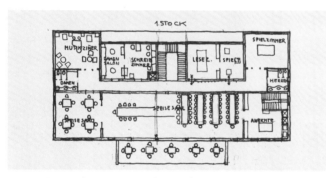

75. Purkersdorf Sanatorium, design drawing, upper floor plan

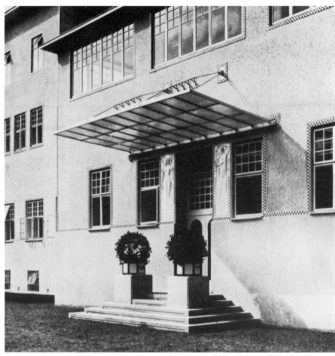

76. Purkersdorf Sanatorium, garden entrance, shortly after completion, 1904

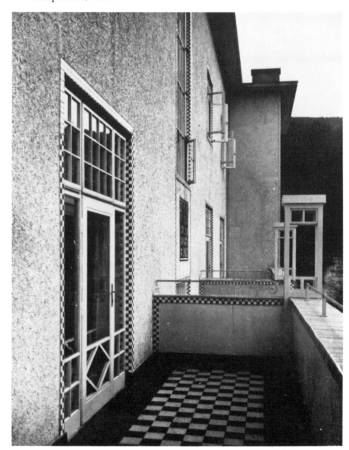

77. Purkersdorf Sanatorium, detail of a terrace on upper floor with access to bedroom

78. (*facing page*) Purkersdorf Sanatorium, corridor on ground floor with view toward the hall

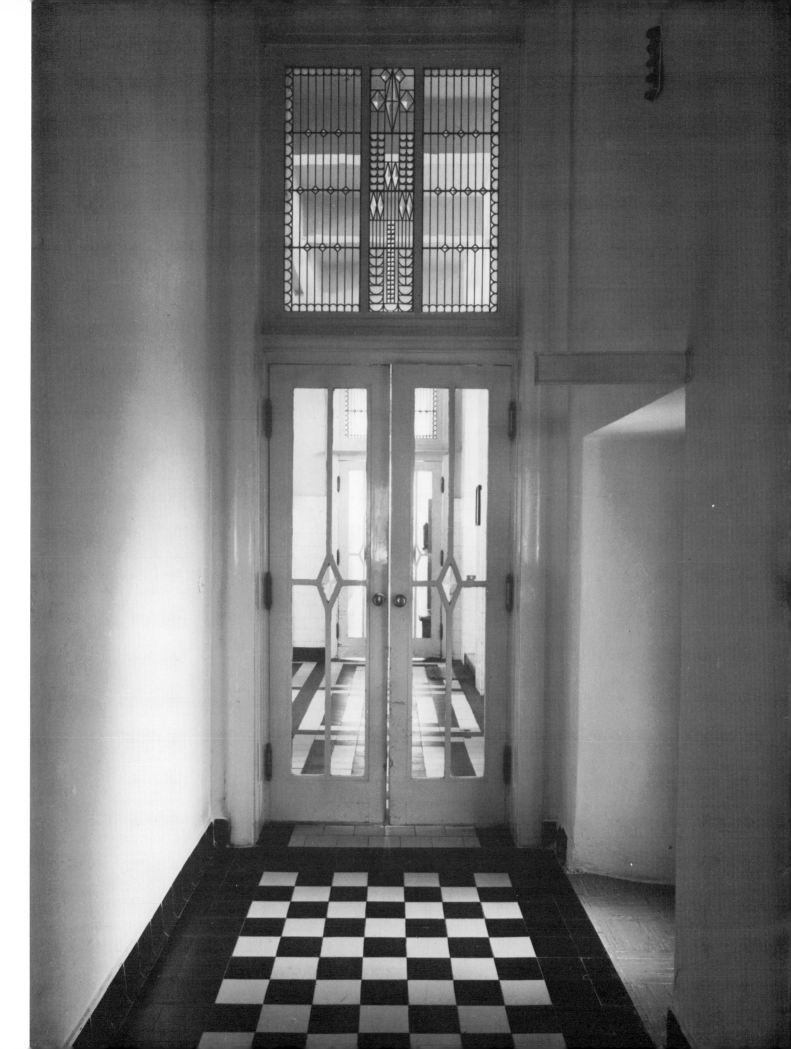

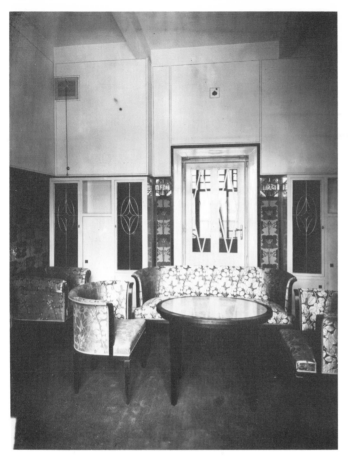

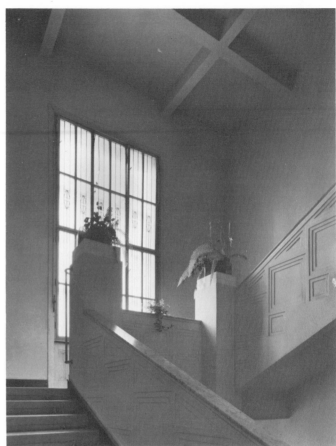

79. Purkersdorf Sanatorium, salon on upper floor

80. Purkersdorf Sanatorium, detail of the staircase

about partly by considerations of economy—Hevesi[50] mentions the "restrictions of a utilitarian building that aims at rentability." The two-story solution would have provided very few bedrooms while in the executed building the entire third story is reserved for this purpose. Yet purely artistic considerations must have played an equally decisive role in the final designs, for a work of great purity came into being. For the year 1904 it was as pioneering in clarity of disposition, consistency of formal treatment, and above all in the extreme simplicity of its cubic form as the Scotland Street School in Glasgow by Mackintosh, Otto Wagner's Postal Savings Bank in Vienna, and Frank Lloyd Wright's Larkin Building in Buffalo, N.Y., even if this last was more original in layout and spatial conception.

It stands to reason that Hoffmann's immediate environment was his most important source of inspiration; this means works by Otto Wagner, by students of Wagner, and by contemporaries close to them. In connection with the Purkersdorf Sanatorium one might think of Wagner's flat-roofed building for the River Administra-

tion in Nußdorf, of the plain, elegant facades by Max Fabiani, and naturally also of the Ernst Ludwig house, which Olbrich had completed in Darmstadt in 1901. But a comparison of these buildings with the Sanatorium leaves not the slightest doubt that Hoffmann's creation is an independent achievement that entirely fits the inner structure of his artistic development. The juxtaposition of cube- and slablike elements (figs. 72, 76) and the composition of the facades at Purkersdorf redeem the architectural promise of the *sopraporta* reliefs of the fourteenth Secession exhibition. At the same time, by constructing his building in reinforced concrete, Hoffmann availed himself of the most modern means building technology had to offer. Design drawings indicate that he intended to utilize this new construction method more radically than proved feasible in the actual execution; originally the ground floor should have received an almost continuous band of windows.

The interior treatment (figs. 78-81), like the exterior, displays a convincing clarity, simplicity, and generosity of conception and execution. Rooms such as the hall on

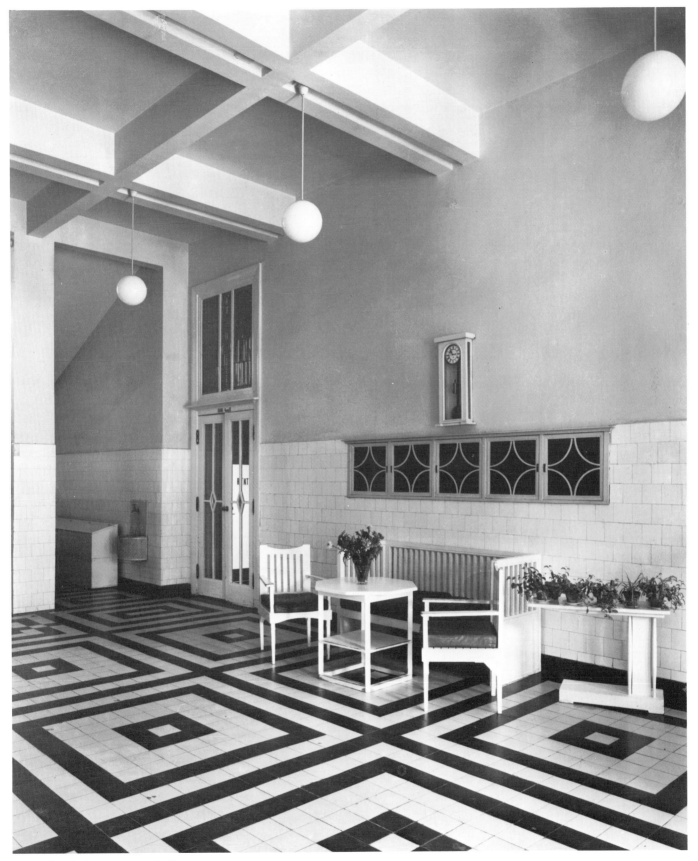

81. Purkersdorf Sanatorium, hall, in 1966

the ground floor, the adjoining staircase, and the large dining room with its projecting glazed veranda are amply dimensioned, with ratios that are arithmetically simple but lack doctrinaire exactitude. In plan the hall is proportioned 2:3, the staircase 1:1, the dining room approximately 1:3, and the small social rooms adjoining the staircase approximately 1:1.

The beams of the reinforced concrete beam-and-slab ceiling system in the large rooms were left visible and utilized for architectural articulation. Particularly in the hall on the ground floor this results in a stress on substantiality and tectonics that stands in contrast to the treatment of the facades. But here too the architect restricted himself to the most simple basic forms: square piers without bases and capitals, and rectangular beams without moldings. These are doubled sideways along the building's long axis so that two reinforced concrete beams, separated by a deep groove, always run side by side in this direction. Despite the restriction to elementary shapes of space and volume, this building too displays Hoffmann's predilection for rooms comprised of segments of different heights. This is exemplified by the spatial sequence of vestibule-hall-staircase as well as by the dining room with its lower glazed veranda.

The building is restrained in its use of decorative enrichment (figs. 76, 77). This is as true of the exterior with its blue-white borders and the sparing yet effective use of figure sculpture as of the interior which employs delicate borders, shallow, stepped-back square panels in the staircase parapets, and monochrome decorative glazing (fig. 78) in severely geometric patterns above the glass doors. No opportunity is missed to impart rhythm to all larger rectangular surfaces by suitable subdivisions and articulations.

The various interiors, some of which were given a richer treatment, provide examples of pleasing contrasts between the very simple spaces and forms of the architecture and such graceful forms of furniture as the light bentwood chairs of the dining room. But there is also a good deal of furniture that shares with the overall architectural composition the predilection for elementary geometrical forms; even a Bösendorfer piano, for which Hoffmann designed an angular, rather bulky housing in black oak, was not exempt. Furnishing the Sanatorium was among the first major commissions the young Wiener Werkstätte received, and Hoffmann collaborated again with Kolo Moser as he had in the earlier interior design projects of the Werkstätte that have already been mentioned.

One has the impression that at Purkersdorf Hoffmann took advantage of the opportunity—for the first time in connection with a work that did not serve only residential or exhibition purposes—to reflect from beginning to end on the elements of design and to render them in the primary forms he had recognized as basically correct. But the formal insights and results he achieved were positively based on the classicist-rationalist tradition he shared with Otto Wagner. It is hardly a coincidence that some of Wagner's Metropolitan Railroad stations serve typologically as formal paradigms for the east facade of Purkersdorf, with its entrance in the central axis, extensive glazing in the upper story, and two lateral elements that are carried up higher like towers. Where Hoffmann by far surpassed his teacher was in the uncompromising renunciation of all reminiscences from the world of classicist forms, including rustication, columns or pilasters, articulated cornice moldings, and crowning balustrades on the roof. In this building classicism was restricted to a basic attitude and was never permitted to appear in the formal treatment. This is in contrast to Adolf Loos, who in a number of projects resorted to the literal quotation of classical forms. Clearly, Hoffmann had set himself the task of inventing a new language to replace the outmoded apparatus of historical forms. And for this purpose it seemed appropriate to begin with questioning the simplest elementary forms: square, rectangle, rhombus, cube, and prism. At the Purkersdorf Sanatorium, perhaps with the demand for a certain hygienic soberness coming to his aid, he succeeded in fashioning for himself an unequivocally personal basic vocabulary and syntax. This facilitated the formal solution of the next major task he was to face: the Stoclet House in Brussels is hardly imaginable without the creative experience of Purkersdorf that preceded it.

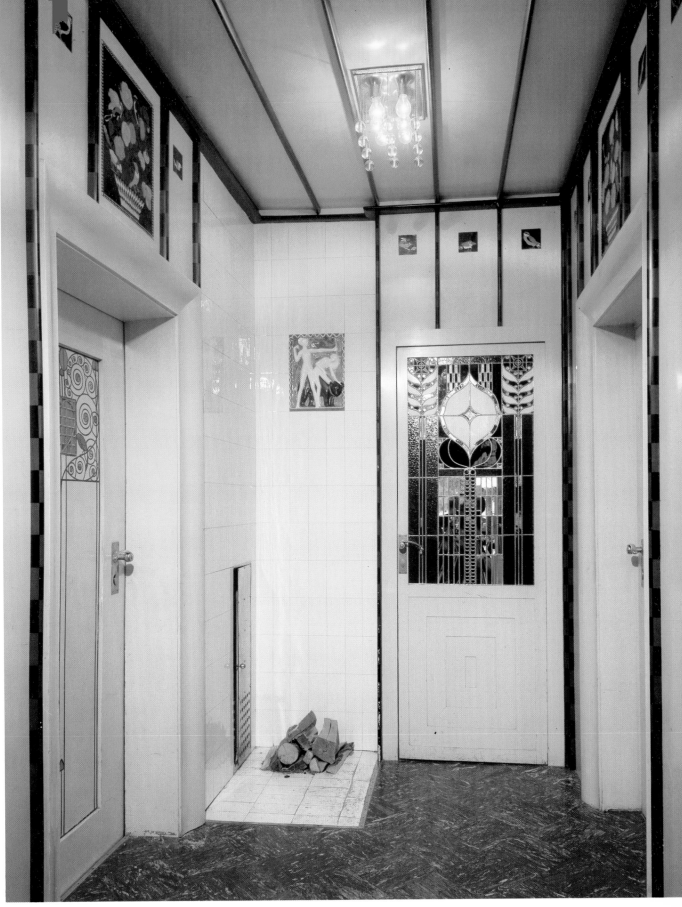

82. Hochreith Hunting Lodge (Cat. 105), vestibule; decorative painting by Carl Otto Czeschka and Josef Hoffmann, ceramics by Richard Luksch, decorative glazing by Kolo Moser(?). The floor covering is of later date.

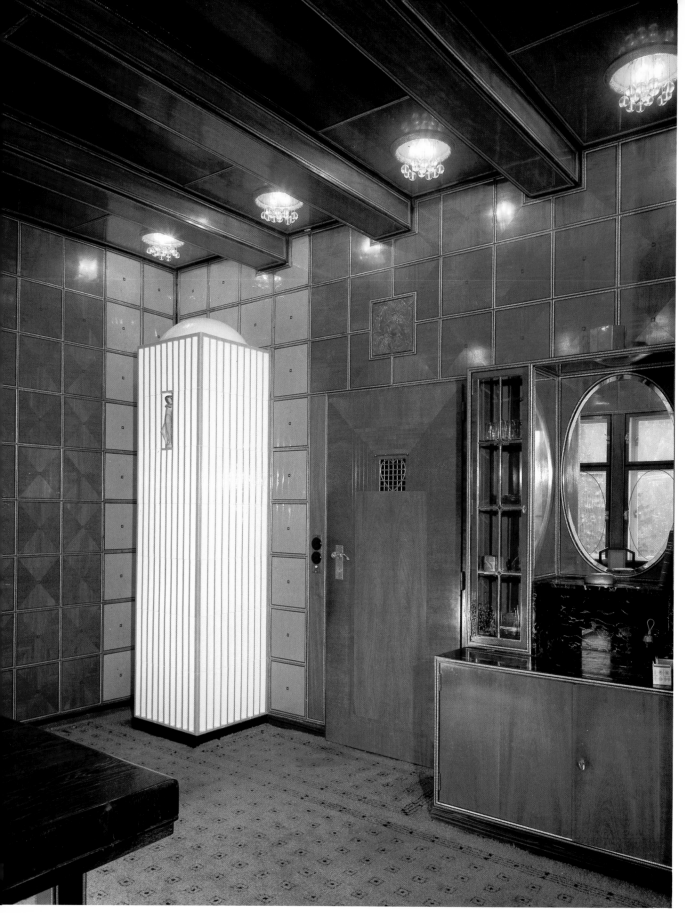

83. Hochreith Hunting Lodge (Cat. 105), main room; paneling of Maracaibo wood, ceramic statuette on tile stove by Richard Luksch

IV. Richness as Artistic Possibility

The years from 1902 to 1904 were the period in Hoffmann's creative activity when simplicity and geometric abstraction reached their culmination and when he tended to restrict himself puristically to elementary forms. Understandably such a purism did not always coincide with the intentions of the clients who even in new creations wanted to find something of the familiar decorative exuberance of historicism: that visible opulence of appointments they considered appropriate to their lifestyle. In addition, Hoffmann's own artistic search for new formal solutions apparently stimulated him to avail himself of the possibilities offered by decorative enrichment. By 1902 in such parts of the Biach interior (Cat. 69) as the buffet and the inglenook, later in the Wärndorfer dining room (Cat. 70) with its glittering silvery walls and the rich decorative treatment of its showcases (figs. 67, 68), and in 1903 in the barrel-vaulted study for Sonja Knips (Cat. 79), the elementary forms and their framing, repetition, folding, or staggering are enriched by the addition of purely decorative elements.

The collaboration with Kolo Moser may have contributed its share toward strengthening this tendency. A particularly sumptuous example dates from 1904 when Hoffmann and Moser were commissioned to redecorate several rooms in grand style, among them a dining room (Cat. 83) at Landstraßer Hauptstraße 138 in an addition to the family residence of Editha Mautner-Markhof, whose daughter Ditha later married Moser in the summer of 1905 (fig. 301). The dining room chairs, probably by Hoffmann, are related to those he designed for Wärndorfer in the straight lines of their design just as the diamond-patterned border of the marble floor resembles the floor treatment at Wärndorfers'; by contrast the inlaid pieces of furniture (buffet and sidetable) are richer than any of Wärndorfer's pieces: presumably they were designed by Moser. The total impression of the room must have been grandiose, as one realizes when one tries to visualize it complete with its works of art, the polished marble, the faceted glass, and the golden glitter of its bird frieze above the buffet—another example of the projection of nature into architecture.

Soon afterward, Hoffmann received another interior design commission, this one from Karl Wittgenstein. It proved to be a considerable undertaking, not in its physical size, but because of the client's desire for representational grandeur. Even though it was only a question of decorating two rooms in Wittgenstein's hunting lodge at Hochreith, Lower Austria (Cat. 105), the expense for this work was higher than what it had been for the construction of two complete houses Hoffmann had designed in 1900 for Wittgenstein's forestry administration (Cats. 45, 46). That this expense went toward decorating a hunting lodge illuminates the character of the client; though he declined to accept a title of nobility, he tended toward an aristocratic lifestyle which included the regular arrangement of hunting parties, hunting having been an aristocratic privilege from time immemorial. Similarly, Alexander Pazzani, the Director General of the Poldihütte steelworks belonging to Karl Wittgenstein, was an enthusiastic hunter and also had a hunting lodge (Cat. 132) decorated by Hoffmann. A hunting lodge like Hochreith might also serve for business dealings, as can be gathered from the columns of *Die Fackel*, where Karl Kraus alleged that a meeting at Hochreith took place in connection with speculations at the stock exchange.[1]

The entry room of the hunting lodge (fig. 82), predominantly white with accents of color, exudes the same, almost childlike, gaiety as certain rooms by Baillie Scott and Voysey, who also used the heart shape Hoffmann employed here. He placed it in a prominent position at the entrance door to the main room, unlike at Purkersdorf, where it appeared only in pieces of furniture. Despite the richness of the artistic appointments, the rooms do not appear to be overloaded; as on other, similar occasions opulence in detail has been bridled by the simplicity and order of the overall composition. This order is omnipresent in the bipartite main room (fig. 83), where the walls and ceiling are covered by a wainscoting of completely regular panels, coordinated with built-in furniture. At work here is the same principle of organization that could be observed in the Purkersdorf Sanatorium: in both buildings one finds clear spatial volumes, simple proportioning based on relations of integrals and the preference for framing all individual surfaces—at Purkersdorf in the facades, here in the interior. The contrast of the straight lines of panels and cubic pieces of furniture with the subtle curves of the fireplace niche is as effective as that between the various colors of the carefully coordinated precious materials. The consonance of all elements in the service of an appropriately char-

acteristic mood, which had been the aim in the first houses at the Hohe Warte, was here perfectly achieved. If one compares this interior with the one created in 1899 at the Bergerhöhe (Cat. 32) (fig. 28), in a comparable context and for similar purposes, one gets a measure of the enormous stylistic distance Hoffmann had covered in seven years and of the sovereign manner in which he now mastered the deployment of all artistic means.

The overall character of the interiors at Hochreith owes much to the decoratively employed works of art: the paintings by Hoffmann himself, the abstract stained glass by Kolo Moser (?), the paintings, metal repoussé, reliefs and embroideries by Carl Otto Czeschka, and the ceramic sculptures by Richard Luksch in which the erotic component of Art Nouveau finds elegant expression. All the works, treating themes of the hunt and of nature, are iconographically attuned to the function of the rooms which they enliven like jewels, while at the same time they fit into the dominating, vigorous geometry. Wärndorfer, always a keen observer and good at putting his impressions into words, found "the total [is] such as I would have imagined the most private room of a Fugger in the Middle Ages."[2]

In the same letter Wärndorfer continued enthusiastically describing the rooms at Hochreith as "simply beautiful beyond measure, absolutely not ostentatious . . . the water that bubbles into the golden washbasin from below looks simply fabulous." He also mentioned that he had surveyed the "state of the works in the building office on 6 August 1906." His list of works, which mentions the Mautner studio addition and the Hochstetter, Moll, and Beer-Hofmann buildings in various stages of planning and completion, begins with the "Stoclet Building." Josef Hoffmann's greatest building, the planning of which was underway since 1905, had just entered the stage of realization, and Wärndorfer concluded hopefully: "Karl W [ittgenstein] has paid his bill . . . now we shall live, I think for another half year—and then it will be Stoclet's turn. May God help further!" It appears that the financial operation of the Wiener Werkstätte at the time was already far from optimal, and the final accounts for the Purkersdorf Sanatorium and the Brauner house were being litigated.

The earliest reference to a design for the Stoclet House (Cat. 104) was published in November 1905 by Ludwig Hevesi who had seen drawings and a model (fig. 89) at the Wiener Werkstätte.[3] Application for a building permit was made in the spring of 1906, and by August of the same year drawings of the facades, scale 1:20, were

prepared and estimates were obtained. According to photographs from the period (fig. 96), the fabric stood to the height of the ground floor by the winter of 1906, and by 1908 the building was largely finished, though without its cladding of slabs which even in June 1909 had not yet been attached.

The earliest known version of a *preliminary design*, presumably the first one, is represented by two sketches of plans (figs. 84, 86), both drawn in Hoffmann's typical manner—freehand with a soft pencil on squared paper (one of them is initialed JH)—showing the ground floor and second floor of the same scheme. These plans differ drastically from later versions; yet the guiding ideas of the program are clearly recognizable. A central hall with a gallery is the chief organizing element of both the early and later plans, and in it a place is designated for the fountain by Minne (marked Minnebr.); it was apparently intended from the very beginning for roughly the same place near the entrance where it finally came to stand. But while dining hall and music room relate to the central hall in a similar fashion as in the final design, this cannot be said of the study. The staircase, too, is in a completely different location, and the two projections on the garden side are square-ended rather than angular.

The exact plan from which the model was built has not turned up, but it must have been much closer to the final plan than to the preliminary design. The model (fig. 89) differs from the final design in several ways. Most striking is the simple, not to say timid, manner in which the tower is handled. The central portion of the garden front has a straight recess on the second floor instead of the curved one which is so effective in the final version. The fenestration shows different rhythms and proportions and finally, apart from other minor changes, there is a most important variation in facade treatment: the white surfaces are delimited not by metal bands but by black lines which were meant to be carried out in black Swedish granite. Accordingly, the model design has the kind of contrast between white and black which by that time had become typical of Hoffmann's personal style. Interestingly enough, Hoffmann seriously considered cladding the facades with white glass slabs. This is evident from captions on plans in the archive of the owner, and from a comment by Wärndorfer in his above-mentioned list of 6 August 1906, which refers to "three glass firms invited for estimates." In 1906 a facade completely clad with glass slabs probably would have been unparalleled, but such an application of new materials would have entirely corresponded to the spirit of Otto Wagner's School; it was not until some twenty years later that the

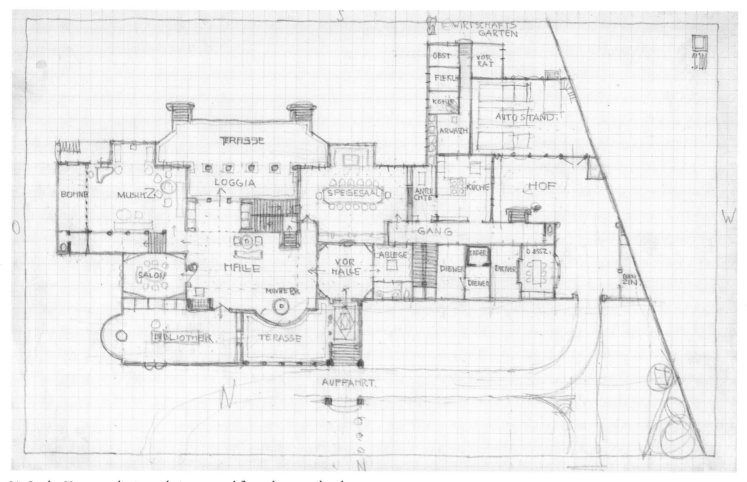

84. Stoclet House, preliminary design, ground floor plan, pencil and green crayon

85. Stoclet House, preliminary design, garden facade, pen and ink

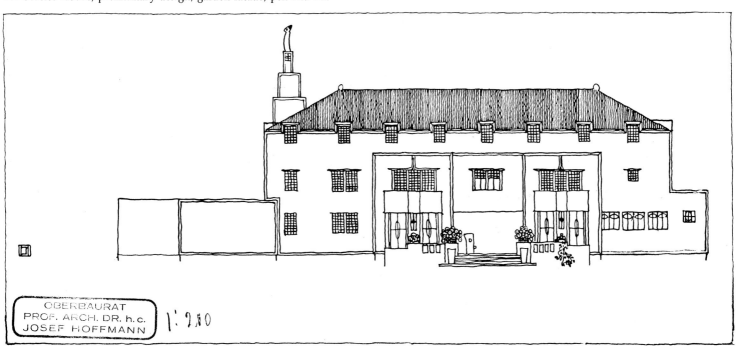

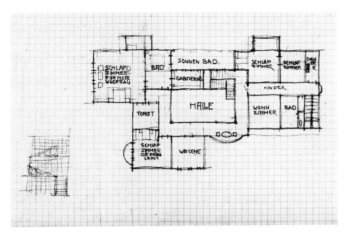

86. Stoclet House, preliminary design, upper story plan, pencil and green crayon

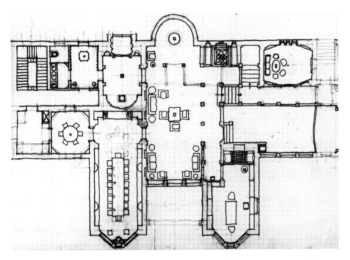

87. Stoclet House, design similar to executed version, ground floor plan, pencil, pen and ink

application of colored glass for facade claddings became widespread, even as a typical characteristic of Art Deco.

A perspective of the garden front rendered in watercolor (fig. 88) corresponds closely to the model; the two projections toward the garden have been given a wedge shape in order to capture, according to Hevesi, the maximum amount of sunlight. The same solution is indicated on a second perspective (fig. 91) that goes together with a preliminary facade sketch, scale 1:200 (fig. 85). The tower here shows some indication of a crowning feature which was not on the model, but the central projection of the garden front is still straight, and the east facade differs from the one carried out, both in the way the staircase is handled and in the design for the end of the music room, which showed a segmental instead of a semicylindrical shape.

Another plan, drawn 1:100, on squared paper and partly inked (fig. 87), still shows some hesitation about the termination of the music room, but its general disposition otherwise comes close to the *final design* (fig. 92). It is interesting to observe that in this plan a central axis is indicated in pencil and that almost perfect bilateral symmetry has been achieved with regard to it. In this as in the final plan all elements are linked in an extremely straightforward and convincing manner, and the maximum of order is imposed. The discipline of regularity and actual coordination is not so apparent in the plan of the ground floor in the final version (Cat. 104), because on this level the wings around the service courtyard to the west form an irregular group with the main building. The plan of the next higher floor (fig. 92), however, clearly shows that the main block of the building is extremely regular and almost—not quite—bilaterally symmetrical around an axis that runs through the middle of the bay window on the street side.

The proportional scheme of the layout is determined in a simple manner by the square. One square of approximately 12m × 12m corresponds to the size of the great hall on the second floor; three squares of the same size form the rectangle of the total second floor, exclusive of the thickness of the outside walls. The square asserts itself in many places in the details of the plan as well as in elevation, notably in the shape of windows and visually important subdivisions of surfaces. The elevation published by Hans Ankwicz-Kleehoven[4] proves that for a while the architect considered putting a small diamond-shaped element in the center of every slab of facade cladding and breaking up the long staircase window into several parts—both devices which would have interfered seriously with the integrity of uninterrupted interlocking planes that is so characteristic of the building as it was finally built.

During the years when Hoffmann was busy with the Stoclet project, his other works clearly demonstrated how much he was preoccupied with the Stoclet House and how he varied the same basic idea more than once. The motif of a hall with a gallery on slender piers, for example, occurs in the cabaret Die Fledermaus, 1907 (Cat. 114), and in the Kunstschau exhibition, 1908 (Cat. 121)—that is, at a time when young Charles-Edouard Jeanneret studied Hoffmann's creations very carefully. It is entirely possible that Hoffmann's spatial compositions are to be counted among the stimuli for Le Corbusier's later frequent combinations of high rooms with lower ones and gallery stories.

Hoffmann himself had pursued the idea of a higher

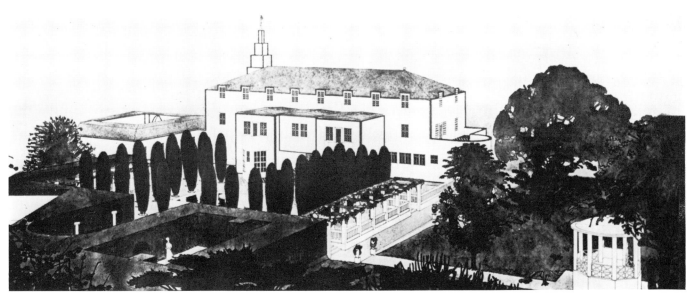

88. Stoclet House, perspective of an early version of garden side, watercolor

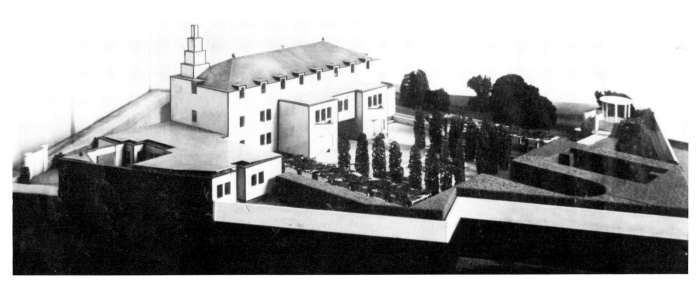

89. Stoclet House, view of garden side of model from 1905

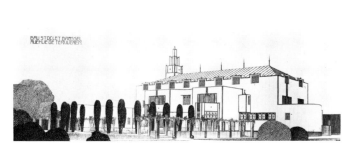

90. Stoclet House, perspective of an early version of garden side, pen and ink

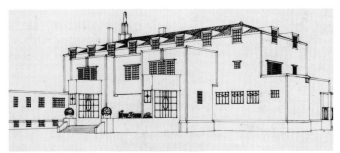

91. Stoclet House, perspective of an early version of garden side, pen and ink

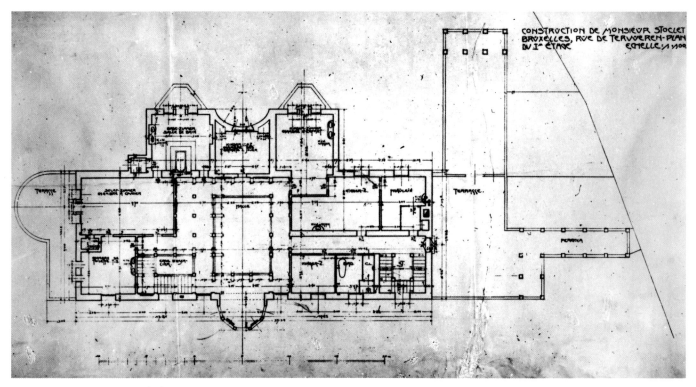

92. Stoclet House, submitted plan, upper story

residential hall in which a staircase begins since the first houses on the Hohe Warte. Equally early precursors exist for the volumetric treatment of the Stoclet House, but except for the pavilion of 1903 (Cat. 80),[5] which anticipates the central concavity of the Stoclet garden facade, these precedents are not necessarily architectural in nature. They may be found among Hoffmann's designs for furniture where, from the very beginning, framed surfaces corresponding to the nature of wood construction occur. Thus the design of a small, wedge-shaped wall cabinet, published in 1901 (Cat. 57/III), invites comparison with the wedge-shaped projections of the Stoclet model design. In the case of Hoffmann, furniture and objects of every kind sprang from the same formal conception as architecture, and there are small metal objects that have an outspoken architectural, monumental effect. But it is an inadmissible generalization to maintain that Hoffmann designed buildings like furniture and furniture like buildings; he was much too much aware of the effect that different materials and scales have on form.

Probably the strongest first impression the Stoclet House makes is that of a building which not only looks different from anything around it—an impression which must

have been even stronger in 1911 (fig. 93)—but which in many ways eludes a search for immediate comparisons with any other building one has seen. It takes some effort to overcome this impact of unfamiliarity and to proceed to a more detailed inspection of the building on the Avenue de Tervueren.

When the site (fig. 95) was selected it must have appeared ideal from many points of view. The piece of property was virtually at the end of the built-up area, on an avenue and promenade that carried a good deal of social prestige, owing both to its being a continuation of the important Rue de la Loi, and to its imposing scale in size and planting. With a fine view toward south and east over wooded deeper-lying areas, partly developed as landscaped parks, the Stoclet site promised the amenities of country life and a fairly undisturbed privacy without sacrificing relative proximity to the center of the city. The parallels to the Hohe Warte in Vienna are striking and, as we shall see, not coincidental. One does not see the long street facade of the building immediately in its full extension, and for someone approaching from the center of town, the staggered western portion of the facade (fig. 1) dominates with its high tower and the long strip of the staircase window. Its verticality contrasts

80

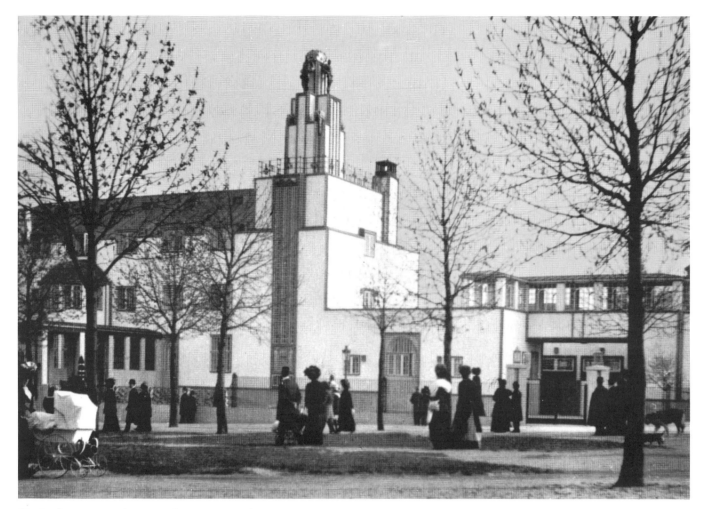

93. Stoclet House and Avenue de Tervueren, about 1911

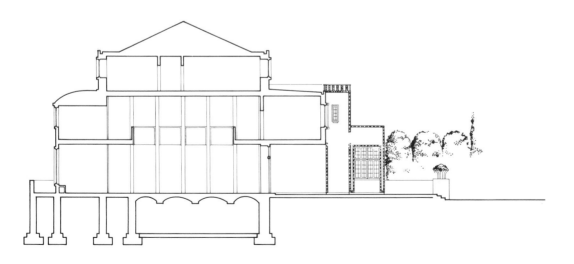

1 0 10 m

94. Stoclet House, section through
the great hall

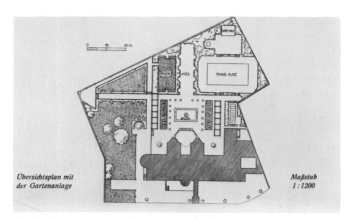

95. Stoclet House, site plan with garden layout

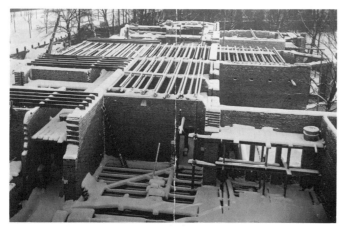

96. Stoclet House, view of construction with completed ceiling girders above the ground floor (Winter 1906)

with the horizontality of the multiply-subdivided entrance loggia and pavilion next to which the polygonal bay window appears of minor importance. It assumes greater visual weight, however, when the street facade is viewed from the lower, eastern end of the site (fig. 97). Seen from here, the bay window, together with the projecting volumes of the east facade, tends to balance the richness of the distant western portion and its tower. The total impression along the Avenue de Tervueren is so varied by means of asymmetrically placed elements that it comes as a surprise to discover that the entrance is placed almost in the exact middle of the facade—a very plausible location, incidentally, from a functional point of view. Owing to the lower service wing, which is seen as a direct extension of the main block in this facade, the building appears impressive even through its sheer extension.

Next to the high staircase and lookout tower the single most striking feature is the molding of gilt and darkened metal which frames all edges (fig. 103). Since it acts three-dimensionally, its effect is much stronger than that of the ceramic borders at the Purkersdorf Sanatorium, which remain on the surface. From the floriated metal cupola that crowns the tower (fig. 100) the framing profiles cascade downward—several of them side by side—until they reach the walls of the building which they enclose like garlands. The profile selected for the framing metal moldings (fig. 103) reminds one a little of the wreath which the female figures modeled by Bacher carried in their hands in the fourteenth Secession exhibition. Moreover, Hoffmann employed edge profiles of unequivocally floral design at the Ast House (Cat. 134) (fig. 172), completed at roughly the same time as the Stoclet House. The profiles at the Stoclet House, occasionally framing an opening the way a rope might,[6] may owe their unique form to a meeting of different formal concepts in the imagination of the architect: reminiscences from the world of classical moldings may have played as much a part as the form of lotus leaves from the Far East and the equating of a framing profile with a garland of flowers.

The strongly linear element introduced by these profiles into the overall composition, however, has nothing to do with visual "lines of force" of the kind found, for example, in the work of Horta or Van de Velde. Since at the Stoclet House the lines occur equally along horizontal and vertical edges, their tectonic effect is neutral. At the corners or any other juncture where two or more of these parallel moldings come together, the effect tends toward a negation of the solidity of the built volumes. A feeling persists that the walls were not built up in a heavy construction but consist of large sheets of a thin material, joined at the corners with metal bands to protect the edges.

Naturally one could justify this treatment by explaining that the brick-built walls were actually clad with thin slabs and that Hoffmann expressed this fact in the formal treatment, just as Otto Wagner at the Vienna Postal Savings Bank (1904-1906) used visible "nailing" to express his stone cladding as an applied veneer that had nothing to carry except its own load; obviously such an attitude was in keeping with Semper's theory about the role of cladding in architecture. Hoffmann himself later gave the following explanation for the cladding slabs: "This material was inexpensive and durable; the usual slab-sizes clearly showed the difference from ashlar construction." With or without such justification, the visual

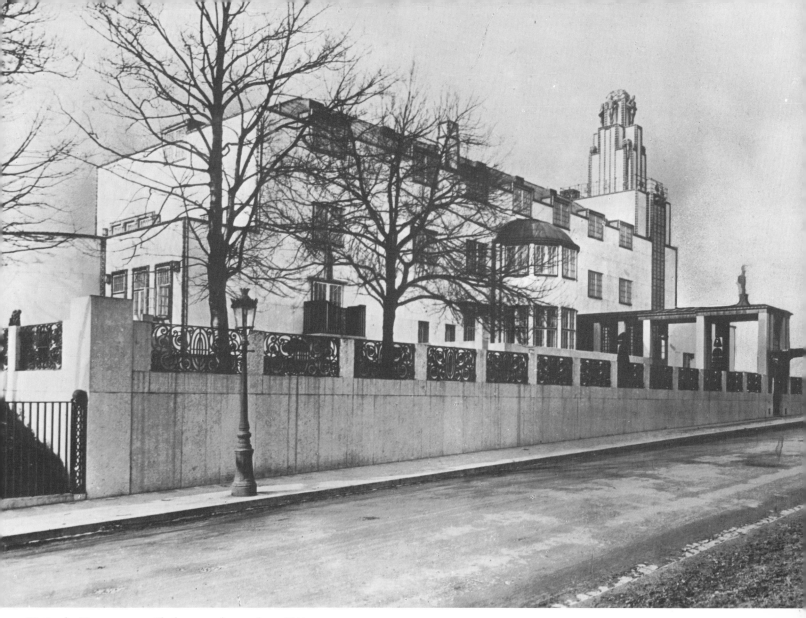

97. Stoclet House, street side from northeast, about 1911

effect of the Stoclet House is striking and atectonic in the extreme. ("Atectonic" here is used in contrast to "tectonic" and both terms describe the artistic manner in which the expressive interaction of load and support in architecture is visually negated or expressed.)[7]

The use of framing metal profiles is not the only atectonic detail at the Stoclet House. Other examples occur at the loggia on the roof terrace and at the entrance pavilion (figs. 98, 99), where heavy piers have nothing of adequate visual weight to support but carry a very thin, flat roof that appears almost weightless. In addition, as at Purkersdorf, the facade design makes no tectonic distinction between the parapet in front of a terrace (a screening element) and the load-bearing wall underneath it (fig. 105). Equally the transition between low and high

parts in the facade is made in one plane without any articulation. The character of the facade as a purely two-dimensional surface is stressed everywhere at the expense of its quality as part of a volume with implications of mass and weight. In this connection it is equally significant that windows are set flush into the facades, even slightly protruding, not in recesses, which would betray the thickness of the wall, and that they cut into the tops of the cornice-less facades. Since the windows are treated as defined planes much as the stone surfaces next to them, the effect is one of interlocking planes rather than of a plane with holes, counteracting any feeling of heaviness that otherwise might have gone with the prevailing planarity. Finally there are many elements which visually seem to slide past each other or at least appear

83

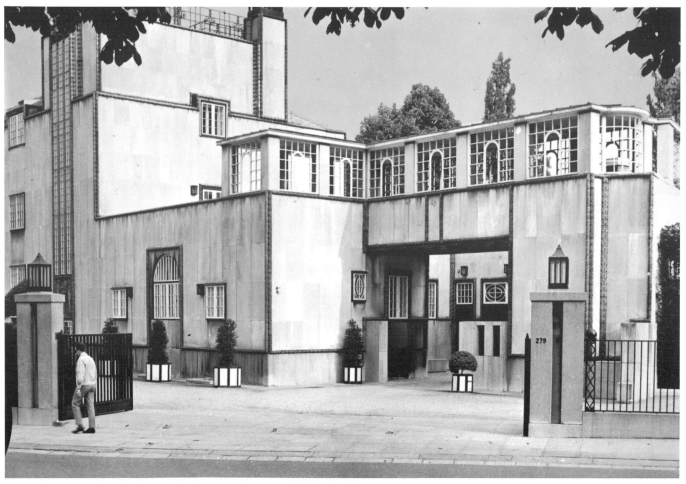

98. Stoclet House, detail of street side from northwest with the bridgelike section above the driveway to the garage yard

ready to do so. This is particularly true of bridgelike elements such as the curved central portion of the garden front (fig. 108), the loggia above the driveway to the garage court (fig. 98), and the tower, with its telescoped, receding stages that seem to have glided past each other.

It appears almost like a symbol of the prevailing atectonic attitude that the shape which is placed in the most important position in the garden, in the central fountain (Cat. 104/V), at first glance vaguely resembles an archaic Doric column with considerable entasis but at closer inspection turns out to be something entirely different: something in the nature of a very elongated vase shape with a top that does not end in a square abacus in a gesture of support but houses a small spout from which water may flow into the basin below.

Hoffmann's rejection of tectonic expression as an artistic means may be explained at least partly by his turning toward elementary geometrical forms, above all the

square, which has been discussed earlier in connection with the *sopraporta* relief of the fourteenth Secession exhibition. Square and cube have this in common: they are inherently nondirectional and therefore without dynamic effect. Something of the feeling that static elements have been joined additively remains as typical for the Stoclet House as the patent negation of any strong tectonic expression. It is also striking that on various points of the building the obvious next step according to the inner logic of the design would have been a visual separation of two contiguous surfaces. This is as true of the various bridgelike elements that have been mentioned as of the angular bay windows on the garden side where the wedge shape implies a virtual movement of the angled planes, as of two door wings about to open. Otto Wagner indicated a similar direction in the way he handled the corners of the Postal Savings Bank, where two facades are expressed as independent slabs which do

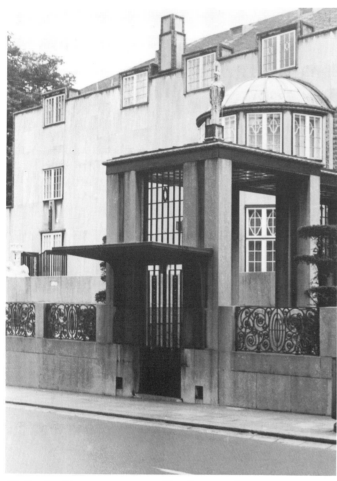

99. Stoclet House, entrance pavilion from northwest

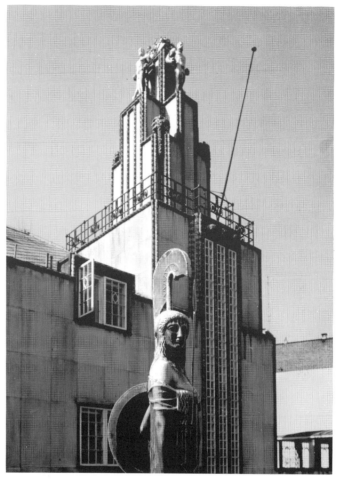

100. Stoclet House, street facade with tower (detail); statue of Pallas Athene by Michael Powolny on the entrance pavilion in foreground

not meet but are separated by a short, oblique surface slightly set back. Yet neither Wagner nor Hoffmann took the decisive last step of "liberating" the interior space by an actual separation of its bounding planes; this would have initiated that process of "active dematerialization" that became so significant for the Modern Movement of the 1920s. This was only achieved by Frank Lloyd Wright[8] and later by others.

In Hoffmann's building, where any virtual movement occurs it is not in the nature of a clearly defined dynamism, but a passive motion, a sliding and gliding of elements which leads to an effect of "passive dematerialization," recalling a similar tendency in paintings by Gustav Klimt, where forms and bodies seem to float past each other, not driven by their own volition but as if in a trance.

With all due caution in making comparisons from one field of creativity to another, one is also reminded of the glissando effects so typical of the avant-garde music of the period, and perhaps even of Hugo von Hoffmannsthal's attempt at a characterization of the whole epoch, written in 1905, the year when the Stoclet House was begun: ". . . the essence of our epoch is ambiguity and uncertainty. It can only rest on that which is gliding and it is aware of the fact that what other generations believed [to be] firm is [actually] gliding."[9]

A new attitude toward the articulation of space was clearly announced and foreshadowed at the Stoclet House, but it was not yet carried through. It is the attitude of the De Stijl movement that found its most telling expression in buildings such as Rietveld's Schröder House and the Barcelona Pavilion by Mies van der Rohe. In anticipating this direction Hoffmann considerably surpasses his Scottish friend Mackintosh, as is demonstrated by a comparison of the Stoclet designs with the competition designs by Mackintosh for the Haus eines Kunstfreundes

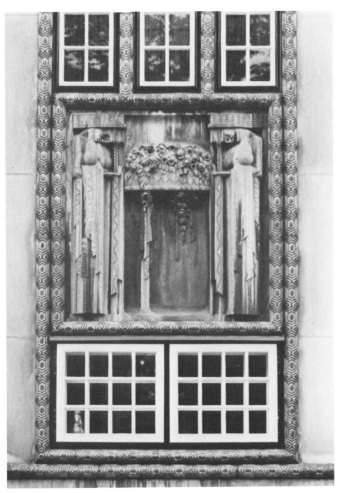

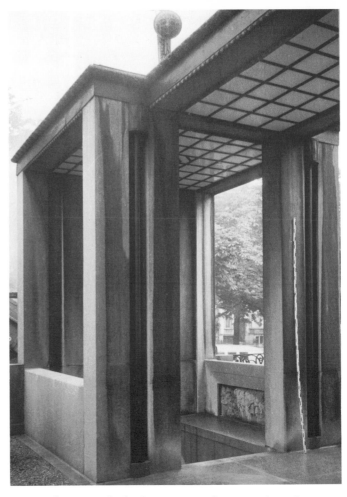

101. Stoclet House, detail of the large staircase window; sculptures by Emilie Schleiss-Simandl

102. Stoclet House, back of entrance pavilion, seen from the house entrance

103. Stoclet House, wooden models for the chased work on the facade moldings

104. Stoclet House, garden pergola at the west of the house, with the client(?)

105. Stoclet House, east end of garden facade

106. Stoclet House, forecourt with entrance pavilion, view toward west

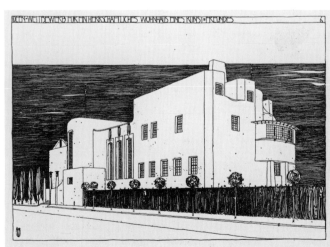

107. C. R. Mackintosh, ''House of an Art-Lover,'' perspective of street side, 1901

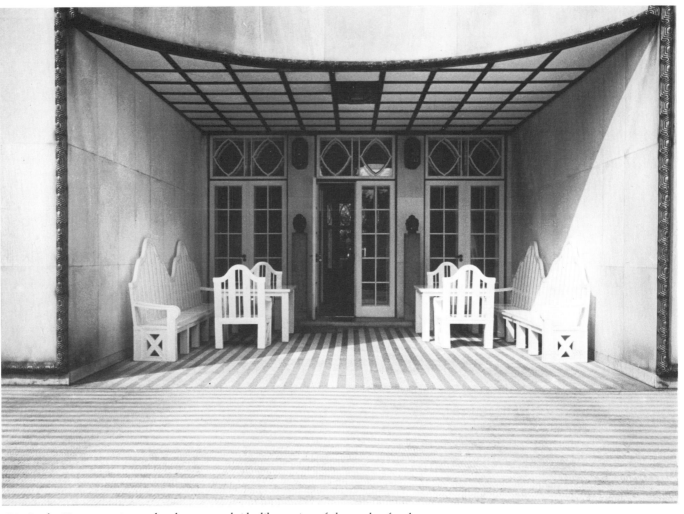

108. Stoclet House, seating under the concave bridgelike section of the garden facade

(House of an Art-Lover) of 1901 (fig. 107). Where the Scotsman handled his surfaces as the modeled boundaries of a sculptural volume into which openings are cut, Hoffmann treated his like so many clearly defined, framed surfaces in their own right, underplaying the sculptural qualities of the volumes. He fulfilled what his teacher Otto Wagner had postulated as one of the leitmotifs of a new architecture:[10] "the slablike treatment of the surface." A second significant difference demonstrated by the comparison concerns the manner of composition; where Mackintosh prefers the loose grouping of superbly modeled volumes, a heritage from the Arts and Crafts movement and the interest in medieval informal planning, Hoffmann retains rigorous axiality as an ordering principle from the classical method of composition.

The axes of the building partially find their continuation in the strictly formalized garden which is an integral component of the total design and which offers views of the house carefully framed by planting. Eduard Wimmer described his impressions on a visit in 1912 as follows:[11] "Late last night Mr. Stoclet even illuminated the garden. A clear starry night, the white, white house reflected in the water of the pool, the dark hedges, above it, an incomparable calm . . . we stayed long, long before it." These words remind one of the special role the period assigned to the garden as aestheticized nature.[12] From certain viewing points, the garden facade gives an impression of complete bilateral symmetry, though in actual fact it is not symmetrical. Because this facade has a southern exposure and receives a large amount of sunlight, Hoffmann modeled it much more strongly than the northern or street facade. The garden facade also expresses in many ways the close interrelation between garden and building. The center portion, two stories high with a terrace on top in front of the three-storied main block, has two prowlike polygonal bay windows on the

ground floor that extend considerably into the garden. Between them an open but sheltered area (fig. 108) forms a transition from the open garden terrace on the ground floor to the enclosed central hall. This area is covered in a bridgelike fashion by an upper story which recedes in a gentle curve. A strong interplay takes place between the receding or hollowed-out center and the flat or advancing sides, and one is tempted to describe it empathetically as gestures of reaching out and welcoming in.

A similar employment of contrasting yet unified compositional devices can be observed when analyzing the second important approach to the central hall, which is from the street side. The carefully considered manner in which the core of the building is reached from the garden has its parallel in the elaborate sequence of preparatory and transitional zones that lead to it from the Avenue de Tervueren. The main gate (fig. 99) sits in an open square pavilion (figs. 102, 106), which in its severe neoclassical monumentality recalls buildings by Sir John Soane.[13] The pavilion, the adjoining partly open, partly glazed loggia, and finally the flight of easy steps in front of the entrance door together form a spatial sequence of carefully calculated imposing effects that, step by step, prepare for the experience of the interior.

It is not difficult to understand why Pallas Athene should have been placed over the gate pavilion (fig. 100). As militant protectress of wisdom and the arts she had been one of the favorite symbols of the Vienna Secession, and such artists as Gustav Klimt and Kolo Moser had represented her. At the Stoclet House she shares pride of place with another tutelary deity of wisdom, the elephant-headed Ganesha at the east end. It is equally easy to understand why, in a panel above the long staircase window, heads should have been placed which form a perpetual lookout. But it is less easy to interpret accurately the four herculean figures placed on the four sides of the tower (figs. 1, 100). They may have been a direct suggestion of the sculptor who did them in 1908: Franz Metzner, from 1903 to 1906 Hoffmann's colleague as a teacher, was fond of a rather heavyhanded monumentality. The monument to the *Völkerschlacht* at Leipzig which he did in collaboration with Bruno Schmitz probably best illustrates the direction his ambitions took. There is, at any rate, something Nietzschean or Wagnerian about the way in which these four figures—embodiments of human pride (?)—stand underneath and around the crowning feature of the whole design—a metal dome of flowers, perhaps reminiscent of the Vienna Secession building. Flowers—age-old as decorative devices and as symbols of a dedication to beauty—occur

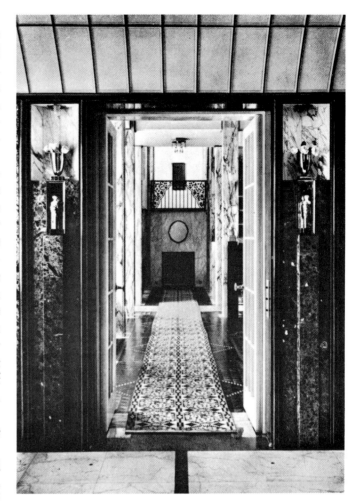

109. Stoclet House, view through the great hall to main stairs (photograph about 1914)

again on the four corners of the tower at a lower level and in the square sculptured panel below the staircase window (fig. 101). Here two female figures in sacrificial attitude carry a basket of flowers.

The interiors (cf. Cat. 104) were clearly planned as a coherent, carefully coordinated sequence of experiences, and, as at the Hochreith hunting lodge, every available artistic means was employed in their design: variation of spatial shape, careful proportioning and introduction of rhythm, effective control of illumination by daylight and artificial light, coloration, and surface treatment. At the same time the rooms are characterized iconographically according to their purpose and prevailing mood, with, for example, representations of the muses in the music room. Yet in the selection of the most suitable theme for a room, Hoffmann conceded complete freedom to his artistic collaborators. Thus in June 1910, Wärn-

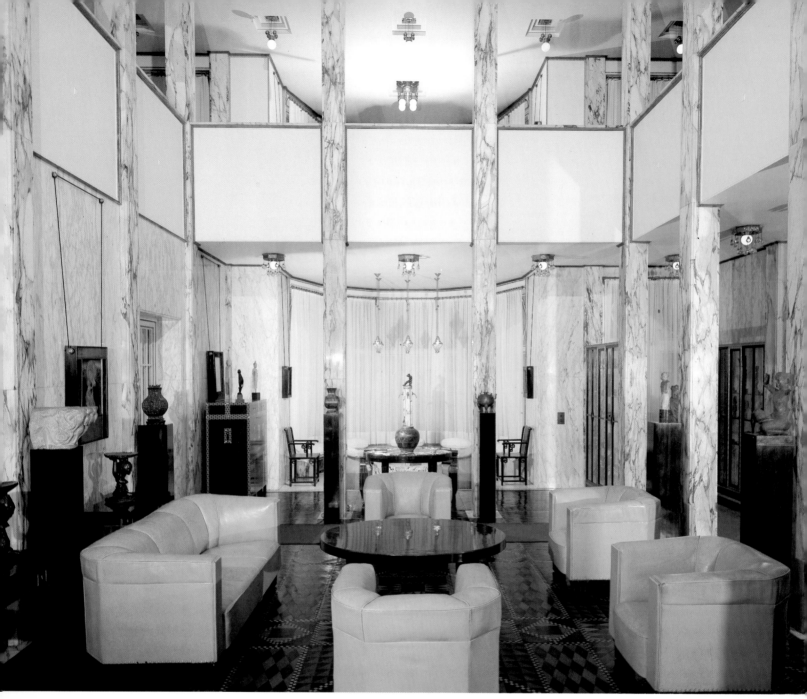

110. Stoclet House (Cat. 104), the great hall, view toward the fountain alcove; Paonazzo and Belgian marble; furniture of Macassar wood, upholstered furniture originally in suede leather. The closed desk on the left is by Kolo Moser; the runner is of later date.

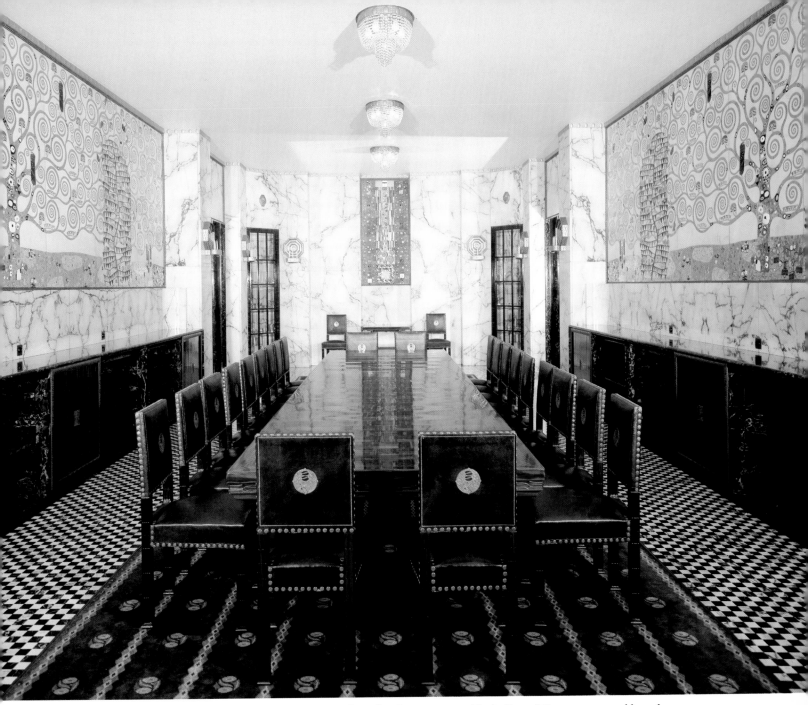

111. Stoclet House (Cat. 104), dining room, view toward rear wall; walls of Paonazzo marble, buffets of Portovenere marble and
 Macassar wood, mosaics by Gustav Klimt

112. Stoclet House, design for the music or theater room, pencil, pen and ink, crayon, watercolors

dorfer wrote to Czeschka about the octagonal ladies' salon:[14] ". . . we need six designs from you . . . for six tapestries. Subject which you want, colors which you want. The tapestries will be carried out . . . under Hoff's supervision. . . . Hoff asked me to tell you, whatever you make is all right with him. . . . Hoff would be very agreeable if you would also design the furniture—salonchair, armchair and divan and small table. . . . Notabene carpet also depends on your wishes. Hoff would like it most if you would add it to what you are going to design. . . . Stoclet agrees to your choice."

The climax of the spatial sequence is the great hall (fig. 110) and its adjoining rooms. Its spatial effect is so strong that one can observe even today how visitors entering it for the first time lower their voices under its impact. It is adjoined on one side by the music and theater room (figs. 112, 113), and on the other side by the dining room (fig. 111). These two rooms stand in strong contrast to each other. They differ in the articulation and coloration of their walls and in the spatial arrangement: the longitudinal axis of the music room ends in an apse and runs at right angles to the longitudinal axis of the great hall, while the axis of the dining room ends in an angular bay window and runs parallel to that of the great hall;

in the apse stands an organ, in the bay window a fountain. Both the music room and the dining room are treated more richly than the hall which, though executed in very precious materials, is more reticent in its color and decoration. This corresponds to the purposes of these rooms, since the hall is both a room of passage and a neutral background for the art collection it houses and for the assembly of guests. By contrast the two other rooms serve purposes which were assigned the highest possible importance by the stratum of society that desired the stylization of existence into an aesthetic experience; music and theater, which Peter Behrens called "Feste des Lebens" (festivals of life), were as much high points on the path to spiritual and sensual self-realization as was the communal meal taken in a room prepared with hieratic splendor for the celebration of sensuous enjoyment. It is no coincidence that in schemes of the period the juxtaposed music room and dining room again and again played a particularly important role: in the Spitzer House at the Hohe Warte (Cat. 63) with the Olbrich music room, in the Wärndorfer House with the Mackintosh music room, and in the Beer-Hofmann House (Cat. 102) and other later interiors.

The effect of the dining room in the Stoclet House

92

113. Stoclet House (Cat. 104), music or theater room, view toward stage with organ, walls of Portovenere marble with gilded copper moldings, floor of teak and coral wood, furniture carved and gilded. Runner and textiles are later replacements.

cannot be conveyed adequately by illustrations (fig. 111); not only Hoffmann's architectural articulation and furniture but also Klimt's mosaics have to be experienced in their three-dimensionality, because Klimt decided to employ slightly projecting and receding materials with surfaces that were not completely flat.[15] Klimt went to Brussels for a site visit with Hoffmann and Wärndorfer in 1906, and in 1911 he traveled to Belgium again for the installation of the frieze.[16] His mosaic and Hoffmann's room form a complete artistic entity: as on other occasions when he had placed pictures by Klimt, Hoffmann with great understanding accommodated his design to the intentions of his admired friend, and Klimt on this occasion equally endeavored with great sensitivity to fit his work into the architecture, just as he had done earlier with the Beethoven frieze.

The walls of the room are recessed in three stages from bottom to top: the lowermost and most projecting zone is formed by the dark buffet cabinets; above them a strip of smooth, light marble follows; and slightly recessed behind it, finally, is the mosaic frieze. The mosaic is so composed that the two figural elements occur in proximity of the window, which means that on entering the room one discovers them only after surveying the whole length of the frieze; in addition, entirely in keeping with the sense of the total composition, entering from the hall, one sees first the *Dancer (Expectation)* and then the *Pair of Lovers (Fulfillment)*. The *Pair of Lovers* is placed on the wall that contains the entrance door, while the *Dancer* is mounted on the wall opposite the entrance door. The third mosaic panel with the abstract image is situated opposite the windows and therefore can be understood as a symbolic window, offering a view of a world that is the antetype of the real one, the garden extending in front of the windows. The obliquity of the surfaces that bound the space in front of the abstract mosaic, and its placement in a twice-recessed flat niche—like the dummy doors of an Egyptian mastaba or the niches of an ancient Mesopotamian sacred building—unfailingly evoke the sensation of being in a zone of transition between two worlds. If someday one were to succeed in unraveling the meaning of the abstract composition, it would be possible to understand what it was Klimt wanted to confront the guests at the communal meal with, here, at the most protected place of the interior. On the long walls he obviously displayed to them a garden of art and of love, a garden that, unlike the real garden in front of the windows, would never wither. Thus Klimt's imagery here as at the fourteenth Secession exhibition permits the view into a mythical landscape,

only its meaning now is quite different from that of the Beethoven frieze.[17]

The various completely abstract segments of the picture, developed from the geometry of square and rectangle, recall the early appearance of such compositions in Hoffmann's *sopraporta* designs from the fourteenth Secession exhibition and, accordingly, pose the question about the relationship between Klimt and Hoffmann. Without doubt Klimt was artistically the leading personality among the Secessionists. This resulted in the decision in 1904 to feature nothing but his works at St. Louis, and is demonstrated by the fact that the artists who in 1905 left the Secession because of ideological differences regrouped under the title of "Klimt-group." Otto Wagner admired Klimt,[18] as did Frank Lloyd Wright, who on a trip to Vienna in 1910 visited him personally and acquired a painting.[19] Mackintosh in turn seems to have transposed elements from Klimt directly into his interior architecture.[20] Hoffmann never disguised his admiration for Klimt and time and again managed to find a place of honor for his paintings in exhibitions and interiors he designed. In the Lederer apartment (Cat. 94), for example, he connected two rooms in order to create a space large enough to provide an adequate setting for Klimt's *Philosophy*.

In 1906 Franz Blei,[21] a good judge of the situation, wrote: "Thus I believe, I see in Klimt the one who fuses the differences of the Viennese masters into that peculiar communality which is called style of the Wiener Werkstätte." Yet it is remarkable how, precisely in connection with the fourteenth Secession exhibition designed by Hoffmann, Klimt's work clearly manifests a change in the direction of a "stylization that has turned away from nature" and a "planar style without compromise" (F. Novotny);[22] it was the movement toward abstraction, as if Hoffmann's striving after elementary abstraction at that time equally affected Klimt. The connection appears particularly plausible, if one considers the great movements in art around 1900. For the avant-garde, among which Klimt surely counted himself, the turning away from autonomous easel painting unconnected to the environment was as much a main tendency as the turning toward the task of artistically forming the environment, something in which as an architect Hoffmann was the expert. Klimt for some time had preferred the square as a picture format; it may be of more than purely formal significance that around 1902 he also began to sign paintings, such as the *Portrait of Emilie Flöge*, by inscribing his name in a square decoratively set into the total composition, thus introducing Hoffmann's preferred ele-

114. Stoclet House (Cat. 104), large bathroom; walls of statuario marble with mosaic decoration and insets of black marble and malachite, floor of Bleu Belge marble; furnishings and silver toilet articles by the Wiener Werkstätte

115. Stoclet House, master bedroom, walls with built-in cabinets and panels of rosewood with inlays

mentary form into the picture. The relationship between Klimt and Hoffmann, who also furnished the painter's studio (Cat. 96), certainly was fruitful for both, as contemporaries had already observed.[23] Carl Moll wrote, ". . . in the friendly intercourse Gustav Klimt—Josef Hoffmann an equilibrium was produced by the artistic collaboration," and Wilhelm Dessauer stated, ". . . the mighty talent of Hoffmann pushes Klimt . . . in an arts and crafts direction."

In addition to Klimt, several other artists[24] created works for the Stoclet interiors, both on the ground floor and the second floor (figs. 114-117). The upper private rooms are of an equally careful characterization and mutual coordination as those on the ground floor. Thus in the parents' bedroom the vaulted ceiling and the wainscoting in rosewood create a sheltered feeling (fig. 115),

while the much lighter ladies' dressing room (fig. 116) entirely in white, black, and gray, provides an ideal, neutral background for the colorfulness of the toilettes that were tried out in it. Finally, the equally bright, marble-clad bathroom (fig. 114), in large dimensions and with its own spacious balcony that could serve for open air gymnastics, anticipated in its attitude toward care of the body thoughts that only became common property of the Modern Movement later on. The expenditure of effort in the detailed solution of even the smallest design problems and in the execution by craftsmen of the Wiener Werkstätte was enormous. Not the least problem in carrying through such a large and complicated project was the organization and coordination. In this respect Hoffmann possessed special capacities and a rich experience acquired by, among other things, his numerous

arrangements for exhibitions. Above all, however, one feels a purposefulness behind every design detail; it obviously motivated architect and client in a similar manner, and it was not the least important reason for the final splendid harmony of the whole.

At the Stoclet House the relation between client and architect was very happy indeed, a fact clearly mirrored in the consistent character and quality of the building, which shows that no compromises were forced onto it. A fundamental agreement must have existed between the taste and predilections of Adolphe and Suzanne Stoclet and the artistic intentions and capacities of Josef Hoffmann. The creations of the Wiener Werkstätte, which had been founded while Adolphe Stoclet and his family lived in Vienna, so completely captured his sympathy that many years later in his testament he expressed the wish to take on his last journey a silk handkerchief for his breast pocket, designed in black and white by Hoffmann. The Stoclets held Hoffmann in the highest esteem and he, in turn, was challenged to the utmost by the well-defined demands of people who were connoisseurs and amateurs of the arts in the best possible sense of these words.

The Stoclet guest book—designed by Hoffmann—preserves between its silver covers names which represent many aspects of excellence in cultural life: Paderewski, Diaghilev, Stravinsky, Cocteau, Anatole France, Sacha Guitry; and a contemporary eyewitness describes how "on many occasions a hand-picked audience would be invited to their theatre . . . to discover an artist as yet unknown—an Indian dancer, a Russian pianist, a French composer or actor."[25] At times there must have been assembled at the house a group of artists and intellectuals fully as brilliant as any found in those famous late nineteenth century Parisian salons that Suzanne Stoclet had known well during the years immediately preceding her marriage. Her father, the art critic and dealer Arthur Stevens, was one of three brothers who played an important role in the art world of Paris; best known among them was Alfred Stevens, the much sought after painter of ladies of high society.

Adolphe Stoclet came from a different kind of background. His family was well established in banking and the high finances of the Belgian economy, which at the time went through a phase of great expansion owing to operations in the Congo. He married the beautiful young Parisienne against the wishes of his family, it seems, and consequently went abroad, first to Milan, then to Vienna, where in 1903 his third child, a son, was born. He and

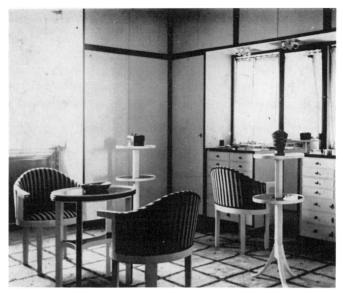

116. Stoclet House, dressing room of Mme. Stoclet; paneling and furnishings in black and white, light gray carpet with black grid

117. Stoclet House, children's room, animal frieze by Ludwig H. Jungnickel largely in black and green, unit below frieze in wood enameled white

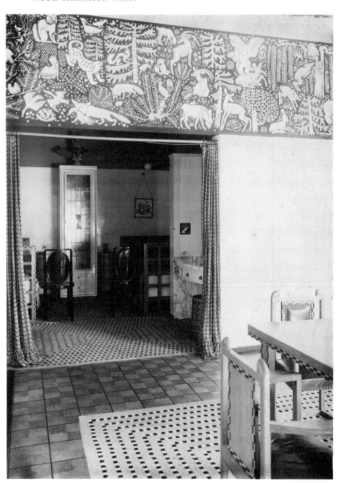

his wife had started their art collection by then and they must have taken an interest in the art life of Vienna, including such events as the exhibitions in the Secession building. But they also explored the city and its surroundings, and it was on one such trip that they met Hoffmann under circumstances which were flattering for the young architect.

The Belgian couple had gone for a morning walk to the Hohe Warte, where one of a group of brand-new residences attracted their attention, and they entered its garden. They were promptly discovered by the owner, none other than the painter Carl Moll, who not only showed his new house to the visitors but also introduced them to the architect the same afternoon.[26]

Since Mr. Stoclet expected to stay in Vienna for some time, he actually went as far as to commission a house design from Hoffmann. It was for a site on the Hohe Warte that was later utilized for the Ast House. The project was never realized because Stoclet was called back to Brussels in 1904 in order to assume his paternal inheritance. But he now had considerable means at his disposal—he never disclosed to his family what the cost of his house had been—and could call on Hoffmann for a design on a palatial scale.

When in 1949 Adolphe and Suzanne Stoclet both died within one month, after a half century of shared love for the arts, they left behind a unique house and an outstanding art collection. With its stress on the highest quality and remoteness in time and place—the archaic and the exotic—the collection as much as the house expresses the character and taste of the two people who were responsible for both. The house cannot be understood fully without the collection nor the collection without its splendid container; for the Stoclets, both demanded a continuous adherence to self-imposed, exacting standards.

Edmond de Bruyn[27] described the Stoclets, on the occasion of a social event, descending the great staircase: "... la maîtresse de maison lamée d'or par Poiret et coiffée d'aigrettes, au côté d'Adolphe Stoclet, droit dans sa barbe symmétrique et lustrée d'Assurbanipal. . . ." The image can be supplemented from the recollections of Georges A. Salles[28] about Stoclet: "His black beard threaded with silver, his manner—charming with just a hint of pomposity—and his distinguished presence gave him a remarkable affinity of style with the objects in his collection, with which he seemed to be quite naturally in contact. In fact the polished surfaces of the marble in the great entrance hall harmonized equally with him as with the carvings displayed against the background of

the decoration: Buddhist deities, Egyptian kings, a head of Darius, a Khmer torso, a golden bear or a green dragon. In this monumental company he was perfectly at ease."

One begins to understand how much the Stoclets were one with the framework they had created for their lives. Nothing was left to coincidence, neither in the design of the house, nor in "les fleurs—toujours d'un seul ton—sur la table et la cravate de M. Stoclet [qui] s'assortissaient sur la toilette de Madame. . . . La bâtisse se manifestait incompatible avec quoi ce soit de banal, de provisoire ou de médiocre."[29]

The "incompatibility with anything provisional" is a particularly well-observed characteristic of the architecture of the Stoclet House, and it results from a quality of Hoffmann's design that has already been noted in connection with other buildings: the visual measurability that is a consequence of the vigorous subdivision and framing of all surfaces. This goes so far in the Stoclet House that a connoisseur of the building arrived at the conclusion that it was the "decorative moldings, that gave the house its character."[30] In this regard, Hoffmann's rooms from this period are comparable to early Renaissance perspective representations, in which a subdivision of the floor into square compartments makes it possible to determine unequivocally the position of every object in the room. With Hoffmann, ambiguity and sliding surfaces may also exist, but never an amorphous lack of form.

The temptation is great, once more, to draw an analogy to the condition of the hierarchical society that provided the greater framework for the lifestyle of the Stoclet family just prior to the First World War. The building was a very personal setting for a way of life based on a profound respect for beauty and the transfiguring power of art, but worked out by a man who was a realist capable of both running a big bank and enjoying a bathroom of the scale and luxury of Roman thermae. Pride of possession in this building is tempered by the reticence of a highly cultured individualist for whom aesthetic perfection assumes almost metaphysical significance. This probably also accounts for the somewhat hieratic character in some parts of the building which so struck contemporaries that they made comparisons with Egypt and Byzantium.

During the few years between the completion of the Stoclet House and the outbreak of the First World War the reaction of immediate contemporaries was entirely positive. Though the enthusiasm of Eduard Wimmer in the letter quoted above may be explained at least partly

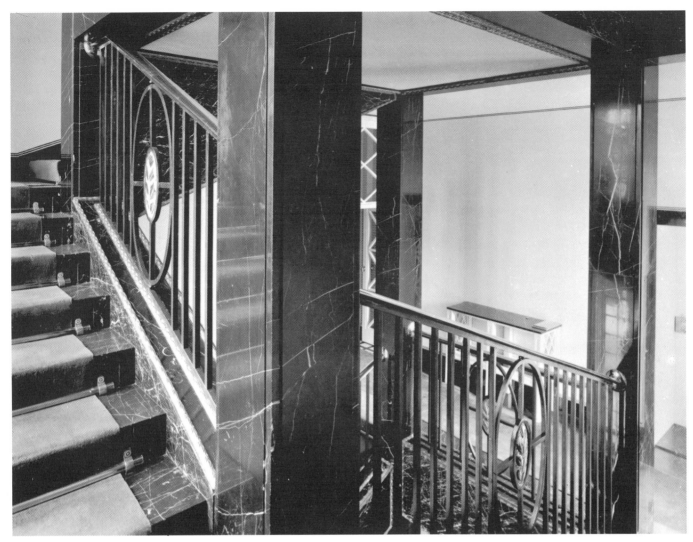

118. Stoclet House, secondary stair, piers and floor of Bleu Belge marble

by the fact that he was one of Hoffmann's collaborators and therefore biased, his genuine emotion is evident when he describes the Stoclet House as "a small piece of the world where finally—finally, one has come quite close to one's ideals, and where one imagines oneself more beautiful and better . . . in Vienna I shall tell you much more, for today I'll add only that to me Mr. Stoclet too is a miracle of a man. Osthaus wrote so well of this happy constellation where Stoclet is your contemporary."

Karl Ernst Osthaus, the founder of the Folkwang Museum, who during the First World War tried in vain to protect the copper roof of the Stoclet House from requisition by the German occupying forces, spoke of the building in a board meeting of the German Werkbund; the meeting happened to coincide with an historic event,

Italy's declaration of war against Turkey in 1911, and all those present understandably showed more interest in the political events than in the agenda until Osthaus finally remarked that for members of the Werkbund a more important fact existed than the Italian-Turkish conflict: ". . . i.e. that the Stoclet House in Brussels had just been taken over by the client,—a work of such maturity and artistic grandeur as had not originated in Europe since the days of the Baroque."[31] A few years later A. S. Levetus introduced her extensive description of the building[32] with the following words: "There can be no doubt that the Stoclet Palace in Brussels represents a landmark in the history of modern architecture. . . ."

There are some interesting remarks about the Stoclet House by architectural critics,[33] but on the whole it did not attract a great deal of professional comment. This

was due partly to the historical circumstances. Three years after its completion the First World War broke out and dramatically marked the end of an era for which the Stoclet House had been such a characteristic monument. The postwar years had interests other than the sumptuous house of an art lover. Yet soon after it was possible to break the silence the war had caused, the Dutch periodical *Wendingen*—renowned well beyond the borders of Holland for its outstanding graphic treatment and advanced editorial program—very extensively illustrated the Stoclet House in its August/September issue of 1920. This publication would have drawn to the Stoclet House the attention of Gerrit Rietveld and other Dutch architects as well as of Ludwig Mies van der Rohe if they had not already known about the building earlier from their own activity in the geographic vicinity: Rietveld in Utrecht, Mies van der Rohe in the Hague, where in 1912 he designed the Kröller House. Mies has even been described as a pupil of Hoffmann's by the British critic Morton Shand, who knew the period well from personal experience.[34] Rietveld must have had a particular professional interest in Hoffmann's furniture; and we know that Theo van Doesburg was impressed by the abstract portions of Klimt's mosaic frieze at the Stoclet House.[35] Robert Mallet-Stevens, a relative of the Stoclet family on his mother's side, often visited and admired the building in his youth, and many of his later designs recall what, as a young man, he had seen there. Numerous other architects and artists visited the house at some time, among them Peter Behrens who praised it highly,[36] Max Bill, Henri Matisse, Richard Neutra,[37] and Le Corbusier. In the United States, too, the building became known through publications, and one of the first designs for the Pennsylvania Savings Fund Society building in Philadelphia seems to show formal borrowing from the Stoclet House, as William Jordy has pointed out.[38]

Erich Mendelsohn, in a letter of 14 March 1914, evaluated the building from the point of view of a young architect: ". . . what is great about it is the new will, much of what I have explained. Only not yet finished, not yet the work, not yet style. These are still surfaces of interior walls and not faces of structure and of tectonic necessity."[39] Some twenty years later, E. Persico could be more detached when he assessed the value of the Stoclet House for his generation in an article in *Casabella* entitled "Trent'anni dopo il Palazzo Stoclet." Not very long ago his words were quoted again, significantly in a key passage that concludes the first of a two-volume history of modern architecture:[40] "We are not talking of the Stoclet Palace here in order to present it as a model of the architecture of today; it is judged as a part of its environment, and from this some lessons are to be drawn. First that it was in tune with its time . . . in the relation of the style to the most vital ideas of its time. Measured by this standard the Stoclet Palace is an outstanding example . . . will the architects of today be able to realize in art a comparable totality of life? To resist the temptations of rhetoric and to retain the tradition of European architecture without deviations? These questions . . . let the Stoclet Palace appear as the monument of an epoch that was glorious for the destinies of art."

In retrospect, it appears indeed that the Stoclet House marked the high point internally and externally in Hoffmann's entire oeuvre. It remained an achievement in scope, quality, and significance which he did not surpass during the rest of a long and fruitful career. At the time it was built, however, it was for the architect and his collaborators in the Wiener Werkstätte but one station on a path they believed would continue onward to new successes; the architect himself later remarked with great modesty:[41] "the correct position of the rooms, their inner rhythm and the external composition that followed from it, the continuous simple treatment in a unified fashion with unremitting stress on the material gave me enough trouble, and perhaps [it] is the only meritorious achievement that indeed one has managed without any old style. Of course it is only a beginning." While work at the Stoclet House was going on, Hoffmann was entrusted with important new tasks, and he was, as always, eager to find ever new forms for their solution. In this way he moved further and further away from the style of the Stoclet House and the early period, in the direction of a stricter classicism and more traditional vernacular motifs.

V. The Turn to Classicism

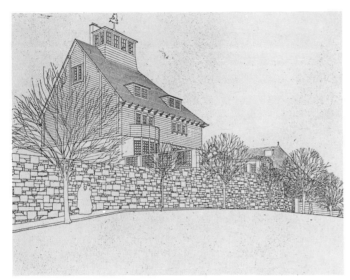

119. House for Alexander Brauner, perspective drawing of street side, 1905

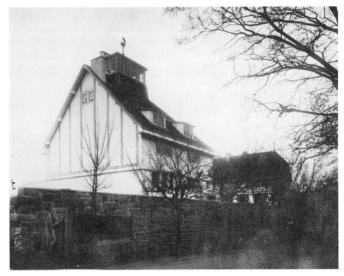

120. House for Alexander Brauner, street side shortly after completion

As the designs for the Stoclet House were assuming their final shape, two smaller houses designed by Hoffmann were built not far from each other in Vienna. They show clearly the two divergent tendencies in Hoffmann's creative activity that have already been discussed in connection with the Henneberg House: the trend toward the "free style" of the English Arts and Crafts movement, which found expression in the house for Alexander Brauner (Cat. 101), and the turn toward classicism as exemplified by the house for Dr. Richard Beer-Hofmann (Cat. 102).

The Brauner House (figs. 119-126), with its horizontal wood siding painted in the typical Hohe Warte colors white and blue,[1] its sash windows, and rooftop glazed belvedere crowned by a blue ship, gives a very Anglo-Saxon, even North American, impression and, compared to the Beer-Hofmann House, displays a very small degree of formality. "Like an audacious figurine of white porcelain with cornflower-blue ribbons and matching little bonnet," it appeared to one contemporary,[2] and another exclaimed, "Hoffmann threw himself with such love into this work that it stands here like a technically perfect doll[house]-toy."[3]

By contrast to the Beer-Hofmann House, Hoffmann was able to design all interiors for the Brauner House,[4] and he published them in a special issue of the periodical

Hohe Warte[5] (figs. 122, 124). With a title borrowed from Ruskin, it was dedicated to "the sanctity of the home," and its accompanying text consisted of quotations from Ruskin and Morris in addition to a review of the book *Das Englische Haus* by Hermann Muthesius, and contributions by the editor.

Here the architect expressed his ideals as clearly as at the Purkersdorf Sanatorium and the fourteenth Secession exhibition—in this case ideal conceptions, derived from England, about house building and livability and the manner in which house and nature should relate to each other. The garden is brought into the house not only pictorially but in reality, as in the entrance lobby where a partition carries natural growth (fig. 121). Except for the historical reminiscence of Tudor arches in the study, the formal language is purely geometrical—an elementary geometry, but with its harshness tempered in each case by the use of textiles.

A comparable unity of the whole, with variations in the geometry of details, which gives a subtle character to each room, is found in the approximately contemporaneous interior for Dr. Hermann Wittgenstein (Cat. 106). Here, as in the Brauner living room, there is a typically Anglo-Saxon arrangement—an inglenook—that stands out as part of the total composition and is handled with particular artistic intensity.

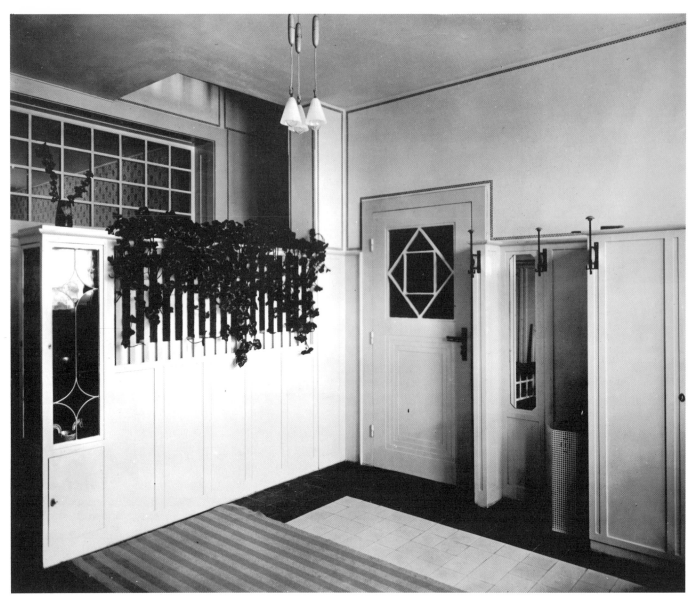

121. House for Alexander Brauner, vestibule

The Brauner House represents not only a high point but also the conclusion of a phase in Hoffmann's activity that was one of the happiest—both as far as the artistic quality of his creations as well as the conditions of his living and working were concerned. It is a phase in which his striving for simplicity and geometric clarity was in complete agreement with the inspiration, derived from Great Britain, to handle tasks in the spirit of the Arts and Crafts movement; this gave to his work a clearly defined, unmistakable personal style. This phase did not come to an abrupt end but changed almost imperceptibly into the next one, which was more attuned to the classical and decorative. Even later Hoffmann occasionally liked to refer back to solutions from this earlier phase. A good example is the Moll House II (Cat. 112), which in its final version (fig. 129), displays a siding of asbestos cement shingles that recalls the shingled surfaces of many English country houses. Peter Davey[6] even compared the towerlike wing of the building with Voysey's J. W. Forster House in Bedford Park (the comparison becomes less convincing if one sees the Moll House in its original condition without a window at the middle level). In our context it is remarkable that the first project for the Moll House II, not accepted by the client, possessed no English

122. House for Alexander Brauner, perspective of seating niche with fireplace (inglenook) in living room

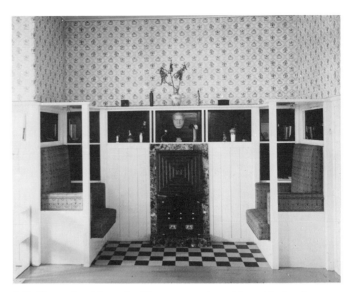

123. House for Alexander Brauner, seating niche with fireplace (inglenook) in living room, 1905

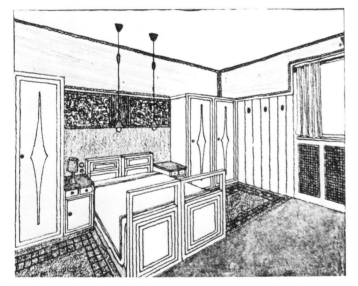

124. House for Alexander Brauner, perspective drawing of bedroom

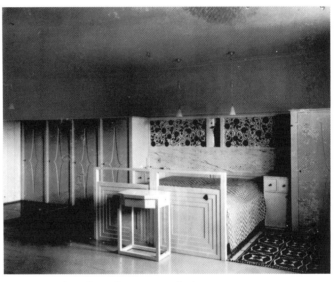

125. House for Alexander Brauner, bedroom

features but was designed with a curved roof (fig. 128). This very economical form, which Adolf Loos also made use of, could derive from the Biedermeier, as a comparison with the round gable at the house of Therese Krones (fig. 127) not far from the Hohe Warte shows. From 1905 onward relations to the Biedermeier and to classicism in general assumed increasing importance in Hoffmann's oeuvre.

Planning for the Brauner House was separated by only one year from that for the Hochstetter House (Cat. 111) (figs. 130-133), but the differences separating the executed buildings are so profound that one can say a new

phase began in Hoffmann's stylistic development around 1905. It is true that superficially the two buildings have much in common: two-storied street facades in which the formal treatment of the upper and lower portions differs, high roofs, bay windows with terraces, and sheltered accesses to the entrance. Closer study reveals, however, that the similarity is more typological than stylistic because the materials employed and the forms of the details are very different: in the upper story, stucco instead of wooden siding; on the ground floor, whitish gray bricks instead of stucco, and above all a completely different treatment of the windows. At the Hochstetter

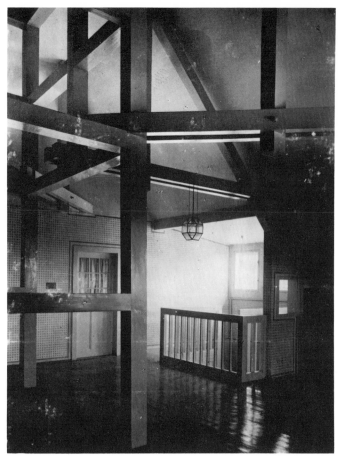

126. House for Alexander Brauner, hall in the attic story

127. House of Therese Krones, sketch by Josef Hoffmann (detail)

House the windows of the upper story are enriched by decorative glazing bars and a large cavetto molding above the lintel. Comparable formal enrichments, not found at the Brauner House, occur in the interior; the vestibule (fig. 133), with its limitation to a black and white color scheme and very restrained, simple furniture, is still completely in keeping with Hoffmann's preceding "puristic" period, but in addition there is a dining room (fig. 132) with chairs of a hitherto unknown intricacy. The original simple geometric form of such a piece of furniture now obviously no longer sufficed, and its components began to receive a decorative treatment that went beyond what had been achieved in earlier years by mere variations within the simple geometry. If in the perspective drawings of the house (fig. 130) the English echo was still distantly heard, in the executed building it has been largely silenced; Hoffmann has become more independent and at the same time more decorative. The approximately contemporaneous work of designing for

128. House for Carl Moll II, first version, design drawing for entrance facade

129. House for Carl Moll II, view of entrance facade shortly after completion; Henneberg House at the right

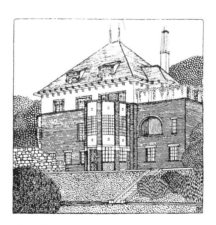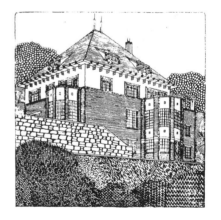

130. House for Helene Hochstetter, three perspective views

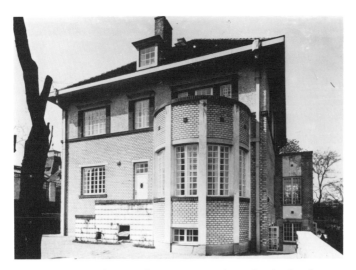

131. House for Helene Hochstetter, view of east facade shortly
after completion, 1907

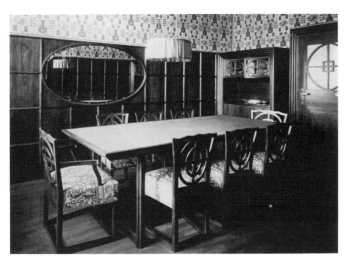

132. House for Helene Hochstetter, dining room

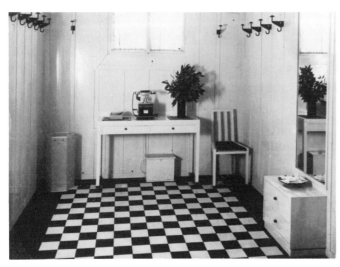

133. House for Helene Hochstetter, vestibule

the Hochreith lodge and the Stoclet House may have
induced this turn toward decoratively richer treatment.

The Beer-Hofmann House (Cat. 102) (figs. 134-139),
with its pilasterlike wall strips, coffering, and completely
symmetrical garden facade, as well as very regular tri-
partite plan, is more classicist than any other building
previously done by Hoffmann. This may in part have
had something to do with the personality of the client
who wished to use many of his fine pieces of Biedermeier
furniture in the new house. Hoffmann had met him,
according to Carl Moll,[7] through the circle of friends
associated with the Secession. Max Reinhardt, after the
opening of his production of *A Midsummer Night's Dream*
at the Theater an der Wien, attended by many Seces-
sionists, gave a banquet at the Hotel Imperial, which in
the early hours of the morning was followed by a visit
to a coffee house at the Stephansplatz. On this occasion
Beer-Hofmann and Josef Hoffmann began a conversa-
tion, and on the marble slab of the coffee house table
the architect drew the first sketch of his idea for the villa
that a year later was nearing completion. During its most
brilliant period, before the Beer-Hofmann family was
forced to flee from Austria, this building provided the
frame for gatherings of a significant portion of the cul-
tural elite from the world of theater and literature, al-
ways in small, very personally oriented meetings of a
few people rather than in great parties or musical soirées.
Miriam Beer-Hofmann-Lens[8] remembered that guided
tours were occasionally organized, when a professor of
architecture wanted to show the house to his pupils, and
on such occasions the "mixture of an entirely modern
way of building with a purely antique manner of fur-
nishing" was particularly emphasized.

That this "entirely modern way of building" showed
classicist features cannot be overlooked and cannot sur-
prise, if one considers the overall picture of Viennese
architecture around 1905 and Hoffmann's position in it.
The classicist-rationalist fundamental trait of Otto Wag-
ner's school has already been pointed out. Though this
had been pushed into the background temporarily be-
cause of the revolutionary mood of the early Secession
and the strong impact of the "free English style," it was
to become significant the moment the early Secession
and the model of the Arts and Crafts movement began
to lose their power to convince. When and how this
happened can be established fairly accurately.

In the Winter 1901 exhibition of the Austrian Mu-
seum, a copy of a Biedermeier room was exhibited, "a
very cosy, allusive ensemble full of reminiscences"[9] that
had an enormous success. In connection with it Hoff-

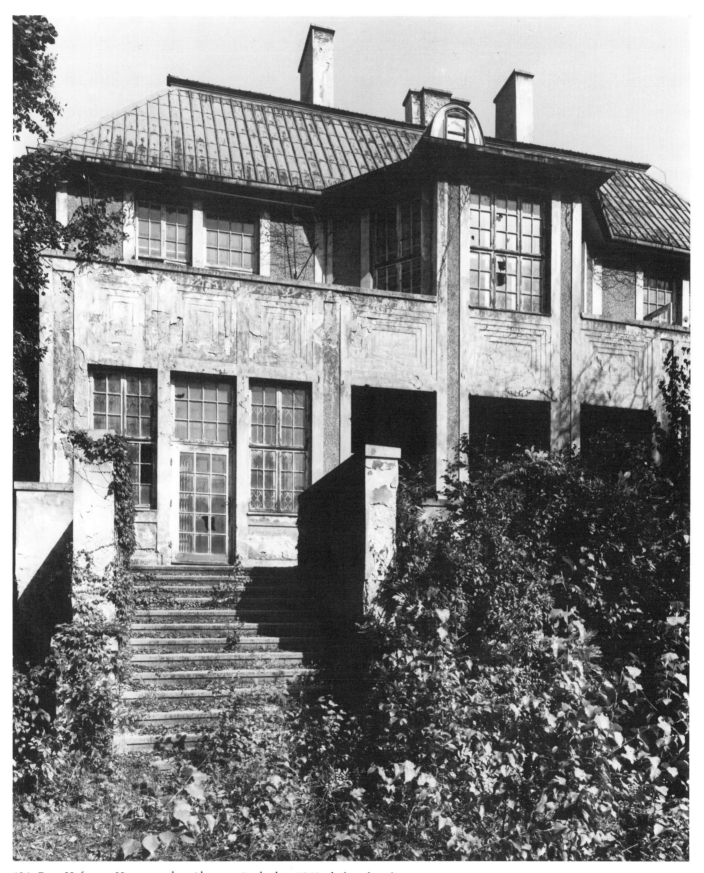

134. Beer-Hofmann House, garden side, state in the late 1960s, before demolition

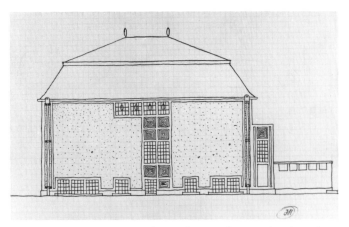

135. Beer-Hofmann House, design drawing for west facade, India ink, 1905

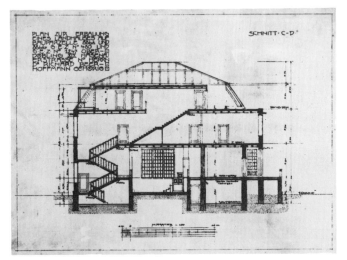

136. Beer-Hofmann House, longitudinal section; large hall and stair to attic are visible (cf. figs. 138, 139)

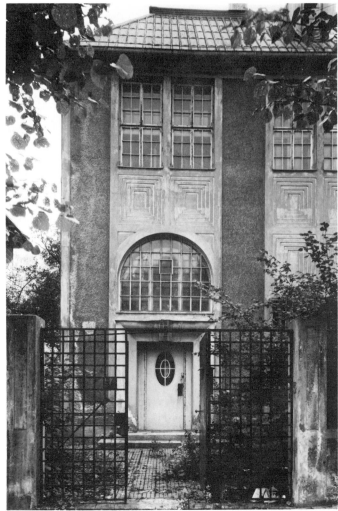

137. Beer-Hofmann House, view of entrance in 1966

mann was described as a "great grandson of Biedermeier, and yet of international modernity," but at the same time reference was made to disagreements between the Museum and the School of Arts and Crafts that had caused, among other things, Hoffmann's polemical statement in the periodical *Das Interieur*.[10] Roughly one year later J. A. Lux already felt obliged to warn[11] that ". . . at the present moment, when once more a false watchword has been issued, it is necessary to be particularly vigilant. Revival of historical styles is the name of the false watchword." The words must have referred directly to the change of policy Hofrat von Scala had effected when, instead of continuing to exhibit "samples of the modern English style," he became "again an adherent of the old styles . . . in order to revive once more the practice of slavish stylistic imitation that had already

been discontinued," as Berta Zuckerkandl described it.[12] As a matter of fact, in the winter 1906 exhibition a few years later, there was a display of selected historical interiors[13] copied with incredible accuracy, as if the revolution against historicism of Otto Wagner's school and of the Secessionists had never taken place at all. In 1903 the publication of *Ver Sacrum* was discontinued.

What happened in Austria corresponded with complete logic to the total European development of art, a development which had turned the Turin exhibition of 1902 into a "demonstratio ad absurdum" instead of a triumph for Art Nouveau. "In the year 1902 the brief spring of our movement faded," one of the involved artists wrote in retrospect,[14] and at the beginning of 1905 it was already possible to boast in Germany:[15] ". . . one has been incapable of going beyond the bases of the historical

108

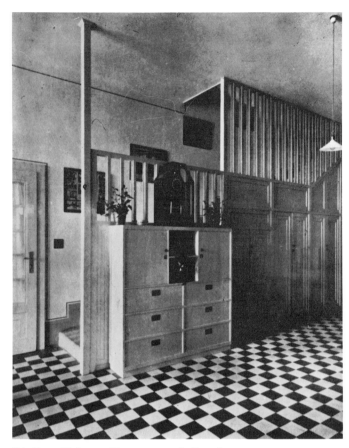

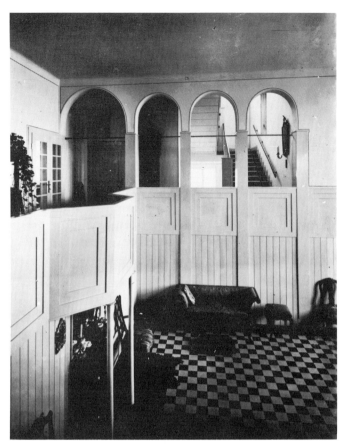

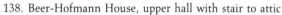

138. Beer-Hofmann House, upper hall with stair to attic

139. Beer-Hofmann House, large hall with gallery

styles. But one is based on them in another, freer spirit. One no longer so stubbornly sticks to details of external historical correctness . . . here we have to look for the sources of the new style." It is only one step from this attitude to the recipe for a new architecture:[16] ". . . one takes up any suggestion, regardless of the period in which one finds it, strips it of its temporal nuances and fits it into the new creation, as a new stylistic element."

In 1906, the year in which the architect Edwin Lutyens built Heathcote, a country house in Palladian form, it was reported from England:[17] "The Arts and Crafts exhibition society has fulfilled its mission, has had its day, and ceased to play a role as a living factor in the development of the modern art industry . . . the fashionable circles have turned away from the 'modern style' in order to revert to the eighteenth century." This turn of taste in England corresponds to various other "second revivals," including the Georgian revival in the United States, and it must have played a decisive role in the decline of Mackintosh's career. His gradual disappearance from the architectural scene, which until now has been largely

attributed to well-known personal problems and signs of decay in his life, might also be explained in part by the fundamental change of the general architectural trend in Great Britain. The library wing of the Glasgow School of Art (1907-1909), so different in style from his early work, possibly expresses the intention of the artist to create a work more suited to the taste of the times by foregoing the subtle curves of his early style. After 1906, Voysey too no longer received any large commissions.[18]

After the shortlived triumph of the "Moderne" in all its variations, disenchantment set in everywhere, and the majority of architects, trained and experienced in historical eclecticism, above all those who adhered to a classical language of forms, came to the fore again after having been pushed into the background or underground for a period of time. The power of style-shaping opinion (or *Kunstwollen*, as one would have said at that time in Vienna, following Alois Riegl's theories) was so strong that even former pioneers of the "Moderne" began to change their old style. Both Peter Behrens and Joseph Olbrich belonged to this group, and it becomes easily

109

understandable why in Hoffmann's style too a distinct change began to be noticeable around 1905.

In his programmatic statement of 1901 (Appendix 4), Hoffmann already had posed the rhetorical question: "Where then shall we . . . find tradition?" And he answered it as follows: "The linking up would only be possible there where with us autonomous creativity has ceased." By "tradition," according to Berta Zuckerkandl,[19] Hoffmann meant the last epoch before historicizing eclecticism became prevalent, the Biedermeier period to which Adolf Loos also referred when later he wrote:[20] "At the beginning of the nineteenth century we have left the tradition. There I want to link up again." The apartment of Mrs. Zuckerkandl had been furnished with existing Biedermeier pieces by Hoffmann's pupil Franz Messner,[21] and this interior was illustrated by J. A. Lux in the first issue of the *Hohe Warte*, which he edited with Hoffmann's collaboration; in the same year he wrote a lengthy essay[22] entitled "Biedermeier als Erzieher" ("Biedermeier as Educator"). Hoffmann himself collected Biedermeier portraits, sketched Biedermeier buildings (Cat. 483), and in the refurbishing of his paternal residence largely utilized Biedermeier furniture (Cat. 146).

However, at the Beer-Hofmann House the references to possible Biedermeier or other neoclassical models are kept purely general and in a strongly abstracted form: there is a mansard roof of the kind Olbrich used for his contemporaneous exhibition building in Darmstadt, and the straight facade has an articulation that very remotely recalls pilaster strips; but no literal quotations of historical forms occur. For Hoffmann the repertoire of classical forms had to go through a filter of purist abstraction before it was permitted to become effective again; in the design of the Beer-Hofmann House one can certainly discern the same will to simplicity and the disciplined planarity one had been led to expect from the creator of the Purkersdorf Sanatorium. The interior, however, for example the upper hall (fig. 138), reminds one less of neoclassicism than of the best creations of the Arts and Crafts movement; the curious pulpitlike projection of the gallery (fig. 139) might even have been directly inspired by Voysey.[23] By the use of openings with round-headed arches at the entrance and in the great hall a certain solemnity is achieved that is thoroughly in keeping with the character of the client.

Solemnity was a favored mood of the epoch and one turned to the arts for assistance in generating it. Monuments, tombs, and monumental fountains were in great demand, and Hoffmann too had to confront these tasks more than once. Two factors—first, commissions for mausolea for the Wittgenstein (Cat. 92) and Stoclet (Cat. 117) families, and second, the fact that at the time in Vienna the topic of a design for a Johann Strauß monument was much in the air—led Hoffmann to draw studies of monuments, which he exhibited in the spring of 1907 as part of a garden design exhibition in the Wiener Werkstätte. He had already designed single funerary monuments early in his career (Cats. 49-51), and in later designs he returned frequently to this kind of task.[24]

It is understandable that in designing tombs and mausolea he consciously sought links to the monumental forms of antiquity, and in the spirit of his striving for elementary simplicity preferred archaic archetypal forms—the upright, the piers with straight lintels in the manner of Stonehenge, the tumulus, the obelisk, the monolithic block as a tympanum. Plantings played an important role in the designs: in one case a mighty memorial oak standing within a circular wall brings to mind the cult of sacred trees, in existence since prehistoric times. In a similar manner Böcklin had represented a "sanctuary of Heracles." In the best of Hoffmann's monuments, to which his later designs for war memorials (Cat. 191) must be added, he succeeded in evoking archetypal experiences. This was something in which, before him, the architects of romantic classicism had been the last to succeed. They too had made archaic forms and those of elementary geometry the points of departure for their creations.

At the same time, in contrast to other contemporary monumental designs with a claim to power that makes them quite unbearable today, Hoffmann's creations usually possessed a humanizing bloom of gracefulness through their moldings, the inclusion of sculpture, or their horticultural treatment. In some of these designs (Cat. 100) one is tempted to assume that he was concerned not only with the Johann Strauß monument but also with the Empress Elisabeth memorial in the Volksgarten, being finished in 1907. Among his completed tombs, Gustav Mahler's (Cat. 150) is particularly impressive: the upright, coarse-grained stone is timeless in its simplicity, yet it is not formless but is ordered by its unequivocally classicist modulation and articulation. Mahler and his wife, the step-daughter of Carl Moll, for many years had been in personal contact with Hoffmann; this is proven by a letter in which the composer wrote enthusiastic words of thanks for a piece of jewelry designed by Hoffmann.[25] Mahler's death unfortunately prevented realization of plans for a summer house on the Semmering (Cat. 148) from a design by Hoffmann.

For architectural tasks that were less tradition-prone

than tombs and monuments, and where function was paramount, Hoffmann, as the Purkersdorf Sanatorium had shown, employed a freer form of language that was largely without historical references. But even these buildings could present a certain mien that can be classical or anticlassical. In this respect the attitude toward tectonics is revealing: in the treatment of the facades of the Sanatorium and the Stoclet House, the external walls do not appear as tectonically articulated, massive supports of roof and ceilings, but as light enclosures that clothe the built volume like a skin. This essentially anticlassical conception is no longer predominant in a project for the enlargement of the School of Arts and Crafts (Cat. 110b). Here, by contrast, a load-bearing skeleton of the building is suggested in the spirit of classical tectonics, and the wall is clearly articulated by piers or projections: the piers reveal themselves as carrying the portions in between as filling elements. This is expressed in the decorative treatment: in the long street facade, for example, the stretches of wall between the windows are designed as multiply-framed panels that are approximately square, i.e., without inherent direction. The most impressive articulation, however, is reserved for the wing that adjoins the old building. For here, both on the street and on the courtyard side, between small piers that suggest a reinforced concrete skeleton, something like a genuine curtain wall has been rendered; it has ribbons of continuous windows, which, in addition, are recessed on every floor in such a manner that the upper terminations of the windows are formed by glazed quarter cylinders that mediate the transition to the wall plane of the next higher story. To achieve maximum illumination in the studios, Hoffmann applied a form of window that sixty years later became extremely popular among the followers of James Stirling. The inspiration for the use of curving surfaces of glass in this case might well have come from Otto Wagner, who in his competition project for the Museum at the Karlsplatz in 1901, had envisaged curved glazing for the hall of sculptures. The motif came from the construction of glass houses; Ohmann had also utilized it in his forcing house at the Burggarten.

Hoffmann also selected a strongly tectonic facade that expressed the skeletal character of the building for two prewar projects of urban factories, the printing house Graphische Industrie (Cat. 171), and the factory of drafting materials Günther Wagner (Cat. 178); the programs for these buildings, insofar as they stipulated the creation of large, well-lit workrooms, were comparable to that for the enlargement of the School of Arts and Crafts. The basic design idea for the facades of the printing house

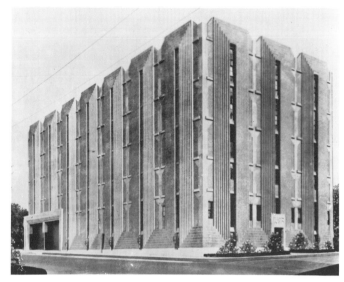

140. Bruce Goff, Page warehouse in Tulsa, Oklahoma (1927). The use of multiple framing as the main motif of the facade is striking.

was provided by the motif of multiple framing, for the other building, by the motif of a high-arched opening. Like Peter Behrens, who in his factory buildings for the AEG had stressed tectonic expression in a comparable manner, Hoffmann—entirely in the spirit of the German Werkbund—was obviously eager to include the place of work in a total program for the artistic treatment of all realms of human concern.

The facade for Günther Wagner remained unknown, while that for the Graphische Industrie was published. It might be possible, therefore, that it provided a source of inspiration for the Page Warehouse in Tulsa, Oklahoma (1927) by Bruce Goff (fig. 140). In addition the treatment of the entrance at the day care center in the Pasettistraße, Vienna (1924), with its multiply-staggered surround, shows a certain similarity to Hoffmann's design for the entrance gate at the Graphische Industrie.

The year 1907 brought a wealth of new tasks for Hoffmann, but also a profound change in his closest milieu: Kolo Moser, friend of his youth and most important collaborator in many projects, withdrew from the Wiener Werkstätte,[26] which from an artistic point of view meant an irreparable loss. His place was taken by Eduard Wimmer, a pupil of Hoffmann's, who for many years was to head the fashion department of the Wiener Werkstätte. His interests and his talent went entirely in the direction of fashion and decoration, and it is characteristic that he carried out the decorative painting on occasions when he collaborated with Hoffmann—for example, in the apartment for Mimi Marlow, the *diseuse* of the Fledermaus

141. Poster design for the cabaret "Die Fledermaus" by Josef
Hoffmann

cabaret (Cat. 152). If he, like so many artistic collabo-
rators, exerted an influence on Hoffmann, it certainly
was different from that of Kolo Moser. Wimmer's first
major task in his new position was a share in the dec-
oration of the Fledermaus cabaret.

It was entirely in keeping with the ideals of the Seces-
sion and the Wiener Werkstätte during the best periods
of both institutions that the effort to remodel artistically
all realms of human endeavor was extended to a place
of amusement, and a cabaret was founded: Die Fleder-
maus (The Bat) (Cat. 114). The Secession had already
sponsored not only exhibitions but also dance perform-
ances. The aims of the new enterprise were explained in
a pamphlet which, like the program brochures and pos-
ters, some of which Hoffmann helped to design (fig. 141),
received careful typographical and artistic treatment.
Hoffmann also designed stage sets and costumes when
necessary.[27] The desire was "to create a place fit to serve
a true *culture of entertainment* through the unified and

organic treatment of all pertinent artistic and hygienic
elements. . . . Through a happy solution of the tectonic
problem, stage and auditorium have been designed so
that without employing external means the 'ideal dis-
tance' of the stage has been abolished and the audience
has the sensation as if it [the stage] were placed in the
middle of the auditorium, in the immediacy of life. . . .
As we go for an immediacy here that reaches the sen-
sation of the eye directly, without detour through re-
flective thought, thus we also [want to proceed] in the
music, which is to have a simple, precise, forcible effect
as a sensual expression.

"Yet we believe that with an aesthetically impeccable
design of the scene only half of what we desire has been
achieved . . . we have considered it important . . . to
turn our artistic attention with as much love to the most
inconsiderable as to what is great: the interior design
just as the table silver, the light fixtures just as the small-
est utensils thus have sprung from the unified basic con-
cept of the room to be created, not forgetting the care
for the practical and hygienic needs of the audience . . .
pure air controlled in temperature, a cultivated cuisine,
the totality of comfortable seating and agreeable service
belong here."

The following artists were mentioned as collaborators
in the decoration: C. O. Czeschka, F. Delavilla, F. Dittl,
J. Hoffmann, C. Hollitzer, G. Klimt, A. Kling, O. Ko-
koschka, B. Löffler, E. Orlik, E. J. Wimmer, and
F. Zeymer. The list of literary collaborators begins with
Peter Altenberg, who also wrote several reviews of per-
formances and dedicated a poem on the Fledermaus to
Hoffmann.[28] "If in us you but see a confused toying with
color/We cannot prevent it—/If it is done with taste/It
even lives without idea." By contrast, Karl Kraus wrote
a critical review[29] in which he damned the whole Fle-
dermaus enterprise.

For the bar, much admired for its ceramic mosaic (Cat.
114) (which may owe something to Voysey's ceramic
fireplace surround at the "Magpie and the Stump"), a
bartender was specially hired from the United States;
the way he performed his function was seen for the first
time in Vienna. From Paris a master chef was procured.
The very restrained architecture of the auditorium with
its marble cladding and the glittering mosaics recalled a
small court theater rather than a music hall; it contrib-
uted materially to the creation of an atmosphere in which
both the performers and the audience could be experi-
enced mutually to their best advantage—as when, for
example, announced by Marc Henry, master of cere-
monies, Marya Delvard sang her chansons, Gertrude

Barrison or the Wiesenthal Sisters danced, Oskar Ko-koschka showed his play of moving projections, and Egon Friedell or Alfred Polgar read from his own works. It was also Friedell who in the jubilee volume of the Wiener Werkstätte in 1928 recounted the brief history of the Fledermaus:

"In 1907 Fritz Wärndorfer, a witty gentleman with a great deal of money and taste—two things that, as we know, are almost never together—hit on the idea to have the Wiener Werkstätte . . . build a cabaret. The color-fully tiled bar as well as the auditorium that was entirely in black and white was a jewel of intimacy and noblesse. As a consequence the whole of Vienna was outraged, because one was . . . used to red plush and gilt plaster for one's money The opening performance turned into an enormous scandal. For the artists connected with the enterprise . . . had the enormous impertinence to do everything, only much more spiritually, personally, and maturely, that the 'Blaue Vogel' performed fifteen years later to a capacity crowd. But they came too early . . . after Fritz Wärndorfer had gone broke, a professional appeared . . . but this first-class professional also went broke and the Fledermaus became a music hall where girls with slender legs, whom one could ask to the table, performed." The name at that time was changed to Fe-mina.

The language of forms Hoffmann used at the Fleder-maus was akin to that of the Stoclet House, and the same is true of the two shops he designed in 1907: the sales room of the Staatsdruckerei (State Printing House) at the Seilerstätte (Cat. 115) (figs. 142, 143), and the outlet of the Wiener Werkstätte at the Graben (Cat. 116) in the city. Both shop fronts have framing, gar-landlike profiles of repoussé metal in the manner of the Stoclet; the effect is strongest at the Staatsdruckerei, where the contrast between gilt metal profiles and black highly polished granite anticipates effects of color and texture that later were favored by Art Deco, especially in the United States. The two shop interiors also show a very similar stylistic attitude in the subdivision of sur-faces: the simple square and rectangular forms typical of Hoffmann are now enriched by segments of circle and oval. In addition, a fundamental novelty can be observed at the shop of the Wiener Werkstätte, which was finished a little later than the Staatsdruckerei. Surfaces such as the show windows of the entry and the showcases in the interior are subdivided in an uneven rhythm, not evenly as had still been the case with the surfaces in the cabaret and the Staatsdruckerei.

As far as the employment of material inside the Staats-druckerei is concerned, oak stained black and its grain rubbed with a white filler predominates as it had already done in interiors of the two preceding years. Hoffmann for many years preferred this treatment of oak, perhaps because the dark stain made the wooden elements appear more slender, while the dramatization of the natural grain that otherwise is not very visible in the oak ap-pealed to his sentiment for strong effects and, at the same time, to his respect for honesty regarding the na-ture of a material. In a broadcast of 9 October 1930, he stated: "We utilize . . . oak stained black and the grain rubbed white in order not to have it appear as an imi-tation of ebony."

Hoffmann's new creations of 1907 did not fail to im-press young Charles-Edouard Jeanneret (Le Corbusier). At the end of his journey through Italy, Jeanneret arrived in Vienna[30] just as the shop of the Wiener Werkstätte was opened,[31] and he stayed till the middle of March 1908. During this period he drew the plans for the Stotzer and Jaquemet houses[32] to be built from his designs at La Chaux-de-Fonds. He lived at Kaiserstraße 82 near the Neustiftgasse, which meant that a visit to the Wiener Werkstätte could be made very easily. But he got in touch with Hoffmann personally only at the very end of his stay when most probably he had already decided to go to Paris. After he had shown his travel sketches to Alfred Roller, who wanted to buy some of them, he went to see Hoffmann, who in the pressure of business at first did not want to see him but immediately showed an interest when he cast a glance into the folder the young man opened. He was obviously convinced that he had recognized the hand of talent because he offered a position to the young man, aged twenty at the time: Jeanneret was to collaborate in the preparation for the celebration of the Emperor's jubilee of 1908.

Though the young visitor accepted the position, and was in addition invited to the Fledermaus and presented to Klimt and Kolo Moser, he never began work for Hoff-mann; before starting his new job he requested a brief delay for a journey—from which he never returned. As he later explained, a performance of *La Bohème* at the opera caused an already existing longing for Paris to become so overpowering that he hurriedly left for that city. Once there, however, he drew plans and sections of the Fledermaus cabaret, and in an accompanying text particularly praised the illumination of the room.[33] To-ward Hoffmann, whom he sent a letter of apology, he remained well disposed during all the following years; a number of written statements, always full of admira-tion, testify to this.

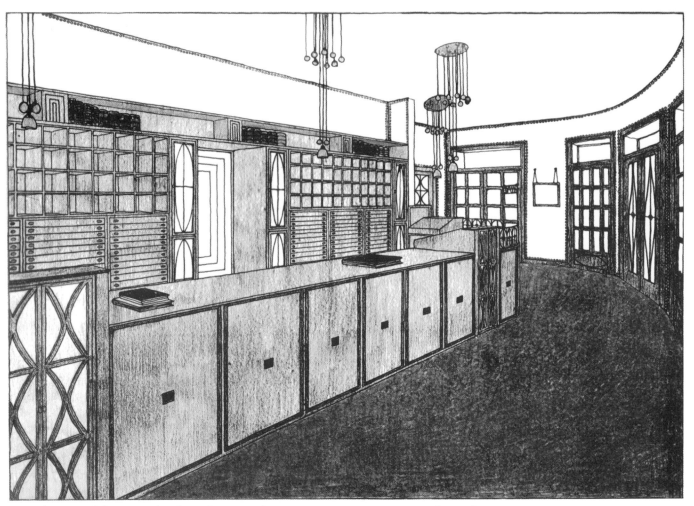

142. Salesroom of the Imperial and Royal Court and State Printing House, perspective design drawing

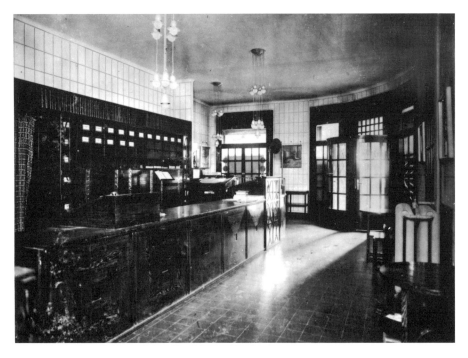

143. Salesroom of the Imperial and Royal Court and State Printing House, interior view toward the entrance

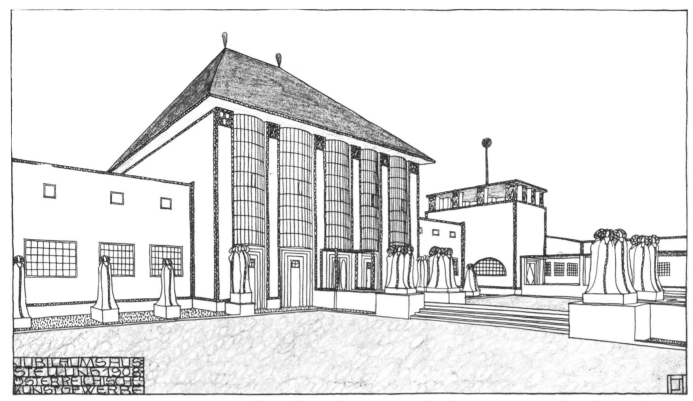

144. Project of an exhibition building for the Jubilee Exhibition of Austrian Arts and Crafts, 1908, perspective design drawing of the main pavilion

The real reason for Jeanneret's departure probably was his attitude toward Viennese architecture: he did not find it particularly appealing. About the illustrations of some interiors by Hoffmann that his teacher had sent to him in Vienna, he commented:[34] ". . . laid, malcommode, barbare et gosse . . . Combien c'est froid, revêche et raide et comment diable est-ce bâti?" But he was of the opinion that Hoffmann in turn influenced the works of Kreis, Olbrich, Lossow and Kühne. This remark is interesting regardless of its accuracy because it gives us a measure of the significance attributed to Hoffmann by a young contemporary, whose teacher had oriented him toward the Viennese architect. As was to be expected, Jeanneret's early buildings at La Chaux-de-Fonds consequently showed that, despite his fundamentally negative attitude, the Viennese atmosphere and particularly the oeuvre of Hoffmann had not remained without influence on him.[35]

The preparations in which Jeanneret was to participate were for the sixtieth jubilee of the rule of the Emperor Francis Joseph, and for Hoffmann they chiefly involved three projects: an imperial pavilion (Cat. 118) for the festive procession, an exhibition of arts and crafts (Cat. 120) (fig. 144), and a grandly conceived Kunstschau art exhibition by the Klimt group (Cat. 121). Only this last, however, was carried through; Hoffmann withdrew from the committee for the jubilee procession after his project had been turned down,[36] and although the buildings for an arts and crafts exhibition were drawn by Hoffmann, they were not realized. It was possible to obtain the necessary subsidies only for the Kunstschau and to build a temporary exhibition building from Hoffmann's design on the site of today's Konzerthaus. Since all three projects concerned monumental buildings for a public celebration, it is not surprising that in at least two of them— the exhibition buildings—Hoffmann's classicist tendency came to the fore again. The third, however, the imperial pavilion (Cat. 118), defies any stylistic categorization. In this unusual work, subliminal references to Baroque triumphal arches and buildings of similar temporary splendor exist side by side with references to Medieval towers, proportioned with the aid of the *quadratura*, with oblique corner buttresses and abundant sculptural embellishment. Within the immediate vicinity of Vienna one can see a crown atop the uppermost ter-

mination of the Baroque building of Klosterneuburg Abbey, signifying highest dignity. The telescopelike upward thrusting of the tower and the close fusion of sculpture and architecture recall the tower of the Stoclet House; there, however, the wall surfaces remained plain, while at the imperial pavilion they are modeled. Had the pavilion been executed, the total impression would have been incredibly varied and dramatic, but such a project would have required an army of sculptors and probably appeared much too costly for a temporary festival building that would have only been used once.

The building for the 1908 jubilee exhibition of Austrian arts and crafts (fig. 144) would have been an equally grandiose undertaking: besides a historic section, it was to house a completely furnished sumptuous residence, numerous individual interiors, a section for ecclesiastical art including a chapel, and the high hall of honor with a statue of the emperor in the central niche. The arrangement (Cat. 120) is completely symmetrical, and with an approach flanked by rows of trees, courtyards and ponds, and high central and lower side wings it invites comparison to an eighteenth-century chateau. Again, influences from the Stoclet design are strong: all facades are edged by decorative moldings, and where the central building joins the side wings there are higher portions with roof loggias that appear to be direct quotations from comparable portions of the Stoclet House. But a very crucial difference exists in the treatment of the roofs; in contrast to the Stoclet House, the exhibition building stresses widely overhanging hipped roofs which thus become an essential element of the total effect. The tall bay windows once again recall British models: they would have imparted a scintillating liveliness to the facade and a dynamic illumination to the interior.

A number of concepts from this project are found again, though in slightly modified form, in the exhibition building of the Kunstschau 1908 (figs. 145-148) which Hoffmann designed and realized for the Klimt group. The task must have been particularly close to his heart; it brought together ideals and artistic personalities to which he had the closest links over an entire decade, and this at a time when the Eighth International Congress of Architects would convene in Vienna. Once more the claim to treat artistically and thus elevate all realms of human existence was to be given a convincing visual expression, and this was to be done in full awareness of the fact that since the great triumphs of the Secession, such as the fourteenth exhibition, years had passed during which the historicist reaction against the "Moderne" clearly had gained ground. In his brief opening speech,[37]

Klimt talked of the "conviction, that no area of human life is too insignificant and inconsiderable to provide scope for artistic endeavors, that, to speak in the words of Morris, even the most unpretentious thing, if it is carried out perfectly, helps to increase the beauty of the earth and that the progress of culture is founded only on the ever-progressing penetration of the whole of life by artistic intentions. . . . And as widely as the concept 'work of art' we will also understand the concept 'artist.' For us, not only those who create, but also those who enjoy carry this name . . . for us 'artistry' means the ideal community of all those who create and enjoy."

The program of the Kunstschau as outlined by Klimt was correctly summed up by a critic as follows: "One wanted to show how the whole of life should be permeated by art."[38] In order to represent this enormous claim successfully in an exhibition where indeed many areas of human concern were touched—including a cemetery, a garden theater, a coffee house, and a private dwelling—it would have been necessary to achieve for the duration of a visitor's stay in the Kunstschau the continuous experience of his own existential reality as an aesthetic reality, something which the fourteenth Secession exhibition probably managed to do to a great extent. Such a complete identification of existential and aesthetic reality as a necessary quality characterizes in general the experience of architecture,[39] and one critic's remark on the exhibition[40] may well refer to this fact: "Perhaps one does not notice that in this exhibition everything is an architectural problem." The statement also illuminates the extent of the architect's responsibility. That Hoffmann's contribution to the Kunstschau, which centered on Klimt as the main artistic figure, went far beyond the realm of architectural design alone was stressed in several contemporaneous reports: "Hoffmann built it, we owe the new way to him . . . he was the driving force . . . he knew how to find the individual participants, to fill them with enthusiasm for their task, through his enchanting manner of uplifting and extracting the best from them." And: "The architectural discipline of Hoffmann is the determining factor for this exhibition . . . this discipline exists not only in the well-thought-out plan that determines the grouping of all galleries and courtyards, it is in the exhibited works of art themselves, which in some sense strive toward the architectural totality."[41]

As far as the general mood of the arrangement was concerned, Hoffmann apparently wanted to give it something of that Mediterranean brightness and lightness that for him was linked with Italy, and he realized this ar-

145. Kunstschau, Vienna, 1908, small court with ceramics by Berthold Löffler and Michael Powolny (cf. illus. Cat. 121/I, Room 8-9)

146. Kunstschau 1908, room of the Wiener Werkstätte with decorative wall painting by Josef Hoffmann, ceramics by Michael Powolny

chitecturally by closely connecting the interior and exterior spaces (fig. 145). This was accurately perceived by a critic who wrote about the "pleasant views into the antique garden- and courtyard-arrangements," where one had the feeling "that here an Italian master-builder of antiquity who loved the sun was at work under the eternally blue sky."[42] Yet Eduard Pötzl,[43] who was anxious to condemn totally the whole Kunstschau, found it "desolate, like a heatstroke, and dripping with perspiration."

The specific quality of Hoffmann's architectural approach in this case might be attributed to his having managed to combine three components: the simplicity of elementary geometry for which he had struggled during the first years of the century; a crypto-classicism; and an original, very effective surface decoration. The resulting forms were generally comprehensible because of their reference to the classical tradition, but they avoided banality through their successful decorative enrichment and a transmogrification based on abstraction that tended toward elementary geometry.

The Kunstschau building offered something new, not in its typology and composition, but rather in the han-

dling of some of its details, in the architectural employment of lettering, and above all in the richness of its decorative treatment. The plan corresponds to the entirely common solution for larger buildings with several wings around courtyards arranged in a regular figure. What is genuinely Hoffmannesque here is the manner in which the entrance facade design connects two systems of symmetry in such a way that one architectural element may be assigned to either system, in perpetual ambiguity. A comparable ambiguity has already been discussed in connection with the design of the ceramics department of the Hohenzollern Kunstgewerbehaus.

The treatment of the two panels of lettering as parts of the exhibition entrance facade (Cat. 121/II) is without direct precedent. The suggestion for this and for the use of lettering as part of architecture inside the exhibition complex (fig. 145) may have come from Hoffmann's colleague at the School of Arts and Crafts, Professor Rudolf von Larisch, who also undertook the execution. Here the supergraphics typical of interior design in the 1960's was in some way anticipated, and the whole arrangement also indicated something about Hoffmann's attitude toward architecture as a "legible" art form. He

117

147. Kunstschau 1908, entrance facade

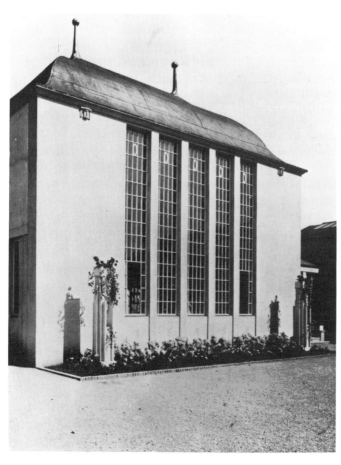

148. Kunstschau 1908, courtyard side of entrance pavilion

utilized every possible means to make his architecture a mode of communication: in part he relied on the legibility of traditional forms for which the iconography was generally understood (e.g., a pyramid for a tomb); in part he tried to invent new symbolic or at least allegoric forms (e.g., appletree capitals in the Hall of Knowledge); and in part he employed the legend or inscription, not only as a supplement to architecture but also as a component of it.

The entrance or reception building (figs. 147, 148) is a modified version of the central building from the project for a jubilee arts and crafts exhibition (fig. 144), enriched by the archaistic dummy doors next to the main entrance and the monumental sculptures; the heads high up on the facade correspond to those on the tower of the Stoclet House (Cat. 121) (fig. 100). The treatment of the interior, with decorative paintings (Cat. 121) so colorful and full of movement that they appear almost too agitated, is entirely novel. In this case the Minoan-Mycenaean inspiration may well have been decisive for both Anton Kling's panels and Hoffmann's surface patterns. Thanks to Sir Arthur Evans' publication of Cretan art at the beginning of the century, Minoan art had become a sensational novelty for many artists. The influence of Mycenaean art on Klimt has been recently established and for Hoffmann as well as his circle the whole of Aegean art was a source of inspiration.[44] Even the delicate butterflies that are freely inserted in the linear decoration of a room of the Wiener Werkstätte (Cat. 122) (fig. 146) are evocative of Minoan or Mycenaean models.[45]

This room, extremely restrained and limited to a few precious objects, as well as the small garden courtyard with its ceramic sculptures (fig. 145), show that Hoffmann knew as well as ever how to be not only graceful but also strict or reserved. This is less evident in his prototypical country house, furnished by the firm of J. & J. Kohn (Cat. 123). Here the walls are decorated with very lively patterns and the furniture forms are frequently restless as a consequence of the bentwood construction that had to be utilized. The building itself, however, despite its small dimensions and the employment of the simplest means, gives the impression of a generous scale and even of a certain formality or dignity. This is achieved on the facade by stressing the tectonic articulation in a classicist spirit. In the interior, the two-storied hall with a flight of stairs corresponds excellently to the deportment of the facade; this house may have been ever so inexpensive, but it did not waive its claim of *haute bourgeois* representation.

At the second Kunstschau, in 1909, Hoffmann's house was furnished with machine-made furniture by the Deutsche Werkstätten für Handwerkskunst, Dresden, from designs by Richard Riemerschmid. This is understandable, since in 1908 this firm had taken over the representation of the Wiener Werkstätte in Germany,[46] and as far as the movement in the arts and crafts was concerned, the relations between Vienna and Dresden were quite close. Thus, for a time Hoffmann's friend J. A. Lux, with whom he had participated in founding the Deutscher Werkbund[47] in 1907, was active in Dresden. In 1912 Hoffmann was even invited to accept an appointment at the Dresden Institute of Technology,[48] and later he received an honorary doctorate from this institute.

At the 1909 Kunstschau there was also a special exhibition of works by Ashbee, Mackintosh, and other British artists, which proves that Hoffmann stood by the loyalties of his early years but not that he was especially well informed about the latest changes of taste in Great Britain. There, by 1906 a clear turning away from the "free style" of the Arts and Crafts movement had already set in, and for the time being, as in most countries on the Continent, the future belonged to a return to classical forms. How much the importance of classicism had increased in Germany is demonstrated by buildings such as Olbrich's Feinhals House in Cologne.[49] It was particularly demonstrated by an event that paralleled the Kunstschau—the great art exhibition in Dresden in 1908.[50] Here, historicism unequivocally predominated, with such heavy-handed, literal quotations of historic architectural forms that it becomes understandable why young Jeanneret did not want to travel from Vienna onward to Dresden in order to study there.[51]

By contrast the 1908 Kunstschau in many respects was more seminal—from the Kokoschka room to the bold reinforced concrete gate by Karl Maria Kerndle and the exhibition of "architectural drawings as works of art"[52] that anticipated avant-garde interest of the late 1970s, when architectural drawings *per se* as graphically attractive works were rediscovered. Yet the architecture of the Kunstschau was not so homogeneous as that of the fourteenth Secession exhibition, the Purkersdorf Sanatorium, or the Stoclet House. For various reasons this was not to be expected. On the one hand, it was impossible for Hoffmann to design the whole complex in detail, and though many of the collaborators were his pupils and used a very Hoffmannesque language, certain discrepancies occurred. On the other hand, the artistic point of departure for the design was already very different in 1908 from what it had been in earlier years. For the

adherents of the "Moderne" no simple, unified position existed anymore; the time of *Ver Sacrum* was over. That some contemporaries realized this quite clearly is proved by the following survey of conditions in architecture in the year 1908 that was published by the editor of the periodical *Der Architekt*:[53] "When roughly one and a half decades ago the modern movement set in with elementary force . . . the entire young school with the full conviction of enthusiasm shared the ideal of striving for something artistically entirely new that had never been here before. Otto Wagner's *Moderne Architektur* was their breviary. Since then many a thing has changed. That first enthusiasm was gradually followed by a certain calming down, critical considerations cropped up, the originally dumbfounded opponents of the 'Moderne' regained their composure . . . the victorious advance of youth by and by began to falter . . . the little, all too little esteemed 'old art' once again regained its authority. Once again one extended . . . a hand to it (in the camp of youth too). National and vernacular sounds mingled with the hymns of victory. One spoke of national identity or even raved about the dear vernacular art. From the 'Hohe Warte' ('high lookout') of youth, suddenly, instead of looking into the blue of the future, one looked back into the gray of the past." If one thumbs through the pages of the periodical in which von Feldegg published these words, one finds not only corroboration for the correctness of his diagnosis but also visible proof that observers like Hermann Muthesius, Richard Riemerschmid,[54] and Franz Servaes,[55] who passed positive judgment on the Kunstschau and its architectural framework, saw matters more correctly than the representatives of the opposite opinion. In their originality and formal quality, the buildings of the Kunstschau that were illustrated in *Der Architekt* belong to the very best that can be seen in any issue of the whole year.

Hermann Muthesius wrote about the Kunstschau:[56] ". . . here the architectural feeling is developed to maturity, the sublime taste raised to highest refinement. The artistic aspiration of this group is entirely universal and comprises all visible human utterances, but always originating from architecture . . . this Viennese modern art perhaps is the most unified and perfect [thing] our time has brought forth so far." In the very same spirit J. A. Lux formulated:[57] "If you want to put in words very briefly the main event of the last years, it is the conquest of applied art by architecture."

Precisely because of its uniform profession of the decorative and of decorative stylization, the Kunstschau shows, however, that there was equally the danger of a conquest of architecture by the arts and crafts, of an overpowering of architectural concerns by those of decoration. What now lay before Hoffmann were years of coming to terms with precisely this problem of the relation to decoration, to the past—especially to classicism—to "national identity," and to vernacular art.

VI. Inspiration from the Vernacular and the Climax of the Classicist Phase

For a Viennese in the early twentieth century, Biedermeier was more than an art-historically stylistic designation—it was an attitude toward life resonant with nostalgia for the "friendly," more comprehensible world of the preindustrial age. This world, moreover, was seen transfigured through the veil of a tradition that, reaching back for more than half a century, tended to emphasize the positive and overlook the negative. In this conception of life rural ways played an important role. It is not surprising, therefore, that, when trying to link up with Biedermeier traditions, architects again turned to the language of classical forms in its most varied modes but also showed a special interest in rural buildings and the treatment of gardens. While Friedrich Ohmann, who taught at the Academy side by side with Otto Wagner, had his students make measured drawings of eighteenth-century buildings, and Hoffmann extolled the Austrian neoclassicist architect Josef Kornhäusel, Hermann Herdtle, Hoffmann's colleague at the School of Arts and Crafts, made his students do measured drawings of peasant houses.[1] But even a student of Otto Wagner, Ernst Lichtblau, accompanied his design for a villa in Vienna, Ober St. Veit (published in *Der Architekt* XIV, 1908, pl. 10) with a declaration that this represented "a profession of the one who created it, who always . . . has listened to the beloved chords of our artistic folk-impulses." In the same year Dr. Stefan Fayans gave a lecture on "Architecture and Folk" at the Eighth International Congress of Architects in Vienna. According to the congress report (p. 626), he maintained among other things that "the simple and the objective, demanded from us by the present, is . . . to be learned from the revelations of the rural art of the peasants."

In literature, from Anzengruber and Ganghofer to Rosegger and Schönherr, there were numerous parallels for the preoccupation with the world of the peasant, and it may be assumed that this arose not only from purely artistic considerations but equally for ideological reasons of the most varied colors: from 1904 onward, side by side with other movements of cultural reform, those for the protection of folklore and homeland ("Heimatschutz") gained increasing influence. It is revealing in this connection that toward the end of 1905 the Austrian Museum of Art and Industry featured an exhibition of cottage industry and folk art, and that during the following years the London *Studio* published a number of special issues on the folk art of various European countries.

In 1904, J. A. Lux founded the periodical *Hohe Warte* (*High Lookout*), the name of which could also be understood as a reference to Hoffmann's colony of villas of the same name. In contrast to the predominantly art-oriented *Ver Sacrum*, it was placed entirely at the service of topical efforts at general reforms. It contained essays on questions of the arts and crafts and social politics, dress reform, the garden city movement, and particularly the preservation of townscapes and monuments, as well as folk art and protection of the nation's cultural heritage: "culture works" (Kulturarbeiten) was the term used by Paul Schultze-Naumburg,[2] a permanent contributor with Hoffmann, Lichtwark, Moser, Muthesius, and Wagner. Lichtwark had already called for the cultivation of the vernacular in artistic education in the introduction to the first part of his book *Palastfenster und Flügelthür* (second edition, Berlin 1901). The attraction was so great that an attempt was even made to show that the Stoclet House was derived from anonymous vernacular architecture: next to a photograph of the Stoclet House model the *Hohe Warte* illustrated an "old Belgian castle" and a building in the "old Belgian manner of building" and, although the comparison appears rather farfetched, Lux[3] added the following comment: "It is downright admirable how the architect has erected his work on a national basis, and has brought it into a form that fits organically into the homeland of the Brussels client."

Lux was the author of many publications, including several parts of the collection of plates *Die Quelle* (*The Source*), volumes of which existed in the reference library of the Wiener Werkstätte. So far, Lux's role in the architectural scene of the period seems to have been insufficiently considered; he certainly spoke up personally for Muthesius in connection with the foundation of the German Werkbund, and he made his periodical available for the polemics that preceded.[4]

Hoffmann at that time was one of the twelve artists, and the Wiener Werkstätte one of the twelve firms, that

signed the appeal for the foundation of the Werkbund. Hoffmann subsequently, in 1908, also participated in the constituent first annual assembly of the German Werkbund in Munich; he was accompanied by Klimt, Löffler, and Wärndorfer.[5] On this occasion he was able to inform himself firsthand about the program of the new organization with its considerable emphasis on the national element. In addition, he was also familiar with Schultze-Naumburg's *Kulturarbeiten* and their confrontations—reminiscent of A. W. Pugin's *Contrasts*[6]—of good old and ugly new buildings, and he had some volumes of the publication specially bound in the Wiener Werkstätte for his own use. The paradigmatic buildings illustrated in the *Kulturarbeiten* are mostly neoclassical and frequently occur in a rural context. The accompanying text left no doubt that here one was dealing not merely with aesthetic questions but with an ethical and social problem: it called for a warding off of[7] "the raw and joyless countenance of a depraved nation that distorts the sense of life into vegetating." In a similar vein Hermann Muthesius stated in 1902:[8] "There is no reason why we should not do the same in our sense what was done in England at that time: to return to simplicity and naturalness in our civic architecture as it has been observed in our old rural buildings. . . . The path to this goal that has been walked in England, i.e., the taking up again of local life and civic and rural architectural motifs, promises, however, the richest harvest precisely in Germany, where the rural manner of building from the past is invested with a poetry and a richness of mood to be matched by hardly any old building. If we but remain attached to the autochthonous, and if each of us only follows his personal artistic inclinations in an uninfluenced manner, then we shall soon have not only a reasonable, but also a national civic architecture."

This prescription for the best architecture of the future, the national character of which was expressly stressed, comes from the small but influential essay *Stilarchitektur und Baukunst*, which Hoffmann owned, again in a special binding by the Wiener Werkstätte, and which he may have received as a gift from the author himself. However, what Muthesius did not mention was that the English models often came from late medieval vernacular architecture, whereas in central Europe later buildings, frequently influenced by the world of classical forms, presented themselves as models. Yet this fact explains, at least partly, why an architect like Hoffmann could feel justified in considering not only genuinely rural but also certain neoclassical architectural forms as particularly autochthonous and national.

As is well known, the emphasis on the "national character" of architecture, already found in the writings of Hermann Bahr, was destined to become in the following decades a polemical leitmotif that attained dismal fame. In the circle around Hoffmann we shall have to deal with it particularly in connection with the history of the Austrian Werkbund, from its beginnings to its split in the year 1933. In 1912 the German Werkbund met in Vienna. On this occasion Hofrat Dr. Adolf Vetter, the staunch supporter of the Wiener Werkstätte and at that time Hoffmann's client for a house in the Kaasgraben estate, gave a lecture on "The Significance of the 'Werkbund'-Idea for Austria," in which he explained: "Whoever correctly understands the 'Werkbund'-movement knows that in its essence it must be autochthonous and national."[9] Adolf Baron Bachofen von Echt, president of the new association and also Hoffmann's (future) client (Cat. 243), spoke in a similar vein at the constituent assembly of the Austrian Werkbund in the following year. He emphasized that " 'Werkbund'-ideas can and should even deepen and fill with new content the folkish national efforts."[10]

It is essential to see the efforts toward cultural protection of the homeland and creation of a national architecture in the larger context of pre-1914 cultural and social history, as has been attempted by Joachim Petsch, Richard Hamann, and Jost Hermand;[11] yet it must not be overlooked that from the beginning warning voices were raised against misuse and exaggerations. Thus Otto Wagner's pupil Leopold Bauer, Hoffmann's former schoolmate, as early as 1899, from the point of view of his "architectural Darwinism," made fun of the "beautifully sounding phrases" that were employed in the efforts "to make the national element the point of origin of our culture."[12] Among several corresponding statements from the following years perhaps those of W. Michel from 1905 deserve to be singled out:[13] he pleaded humorously against the rough "sermons about . . . national identity in which foursquare lumps of words such as 'autochthonous,' 'clodlike,' 'root true,' 'soil pregnant' . . . come rumbling along by the dozen" and he warned that "the emphasis of the national movement is apt to favor all kinds of inertia and backwardness. . . . In every moment of creation the artist is neither a German nor otherwise a 'countryman,' but in the first place a human being." Muthesius himself[14] smiled at the fact that "some supporters of the cultural protection of the homeland for the time being labor under the delusion that one can cure the sick body of architecture with a prescription 'antitoxic serum 1830,' " and he added that "vernacular art is only

a surrogate for real artistic sensibility." And in the last volume of *Hohe Warte* in 1908 Lux became particularly articulate[15] and asserted with regret: "Of late a strong national sentiment . . . makes itself felt in architecture . . . [architecture] frequently models itself on the old, the past, and the worn out, and formally it wants to fit itself to the small and no longer sufficient. The question is whether this will mean progress." Four months later, in a farewell article, he expressed himself even more forcefully, as he warned of an exaggerated "attachment to the soil" (Bodenständigkeit), and "vernacular art," and, in conscious contradiction to William Morris, concluded with the words:[16] "Art for the people, it does not exist." It is possible that Lux was reacting against the criticism of the Vienna Kunstschau exhibition of 1908 by Albin Egger-Lienz, who reproached it[17] for "disparagement of the fundamentally healthy folk awareness," a typical phrase that throws characteristic light not only on Egger-Lienz but also on the whole situation in those years.

That Hoffmann certainly needed no special pleading to awaken his interest in popular art and architecture (figs. 149, 150) was sufficiently borne out by his activity thus far. Beginning with his first publication on the anonymous architecture of Istria (Cat. 3) he had found opportunity time and again to praise the traditional popular forms of architecture; he even employed them directly as a source of inspiration, for example in an ideal study for a country residence (Cat. 55). Similarly, he never concealed his admiration for popular art, which he collected, and his designs were enriched by many impulses from the wealth of its motifs. When Max Eisler once tried[18] to engage Hoffmann in a discussion about the essence of art, the architect characteristically refused to enter into any theoretical debate but proffered instead a recollection from his youth concerning a Moravian peddler who sold handmade embroideries. Of this popular cottage industry, the colorful textile patterns of Slavic folk tradition, Hoffmann said, "This, if it has to be, might be called 'art.' "

In view of Hoffmann's often proved animosity toward theory and his carefully observed self-limitation to purely artistic and practical concerns, it is unlikely that his predilection for popular art and architecture was strongly influenced by the ideological reasons discussed above, which motivated many of his contemporaries. For him what probably counted primarily was the fact that the forms and colors of popular tradition, familiar since his youth, actually appeared lovable to him, and not that such tradition, with reference to its folk origins, could

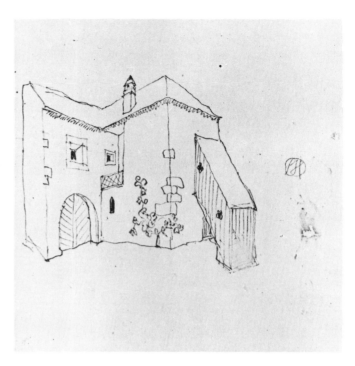

149, 150. Josef Hoffmann, sketches after vernacular buildings, pencil

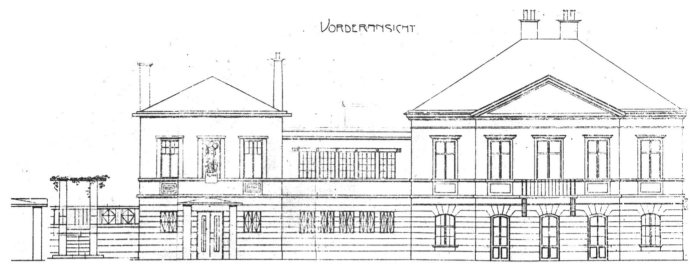

VORDERANSICHT

151. Country house for Dr. Wilhelm Figdor, Baden near Vienna, with addition by Josef Hoffmann, submitted plan of street facade, 1904

be interpreted as the root of national greatness. It is true that his affection for the rural small-town environment of his native Pirnitz was genuine, but he was a confirmed city dweller, and as a pupil of Otto Wagner he was too much of a person who affirmed the twentieth century and its technological achievements to be overly moved by romantic Utopian nostalgia for the salutary blessings of simple country life. The rural and other vernacular buildings he admired and sketched (figs. 149, 150) were a genuine source of stimulation for his creative imagination, but only one among many. For gardens and garden pavilions, those havens of modest, carefree enjoyment, he certainly kept a lifelong predilection. But even here he never gave up a certain formality, which meant that gardens were designed axially with pergolas, sitting places, and ponds or fountains. His most successful pupil in garden design, Franz Lebisch,[19] proceeded in a similar manner in his own projects. Before the First World War his designs were published several times and they comprised the major portion of a garden design exhibition organized by the Wiener Werkstätte in 1907.

Up to now it has scarcely been noticed that Hoffmann also took an interest in questions of the protection and preservation of historic monuments. This interest was entirely in the spirit of William Morris and the Society for the Protection of Ancient Buildings he had founded, whose precepts were published[20] in the *Hohe Warte*. A paragraph about the restoration of old buildings is included in Hoffmann's manifestolike essay from the year 1901 (Appendix 4), and in his oeuvre there is ample proof that he was willing to show consideration for all the buildings of a region and to adapt to the local character.

An early example is the addition to the Figdor country house in Baden near Vienna (Cat. 95) (fig. 151). Berta Zuckerkandl deemed it worthy of a review of its own, in all likelihood because she was a particularly ardent advocate of the Biedermeier tradition, and this was a showcase example. She wrote:[21] "The architect here has applied neither past forms nor that wild use of linear ornament that unfortunately is generally characterized as 'Moderne.' He also avoided . . . the cottage style that is derived from good English models. For he felt positively and profoundly that a fine symmetrical sentiment was always inherent in the Viennese, or rather the Austrian style, that even the most Baroque evolutions always tended toward a defining simplification and clear structural relations. He felt thus precisely because the modern style of architecture in Austria . . . linking up with the broken threads of a fine tradition, in the new spirit of the time tectonically shapes elements of mood flowing from the folk sentiment."

The building no longer exists, but in a facade drawing (fig. 151) one can see that Hoffmann had indeed adapted his addition to the existing building in a most convincing manner; probably the difference is not even noticeable at first glance. Though the neoclassical moldings of the original were omitted, its general articulation was repeated, and the facade below the hipped roof of the new building took over from the old building the exact dimensions of the central projection. The fact that it had an almost square outline surely could have been nothing but welcome to Hoffmann; in addition, it provided a reminder that the tradition of using the square as a geometrical basis of design was a very old one.

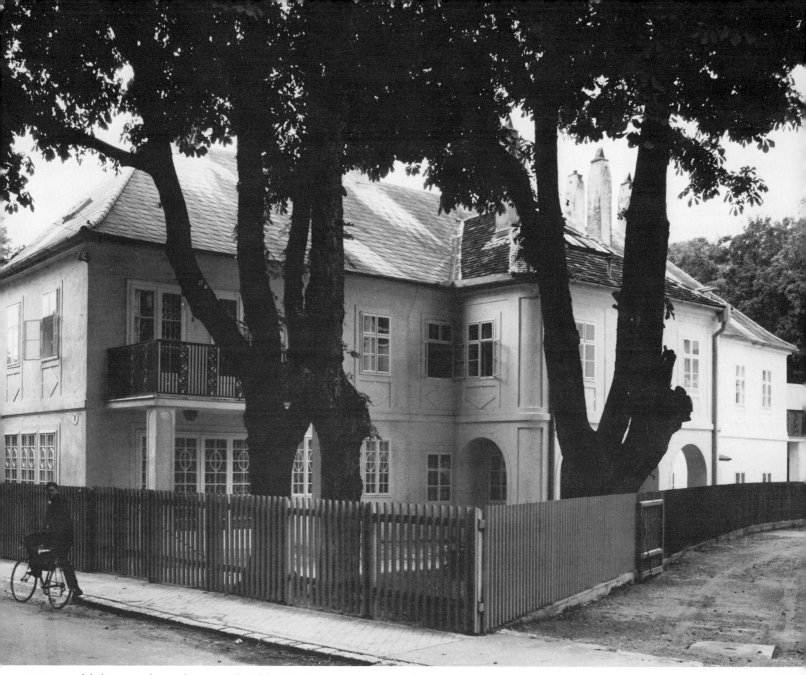

152. Remodeled country house for Heinrich Böhler, Baden near Vienna, view from the street in 1966

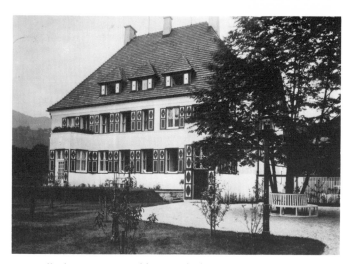

153. Villa for Dr. Otto Böhler, Kapfenberg, Styria, view of south facade shortly after completion

In another remodeling, carried out in 1910 for Heinrich Böhler in Baden (Cat. 137) (fig. 152), the architect similarly succeeded with a solution so restrained that only careful scrutiny will reveal his hand in such details as the balcony grilles or the subdivision of glazing bars in newly inserted windows and glazed doors. Disregarding these, a cursory observer certainly might take the building for a Baden Biedermeier residence. A Biedermeier model can even be found for the round-headed garden door in the "old Viennese garden entrance" illustrated in the first volume[22] of the *Hohe Warte*; Hoffmann later employed the same motif in several buildings such as the Bernatzik House (Cat. 168), the approaches to the garage building of the Primavesi House in Winkelsdorf (Cat. 179) (fig. 165), and the porter's lodgings of the Ast country house (Cat. 254) (fig. 166).

At the Böhler house, special care was bestowed on the treatment of the garden, including various small buildings, and a total complex was created that superbly fitted the local tradition and the rural surroundings. It stands to reason that this must have corresponded to the express wishes of the client. Hoffmann appreciated him as a "man of quite special talent and characteristic wit"; in addition he later furnished an apartment for him in Munich as well as a house[23] built in 1916 by Heinrich Tessenow in Saint Moritz. Tessenow and Hoffmann, despite their differences, understood each other quite well:[24] while their architecture differed, they shared a love for integrity of craftsmanship and a belief in a future for the craftsman's quality work.

The entire Böhler family, members of which were

Hoffmann's clients several times, showed themselves to be progressive in their artistic preferences, but traditional in their attachment to rural forms of life. Thus the painter Hans Böhler, who had his close friend Hoffmann furnish his Viennese studio, lived next to his relative in Baden[25] in an old mill that was later remodeled by Hoffmann's pupil Karl Bräuer.

Roughly contemporaneous with the house in Baden is a large residence (Cat. 138) (fig. 153) built for Bergrat Dr. Otto Böhler at Kapfenberg, seat of the Böhler works. Like the house for Heinrich Böhler it was designed with its rural surroundings in mind, and its high roof and green and white window shutters give it a decidedly traditional appearance, perhaps comparable to the manor house of a country squire.

It is remarkable that two of the greatest Austrian steel industry tycoons—Böhler and Karl Wittgenstein (Poldihütte)—were alike not only in becoming Hoffmann's clients on several occasions, directly or through relatives, but also in commissioning buildings with a conscious rural orientation. One remembers that Alexander Pazzani, Director General of the Poldihütte, too, like Wittgenstein, shared an aristocratic passion for hunting; he had Hoffmann design a hunting lodge with a service building (Cats. 132, 133), probably a chalet for hunting purposes (Cat. 91), and the addition to a large farmstead (Cat. 224). The approximation of anonymous rural architecture is particularly striking in the one-story hunting lodge service building, which looks like a typical Lower Austrian peasant house, and in the chalet that was constructed as a log cabin. The hunting lodge, prefabricated from wooden elements, represented a special case: surviving drawings (Cat. 132/III, IV) show that the architect was anxious in this case to create homey interiors that have a rustic effect without being imitation "peasant rooms" (Bauernstuben).

For another important industrialist, the chemist and director of the Elektrobosna A.G., Dr. Hugo Koller,[26] Hoffmann again tackled the problem, similar to that at the Figdor House, of adding to a historic building, in this case an old water mill in Oberwaltersdorf, Lower Austria, that had been converted into a factory (Cat. 172). It seems particularly appropriate in this case to remark that Hoffmann found a truly preservationist solution: the factory not only looks more elegant for Hoffmann's intervention but is even more historically convincing. In the interior, the adaptation of the former kitchen as hall (fig. 154) provides a particularly good example of the successful reuse of old elements in a new framework.

Dr. Koller was not only a scientist and successful in-

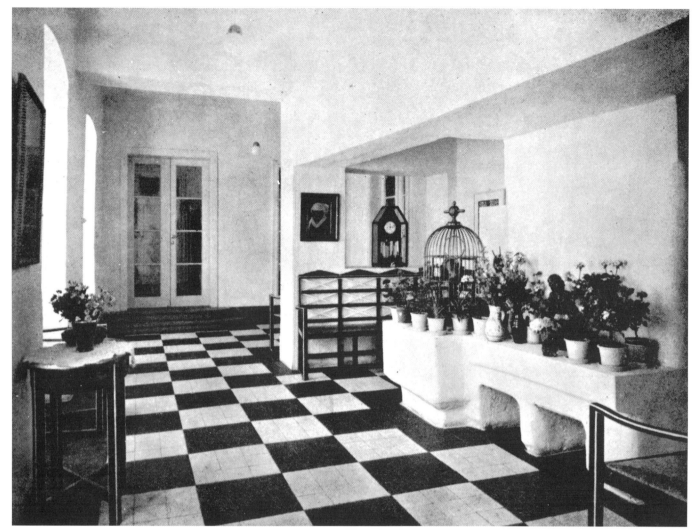

154. Country house for Dr. Hugo Koller, Oberwaltersdorf, Lower Austria, former kitchen remodeled as living hall

dustrialist but also a bibliophile, and was married to a painter, Broncia Koller, who was close to the circle around Klimt. Hoffmann obviously was dealing with particularly congenial clients, and this is borne out by the rooms he furnished for them in Vienna (Cats. 61, 165). In Oberwaltersdorf the rooms that adjoin the hall were decorated by Hoffmann with existing Biedermeier furniture, a procedure recalling the renovation of rooms in his own paternal house at Pirnitz (Cat. 146) the year before.

By contrast to the rural buildings for Alexander Pazzani and the remodeling for Dr. Koller, which were comparatively modest tasks, a commission came to Hoffmann in 1913 that compared in magnitude to the Böhler House in Kapfenberg; it was, however, conditioned by circumstances that led to a completely different solution. Hoffmann had been friendly with the sculptor Anton

Hanak since the Roman art exhibition of 1911, and in 1913 Hanak became his colleague as professor at the School of Arts and Crafts. Through him Hoffmann established a closer connection with the family of the industrial magnate and banker Otto Primavesi in Olmütz. Primavesi was a Maecenas and philanthropist, a confidant of the Austrian Werkbund, and had had portraits of his wife and daughter done by Klimt.[27] He commissioned Hoffmann with both the modernization of his banking house (Cat. 181) and the interior design of two rooms in his house at Olmütz (Cat. 190), but most important was his commission for the design of a great country house with service buildings (Cat. 179) (figs. 155-165) in the magnificent landscape of the Altvater area around Winkelsdorf.

The house was intended—mainly following the advice

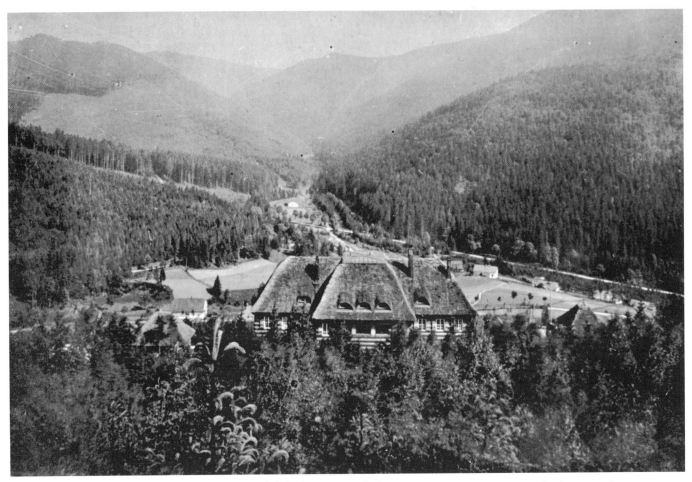

155. Landscape of the Tess (Desná) Valley near Winkelsdorf (Kouty) with the Primavesi Country House in the foreground

156. Primavesi Country House, building site at the start of construction

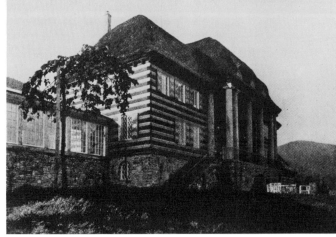

157. Primavesi Country House, view of the front shortly after completion

128

of Hanak and the wishes of Mrs. Primavesi—to relate both internally and externally to Moravian popular tradition; it was, according to Hoffmann's own statement, to be completely genuine, chiefly utilizing materials available locally—entirely in keeping with the ideals of the movement for cultural protection of the homeland. Accordingly a socle of rubble stone was constructed on which was placed a mighty log building with a widely overhanging, thickly thatched roof with softly curving shapes, alone capable in Hoffmann's opinion, of achieving the ideally close connection between building and landscape. A preliminary design shows that for a while Hoffmann even considered following the Slavic tradition of using a frame construction with an infilling of vertical planks, but eventually he decided on the log construction; it was widely used in the region and can still be admired at the wooden church of Bad Groß Ullersdorf (Velké Losiny) only a few kilometers away from Winkelsdorf. Measured drawings of such log buildings with thatched roofs were done by students of the Vienna School of Arts and Crafts, and even published[28] in *Der Architekt*.

Country villas comparable to the Primavesi House are hard to find. Buildings such as the Villa *Dora* in Zakopane by Zygmunt Dobrowsky and the log villa in Rezek by Dušan Jurkovič[29] are based on similar ideas and a comparable emphasis on folkloristic motifs. But the building by Jurkovič has a much more restless appearance because it was composed with an eye to picturesque effects. Hoffmann by contrast subjected the folkloristic material to the discipline of his classicism. From a ground plan (Cat. 179) that recalls Palladian examples in its proportions and strictness and that relates typologically to the Böhler House in Kapfenberg, he developed a volume that, with its central projection and "colossal order," adopts the canonical scheme of chateau and palace design. This comparison becomes even more obvious in the first version of the design, where the middle of the building is crowned by a small belvedere with cupola.

The interior[30] (figs. 158-164) had colorfully painted carved wooden decorations, painted furniture, hand-printed linen and silk fabrics by the Wiener Werkstätte, and a polychrome, richly sculptured large tile stove by Hanak. As at the Stoclet House, the appointments, including tableware and bed linen, were also designed by Hoffmann. All this in the service of a lifestyle in which hospitality and festivity were integral components: Mrs. Primavesi even kept a notebook with the preferences of her guests regarding rooms, food, flowers, number of cushions, and the like. At the same time the atmosphere was one of rustic informality; consequently, one did not,

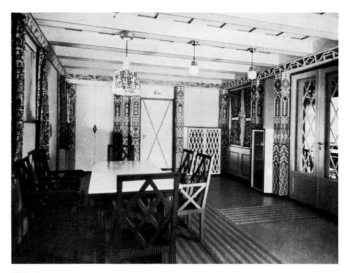

158. Primavesi Country House, children's dayroom in the upper story

159. Primavesi Country House, veranda adjoining the dayroom in the upper story

for example, dress for dinner but wore a silk gown, specially designed for this purpose, made of hand-printed material from the Wiener Werkstätte. In the basement, next to the bowling alley and a meat curing room, there was a large room (fig. 162) with a single colossal table in the middle: here the "pig festivals" (Schweindelfeste) were celebrated with appropriate delicacies of Moravian cuisine, and here—as Hoffmann later recalled with a smile[31]—secret drinking sessions were held at hours of the night when, according to the strict health regimen of Mrs. Primavesi, the master of the house and his guests should long have been in bed.

160. Primavesi Country House, parents' living room largely in green tones with colorful accents

161. Primavesi Country House, living room of daughter Mäda in light blue and dark blue

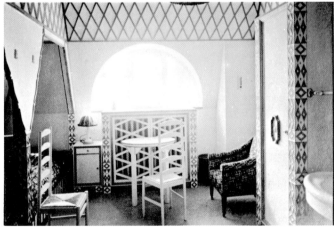

162. Old photograph of a party in the cellar of the Primavesi Country House. Seated in the foreground: Josef Hoffmann (*left*) and Anton Hanak (*right*); standing: Otto Primavesi (*left*), Gustav Klimt (*center*); in background: Mrs. Primavesi (*left*)

163. Primavesi Country House, guest room in the attic, preferred by Anton Hanak

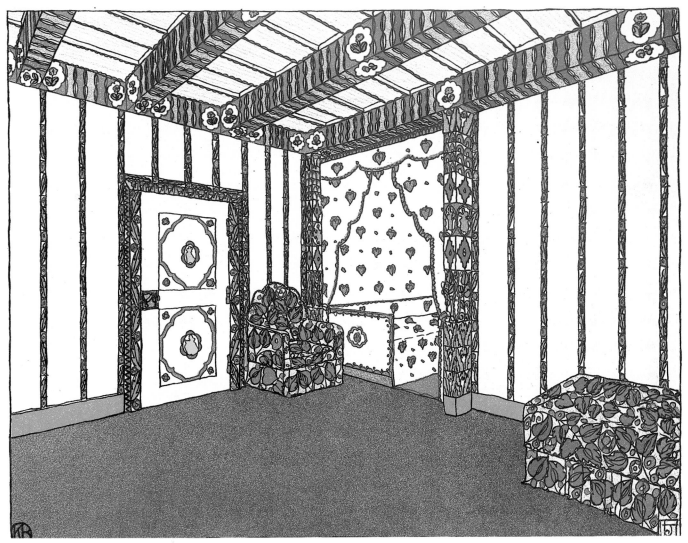

164. Primavesi Country House, perspective drawing for a bedroom, drawn by Karl Bräuer (Cat. 179)

Before one can even begin to come to terms with the architecture of the house and, above all, with its interiors, one should attempt to evoke the cheerful, slightly patriarchal, perhaps matriarchal, atmosphere—the long discussions in the cozy corner next to Hanak's stove, with Klimt a rather quiet listener in his great armchair, or the long stories and songs accompanied by the guitar that Hanak supplied from his years of wandering. Often Hanak was there for weeks and felt happy in the congenial atmosphere. The keynote of that atmosphere was provided by the local northern Moravian popular art; and for anyone, unlike Hanak and his circle, to whom this art had little or nothing to say, the ornament derived from it must have soon become as oppressive as, for example, the Salzburger Volkskeller (Cat. 156) that was decorated in the same spirit with forms from the Alpine region. Judging from a distance of more than half a century later, in a completely different context, it is easy to condemn the artificiality of the whole, with its designed folk art partly manufactured in Vienna. The criteria for judgment of those who designed and used it, however, were of a different order. They believed in good conscience that they were doing the right thing in every way—aesthetically, ethically, and socially. Ruskin, whose works were available in Winkelsdorf on Hoffmann's recommendation, confirmed their convictions, as did the most influential contemporary critics—for example, Max Eisler and Berta Zuckerkandl.[32] Only the singer Leo Slezak remained skeptical and commented, as Mäda Primavesi recalled: "Indeed this is certainly a very beautiful house but I would not like to live in it." Hoffmann himself best liked to stay in the guest room on the ground floor that was entirely in white and black, and Mäda Primavesi remembered that at times she left her own room (fig. 161), decorated in two shades of blue with very flickering patterns, for no other reason than to seek more restful surroundings; she found them eventually . . . in the woodshed.

Berta Zuckerkandl in her discussion of the house correctly drew attention to its singular situation amidst a landscape of extraordinary beauty (fig. 155); in judging these interiors one must indeed not forget the expansive, quietly strong landscape that serves as a foil to them. As with genuine peasant art, strong accents of color and form appear entirely acceptable when seen in contrast to the magnificence of the landscape.

Just at that time the strong effects of popular art and the art of the "primitives" had been discovered by the European avant-garde Expressionist artists. The *Blaue Reiter*, published in 1912, just one year before construc-

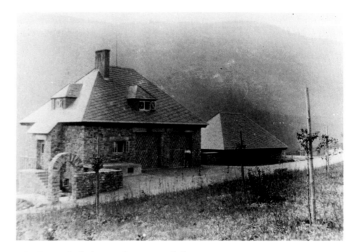

165. Porter's lodge and garage of the Primavesi Country House

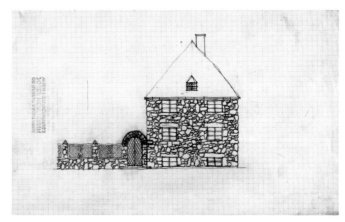

166. Design drawing for the street facade of the porter's lodge of the Ast Country House

tion at Winkelsdorf began, displayed peasant paintings next to Polynesian wood carvings. But it was not the first: six years earlier, the periodical *Hohe Warte* had also promoted popular art, again with illustrations of Polynesian anthropological items. Thus the Primavesi House was not only affected by vernacular art but also by a good deal of Expressionism: the jagged forms of all the rhomboids, diagonal intersections, and stars (fig. 158) attest to this influence. A direct line may well lead from this building, illustrated in several publications, to the first major postwar building by Walter Gropius—the Sommerfeld House, Berlin-Lichterfelde—built in 1920 in log construction with elaborate carvings on the inside. In a letter to Hoffmann[33] before the end of the war, Alma

132

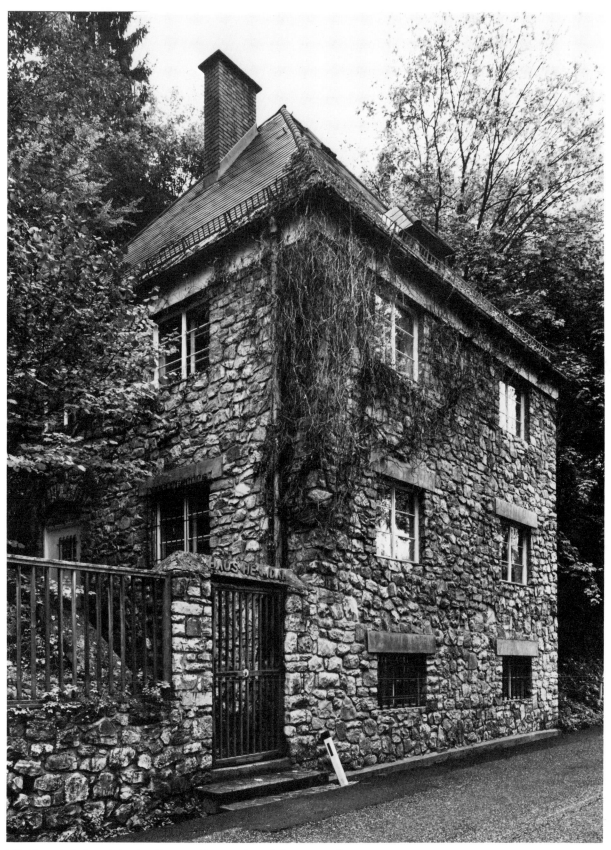

167. Porter's lodge of the Ast Country House, view of the street side

Maria Gropius stated: "My husband loves your art and your way of thinking."

The Primavesi House went up in flames in 1922, but the porter's lodge with garage (fig. 165), standing separately, survived the catastrophe. This building demonstrates how Hoffmann solved the problem of fitting a small house into the landscape setting in such a manner that it matched the architecture of the main building. He relied primarily on the effect of the material, constructing the small building in the same stone as the substructure of the large one. A decade later he dealt with a similar problem in the porter's lodge of the Ast country house on the banks of the Wörthersee (Cat. 254, figs. 166, 167), and had equal success placing this building in a different, equally beautiful, landscape. While this lodge is comparable in material and masonry technique to the one at Winkelsdorf, Hoffmann gave it entirely different proportions and above all a different form of roof that he might well have selected as a means of adapting his building to local architectural tradition—it is pyramidal, of the type not infrequently found on old Carinthian peasant houses.

In contrast to the doctrinaire advocates of autochthonous architecture who insisted unconditionally on vernacular forms—even for railway stations, as the *Hohe Warte* disapprovingly reported[34]—Hoffmann differentiated his formal language depending on whether he had to deal with a building in generally rural surroundings or with a suburban villa. This is evident in his designs for the houses of a second "artists' colony" in the Kaasgraben (Cat. 167) (figs. 178-182), not very far from the Hohe Warte. It was built in 1912-1913, a period extremely close to the climax of the most pronouncedly classicist phase in Hoffmann's style. This phase began between the two Kunstschau exhibitions and lasted into the war years; its inception has already been discussed (see Chapter V) and its consequences never entirely ceased in his work. It fit completely into the general stylistic tendencies of those years, when the prevailing interest in all of European architecture was in novel variations and alterations of the classical language of forms. Nor was there a lack of examples in the work of Hoffmann's closer colleagues; for example, the Church of the Holy Ghost by Josef Plečnik (1910-1913), the house in the Kobenzlgasse by Oskar Strnad and Oskar Wlach (1910), the German embassy in Petersburg by Peter Behrens (1911-1912), and the Dalcroze Institute for Physical Education at Hellerau by Heinrich Tessenow (1910). When it came to the treatment of form, however, Hoffmann's personal handwriting remained unmistakable. It was

168. Eduard Ast House, Vienna, Hohe Warte, first version of design, perspective view of street side

169. Eduard Ast House, view of the garden facade shortly after completion, 1911

170. Eduard Ast House, view of the street facade in 1966

characterized by the employment of classical principles of composition, basic motifs (tympanum, portico, fluting), and proportions, coupled with avoidance of exact, classicist detailing; a tendency toward reinterpretation and tectonically not quite unequivocal effects was also typical. As a consequence, excesses of clumsy monumentality, so frequent in other architectural creations of the period, were avoided.

Soon after the Kunstschau exhibition, Hoffmann had the opportunity to create a house in Vienna that, though smaller than the Stoclet House, was as comparable to it in its striving for great preciousness and elegance as was the Skywa-Primavesi House at a later date. Eduard Ast, the Austrian pioneer of reinforced concrete construction,

who had often collaborated on Hoffmann's projects as building contractor, decided to build a villa at the Hohe Warte for his own use (Cat. 134) (figs. 168-177). The building was finished in 1911, and its comparison with those completed roughly a decade earlier for Moll, Moser, and Dr. Spitzer impressively demonstrates how much Hoffmann's formal language had changed during the intervening period. But a comparison with the Stoclet House is instructive, too; it shows that by contrast to the house in Brussels the familiar appearance of a traditional house with high hipped roof was envisaged for the Ast House from the beginning.

The first version of the design (fig. 168) still displayed a certain reference to regional tradition, that is to say,

135

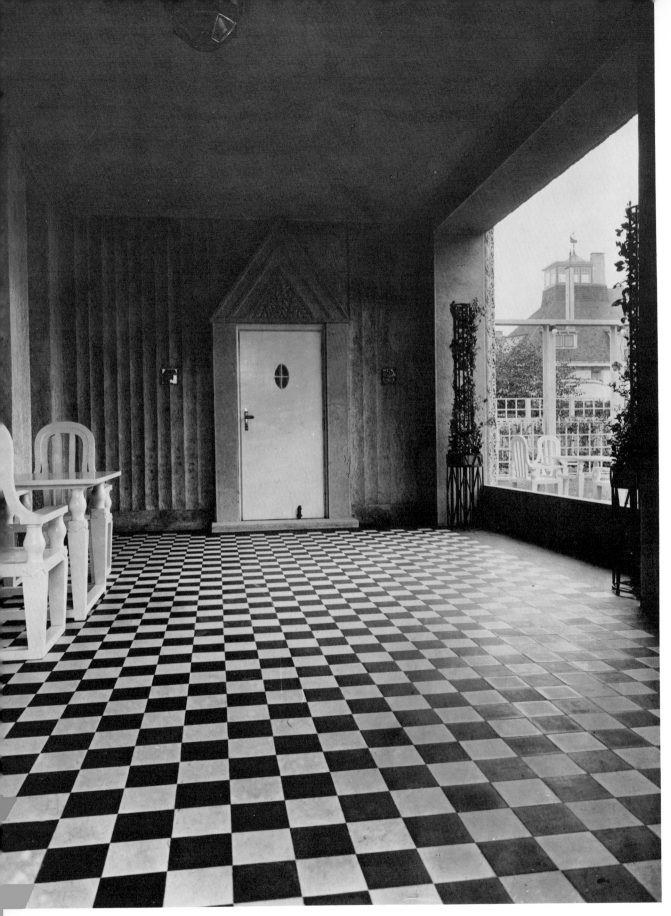

171. Eduard Ast House, garden veranda. The Brauner House is visible in the background.

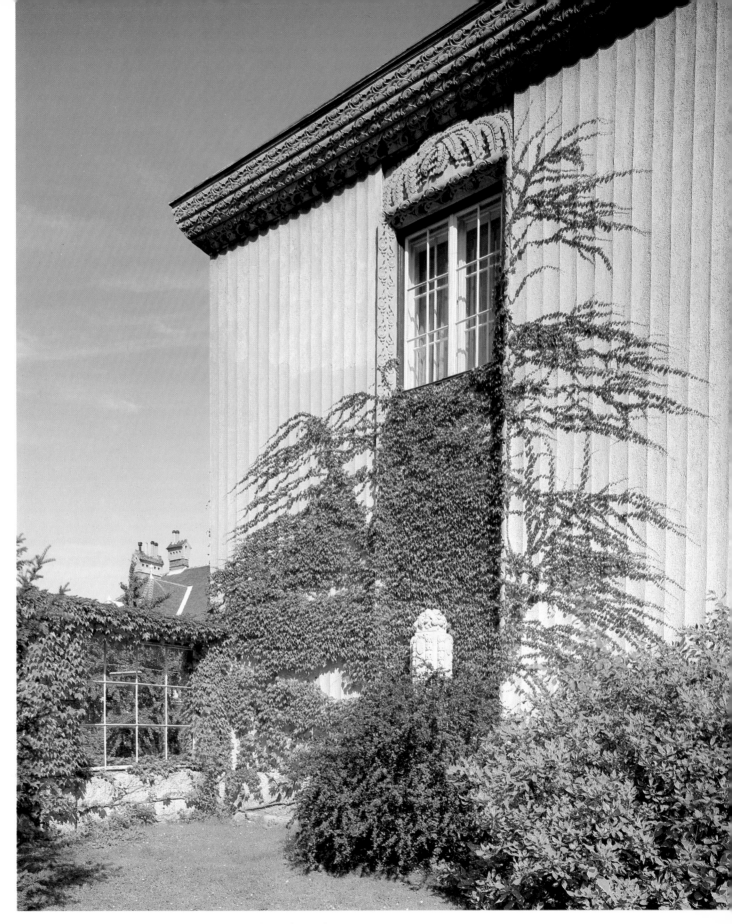

172. Eduard Ast House, view of the west facade from the garden (1966)

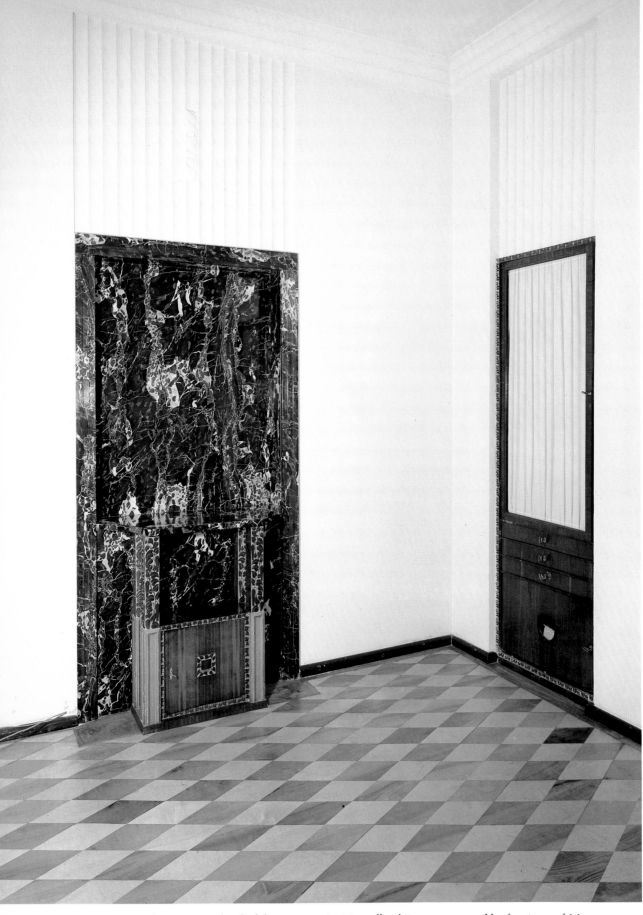

173. Eduard Ast House, detail of dining room (1966); walls of Portovenere marble, furniture of Macassar wood with carvings on gold ground (cf. fig. 174 and Cat. 134)

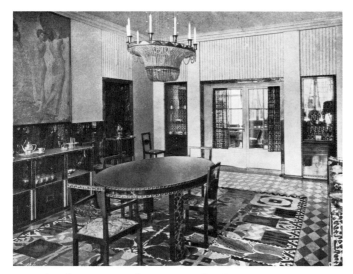

174. Eduard Ast House, dining room shortly after completion, 1911

175. Eduard Ast House, kitchen in the basement with raised platform for the housekeeper

the typical amalgamation of classicism and "vernacular style" found equally in other buildings by Hoffmann from approximately the same period. In this case models from the country house and castle architecture of Lower Austria were decisive; they could be found on the pages of *Die Quelle* and were employed by other architects, especially those close to Ohmann.

In the second version, roughly half a year later (figs. 169-172), the building's dimensions are the same, but a much more dignified and rich effect is achieved by the changed articulation of its facade and the considerable heightening of its roof. The vertical fluting of most wall surfaces contributes as much to this result as their decorative treatment and, closely related to it, the design of the cornice. Possibly one reason for these significant changes was to be found in the client's wish to demonstrate the decorative possibilities of the incrustation technique he perfected; it was with the aid of this technique that the decoration of the facades was executed. The garlandlike moldings around the windows recall the comparable employment of metal profiles at the Stoclet House, except that at the Ast House, in keeping with the nature of the material, they appear more substantial. Altogether the effect of weightless gliding, frequently approaching insubstantiality, of the Stoclet facades has nothing comparable at the Ast House: here the facades on their rough ashlar socle appear fairly massive, at times even heavy. In addition, the vertical tying together of pairs of windows by framing profiles together with the fluting of the window piers emphasizes a conception of tectonics in the classical sense; the same is true of the

comparatively heavy, widely projecting main cornice, the profiling of which, however, is handled in an entirely unorthodox manner.

Equally unorthodox is the treatment of the doors in the veranda on the garden side (fig. 171). They are flanked by two pilaster strips without bases and capitals carrying a high triangular panel.[35] The shape of this panel recalls the relieving triangles of Mycenaean architecture and therefore appears as archaic as the comparable triangles at the entrance building of the Kunstschau (Cat. 121/II) and above the entrance door in a design that may have been intended for the architect's own house (Cat. 158/I). In this latter design the impression of something Mycenaean is enhanced by the manner of the rich ornamentation. Moreover, by leaving the upper story without windows on the street side, the effect of a very high attic story and thus a certain monumentality is achieved. If this was indeed the design for the architect's own house, this aspiration toward dignity and the wealth of ornamental moldings would correspond to Hoffmann's decided sense of decorum, displayed on so many occasions. He probably was one of the few architects of the twentieth century who, uninfluenced by social criticism about the role of ornament in his time, was still capable, purely on the basis of his intuition, of experiencing a genuine connection between decoration and decorum.

The triangular panels above doors, which occur again in the Knips apartment (Cat. 193), can be understood as a reinterpretation of the classical, less steep, tympanum, just as the pilaster strips on either side of the doors can be interpreted as taking the place of classical pilasters.

176. Eduard Ast House, vestibule in basement with stairs to main floor

177. Eduard Ast House, main staircase from living hall to upper story (1966)

In both cases a process occurred in which a classical quotation remains recognizable but in its form is extensively reinterpreted, even metamorphosed. This *modus operandi* is typical of Hoffmann's ability to avoid a historical, literal classicism and to extract from the old storehouse of forms new applications by means of simplifications, elisions, transformations, and metamorphoses of every kind. A typical example is provided by the vertical shallow fluting of wall expanses.

Such fluting of surfaces was a favorite motif of the architect at this time; he applied it in almost all the houses that are close in date to the Ast House, such as the Kaasgraben colony of villas and the Bernatzik House. The colony (Cat. 167) (figs. 178-182), consisting of four pairs of semidetached one-family residences, owed its existence to the initiative of Yella and Emil Hertzka. Yella Hertzka, cultural reformer and feminist, was the owner of a tree nursery in which gardening courses for girls were also taught; Emil Hertzka held a key position

in Viennese musical life as the director of the renowned Universal Edition. It is not surprising therefore that in addition to Mr. and Mrs. Hertzka, Egon Wellesz, the music historian and composer, and Hugo Botstiber, secretary general of the Konzerthaus were among those who bought plots at the Kaasgraben. The poet Robert Michel, a friend of Hofmannsthal and Andrian, also moved into the colony, as did three high civil servants: Dr. Adolf Drucker, Ing. Hans Küpper, and Dr. Adolf Vetter, who as head of the Office for the Promotion of Trades had a close relationship to Hoffmann and sent him a particularly cordial letter of appreciation after the completion of his house.[36]

The designation of the Kaasgraben houses as a "colony of villas," in one case[37] even as the "colony of the Wiener Werkstätte," is a reminder that for Vienna this new form of dwelling was something of a pioneering venture comparable to the establishment of the *Cottageviertel* estate at Währing in the nineteenth century. Although the

178. View of the Kaasgraben Colony shortly after completion, 1913

179. Houses in the Suttingergasse shortly after completion

180. Kaasgraben Colony, stair in the Vetter House (1966)

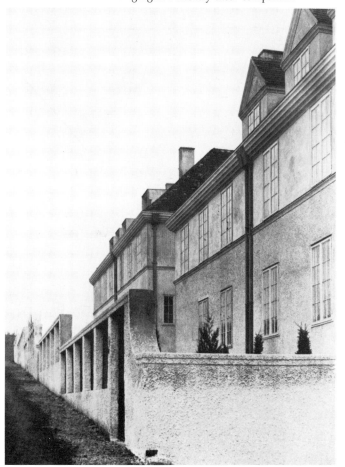

181. Kaasgraben Colony, garden view of the Vetter and Michel Houses shortly after completion

182. Kaasgraben Colony, garden view of the former Vetter and Michel Houses (1966)

ideals of the English garden city movement undoubtedly were involved, and, as far as the situation and nature of the task were concerned, house types from arts and crafts architecture seemed appropriate, Hoffmann preferred a very restrained yet clearly noticeable classicism. It is the same unobtrusive classicism, reinterpreted in its essential elements, that characterizes the house for Edmund Bernatzik, the professor of constitutional law (Cat. 168) (fig. 183), though this was considerably larger than any of the Kaasgraben houses.

One of Bernatzik's daughters, Helene, was for many years an enthusiastic collaborator at the Wiener Werkstätte, and at the time the Secession was founded, her family had already established a connection to Josef Hoffmann through her brother, the painter Wilhelm Bernatzik.[38] It was continued very amicably after the completion of the house, and still further in later years when the architect drew designs for furniture and architectural alterations. One room was specially adapted to house the collection of Hugo Bernatzik, the ethnologist. It is characteristic that Hoffmann was particularly interested in the products of various exotic cultures and that he consciously harmonized his own designs with the ethnographical material.

Although the Bernatzik House and the Kaasgraben houses had to be built on considerably lower budgets than the Ast House, they were clearly based on the same ideal of a dwelling which is derived from the classicist tradition but which alters it at the same time.[39] By contrast to the early colorful houses of the Hohe Warte with their picturesque outlines, it was now a matter of mon-

ochromatic buildings with a blocklike effect that fitted as unobtrusively as possible into their surroundings and were closely related to their gardens by a growth of creeping vines Hoffmann himself had stipulated. The built volumes are articulated horizontally by socles and molded cornices; they have high hipped roofs and a regular distribution of similar windows. Where vertical articulation occurs, it is achieved by piers or arcades and vertical fluting which stress the substantiality of the formed volume and not the dynamics of formed space. Nothing comparable had been built in Austria before, as is proved by examining the architectural periodicals of the day and by a glance into a survey of residential architecture published in Vienna in 1910 by Arnold Karplus under the title *Neue Landhäuser und Villen in Österreich.*

Hoffmann applied the vertical fluting of walls (also employed by Otto Wagner in his church at the Steinhof) not only to facades but also to interior surfaces, as in the Stoclet bathroom, the reception room in the exhibition of Austrian arts and crafts 1911/1912 (Cat. 149), the dining room of the Ast House, and the dining room of the exhibition in the Austrian museum 1912 (Cat. 154). What fluting does for a surface is evident: since it consists of contiguous shallow deepenings, it emphasizes the substantiality of a material. According to the rules of classical form, in conformity with its derivation from the antique columnar shaft, its use was restricted to the family of forms indicative of support—columns, piers, or pilasters. Wall surfaces between these supporting elements were treated differently in intentional contrast. The fluting of walls, therefore, from the standpoint of

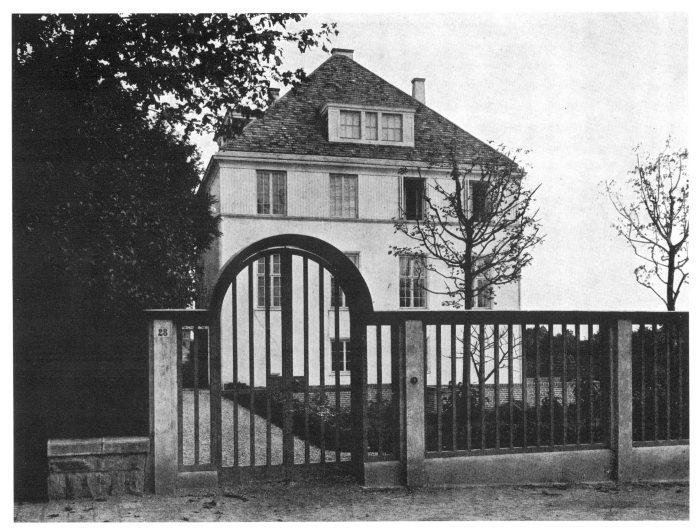

183. Villa for Dr. Edmund Bernatzik, street view shortly after completion, 1913

an orthodox classicist, was an unusual inversion to be regarded, according to one's viewpoint, either as a frivolity or a revolutionary liberating invention. Hoffmann probably appreciated shallow fluting primarily as a decorative treatment that both optically and haptically contributed to an enrichment of the sensuous experience.

This surface treatment does not yet seem to appear at the 1908 Kunstschau; there, apparently only the multiple framing or the articulation by surface patterns occur. And the first version of the theater auditorium at Kapfenberg (Cat. 139) (fig. 184) still had walls with a regular subdivision into panels matching the treatment of the facades, which recalled the Stoclet House. The second version, however, published in 1912, preferred the classicist effect of vertical fluting. The introduction of this motif into Hoffmann's repertoire approximately around 1910 may have had something to do with a task

of representational design that occupied him at approximately the same time as the second version of the Ast House, i.e., the Austrian pavilion for the international art exhibition of 1911 in Rome (Cat. 141) (figs. 185-189). In this building no entire wall surfaces were fluted, but the motif was transferred in an unusual manner to other elements of the building such as the architrave. In addition a combination of fluting and multiple framing was used to achieve an effect that approximated continuous fluting.

Owing to the political significance of the exhibition and because of its international character, special importance attached to the Roman pavilion: in 1911 the kingdom of Italy celebrated the first half-century of its existence, and in this connection two international art exhibitions were organized, one in Turin, the other in Rome. In the latter, monumental art was to predominate,

143

184. Project for a theater in Kapfenberg, Styria, perspective of the first version of the auditorium

185, 186. Austrian Pavilion at the International Art Exhibition in Rome, 1911, elevation and ground plan of the first version

and from the outset, as preliminary studies (figs. 185, 186) indicate, Hoffmann was never in doubt about the type of pavilion he wished to create. It was a type entirely derived from the classical repertory, with a *cour d'honneur*, two flanking side wings, and the main room in the central axis.

Though the basic concept is strikingly simple, there is no impression of artistic poverty because the architectural means of expression have been employed in a particularly effective manner. Thus the proportioning of the facades clearly aims at that certain effect of dignity and elegance often observed in good neoclassical buildings, which results from the repeated use of tall rectangular bays and slender supports. At the same time the plastic articulation of the facades is quite pronounced, but only with the aid of delicate planar modeling—as if to avoid any possible competition with the monumental heaviness and fully three-dimensional modeling of the Hanak sculptures that were to be exhibited. The impression of lightness appears very appropriate to the temporary character of an exhibition pavilion.

At the Roman pavilion classical tectonics with its flavor of heaviness and massiveness is negated by a conception that can be called antitectonic though not atectonic since it does not reject the means of tectonic expression but devalues or reinterprets them: not only vertical supports but also horizontal soffits have fluting (fig. 187); there are piers and pilasterlike elements without bases or capitals, and the main cornice has been kept so low in relation to the width of the piers that there is no sensation of something weighing heavily on its supports.

In a comparable manner the strip of masonry at the foot of the building (Cat. 141/III) eludes any classification into a tectonic system where every element unequivocally supports or is supported. Along the sides of the pavilion it functions as a socle on which supports and walls are resting, while under the windows and in front of the sculpture courtyard it assumes the double function of socle and facing parapet, without, however, the slightest visual differentiation of the different functions of supporting or screening. Similar visual fusions of parapets with socles or bearing walls occurred from the very beginning in Hoffmann's work, and they continued to remain characteristic of his conception of architecture: what counted was the effect of the visible, not the expression of the actual construction or function.

The interior of the exhibition pavilion was carefully and effectively designed, both to relate to the sculpture courtyard and with a view to harmonizing the galleries with the works of art exhibited in them. The entire ar-

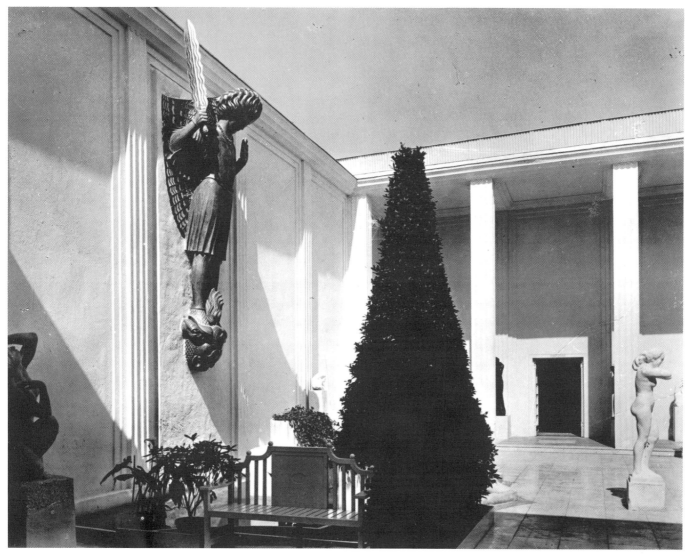

187. Austrian Pavilion, Rome 1911, view into the statue court with the archangel Michael by Ferdinand Andri at the center of the rear wall

rangement found the full approbation of the critics. Thus in June 1911 Georg Biermann wrote in the *Cicerone*: "One walks through these rooms with awareness that Austria is in possession of that splendid culture of taste that saw the Wiener Werkstätten [*sic*] originate. . . . No other pavilion is arranged more beautifully and artistically than the Austrian exhibition." The reviewer of the periodical *Die Kunst* (October 1911), Kurt Rathe, was also full of praise: "Every room is individualized in the happiest manner and fitted to the works of art in choice taste. . . . Architect and organizer, Josef Hoffmann and Friedrich Dörnhöfer, the director of the Modern Gallery in Vienna, in the Austrian pavilion have come together to work most fruitfully." Finally, Oskar Pollak, who wrote an extensive report for the *Zeitschrift für Bildende*

Kunst (December 1911), was of the opinion that "the building is . . . wonderfully clear and transparent in its arrangement. . . . In the interior the halls without exception are bright and airy, the 'decoration' is reduced to a minimum. One should think that this, after all, is something that holds true everywhere in the world. Unfortunately a stroll through the pavilions of other nations shows that for a long time to come yet one will not give up the arrangement with dark wallpapers, stuccowork, turned and carved iron beams and similar things. . . . A novelty . . . is above all the courtyard. . . . The effect here is so advantageous as could never have been achieved . . . in a top-lit hall." Rathe too, who, incidentally, addressed the building as a "purely functional architecture" and emphasized the conscious renunciation of a pur-

145

188. Austrian Pavilion, Rome 1911, view into the Klimt room

189. Austrian Pavilion, Rome 1911, left side gallery with stairs to room for graphic arts

poseless sumptuous facade, considered the garden court-yard a particularly felicitous idea, and commented: "Perhaps the artist owes it to the place where his work was destined to arise, the Roman soil itself," an obvious allusion to the peristyle of Roman villas. Whether this derivation is valid, or only corresponded to the then current desire to prove that good architecture derived from regional models, may remain undecided.

While today, a lifetime later, those stylistic qualities of the Roman pavilion that characterize it as neoclassical first strike the eye, its effect on contemporaries seems to have been much more one of simplicity, clarity, and restraint. This is understandable if one considers that the other pavilions were "a witch's dance of frantic ornaments and compendia of architectural style turned stucco" (Pollak). After the conclusion of the exhibition, Hoffmann's achievement was recognized by the award of a decoration in Italy and by his appointment as *Regierungsrat* in Austria.[40]

It appears that Hoffmann's example did not remain without effect in Rome. As Paolo Portoghesi has pointed out, influences from Hoffmann can be traced in the work of Marcello Piacentini, and it appears plausible that the two architects, occupied with designs for the same exhibition in 1911 in Rome, even became personally acquainted, though later Piacentini criticized Hoffmann's architecture.[41] Hoffmann himself pursued design ideas from the Roman pavilion in his next great exhibition building, the Austrian House at the Werkbund exhibition at Cologne, in 1914; this however was preceded by another exhibition design in 1912 for an Austrian pavilion at Venice.

For the parklike setting of the Biennale Pavilion, Hoffmann in 1912 designed two versions of a pavilion conceived as a centralized building (Cat. 157) (fig. 190). The version with fluted piers, tympanum, and semicircular windows undoubtedly is the earlier one, and the other, which relies less on historicizing forms, most probably is a considerably later reworking of the project. The choice of a centralized building preceded by a gabled portico in all likelihood represented a conscious response to the local Venetian tradition with its Palladian churches and villas. The portico of the pavilion provides an interesting example of the direct transference of fluting from piers to walls. While the appearance of the Venetian pavilion recalls Palladian classicism, the ground plan suggests comparisons with Roman and early Christian examples, such as bath buildings, baptisteries, and memorial chapels, where similar octagons with vestibules and side rooms occur. Hoffmann would have been familiar with such

190. Project for an Austrian Pavilion at the Biennale in Venice. First project, perspective drawing of the entrance side

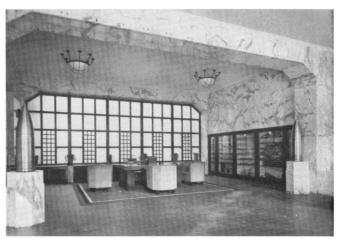

191. Office building of the Poldihütte (Steel Works), Vienna, view into the reception room

solutions from his student days, particularly from the Academy lectures of Georg Niemann, the outstanding archaeologist and draftsman, who became renowned for his share in publishing the palace of Diocletian at Spalato. This does not, however, mean that for Hoffmann these historical, perhaps long-since-forgotten, reminiscences offered more than subliminal stimuli for his own free invention of forms.

A total freedom from direct historical references prevails in the pillared hall (Cat. 153) Hoffmann created the same year for the display of Hanak's sculptures at the Dresden art exhibition—an achievement that, like the Roman exhibition pavilion, led to the award of a decoration. In Dresden as in Rome he succeeded in providing an unobtrusive yet immensely monumental frame for the sculptures with their equally monumental effects. His row of piers with the top-lit sculptures illuminated from skylights in the coffered ceiling attains a stern dignity in keeping with the character of Hanak's sculptures and recalling the severe world of such revolutionary classicists as Friedrich Gilly. By means of a similar severity combined with extreme simplicity, in the reception hall of the Poldihütte administration building in Vienna (Cat. 170) (fig. 191), Hoffmann achieved an almost frightening monumentality that was entirely appropriate for the gigantic artillery shells on display there.

Had Hoffmann considered the exhibition of Austrian arts and crafts of 1911/1912 as a personal triumph, this would have been understandable in view of the decisive role his former students played in it. As Arthur Roessler[42] wrote: "This year's exhibition of Austrian arts and crafts more than any of the previous ones bears the charac-

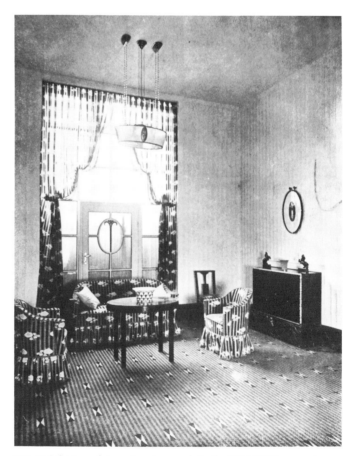

192. Exhibition of Austrian Arts and Crafts 1911/1912, reception room in black and white, view toward window

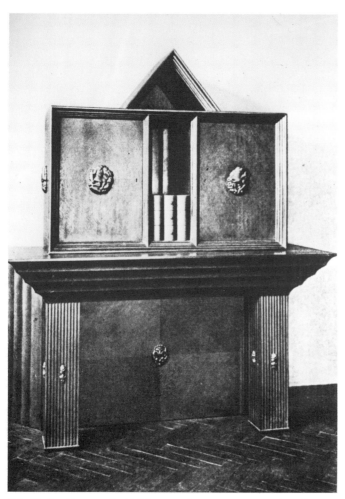

193. Hall cabinet at the Exhibition of Austrian Arts and Crafts 1913/1914

At the next exhibition of arts and crafts in the Austrian Museum, organized in 1912 for the congress of the German Werkbund in Vienna, Hoffmann was again splendidly represented—in the room of the Wiener Werkstätte and in the architectural section of the exhibition, as well as through the works of his students, and finally by the design of an extremely impressive interior, this time a dining room (Cat. 154). Like the reception room in the preceding exhibition, this room was carried out in black polished wood and had fluted walls, but at the same time it showed a more massive and richly decorated treatment similar to the dining room of the Ast House (fig. 174). The walls were tinted yellow, the fabrics colorfully patterned, and mother-of-pearl inlay was paired with floriated carving in the pieces of furniture.

To surpass such a room seemed impossible but Hoffmann found a way to increase his effects further by introducing a pronounced monumentality into his interiors. In this manner he was able to extract unusual effects from the task, not very promising in itself, of designing rooms for an exhibition of wallpapers (Cat. 175). In one room he arranged a piece of furniture that gave a strongly architectural impression, in the other, a sculpture on a high pedestal in the manner of a monument. Finally in the hall that he designed for the last exhibition of Austrian arts and crafts before the outbreak of the war (Cat. 186), the pieces of furniture (fig. 193) were weightier than in any of the previously mentioned rooms and, in addition, more varying in outline: side by side with the classicism of the very architectural moldings and flutings, the pieces already displayed an Expressionist excitement. Hoffmann at this time obviously was on a course that led him to continuous intensification, if not exaggeration, of all means for the achievement of effects—for example, excessive dimensioning or multiple repetition. This was already manifest in the interior for Professor Otto Zuckerkandl (Cat. 166) with its very lively black and white textile patterns, mighty fluted wooden piers as table legs, and its cornice molded in threefold repetition. In the hall at the last exhibition the cornice was even molded in fivefold repetition.

During the years from 1910 through 1914, which for Hoffmann were particularly rich in commissions, the strength of his taste for decoration and classicist monumentality found significant expression in the fact that he handled even comparatively less important tasks, such as designs of simple houses and residential interiors, in this manner. Yet on such occasions the discipline of simplicity from his early geometrically purist phase also asserted itself. Compared to the earlier interiors—such

teristic imprint of Professor Josef Hoffmann's powerfully formative personality. In almost all areas of the Austrian arts and crafts his teaching had a fruitful impact, his own work the effect of creating style.'' Hoffmann created for this exhibition a particularly successful ''reception room of black and white. Most distinguished, coolly reserved elegance, slender forms—distant reminiscence of the *Empire*—most modern rejection of stylistic copying . . .''[43] (Cat. 149) (fig. 192). The room is furnished with only a few pieces and therefore appears particularly spacious while, due to its vertically fluted walls, it also appears high. It seems, as a matter of fact, impossible to find exact historical models for any of the details, yet there is a very insistent presence of history; one is tempted to adduce as a comparison a contemporaneous work from another branch of the arts: the opera *Der Rosenkavalier*, loved by Hoffmann, that was first performed in 1911. In it, too, the historical reference is essential, but the artistic result is not at all a copy of historical style.

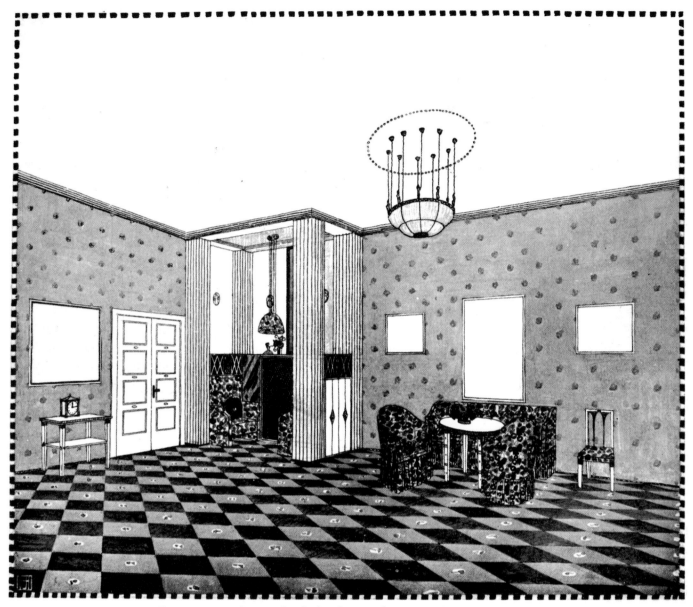

194. Apartment for Moriz Gallia, perspective drawing for the boudoir or salon

as the dining room for Helene Hochstetter of 1907 (Cat. 111), and those for Sonja Knips (Cat. 129) and Professor Pickler (Cat. 131), still similar in overall conception, treatment of work, and detailing—those completed after 1910 overwhelm with their sophisticated deployment of richness in material and decoration. Besides the interiors created for exhibitions, and which therefore naturally received a particularly impressive treatment, the furnishings for Moriz Gallia (Cat. 174) (fig. 194) and Ferdinand Hodler (Cat. 180) deserve special mention in this connection. A stronger relationship to historical models from Empire and Biedermeier is striking but not surprising in view of the popularity of these styles. Even

some years later Paul Wittgenstein had Hoffmann design a large salon in a similar manner which included genuine Biedermeier furniture (Cat. 203).

Hoffmann could achieve equally strong decorative effects even in less expensively treated rooms, albeit with simpler means, as for example in the Steckelberg (Cat. 151) and Marlow (Cat. 152) interiors, with their vividly patterned textiles and painted wall decoration. In the Marx interior (Cat. 145), besides surface patterns with very strong optical effects, reminiscences of the Biedermeier are again noticeable. They can be seen even in the unusual horizontal striation of the wallpaper; here, however, the effect assumes a life of its own that seems

149

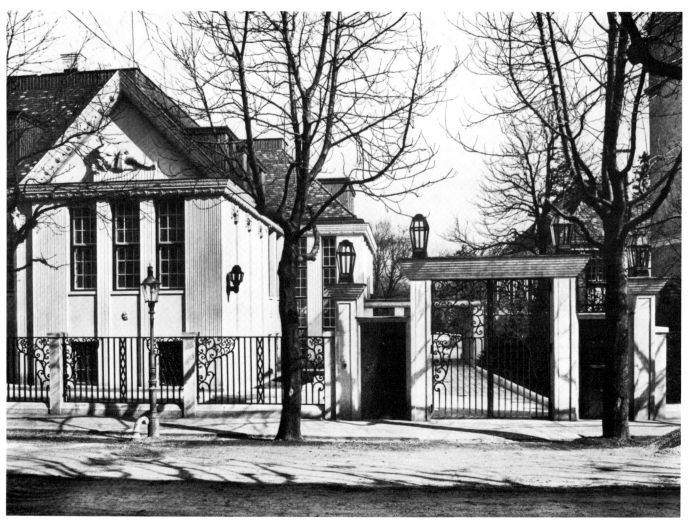

195. Skywa-Primavesi House in Vienna-Hietzing, street side and entrance gate in original state, 1915

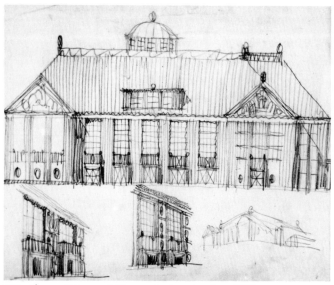

196. Skywa-Primavesi House, design sketches, 1913

entirely free from historical connotations. The result was so singular that according to Leopold Kleiner[44] it supposedly inspired Hoffmann to introduce similar horizontal striations and moldings into his architecture. This derivation of a motif that indeed was frequently used during the 1920s would be more convincing were it not for such a considerable gap in time between the Marx interior and the next occurrence of a wall treatment with horizontal striation. Generally Hoffmann was in the habit of employing a new motif he liked several times in a row within short intervals, and not after a break of some years.

The year 1913[45] brought Hoffmann two unusually large and attractive tasks: the Austrian pavilion for the exhibition of the German Werkbund in Cologne 1914 (Cat. 182) and, in the domain of interior design and residential construction, the Skywa-Primavesi House in

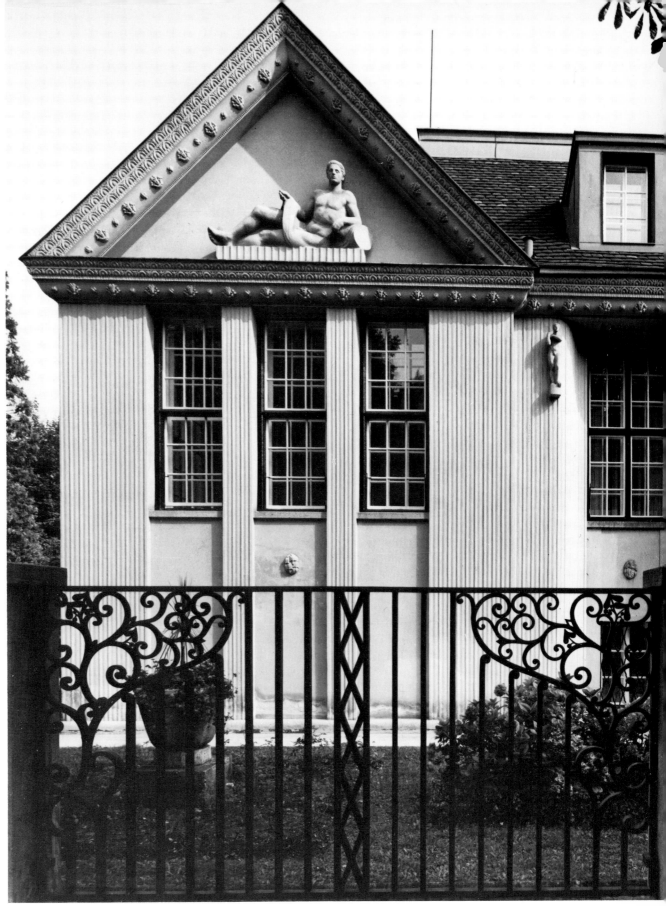

197. Skywa-Primavesi House, view of the left corner pavilion of the street facade, gable sculpture by Anton Hanak (in 1966)

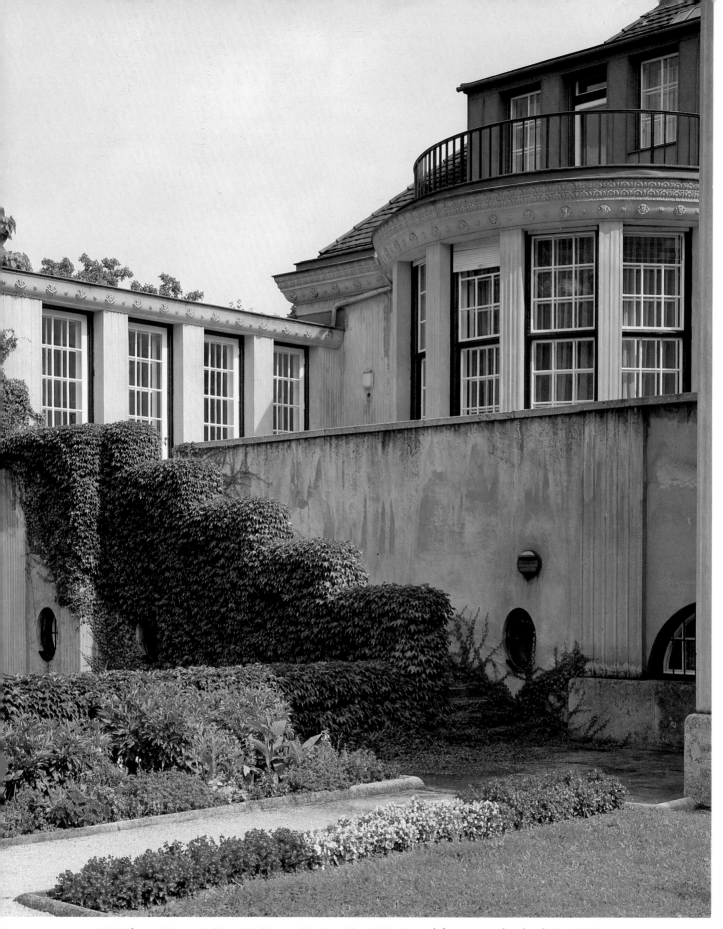

198. Skywa-Primavesi House in Vienna-Hietzing (Cat. 185), view of the west garden facade (in 1966)

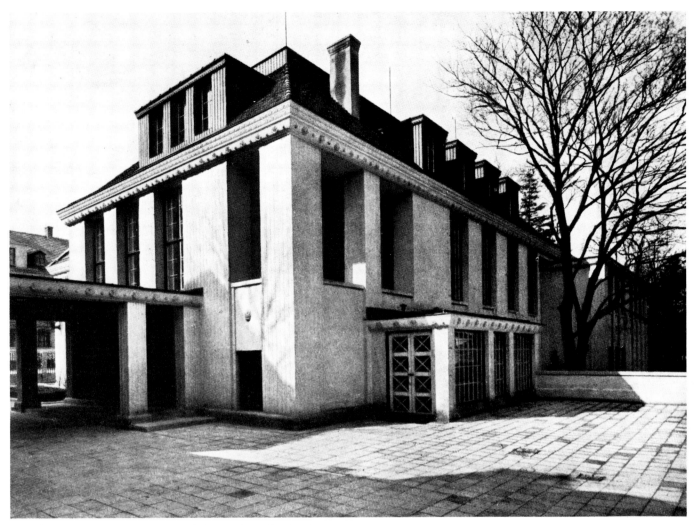

199. Skywa-Primavesi House, view of the north garden facade with service entrance and open loggia on upper story, 1915

Hietzing, Vienna (Cat. 185) (figs. 195-205), which was not completed until the war years.

The main facades of the Cologne pavilion and the Skywa-Primavesi House are very closely related as far as typology of form is concerned. In both cases an order of piers provides the main articulation. Gabled lateral projections flank a central portion, above which the main roof has been carried up higher. Here, the interaction between space and mass is more intensive than in the lateral projections because the wall surface has been recessed and because at the pavilion there is a complete opening up toward the courtyard behind. This typological kinship is explained partly by the fact that both designs were made at approximately the same time, but also by the need to create in each instance a predominant sense of dignity and stature. For the exhibition pavilion this is self-evident; for the house it was generated by the personality of the client and his position in society.

Robert Primavesi, cousin and brother-in-law of Otto Primavesi, who had commissioned the house at Winkelsdorf, was a member of the House of Representatives, and as a large landowner and industrialist he was accustomed to entertaining lavishly. During the hunting season, weekend invitations for fifty guests were not uncommon at his castle in Moravia. His niece[46] remembered him as a particularly impressive personality: ". . . tall, strong, keeping himself very straight, his finely cut features with a ruddy complexion framed by the gold and silver shimmer of a beard . . . when his uncommonly bright blue eyes rested on somebody, whether it was a maid, a guest, or my mother, then their eyes sparkled, their faces became animated, and their movements quickened. . . . To us children he always appeared as the king."

153

200, 201. Skywa-Primavesi House, design drawings for the entrance hall with stairway, pencil, India ink, and watercolors, 1913

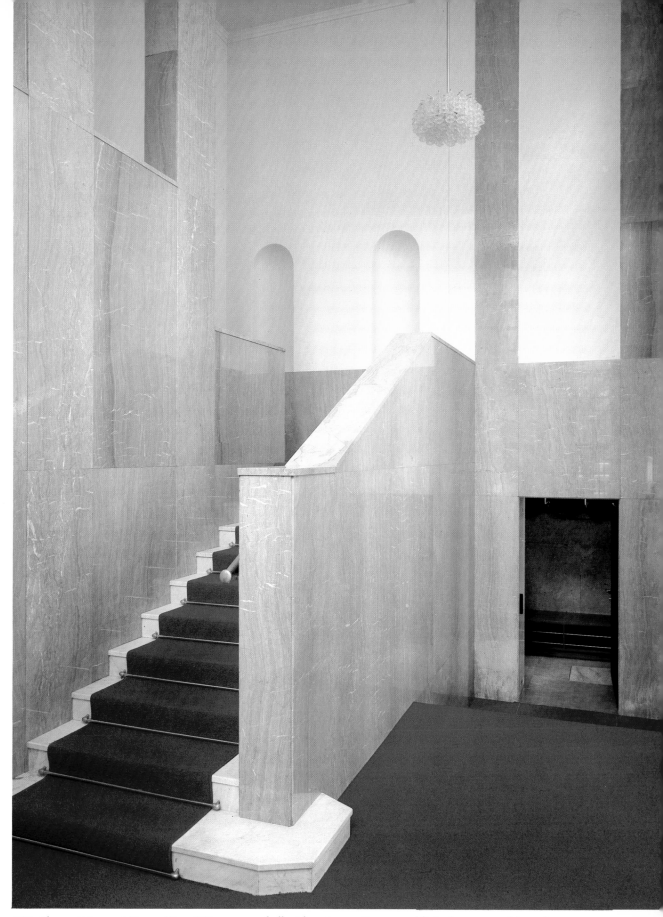

202. Skywa-Primavesi House (Cat. 185), entrance hall with stairway. Runner and light fixture are of later date.

203. Skywa-Primavesi House (Cat. 185), corner in salon, floor in lemon wood with black inlaid strips, door frames of Arabescato marble, white stucco decorations on light brown ground (in 1966)

After his young, much-loved wife had succumbed to a lung disease, he had not wanted to remarry, but in Josephine Skywa, brought to the city from Moravia, he found the companion of his later years with whom he shared the house in Vienna. He did not have as close an involvement with modern art as had Otto Primavesi, and it was on the recommendation of the latter that he commissioned Hoffmann with the design of his house. This came at a time when Hoffmann had already separated his architectural office from the Wiener Werkstätte, and Max Fellerer took over the important role of office manager from Karl Bräuer, whose predecessor had been Paul Roller; Fellerer's successor was Oswald Haerdtl.

With its monumental porte-cochere, high luminous staircase (figs. 200-202), and large hall (fig. 206), the Skywa-Primavesi House answered to entirely different dictates of social status than the recently finished Ast House, which despite its external sumptuousness finally presented itself more as a private dwelling. In size and character the Skywa-Primavesi House is more comparable to the Stoclet House, though both buildings express the very different tastes of their respective owners. The hall of the Skywa-Primavesi House, entirely wainscoted in wood, with decorative glazing almost reminiscent of bull's-eye glass, is a reminder of the client's predilection for rustic elements. He was, however, equally fond of Orientalia; his study was hung with Oriental carpets and Hoffmann designed an orientalizing chandelier for it.[47] Individual pieces of furniture such as the ladies' writing desk in the living room[48] (fig. 216) show, moreover, that Hoffmann continued to develop the ever richer decorative effects so clearly observable in the various exhibitions of arts and crafts.

By combining classicist elements with a picturesque, free overall arrangement, the architect reverted to a manner of design that was typical for him. He had used it for the first time at the Henneberg House (see Chapter II) and again at the Stoclet House and the Böhler House in Kapfenberg. The irregular joining of volumes apparent in the western garden facade (fig. 198) obviously belonged to the tradition of the "free style," so entirely different from that which informed the classical symmetry of the street facade with its solemn monumentality perfectly echoed by Hanak's powerful gable sculptures. Consequently, as at the Henneberg House, there are problematic transitions where the two worlds meet; this is revealed by a glance at the southwest corner where the picturesque side facade abuts the monumental front facade.

The outbuildings are related to each other and to the

204. The small teahouse in the garden of the Skywa-Primavesi House in its original state

205. The small teahouse in the garden with pergola and reflecting pool (in 1966)

206. Skywa-Primavesi House (Cat. 185), view into the great hall with stairs; paneling in dark polished oak. Lighting and floor covering are later additions (in 1980).

main building primarily in a picturesque manner. Among them a little "tea temple" (figs. 204, 205) with pond and pergola deserves special consideration, for it was unique in Hoffmann's built oeuvre. Its light forms and graceful carvings find their match inside the house in the small salon (fig. 203); its decorations in stucco and other materials are in no way inferior to the cheerful lightness of a precious Rococo cabinet. It is not known if the little garden temple and salon were designed for the lady of the house, but it is difficult not to think of a feminine component in the play of forces that conditioned the design.

Despite all the differences between the Ast and Skywa-Primavesi houses, stylistically there is more that connects than separates them. Together with the unexecuted design for a house in Pötzleinsdorf (Cat. 160) they represent a perfect type of large-scale villa, thoroughly expressive of stability and solidity, unequivocally linked to tradition, and displaying a very idiosyncratically understood classicism. It was a type that corresponded ideally to the needs of a stratum of society whose days, in 1913, were already numbered. It was the same stratum from which—with Baron von Bachofen and the Director General Pazzani—the presiding board of the Austrian Werkbund was recruited. To design the representative pavilion of this organization for the 1914 exhibition of the German Werkbund in Cologne (Cat. 182) (figs. 207-209) was Hoffmann's next major task.

The Austrian pavilion at this exhibition definitely must be seen in a larger context. In the programmatic concept of the exhibition's goal, and in the spatial context of the actual exhibition layout, the intention at Cologne was to review the results of seven years of Werkbund activity and to show[49] "how Germany arrived at developing a style of its own and transferring this development of taste to the sphere of the trades. . . ." Instead there was such a bewildering variety that one observer[50] exclaimed: "Less would have been more," and continued: "an uncanny breadth caused endless repetitions and did not arouse the desired effect of monumentality but that of uncalled-for fellow travelership." Except for the few examples that have since become famous (works by Gropius, Taut, and Van de Velde), the exhibition buildings mirrored the current situation of architecture between neoclassicism and vernacular style as faithfully as earlier exhibitions had done, among them the German section at the Brussels World's Fair in 1910[51] and the Dresden House at the International Building Exhibition in Leipzig in 1913.[52] At Cologne, in addition to a Lower Rhenish village in vernacular forms, there were numerous small-

207. Austria House at the German Werkbund Exhibition, Cologne 1914, perspective design sketch

scale columnar halls and lodges as well as buildings with Schinkelesque reminiscences, domed and mansard roofs—all so colorful that to an American visitor[53] they appeared "barbarically" overwhelming.

The Austria House accordingly could not fail to stand out as a pleasant contrast, with its unobtrusive dark gray exterior and predominantly black and white interior, and its overall unified and grandiose architectural appearance. It is noteworthy that the great professional periodicals *Die Kunst* and *Deutsche Kunst und Dekoration* began their reports from Cologne with illustrations of the Austria House, and even a rather scornful observer[54] considering the Austrian interiors had to concede: "The means are the simplest conceivable, but the effect is absolutely stunning . . . in every instance only a few things are placed together, only things that match in material, in color, in the range of shades: colored textiles, porcelain, ceramics, etc., skillfully juxtaposed according to color and form, as in a well-painted still-life. However, the purpose is always achieved: to have exhibits in sophisticated, beautiful lighting, [combined] with skillful arrangement affect the viewer in such a way that again and again they attract, captivate, and arrest him. We can learn a great deal from the Viennese about arrangement. If as much from their art and their design, we would rather leave undecided."

The official report in the yearbook of the German Werkbund for 1915 also mentioned the Austria House first, "because all hopes and wishes of the Werkbund nowhere approached fulfillment more closely." What was

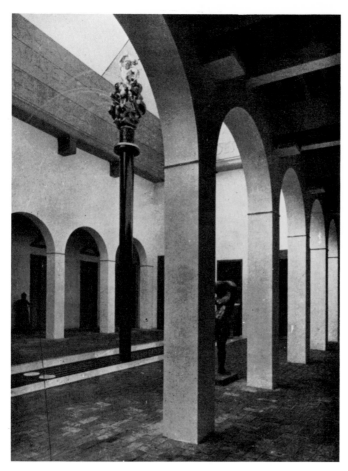

208. Austria House at the German Werkbund Exhibition, Cologne 1914; inner court by Oskar Strnad, sculpture by Jan Stursa, fountain figure carved by Franz Barwig after a design by Strnad

meant by this and by one orator's proclaiming the rooms of this pavilion "the climax" of the whole exhibition[55] is explained by the striking stylistic unity and the genuine consonance of all interiors; it seemed that this pavilion succeeded where the remainder of the exhibition failed, in achieving a clearly recognizable style of its own. It was the style of Josef Hoffmann: as in the preceding exhibitions of arts and crafts in Vienna, here he was again assisted exclusively by architects who either came from his school or at least had close ties to it. Moreover "his" enterprise of the Wiener Werkstätte was represented with a room of its own that earned additional praise.

Oskar Strnad, who had only collaborated on small decorative plaques at the Roman pavilion of 1911, at Cologne not only took over the design of the courtyard (fig. 208), so important to the overall impression but also did the arrangement of the room for monumental art—

proof of how much Hoffmann appreciated him. Strnad had the happy idea to contrast the predominant rectangular linearity of Hoffmann's row of facade piers with a round-headed arcade inside the courtyard and, in addition, to create a color contrast between the red brick flooring and white walls of the court and the dark gray of the facades. One must assume that this had been discussed with Hoffmann.

Where the external architecture of the pavilion (fig. 209) surpassed that of all other neoclassical exhibition buildings was the manner in which the historical stimulus was transmuted into something genuinely new. It had already been Hoffmann's concern to do something similar in earlier buildings, beginning with the Kunstschau exhibition. Hoffmann's success in Cologne was so complete because he had finally shut the rulebook of classical orders he had mastered in his youth. As a consequence, he dared to place a very thin cornice profile, instead of an entablature, on fluted piers that were closely spaced in an archaic manner and had no bases and capitals, thus totally negating classicist tectonics. As if this alone were not enough, however, he followed this by negating this negation: the stepped pyramid of the high thrice-recessed attic story and its superincumbent, archaically steep tympana do not convey a feeling of additional lightness but of colossal massiveness and heaviness—thereby heightening in turn the monumentality of the whole in a decisive manner. Such monumentality, though in different formal guise, had been known to revolutionary classicism, but there was no direct model for that which Hoffmann created here as a coherent totality. Rather it was the result of a personal dialogue with classical forms, a process that lasted for years; included in it were the Venetian and the Roman pavilion.

Similarly, Hoffmann's interiors for the pavilion at Cologne (Cat. 182/III, V) represented the result of years of creative work. Both in the room of the Poldihütte and in the reception room, which was decorated with the utmost economy of artistic means, one is as much reminded of the reverence for empty white walls from Hoffmann's early period as of his talent for making exhibits properly visible by isolating them. The painting in the reception room was the only accent of color in the black and white interior, and thus it became the focus of the room, as so often had happened with a painting by Klimt in earlier interiors. This time it was a painting by Schiele, *Three Houses by the Sea*, which came from Hoffmann's own collection.[56] Max Eisler[57] was convinced this room was "almost the representation of architectural lawfulness" and he admired ". . . the mastering and

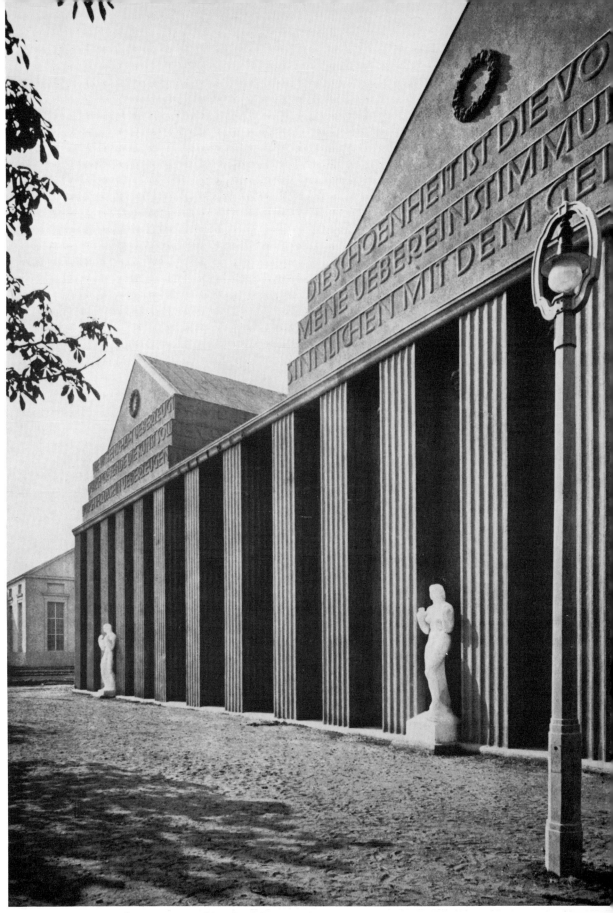

209. Austria House at the German Werkbund Exhibition, Cologne 1914, view of the main facade;
sculptures by Anton Hanak, lettering by Rudolf von Larisch

210. Perspective design drawing for a room in the Austrian Pavilion of the International Exhibition for Book Trade and Graphics in Leipzig

212. Design sketches for "Soldatengräber und Kriegsdenkmale" ("Soldiers' Graves and War Memorials") (cf. Cat. 191)

211. Robert Mallet-Stevens, design for the entrance facade of an exhibition pavilion, published in *Der Architekt*, 1914/1915

ruling will of one artist who brings about the unity." Since it is the unity of a closed tectonically conceived form, precisely determined in a linear fashion, one can speak here of classicism, despite the peculiar ambiguity of the ceiling design, but it was a classicism that in the abstractness of its diction was closer to the new than any other interior of the exhibition that owed something to classicism. In what spirit Hoffmann's creations were to be understood was evident from the Grillparzer quotations on the attic story, where in letters by Rudolf von Larisch one could read: "Science convinces by reasons, art should convince by its existence. . . . It is not the idea that makes the work of art but the representation of the idea." Hoffmann had already employed lettering as an integral part of facade design at the Kunstschau exhibition in 1908, but in a manner less boldly innovative than at Cologne, where the ancient model of inscription on the face of a frieze was transformed into a motif of much greater formal significance.

If one considers that in 1914 Hoffmann designed not only the pavilion and several rooms for Cologne but also the Austrian section of the international exhibition for the book trades and graphics at Leipzig (Cat. 188) (fig. 210), and that he was also busy with the exhibition of arts and crafts in the Austrian Museum (Cats. 186, 187), as well as with the continuing building projects of the Primavesi family, one can judge how happy and filled with work this period of his activity must have been. The leading role he played in his profession had been recognized; he had created for himself a clearly recognizable personal style. The rewards of one-and-a-half

decades of successful work included many generally admired buildings, the Wiener Werkstätte, and a circle of likeminded, successful pupils.

In Cologne, Hoffmann had even been allotted a place of his own in the main hall as one of the twelve "pioneers" of modern design, and it was now also possible to find architects abroad who were obviously inspired by Hoffmann's creations or who directly imitated them. Among these were A. S. Grenander, Bruno Schmitz, Bruno Paul.[58] Some of Robert Mallet-Stevens' early work (see Chapter VII) was done entirely under Hoffmann's spell. This is evident in a series of projects that were published in *Der Architekt*,[59] perhaps through the good offices of Hoffmann. The "entrance for an exhibition pavilion" (fig. 211) is particularly striking. It anticipated the compositional principle of Le Corbusier's street facade for the Villa Schwob, but its lateral reliefs in niches that are multiply framed, and triangular panels above the reliefs are strongly reminiscent of the entrance pavilion of the 1908 Kunstschau exhibition.

In 1914 everything seemed to indicate that Hoffmann could look to the future with confidence, and that with the flourishing building activity of Vienna's late speculative development,[60] he might expect additional challenging tasks. The restriction and final cancellation of all larger building and exhibition projects due to the First World War must have been all the more a severe blow for him.

Hoffmann's personal reactions to the shattering events of the war are not known, but he obviously saw no reason to give up the ideal of designing for all areas of human concern, nor to turn down any design problems brought to him—from the model of a war cross for civil merit to the elaboration of proposals for dignified soldiers' tombs.

The "soldiers' tombs and war memorials" (Cat. 191) (fig. 212) which he designed as models for a volume of illustrations mostly show the simple form of block and stele. They appear in conjunction with classical elements that have been transmuted in the same fashion as in Hoffmann's architecture of the preceding years: thus, one stele has shallow fluting; and two capitals display the multiple repetition of the same profile, enlarged to gigantic dimensions. At times an attempt is made to achieve monumentality with uncommonly large dimensions, but on the whole a pleasant plainness prevailed. In one case, at the uhlans' tombs with their sharp-angled upper terminations, one is reminded of the infiltration into Hoffmann's formal language of Expressionist features; this is most clearly recognizable in the complicated oblique forms of the crowning battlements in the project

213. Project for the city hall in Ortelsburg, perspective drawing of general view

214. Dr. Alexander Wacker Gesellschaft für elektrochemische Industrie, Burghausen on the Inn, construction photograph of oxygen plant of 4 July 1917

215. Design sketches for a World Peace House, ground plan and elevation

of a city hall for Ortelsburg (Cat. 206) (fig. 213) from the year 1916. By contrast, the designs of the same year for the industrial buildings, important to the war effort, of the Dr. Alexander Wacker Chemical Works (Cat. 195) (fig. 214), despite their functional simplicity, most nearly fit the description of classicist: proof of Hoffmann's conviction regarding the need to give a certain dignity even to industrial work places, just as Peter Behrens, employing the principles of neoclassical design, had done with the factory buildings of the AEG. A neoclassical-rationalist method of design, perhaps in the manner of J.N.L. Durand's much utilized textbook *Précis des leçons d'architecture*, also provided the basis for Hoffmann's large utopian project for a World Peace House (Cat. 207) (fig. 215). Here, however, the neoclassical vocabulary of forms through utmost simplification has been so far removed from the world of original classical forms that it is only a small step to the soberness of the "new objectivity" (Neue Sachlichkeit) or the monumental abstractions of Third Rome classicism. Hoffmann concerned himself with this task at the request of the pacifist cultural reformer Erwin Hanslik, while his commission for the Wacker Chemical Works followed from contact with Dr. Koller (see Chapter V) who had direct business connections with the German company.

It was through Otto and Mäda Primavesi that the Wiener Werkstätte opened several additional salesrooms during the war years. In 1914, Primavesi took over the role of financial supporter from Wärndorfer, who had exhausted his financial means and found himself forced to leave the Werkstätte in order to begin a new career in the United States.[61] Henceforth the direction and atmosphere of the Wiener Werkstätte were determined by, except for Hoffmann himself, an entirely different group of people than during the first years. A business manager appointed by Primavesi replaced the art enthusiast Wärndorfer, and the positions once held by Kolo Moser and C. O. Czeschka were taken by Eduard Wimmer and, from 1915, Dagobert Peche. Perhaps it was Peche more than anyone else who, through the transmission of new artistic stimuli from abroad, was responsible for the inception of a new stylistic phase in the Werkstätte. This new phase soon became noticeable in Hoffmann's own creative activity as well.

VII. The Climax of the Decorative Phase and the Inspiration from Cubism and Expressionism

In any discussion of Hoffmann's activity as an architect, the significance of his deep inner relationship to the arts and crafts must be emphasized again and again. He belonged to the generation for whom it was a revolutionary, liberating act to turn to the arts and crafts in the spirit of William Morris, and he clung to this conviction even when the positive artistic function which the arts and crafts had served around 1900 in overcoming historic eclecticism no longer existed. This circumstance explains in part his problems in the 1920s.

His identification with the arts and crafts production of the Wiener Werkstätte found frequent expression, and consequently the profound changes in this organization, its recurrent crises, and finally its collapse could not fail to affect him not only materially but also mentally. Besides the changes in the staff of collaborators, the shifting of emphasis in production must have played no small role. While in the original program of work for the Werkstätte, fashion and textiles were not mentioned, in later years, for the easily understandable reason of boosting turnover, they assumed increasing importance. Parallel to this, however, the concern with fashion design also increased in Hoffmann's class at the School of Arts and Crafts. Consequently fashion drawings were prominently displayed in an exhibition "Drawings from the Hoffmann School" at the Austrian Museum in 1924. Leopold Kleiner, Hoffmann's assistant, explained[1] that, although Hoffmann's class was a special class for architecture, its work extended to "all possible objects in need of . . . design," with architecture and the design of a dress coming from the "same preconditions of creation." Hoffmann completely disregarded the different temporal rhythm appropriate and possible for each art form: on the one hand, shortlived fashion, and on the other, architecture built to last. The danger of taking the analogy of fashion design and architectural design too seriously could become especially great for an artist like Hoffmann, whose abundant inventions of form always pushed in the direction of change and innovation.

It seems a symbolic coincidence that a profound change in Hoffmann's language of form is actually first recognizable in two salesrooms that had to do with fashion. They were among the few real tasks the war years brought:

in 1916, Hoffmann and Eduard Wimmer designed new salesrooms for the fashion department of the Wiener Werkstätte (Cat. 197), and late in 1917 he created a shop for the textile department (Cat. 208). Although the two shops are separated by barely two years, Hoffmann went in very different directions in their designs.

In the reception room of the fashion department, rectangular linearity and regularity prevailed; the main decorative accent was provided by the pattern of flowers and tendrils on the wallpapers and fabrics with its traditional effect; it was uniformly employed on walls and ceiling and thus helped unify the room. Every detail, moreover, recalled something already seen in Hoffmann's work: one recognizes from earlier interiors the thrice-fluted cornice, the bentwood chairs, and the typical black and gray carpet of the Wiener Werkstätte. The chair in Wimmer's own room is even a conscious historical reference, since it is the model designed more than a decade earlier for the Flöge fashion studio.

The salesroom of the textile department, by contrast, shows a series of formal innovations. The room was made dynamic by slanting parts of the ceiling area. It was animated by playfully irregular decorative wall paintings, and it housed pieces of furniture with many curvilinear decorative bars and slightly curving forms. Among these were tables with legs that, like parts of the Hodler furniture (Cat. 180), recalled the double curve of legs from rococo furniture; there were, however, other types of legs which widened in a gentle curve from bottom to top. These now replaced the straight, fluted, or carved leg forms characteristic of Hoffmann's furniture in the preceding years.

Apparently it was not until 1915 that, except in some earlier massive garden furniture, the elongated, truncated pyramids with straight or curving sides appeared in Hoffmann's repertoire of support forms. Examples are provided by the lady's writing desk from the Skywa-Primavesi House (fig. 216) and the dressing table from the new Knips apartment (Cat. 193) which also included other striking examples of stylistic change. This was also the year when Dagobert Peche entered the Wiener Werkstätte; it is Peche's manner of surface decoration—the loose, delicately drawn motifs—that one recognizes in

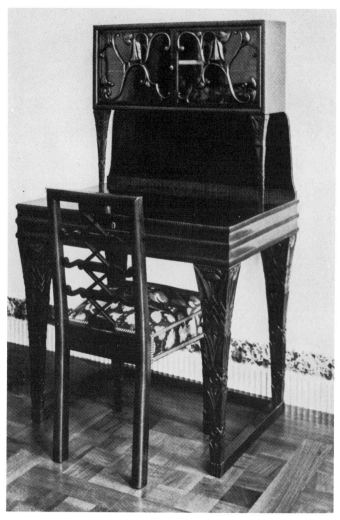

216. Lady's desk from the living room of the Skywa-Primavesi House

the wall paintings of the textile department. Shortly before, he had employed the same mode in his remodeling of the Wiener Werkstätte shop at the Graben.[2]

As a pupil of Ohmann, Peche, whom Hoffmann admired exceedingly, had received a training that predestined him for using historical models and for seeking graphically attractive effects. After graduation he studied art in Paris for half a year in 1911, and "his predilection characteristically went to Louis XV models" (H. Ankwicz-Kleehoven). The first chair he exhibited was designed accordingly, and his first interior, a lady's salon for an exhibition in the Austrian Museum in 1913, showed an equally strong historicizing treatment. It is unlikely, however, that Peche studied only historical masterpieces in Paris and not the most recent developments in painting as well. One contemporary critic[3] specifically mentioned

Expressionism side by side with China and the rococo as an important influence on Peche's art, and he probably should have also made a reference to Cubism: the technique of shading (called "Ombrieren" by contemporaries) for which Peche had such a preference, though it had remote antecedents in the Biedermeier, most likely had its immediate origin in modern painting. If so it could be seen as a translation into the realm of decoration of the *passage* technique that was so decisive for Cézanne and the Cubists, but was also adopted by German Expressionists. Just as the *passage* technique in painting used gradual color changes to create transitions, with overlappings and spatial effects between contiguous pictorial elements, so the shading technique of "Ombrieren" equally achieved sliding transitions and spatial effects by varying as imperceptibly as possible the brightness and intensity of a hue. This could be done by gradated washes or by varying the distance between parallel lines. The technique was employed in the Wiener Werkstätte shop in Zürich, designed by Peche in 1917, and time and again until it finally was considered typical of many Wiener Werkstätte textiles.

Owing to Peche's capability and great charm, his influence in the Werkstätte and on Hoffmann himself was very significant and lasted beyond his death in 1923. Most contemporary observers found words of praise and admiration for Peche; Josef Frank in a thoughtful essay of 1923 about the condition of the arts and crafts[4] saw matters in a different, perhaps more correct, light: "Dagobert Peche, the draftsman, took the place of Josef Hoffmann, the form giver. A draftsman of unusual skill, of magnificent imagination, who for years exerts the greatest influence, even abroad, but nevertheless a simple draftsman. His labor is no longer dominated by the love of form but by that of skill. He already has almost lost sight of the organic relationship that exists between material and its treatment. His young school suffers from the consequences of this. The works produced by its members are exercises of the imagination comparable to the boldest experiments in painting, the Cubist and Expressionist tendencies, but no longer have any relation to the more ordered art of architecture."

Peche of course did not represent the only connection between the circle around Hoffmann and the world of art and the decorative arts in Paris. Otto Lendecke, for example, a collaborator at the Wiener Werkstätte, expressly signed himself "Cubist" in a letter to Hoffmann from Paris[5] in 1912, and the Parisian fashion designer Paul Poiret more than once visited Hoffmann in Vienna. Poiret was Hoffmann's personal friend and an admirer

of the Wiener Werkstätte; he had discovered it on a visit to Vienna in 1912, when he acquired numerous arts and crafts products. At the suggestion of Hoffmann and Moser he also traveled to Bohemia, Moravia, and Hungary at that time in order to collect works of popular art. Subsequently he traveled to Brussels expressly to see the Stoclet House, and he finally had Hoffmann design a house for him on the rue Victor Emanuel in Paris (Cat. 159). "It was particularly Hoffmann's black-white and the sonorities of Klimt's . . . palette that had . . . an effect in the fashion which Poiret created in Paris in 1912 and 1913."[6] Poiret was most likely inspired by Professor Cizek's pioneering art class for youngsters to found his own school of arts and crafts for children, the École Martine.[7] Among the Parisian painters, Fernand Léger[8] and Jean Lurçat visited Hoffmann in Vienna on various occasions. In turn, his former collaborator Gabriel Guevrekian was active in Paris during the twenties: he worked for Robert Mallet-Stevens, among others, furnished a shop for Sonja Delauney, and, for the international exhibition of decorative arts in 1925, designed a garden made up entirely of geometric forms, which attracted a certain amount of attention. His connection to Vienna was renewed in 1932 when he designed a house for the Werkbund estate.

In the Wiener Werkstätte, impulses from the avant-garde currents of painting were not taken up in a spirit of continuing the painterly dialogue with pictorial problems; rather, they were converted into something decoratively useful and fashionably novel. In this manner it was possible to create new decorative motifs and effects that were free of references to history or to popular art. The Parisian art world was also thoroughly familiar with this process, as is proved, for example, by Sonja Delauney's fashion designs.

In 1925, on the occasion of the Parisian exhibition of decorative arts, Waldemar George[9] commented: "The entire modern production in the area of the decorative arts develops under the sign of Cubism." In the same year Max Eisler,[10] reviewing the ceramics in the Austrian pavilion, was struck by the fact ". . . that neither Cubism nor Expressionism have been in vain. . . . they have fruitfully helped the renewal of form." In connection with Hoffmann's own creative activity, the process was seen at a later moment by his friend Albert Paris Gütersloh[11] in the following way: "While viewing the drawings of the master and architect, much revered by me . . . Hoffmann, it is impossible to avoid the opinion that, haunted by the invention of abstract painting . . . [he tried] to apply this method to the . . . beautification

of the fabrics." Hoffmann's *modus operandi*, which Gütersloh had correctly intuited, was consistently derived from the period before 1900 when in fact—as Hoffmann emphasized time and again—inspiration from painting had rejuvenated the arts and crafts as well as architecture. Thus in a lecture of 25 March 1926, at the Austrian Museum he declared, "It is the painters who first tread new paths . . . ," and on another occasion, ". . . we would have to despair if just at this time particularly in Paris an . . . art with entirely new ways had not originated . . . reminding the arts and crafts again of their very own duty." Accordingly it is not surprising that, as an example, Mathilde Flögl's wall paintings remind one of Purist models, or that Viennese sheet metal sculptures resemble the copper heads by André Dérain.

When Peche returned from Zürich to Vienna after the end of the war, he was confronted with the material misery of the inflation years that very much hampered both the practice of architecture[12] and the continuation of work at the Wiener Werkstätte. Yet in the face of all these difficulties, Hoffmann in 1919 expressed optimism about the future of Vienna in the periodical *Der Merker* (Appendix 9). Here, admittedly without concerning himself more closely with the economic and social realities of the time, he demanded "nothing but the outstanding, outstanding above all else, can bring us to the top again, and therefore we should rather produce nothing than something not entirely good. Our ambition should be to strive only for the best and to seek perfection."

What Hoffmann meant by this was shown, at least in part, in the 1920 exhibition of the Kunstschau, of which he was then president. Dagobert Peche was allotted a room of his own, in which a painted cabinet of unusual form with four small corner pyramids on top was the most striking piece. Painted cabinets were also exhibited in the gallery of the Wiener Werkstätte, where, among more than one hundred and fifty exhibits, the ceramic figurines, some of them life-size, stood out above all. As on comparable occasions before the war, one could see various precious objects in the showcases of the gallery, but in 1920 the discrepancy between the sumptuousness on display and the misery of daily life was particularly flagrant. Arthur Roessler denounced this in a sharply worded review, in which he also touched on the close connection, inadmissible in his opinion, of Kunstschau exhibition, School of Arts and Crafts, and Wiener Werkstätte, as well as on the events in the Austrian Werkbund,"[13] which had just been split by the withdrawal of Hoffmann and his followers, a process that was to repeat itself at the beginning of the 1930s. The reproaches that

217. Facade design for a café-restaurant in Laxenburg, Lower Austria

were brought forth against Hoffmann in 1920, coupled with the fundamental questioning of the entire domain of the arts and crafts, formed a prelude to the polemics that were destined never to cease during the entire decade. Although they were annoying and distressing for Hoffmann, they were useful in the final analysis, since they forced him to confront the changed conditions of the times and the new ideas. This resulted in numerous lectures and essays.

While the arts and crafts were amply represented in the 1920 Kunstschau exhibition, in the fine arts galleries only the twelve sculptures by Hanak testified to any strong activity in that realm. Kokoschka showed only a few pictures, and among the other painters none reached the level that prevailed in the two memorial retrospectives for Klimt and Schiele in 1918. Moreover, Lendecke, Metzner, Moser, and Otto Wagner had also died, leaving gaps in the circle of Hoffmann's closest friends. What this meant was that he suddenly found himself largely deprived of that spiritual support that could only come from contact with such outstanding creative personalities

as Klimt and Wagner. They left a void that during the remainder of Hoffmann's career no one was able to fill.

In contrast to earlier Kunstschau exhibitions, architecture was not represented at all in the 1920 exhibition. This is not surprising, since nothing worth mentioning had recently been built or designed. The conditions determining Hoffmann's activity at the beginning of the 1920s were obviously very different from those surrounding him during the prewar era. At first there were only architectural projects that remained on paper, such as the café for Laxenburg with its cheerful paraphrase of a neoclassical palace facade (Cat. 227) (fig. 217), and projects that were carried out later by others, such as the preliminary design for a Festival Hall in Salzburg which according to Hans Tietze[14] was entrusted to Hoffmann as well as to Hans Pölzig in 1920.

A house designed in 1919 for the Knips family was only carried out five years later and then in changed form (Cat. 265). In its early version (fig. 218), the sharp-angled details of the windows demonstrate the same trend toward Expressionism that characterizes the town hall

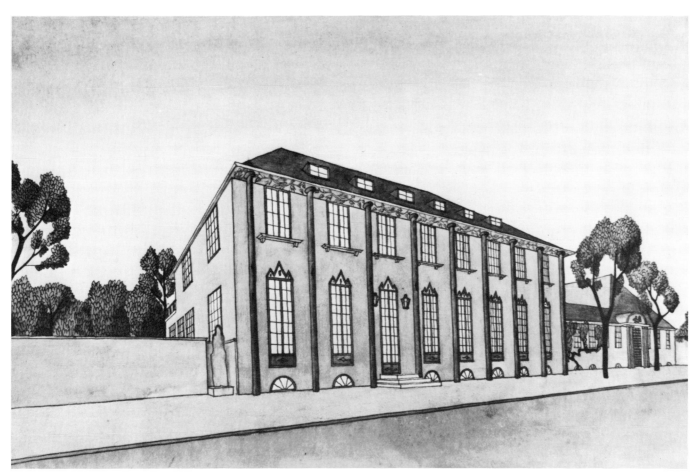

218. House for Sonja Knips, first project, perspective drawing of street side, India ink and watercolors, 1919

for Ortelsburg (Cat. 206) (fig. 213) and various interiors and pieces of furniture from the same period. Hoffmann could have received impulses in this direction not only from Philipp Häusler who was in charge of the Ortelsburg designs, but also from his former pupil Emanuel Margold who came forth for a while in Germany as an enthusiastic exponent of that "architectural Expressionism" to which, in a very critical review, Dagobert Frey took exception in 1921.[15]

After the war, Hoffmann's first major designs to be realized were invariably done for clients in the Monarchy's northern succession state, Czechoslovakia, where economic conditions were better. There, through the Primavesi family, Hoffmann already had contacts to entrepreneurial circles in Moravia and former Austro-Silesia. Thus, several commissions from members of the Grohmann family came about; they owned a large textile enterprise in Würbenthal (Vrbno pod Pradĕd) and were related to the Primavesi family by marriage. Roughly at the same time, a large house was done for Sigmund Berl (Cat. 226) at Freudenthal (Bruntal) not far from Wür-

benthal; two decades earlier the wholesale merchant David Berl had been one of Olbrich's early Viennese clients.[16]

The houses for Sigmund Berl (Cat. 226) (figs. 219, 220, 223-227) and Fritz Grohmann (Cat. 231) (figs. 221, 222) as well as an unexecuted project for Kurt Grohmann (Cat. 253a) all belong to the type that directly continues prewar solutions. In plan this invariably meant that the main staircase led from the hall/living room to the upper story. The treatment of the interiors, however, clearly displays the same new phase of Hoffmann's decorative conception that could be observed in the textile department of the Wiener Werkstätte. In color the living room and breakfast room in the Berl House were limited to a cool bluish gray which, together with the white ceiling, created a feeling of calm spaciousness as well as providing a strongly contrasting background for the fabric upholstery, a large colorful pattern on a black ground. The quiet, spreading-out effect was further enhanced by a wainscoting in the living room (fig. 220) which used horizontal rectangular panels rather than vertical rectangles or squares as in earlier interiors. Among the

219. House for Sigmund Berl, Freudenthal (Bruntal), vestibule, furniture in gray blue eggshell finish

221. Remodeled house for Dr. Kuno Grohmann in Würbenthal-Pochmühl (Vrbno pod Praděd), view from living room into dining room

220. House for Sigmund Berl, Freudenthal (Bruntal), door between living room and dining room

individual partly lacquered and spaciously placed pieces of furniture, sharp angles and slightly curving forms predominated (fig. 219), except where a traditionalism desired by the client prevailed, as in the dining room. In the interiors for Dr. Kuno Grohmann (Cat. 238a), flat varnish in colors appropriate to the function of each room was employed: dark in the dining room, light yellow hues in the lady's bedroom. Here, as a novelty, stucco cornices were replaced by painted cornice boards decorated with carved, colored, flower motifs (fig. 221). The exteriors of these houses (figs. 222, 223) were determined by the block shape of the built volume that is articulated at most by projections on one side. It supports a high hipped roof covered by slate, and has two-storied facades with tall windows or glass doors in the lower story. Vertical fluting, so characteristic of many prewar houses, was not employed at first. Instead, a facade decoration of applied stucco ornament—sparse or rich in conformity with the client's wishes and means—was envisaged that continued ideas from the Ast and Skywa-Primavesi houses. In particular, the first design for the Berl House (Cat. 226/I) and studies for its facade treatment (figs. 225, 227) show the wealth of decoration which appeared to Hoffmann as ideal. Nothing of the kind can be found at the Grohmann House, however, because here the client insisted on greater simplicity. Accordingly the architect was forced to limit himself to small stucco ornaments between the windows and channeled parapets underneath the ground-floor windows.

At the Berl House the gray slate roof and the white stucco of the facades provide a neutral background for the colorfulness of flowers in decorated concrete window

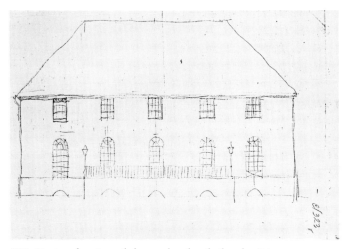

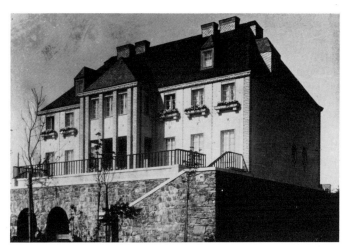

222. Design drawing of the garden facade for the Fritz Grohmann House in Würbenthal-Pochmühl (Vrbno pod Praděd)

boxes, but on the whole the execution is a bit more restrained than the design (figs. 223-227). Still, for the total effect, especially in the garden facade, the decorative treatment of moldings and ornamental motifs remains decisive. Unfortunately, the lateral portions of the garden facade and the street facade have since been deprived of their decoration, but photographs of the original condition reveal with particular clarity the degree to which decorative treatment was integral to Hoffmann's architecture. Its purpose clearly was not only to enrich the surfaces but also to impart rhythm to the facades, to establish relationships, to place accents, and, in the case of openings, to avoid the "figure/ground conflict" by means of framing. Rudolf Arnheim[17] has clarified the conflict in gestalt perception that occurs with unframed openings: window openings that are small in relation to the surface of the facade, on the one hand are perceived as "figures" on the "ground" provided by the plane of the facade; on the other hand they cannot sit on this ground because they are obviously cut into it. Framing takes care of this visual dilemma because the molding not only "confirms the figure character of the opening" but also "provides a protrusion beneath which the ground surface of the wall can end."

The design of piers and pilaster strips at the Berl House (fig. 227) represented something entirely new: vertical supports made from parallel horizontal moldings. The basic element of these, with its two cymas and the applied leaf, obviously came from the world of the decorative arts. In his project for the Bachofen von Echt House in Vienna (Cat. 243), Hoffmann had envisaged similar pilaster strips that remotely recalled rustication and quoins.

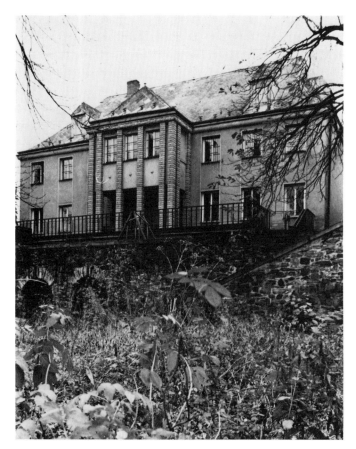

223, 224. House for Sigmund Berl, Freudenthal (Bruntal), garden facade shortly after completion and in 1980

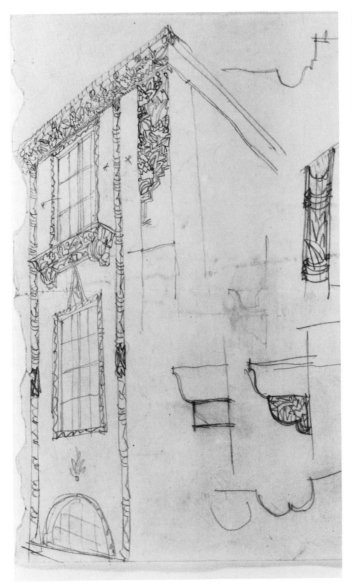

225. House for Sigmund Berl, Freudenthal (Bruntal), perspective design drawing for treatment of garden facade

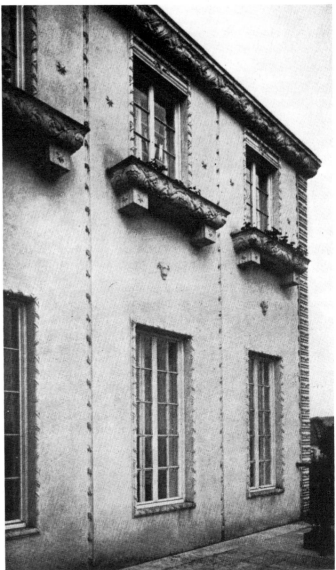

226. House for Sigmund Berl, Freudenthal (Bruntal), detail of garden facade in original state

It is evident that from such horizontally layered elements of support it was only a small step to treating an entire facade with horizontal moldings. Hoffmann took this step in 1923 at the Ast Summer House (Cat. 254) (figs. 228, 229), one of the first more important building projects that were eventually to occupy him in Austria as well. Earlier at the Dunckel House in Budapest (Cat. 244), he had already emphasized the horizontality of the facades by applying several strips of stucco in the manner of stringcourses. In the general architectural development of the following years, the horizontal line became an especially striking stylistic characteristic, as exemplified in the typical cantilevered slabs, bands of windows, and by Le Corbusier's *fenêtre en longueur*.

With Hoffmann the bias for horizontality in the treatment of exteriors exactly corresponded to a preference for horizontal rectangles as subdivisions in interior design; both implied a conception of the built volume as something broadly spread out and, of course, particularly suited to receive a flat roof with its negation of any verticality. As a matter of fact, for the Ast Summer House, in contrast to the Moravian-Silesian buildings, Hoffmann envisaged a flat roof from the outset. This is proved by a preliminary design (Cat. 254/I) that, incidentally, differs considerably from the execution. Hoffmann also planned a flat roof for the Viennese villa of Dr. Hans Heller (Cat. 252) at the same time, but its facades were to be fluted vertically in the greatest con-

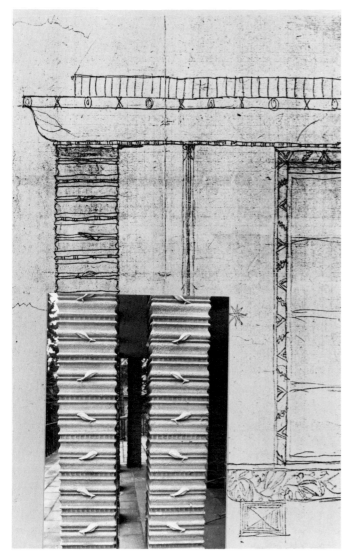 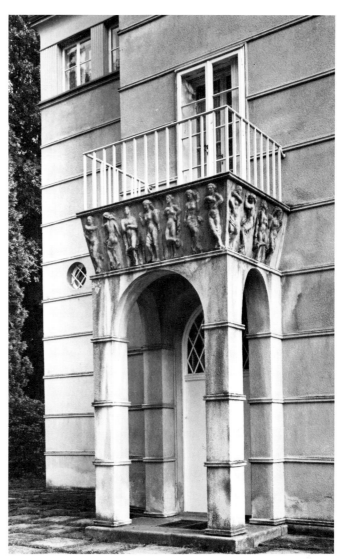

227. House for Sigmund Berl, Freudenthal (Bruntal), design drawing for decorative treatment of garden facade and detail of pillars on executed facade; the vertical supports are made up of horizontal moldings

228. Eduard Ast Country House on the Wörthersee, view of the entry with frieze by Anton Hanak. The facade is articulated by horizontal moldings.

ceivable contrast to those of the Ast House. This trend toward cubic built volumes with flat roofs is probably an accommodation to the new direction of international architectural development, already clearly noticeable in 1923. At this time, Hoffmann was able to inform himself about the most recent architectural developments not only through his own observations but equally through those of a new collaborator who was most interested in the international architectural events: Oswald Haerdtl who joined Hoffmann at the School of Arts and Crafts in 1922, one year after he had finished his studies with Strnad.

The arched concrete pergola (Cat. 254/II) in the garden of the Ast Summer House in all likelihood also repre-

sented the artistic reaction to a trend of the period, since in the 1920s interest in the technology of reinforced concrete was at a high point. The client, moreover, was a leading figure in Austrian concrete construction. How successful Hoffmann's idea was is demonstrated by the fact that Clemens Holzmeister took it over directly in his design for the garden of the presidential palace at Ankara. In this case, Max Fellerer might have played the role of the intermediary, since he worked for Holzmeister after he had left Hoffmann.

The interiors of the Ast Summer House (figs. 230-232) bear an unmistakable relationship to those in the Berl House. One finds the same employment of a multifoil arch over the beginning of the hall stairs, similar

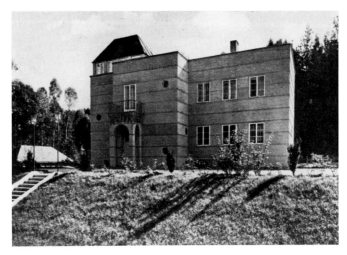

229. Eduard Ast Country House on the Wörthersee, view of entrance side shortly after completion

230. Eduard Ast Country House on the Wörthersee, living hall with view into dining room; light green walls with red-brown moldings, dark green and black floor covering

231. Eduard Ast Country House on the Wörthersee, upper hall and staircase; walls and furniture in a pale greenish blue

round openings between living room and dining room—except that in one case they occur in the door leaves, and in the other, in the walls—and there is the same contrast between empty wall surfaces and decoratively treated, freely distributed pieces of furniture. What was abandoned in favor of a new, freer, and less compact arrangement was the carefully composed organization of earlier interiors, as at Hochreith, where every piece of furniture was assigned a fixed location in connection with the articulation of the walls and within a network of actual relationships.

In a comparison of the Ast Summer House and the Berl House, the different character of the clients and the programs finds forceful expression. The interiors in the summer house are much more colorful and free of reminiscences to tradition than those in the Berl House. It is striking, moreover, that here the motif of horizontal striation in the facades returns several times in the painting of the walls and patterns of the curtains found in the bedrooms. The very facade treatment, however, is proof that Hoffmann's buildings bear only a superficial and not a theoretically reasoned relationship to the buildings of Oud or Le Corbusier. Where for them the integrity of the surface as an element of spatial definition was paramount, the effect of the surface as something that can be experienced sensually was what counted for Hoffmann. Where the others were more revolutionary on the path toward a new conception of architecture, he was more humane with regard to the user and viewer because he offered their senses a greater variety of stimulation.

Eduard Ast, who simultaneously loved art, and, as an engineer, consciously adopted a progressive attitude, was for Hoffmann as ideal a client as the Knips family, and while the Ast Summer House neared completion, the final version of the Knips House was begun. The Knips House (Cat. 265) (figs. 233-239) was destined to be the last of the great urban villas in Vienna that Hoffmann was able to execute; it is particularly fortunate that it has survived more than half a century with comparatively few alterations. In connection with this building, Sonja Knips, née Baroness Potier des Echelles (fig. 238), was the decisive personality. In her habits and attitudes toward life, she still belonged entirely to the prewar world, to the years when by commissions and acquisitions she had often proved her loyalty to her intimates in the circle of artists around Hoffmann, Klimt, and the Wiener Werkstätte.

Hoffmann was fully aware of the nature of the task facing him in this case: to fit the house into the Döbling environment, so familiar and dear to him with its nu-

232. Eduard Ast Country House on the Wörthersee (Cat. 254), bedroom in eggshell finish (in 1980)

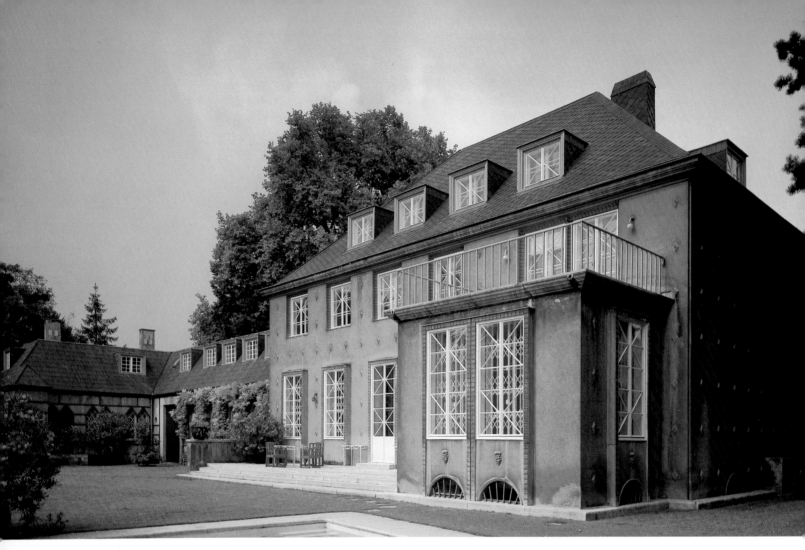

233. House for Sonja Knips, Vienna XIX, Nußwaldgasse (Cat. 265), view of the garden side (1980)

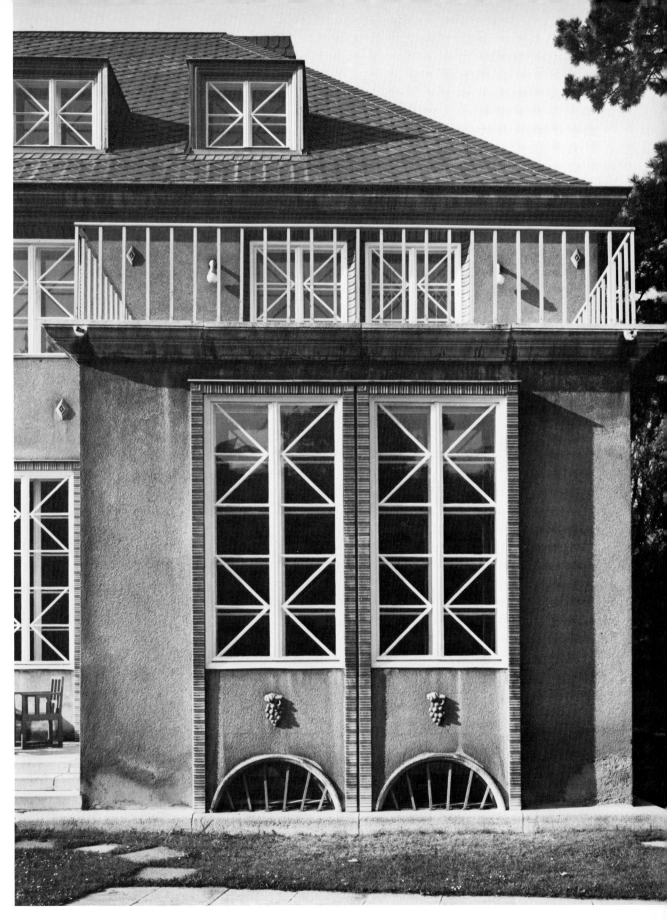

234. House for Sonja Knips, detail of garden facade

235. House for Sonja Knips, view from living room into dining room

236. House for Sonja Knips, view from kitchen into pantry

merous reminiscences of Biedermeier tradition. He accordingly had recourse to the traditional house type, with a high, all-encompassing roof and a volume broken only by the addition of the low side wing. A feeling of restraint but nonetheless clearly noticeable distinction was created by moving the house back from the street and preserving the large tree in front of it; in addition, the articulation of the facade was very strictly ordered, with a distinct emphasis on the *piano nobile* by means of windows that appear higher because of their decorative surrounds. It is striking that the verticals of these surrounds (fig. 234), similar to the piers of the Berl House, are made up of superimposed horizontal elements. The stucco decoration is used sparingly, and the side wing alone somewhat loosens up the total effect; its double-peaked windows are carry-overs from the period of Expressionist motifs.

In the garden facade particularly (fig. 233), the accord between a very simple basic concept and sparsely but effectively employed decorative elements is extremely

successful. It finds a correspondence in the large rooms of the ground floor with its seductively simple plan derived from the arts and crafts tradition. Here too a consonance between simplicity and richness was achieved: large empty wall surfaces are framed by pilaster-strips and cornices that are modeled and painted; their decoration, with its alternation between abstract geometrical and floriated motifs, perfectly matches Peche's fabric on the upholstered furniture. The manner in which the color scheme of the stucco decoration fits the overall concept indicates that Hoffmann had found a congenial collaborator in his pupil Christa Ehrlich.

The use of cabinets of wall height glazed on both sides to connect the hall and dining room as well as the kitchen and office (figs. 235, 236) shows how Hoffmann extensively used transparency as a medium of spatial fusion. Perhaps one can detect in this a reference to the treatment of space that characterized the Modern Movement, in contrast to the additive joining of clearly defined, finite

237. House for Sonja Knips (Cat. 265), view from dressing room into bedroom; bedroom closets of lemon wood; carpets are of a later
date (in 1980)

238. House for Sonja Knips, library on the second floor (in 1957). The Klimt portrait of the owner was originally in another place.

239. House for Sonja Knips, sofa niche in gentleman's bedroom; paneling in brown polished walnut, brown carpet, green upholstery

spatial units of neoclassicism. Hoffmann had already provided a similar transparent connection between living room and dining room in the house for Dr. Kuno Grohmann (fig. 221).

In the rooms of the upper story at the Knips House (figs. 237-239), where the interiors from the city apartment (Cat. 193) were partially reused, Hoffmann employed his entire mastery in the orchestration of coordinated forms and colors to create moods appropriate to the individual functions of the rooms. This can be observed especially in the rooms for Sonja Knips herself: a ladies' salon, bedroom, and dressing room. In the bedroom (fig. 237) the cozy, warm coloration of cherry wood and gilt metal prevails, but the adjoining dressing room is entirely neutral and cool in a light bluish gray that obviates any possible color conflict with the gowns to be tried on here. Finally, in the ladies' salon (Cat. 265/VI), as earlier in the room of young Sonja Knips (Cat. 79), a painting by Klimt—in this case *Adam and Eve*[18]—provided the compositional climax. The color scheme of the room consisted of varying hues of red, from delicate pink to the darker red of the richly carved chairs and the table; these hues were ideally suited to enhancing the opalescent sheen on the skin of Klimt's Eve. The room was Hoffmann's genuine, perhaps unconscious, homage to two people, Sonja Knips[19] and Gustav Klimt, who by their inspiration and trust had contributed a great deal to making his artistic career what it was.

In the finished attic, the molding of the wooden cornice is striking; it takes up ideas from the period around 1914 with its multiple repetition of the same concave profile. Equally unusual is the manner in which the sofa has been built into a wainscoted niche in the gentleman's bedroom (fig. 239).

Somewhat earlier, Hoffmann had employed a similar installation as the main motif in the Boudoir (Cat. 247) (fig. 240), which he exhibited on three successive occasions. The room was originally designed for an exhibition at the Austrian Museum in 1923; subsequently, however, it was also displayed at the exhibition of decorative arts in Paris 1925 (Cat. 267) and in an international exhibition of applied arts at Macy's Department Store in New York City (Cat. 292).

The repeated reuse of the Boudoir occurred for reasons of economy, but Hoffmann would not have permitted it had he not considered the room truly representative of his artistic attitude at the time, and had he not felt that it responded to the interests of the public at the moment. As a matter of fact, the room, its intarsialike paintings by Maria Strauss-Likarz, and the decorative art objects

arranged in it are as much a perfect expression of the prevailing taste of the time as, for example, the bathroom of the Duchess of Alba of 1925, designed by Armand Rateau.[20] Even the selection of the functional program was revealing: what was shown was not the usual reception room, hall, or dining room, as in exhibitions of the prewar period, but a type of a room specially created, something between a boudoir and a bedroom, with an entirely erotic iconography: from Susi Singer's sculpture to the paintings in the dominating central panel that show a coquettish Venus with amoretti, surrounded by scenes from the life of a lady. In one of these small representations we see her gracefully reclining on a chaise longue and smoking as she receives an admirer who appears to be on his knees. By contrast in the actual Boudoir, Hoffmann had devised a comfortable armchair for the visitor, in which he can sit beside the sofa that here takes the place of the chaise longue. This sofa is built into a decoratively framed niche and lit from the top, imparting a stagelike character to the whole arrangement and, as it were, inviting the visitor to become a voyeur. The wall niches on either side of the sofa, housing a foldout writing surface and a little cabinet that holds glasses and bottles of liqueur, fit equally well into the overall atmosphere, as do the carved wooden edging with its slightly exotic effect and the various containers and vessels for refreshments, sweets, and cigarettes. The books alone, beautifully bound and neatly arranged in rows, appear a little out of place, even though the golden glitter of their tooling and the warm color of their leather bindings go superbly with the ensemble.

When the Boudoir was exhibited in Paris in 1925, a French reviewer remarked that the room lacked nothing but the smell of opium, and one might surmise that it was "destined for a special purpose, if next to the entrance door there did not stand a small basket containing balls of knitting wool that conjure up the shade of the prudent and faithful Penelope."[21]

The Boudoir exactly suited the mood of the public segment that caused the revues, cabarets, and jazz nightclubs to flourish in the 1920s. It may equally have mirrored personal interests of the architect himself at that time: in the same year in which the Boudoir was shown in the *Galérie des Invalides* as part of the Austrian contribution to the great Paris exhibition of decorative arts, Karla, an attractive fashion model of the Wiener Werkstätte, became Hoffmann's second wife.

Besides the Boudoir, Hoffmann exhibited two more rooms (Cat. 267) that had already been shown in Vienna, at the 1924 Jubilee Exhibition of the Association for Arts

240. Boudoir, view into sofa niche; polished walnut with brown, red, and black upholstery

and Crafts (Kunstgewerbeverein) (Cat. 260). One was a study or smoking room with a ceramic fireplace by Hertha Bucher, the other a living room or salon with a tentlike ceiling painted by Camilla Birke. Both rooms were characterized by colorful decoration, overstuffed seating, and bulky cabinets strongly modeled with richly contrasting moldings. They share with the Boudoir a striving for maximum effect through constellations of form never seen before: one will probably not find models in the entire history of furniture for the manner in which the surfaces of these cabinets have been broken up into parallel horizontal or vertical wavy moldings. Nor will one readily find comparable examples for the transference of the same kind of wavy molding—only enlarged in scale—to the entire expanse of a facade, as in Hoffmann's Austrian Pavilion (Cat. 266) (fig. 244). These wavy facade surfaces cannot be compared to the Baroque, as several French critics tried to do. It is true that undulations and swellings occur in that style but never in a parallel layering of identical moldings; this would have been contrary to the Baroque structural principle which demanded hierarchical intensification through the separation of subordinate and dominant elements. Nor can the dramatically modeled design fantasies of Mendelsohn and several German Expressionists of the immediate postwar period be adduced for comparison: their forms resulted from free sculptural modeling or from the consideration of structural curvatures, while Hoffmann molded in the classical sense of the word that refers to architectural profiles. As so often before, his originality was to be found in the manner in which he bestowed new effectiveness on a familiar form by employing it in

241. The Austrian Pavilion at the International Exhibition of Decorative Arts, Paris, 1925, during construction

242. The Austrian Pavilion during stucco work

243. Entrance to the Austrian Pavilion

an unfamiliar context, treating it, as it were, as an *objet trouvé.*

The context into which he had to fit his exhibition pavilion this time was extremely demanding and delicate: he was called upon to confront the international competition in his very own domain of the decorative arts in a city that in this domain was the most prestigious in the world—Paris.

The international decorative arts exhibition in Paris, officially titled the *Exposition Internationale des Arts Décoratifs et Industriels Modernes,*[22] was delayed approximately one decade because of the First World War. At the time when it was planned it would have been something like a French answer to the 1914 Werkbund exhibition in Cologne; and just as with that event, economic considerations played a determining role. The hope that a worthy presentation in Paris would procure better export opportunities for Austrian arts and crafts and the desire to cut a good figure in the first postwar appearance on the international stage induced the Austrian government to work with the city of Vienna and other financing agencies to raise the necessary funds. Adolf Vetter was the Austrian commissioner general for the exhibition, and Hoffmann was appointed the architect. It is hard to imagine that in Austria at that point in time another architect could have been entrusted with this commission, because no one else had a comparably rich experience in exhibition matters and such great international prestige.

As at Cologne in 1914 Hoffmann procured the collaboration of outstanding professional colleagues: Strnad, Frank, Haerdtl, and Peter Behrens, who since 1922 headed a master class at the Academy of Fine Arts in Vienna.

244. The Austrian Pavilion at the International Exhibition of Decorative Arts, Paris, 1925, gallery wing

Adolf Loos, according to a later account by Hoffmann,[23] declined an invitation to collaborate. In addition, students and graduates of the School of Arts and Crafts were employed as artistic collaborators for the details and practical assistance in furnishing the pavilion. Thanks to the energetic on-site supervision by Max Fellerer, the Austrian Pavilion (Cat. 266) was one of the few completed almost in time for the opening of the exhibition. Except for the concrete terrace and the glass pavilion, it was constructed in timber with stuccoed siding (figs. 241, 242). The profiles of the facade accordingly could be molded in the stucco, and they were lightly tinted in a reddish hue.

Hoffmann's very free disposition of the ground plan (Cat. 266/III) not only facilitated the joining of portions of the building designed by different architects, but also made for a particularly good adaptation to the site—a not very large tree-lined plot along the Seine. Hoffmann in effect included the river in his composition by moving a terrace on supports close to the water and installing on it a Viennese coffeehouse—a particularly happy invention, since the Café Viennois became a popular rendezvous at the exhibition. In bad weather the visitors to the coffeehouse could withdraw into a wide covered corridor that led to (fig. 245) the winter garden designed by Behrens as a glass pavilion. Behrens originally had envisioned colored glass for his room, which would have heightened the restless effect already produced by vegetation and the many oblique glazing bars; Hoffmann, however, managed by a cleverly placed comment[24] to dissuade him from his original intention. Aside from the glass pavilion, which was quite visible from the Seine, the organ tower by Strnad was the landmark of the pavilion; the parts of the building designed by Hoffmann

183

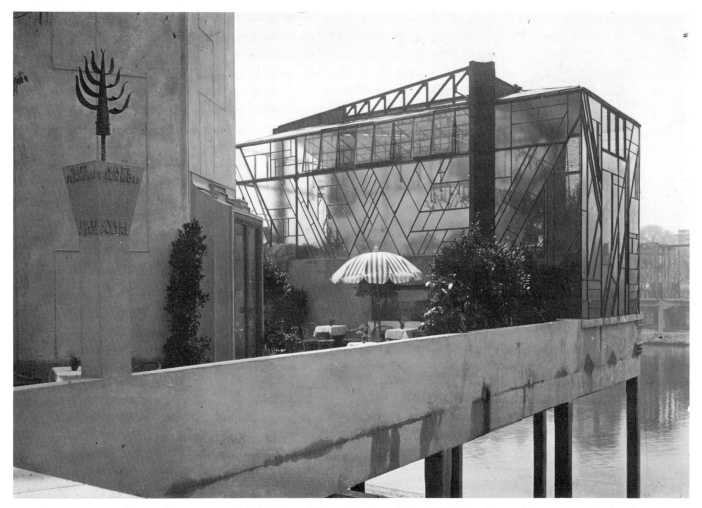

245. The Austrian Pavilion at the International Exhibition of Decorative Arts, Paris, 1925, view from café-terrace to the glass house by Peter Behrens

himself were less visible since they remained close to the ground, fitted between the taller trees, thereby enhancing a feeling of informality.

In the interior too a monumental note was sounded only in the entrance hall, where Hanak's sculpture *Der brennende Mensch* (*The Burning Man*) appeared as a symbol of the artistic creator, and in the "cult room" (fig. 247) designed by Hanak's class. Otherwise the prevailing mood was set by the wide use of transparency and the colorfulness of a bazaar with galleries entirely dissolved into glazed, painted showcases and mirror surfaces (fig. 248). Hoffmann obviously had arrived at the conclusion that in view of the overwhelming wealth of exhibition material the only possible solution was to achieve strong overall effects instead of pinpointing a few selected pieces in front of a quiet background.

What held the pavilion together visually was the uniform treatment of the facades with the multiple flourish of their moldings (fig. 244)—a treatment which Hoffmann adopted, as study sheets show, only in the process of working out the design; on one sheet, on which the overall disposition of the pavilion does not yet correspond to the final form, facades in the manner of the Ast Summer House were envisaged; on another sheet, which indicates a volumetric disposition close to what was finally executed, only some irregularly scattered stucco decorations and richly ornamented cornices were provided, but the facade surfaces remained plain.

The composite curve of the horizontal moldings that were finally selected is the same as that found on the pieces of furniture Hoffmann displayed in the *Galérie des Invalides*; this caused a French critic to point out Hoffmann's predilection for the employment of certain leitmotifs (fig. 246) with the aid of which one could even date his work from year to year.[25] In the following years comparable moldings were used by others in many places

for buildings and pieces of furniture, and an exhibition pavilion visibly inspired by the Parisian one was illustrated as late as 1935 in the periodical *Profil* (vol. III).

Rochowanski[26] compared the pavilion to a "box with many drawers and shelves into which one can put . . . rustling silks and seductive jewelry," but Hoffmann would have hardly thought in such analogies. At that time the use of horizontal moldings, which after all had already appeared at the Berl House, was simply his favorite means of enriching the surface effects of facades plastically. Additional evidence for this is found in his decoratively rich facade projects of 1924 for remodeling the building of the Central Boden Credit Bank in Vienna (Cat. 258). What mattered to him here was achieving the liveliest possible play of light and shadow and a strong contrast to the smoothness and transparency of the glazed portions.

Photographs, particularly in black and white, cannot convey an adequate impression of the Paris pavilion, since a major portion of its effect was based on three-dimensional consonances that also importantly involved color. Consequently a well-founded aesthetic value judgment about the pavilion is no longer possible, and one must be content to compare it with the photographs of other pavilions, in which case it fares very well.

There are also interesting evaluations by eyewitnesses, though their opinions must have been strongly colored by their respective polemical standpoints on the exhibition. Gabriel Guevrekian, more than a quarter-century later,[27] remembered very clearly that the pavilion "had great success and was extraordinarily well received by the artists, the public, and the press"; in his words, the building possessed "a wonderful and refined space conception, and was one of the best pavilions." The secretary general of the admissions committee of the exhibition commented: "The impression is very agreeable. . . . Hoffmann here has created a place of welcome and of rest with amiable lines, at once familiar and aristocratic"; and even the French prime minister, Painlevé, highly praised Hoffmann.[28]

The French summary report on the exhibition[29] found very flattering words for Hoffmann who as the most brilliant pupil of Otto Wagner and a man of European reputation had shown once more "that he was not a man of one formula and that in him practical reason accords with the fantasy characteristic of Austrian art. . . . the undulating surfaces . . . adorn ephemeral galleries with a singular gracefulness." In view of this official approbation, it becomes understandable why Hoffmann was awarded the cross of a commander of the *Legion d'hon-*

246. Design drawing for a metal coffeepot; profiles akin to those of the Austrian Pavilion

neur in recognition of his merits on the occasion of this exhibition.

The art and architectural critics of the major periodicals also were positively impressed. J. Porcher (in *L'Architecte*) was of the opinion that altogether only the pavilions of Poland, Sweden, Holland, and Austria deserved a more detailed discussion; his selection implied a conservative viewpoint, and this is further corroborated by his rejection of the Russian pavilion. For him only the Dutch and the Austrian pavilions were truly original creations, and he thought[30] he could recognize in Hoffmann's building "the discreet, slightly precious elegance of the 'Leopoldinischer Trakt' [of the Vienna imperial castle]." He criticized the interior design as "perhaps treated a little too much from the standpoint of an effeminate decorative artist." J. Mourey, a critic familiar with Hoffmann's works for many years, apparently was not quite convinced by the architecture of Hoffmann's pavilion when he wrote,[31] "One can like this or not; one cannot deny that it has something undeniably seductive, perhaps a little dangerous, perhaps a little perverse, but where the composite Austrian taste is well expressed." His colleague T. Harlor[32] by contrast was unconditionally

247. The Austrian Pavilion at the International Exhibition of Decorative Arts, Paris, 1925, corridor with view toward the "cult room" of the Hanak school

enthusiastic about the interior displays: "Austria, this old country, displays the avant-garde sensibility of a young nation. The presentation of the innumerable objects that have been brought together in the pavilion with the severe exterior bordering the Seine, is one of the most original, one of the gayest, despite the selected design scheme of black and white frames around the showcases in the great hall."

In order to round out the picture of the French reception of the Austrian contribution at Paris one finally must mention the fact that despite criticism both the pavilion and details from the other Austrian rooms were illustrated more frequently in the reviews than any other non-French contribution to the exhibition. All in all one is left with the impression that Hoffmann's prestige in France was very great at that time. Even Le Corbusier, who in his book *L'Art décoratif d'aujourd'hui* had just pointed out that in the age of mechanization the arts and crafts attitude was nothing but an anachronism, arrived at the following diplomatic, friendly formulation vis-à-

vis Hoffmann and the Austrian Pavilion: "If one does it as well as you, one can do anything," while Hoffmann stated that he himself had made something similar to Le Corbusier's *Pavillon de l'Esprit Nouveau*, twenty-five years earlier.[33]

Aside from pertinent suggestions[34] by Giulia Veronesi and Yvonne Brunhammer, it has been too little noticed what an immense influence on the French decorative arts movement was exerted by Hoffmann, his school, and the Wiener Werkstätte; an influence that should be seen together with that of the Werkbund exhibition in the Salon d'Automne of 1910, since some of the works shown there were indebted to the Viennese model. In a 1912 report on the Arts and Crafts movement in Germany, Charles-Edouard Jeanneret expressly emphasized the exemplary achievement of Hoffmann and the Wiener Werkstätte, a fact noted with satisfaction in 1916 in the pages of the periodical *Innendekoration*. Finally in 1925 Henry van de Velde[35] succinctly stated: "In the year 1914 European taste took its directives from Munich and Vienna" and "before 1914 triumphed in Paris—Vienna and Munich."

If one thumbs through the extensive publications about the Paris decorative arts exhibition of 1925 one finds again and again details of architecture and interior design as well as objects and decorative patterns for which Hoffmann's work provided models. Consequently it is not surprising that an American observer[36] posing the question how "has [France] developed a special style almost overnight?" and "where has it found the prototype for it?" answered that it was "in the decorative arts of Germany and Austria." One begins to understand why Hoffmann was referred to as "the most famous architect of Central Europe" by a high functionary of the exhibition administration[37] and why the periodicals *L'Amour de l'Art* and *Art et Décoration* in the years 1923 and 1924 devoted long, richly illustrated reports to his activity.

But the influence of those Austrian achievements of Hoffmann and the Wiener Werkstätte that reached their climax in 1925 at the Paris exhibition was even more far-reaching: the adoption by R. Candella and C. P. Jennewein of the Paris pavilion molding for an apartment building, dated 1937, at 19 East 72nd Street, New York (fig. 249) is but one especially striking example of the continued effect of Hoffmann's design ideas in the United States. In the American version of Art Deco architecture, characteristics abound that in the last analysis can be traced to Hoffmann. A building of 1927 by Bruce Goff, of interest in this connection, has already been men-

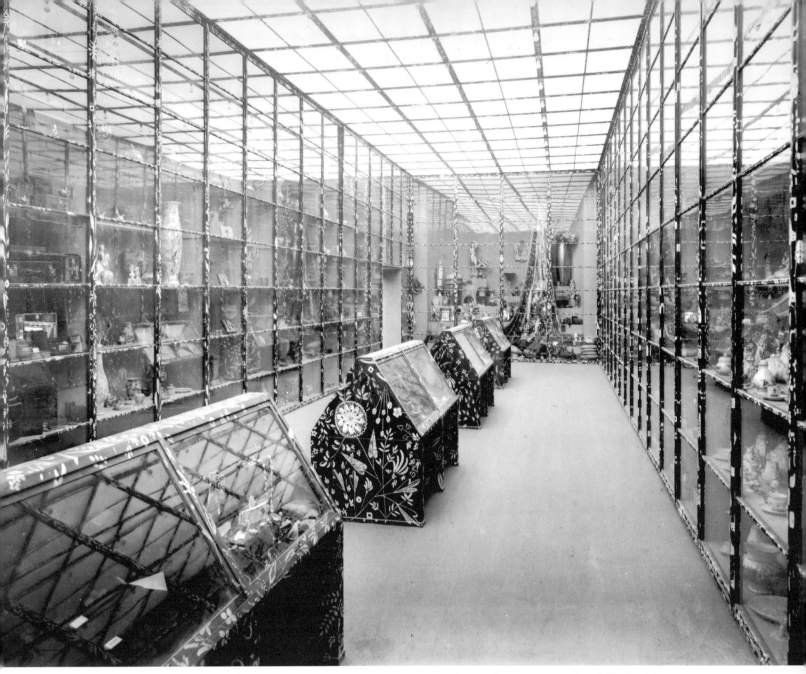

248. Austrian Pavilion at the International Exhibition of Decorative Arts, Paris, 1925, large gallery room; woodwork black with white decorative painting, fabric covering inside the showcases yellow

249. Detail of an apartment house entrance in New York by C. P. Jennewein, sculptor, and R. Candella, architect. The moldings recall the Austrian Pavilion in Paris, 1925.

250. Ely Jacques Kahn, vestibule in the apartment of Mrs. Rose in New York, with fluted walls

tioned (see Chapter V). Ely Jacques Kahn, one of the creators and masters of this stylistic direction, utilized numerous Hoffmannesque motifs, including the vertical fluting of wall surfaces (fig. 250). For a while Kahn also employed the young Austrian Ernst Plischke,[38] and a direct connection to the circle of Hoffmann was established through Kahn's sister, Rena Rosenthal. She had a decorative arts studio called The Austrian Workshop and an arts and crafts import business that necessitated frequent contact with European artists.[39] Her husband, Rudolf Rosenthal, together with Fritz Wärndorfer, for a while even entertained the idea of bringing Josef Hoffmann to New York as the director of an "American arts and crafts academy" that was to be founded.[40]

Stimuli from Hoffmann, however, reached America not only directly from Vienna but also indirectly, as for example through the designs by Mallet-Stevens. Numerous ideal projects of this architect found their way into Sheldon Cheney's 1930 book *The New World Architecture* in which, accordingly, one can detect many echoes of Hoffmann—multiple repetition and staggering, telescoping superimpositions, windows cut into the upper edge of a facade, even, in one sketch, a statue of Pallas Athene (fig. 251) that resembles the sculpture that crowned the entrance pavilion of the Stoclet House. By the end of the 1920s, then, Hoffmann was no longer an unknown figure in the United States but, like Otto Wagner before him, an admired personality. In 1927 he was appointed honorary corresponding member of the American Institute of Architects, and in 1928[41] he was referred to as "the most venerable, stimulating, and fertile figure of the Austrian architects."

Almost a quarter-century had passed since Hoffmann's first work in the United States—the room at the St. Louis exhibition of 1904 (Cat. 86)—and in the mean-

251. Robert Mallet-Stevens, imaginary design of a modern cityscape, 1922 (cf. fig. 211)

188

time points of contact had always existed. Before the First World War, Hoffmann's student Eduard H. Ascherman, who came from Milwaukee, had set up a successful studio in New York[42] and had produced works entirely in the style of the early school of Hoffmann. At the same time the architect Eugene Schoen brought back lasting impressions of Hoffmann's work from a tour of study in Vienna[43] and effectively transposed them into designs of his own in New York. Paul T. Frankl, a graduate of the Vienna Technical University who, having been surprised by the outbreak of the war during a journey to Japan, began to practice in America, equally showed in his work that he was familiar with the Hoffmannesque milieu; it was from him, incidentally, that Frank Lloyd Wright received a small painting by Gustav Klimt[44] as a gift.

The Wiener Werkstätte itself, however, had less independent success in the United States than Hoffmann did. In 1909 Fritz Wärndorfer mentioned in a letter[45] that two American women, "the wives of directors of museums," visiting the Wiener Werkstätte had explained to Hoffmann how it was known in the United States that he made "the style for the whole world." In 1912, photographs of the Stoclet House and Viennese interiors by Hoffmann were shown first in Newark, New Jersey, and later in six other cities as part of an exhibition organized by the German Museum under Osthaus. Following the warm reception of Hoffmann's work, the Wiener Werkstätte tried to establish itself in the United States in 1913. The attempt was as unsuccessful as all later comparable initiatives, including the last one in 1928 by Dr. Kuno Grohmann. By contrast, Marianne Willisch succeeded in establishing a salesroom of the Austrian Werkbund in Chicago.[46]

After the First World War, Hoffmann renewed his contacts in the United States with Joseph Urban, who like himself had been a pupil of Hasenauer's. Urban not only assisted Wolfgang Hoffmann but also in the early 1920s opened the Wiener Werkstätte of America in New York.[47] In its display rooms on Fifth Avenue one could see, besides furniture, pictures by Klimt and Schiele as well as arts and crafts objects of all kinds—including several sets of silverware and metal vases by Josef Hoffmann. Hoffmann's closest collaborators, Häusler and Wimmer,[48] traveled to the United States at that time in order to visit Urban. Walter Creese has pointed out[49] that Raymond Hood might have been inspired by Urban to employ the color combination of black with gold at the American Radiator Building (1923-1924); but this juxtaposition of colors, so typical of one phase of American Art Deco, might also owe something to a direct knowledge of the music room in the Stoclet House, since Hood had visited Brussels.

When Hoffmann's Boudoir (Cat. 247) was shown at Macy's in the International Exposition of Art in Industry in 1928, the same exhibition featured the rooms by the above-mentioned Eugene Schoen and by Kem Weber, who came from Germany as a pupil of Bruno Paul. At that time native German speakers were so strongly represented among designers in New York that the meetings of the first professional organization for the decorative arts, AUDAC, occasionally were held in German.[50] In view of this fact, it is not particularly surprising that Hoffmann's works were known and that contact with him continued throughout the 1930s.[51]

The success of Hoffmann's Austrian Pavilion in Paris had been signal but shortlived. The course of its career was exactly the opposite of what happened with the pavilion Mies van der Rohe designed for the Barcelona exhibition in 1929,[52] which was hardly noticed by the critics at first but finally achieved international fame as a key work of the epoch. Hoffmann's pavilion received predominantly positive evaluations immediately after its completion and was frequently published; G. Platz even included it as one of the important buildings of the twentieth century in the *Propyläen Kunstgeschichte*. But soon afterward it was either entirely forgotten or negatively assessed.[53] One can conclude from this that while it was a good expression of the taste of its time, it came at the end of that phase, whereas the pavilion by Mies stood at the inception of a new phase. That the taste for decoration and the arts and crafts as displayed at the Paris exhibition had actually reached the end of its dominance was apparent from the fact that some critics not only judged the Austrian Pavilion negatively or passed over it in silence[54] but even disparaged the exhibition of decorative arts as a whole. Le Corbusier's criticism has already been mentioned, but he was not the only one: partly inspired by him, Guillaume Janneau[55] and Waldemar George[56] also turned against the exhibition. George asserted that it would have been better to build a whole new city quarter and give consideration to technology that had a fundamental impact on the face of the cities and the way of life in them. "The art called decorative," in his opinion, "is nothing but an arbitrary search for something new. . . . modern decorative art . . . is antisocial, antidemocratic. . . . false luxury is the dominating note of the whole exhibition. . . . from a social point of view the exhibition of 1925 is a total failure. . . . with the theater of Perret, the two pavilions by

Robert Mallet-Stevens, and the Pavilion of the USSR, the villa [sic] of the 'l'Esprit Nouveau' is the only building in the whole exhibition that can be termed modern." Janneau in turn spoke of the urgent necessity not to "replace one outdated decorative system by another system . . . but rather to revise the fundamental programs." It is therefore understandable that Hoffmann's own young collaborator Haerdtl was not happy about the Paris exhibition[57] and wrote to Vienna about "the exhibition in Paris . . . which makes a depressing impression. Austria can be easily first among this trash—though I like Russia better, because it's much more powerful and original."

Haerdtl himself arranged the room of Austrian architecture in the *Grand Palais* entirely in the spirit of the Neoplasticism of the De Stijl movement, a mode he had already tried out a year earlier in an architectural exhibition of the School of Arts and Crafts in the Austrian Museum of Vienna. Similarly, for the room devoted to Austrian theater in Paris the painter Friedrich Kiesler repeated an arrangement closely related to Neoplasticism and perhaps also to Constructivism that he had first shown in Vienna. There in 1924 an international exhibition of new theater techniques (Internationale Ausstellung neuer Theatertechnik) designed by him was displayed at the Concert House; its exhibits and catalogue, also designed by Kiesler in the typographically aggressive manner of De Stijl and El Lissitzky, presented a truly representative cross-section of European avantgarde art.[58] If one considers that in the same year the German Werkbund showed its exhibition *Die Form ohne Ornament*, one becomes aware of the gulf that separated Hoffmann's rooms for the Jubilee Exhibition for the Association for Arts and Crafts (see above) from the most future-oriented movements of the architectural avantgarde.

Already in 1923, the year of the great Bauhaus exhibition in Weimar and of the appearance of Le Corbusier's *Vers une architecture*, it must have been clear to every sensitive observer that the architectural scene had started to change dramatically. Hoffmann would have been the last not to react immediately to an artistic movement in which he thought he recognized something genuinely novel. However, he was always interested primarily in matters of form, not of doctrine, and accordingly he did not, for example, find it at all incompatible to superimpose a small addition with a hipped roof on top of the flat-roofed cubic volume of the Ast Summer House.

Haerdtl and Kiesler had presented in their exhibition rooms a conception of architecture as the dynamic articulation of space by freestanding or hovering, largely dematerialized, plain colored surfaces; it was implied that these plain surfaces remained smooth and completely devoid of any molding. This was the conception of the Barcelona Pavilion, not that of the Austrian Pavilion in Paris. Although Hoffmann approached it, he never made it entirely his own. Certainly this had much to do with the special, increasingly polemical, position into which he was forced as the protagonist of the Arts and Crafts movement. As such he could not possibly approve of an architecture that dogmatically negated any ornament, recognized only undecorated surfaces, and considered the handicrafts outdated. Since, however, at the same time he kept his positive attitude toward youth and the new and was ready to promote, if not to join, the most recent movement of the avant-garde, he was confronted with a basically insoluble problem. It was due to his extraordinary artistic alertness, openness, and versatility, as well as to the genuine collaboration with Oswald Haerdtl, that in the end, after 1925, he mastered this extremely difficult situation by finding a way to come to terms with the Modern Movement without surrendering his artistic integrity.

That Hoffmann at this time was suffering from incredibly depressing material circumstances and poor health can be gathered from letters he wrote to his emigré son. He complained in October 1926:[59] "In my studio there is no more work at all. The building technician has died and there is nobody left except Miss Ehrlich who still has a little work with the old things. I really don't know how it can go on." A year later he reported again[60] that there was nothing positive to mention, though in the Wiener Werkstätte the worst had been averted once more. "In the W. W. we have lived through terrible times," he wrote, continuing: "We were about to disappear. Now Kuno Grohmann has placed himself on our side as the helper. I have suffered enormously under the various transactions, with my nerves too that still have not improved. No significant commission has yet arrived, nor is it in sight. I would like best of all to pack up and depart."

Hoffmann's depression may have been partly the result of the critical campaign against him and the Wiener Werkstätte that, following the Paris exhibition, was organized in Vienna[61] by a small group of embittered adversaries, among them Leopold Bauer. It found its climax in a public lecture delivered on 20 April 1927, by Adolf Loos, whose purpose it was to "finish the dying Wiener Werkstätte with the claw-stroke of his speech," as a newspaper[62] reported. He maintained that with the Paris

exhibition "one had destroyed forever the good traditional reputation of the city of Vienna" and he apostrophied the "feministic eclecticist rubbish arts and crafts of the Wiener Werkstätte." Even his admirer Max Ermers was taken aback by such "bitterness of polemics," and there was an epilogue in court in the shape of a libel suit. In the fall of the same year, Hoffmann for health reasons even had to transfer the direction of his office to Oswald Haerdtl temporarily, and the energy of the younger man must have been of great assistance in the attempts to obtain commissions. At any rate the entries in the plan book of the office show that after 1928 more work came in.

The immediate effects of the response of Hoffmann and his circle to the most recent tendencies in architecture and art can be seen in two smaller jobs that were among the few tasks carried out in 1927. They were an interior for the director general Ernst Bauer (Cat. 278) (fig. 252) and the design of two rooms at the Kunstschau 1927 exhibition (Cat. 277) (fig. 253).

The interior design for Ernst Bauer dealt with the decoration of a few multipurpose rooms with folding beds. The formal language of the few pieces of furniture was simple, and instead of a more expensive wall treatment decorative painting was employed. In the parents' room the painting was done by Maria Strauss-Likarz, who worked with predominantly transparent, geometrical abstractions on wall surfaces left otherwise bare. This produced a powerful contrast between the wall surfaces and the strong accents of color and form provided by the fabrics and such furniture as an upholstered seat near the fireplace and a combination standing lamp and table. Such juxtapositions between empty surfaces and decorative pieces had characterized Hoffmann's manner of composition ever since the Berl House, although his preference for large empty surfaces was not new and can be traced back to the period of the Secession.

With the exception of the rooms for painting and graphics, the whole Kunstschau 1927 exhibition can be said to have been still largely under the sway of Hoffmann and his collaborators, pupils, and colleagues from the School of Arts and Crafts. This is as true of the overall arrangement of the exhibition by Oswald Haerdtl as of the pictures in the catalogue which were the responsibility of Mathilde Flögl. Both these and the typography of the catalogue pages, with its consistent use of lower-case and broad horizontal bars as subdivisions show clearly that Hoffmann and his circle had completely adopted the avant-garde tendencies, already represented by Kiesler in 1924, of artists such as El Lissitzky, Moholy

252. Apartment for Director General Ernst Bauer, detail of children's room in pink eggshell finish

Nagy, and Theo van Doesburg. Hans Tietze, the keen-sighted observer of the Viennese art scene, having read the catalogue of the Kunstschau 1927[63] commented: "It is strange how in Vienna all cultural efforts immediately take a turn toward retrospection. . . . the retrospective way of thinking . . . does not, however, quite fit the spirit of the exhibition in which for the attentive observer two contradictory endeavors run together.

"The dominating genius of the Kunstschau group is the faith in the prerogatives of the creative forces. . . . In this devotion to art . . . lay the strength and the weakness of the movement. The striving for perpetual increase of quality, for a never-ending refinement of taste, for a cult of the exquisite and unusual; at the same time the propensity toward the playful, the predilection for that which is sophisticated, exotic, remote from life, the fateful anchorage to the superfluous in the domain of arts and crafts. The style of the Kunstschau was the finest blossom of an endeavor directed toward the highest

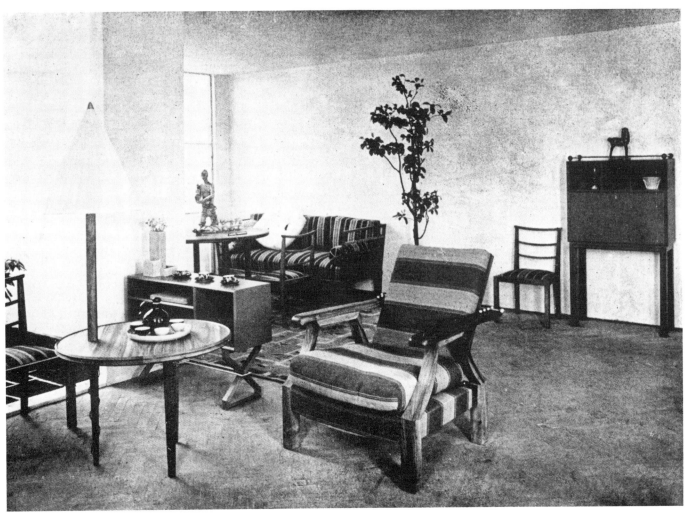

253. Kunstschau 1927, living room with informally arranged furniture

luxury; its realization was tied to the existence of, one might say, unrestricted means, otherwise an ersatz style came into being in which the high-minded artistic intention could be debased into its own caricature. . . . The social shifting has deprived this kind of art of its soil.

''. . . Under this iridescent surface that mirrors what was yesterday, a new spirit has grown up that claims the leadership; its roots, too, reach far back to the beginnings of the Kunstschau. . . . the sense for the terse, sober, workmanlike has always played a role in it—, but only now the misery of the time has secured its predominance. . . .

"Small apartments, workrooms, simple furniture—these are the topics it has set for itself. . . .

"As an elegant has-been the Kunstschau seeks to apply to the necessity of today what was learned from the excess of yesterday. . . . The Kunstschau 1927 stands at a divide. Its dichotomy attests to its will to rejuvenation: its old and its new striving despite the seeming opposition are one: the devotion to artistic achievement now should ennoble the creation of an effect in breadth.''

In the design of his two rooms, Hoffmann avoided anything that could have recalled the past: there was neither decorative stucco nor articulating wooden molding, not even decorative painting on the walls. Moreover, the pieces of furniture were no longer treated as a "set" with clearly recognizable stylistically correlated motifs, but freely grouped and designed in such a manner that their effect primarily depended on their form and the attractiveness of the materials employed.

Hoffmann resorted to a similarly restrained manner of design for the Austrian rooms in the arts and crafts exhibition at the Grassi-Museum in Leipzig (Cat. 274). There, as in the Vienna Kunstschau, colorful decorative

richness was only found next to or inside the showcases of the Wiener Werkstätte, except for a painted stucco cornice.

After the financial ruin and death of Otto Primavesi, the Werkstätte had once more encountered the greatest difficulties, and was forced to apply for a settlement and finally almost faced liquidation. After its temporary rehabilitation by Dr. Kuno Grohmann, however, it was able in 1928 to celebrate its twenty-fifth anniversary in grand style and to issue a jubilee volume for the occasion. Mathilde Flögl collaborated with Vally Wieselthier and Gudrun Baudisch to create a very idiosyncratic design for the book *Die Wiener Werkstätte 1903-1928, Modernes Kunstgewerbe und sein Weg*, which was published in 1929 by Krystall Verlag in Vienna. The two most significant literary contributions are appreciations of Hoffmann by Peter Behrens and Le Corbusier (Appendices 12, 13).

By comparison with the earlier Kunstschau exhibitions between 1908 and 1920, the lack of sculptural work and of dominating personalities in painting in the 1927 exhibition must have been striking: even in the Kunstschau exhibition of 1920, Klimt and Schiele were still represented retrospectively; in 1927—even though Kokoschka and Hanak were then active—there was nothing of comparable quality on display. Hanak perhaps was not exhibited for organizational reasons because he had a large personal exhibition in the same museum that year, but he might also have declined participation because he was of the opinion that art and decorative arts should not be exhibited together.[64] As far as Austrian painting was concerned, the situation had changed since the time of Klimt and Kokoschka: there certainly was no lack of good painters, but one could no longer speak of a genuine connection to the European avant-garde or of a claim for leadership. From Austrian painting, therefore, architecture and the arts and crafts could no longer expect direction-giving stimuli. These had to come from outside instead, from the architectural manipulation of the achievements in the fine arts found in Cubism, Neoplasticism, Constructivism, and Suprematism. That this actually happened was revealed in the models by Hoffmann's class exhibited in the architecture room of the Kunstschau 1927. They show a complete breakthrough of the new movement seen again one year later in the architectural models exhibited on the occasion of the sixtieth anniversary of the School of Arts and Crafts. It is the privilege and advantage of youth to be closer to the future, and it was Hoffmann's advantage to remain close to youth. His works from the following years demonstrate that his own creative activity was rejuvenated by this contact.

VIII. Coming to Terms with the Modern Movement and New Architectural Solutions in Housing

The year 1927 brought Hoffmann the opportunity to take a public position regarding the new developments in architecture, for he was appointed to the International Jury of the great competition for a Palace of the League of Nations in Geneva—further evidence of his very considerable world-wide prestige at the time. In the following years too, this led to frequent invitations as a juror. For the League of Nations building, he, along with Berlage, Tengbom, and Karl Moser, voted for the project of Le Corbusier. That Victor Horta voted against it should have come as no surprise to anyone who had seen his pavilion at the Paris exhibition of decorative arts. Both Berlage and Tengbom subsequently wrote to Hoffmann to express their indignation about the outcome—unfavorable for Le Corbusier—of the Geneva competition,[1] and Hoffmann also defended Le Corbusier's project. In a statement, quoted by Sophie Daria,[2] he wrote: "Le Corbusier, in the so serious manner he is known for, has admirably recognized the fundamental conditions of the program and has found for them the most poignant expression. . . . he offers a perfect, clear, and simple solution that represents a great step forward." In addition he wrote in a report for the *Deutsche Bauzeitung*: "Refreshingly novel with charming simplicity was the effect, at least on us . . . of the work of . . . the architect Le Corbusier. . . . the architects of the École des Beaux Arts, in all likelihood intentionally, have bypassed all movements of the past decades." But he stressed that "the working of the jury, despite the contrasting opinions, proceeded in an absolutely impeccable manner," and that it was untrue that "the Le Corbusier project . . . was not awarded first prize because it was not inked in india ink."[3]

Hoffmann also proved his esteem for the architect by taking Viennese students, in Paris for the exhibition of decorative arts, to visit a house by Le Corbusier which was just being completed.[4] In 1926, through Hoffmann's colleague at the School of Arts and Crafts, Eugen Steinhof, a special Le Corbusier exhibition came to Vienna as part of a French art exhibition. In 1927 Hoffmann visited the Le Corbusier buildings at the Stuttgart Weißenhof Estate following the opening at the Grassi Museum in Leipzig of the exhibition "European Arts and Crafts" (Cat.

274).[5] In Stuttgart at that same time the international exhibition of plans and models of the German Werkbund was offering a very extensive cross-section of Modern Movement works.

Hoffmann was always ready to travel in order to gain personal impressions of the most recent developments in the areas that concerned him, and he even undertook a long journey to Sweden to visit the 1930 exhibition in Stockholm that sealed the victory of the Modern Movement[6] in Scandinavia. As was to be expected in view of his personal acquaintance with Gropius, he also visited the Bauhaus and became a board member of the Friends of the Bauhaus.[7] At the founding session of the Congrès internationaux d'architecture moderne (CIAM) in La Sarraz in 1928, Hoffmann was proposed for membership on an honorary committee that was to consist of "Pioneers of the Modern Movement," but both his name and that of Frank Lloyd Wright were struck from the list—before, finally, the whole idea was dropped.[8]

If in 1923 it could be said that the architectural scene around Hoffmann had begun to shift, in 1927 it was clear that fundamental changes had taken place in it. This could be seen from books like *Der moderne Zweckbau* (1927) by Adolf Behne and the second edition of the Bauhaus book *Die internationale Architektur* (1927) by Walter Gropius, as well as from the various architectural periodicals and exhibitions. The founding of CIAM in 1928 had only confirmed the historical situation, not created it, and it was a situation one could no longer disregard anywhere in Europe.

Hoffmann's reaction to the new conditions can be well observed in his ideal project for a "Welttonhalle" (world concert hall) in Vienna (Cat. 279) (fig. 254). For this project he envisaged a "place for the most grandiose cultivation of music that should attract all the musical potentates of the whole world and stimulate them to create new works";[9] accordingly he designed a complex of gigantic dimensions, to be situated in the Augarten. The disposition of the plan and the proportions are unequivocally neoclassical, but the treatment of the facades and interiors is limited to plain wall and glass surfaces free of any cornices or ornaments. In the vestibule (Cat. 279/II) the glazing from the front wall is carried across

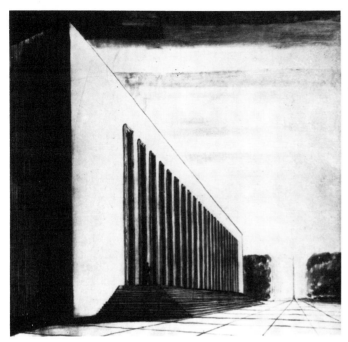

254. Project for a world concert hall, perspective of entrance facade

the ceiling and the rear wall in the same width, thus providing a regular alternation between glazed and unglazed surfaces as the sole articulation of walls and ceiling. The fact that the glass surfaces butt at the edges of the room probably should be understood as a gesture toward modernity, while the treatment of the ends of the vestibule might be taken as an equally demonstrative gesture of appeal to his own past. In the first case one is reminded of the glazed corners of the Fagus Works and its many successors in architecture, in the second case of Hoffmann's most famous leitmotif, the square, for precisely this form has been given to the large, plain

wall surface above the glazing on ground level. In neither case can it be stated with certainty that Hoffmann proceeded consciously with these intentions in mind, but the temptation is strong to understand this unusual room as a message. Its meaning would have been that in the framework of his own design tradition the architect was capable of being just as modern as anyone among the most radical exponents of the Modern Movement. What is lacking completely in the Welttonhalle project is any visible sign that Hoffmann had come to terms with construction and tectonics, factors that were of great importance to others in the Modern Movement, as can be seen in a comparison between Hoffmann's vestibule and that of Le Corbusier's League of Nations project. An equal contrast to the formal ideals of the Modern Movement is found in the pronounced cryptoclassicism of the main front, a feature this facade incidentally shares with the design by Oskar Strnad for a Sanatorium with large hall at Bad Schallerbach (1925).[10]

Another major project, more realistic and more interesting urbanistically than the concert hall, was worked out by Hoffmann in connection with an architectural exhibition and a world congress of painters and sculptors planned for Vienna. In the spring of 1928, the same exhibition that had been shown in Stuttgart in conjunction with the Werkbund Estate traveled to Vienna where it was put on display in the Neue Hofburg along with a selection of Austrian examples. Hoffmann's contribution was a grandly conceived exhibition building (Cat. 287) and adjoining hotel, planned for the Karlsplatz in Vienna. In its constructional and formal treatment it declared itself as belonging entirely to the new movement (fig. 255). It was so convincing that Bruno Taut included the design in his collection of examples *Die neue Baukunst in Europa und Amerika.* However, a study of the facade

255. Project for an art and exhibition hall in Vienna, Karlsplatz, drawing of the facade on the Wiedner Hauptstraße (cf. figs. 256, 257)

256, 257. Project for art and exhibition hall in Vienna, Karlsplatz, design sketches of two versions of a facade

design variations (figs. 256, 257) Hoffmann drew at the time reveals that he originally wanted to emphasize the main lines of the skeletal construction with ornamentation, and in one case he intended a stone facade with quoins for the upper story. Obviously he had not completely converted to the principles of the Modern Movement and to a complete renunciation of ornament; instead he regarded the new language as an additional possibility without any claim to absolute exclusivity. Probably it was due to tactical reasons as well as to the influence of Haerdtl, that in the end Hoffmann's project was a completely undecorated version.

The urban design solution testifies to a sensitive and skillful consideration of complicated conditions. Hoffmann was familiar with these conditions because earlier, in 1901, he had been a juror of the Preliminary Competition for the Construction of the Emperor Francis Josef City Museum, and later he took a lively interest in the discussions surrounding Otto Wagner's project for this

building. His memorial oration delivered on the occasion of the tenth anniversary of Wagner's death proved that he had not forgotten his old teacher;[11] but when it came to his own project for the Karlsplatz, his respect did not prevent him from envisaging the removal of the Metropolitan Railroad station buildings which Wagner had designed.

One year later he began the project of a monument to Otto Wagner (Cat. 323), which was finally carried out in 1933 in the shape of a simple stone pier with a band of lettering. Neither the final solution for this monument, so attractive in its simplicity, nor the extremely "objective" final version of the project for the Karlsplatz gave any inkling of the considerable number of much more decoratively treated variations that had preceded them. The designs for the Wagner Monument and those dating from 1928 for a synagogue in Sillein (Cat. 285) (figs. 258-261) make it possible to observe particularly well Hoffmann's method, his search for form, because in both cases not only the final project but also many, perhaps even all, preliminary studies have been preserved.

When working out the design for the synagogue (figs. 258, 259), Hoffmann concentrated primarily on the formal problem of finding the appropriate shape for the main building. In most sketches the auxiliary buildings are not even shown—their solution was patently considered a matter of routine. In keeping with the traditional nineteenth-century image of how a synagogue should appear, the conditions of the competition had stipulated a cupola for the main building. Accordingly, Hoffmann experimented with both the low, segmental dome typical of antiquity and early French neoclassicism, but with a slightly pointed profile, and with the dome on a high drum found in late Byzantine architecture, with a pointed or parabolic profile for the vaulted surface. He did not, however, directly borrow individual forms or details in a historicizing, eclectic manner. Here, as on other occasions, Hoffmann demonstrated both his familiarity with a large segment of world architecture and his capacity to utilize formal prototypes in new contexts as fertile points of departure for completely new constellations of forms.

One design sheet for the synagogue suggests a dome on a drum and a gently pointed roof above a glazed clerestory, indicating that here a new idea became effective; in addition, memories of the vernacular architecture of the area for which the synagogue was planned seemed to have come to life. There are indeed Slovakian timber churches with pointed roofs on top of main towers

258. Competition project for a synagogue in Sillein (Zilina), design sketches with versions of main building

259. Competition project for a synagogue in Sillein (Zilina), design sketch for entire complex (cf. Cat. 285)

and with several pointed gables not unlike those found in some versions of Hoffmann's design. In a manner already familiar from Hoffmann's early activity, the motif, once found, was subsequently varied, reinforced in its effect, but also transmuted by repetition and, in one case, by multiple framing. The final solution was derived by radical simplification of the last variation, with a steeply pitched roof atop the central portion of the building; but it was not decided on before Hoffmann had explored yet a third group of solutions. These envisaged covering the main building with a single, multiply corrugated roof. Since the plans of the final project indicate a construction in reinforced concrete, it is possible that Hoffmann also envisaged the corrugated roof as folded plate in the same material. Max Eisler[12] already was struck by the fact that a tentlike impression is of particular symbolic significance for a Jewish house of prayer. Flower- and blossomlike finials crowning the pointed gables, geometrical ornament in stucco on a horizontally striated wall, and an alternation between horizontal and vertical grooves or strips in another case are sufficient proof that besides the preoccupation with an iconography appropriate to the special function of the building, the sheer pleasure in decoration was also at work in Hoffmann's design.

The same can be said *mutatis mutandis* about the Otto Wagner monument (Cat. 323) (figs. 260, 261), only in this case there were no considerations of practical utility, and Hoffmann faced the problems of form and iconography exclusively. He had to do no more and no less than invent a symbolic form for one of the urbanistically most important areas of Vienna, the Heldenplatz. In the manner characteristic of him and comparable to his procedure when designing the synagogue, he investigated various possibilities in his drawings in order to derive new forms from the typological tradition. One finds such monumental archetypes as the pier and the gate of piers, the column, the row of piers with lintels, the arch and the baldachino, but Hoffmann uses them without historicizing details in such a way that they appear familiar and novel at the same time. One design, which also exists in a perspective sketch variation (Cat. 261), belongs to a special group. It provides for a reinforced concrete construction with horizontal cantilevered slabs as the determining elements. The design directly recalls the 1925 Paris tourism pavilion by Mallet-Stevens[13] as well as various Neoplasticist works. On every drawing the scale is indicated by a human figure—usually a woman.

It may have been due partly to economic considera-

198

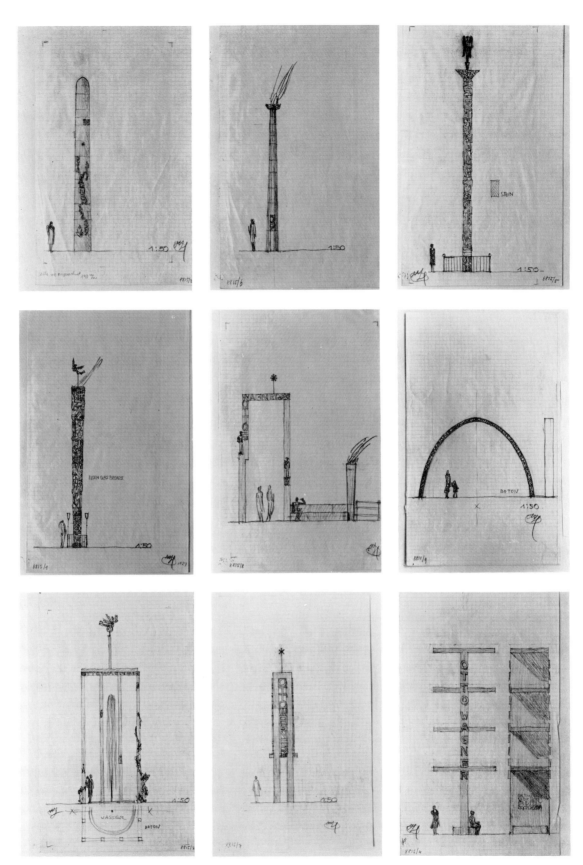

260. Monument for Otto Wagner on the Heldenplatz in Vienna, design sketches (cf. fig. 261 and Cat. 323)

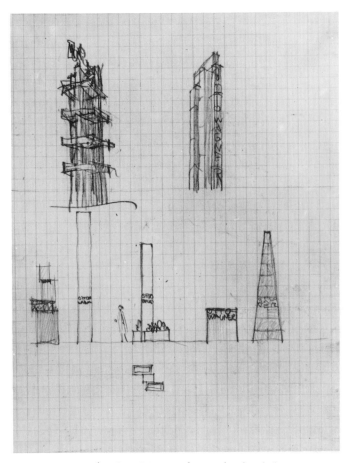

261. Monument for Otto Wagner, design sketch (cf. fig. 260)

tions that the design finally chosen from among all the variations was a very simple and thus timeless form (Cat. 323). Yet apparently a process of self-control was at work that in certain cases caused Hoffmann to prefer the simpler solution although in the joy of invention he had tried out an abundance of richer and more complicated possibilities. After the unveiling one critic[14] praised the Wagner Monument for ". . . all the merits Josef Hoffmann's infallibly accurate proportionality has to bestow." He also exclaimed, "The facility of creation, characteristic of the happiest of all the students of Otto Wagner, pulsatingly animates this aspiring square pier; at a surprisingly convincing place it projects slightly and thus gets a glorious strengthening of its fragility. In the best sense, one can hardly be more quintessentially Viennese."

From the series of designs for the Wagner Monument the idea of a light baldachino on piers was taken up once more in 1936, when a related problem was to be solved—

the design of a monument in honor of Austrian musicians (Cat. 374). In design the creative imagination needs a point of departure, and it is self-evident that a designer will frequently find such a point in his own earlier work. In this manner inner relations are established that in the best cases contribute to the consistency and stylistic coherence of a total architectural oeuvre. Self-quotations are naturally more frequent during the later years of an architect's career than in his early period. For the musicians' monument, Hoffmann began with Carl Moll's suggestion for transforming the Temple of Theseus in the Viennese Volksgarten into a hall of fame with crypt (Cat. 373).[15] Then as with the Wagner Monument and the Sillein Synagogue, he produced a series of designs for possible selection. He investigated baldachinos over polygonal and round plans, as well as various kinds of staircases for the descent into the crypt; the tall baldachinos, gracefully placed in space, here created the greatest possible contrast to the dark, vaulted spaces of the crypts. Yet there is also a version of the design which replaces the baldachino with a massive, sarcophaguslike built volume, thereby establishing a relationship to the tomb as a typological model.

If one summarizes what the examples of Hoffmann's designing just discussed have in common, his procedure might be described as follows. For each design, he did not start out from chaos, or zero, so to speak, but from a point of departure provided by, among other things, his familiarity with both past and present architectural forms and spaces, or by his own earlier works. However, he largely avoided giving traditional forms to details and copying directly from models; he was a typological, not a formal, eclectic. He achieved something new by treating familiar formal types in an unorthodox manner; this might be done by employing them in an unexpected context (e.g., when an ecclesiastical building type appeared as a Russian exhibition pavilion [Cat. 256]), by formal estrangement, drastic changes of proportion (e.g., elongation), drastic simplification (elementarism), or the use of novel decorative motifs and effects. He was inclined to try out numerous solutions and in the end to couple the final selection with a process of rigorous simplification.

In 1930, the year of Hoffmann's sixtieth birthday, a series of welcome successes and recognitions came to him. The monument for Otto Wagner was unveiled, he was given responsibility for the Austrian contribution to the Triennale at Monza—its design he left to Oswald Haerdtl—and his arrangement of the aestival Werkbund Exhibition was followed in the winter by an impressive

200

retrospective of his lifework in an exhibition and a beautifully produced festschrift.

In the Werkbund Exhibition (Cat. 324), occasioned by the nineteenth Congress of the German Werkbund held in Vienna in 1930, Hoffmann proved once again not only his mastery of exhibition design but also his sensitivity, certainly sharpened by the collaboration with Haerdtl, regarding what was appropriate for the event. His design contribution to the exhibition relied entirely on spatial effect and avoided any ornament. It was a grandiose baldachino tented over a central hall—a self-quotation from the twelfth Secession Exhibition (Cat. 56)—and joined to a coffeehouse (figs. 262, 263) with garden terrace. Here too the enrichment of the basic forms was achieved only through the choice of material—richly veined veneer, patterned fabric—and by the incorporation of works of art—ceramic sculptures placed so effectively in circular niches that soon afterward Clemens Holzmeister adopted a comparable arrangement in the President's Palace at Ankara.[16] Arts and crafts objects were displayed only in the corridors next to the main rooms, and so could hardly detract from the exhibition's emphasis on the practical and economical. This followed from the general program for the exhibition that Hoffmann had selected, stipulating that only rooms would be shown, such as sales, display, or restaurant rooms, that fulfilled a genuine function in the life of a large city. As so often, the execution with few exceptions was entrusted to colleagues, collaborators, and former students of the School of Arts and Crafts, which in matters of formal treatment guaranteed that common thread that so impressed the critics.

It had been intended that Adolf Loos would design a bar,[17] but he refused to take part in the exhibition. However, represented by his collaborator Heinrich Kulka, he did participate in the planning of two residences for the housing estate that originally had been envisaged, under the general direction of Josef Frank, as a parallel event to the exhibition. Frank also gave an important address at the Werkbund Congress: "He set off fireworks . . . honed and scintillating vocables, precious blasphemies and strange superstitions to the topic: *what is modern?* He has not answered the question; but the dissonance remained that this time the omitted answer was no answer."[18] Thus wrote Robert Breuer, who was otherwise just as enthusiastic about what was offered in Vienna as Ernst Jäckh,[19] President of the German Werkbund, had been a year earlier on his visit to the jubilee exhibition of the School of Arts and Crafts. He had commented that "Hoffmann's leadership and fecundity made the Vi-

262, 263. Exhibition of the Austrian Werkbund, 1930, view into the café, and design sketch

ennese school paradigmatic for the whole world." Breuer in turn, like other critics, emphasized the particularly Viennese note he thought he detected, the "advantages of the musical and the mathematical sensuousness that we appreciate in our Viennese friends," and he praised the pleasant feeling with which one experienced the "ordering hand, the distancing passion, the cool assurance of Josef Hoffmann."

Like the Congress and Exhibition of 1930, the model estate which finally opened in June 1932 at Lainz, a suburb of Vienna, was impressive evidence of the fact that since 1929, under the presidency of Hermann Neubacher, the Austrian Werkbund had become active again. Hoffmann, initially a member of the Werkbund board, showed four row houses (Cat. 333) (fig. 264) with two different types of layout, and one of the buildings designed by him was among the few that were sold before the exhibition opened. By this time he had accumulated ample experience in the design of housing estates and

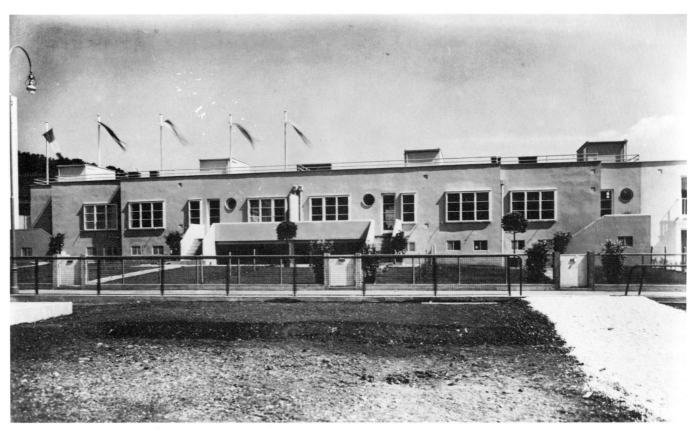

264. Four row houses of the Werkbund Estate, Vienna XIII, Lainz, view shortly after completion

265. Project for row house in the ''Neustraßäcker'' Estate, perspective view of garden side

202

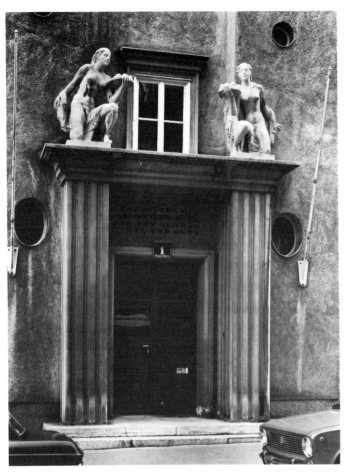

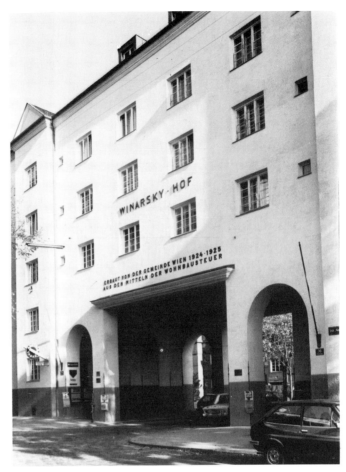

266. "Klosehof" municipal housing, view of entrance with
sculptures by Anton Hanak

267. "Winarskyhof" municipal housing, view of the street side

apartment buildings since he had been busy with com-
missions of this kind since the early 1920s.

In 1922, Hoffmann planned various detached and sem-
idetached residences in a housing scheme for the workers
and employees of the Grohmann firm in Würbenthal
(Cat. 246). In each case, he designed plain, single-story
buildings dominated by a high roof with finished attic.

In dramatic contrast to these houses, a project two
years later for a large housing estate at the Neustraßäcker
near Stadlau outside Vienna (Cat. 257) (fig. 265) was
characterized by flat roofs and thin cantilevered concrete
slabs. This project anticipated much that was realized
only years later in the Werkbund Estate and in the proj-
ect for a Growing House (Cat. 337). In particular, the
cantilevered slabs—which at the Neustraßäcker Estate
sheltered the exits onto roof terraces—had been a pre-
ferred formal element for the avant-garde since Tony
Garnier's project for a Cité industrielle; they were also

found in the Maison Citrohan project by Le Corbusier
exhibited in the Salon d'automne of 1922, and they later
provided a characteristic motif in the housing estate at
Pessac. It is not surprising that similar solutions with
flat roofs and cantilevered slabs were seen in work from
Hoffmann's students at the School of Arts and Crafts
shown in the exhibitions of 1924 and 1926. There, one
could see projects which in boldness surpass anything
actually built in Austria at that time.

A second, later, project with row houses (Cat. 302)
related to those at Neustraßäcker is striking for the way
in which through proportion and a cornicelike horizontal
band Hoffmann subtly reinterpreted the new vocabulary
in the spirit of a classicism he had never quite abandoned.
Similar effects can be found in his treatment of two
housing projects he did for the city of Vienna during the
1920s. In the fall of 1923, a large-scale housing program
was adopted in Vienna, and Hoffmann was soon com-

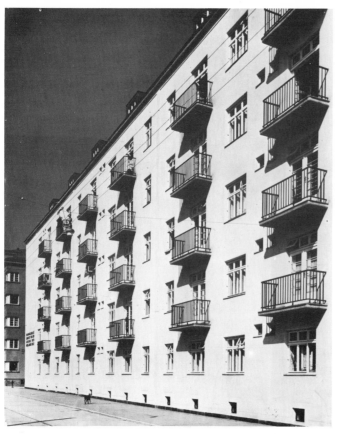

268. Municipal apartment complex Laxenburgerstraße 94, view in the Reichenbachgasse

missioned to plan the Klosehof (Cat. 255) (fig. 266), a low-cost apartment block (Volkswohnhaus) at the Felix-Mottl-Straße. Shortly afterward, work was also begun on his portion of the Winarskyhof housing block at the Stromstraße (Cat. 264) (fig. 267), where as far as formal detail was concerned, he was undoubtedly the most traditional of the planning architects. By contrast, for example, to Josef Frank and Oskar Strnad who collaborated at the same project, he did not provide any balconies or loggias. The Klosehof, otherwise treated in a very similar manner, at least has these elements at the eastern and western street facades, where they make for a more strongly modeled articulation of the surface. At the Klosehof the individual staircase entries are also treated more richly, and the main entrance from the street is even emphasized by a definitely classicist portal composition that finds its climax in two sculptures by Anton Hanak after sketches by Hoffmann (fig. 266).

Hoffmann had learned at the outset of his career to reject showy facades for blocks of rental apartments, feeling that they tried to appear to be more than what they were. Consequently, he emphatically stressed the uni-

formity of the rental units with two street facades that lacked any architectural articulation and had as their only decoration almost imperceptibly small stucco ornaments. However, such a demonstration of architectural sincerity was not received kindly by either the client or a portion of the press.[20] Max Ermers, a critic close to Adolf Loos, and for a time administrator of housing estates in the Municipal Building Department, called the building "one of the ugliest buildings of the postwar period," but added a few weeks later that he "appreciated Josef Hoffmann as one of the most important Austrian architects, despite the building in the Felix-Mottl-Straße."[21] Hoffmann considered replies to some of these criticisms, and some of his pertinent notes[22] illuminate his manner of thinking at the time. He declared: "We are poor and must be satisfied with the built volume as such, with the necessities that follow from the ground plan . . . we begin to feel, what matters in a building is not [whether it is] rich or less rich, but merely the relationship of the masses" and, *ad personam*: "everything you censure is either a new idea or at least something I like. Thus we are not at all attuned to each other. Might this not be the fault of your intensive intercourse with Loos? Loos as practicing artist has the right not to agree with any other manifestations. You as a critic should. . . ." In retrospect it appears almost paradoxical that Hoffmann, of all people, should have been reprimanded for lacking too much in decoration, and this by a critic, of all people, who had close relations to Loos!

As far as the architectural solution was concerned, the reviewers overlooked the fact that the design would have had an entirely different effect if the towerlike portion of the building in the middle of the courtyard (Cat. 255/I) had been carried up to the height intended by Hoffmann. His design contained ideas about residential skyscrapers that in Vienna were realized only a quarter of a century later. But in the last resort, and disregarding personal quarrels, the real reason for the differences of opinion was the differing conception of what architectural iconology was appropriate. For Hoffmann, who after all was still under the influence of Wagner's rationalism, the conscious goal was to have the blocks of low-cost housing read as simple (in Tessenow's sense), though large, houses. For the client, thinking in political terms, such a housing block was something else—something Josef Frank once apostrophized as a "popular dwelling palace" (Volkswohnungspalast).[23]

In his block of flats in the Laxenburgerstraße (Cat. 307) (fig. 268), carried out at the beginning of the 1930s, Hoffmann again remained faithful to his basic principle

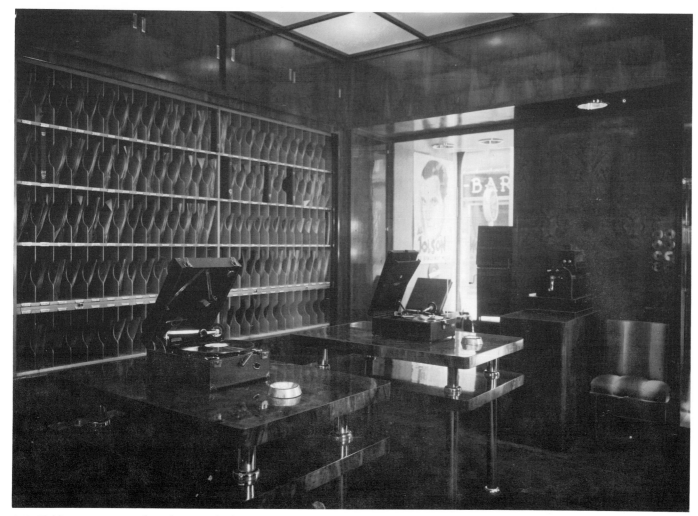

269. Doblinger (Herzmansky) phonograph shop, view into salesroom

of a comparatively unified treatment of the facade. In this case, however, a certain animation is achieved by the numerous balconies, by rhythmically disposed windows of different sizes, and by a slightly stepped arrangement of certain portions of the building. Roughly at the same time, Hoffmann was busy with preliminary plans for some smaller apartment houses for the city of Vienna (Cats. 319-321); perhaps in consideration of their smaller size he attempted a somewhat richer facade treatment, even incorporating some decorative elements. But these projects remained on paper, as did those of housing schemes for the municipally sponsored GESIBA (Cat. 334), for Dr. Grohmann (Cat. 336), for the state-owned Trazerberg site (Cat. 349), and for building up the Arenberg plots in Salzburg (Cat. 342). Various projects for private apartment houses and rental villas (Cats. 326-331) fared no better; they had been worked out with

Haerdtl, who in the meantime had been advanced to partnership in Hoffmann's office. Only a few single-story steel houses (Cat. 296), prefabricated from Hoffmann's design, were actually produced and sold. In these houses the motif of horizontal fluting was adapted to the material—pressed sheets of steel—but it appears that Hoffmann showed little interest in the technological and experimental side of the project. The same was true on another occasion when technical considerations were of great importance. For several years beginning in 1927, he was commissioned to design the interiors of railway carriages (Cat. 284). Hoffmann and his partner found solutions that in general conception and detail were carefully thought out and formed so as to assume a pleasant inconspicuousness characteristic of the best examples of industrial design.

Yet Hoffmann's strength was neither in technologi-

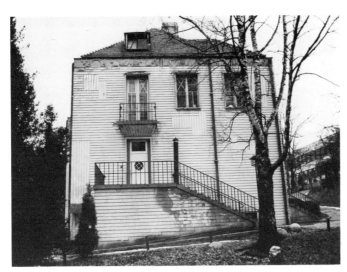

270. House for Isidor Diamant, Klausenburg (Cluj-Napoca), view of the entrance side (in 1975)

271. Villa for Dr. Lengyel, Bratislava, view into the walnut paneled dining room

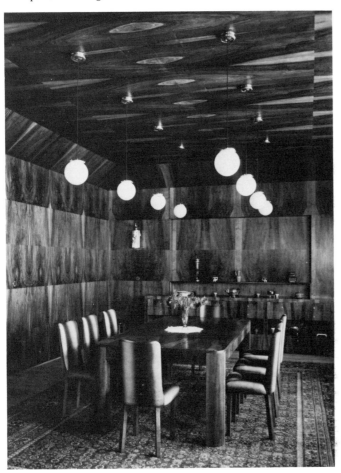

cally oriented design nor in planning low-cost blocks of flats and housing estates. As always, it lay where artistic imagination counted above all else and where architecture and the decorative arts appeared in the closest connection—in splendid individual dwellings, shops (fig. 269), and exhibitions. Owing to the economic depression, the late 1920s and early 1930s were not rich in such tasks, and the only dwellings Hoffmann designed were not in Austria but in Rumania and Czechoslovakia. In Klausenburg (Cluj-Napoca), Rumania, Hoffmann was able to design a large house (Cat. 305) (fig. 270) for a successful contractor who also commissioned an office building (Cat. 304). In Preßburg (Bratislava), Czechoslovakia, he remodeled and furnished an existing house (Cat. 314). In both cases the solutions represented a compromise, insofar as Hoffmann aimed at reconciling the Modern Movement trend toward plain surfaces with his own preference for decorative effects. Accordingly, although the Diamant House in Klausenburg does not display facade decoration in the manner of the Berl and Knips houses, its stucco is treated with complicated patterns of horizontal and vertical grooves, and in lieu of an orthodox, projecting main cornice it has a flat strip of ornament suggesting a building originally planned with a flat roof. At the Lengyel House in Preßburg (Cat. 314), the function rooms furnished by Hoffmann (fig. 271) also avoid any direct application of decorative ornament and moldings. In the manner of the Boudoir (Cat. 247) they are instead totally wainscoted in a veneer selected for its symmetrically paired veining, resulting in a very opulent, decorative overall impression. It is understandable why one Bauhaus student, L. Foltýn, regretted that the original purity (in the Modern Movement sense) of the Lengyel House, as the architect Weinwurm had created it,[24] had not been left untouched.

One finds a similar combination of simplicity and richness in the shops and restaurants done by Hoffmann and Haerdtl during this period, but in order to achieve stronger effects decorative painting is also occasionally applied, as for example on the ceiling of the Altmann & Kühne Confectioner's Shop (Cat. 295) and in the remodeling of the Grabenkaffee (Cat. 303).

The Grabenkaffee (Cat. 155) had been renowned as a particularly attractive social meeting place since 1912, when Hoffmann first furnished it, adding the coffee-colored wooden pavilion that for so long remained a familiar sight at the Graben. Since the coffeehouse flourished in the postwar years, the owner could afford modernization (figs. 272, 273), again entrusted to Hoffmann, in 1928. Hoffmann collaborated with Haerdtl and em-

ployed Mathilde Flögl for the wall paintings. Adolf Loos probably did not see the bar she had decorated in a particularly unusual fashion (fig. 273) when he inspected the coffeehouse late in the evening before the opening day, since he asked Hoffmann's young collaborator Herbert Thurner, who was present at the building site, to convey to his employer the message that Adolf Loos was happy because Hoffmann had now arrived "where he had wanted him 30 years ago." The rooms of the coffeehouse proper had light-gray marble walls and red ceilings and were enlivened mainly by the curves of bentwood furniture and boldly patterned fabrics, with an overall effect that was indeed both calm and festive. The bar, however, was deliberately restless, even noisy, with its stepped-back ceiling and the strong effect of decorative paintings. It certainly must have looked too much like Wiener Werkstätte for the taste of Adolf Loos. His comment, however, probably intended for a wider public than Hoffmann and his collaborator, might suggest that perhaps the Loos/Hoffmann relationship with all its problems was more complex than the vulgarizing local tradition admitted.

Exhibition rooms, because of their function, usually manifest artistic tendencies with particular clarity: in their competition for the attention of the visitor they must necessarily use the strongest effects and take unequivocal artistic positions. Accordingly, it would be possible to sufficiently illustrate the phases of Hoffmann's creative activity using his solutions for exhibitions alone, and it is tempting to suppose that his designs for exhibitions crucially influenced his attitude toward architectural problems—a fact that was bound to have both positive and negative consequences. His Tea Room of 1928 (Cat. 289) and the Music Room of the following year (Cat. 318) proved his capacity for fully exploiting the achievements of the Modern Movement in the service of exhibition design, without simultaneously foregoing the sensuality of earlier comparable arrangements. The effect of both rooms, with plain walls and a minimum of elements, was such that the experience of space was dominant in itself. This was emphasized in the Tea Room by the apparent weightlessness of furniture which almost appears to hover, and in the Music Room (Cat. 318) by the complete opening out on one side of the room onto a winter garden. In both rooms an additional effect was achieved by incorporating the visual arts—in one case decorative wall paintings, in the other a sculpture opposite the piano that created a second center of gravity. Undoubtedly, some of this was willful, precious, and probably more in the spirit of the arts and crafts than

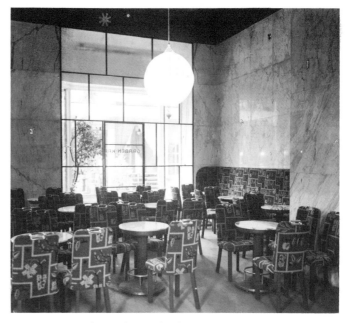

272. View into the Graben Café after remodeling

273. View into the bar of the Graben Café after remodeling; decorative wall painting by Mathilde Flögl

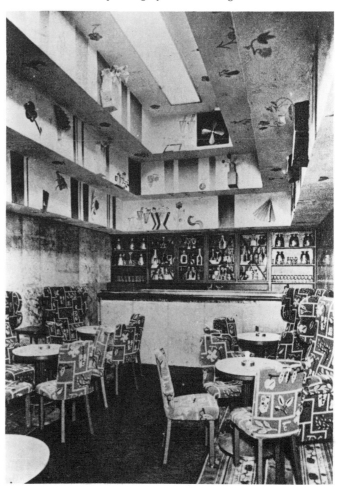

274. Model furnishings for a small apartment at the exhibition "Vienna and the Viennese," 1927

"objective" (sachlich), but it was done in masterful fashion.

When Hoffmann applied similar principles to the model furnishings for a small apartment (fig. 274) and his interior at the Werkbund Estate (Cat. 333), he demonstrated his involvement with the socially relevant tasks of the time. The unacceptability of his works from the point of view of the Austrian adherents of the Modern Movement, therefore, can hardly have been the reason why since 1932 there had been a continual increase of tension in the Werkbund between Hoffmann and his circle and the group around Josef Frank; it ended with Hoffmann's withdrawal and a complete split of the organization.

The reasons for these disagreements were multiple and can only be understood if one remembers the unfortunate economic and political conditions of those years. The opening of the Werkbund Exhibition coincided almost exactly with the formation of the first Dollfuß government, and the constituent general assembly of the new Werkbund took place in February 1934, a few days before street fighting broke out in Vienna. The more people were out of work, the more personal financial interests were aggressively pursued and interwoven with political and anti-Semitic ideologies. "As far as building commissions were concerned, the way it looked was roughly like this, that there were five clients and five hundred architects," a contemporary[25] remembered; Frank himself attributed equal significance to economic motives when later he recalled:[26] "Around this time the only

goal Hoffmann and his group had was to keep the W.W. alive, but this was impossible since this luxury was so entirely inappropriate for these impoverished conditions."

Besides nonarchitectural and purely personal motives, profound differences regarding the reception of the Modern Movement played a decisive role. In this regard it was possible for Hoffmann to come to positive terms with the new movement on the formal level, because willing acceptance of new forms was a constituent element of his basic attitude as a designer. Thus, in a programmatic document he quoted a statement by Cizek:[27] "Everything that is in flux is alive, and only stagnation means the end," adding "we therefore need not be ashamed to adapt ourselves daily to the demands of the time, but we do not want to get stuck in a merely speculative attitude." With this postscript he pointed precisely to his difficulty with the new architectural tendencies, that is, in the matter of the theoretical underpinnings of the new system of forms. As is well known, the creation of a theoretical and scientific, or pseudoscientific, substructure for many leading representatives of the Modern Movement was as important a goal as design itself—the Bauhaus, CIAM, and De Stijl come to mind—but in Vienna such ideas were accepted and critically illuminated only by a very few. For this, Josef Frank possessed both the necessary mental equipment and pertinent connections to the avant-garde abroad. Thus he was, for example, the only Austrian invited to collaborate at the Weißenhof Estate and to participate at the founding congress of CIAM. It was typical of his independent, critical attitude that he soon fell out with Le Corbusier and later no longer participated in the work of CIAM. Yet for Vienna he remained an important exponent of those new ideas for which Hoffmann was unable to muster the same kind of enthusiasm he showed for new forms. Particularly in their views of the future for national arts and crafts, a growing divergence became noticeable between Frank and Hoffmann, and this despite the fact that both architects originally started with the same basic assumptions, i.e., those of the English Arts and Crafts movement, and neither could ever entirely accept the replacement of the crafts-oriented by the industrial, machine-oriented process of production.

At the outset, Frank apparently behaved toward Hoffmann as the admiring younger colleague—he was fifteen years younger and taught at the same school from 1919 till 1925—having nothing but praise for him. In an essay of 1921 about the future of the Viennese arts and crafts,[28] he spoke highly of Hoffmann's "important personality"

and the charm of his individual mastery. In 1926, he described him[29] as "in the true sense pioneering," and in 1930, he contributed a fine appreciation to the Festschrift on the occasion of Hoffmann's sixtieth birthday (Appendix 14). However, at the same time he also contributed warm words of admiration to the Festschrift for Adolf Loos. The consistent pursuit of his own ideas from the year 1921 on forced Frank to become more and more critical of the arts and crafts, and finally to condemn completely what he called the arts and crafts mentality, the striving "to unify formally everything that exists."[30] He described work by Dagobert Peche as "vacuous banality,"[31] said of ornament that it "had always destroyed form,"[32] and commented during a Werkbund discussion[33] in 1932 that "mere decoration" is "uncreative." He also did not hesitate to publicly criticize a door handle from Peter Behrens's early period; but while Behrens received such criticism calmly, Hoffmann, on a similar occasion, requested the appointment of a court of honor[34] by the president of the Werkbund. His keen sensitivity to criticism of the arts and crafts at that time must have been due to the fact that he was most seriously worried about the Wiener Werkstätte, then at the brink of liquidation; moreover he was unwilling to keep apart objective and personal criticism. When Frank made certain critical comments at a board meeting of the Werkbund, Hoffmann interpreted it as a personal offense, and when in addition the board decided behind his back to entrust Strnad and not himself with the design of the Austrian section of the 1933 Triennale at Milano, he left the Werkbund in order to found the Neuer Werkbund Österreichs, together with Clemens Holzmeister (who played the leading role in it) and a group of likeminded colleagues.[35]

In recognition of the limitations of his own capacities, Hoffmann avoided public polemics with Frank and, earlier, with Loos, but a sufficient number of written statements clarify his position and show which of Frank's ideas he found unacceptable. The relevant documents are a letter to Max Welz (Appendix 15), the draft of a letter to Oskar Kokoschka,[36] who apparently had undertaken an attempt at mediation, and a draft of a letter to Laszlo Gabor.[37] Copies of the letter to Max Welz were sent to all members of the Werkbund.

In the letter to Gabor, dealing more with the course of events in detail than with matters of principle, Hoffmann expressly emphasized his good relationship with Strnad and his appreciation of him and stressed that he might easily have approved the idea of giving the commission to Strnad if only he had been approached in the right way. He also expressed his regret at having been driven into a "never intended opposition to Professor Strnad." About the new direction in architecture he declared: "I personally of course have not the slightest aversion to the new [sic] Objectivity and in this don't differ with colleagues; for 35 years I myself have fought for such a conception as a fundamental condition and [have] merely striven for an extension in a creative, higher manner . . . in order to guard the movement from drying up." In the same spirit he wrote elsewhere: "The need for simplicity, appropriateness, and cheapness has led to a new architecture . . . and after fulfilling these fundamental principles we feel the duty . . . to keep awake the joy in creative work. To advance from the correct to the noble conception. . . ."

In his letter to Kokoschka, Hoffmann clearly expressed his distaste for intellectual speculation in the arts and made general observations similar to those in the letter to Welz (Appendix 15), but he also added some purely personal remarks on how much he suffered from the turn of events: "How beautiful it would have been if we, hounded and never presented with real tasks, could have [undertaken] great deeds with you. Poor Austria, that time and again does not see and appreciate its real wealth. . . . it is unbearable for an older person to be forced time and again to count on [having] an enemy from the rear."

From his letter to Welz and the statement of principles he composed for the constituent assembly of the new Werkbund, Hoffmann's own position can be summarized roughly as follows. In contrast to the opinions represented by an All-World Internationalism (this referred to Frank), one should strive to create in accordance with the characteristic qualities of the Austrian, because, according to Hoffmann's argument, "today we know definitely that the labor of a people counts in the world on the condition that it is not only good but also characteristic. It must spring from the soil and sentiments of our homeland and in this manner enrich the total image of the world."

When Hoffmann spoke of labor, he thought primarily of the handicrafts and arts and crafts, although he emphasized: "It is not the machine that should be fought but its misuse." He spoke repeatedly of the need to promote talent in the fine arts and the arts and crafts, and "to employ the skillful hands of our collaborators," but he did not want "to see this work abused again as unfortunately threatens to happen through an unprincipled egotistic capitalism that is about to exploit to the utmost the master who does piecework." He concluded: "The old public has either died or stepped aside, careworn

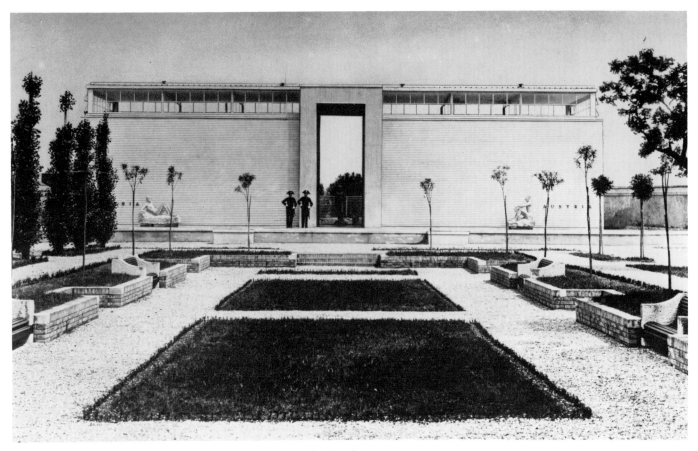

275. The Austrian Pavilion at the Biennale in Venice, 1934, shortly after completion

and impoverished. We must start again from the beginning."

All of this, as beautiful in its optimism as it may appear in places, does not reveal a genuine ideological coming to terms with the great technological, economic, and social changes that profoundly altered the Europe of the 1930s. Rather one senses a persistence of insights and convictions gained early on, even if they hardened into prejudices. In an act of concentration on what for him was the essential, Hoffmann withdrew to unshaken points of departure, and to what, above all, was his own territory: design and education. Nevertheless he could not evade the realities of a new situation in Austria: one was no longer so well disposed toward him as to approve an extension of his teaching activity beyond the usual age of retirement, and in the play of forces within the Austrian architectural scene new constellations formed, with the result that positions in which he had long been unchallenged were claimed and even taken over by others. Above all, there could be no doubt that after 1934, Clemens Holzmeister had moved into an undeniable position of leadership as Rector of the Academy, friend of

the Minister of Education, State Councilor for Art, and very busy architect. Yet Hoffmann's qualifications for certain design tasks then as before were so outstanding that his commission, on the basis of a limited competition, for the Austrian exhibition pavilion for the Venice Biennale (Cat. 361) (fig. 275) in 1934 was almost a foregone conclusion.

Hoffmann began his design for the pavilion in his usual manner, by recalling a model that had several times previously served well for exhibition pavilions: a symmetrical arrangement with one rectangular gallery on either side of a central connecting wing. In his first project for the Biennale pavilion from the year 1912 (Cat. 157), the connecting wing had consisted of a vestibule with a loggia of five bays. In a preliminary project for the Paris exhibition of 1925 (Cat. 266), the place of a vestibule with loggia was taken by a loggia alone; it had five axes and was three bays deep, and higher than the adjoining galleries, a characteristic still found in a preliminary project for the final Biennale pavilion (fig. 276) where, however, the loggia is only two bays deep.

The idea of a central loggia, though in a very reduced

210

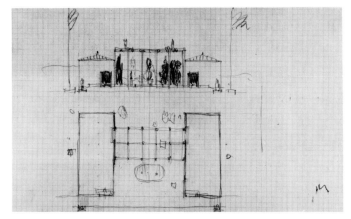
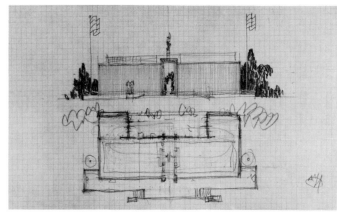
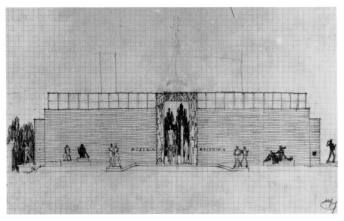
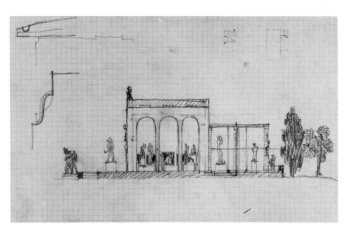

276. Four design sketches for the Austrian Pavilion at the Biennale in Venice

form, is still alive in the executed project wherein the sides of a central vestibule are treated like loggias with tripartite arched openings through which one can look into the galleries. As far as the proportions of the building are concerned, the square not surprisingly plays an important role. The side elevation of the gallery (without roof) corresponds to a square of 6.80 m × 6.80 m, all clerestory windows are square, and the height of the vestibule arcade equals twice its width. For both the central portal and the walls of the galleries on either side of it, Hoffmann tried out various possibilities in his drawings including a choice between vertical and horizontal fluting for the galleries. The building as carried out lacks the sculptural enrichment Hoffmann originally envisaged (reliefs for the travertine frames of the portals, a crowning sculpture above the entrance, and a fountain with sculpture in the courtyard). In the end, only two works by Fritz Wotruba were placed in front. The pavilion was well received critically and during almost half a century has proved its usefulness as a flexible exhibition facility. At the same time it lost none of its aesthetic effect, which depends chiefly on the timeless simplicity of the basic concept and on the economy of artistic means. These included the light horizontal fluting which prevents the cubic volume of the building from appearing brutal in its unmitigated mass, the use of arcaded openings and lowered gallery level to dramatize the spatial experience, and the contrast between the compactness of the front and the openness of the rear onto the statue courtyard with its completely glazed side wings.

This small building in the gardens of the Biennale (fig. 275), graceful for all its severity, was to be Hoffmann's last executed exhibition pavilion, because his designs for the Austrian pavilions for the Brussels 1935 and Paris 1937 Universal Expositions both failed to win first prize; these went instead to his partner Haerdtl.[38] For the Paris exhibition, however, Hoffmann succeeded in creating a luxurious boudoir (Cat. 376), quite in the tradition of the Boudoir of 1925 (Cat. 247). He achieved the effect of dematerialization in this room not with the usual

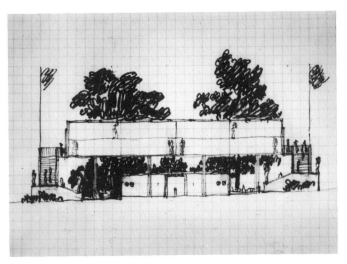

277. Design sketch for the Austrian Pavilion at the Paris Universal Exposition, 1937 (detail)

artistic means of the Modern Movement but by installing a floor of mirrors.

It is no longer possible to establish if and how far Hoffmann's ideas for exhibition pavilions affected Haerdtl's designs, but among the sketches for the 1937 Paris pavilion (Cat. 375) is a sheet on which the basic idea of Haerdtl's pavilion is suggested—an entirely glazed front behind which a photomural is visible. Since it cannot be determined whether the sketch originated before or after Haerdtl's design, it cannot be considered conclusive evidence for the authorship of an idea which at any rate was not far-fetched at that time. The case is clearer with another design for Paris 1937 (Cat. 375) (fig. 277) which unequivocally anticipates the fundamental idea of the 1948 Austrian pavilion in Brussels, by Karl Schwanzer. Since Schwanzer was Haerdtl's assistant from 1947 until 1951, it is not difficult to establish for him a direct connection to the Hoffmannesque tradition.

Even though after 1934 no exhibition buildings were executed from Hoffmann's designs, he did not lack opportunities to arrange exhibitions or individual exhibition rooms during the 1930s. In particular, the year 1934 brought several major commissions of this kind: the jubilee exhibition of the Association for Arts and Crafts (Kunstgewerbeverein) (Cat. 353) and the design for an Arts and Crafts Gallery in red-white-red for the Austrian exhibition in London (Cat. 352) were followed in November by an arts and crafts exhibition in Vienna with the polemical title "The Liberated Handicrafts" ("Das befreite Handwerk") (Cat. 357). This was linked to the jubilee exhibition of the Arts and Crafts Association that had been shown a few months earlier not only in pro-

gram but also in design, since for reasons of economy Hoffmann utilized the same built-in showcases and changed only the decorative painting. In the preface to the catalogue[39] the organizers made no secret of the motive behind the exhibition, but spoke of "the avowed intent to guarantee . . . work and bread for the suffering art workers, especially the pure decorators [trades]." They further stated: "The Viennese arts and crafts will show that they do not want to give in to the pressure of alien stylistic movements or go under without resistance and that they are willing to guard their Austrian individuality under all circumstances." According to Dr. Richard Ernst, it was a "declaration of war against the ever-more reduced new form of the merely objective, or appearance of objectivity, behind which at times there may be hidden no less incapability and preciosity (Verschmocktheit) than in the most overloaded object."

For Hoffmann this exhibition, like the earlier jubilee exhibition, no doubt was a settling of accounts with Frank and the Werkbund, as well as a reply to the exhibition "The Good and Inexpensive Object" which the Werkbund had organized in 1932. He took advantage of the opportunity to design a considerable number of richly decorated pieces of furniture, executed in this case by Max Welz and numerous other firms. For one showcase (fig. 278), in a demonstrative gesture he even employed carved caryatids, a motif that also occurs in residential architectural design (Cats. 420, 454) (fig. 279), where it anticipated Lubetkin's Erechtheion maidens in his luxury apartment building Highpoint II.[40] Though Lubetkin and Hoffmann started from entirely different assumptions, they both consciously contrasted the caryatid, a classical architectural feature, with the plain surfaces of a different architectural conception. The Russian architect, working in England, used the contrast ironically, however, in order to achieve a surrealistic effect, while Hoffmann, half-seriously, half-playfully, handled the motif because of its potential for achieving novel effects.

In a brief essay of 1936, "Österreichische Baukunst nach 1918" ("Austrian Architecture after 1918"), Hoffmann attempted to explain the principles underlying his architecture at that time:[41] "For us too it is especially important in drawing plans to work out the technical and practical claims. We aim at an overall effect through the mastery over and incorporation of the volumes. Nonsensical detail, merely decorative in kind, we would like to avoid, but nevertheless we think of a more refined and attractive treatment.

"An enrichment, plastic above all, is for us a requirement if the purpose of the building permits a more ex-

pressive treatment. The solution of all details, use of correct material and its correct treatment is important to us, and [it is] a necessity to achieve an expression . . . characteristic for our country. . . . We attach great value to the uniform, i.e., to the coordinated treatment of the entire interior furnishings, absolutely avoid any stylistic copying, and would not want to miss the chance for individual art."

How strong was Hoffmann's attachment to old convictions and how far removed he was from the ideological claims of the New Objectivity is suggested by the following remark from the beginning of the 1930s, which he made to a former student almost as if he were talking to himself:[42] "If I were to build a house now, I would decorate it from top to bottom." Yet in his actual practice as a designer this attitude finds almost no strong expression. The majority of projects for houses done at the time, which invariably remained on paper, showed little or no decoration. On the contrary, if one studies the numerous projects from this period (Cats. 340, 350, 351, 364, 367, 371, 404-452), it is clear that Hoffmann, like his contemporaries Asplund and Salvisberg, was capable of combining the achievements of the Modern Movement with those of the classical tradition in an outstanding fashion, and with much imagination. Yet he was largely denied the possibility of realization. It is thus all the more impressive to watch how, with the obsession of a man to whom the activity of designing is a necessary element of life, he worked out one project after another— from the smallest house to palatial, seignorial residences, to apartment houses, to club buildings. If circumstances are such that the gifts of a creative mind remain unused, it is always a tragic situation, and Hoffmann's case in this phase of his career is no exception.

One design, at least, was carried out, although under very unusual circumstances and not in Austria but in the United States. This was the Wertheim/Wiener House, New City, N.Y. (Cat. 343) (fig. 280). However, because Hoffmann's design sketches were changed into American working drawings, such fundamental alterations occurred that one no longer feels justified in speaking of the finished building as a house by Hoffmann. A comparison of the design with the finished building is instructive in illustrating the difference between Hoffmann's conception and that of a conscious partisan of the Modern Movement (then just "discovered" in the United States under the label of the International Style). The owner, Paul Lester Wiener, completely altered Hoffmann's design in the manner of the International Style in order to increase the propaganda value of the building,

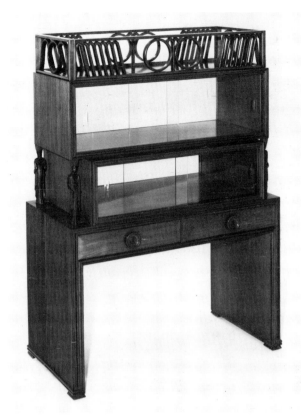

278. Showcase in walnut with caryatids from the exhibition "Liberated Handicraft" (Execution: Franz Konečný)

279. Design drawing for a house with caryatids

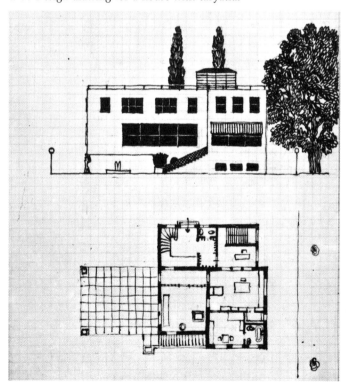

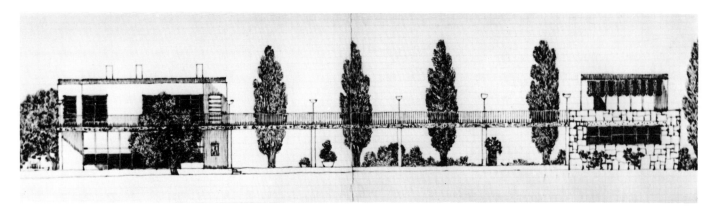

280. Project for the Wertheim/Wiener Country House, design drawing of two facades

which he christened "Contempora House" after the Contempora arts and crafts oriented design firm he headed. In his changes he eliminated the decorative strip of stucco Hoffmann had provided as a stringcourse, the strip that served as an upper termination and masked the flat roof, and all the door frames as well as textural effects. He thus created a house which consisted of nothing but white geometric volumes and which closely approximated the ideal image of the International Style.

Photographs of the building were not only published by Wiener but also mailed to Josef Hoffmann. Hoffmann combined them with his original plan and a text by a young collaborator in his studio and submitted them to the periodical *Die Pause* where they were duly published—without even a mention of Wiener's name.

When Wiener happened upon the publication on a visit to Austria in 1935, he was understandably annoyed and challenged Hoffmann in a letter. The reply was apologetic but contained a reminder[43] that "Mrs. Wertheim was present in Vienna for several weeks" and mentioned "how much pleasure it had been to work out the plans of the house with her." In addition, Hoffmann, probably not without sarcasm, expressed his satisfaction to Wiener that the house had turned out so well, "which of course was only possible through your collaboration." Hoffmann apparently, and not without reason, still considered the essential elements of his design his mental property and therefore had permitted the publication; in addition he might have hoped that such a publication would strengthen his position with the avant-garde in Austria. After Wiener's discovery of the article the whole affair must have been rather embarrassing for Hoffmann, perhaps further wounding a self-esteem already weakened by lack of success in competing for the Brussels

pavilion. Consequently, the invitation to participate in an international limited competition must have been all the more welcome, particularly in view of the significance of the program, which could be said to match that of the League of Nations Palace in Geneva. This concerned the design for a new parliament building in Turkey, to be erected in Ankara (Cat. 370) (figs. 281-289).

Since the Rome Prize project of his student days, few opportunities to design monumental complexes had come to Hoffmann. When they did, as for example with the project for a World Peace House (Cat. 207) and a World Concert Hall (Cat. 279), it was only a matter of rough sketches, not of designs worked out in detail. Only the project for an exhibition hall at the Karlsplatz (Cat. 287) went further in this respect. The Rome Prize project had been organized in such a manner that its volumes were linked by a linear connector, in this case colonnades, thus achieving a complex with a very articulated space. Hoffmann remained faithful to this manner of composition for the rest of his life, and linear elements played an important role in many of the other monumental projects just mentioned. It is not surprising, therefore, that he proceeded in the same manner with the largest monumental project of his life, and linked the main elements of the complex—the assembly halls—by long wings with, invariably, single-loaded corridors. The resulting arrangement (Cat. 370/I,II) was very clear and generous, but uneconomical because of its long traffic paths. Whereas in the finished building, as finally designed by Clemens Holzmeister,[44] the most important halls are practically side by side, separated only by vestibules, in Hoffmann's project considerable distances lay between them.

Hoffmann's arrangement did, however, create a large central courtyard, just as in his Rome Prize project a

214

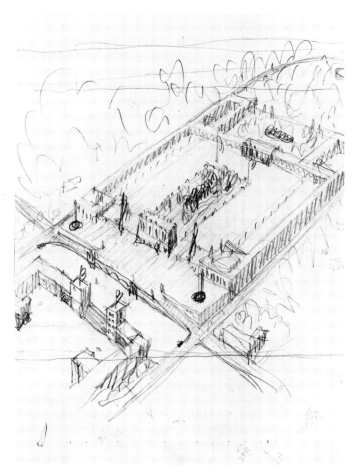

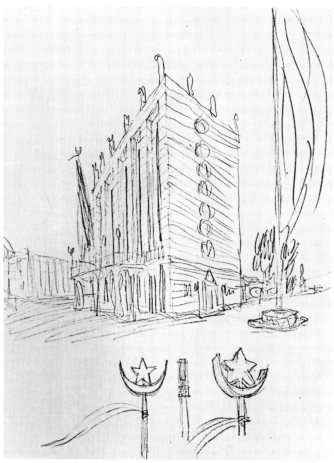

281. Competition project for the parliament, Ankara, perspective sketch in bird's-eye view

282. Competition project for the parliament, Ankara, perspective design sketch of Hall of Honor

forum for the same purpose had been provided in front of the central domed hall. With a courtyard width of roughly 180 m and enclosing buildings approximately 11 m high, the primary impression would have been that of a very spacious, loosely defined open precinct, not that of a courtyard, which overwhelms with the monumentality of its spatial boundaries and where the feeling of enclosure would predominate. The width is only a little less than that of the Place du Carrousel of the Louvre in Paris at its most narrow point—only there the buildings are considerably higher. For scale comparisons in Vienna only the *cour d'honneur* at Schönbrunn Castle, roughly 165 m wide, and the Heldenplatz qualify. In the latter, the distance from the outer gate at the Ringstraße to the entrance into the castle proper amounts to a little more than 180 m. The core of the composition was the architectural space and not the built mass, but Hoffmann did not achieve the sense of openness and elegance solely through the relation of building height to the dimensions

of the courtyard. The treatment of the facades contributed equally through the detailing of forms—the glazed openings are very large in comparison to the stone wall surfaces (fig. 285). The roofs of the two great assembly halls are raised in gentle curves, and Hoffmann avoided the grand gesture of the crowning dome that provides the main accent in the project of another participant in the competition. The unbroken horizontal line that forms the upper termination of the two-story buildings remains uninterrupted except where the portico of the great entrance hall and staircase hall of the presidential wing projects in front of the facade, and more strongly at the portion of the building endowed with the highest symbolic content—the Hall of Honor, designated the Pantheon (figs. 282-284)—a freestanding building in the central axis that marks the climax of the main facade and houses rooms for the president of the republic. In this building and in the large assembly halls that flank it, Hoffmann deployed a wealth of artistic means, including

215

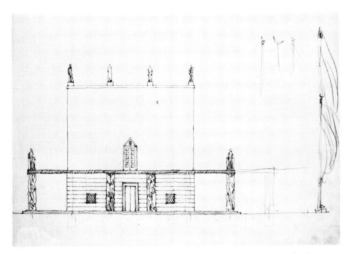

283. Competition project for the parliament, Ankara, study for the side facade of the Hall of Honor

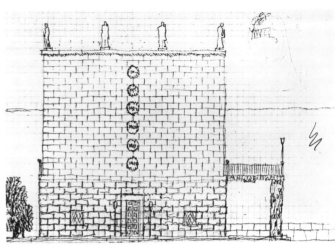

284. Design drawing for the side facade of the Hall of Honor

285. Competition project for the parliament, Ankara, design drawing for wall treatment of main building

architectural sculptures, but never abandoned that certain noble reticence which characterizes the whole design and preserves it from having a brutal or exaggeratedly historicist effect.

The inner arrangement was expressed in the facades of the hall buildings, which played the role of corner pavilions in the total composition, by having continuous glazing in front of the higher vestibules and two rows of windows in those portions of the building where there is a gallery story. The facade treatment of the Hall of Honor also employed tall window openings, which inspire respect by their stern slenderness, and which reveal where the great hall is situated; its importance is further emphasized by its placement above a socle story. A perspective bird's-eye view (fig. 281), roughly sketched yet grasping with precision all the essentials, reveals the strong predominance of space over volume in this composition. At the same time it is apparent that the large courtyard behind the Hall of Honor was subdivided into several areas by plantings and other devices and that its articulation was meant to provide a U-shaped procession route. In an earlier design study for the distribution of the built volumes, the composition remains entirely open at its upper, northern end, which could have been justified by the fact that the old town is situated in this direction.

This variation envisaged a monumental gate building (Cat. 370/V) in place of the Hall of Honor. With a portico flanked by two built volumes, the type referred to such projects as the pavilion for Cologne 1914 (Cat. 182) and the preliminary designs for Paris 1925 (Cat. 266) and Venice 1934 (Cat. 361). In this case, the built volumes were handled like towers, as in Klenze's propylaea in

216

286, 287. Competition project for the parliament, Ankara, perspective studies of various building complexes

217

288. Competition project for the parliament, Ankara, sketches
with ground plan studies

Munich; their verticality, however, is counteracted by an emphasis on the horizontal joints or grooves, and this contributes as much to the subtlety of the overall effect as the variation in axial distance between the piers due to a contraction of the end bay. The opening at the north end would have stressed the predominance of space over mass even more, creating an even stronger contrast to the projects of the other participants, who preferred to rely on tried-and-true large masses in multistory buildings to achieve monumental effects. Hoffmann alone managed to combine monumentality with grace.

Hoffmann invested an enormous amount of work in the project, and in addition to the parliamentary complex,

he designed numerous other government buildings (figs. 286, 287), but faced with the choice between going to Turkey or staying in Vienna and accepting a onetime fee as compensation, he opted for the latter. The designs he left behind are tangible proof of what had been completely forgotten for decades, that he was indeed more than a skillful specialist in exhibitions and arts and crafts design, and that he was still as capable as ever of redeeming the promise his Rome Prize project had represented. Unlike the best projects at the competition for a palace of the Soviets at Moscow, his Ankara project stylistically looked backward and not forward; but it withstands comparison with the other competition projects submitted. Hoffmann possibly may even have toyed with the idea for a design in the manner of Le Corbusier's project for the palace of the Soviets. Some small, very cursory sketches (fig. 288) on the back of a sheet Hoffmann had used for drawing a ground plan show several experiments using corridorlike wings to connect assembly halls that have a plan in the shape of a truncated V, as in Le Corbusier's project.[45]

Even though the Ankara project was not realized, it turned out to be useful preparation for another monumental task with which, soon afterward, Hoffmann was entrusted in Vienna—not by an Austrian client, however, but by the German armed forces, for whom an officers' club was to be designed. After the loss of Austria's independence, the architect, aged sixty-eight at the time, once more faced a completely changed situation, just as he had twenty years earlier after the collapse of the Monarchy.

IX. The Late Work

Architecture, ideology, and political reality are always interwoven, but the intensity of their relationship may vary. In Austria the intensity increased steadily after the beginning of the 1930s, and the architectural events between 1938 and 1945 cannot be understood at all apart from the political situation at the time. This is equally true for the architecture of Josef Hoffmann even though he was anything but a politically interested or engaged man. "I don't understand anything about it," he used to say about political questions, and the statement probably was very close to the truth. In contrast to architects like Holzmeister and Kramreiter, he was not closely connected with either the Catholic Church or the party linked to it, nor did he have any connection to the Social Democratic Party.

From his origins among the German-speaking minority of Moravia, he was conditioned to have sympathies for the German National camp, but that their excesses repulsed him is shown, for example, in a letter to his son in which he laconically commented about a relative:[1] "[X] is German National anti-Semitic without intelligence." Hoffmann knew too much of the world and its broad cultural spectrum not to possess a certain tolerance and a wider perspective than was to be found among his doctrinaire German National, and later National Socialist, contemporaries. In addition, he probably was too much aware of the prominent role that Jewish clients, colleagues, collaborators, and friends played in his life ever to become an anti-Semite of the National Socialist ilk.[2]

At times Jewish collaborators had worked in his office, as had others who were rabid anti-Semites and later became party officials of the Nazi regime. Among them was one who in 1938 appeared at the School of Arts and Crafts in uniform proclaiming himself its new head, and another who functioned as provisional head and liquidator of the New Austrian Werkbund.

Hoffmann welcomed the new regime because it promised economic progress and, above all, revived his architectural practice. He also hoped finally to accomplish long-cherished plans for a reform of art education that would have culminated in a fusion of the Academy and the School of Arts and Crafts. Two memoranda[3] he wrote immediately after the annexation of Austria attest to this hope. A close relative of Hoffmann's now took over the function of arts and crafts expert in the municipal office for cultural affairs, and an old acquaintance, Hermann Neubacher, was appointed mayor of Vienna. The new rulers, as part of their cultural politics, were anxious to be accommodating to the renowned architect, and accordingly he was soon commissioned with arts and crafts work and festival decorations (Cat. 386). Haerdtl assisted him in this only until 1939, when their partnership dissolved in a stormy session. In all matters of organization and business management, Hoffmann then gladly accepted the assistance of a much younger, politically well-placed, colleague, Josef Kalbac, a pupil of Strnad's. Hoffmann was able to hand over his former apartment to the new collaborator in 1939, since he himself moved into a larger apartment in a particularly fine location. On the occasion of his seventieth birthday in 1940 he was honored in various ways. On the eve of the celebration a dinner was held in the City Hall; in February 1941 an exhibition was organized in the museum at the Stubenring; and in addition he was later awarded the Alfred Roller Prize for arts and crafts. Hoffmann, who designed the Stubenring exhibition himself, avoided a chronological organization of the material, and instead, in a manner characteristic of his attitude toward his own work, displayed early and late works side by side.

Baldur von Schirach—"Gauleiter" of Vienna since 1941—regarded Hoffmann as a kind of bridge between the older and the more recent culture and proposed that he should revive the Wiener Werkstätte; but Hoffmann wisely refused. Although Paul Schmidthenner, a leading architectural ideologist of National Socialism, had attacked Hoffmann in a lecture in Vienna as a degenerate decorative artist,[4] in 1941 Schirach appointed the Viennese architect to the position of Special Commissioner of the Office of Cultural Affairs for the Artistic Restructuring of the Viennese Arts and Crafts. In addition, he ordered that Hoffmann's portrait should be painted by a distinguished artist.[5] Of more real usefulness was the inauguration, under the aegis of the Office of Cultural Affairs, of an Experimental Workshop for Artistic Form-giving at Kärntnerstraße 15. During the war this became the so-called Künstlerwerkstätte (Artists' Workshop). Hoffmann's concern with questions of arts and crafts also found its expression in two essays; one appeared in

1941 in *Die Pause*,[6] the other was even published in 1944 in the official newspaper of the party, *Völkischer Beobachter*.[7]

The article in *Die Pause* culminates in the statement, "The Viennese arts and crafts will finally accomplish that for which they are endowed with a special force." It ends with an expression of hope that "the new mankind . . . realizes the eternal dream of an existence in beauty, goodness, and harmony." In the second year of the war, these words reverberate with a strange and almost touching unawareness of the realities of the surrounding world. There was also a scarcely veiled criticism of the officially promoted revival of classicist models: "If we do not succeed by and by in developing every object to perfection, we would not even have achieved what was a matter of course a hundred years ago. . . . we shall have to do everything in order to accomplish such a blossoming, without making the mistake of imitating that period and its form of expression."

In the second article, after a longish historical introduction, Hoffmann formulates demands that never go beyond what he had already requested a decade earlier for the promotion of craftsmanship and the arts and crafts. If in both articles general statements about the "time of world-historic change of unfathomed greatness" and "the grandiose, leading planning . . . in the Reich" are worked in, these correspond to the same eagerness not to lose the goodwill of the political authorities that motivated him to begin a statement[8] a few years earlier with "in the corporate state [Ständestaat] it is absolutely necessary," etc. The *captationes benevolentiae* might change, but the content of the message remained the same. When it came to the arts and crafts, Hoffmann was an idealist whose ideas did not change, but when it came to finding ways to realize his ideals, he was a realist.

Two reports Hoffmann drew up about his activity as commissioner for the arts and crafts and about the experimental workshop[9] give a clear picture of the practical and bureaucratic difficulties he faced due to the war, since everything needed for arts and crafts activities was lacking. It was mandatory, for example, to have "designs even of the smallest objects in wrought iron sent to Berlin," where subsequently the original designs were left in the file since presumably one had quite different worries than the petitions from this old gentleman in Vienna that sounded a little odd and were not even signed with the proper "German greeting." But for a while Hoffmann apparently had to attend almost daily to "inquiries, certifications and petitions"; in this connection, he points out that "petitions concerning military matters . . . only rarely were approved . . . by the competent authorities."

There was soon so little possibility for architectural activity in Vienna that Hoffmann's new partner had to leave in order to find work elsewhere. Just prior to and briefly after the beginning of the war, a few commissions had come to Hoffmann. Besides shop interiors, he was able to do two major remodelings and to begin two projects—the design for a guest house for the city of Vienna to replace the Kursalon in the Stadtpark (Cat. 384), and for a Hanak Museum in the Augarten (Cat. 385). Neither of these projects was ever carried out, but they assume a more than average significance in the evaluation of Hoffmann's stance as an architect, because they prove unequivocally that in artistic matters he had considerably more character than many of his colleagues. In contrast to architects (like, for example, Fritz Breuhaus) who could not have changed their style faster[10] to please the new regime, these two projects from the era of National Socialism do not show any striking difference from those designed in the early 1930s. The same holds true for a still later project, a large residence in Grinzing (Cat. 392), except that here the ample use of cross-vaulted bays is an unusual, strongly traditionalist feature.

If one recalls the architectural ideals of the Third Reich as realized in the official buildings by Troost, Kreis, or Speer, one can see that if Hoffmann had taken them into consideration, the official guest house would have looked quite different from his design, with its flat roofs and entirely glazed ground floor. Similarly, the Haus der Deutschen Kunst in Munich was a model for what, from a doctrinal National Socialist standpoint, an art museum should look like—nothing at all like the loosely composed, picturesque Hanak Museum (Cat. 385). In this building the tall, pillared loggias of the 1930s are combined with a centralized building that may even contain very distant reminiscences of the studies for, of all things, the synagogue in Sillein (Cat. 285) (figs. 258, 259). Hermann Neubacher, of course, who commissioned the guest house, was the man who had formerly been president of the Austrian Werkbund responsible for carrying through the Werkbund Estate, and under the new regime he kept his position as mayor of Vienna for a short time only.

The two remodelings were done to create a Haus der Mode (House of Fashion) (Cat. 382) (fig. 290) and a Haus der Wehrmacht (House of the Armed Forces) (Cat. 388) (figs. 292, 293), both representational buildings. The idea of a fashion center for Vienna had already been propagated by Hoffmann in 1936 when he insisted in a newspaper

article,[11] "Vienna needs a fashion bureau," and went on to discuss the planning and coordinating functions of such an agency. He was particularly well qualified to make constructive suggestions in this area since he had decades of experience to look back on: an early design by him for a lady's dress is dated 1904 (fig. 289), another was probably done not much later, and still others followed in many periods of his creative activity. In addition, he had always designed jewelry and accessories. The necessity of constantly inventing new compositions and working with living material when doing fashion design exactly suited his special talent and inclination. At times he even used to appear personally in the salesroom of the textile department of the Wiener Werkstätte in order to suggest to customers, with the aid of improvised draping, which fabrics they ought to wear in what manner. It has already been stressed that in the years after the First World War, fashion design played an important role in his class at the School of Arts and Crafts. The fact that at the end of his career, too, Hoffmann was interested in questions of both fashion and urbanism proves that something lived on in him that had been characteristic of the avant-garde at the turn of the century—the claim to total design in all realms of human concern.

When the time came to realize the Haus der Mode (fig. 290), the beautiful old Lobkowitz Palace—the function rooms of which could still be used—offered itself as an ideal home for the new organization. On the upper floor where several rooms had to be remodeled and furnished, Hoffmann created interiors that as a whole followed the direction he and Haerdtl had pursued in their interior designs of the 1930s, for example at the Baden Casino (Cat. 378), but with the addition of more slightly historicizing details, such as flutings here and there. In the room for the artistic directress, the furnishings, in black with gilt carvings, suggest a return to designs of the period around 1914, except that they are conceived less massively. The slight curves or roundings off that were so characteristic of the taste propagated at the time predominated; they represented a reaction against the precise geometrical formulations of the Modern Movement. Nowhere, however, does one find the excesses of historical eclecticism that could be seen, for example, in the interiors exhibited at the same time by Ludwig Troost in Munich. The same holds true of Hoffmann's interior for the salesroom of the Meißen porcelain manufacture (Cat. 387) (fig. 291), where he succeeded in finding a solution that satisfied both the practical and representational needs of this prestigious firm, while at the same

289. Fashion design by Hoffmann, 1904, pencil

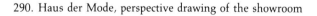
290. Haus der Mode, perspective drawing of the showroom

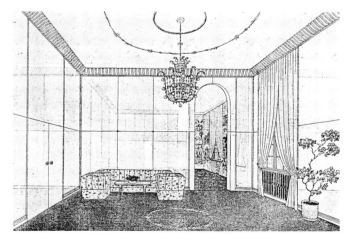

221

291. Salesroom of the Meissen porcelain manufactory, showroom in basement

292. House of the Armed Forces, general view of entrance side

time sensitively accommodating to the existing setting. For the display of outstanding pieces in the main salesroom, he had recourse to one of his own ideas from the coffee house of the 1930 Werkbund exhibition (Cat. 324): he provided curved niches in the wainscoting, but this time they were oval and not circular.

The Haus der Wehrmacht (Cat. 388) (figs. 292, 293) was an extremely complicated task. It involved the remodeling of the existing German embassy, a nineteenth-century building in Renaissance style that early in 1939 had been transferred to the administration of the armed forces. Hoffmann, in his typical manner, studied the problem of changing the existing facade by drawing numerous variations; from among them he selected—again typically—the simplest and most severe. For the main facade he obviously remembered his design for the Hall of Honor at the Ankara competition (Cat. 370) (fig. 283), where in one study he devised exactly the same arrangement of the main elements as was to be found at the entrance of the House of the Armed Forces. Above a grooved socle-story a main story rises that has tall rectangular openings crowned by triangular panels and above them a high blank wall. The triangular panels have a long history in Hoffmann's architecture that reaches back to the period before the First World War. It is striking that despite his compliance with his client's demand for a rhetorical architecture he did not hesitate to place a pergola of steel tubing in the garden which quite un-

293. House of the Armed Forces, detail of main entrance

222

equivocally belonged to the world of the Modern Movement; he also avoided all romantic-historicist allusions, although it would have been easy to employ them here.

Hoffmann afterward explained his design procedure in a short article[12] in which he stated that after the old stucco had been removed from the facades the proper form emerged automatically. "The high wall surfaces above the windows of the first upper story appeared as necessary emphasis for the height of the interiors and immediately produced a special motif. . . . on the whole a strict, simple ductus had to predominate everywhere, and the important points were to be emphasized by affixing the insignia of the German armed forces. A clear garden design, the unpretentious enclosure, and a strong effect of railing at the additions . . . had to form important elements of a total solution. . . . since, incidentally, in the immediate area of the building neither a continuous architectural intention has existed, nor were there other artistically valuable objects, it was permissible to opt for a more independent solution that nevertheless did not disturb the [urban] whole."

In 1944, when Vienna was already the target of air raids, which also damaged the house in which Hoffmann lived, he, through the good offices of Hermann Neubacher, was called once more to deal with an official project, admittedly one that in oddness left little to be desired. He was asked to design a mausoleum for Skanderbeg in Krujë, Albania (Cat. 393) (fig. 294), with a showcase to be placed inside it, the whole obviously a diplomatic gesture to elicit sympathies for the German side in Albania. For the mausoleum he chose the archetypal form of a truncated step-pyramid and brought the light in dramatically from above, as he had in his project for a musicians' memorial in the Volksgarten (Cat. 374). The design of the showcase for the national hero's helmet and sword was exactly right iconologically and formally, combining Renaissance dignity with exotic wildness—proof that Hoffmann's creative imagination was still strong enough to find a solution even for such an unusual task.

Hoffmann was seventy-five at the end of the war and he had been severely affected by the hardships of the last months of the war and the first few months after it. His paternal house in Pirnitz was confiscated and he lost many crates of belongings that for purposes of protection had been deposited in the same shelter in which Klimt's university pictures perished. Yet he took up his professional activity as soon as it was at all possible, not only returning to his own design work but also concerning himself with the artists' workshop in the Kärntnerstraße and the reorganization of the Secession that began im-

294. Perspective drawing of showcase for the helmet and sword of Skanderbeg in the planned mausoleum, Krujë, Albania

mediately in 1945. He served as president for two years, designed new furniture for its secretariat that, however, was not carried out; and he participated faithfully and with visible enjoyment in all events, including the carnival parties. In 1951, he invited Kokoschka to become honorary president of the Secession, but the painter declined, giving as a reason that this would only have been meaningful at the time when Hoffmann himself was president—which he then no longer was. Kokoschka expressed his devotion to Hoffmann explicitly when he wrote:[13] "I would have willingly undergone this honor too only for your sake, to whom I owe so much courageous understanding and loving encouragement in my youth. . . . the two of us, after all, are the last of a circle of friends . . . from the time of *Ver Sacrum*, a time with a style of its own (perhaps the last time in Europe). . . . I long very much to meet you again hail and hearty somewhere and at some time!" (see fig. 295).

In December 1945, Hoffmann published the first article of his "Gedanken zum Wiederaufbau Wiens" ("Thoughts on the Reconstruction of Vienna"), which was followed in April 1946 by a second installment[14] (Appendices 9, 10). In these he took up ideas on urban design that in part he had formulated on various earlier occasions. He had always shown a lively interest in the

223

295. Encounter of Hoffmann and Oskar Kokoschka at the Vienna Secession, October 1955

urbanistic appearance of Vienna.[15] On one occasion[16] he complained that the Ringstraße was "interrupted and fragmented in many places by squares and parks." As a remedy he proposed a number of changes that would have created a series of enclosed squares, some with colonnades, in the spirit of Camillo Sitte whom, after all, Hoffmann had known. He also suggested improvements in the old city. On another occasion he demanded a comprehensive reorganization of the area of the Prater between the Danube and Wurstelprater, because he was of the opinion that "the omission—of nowhere being able to see [that] Vienna is on the Danube—absolutely must be rectified." He conceived of a spatial sequence of grandiose squares beginning at the river: there he wished to see an "important lighthouse" and a "colossal figure of Vindobona" next to a steamship station; next, linked by colonnades, a square with fountains and illuminations in the center and great hotels at the perimeter; another with special restaurants was to follow; and finally, a bathing establishment with a swimming pool 300m long, a hall for mass meetings, an open air theater, and much else.

As untimely as many of Hoffmann's proposals appeared immediately after the end of the war—the editor in an apologetic postscript even referred to the content as "in many places somewhat grotesque [sic]"—they appear prophetic in light of the actual developments that took place during the next thirty-five years. For Hoffmann demanded, among other things, nothing less than a "revitalization" of the inner city. "How would it be," he wrote, "if one were to evacuate and clear out this

inner city quarter completely? The few new buildings which, just here unfortunately turned out to be particularly ugly and disturbing, above all should be either remodeled or removed. . . . On the ground floors only small, quality shops ought to be accommodated in the fashion typical of old Vienna. . . . In between, places of amusement. . . . Inside the often charming courtyards the decent, unrambunctious 'Heurigen' setting of earlier times . . . could also find its place. . . . It must be possible to find everything here that fits into the framework of our old Vienna. Thus, for example, antiquarian bookshops, art dealers . . . driving in these quarters should be prohibited during certain hours. . . . For our city, which will have to rely on cultivated tourism, no better publicity can be made . . . it goes without saying that any shallow kitsch must disappear, everything must reach the highest level of quality." In addition, Hoffmann turned once more to the necessity of reorganizing the Prater, and he especially welcomed planning for an artistic reconstruction of the Wurstelprater that had already begun.[17] In 1950 another essay, "Utopian Proposals for the Design of the Stephansplatz,"[18] followed in which he argued that one ought to follow the principle "the narrower the surroundings, the greater the effect," and reenclose the space around the cathedral as it had been in the Middle Ages. It was his opinion that "above all, the rounding off at the Graben . . . should be avoided at all cost in order not to rip open brutally the square that is to be created" (Appendix 20).

In 1950, Hoffmann again received many honors on the occasion of his eightieth birthday. He was awarded the State Prize for art and a small exhibition was organized in the rooms of the government printing office. Rochowanski published a small book which included graphic designs by Hoffmann, and many letters and telegrams came from all over the world. He also received an honorary doctorate from the Institute of Technology (later Technical University) of Vienna. In his speech at the degree ceremony on 21 April 1951, and in a later lecture he was obviously striving to sum up his life's work.[19] He was, of course, eager to emphasize his role as a pioneer and above all to speak of things which he assumed would mean something to young listeners in 1951. But since what he said was completely in line with statements he had made much earlier on various occasions, these speeches may be considered a truly valid summation of his convictions. After a historical introduction, he spoke of the period that had started the battle against "the traditional imitation style" and, drawing a contrast to the historicists, he proclaimed, "but for us

the naked wall was sacred," perhaps referring to the fourteenth Secession exhibition and the Purkersdorf Sanatorium. He went on to recall his lifelong effort to create beautiful objects of use with the comment that "machines . . . represent wonderfully beautiful creations," but unfortunately produce things that are "bad in every way," because they are produced without consideration of aesthetic values. After remarks on the correct placement of works of art and the duty to preserve old monuments, Hoffmann turned to questions of town planning and housing. "Instead of the power consciousness" of past epochs, "the communal coexistence, worthy of human beings, [should] be expressed." The overall plan of a housing estate should assume a villagelike character, and boring monotony should be broken up. Instead of having old quarters regulated, new districts should be created as complete units free from vehicular traffic; in addition housing estates should stand entirely "in water," meaning along canals, in order to break "the tyranny of the habitual."

Hoffmann stressed that the objectives, purposes, and the importance of the structural engineer should be fully recognized, but the necessity of artistic creation must be appreciated as well. In this respect "living nature . . . [can] be our model. Daily it brings forth forms that do not stem from purpose alone." The conclusion was particularly forceful, and one could sense that even after a very long career the enthusiasm of the days of the Secession still burned in Hoffmann as he exclaimed: "It lies in the nature of man to sacrifice himself for an idea, and it is our fault if we do not set goals. . . . it is a matter of struggling to achieve freedom for the creative spirit. There is only the eternally new that creates itself from the developed elements of the past, and genuine longing is always productive. . . . even the most ingeniously reasoned out deed is transitory, and beauty alone [is] timeless."

In the years after the Second World War, Hoffmann executed no important buildings. This was due to his advanced age but also to the fact that in the immediate postwar period he did not stand in particularly good political repute. He was busy nevertheless with a number of projects and smaller buildings. Eventually he was entrusted by the municipality of Vienna with several dwellings which he planned in cooperation with Josef Kalbac, without, however, abandoning his practice of personally drawing sketches on squared paper for all essential design decisions.[20] Unfortunately, the very strict regulations that governed public housing at the time left practically no scope for his imagination, and most of the details that

did not conform to prevailing standards were omitted when the buildings were executed. Only in occasional details—in a front door or a cornice—can one still sense his hand. The housing complex in the Silbergasse (Cat. 400) was the only exception: here his artistic presence asserted itself even in the spatial composition of the total arrangement; later it was seriously impaired by alterations, including the removal of the pergola Hoffmann had designed personally.[21]

Through the intervention of his collaborator, several projects materialized in Lower Austria, for example in Langenzersdorf, to furnish an apartment (Cat. 465); in Deutsch-Wagram (Cat. 500); Hainburg (Cat. 496); and most importantly in Stockerau (Cats. 497, 501). There, in 1951-1952, a girls' school was constructed that in its general lines, though not in detail, corresponds to Hoffmann's ideas about the rural schoolhouse. In a preliminary project he designed the building with a flat roof, but in the execution it received a hipped roof. Roughly at the same time he busied himself with the design of various types of dwellings for housing complexes, and in doing so he tried to find imaginative solutions with round or polygonal layouts (Cats. 451, 494, 495). Among the larger projects that were not carried out, two designs for public buildings—a museum and a city hall—in addition to plans for an apartment house in the Salesianergaße, Vienna (Cat. 398), deserve special attention. The museum (Cat. 401) (fig. 296) was intended for the display of arts and crafts and for related activities, and it revived ideas from the Hanak Museum project (Cat. 385). Hoffmann had formulated his principles for the planning of museums by 1936,[22] and later he included them among his ideas for the reconstruction of Vienna, where, he insisted,[23] "museum-type clublike accommodations, libraries, lecture halls, collections of the best art objects at any given time . . . should provide welcome tasks for different architects. . . . all these buildings, linked through arcades, and enhanced in effect with the aid of modern garden design, should appear placed on an island in the middle of a large pond." As his plans show, Hoffmann here arrived at something like an "open form" long before this concept became a catchword of the avant-garde, and it is particularly remarkable that he thought of a solution which—as formerly in the Paris exhibition pavilion—would have permitted various artists to make their contributions in the framework of a loose overall concept.

The same method of a loose yet highly ordered joining of elements found its application in his last monumental project, a city hall in Addis Ababa (Cat. 403). The in-

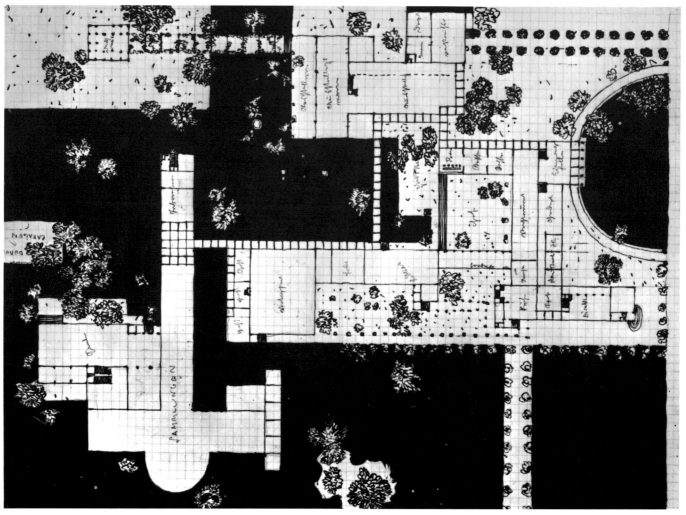

296. Project for Museum of Arts and Crafts, ground plan

vitation had been procured once again by Hermann Neubacher,[24] who had ended up in Abyssinia. The formal commission went to Hoffmann jointly with the architects Anton Ubl and Franz Matuschek. Hoffmann organized a comprehensive program of accommodations (roughly 15,000 square meters) around a large inner court. At one corner of the main building he placed a tall towerlike construction, which could be described as a distant reminiscence of his Karlsplatz project (Cat. 287). From this earlier project the idea of extensively glazed facades may also have originated. Actually they would have been out of place in the climate of Addis Ababa, as Neubacher subsequently explained in a letter. The monumentality of the House of the Armed Forces was completely lacking in this design; rather, it shows a clear striving for maximal "objectivity." The project seems to have been dropped by the city in 1955, for in a letter from this year Neu-

bacher wrote, "It remains to be seen how the old projects (e.g., the city hall) continue to develop."

The postwar years brought an accumulation of nonarchitectural responsibilities as opposed to design commissions, such as membership in the Art Senate and the role of commissioner general of the Austrian section at the Venice Biennale. Hoffmann was also responsible for the graphic design of some of the Austrian Biennale catalogues—the last one in 1956.

Soon after the end of the war, Hoffmann again took up the design of bookbindings and book graphics, an interest that indeed goes back to the beginnings of his career.[25] He designed covers for the periodical *Die schönen Künste* and the almanac volumes of the Agathon editions that his friend Rochowanski produced. In addition, there are many sheets of graphic designs (fig. 297) from this period, mostly pen drawings done for no

226

297. Decorative graphic studies

particular purpose, only a few of which became known through publication.[26] Viewing these drawings as a group, one finds that while the individual sheets appear quite different and display an enormous wealth of the most varied designs, in the last analysis they go back to comparatively few basic motifs and were created by means of comparatively few formal devices. There is an evident parallel between these drawings and the way in which Hoffmann's architectural designs were generated by means of typological points of departure and selected formal operations. The most important basic motifs of the drawings are: plant forms, which predominate, as well as stylized linear compositions derived from them; fantastic rock and landscape formations with vegetation in which small buildings might be placed; architecture (skyscrapers) and architectural elements (capitals), now and then overgrown by plant growth; stylized human figures frequently in close connection with forms of vegetation; and purely abstract linear patterns. Among the plant motifs there are curving stems and twigs with leaves, blossoms, buds, panicles, umbels, ears of grain, and in addition shapes like seaweed. There are works that look almost like studies from nature, and others where stylization and abstraction have progressed so far that one can hardly recognize the vegetal origin.

Some of the abstract linear motifs recall Hoffmann's graphics from the period of the Secession, and the stylized plant forms not infrequently relate to patterns of the 1920s, above all to designs by Dagobert Peche who had also favored the decorative fusion of people and vegetation and even used the theme of Daphne[27] which Hoffmann also employed. In some cases, however, one has the impression that the sheet owes at least as much to the pleasure of intuitively pursuing a curve as to any generating motif. As far as the formal operations are concerned, Hoffmann applies various kinds of symmetry (bilateral, translational) along with the multiple repetition of parallel lines recalling his preference for multiple framing in architecture. In addition, there are frequent contrasts between simple, bold flourishes and small, accompanying complements, mostly with the flourishes in double curves forming elegant serpentines.

The total impression left by these compositions is one of much elegance and arcadian serenity. A unique poetic peace imbues these landscapes, architectural images, and graceful human beings, which all seem to become one with the sprouting, blooming vegetation. Since the beginning of Hoffmann's career, real or symbolic gardens and forms of vegetation played a significant role in his architecture, and one recalls his gentle manifesto of the "dream of an existence in beauty, goodness, and harmony."

Hoffmann's eighty-fifth birthday turned into a triumph: congratulations arrived from leaders of the architectural profession in many countries. He was awarded a very well-endowed special prize in Austria, and in Belgium, a high decoration. To accept it, he and his wife traveled to Brussels where the Stoclet family opened their house for a magnificent celebration. He was particularly pleased to find that his greatest and most famous building was in perfect condition and as much admired and appreciated as ever, and he even took the trouble to descend into the basement of the building in order to establish to his satisfaction that his construction had withstood the test of time in every way.

After his return to Vienna, he was busy with preparations for the Venice Biennale, when, on 7 May 1956, he suffered a fatal stroke. On 15 May he was buried in an honorific tomb at the Vienna Central Cemetery. The most fitting obituary was contained in a short message of sympathy Le Corbusier had telegraphed: "I must tell you how much grief I feel, how much respect I had for him as a person. Fifty years ago he was already one of the lights of the architectural route."

Le Corbusier spoke of fifty years; the total of Hoffmann's creative activity actually comprised one more decade—his project for the Rome Prize (Cat. 2) and that for Addis Ababa (Cat. 403) were separated by sixty work-filled years. In the course of those years, European architecture changed more thoroughly than rarely ever before, and Hoffmann was a leading protagonist in this change. One need only compare the Rome Prize project with the Purkersdorf Sanatorium, or the Moll/Moser House with the Ast Country House to understand what this meant.

The life work of every architect can be scrutinized for the changes in it, or for what remained unchanged. With Hoffmann it is not difficult to recognize the phases of change: the historicist beginning, a brief period of curvilinear Art Nouveau, a period of geometric purism or elementarism, a classicism side-by-side with folkloristic regionalism of increasing decorativeness, an Expressionist interlude, and finally the acceptance of stylistic features from the Modern Movement. Out of this came, in a strongly personal formulation that never entirely lacked decorative additions and a relation to classicism, the style that remained characteristic for the remainder of Hoffmann's activity—albeit with concessions to the taste of the years after 1938.

If, in this stylistically varied picture, one seeks the

constants to characterize what—other than the change-fulness itself—is typical of Hoffmann, one finds comparatively few factors. Discussion of them is only meaningful in connection with a comprehensive visual documentation, for concepts alone cannot entirely cope with things that themselves are the results of visual thinking.

If Le Corbusier, referring to neoclassic architectural theory, once spoke of unity in detail and tumult in the whole,[28] in the case of Hoffmann the opposite applied. For his built volumes and facades, he preferred simple forms conveying an overall impression of unity, but he subsequently enlivened them with additional elements (light superstructures, crowning features, flags) and with a richness of detail that at times could be overdone. In a similar manner, his furniture and work in the decorative arts in most cases is distinguished by unity and clarity in the overall form, often accompanied by a strong measure of added decoration. To achieve unification and the creation of visually ordered relations in space, Hoffmann employed the same artistic means again and again, even although from case to case the formal language might vary a good deal. The means included limitation to a simple geometry of basic forms; visual simplification, extension, and completion; symmetry; axiality; and above all repetition and framing.

For the basic forms just as for the treatment of surfaces, the clarity of strong contrasts was preferred—with a special bias for playing out oblique lines (broken lines) or curves against a reference system of horizontals and verticals. To achieve simplification, cornices were omitted, windows were made to sit on the edges of socles and on stringcourses, and roof edges were set back behind the plane of the facade. For purposes of visual extension, parapets, garden walls, rows of piers, and pergolas were employed, in many cases in such a way that they were closely linked or even fused with the adjoining wall surface. In a similar manner, symmetries were created—frequently, for example, by the rhythmical subdivision of an opening into three parts—and axial relationships between elements of the building, the furniture, and the garden design were established. One detects the contin-

ued effect of the principles of classical composition, such as Otto Wagner had taught them. Peculiar to Hoffmann's employment of symmetry as an ordering principle is his tendency to create ambiguity by assigning one element of composition to more than one system of symmetry. Also especially characteristic is the preference for tectonically ambiguous or outspokenly atectonic solutions.

Hoffmann particularly enjoyed the use of reiteration, with multiple framing and staggering as special cases. To repeat is a positive gesture of ordering; it underlines and emphasizes and, therefore, enhances the effect. Like a word that simple in itself may acquire a magical effect through repetition, a multiply-framed surface may assume the character of a picture, and a simple configuration of repeated lines may become an ornament. Hoffmann was familiar with this from his graphic works and from the design of surface patterns, where the application of repetition and symmetry belongs among the basic devices that one learned at the beginning of one's training in stylization.[29]

With these artistic means as tools, a rich store of typological models as points of departure or linkage, and an inexhaustible imagination, it was never difficult for Hoffmann to begin working. Like many artists, he knew that what mattered in designing was not to wait for a "creative moment," but to give imagination the opportunity to realize itself through a method, even a routine, of creative work. Hoffmann made this possible by an act of will that had become habit. It was guided by an unchanging sense of artistic direction—from the very early imaginative designs for Mediterranean villas in parks, through the executed garden villas, led by the Stoclet House, to the late, half-utopian studies such as the one (Cat. 447) in which, in five upper stories, hanging gardens alternate with largely glazed luxury apartments. From all these the same mood of *Luxe, calme et volupté*[30] emanates as from the precious vessels, utensils, and pieces of jewelry Hoffmann created. His architecture was a profession of faith in the possibility of a life rendered happy through beauty.

298. Josef Hoffmann, about 1925(?), portrait photograph

X. Hoffmann the Man, the Artist, and the Teacher

Josef Hoffmann's human and artistic qualities have been remembered and described in very different ways by his contemporaries.[1] Because the image of Hoffmann as a man has to be pieced together like a mosaic from many small fragments of information, the margin of error is great and the possibility of achieving completeness, small. Nevertheless, in the following attempt at characterization, conjectures and unduly speculative interpretations have been avoided as far as possible.

While Hoffmann was amiable and sociable, he was at the same time not easily approachable. One might almost call him taciturn. He was anxious not to afford anyone glances into his private life, and once he jokingly objected to housing developments because "one cannot lead an immoral life . . . inside a housing estate [Siedlung]."[2] About his reticence or reserve there was unanimity among all his former students, collaborators, and acquaintances who were questioned. "He was as if inside a cellophane skin and did not permit anything to rub off on him, and he also appreciated this quality in others," a collaborator[3] from the Künstlerwerkstätte remembered. "He was laconic, humanly very unapproachable . . . ,"[4] one of his pupils stated, and this is supplemented by similar statements from others, such as: "He faced us, his pupils, with a, I should say, conciliatory inaccessibility,"[5] and "he never showed any stirrings of emotion."[6] His former assistant Leopold Kleiner, author of the first book about him, was deeply disappointed that Hoffmann showed no reaction whatsover when the volume was handed to him. Kleiner concluded, "It was impossible to come closer to him humanly. He always kept secret anything [personal]."[7]

This went so far that for a long time his closest collaborators were unaware of the existence of his only son, Wolfgang, born in 1900,[8] until one day a grown young man appeared at the School of Arts and Crafts, where he studied with Oskar Strnad. Hoffmann for a while kept his bachelor's quarters at Margaretenstraße 5 and permitted acquaintances to accompany him home to this address, giving no indication that he had a second apartment at Münzgasse 5, where little Wolfgang and his mother lived until 1905 when they moved to Neulinggasse 24.[9] Later when Wolfgang himself was already married and had emigrated to the United States, his father informed him of his second marriage only after a delay of almost one year. At his son's departure, Hoffmann's words of farewell were: "Never forget that you are a gentleman and make no debts!"

Wolfgang Hoffmann had inherited something of his father's talent and in the United States managed to have some designs executed, but he lacked his father's strength of will and the energy to establish himself as an architect in his new homeland. Nevertheless, and without regard for the wishes of his family, he later refused to return to Austria. He summed up his relationship to his father in the following words:[10] "You know, we were never very close." An exchange of letters between father and son shows, however, that during the last years of Hoffmann's life, the relationship visibly improved, and above all it gave a great deal of joy to the octogenarian to learn of the birth of a grandchild, Pamela. The account of Wolfgang's widow about his death in 1969 proves that the inner connection between son and father was deeper than it appeared. In his final delirium, Wolfgang time and again conversed with his father.

Josef Hoffmann himself enjoyed a happy childhood, sheltered in a rural family circle that provided stability for his early character formation. He was very attached to the home of his youth. Not only did he return to Pirnitz for recreation again and again, he also still attended "Pirnitz evenings" in a Viennese restaurant in the 1920s.

During early adolescence, Hoffmann experienced his first serious crisis, and its external climax was that he failed secondary school. But there are no indications that he suffered the typical problems of puberty. We learn instead that by the time he left the Höhere Staatsgewerbeschule in Brünn, he was already a good dancer, that he also attended dancing lessons during his subsequent stay in Würzburg, and that in Vienna he liked to become acquainted with women by participating in the great fancy dress balls. On such occasions his characteristic charm did not fail to have its effect.[11] It was at such an event that he met his attractive first wife, a cashier in a coffee house, but we do not know whether it was at that memorable architects' ball of 1897 when Olbrich was the president and Wagner the honorary president of the ball committee.[12]

When dealing with others Hoffmann was generally kind, accommodating, and generous, although occasion-

ally he could also be sarcastic or malicious. He surprised friends and their children with exquisite gifts on all kinds of occasions, and the poet Peter Altenberg, for example, once thanked him for his kindness with the following dedication:[13] "Accounting. . . . and then I remember those who were mild to me because for some light they forgave my darknesses." Hoffmann more than once proved by his words and behavior that he strove for a fair attitude toward people even if, like Adolf Loos, they were his professional enemies. In an essay about Viennese furniture design, Hoffmann praised the Kärntner Bar by Adolf Loos as a "jewel" even though Loos mercilessly criticized his own works.[14] Hoffmann was considered unshakably calm, a "man who does not know nerves . . . he keeps his equanimity and immediately has a way out, makes a virtue out of every necessity. Annoyance, disappointments, the world once more nailed shut by planks . . . , he collects himself and spreads composure around himself." "He was tranquility and assurance incarnate."[15] But appearances were deceptive; he could react explosively, and this often took the form of an abrupt withdrawal, for example by giving up membership in an association or resigning a commission. Hoffmann was capable of refusing a decoration he considered too small,[16] without regard for the personal consequences.

According to several corroborating descriptions, Hoffmann displayed some striking idiosyncrasies in his dealings with people. For example, he was very particular in connection with everything that had to do with direct contact or touching, and he paid special attention to his hands. For him, the pioneer of artistic handicrafts—work of the hands—the hands seemed to bear witness to an ethically correct life, and he wrote in this connection:[17] "beauty . . . is a consequence of centuries of caring and ordering . . . care includes the improvement of outer and inner man. Men who do hard work such as sculptors . . . can have beautiful hands just as every worker. . . . for every kind of work with the hands there has to be . . . the correct cleanser. It is not unimportant but absolutely necessary . . . the worker has no inkling of what enormous potential of cultural power he possesses through his work." Hoffmann once wanted to leave a gathering when a lady with red lacquered fingernails entered. He had to force himself to shake hands, and according to the statement of a close collaborator, he would never have offered a job to anyone with "bad hands." He also refused to eat dishes prepared by a cook whose hands he found repugnant, and in general it was wise to keep him away from a disorderly kitchen, if one didn't want to risk his declining the food prepared in it.

Hoffmann avoided, at all cost, people he deemed unpleasant, even at the price of having to hide for a while in his private studio. He also found it embarrassing to be visited by foreign admirers or to be praised in public; occasionally he even displayed a certain shyness toward his clients. Instead of negotiating personally, he would rather send his office manager as a substitute, for example, Max Fellerer or Oswald Haerdtl. Yet to some of his clients Hoffmann remained a personal friend for many years; they were fascinated by the ease of his formal invention and attracted by his strong personal charm. When Sonja Knips showed her house in Döbling to some young architects a few months after its completion, she asked if perhaps they knew of a buyer for the house—because she would have liked so much to build another house with Hoffmann![18] In keeping with this attitude she insisted that nothing at all of his interior design and furniture be changed. Unfortunately, there were also cases time and again when Hoffmann's lack of interest in the budgetary aspects of a commission led to serious difficulties. The remodeling of the Nebehay Gallery (Cat. 245) is a good example of this: when the final bill more than doubled the amount of a predetermined limit, the client refused to pay—something which apparently Hoffmann was unable to understand, since he wrote to his son about this matter:[19] "Nebehey [sic] . . . for some reason has completely let us down with his payment. It is a severe blow for the office. They all don't want to tell me the whole truth [reinen Wein einschenken] about what has happened."

One gains the impression that what interested Hoffmann most was the pure invention of form and the act of designing; all further steps in the lengthy process of finishing a building seem to have been of minor importance to him, and financial matters remained entirely in the background. He was not a good businessman and once remarked, "If I see an architect with a bank account, I am already suspicious." He was always inclined to underestimate the fee for his designs of objects and patterns, perhaps because designing came so easily to him and gave him so much pleasure. More than once it happened that he asked a colleague how much one might charge as fee for a certain design.[20] The motto "Live and let live" might have been invented by Hoffmann; his positive attitude toward and sensuous enjoyment of life constantly led him to seek company, preferably artists, either in a coffee house or restaurant, or in a bar, or at the Heurigen, that typically Viennese institution where, in a garden close to the vineyards, one drinks new wine. On such occasions he showed a naive pleasure in prac-

299. Josef Hoffmann in Kolo Moser's studio, about 1898

300. Josef Hoffmann at a building site, 1903

301. Josef Hoffmann (right, seated) and Kolo Moser (extreme left) at a party on the occasion of Moser's wedding, 1905

302. Josef Hoffmann at the building site of the Kunstschau 1908, with Karl Witzmann (left) and Eduard Wimmer

303. Emil Orlik, portrait of Josef Hoffmann, color woodcut, 1901

304. Josef Hoffmann with his hosts at St. Idesbald near La Panne, Belgium, about 1906(?)

305. Josef Hoffmann with sketchbook in Rome

306. Hoffmann's first wife, Anna, *née* Hladik, in the apartment at Neulinggasse 24

tical, often rough, jokes that were frequently at the expense of friends who did not share his tolerance for alcohol. For himself, however, he refused to participate in any improvised mischief, especially when there was a danger that he might find himself in a ridiculous position. There is no evidence to the rumor that Hoffmann spent a large portion of the fee for the Stoclet House with his collaborators and friends during a grandiose stay in Paris, but this story circulated in Vienna. By contrast it is established beyond doubt that during his stay in Paris on the occasion of the 1925 exhibition he spent money very liberally and usually returned to his hotel long after midnight.[21]

Hoffmann always valued a good appearance, and the colors gray, black, and white were his preferred personal choice in dressing. As far as dressing for the evening was concerned, he was of the opinion that—in contrast to the many colors of women's fashions—men should wear only nonchromatic hues. Gabriel Guevrekian,[22] who worked for him in 1920, described him as "the most perfect gentleman, le grand seigneur. . . . He was always smartly dressed, very often in the company of smart and beautiful women . . . ," and Ernst Schwadron remembered Hoffmann with almost identical words: ". . . always elegantly dressed, with Homburg hat and walking stick . . . surrounded by pretty women." To shatter his apparent indifference seemed to pose a special challenge to some women and—as with Klimt—in the circle around Hoffmann there was no lack of stories and rumors about the well-guarded secrets of his private life. His second wife, Karla, whom he married in 1925, was a much-admired beauty whom he had met through her job as a model in the fashion department of the Wiener Werkstätte. She later took excellent care of him in his old age and outlived him by almost a quarter of a century.

The apartment in Vienna IV, Schleifmühlgasse 3/Paulanergasse 12, where Hoffmann lived for many years, housed in a rather constrained space a collection of toys, popular and oriental art, and arts and crafts, as well as a large number of unframed Biedermeier portraits that were displayed in such a manner as to cover the walls of one room completely.

Hoffmann's health was not the best, even though he undertook several nature and regeneration cures and observed special dietary and sleeping rules.[23] At the end of 1919 he was forced to spend an extended period in a sanatorium on the Semmering, and in 1923 his condition was so serious that at times one feared for his life. He suffered from occasional losses of consciousness, and he underwent treatment for nervous conditions and weak-

307. Hoffmann's studio in the School of Arts and Crafts, about 1924

308. Josef Hoffmann "flying" with his collaborators (right to left) Camilla Birke, Hilde Polsterer, Christa Ehrlich, humorous photo from Paris(?), 1925

ness of memory about which he complained in letters to his son and to Wärndorfer.[24] On 27 August 1927, he wrote to Oswald Haerdtl:[25] ". . . for the near future my illness precludes any kind of intensive activity in my office . . . ," but by the time of his sixtieth birthday in 1930, he had overcome this crisis, and despite the hardships and deprivations of the war and postwar years he reached a stable old age untroubled by any serious illnesses. During the years after the Second World War, one found him again in sociable company in a coffee house or at the Heurigen, and at the great carnival festivals of the Secession one could still meet him frequently, even at late hours, surrounded by young people.

Hoffmann traveled a good deal, mostly on business and in order to inform himself about the most recent developments in his profession, visiting, for example, the Bauhaus and the Weißenhof estate. He declined all

309. Josef Hoffmann, August 1931

310. Hoffmann's second wife, Karla, *née* Schmatz, photograph from her youth

invitations to go abroad permanently (Darmstadt, Dresden, New York),[26] but it is known that he visited Belgium, Czechoslovakia, Germany, France, Great Britain, Holland, Italy, Yugoslavia, Poland, Scandinavia, Switzerland, and Hungary; he also probably visited Rumania.

After 1912, when the architectural section of the Wiener Werkstätte was discontinued,[27] Hoffmann had his own office in the School of Arts and Crafts (fig. 307). It consisted of a small anteroom, his own narrow room, and the drafting room in which the tables stood at right angles to the window wall, with the office manager in the first row and behind him a group of draftsmen which was never very large. Hoffmann, like Otto Wagner, observed a precise daily routine. He never varied the hour when he came into the office, when he went to criticize the work of his class, and when—usually in the company of a crony, such as the sculptor Michael Powolny—he would walk along the Ringstraße to repair for lunch to his favorite restaurant. He also always went to the same coffee house where he was the center of a regular circle. One day when an artificial palm tree appeared and was not removed despite Hoffmann's protests, he changed

coffee houses. He liked to bring along to the coffee house, and sometimes to the Heurigen in the evening, the numerous visitors from inland and abroad who had come to study the Viennese art and architectural scene and who frequently made a point of visiting Hoffmann first.

Among these visitors were the Frenchmen Fernand Léger, Jean Lurçat, and Paul Poiret, the Dutchmen Hendrikus Berlage and Theo van Doesburg, the Italians Marinetti and Prampolini, the Scandinavians Asplund and Tengbom, from Germany Walter Gropius, Bruno Paul, and Richard Riemerschmid, and, last but not least, the great American Frank Lloyd Wright who, returning from Russia, visited Hoffmann and spent some time with him at the Heurigen.[28] On such occasions Hoffmann avoided any kind of hard theoretical debate, which he deemed useless. His distrust for intellectual theorizing about art probably finds its clearest expression in a statement he made when he declined an invitation to give a radio talk about art. He explained: "What should one say about art? To make it or to leave it! There is nothing to talk about, is there?" On another occasion he said: "There are two kinds of artists, the ones who build up a matter

236

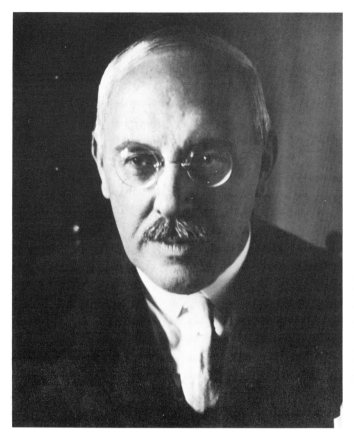

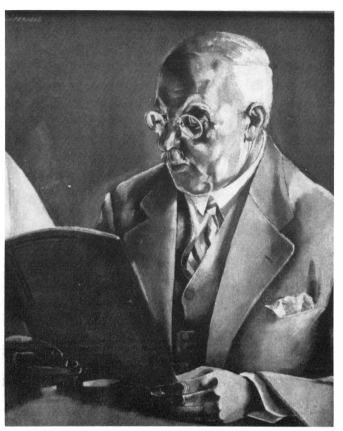

311. Josef Hoffmann about 1930

312. Albert Paris Gütersloh, portrait of Josef Hoffmann, oil

rationally and develop it systematically, and the others who have a sudden inspiration—I am more for those with inspiration. One should not obstruct the intuition. . . . I for myself always have to close my eyes and imagine the matter before I begin it."[29]

As an artist, Hoffmann possessed a securely established, strong character; in the words of Richard Beer-Hofmann, he had the gift "to remain willingly wide open to all living, future-oriented currents of his time—and yet to remain the incorruptibly faithful guardian of the innermost core of his own being."[30] Absolute confidence in his own intuition gave him certainty of decision and the power of conviction during the process of implementation. His creative imagination was inexhaustible and he had made a habit of pursuing its ideas to the last consequence without compromise, even if the results looked unusual and perhaps strange. Motifs once deemed successful were applied in ever-new variations until new formal inventions replaced them. Accordingly, there are what might be called genuine leitmotifs for certain periods. For example, the multiple frame, the vertical fluting of wall surfaces, the horizontal striation or molding

after the manner of the Paris pavilion of 1925, or the treatment of a cornice with multiple repetition of a profile. Such leitmotifs are also characteristic of Hoffmann's designs in the decorative arts, as has been shown earlier.

Architectural motifs for Hoffmann were elements to be applied freely according to the judgment of the designer, and they did not carry a meaning that involved the whole building, as Le Corbusier had insisted they do in "Five Points of a New Architecture."[31] In many cases the motifs apply only to the articulation of surfaces or built volumes and do not involve the conception of space. This may have something to do with the fact that Hoffmann's preferred method of allowing the creative imagination to unfold freely was to invent decorative patterns, something which, as we know, he also considered very important for his students. Here he was able to abandon himself to the pure invention of form—unhampered by such external objective constraints as function and construction. In this sense, decorative design was for him what painting was for an architect like Le Corbusier: the possibility and the coercion of a direct creative confrontation with form and color—though coming from dif-

237

ferent assumptions as far as content is concerned. The painting of Le Corbusier is meant to convey a message, albeit an hermetic one, while in most cases the significance of Hoffmann's patterns resides directly in their decorative presence; he is interested in the form, not in its significance, and therefore he does not hesitate to utilize, for example, the same form of a stele for a tombstone (Cat. 253) and for the sign of a coffee house (Cat. 266) (fig. 245). All observers who have commented on Hoffmann's designing note that he put his form on paper with great facility and incessantly—supposedly even during attendance at concerts.[32] His favorite composers were Mozart and Richard Strauß whose *Rosenkavalier* and *Salome* he particularly admired; he disliked piano music, however.[33] While he was designing, he would occasionally sing to himself, and at the Heurigen too he enjoyed the performance of good singers.

It is well known that architectural designs represent only a fraction of Hoffmann's total activity as a form giver, and it is certain that his designing for the decorative arts contributed significantly to his facility in finding formal solutions in architecture. He characteristically designed without T-square and triangles or the aid of transparent paper, and in contrast to many of his colleagues he never resorted to repeated redrawings on superimposed transparent sheets. If a design did not please him after the first attempt, he began afresh, drawing a series of other solutions which might be similar or completely different. This may be seen very clearly in the designs for the synagogue at Sillein (Cat. 285) and for the Otto Wagner Monument (Cat. 323) (figs. 258-261). It is striking that in every case there is no slow groping toward the final solution but an evaluative comparison of different possibilities, each drawn without hesitation, in one go.

Hoffmann's freehand drawings of plans, elevations, and sections were usually done on (horizontally and vertically) ruled paper, often directly in ink or india ink with very little if any dependence on preparatory pencil lines. The additional use of crayons, washes, and watercolors frequently produced sheets that are graphically very attractive. The indication of planting with trees and bushes, drawn lovingly and with graphic skill, played an important role, and occasionally complicated details were rendered in small additional sketches on the same sheets. While designing, small perspective sketches were also drawn and their vanishing points positioned so that dramatic foreshortenings contributed to the three-dimensional effect and the clarification of spatial relationships (cf. Cats. 467, 476, 486). Former collaborators report

that Hoffmann regularly brought his designs to the office completely finished in all essentials, ready to be drawn up and detailed.

Drawing is a manner of thinking—visual instead of conceptual thinking. Though Hoffmann was very curious intellectually—he owned a large library and once declared, "I have read selectively all sorts of things"—he, like other important architects, was primarily a visual and not a conceptual thinker. He was suspicious of any conceptual analysis and explanation of visual events and experiences and when one of his assistants once asked him:[34] "Professor, how actually do you do this [the designing]?" Hoffmann replied: "I simply do not know." In the same spirit he wrote to Oskar Kokoschka:[35] ". . . you know that intelligence and excessive knowledge kill the cultural impulse . . . only the right sensitivity and the inborn feeling count." He expressly acknowledged basic principles, but these were ethical or moral and not aesthetic in nature, dealing with respect for the appropriateness of a solution to a given purpose, to the nature of a material, and to one's own period. They stemmed from the teachers of his youth—Ruskin, Morris, and Otto Wagner—and they remained constant throughout his career. An ethical principle equal if not superior to his convictions about appropriateness was the profound conviction of beauty's power to bring happiness.

Great architects are characterized by three qualities: they have "talent," i.e., they possess creative imagination and are gifted visually; they have an intellect strong enough to grasp quickly the essential problems of a task and to recognize the right path to their solution; and they are endowed with sufficient power of will and strength of character to enforce a correct design solution and to guard it from inadmissible compromises. The share each of these qualities has in the total makeup of an architect will vary from case to case and will help to determine the unique character of the particular creative achievement.

Hoffmann never displayed a lack of will power; having asserted even at the beginning of his career,[36] "Most designing artists do not lack talent so much as character," he proved his own strength of character more than once—most dramatically by resigning from a commission when he recognized that it would be impossible to find a common denominator for his own intentions and those of the client. His pupil Viktor Winkler remembered being present at a crucial meeting when a project by Hoffmann for a housing estate was discussed and did not meet with the approval of the authority that had commissioned it:[37] "Hoffmann sat among the participants in the meeting

313. Sergius Pauser, portrait of Josef Hoffmann, oil, 1951

314. Josef Hoffmann in dining car on trip to Brussels, 1955

315. Josef Hoffmann with Mme Jacques Stoclet at a banquet in the Stoclet House, 1955

316. Josef Hoffmann about 1955(?)

like a block and repeatedly stated that he could not understand what they actually wanted from him. He finally succeeded in inducing the presiding official to sketch his own concepts, then he got up and declared that for him something like what had just been sketched was unacceptable and he gave back the commission.'' Basically however Hoffmann was not at all a contentious person and preferred to avoid altercations.

Mäda Primavesi[38] summed up her memories of Hoffmann by stating that with him one had ''the sentiment of a quiet kindness'' and that ''he said much which impressed one deeply.'' Many others corroborate his capacity to impress, the sense that from him came a ''strong positive emanation.'' To this quality among others Hoffmann owed his signal success as a teacher. It is true he did not leave behind a school linked by a common doctrine as Otto Wagner had; instead he brought about the fullest unfolding of the enthusiasm and creative potential of a large group of highly talented young men and women who were to play an important role in Austrian architecture during the first half of the twentieth century, and even later. But it would be erroneous to assume that Hoffmann's influence remained restricted to Austria. In 1920, Hartwig Fischl, reviewing Hoffmann's activity in retrospect, stressed the pedagogical component of his activity and its wide influence.[39] ''He became the leader of a rising young generation from which again and again new productive forces . . . became leaders themselves. . . . As a teacher and creator, fructifying and shaping anew, Hoffmann has managed to raise Austrian artwork to a height whence it shines brightly beyond the borders of the narrow fatherland, radiating its effect afar. . . . In this power of his artistic work and his character to win over . . . in this multiplicity of his effects, resides the greatest importance of his work.'' Hoffmann taught from 1899 until 1936, the year in which he retired— very much against his will.[40]

Although he had taken over a special class for architecture, his students' activities were not at all restricted to architecture alone, and the first student projects, published in 1899,[41] were of decorative patterns. A few years later, numerous student projects for furniture and interiors—strikingly uniform and strictly disciplined in attitude—were published in a special issue of *Das Interieur* and elsewhere.[42] Looking at these designs, one understands what Eduard Leisching was referring to when in 1906 he wrote about the Hoffmann School:[43] ''Knowledge of the material and permeation of the form by the purpose of its existence, in an almost taciturn conciseness, are the bases of this school in which young people

design furniture and small objects of all kinds but also houses and gardens.''

Similarly, A. S. Levetus stressed the versatility of instruction in her report.[44] The same image was conveyed by the regularly recurring school exhibitions: in 1912 one could see[45] interior design, architecture, furniture, vessels, fabrics, carpets, jewelry, and pattern designs which were described as ''color designs for patterning surfaces, executed in large scale.'' The close contact between school and life was stressed, and it was pointed out that many students who exhibited ''already came forward as independent artists with their designs for executing workshops.'' Leisching too expressly mentioned that ''Hoffmann has among his pupils a whole series of sons of cabinetmakers with whom the transition from learning to practice occurs very easily.'' From the years before the First World War, names such as Hergesell, Hollmann, Jonasch, Pospischil, and Ungethüm in the registers of Hoffmann's class prove the correctness of Leisching's observation—they coincide with the names of the most important firms of Viennese cabinetmakers of the period. At that time the class averaged about fifteen students, among them one to three girls in one year. By contrast, in the 1920s class sizes of thirty to forty pupils were normal, almost half of them girls. Obviously, the character of the school and the class had changed considerably, and in 1925 Oswald Haerdtl wrote, not without irritation:[46] ''. . . have not fallen out with Hoffmann, the matter simply does not suit me—above all this shocking girly-business [Pupperlwirtschaft].''

In view of so much female influence, it is not surprising that in an exhibition of drawings from Hoffmann's class of 1924 many fashion designs were displayed, a fact which Leopold Kleiner commented upon in the following manner:[47] ''. . . regardless whether it is a matter of architecture proper, or of designing a piece of furniture, a metal utensil, a wallpaper, a dress: there are always the same conditions of creation from which the work comes. As with all artistic achievements, they are based on the characteristic personal qualities of the creator . . . since the flowing of the mental-spiritual forces in the work is always based on the freedom of the individual, the class of Hoffmann offers to every individual the greatest possible freedom of development in every regard.''

Hoffmann accordingly refused to answer students who asked: ''What should I do?'' Or he joked: ''Have yourself photographed and copied!'' However, he insisted on neatness. He abhorred cigarette ash or burned spots, and he turned any soiled drawings over so that the students

could not see the design while he discussed it. Once when great disorder prevailed in the studio, he refused to review the work. The reason he gave was that "under such conditions architects certainly cannot be educated!"

Personal reminiscences of Hoffmann's students[48] from the 1920s enable us to get a fairly exact idea of the way the school functioned at that time. The students worked in two rooms, one of which was subdivided into cubicles, and an assistant was in charge of their care and supervision—first Leopold Kleiner and afterward Oswald Haerdtl. Hoffmann saw every student twice a week, usually starting his reviews with the women, and never said much; he would however, if necessary, draw on the sheets submitted to him with the unmistakable lines of a soft pencil which made it impossible for the student to continue the same drawing. In this manner he underlined his teaching that one should never try to emend but should always start afresh.

He tried to find something positive in every design, for example by covering an unsuccessful pattern design with pieces of paper until only a small area remained visible of which he could say that it showed a successful juxtaposition of color. Though he refused to give instructions and remarked, "I can only say what is bad, the good you will find for yourself . . . , if you are a talent," he sometimes made statements about matters of principle, such as the admonition never to make the same thing once small and once large, but instead to repeat the small unit several times. He suggested to a new student, Herbert Thurner, that he draw something so that his teacher might get to know him. When Thurner had designed a cabinet, Hoffmann asked what was inside, and when the student did not have an answer, he commented: "There are thousands of kinds of butterflies whom God has created, but every one has a heart, a lung, etc., so that it can live. But only when the dear Lord had something to spare, then he made it scintillate . . . and you can only make moldings if you have somebody who pays for it and if the function is correct."

Arts and crafts designs frequently were made for actual clients or sold to visitors who, like Paul Poiret and Jean Lurçat, might also come from abroad. There were continuous small internal competitions, and whoever won or sold something invited his closer friends from the class to a party, perhaps at the Heurigen. There were few funds but many parties, among them a costume party on the Leopoldsberg, and some students even formed a jazz band of their own. The loose, stimulating atmosphere of the class, like the total ambience of the school, was an essential constituent of the process of education.

There were frequent discussions of the latest art events, and occasionally Hoffmann might even show students "before a visit to the Heurigen" the houses at the Hohe Warte and in the Kaasgraben, or he would draw their attention to buildings by Josef Kornhäusel.

In 1924, Hoffmann explained his thinking about architectural education in an essay (Appendix 10), and in a letter on the same topic in 1925 he wrote:[49] "I should like very much to fulfill your wish and develop some program for the education of the architect.

"Unfortunately, I myself, probably because of absolute incapability, do not possess one.

"I confront the task constantly. Most of the time the human being, as such, interests me and I almost believe that an architect, who, for example, is capable of creating a good garment, should also be a good builder.

"In my school therefore everything which has any connection with the life of modern man is tried. . . .

"What matters to me are not necessarily new, but pure, free achievements.

"Naturally, I force nobody to make this or that. It is completely immaterial to me what happens to be tried or aimed for, as long as the result is noticeable.

"I should prefer that a young architect today not practice the usual designing.

"He should understand the task completely, above all from the human point of view, and then he should begin to create and build in three dimensions, not on the [paper] surface.

"Always, the human being as the one who enjoys his [the architect's] work must be kept in mind so that he [the architect] does not pursue false dimensions and senseless fancies.

"Intuitive contemplation of good art, not acquired learning, must school his sensitivity, just as with the musician or painter, and must awaken his spirit of invention not his imitative instinct.

"He must grasp fully and entirely the time in which he lives. . . .

"He must have a sense for all technical and industrial innovations, recognize these as his most important stimuli, and make nothing that would stand below the level of these manifestations and therefore would be senseless.

"Whether despite this or precisely for this reason something wonderful originates will depend only on the talent of the individual . . . what nature by itself has put into each of our young artists, we cannot bring forth artificially.

"We must at best recognize it in good time and incite

and promote it constantly. We must know to appreciate it with sincere admiration.

"To recognize in this connection what can be stimulating and useful for a young artist, this is what constitutes the quality of a teacher.

"The young themselves are the best judges of this capacity, which has to be just as inborn as talent itself."

When Hoffmann sensed talent, he was ready to promote it. Le Corbusier,[50] Egon Schiele, and Oskar Kokoschka all benefited from Hoffmann's support. Schiele was aided and encouraged by Hoffmann in many ways,[51] by the acquisition and the sale of drawings, by arranging for him to meet Dr. Heinrich Böhler, who took painting lessons from him and gave regular financial subsidies, and by prominently displaying his works in exhibitions for which Hoffmann was responsible. Among these the most important was probably that in the Austria House of the Werkbund Exhibition in Cologne in 1914 (Cat. 182). Kokoschka was granted commissions for the Wiener Werkstätte and promoted through the invitation to collaborate in the Fledermaus Cabaret as well as by an exhibition of his works in the 1908 Kunstschau. He remained well disposed and grateful to Hoffmann,[52] though he developed closer relations to Adolf Loos. Finally, Oskar Strnad, Hoffmann's colleague as teacher at the School of Arts and Crafts, wrote to him on the occasion of his sixtieth birthday:[53] ". . . in your sphere of influence everything becomes simple and easy. You help all in whom you believe. You have smoothed my way."

Hoffmann frequently helped his pupils on the road to professional success by trusting them, despite youth and inexperience, with responsible work in connection with his own commissions, perhaps having them arrange a complete interior, collaborate in decorating, or take over the site supervision at an exhibition. It is impossible to discuss in detail here the achievements of Hoffmann's pupils, even if one were to select only the most important, since during almost four decades approximately four hundred students from home and abroad passed through his class. It is possible however to pursue a thorough, although not complete, study of his activity and importance beyond the framework of the school by means of the critical evaluations his work underwent during the course of the years.

After the first positive references, above all from Ludwig Hevesi, a thorough, well-illustrated review of Hoffmann's work appeared in *The Studio* in 1901; it deserves special notice because it was written by the painter Fernand Khnopff and because *The Studio* served an extensive international circle of readers.[54] Khnopff pointed particularly to the good reviews Hoffmann had received on the occasion of the Paris Universal Exposition, and he characterized him as "essentially rational and reasonable in all he does, with compositions that are never extravagant, never intentionally loud as are those of some of his more western *confrères*."

A year later the periodical *Innendekoration*, published by Alexander Koch in Darmstadt, devoted to Hoffmann a long, richly illustrated essay[55] by Joseph August Lux. Koch as publisher and Lux as writer were destined to play a not unimportant role in Hoffmann's future career as well. Koch gave sumptuous special presentations to the Wiener Werkstätte between the years 1904 and 1907, and he often prominently featured Hoffmann and the Wiener Werkstätte in the periodical *Deutsche Kunst und Dekoration*, which he also published. In this manner he contributed a great deal toward making the Austrian architect internationally known. In addition he paid regular visits to Vienna even in later years. Lux, who among numerous other works published monographs on Otto Wagner and Joseph Olbrich, collaborated closely with Hoffmann as editor of the *Hohe Warte* and frequently wrote about his work. In an article of 1902 he compared interiors by Hoffmann with those of the Biedermeier, expressing the opinion that in both he could sense the Viennese *genius loci*; for him, "the achievements of Hoffmann" were "an important beginning toward that desired folk art that is not only the prerogative of the privileged classes but the union of all expressions of life of wider and wider circles of people."

Berta Zuckerkandl, who, like Lux, was to speak out frequently on Hoffmann's behalf, dealt with his architecture and its principles in 1904, in a long, heavily illustrated article in *Dekorative Kunst*.[56] She stressed his ethical motivation and declared: "With him creation and personality are one. His artistry grows from his ethical and social views. . . . after a struggle he has reached the conviction that a style can be shaped only by recognition of the psychic and physical needs of a time, by translating this recognition into forms that are logically shaped and that stress the purpose as clearly and strongly as possible!" But entirely in the spirit of what Lux had maintained, she added: "By linking himself to the genuinely vernacular, the artist now has spread the veil of sensuous beauty over the unyielding constructional purity of his shapes," and in this context "genuinely vernacular" meant the Biedermeier style. For our purposes it is interesting that in 1904, the year of the Purkersdorf Sanatorium, this article could conclude with the statement, "Professor Hoffmann has made his way in a surprisingly short time

242

. . . today he is already somebody recognized and appreciated over a wide area." Five years later, L. E. Tesar made a similar statement:[57] "Foreign countries know the name of Hoffmann and when they mention it, the reverence induced by everything artistic is tinged by the enticing memory of Vienna, whose colorful joyousness, architectural culture, and music of lines the Master unites in his oeuvre."

Periodicals not published in German were of special relevance for Hoffmann's growing recognition abroad. Among them at least two deserve special mention: on the one hand the Parisian *Art et Décoration*,[58] where M. P. Verneuil sympathetically discussed and characterized Hoffmann's style, and *The Art Revival in Austria*, a special volume arranged by the editor of *The Studio*, which appeared in 1906 and contained a thorough, well-illustrated discussion of Hoffmann's oeuvre by A. S. Levetus, the Vienna correspondent for *The Studio*. It was the article in *Art et Décoration* that helped draw the attention of the young Jeanneret to Hoffmann; he later used an illustration of the dining room for Max Biach in his book *L'Art décoratif d'aujourd'hui*.

Aside from the numerous shorter publications on Hoffmann's work which contributed to his professional reputation, his activity as a designer of exhibitions abroad made him a personality of European rank. Above all, the two great pavilions in Rome in 1911 and Cologne in 1914 together with the Stoclet House contributed most to his international reputation. Although the First World War severely interrupted this process of recognition, it could not destroy it. When Hoffmann celebrated his fiftieth birthday in 1920—Wagner and Olbrich were no longer alive—he was certainly the architect who, on the basis of his buildings and his work in the arts and crafts, was best known and most highly esteemed abroad. Appreciations by such outstanding experts as Hans Tietze,[59] Dagobert Frey,[60] and Max Eisler[61] demonstrate the extent to which his importance was recognized. Max Eisler wrote about Hoffmann in the Dutch architectural journal *Wendingen*. In 1916 in his book *Österreichische Werkkultur*, he paid special attention to Hoffmann's works, and in 1924 he was responsible for the entry on Hoffmann in the *Lexikon der bildenden Künste* by Thieme-Becker. Among these three art historians, all of whom stress Hoffmann's international significance as much as the specifically Viennese or Austrian character of his art, Tietze, despite his admiration, is the most critical. Speaking of the last great villas, he warned: "The spectre of *l'art pour l'art* menacingly hovers around these harmoniously shaped, artistically distinguished, organ-isms." In the arts and crafts, he deemed Hoffmann "responsible . . . for the rank growth in the direction of the odd, the playful, the pointless, that to the effortless Austrian talent is so tempting . . . because he did not know how to impose the strict self-discipline, which he himself owed to the training by Otto Wagner and which for his own person he never gave up, on that wide circle that he dominated as the leading teacher at the School of Arts and Crafts and through the weight of his personality."

In the same issue of *Wendingen* in which Eisler's essay appeared, the following appreciation by Oskar Strnad was also published: "Josef Hoffmann. A wonderful human being. Completely balanced. Everything he does is the result of purity of the heart. Modest, unselfish, cheerful, blessed by God with eternal youth. He always carries in himself the suffering of those people, so rare today, who experience space, and this enables him to clad in physical form everything he feels. Through this he is independent of everything historical, he is always himself, always new and always good. This makes him the culture bearer of humanity and his works so significant. Not the surface of the things created by him, but their spirit is what is wonderful."[62]

Hoffmann found the greatest recognition and appreciation in his sixth decade. This was expressed not only in his appointment to the jury of the most important international competition of the period—for the Palace of the League of Nations in Geneva—and in the award of international honors,[63] but also in the fact that there were a greater number of foreign publications about him, and he was invited to contribute the entry on modern interior decoration for the fourteenth edition (1929) of the prestigious *Encyclopaedia Britannica*. In 1924, twenty years after the first essay about Hoffmann in *Art et Décoration*, a long, illustrated article about him appeared once again in the same periodical.[64] The author, Leopold Kleiner, followed this with a book about Hoffmann in 1927. Also in 1924 the *Journal of the American Institute of Architects*[65] carried an article about Hoffmann's oeuvre by no less an expert than Peter Behrens. A few years later a second, longer essay about him appeared in the United States, this time in *Architectural Forum*, and the author, Shepard Vogelgesang, a student of Hoffmann's, maintained:[66] "No recent architect has influenced Europe more comprehensively than Hoffmann." Finally in 1929 Henry-Russell Hitchcock, doyen of American architectural historians, discussed Hoffmann extensively in his book *Modern Architecture, Romanticism and Reintegration*. In the chapter "The New Tradition in Austria and Germany," he wrote that after the death of Wagner

and Olbrich, "It was left to Josef Hoffmann to bring to its fulfillment the Austrian New Tradition."

It is particularly interesting to note how Hitchcock—presumably judging objectively as an outsider—saw the relationship between Hoffmann and his contemporaries. He wrote: "Hoffmann has had many pupils both in architecture and in decoration. . . . his influence has not been limited to his pupils. From Holzmeister through Strnad, Wlach and Frank, the architects of Vienna have followed him very closely . . . the only architect of Hoffmann's generation who stood apart was Adolf Loos.

"In Germany as well as in Austria, Hoffmann's manner has profoundly influenced the New Tradition. . . . Within the New Tradition as a whole there exist many focal points. Of these the versions of Wright and Berlage are perhaps the most intrinsically important. Their manners, derived on the whole from rationalized Mediaevalism; the more definitely traditional architecture of craftsmanship in England, America and the Scandinavian countries; and the Classically derived ferro-concrete functionalism of Perret in France are all perhaps less central than the version of the New Tradition exemplified by Hoffmann and those Austrian and German architects who have followed him."

As important as was Hitchcock's book for the United States, the volume on twentieth-century architecture in the series of the *Propyläen-Kunstgeschichte* was for the German-speaking readership. Its author, Gustav Platz, called Hoffmann a "fine and strong artist" under whose leadership the Viennese had undergone the "development towards the specifically architectural."

In 1930, the year of Hoffmann's sixtieth birthday, numerous short articles appeared, and also a new book by Armand Weiser and a Festschrift with appreciations from around the world. Excluding the Austrian contributions, letters were received from the following: Gunnar Asplund, Peter Behrens, Hendrikus Berlage, Le Corbusier, Walter Gropius, Alexander Koch, Karl Moser, Roberto Papini, Bruno Paul, Hans Poelzig; C. R. Richards, Director of the Metropolitan Museum of New York; Axel Romdal of Göteborg, Morton Shand, Ivar Tengbom, and *The Architectural Review*, London (see Appendix 14).

Morton Shand conveys a particularly interesting image of the architectural scene around 1930 as it presented itself to British eyes. It may come as a surprise that he mentioned Sweden and Austria as the two most important sources of inspiration for "young England" and added: "And to us Austria means Hoffmann and the tradition Hoffmann has created there We see in Hoffmann

not only the greatest architect now living, but also a gifted master of design in every area." This was followed by some examples of designers in whom he believed he could detect Hoffmann's influence.

Four years later, Shand once more wrote about Hoffmann in the *Architectural Review*, and on this occasion he pointed to his influence on Mies van der Rohe.

When, after this, things quieted down concerning Hoffmann, the reason was as much to be found in the turn that world architecture took as in the political development that found its climax in the catastrophe of the Second World War. In the history of the Modern Movement Austria was a border province; the centers of gravity were situated in Germany, Russia, Holland, and with Le Corbusier in France. The historian and ideologist of the new movement, Sigfried Giedion, scarcely mentioned Hoffmann in his work *Space, Time and Architecture* (1941), and it is not surprising that the generation that followed the formative years of the Modern Movement and that was educated with Giedion's book at the drawing board knew nothing about Hoffmann—even though Nikolaus Pevsner in his influential *Pioneers of Modern Design* (1949) drew renewed attention to Hoffmann's achievements. Approximately at the same time Alvar Aalto, on the occasion of a visit to Vienna, stated:[67] "Without Hoffmann I personally could not imagine myself." This comment turns out to be more than an expression of mere politeness if one considers everything Aalto and Hoffmann had in common: not only the descent from classicism and the predilection for the staggered repetition of architectural elements, but also matters of principle such as the absolute confidence in intuition, the interest in regional individuality, and last but not least the rejection of theoretical explanation.

From the point of view of after-effect and formation of a school, such a rejection of the conceptual naturally had enormous disadvantages. The temporary, almost total, eclipse of Hoffmann in the living tradition of architecture can be explained both by the particular historical circumstances of his career (including what was felt to be an untimely tie to the realm of the handicrafts) and by the fact that he was only able to convince visually, by the quality of his creations, and not conceptually, through accompanying polemical writings in the manner of such architects as Berlage, Sullivan, Wagner, and Frank Lloyd Wright—not to mention Loos and Le Corbusier.

The short study published in Austria by L. W. Rochowanski in 1950 on the occasion of Hoffmann's eightieth birthday was hardly noticed and soon went out of print. A more comprehensive volume planned by the

same author remained unwritten, as did a monograph on the Wiener Werkstätte by Hans Ankwicz-Kleehoven, who, like Rochowanski, had the advantage of close personal acquaintance with Hoffmann and his collaborators. Thus Vittoria Girardi with some justification entitled an obituary in 1956[68] "Josef Hoffmann maestro dimenticato," even though an impressive number of congratulations from all over the world seemed to have proven the opposite at the time of his eightieth and eighty-fifth birthdays.

In Austria one was much too busy reestablishing the ties to the living development of architecture and finding connections to modern world architecture—that is, too busy satisfying a need to catch up—to pay much attention to architects of one's own immediate past. Lichtblau and Frank, who were also still alive during the first postwar years, were equally treated as marginal figures and were paid little attention.

Yet in the year of Hoffmann's death the process of rediscovery had already begun with a small book by Giulia Veronesi.[69] Ankwicz published several useful articles about his deceased friend and provided a substantial contribution to the series *Große Österreicher (Neue Österreichische Biographie)*. Exhibitions in the memorial years of 1960 and 1970 also did their share to keep the memory of Hoffmann alive. But the dramatic increase of interest in his oeuvre which the 1970s brought would not have occurred had there not been significant changes in the international art and architectural scene.

The course of interest in Hoffmann illustrates the correctness of a statement by Hans Tietze:[70] "The artistic volition of a period determines not only its own art but also its relation to every other [art]." It was a process that in its first inception, with the turning of art historical interest toward the Art Nouveau, occurred just at the time Hoffmann died. In subsequent years numerous books, articles, and exhibitions,[71] some on a very grand scale, followed each other. Naturally this involved a rediscovery of the Vienna Secession and with it an increase of interest not only in Klimt but also in Hoffmann; the ensuing effects on the art market were dramatic in turn. An increased interest in the cultural history of Vienna at the turn of the century that found expression in exhibitions, symposia, and in a continually growing body of literature had the same effect. Moreover, art historical research did not stop at Art Nouveau but moved on the one hand in the direction of the 1920s and Art Deco, and on the other in the direction of nineteenth-century historicism. Consequently the one-sided, unduly simplified picture of twentieth-century architectural history conveyed by Giedion became less and less tenable while at the same time the vulnerability of his ideological position increased. If in addition one recalls the well-known fact that as generations change the predecessor is "overcome" and negated in each case by the successors, and that the death of the leading architects of the Modern Movement in the mid-1960s visibly marked the end of an epoch, it comes as no surprise that the 1970s brought a dramatic questioning of the architectural concepts that had prevailed up to then.

It was inescapable, accordingly, that renewed attention would be paid not only to Wagner and Loos but also to Hoffmann, both as a historical phenomenon and as a source for formal borrowings. Whether he himself, who throughout his life spoke out against copying of any kind, would have been happy about this development is a moot question. What the turn of events proved is the correctness of his statement about the timelessness of beauty: when the ideological and sociological preconditions of an architectural work of art have long become irrelevant or mere historical curiosities, it is its quality alone that can be experienced and rediscovered by later generations. In the same measure in which the memory of Josef Hoffmann as a human being and the temporal circumstances of his life and activity are transferred from the realm of personally experienced time into that of historical time, and as that which becomes history increasingly leaves the realm of polemics—in the same measure as this removal occurs, only the form and the space of Hoffmann's creations remain behind as realities. The fact that they patently have something of value to offer young architects who create under completely different conditions is testimony to their genuine quality.

THE ARCHITECTURAL WORK

Descriptive Catalogue

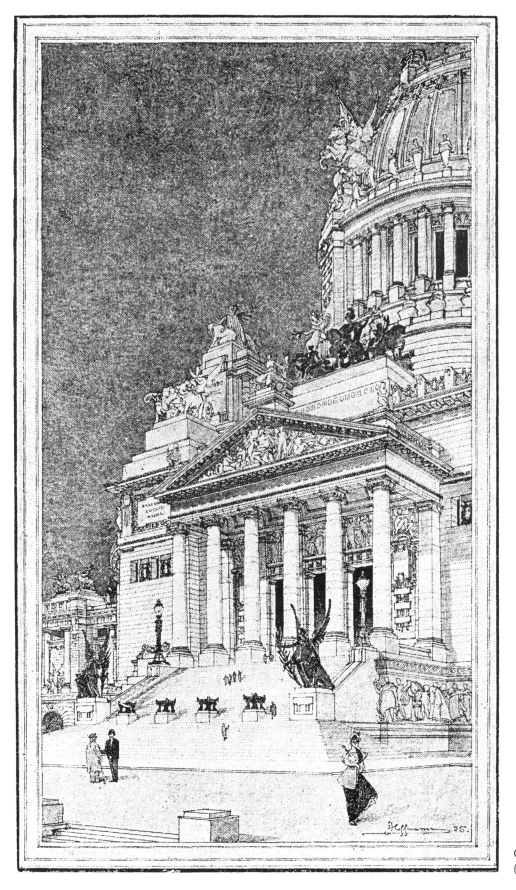

Cat. 2. Perspective view of the domed hall
(cf. text figs. 5, 6)

248

Cat. 1 1891-1894

Early drawings

From these early years there are hardly any architectural drawings except travel sketches, the earliest from Passau, Prachatitz (Prachatice), and from Italy(?). The Italian sketches are signed and dated 1893 by Hoffmann himself, but the possibility of error cannot be excluded. He often signed drawings much later and dated them incorrectly from memory; in this case there seems to be a discrepancy between the handwriting of the titles and the dates; this is not the case with the drawings from Passau and Prachatitz.

Bibl.: Drawings: Estate.

Cat. 2 1895

Competition project for Rome Traveling Fellowship
Motto: ''Forum orbis, insula pacis''

With this final project at the Academy of Fine Arts, Hoffmann won the Rome traveling fellowship. As his graduation certificate was issued 23 July 1895, the project must date from the first half of the year. The project description reads: ''The present project shall architecturally embody the union of many nations on a social basis, as it were the supreme court of all human justice.

''Thus, it represents a kind of congress palace of nations, located on international territory, namely at sea.

''A giant wire suspension bridge connects the island with the mainland. A large plaza with colonnades and triumphal arches, port installations and lighthouses, prepares the architectural image on the mainland.

''On the island one first enters a forecourt that is separated from the actual f o r u m by colonnades and two tall triumphal columns crowned by glowing red globes that serve as landmarks for the entire complex.

''The forum is surrounded by administrative buildings, embassies, session halls, and finally the hall of glory, the pantheon; it encloses a slightly depressed, and therefore traffic-free, inner area for mass meetings. Through and at the sides of the pantheon we reach the temple court with the temple of truth.''

Hoffmann designed a layout with a symmetrical ground plan in which the contrast between straight and curved forms played an important part. With ample use of colonnades and fountains, he created a strongly articulated complex with rich sculptural decoration. The elevation has a giant Roman-Doric order over a high base with horizontal grooves. He chose huge dimensions; the total length is almost a mile; the height of the central domed building is 160m, taller

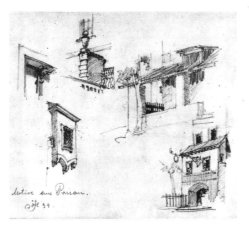

Cat. 1. Sketches from Passau, 1894

than the spire of St. Stephen's cathedral in Vienna. The India ink and wash presentation drawings are impressive proof of able draftsmanship.

Bibl.: Drawings: Estate (Design sketch, ground plan, two facade drawings); *Architekt* I, 1895, 53, 55, pls. 93, 94; *Architekturforum* IV, 1973, no. 8, 32ff.

Cat. 3 1895

Travel sketches from Istria

Five pen-and-ink drawings show picturesque motifs of folk architecture in Istria; buildings in Voloska and Lovrana, with open stairs, loggias, arcades, and chimneys, displaying strong modeling and lively effects of light and shade.

Bibl.: *Architekt* I, 1895, 37, 38.

Cat. 4. Perspective view of villa

Cat. 4 1895

Sketch for a villa

With the travel sketches (Cat. 3) this perspective served as an illustration for Hoffmann's first published article, ''Architektonisches aus der österreichischen Riviera'' (''Architecture from the Austrian Riviera''). The pen-and-ink drawing shows an obviously Mediterranean villa in a garden with an open, vaulted hall in the basement. At the top of open stairs is a loggia with columns; another loggia with pillars forms the upper story of a tower dominating the composition. The building is smoothly stuccoed, with simple stone window surrounds; the roofs have slight slopes and wide projecting eaves.

Bibl.: *Architekt* I, 1895, 37, 38.

Cat. 6. Travel sketch from southern Italy (cf. text figs. 8-18)

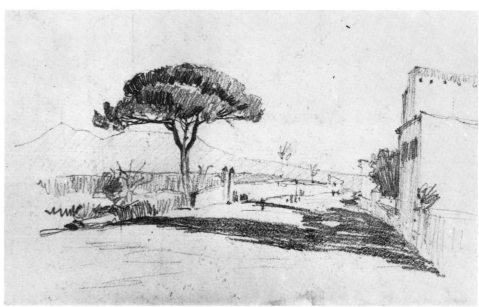

Cat. 5 1895

Book decoration and illustrations

In this year the periodical *Der Architekt* contained decoration and various illustrations after drawings by Hoffmann, including perspectives he drew for other architects.

Bibl.: *Architekt* I, 1895, 1, 3, 11, 20, 28, pls. 2, 15, 19, 45, 70, 72.

Cat. 6 1895–1896

Architectural travel sketches from study trip in Italy

More than 200 sketches from this and perhaps other sojourns in Italy are known from the architect's estate. Most are pencil drawings but there are also pen-and-ink, crayon, and wash drawings, and watercolors. The pictures allow us to trace the journey via Vicenza, Venice, Florence, and Ancona to Rome and from there to southern Italy, Naples, and Capri. Hoffmann used six sketches of Capri as illustrations in an article he published in 1897 in *Der Architekt*.

Bibl.: Drawings: Estate; ÖMAK; Academy; HMSW. A selection from these sketches was shown in 1972 in the exhibition *Österreichische Künstler und Rom vom Barock zur Secession* ("Austrian Artists and Rome from the Baroque to the Secession") at the Academy in Vienna. The catalogue (pp. 73ff.) contains the article by E. Sekler, "Zu den italienischen Reiseskizzen von Josef Hoffmann und Joseph Olbrich" ("On the Italian Travel Sketches . . ."). An Italian edition of the catalogue appeared at the exhibition in Rome.

Cat. 7 1896

Architectural studies and sketches following the Italian journey

1. Two garden gates and a villalike building with open stairs, semicircular portico and loggias on the roof as "hasty architectural sketches the author brought from his study trip through Italy." One of the two garden gates features quadruple female herms.
2. "Design for an antique villa" in the form of a cubical building with high center and lower wings, porticoes, terraces, and open stairs in a southern landscape.
3. Architectural study: Part of a monumental building. Perspective sketch with curving, freestanding, multistory colonnade over a two-story grooved base, with rich sculptural decoration. This sketch was published in *Der Architekt* on the same page as the "Design for an antique villa" and a travel sketch.
4. Architectural study: Entrance to a monumental building. Perspective sketch shows a grillwork gate between two blocks leading into a court of honor. The corners of the blocks feature tall pillars bearing animal pairs (lions?). The

Cat. 7/1a. Study for a garden gate

Cat. 7/1b. Study for a villalike building

Cat. 7/2. Design of an antique villa

sketch was published in 1899, but theme and presentation suggest that it probably belongs to the above studies.

Bibl.: *Architekt* II, 1896, 44, pl. 78; III, 1897, 1; V, 1899, 50.

Cat. 8 1896

"Ars Arti" (České Lidové divadlo v Plzni) Competition project for the new building of the Czech People's Theater in Pilsen designed with Franz Krásný

Cat. 8/I. Ground plan, People's Theater, Pilsen (cf. text fig. 22)

(Received one of two second prizes; first prize was not awarded)
Competition deadline: 15 September 1896

The design is clearly structured into three areas, i.e., vestibule, auditorium, and tall stage house in neoclassic forms with rich sculptural decoration. The entrance facade has glass-iron marquees; above is a tall columned loggia in the Roman-Doric order flanked by towerlike blocks with crowning figures. Site plan, two ground plans, main facade, two perspectives, a perspective detail, and ornamental frames for the drawings were published.

Bibl.: *Neubauten und Concurrenzen* II, 1896, 32, 86; *Architekt* III, 1897, 9, 10, pls. 17, 18.

Cat. 9 1896

Book decoration

Two vignettes for *Der Architekt*. One shows the head of a youth with determined expression with a draftsman's triangle; the other the partial view of a youth with a background of Mediterranean landscape and a frame ornamented with peacock feathers.

Bibl.: *Architekt* II, 1896, 54 (98).

Cat. 10 1897

"Pecuniis Potestas" (Návrh budovy Zivnostenské Banky v Praze)
Competition project: Design for building of Trades Bank in Prague
Jointly with Franz Krásný
Competition deadline: 31 January 1897

Plan for an office and apartment building on an irregular, elongated, difficult lot in the center of Prague. The transition between the street front and the angled tract at the rear was made by an oval vestibule as the "joint." The 5-story facade with high attic has very rich sculptural decoration. Facade elevation, its perspective view, and ground plan were published.

Bibl.: *Neubauten und Concurrenzen* III, 1897, 4, 29; *Architekt* III, 1897, 21, pl. 42.

Cat. 11 1897

"1848-1898"
Competition project: Exhibition Pavilion of the City of Vienna at the Jubilee Exhibition 1898 (Honorable Mention)
Vienna, Prater, Rotunda Grounds
Competition deadline: 15 October 1897

Design for a single-nave, lightly constructed hall, divided into three spaces by openwork wood partitions. The upper part has an approximately

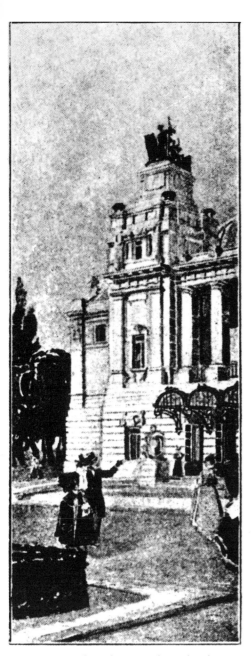

Cat. 8/II. People's Theater, Pilsen, detail from perspective of entrance facade

Cat. 9/I-II. Vignettes

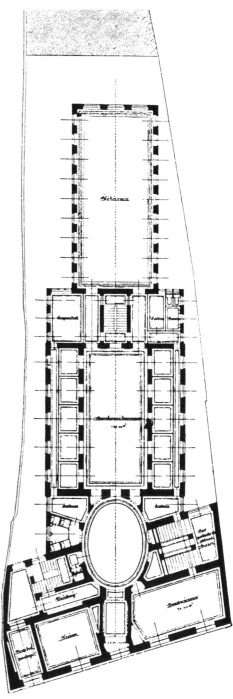

Cat. 10. Ground plan, Trades Bank, Prague (cf. text fig. 21)

parabolic section. The walls were to be partially frescoed. In contrast to the previously mentioned competition projects which still used a classicist vocabulary, this design already shows a Secessionist attitude. Ground plan, two sections, an interior perspective, and a facade study were published.

Bibl.: *Wiener Bauindustrie Zeitung* XIV, 1897, 558; XV, 1898, 72; *DK* I/2, 1898, 208, 227; *Architekt* VI, 1900, pl. 18.

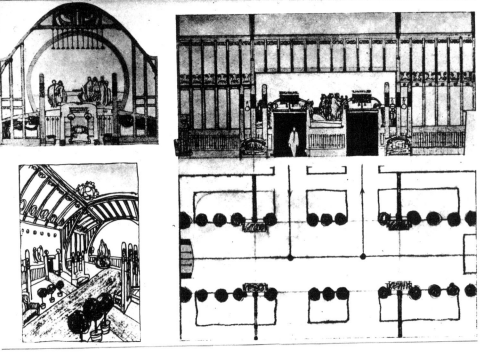

Cat. 11. Competition project: Pavilion of the City of Vienna, 1898 (cf. text fig. 19)

Cat. 13. Facade, houses in the Donnergasse

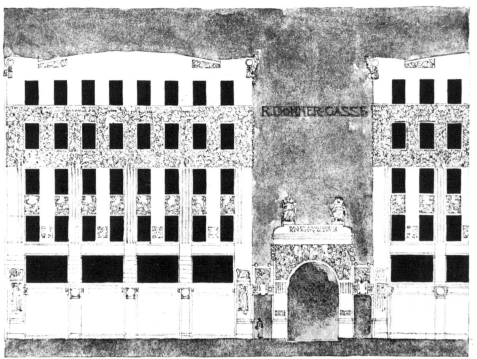

Cat. 12 — 1897

Book decoration

Der Architekt published six sketches or vignettes by Hoffmann including two putti with lantern, the heads of a male water sprite, and a spring nymph at the beginning of a review of a "Competition for a spring temple."

Bibl.: *Architekt* III, 1897, 1, 8, 25, 26, 31, 34.

Cat. 13 — 1898

Project: Two apartment houses
Vienna I, corner of Donnergasse and Kärntner-straße

Two apparently identical 6-story apartment houses on a site very important in the Vienna cityscape. The facades have a stucco decoration of stylized laurel trees with bronze green leaves and inset matte light bulbs and, instead of a main cornice, a gently curved plain top. The Donner Fountain on the Neuer Markt was to be seen through a kind of triumphal arch, ornamented with sculpture, linking the two buildings.

Bibl.: *DK* I/2, 1898, 207, 227 (reprint: *AUMK*, no. 113, November/December 1970, 27); Hevesi, *Acht Jahre*, 138, 171.

Cat. 14 — 1898

First exhibition of the Vereinigung bildender Künstler Österreichs (Secession) in the Gartenbausäle (Horticultural Hall)
Vienna I, Parkring 12
Opening: 25 March

Design of the *Ver Sacrum* Room and collaboration with Joseph Olbrich on the design of the Exhibition (with the participation of a "Decoration Committee").

The *Ver Sacrum* Room, serving to publicize the Association's magazine of the same name, is "executed as a modern room with modern furnishings; the furniture blue with bright copper ornaments, the inexpensive draperies with sewn-on stylized velvet flowers, the ceiling beams even pierced with rows of animal figures" (Hevesi). The walls are framed by the sparing use of wooden boards and divided into a base and an upper zone. The door and window frames are also made of boards. The furniture design equally stresses the use of wood in the form of boards; flat and sawn shapes predominate.

Bibl.: Catalogue, *1. Kunstausstellung der Vereinigung bildender Künstler Österreichs*, Vienna, 1898 (with numerous vignettes by Hoffmann); *VS* I, 1898, nos. 5/6, 7; *DK* 1/2, 1898, 261; Hevesi, *Acht Jahre*, 14, 39; H. Bahr, *Secession*, Vienna, 1900, 35.

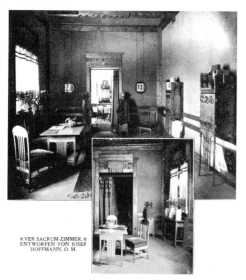

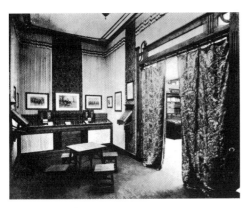

Cat. 14. *Ver Sacrum* Room

Cat. 15. *Viribus Unitis* Room

Cat. 16. Editor's office of *Ver Sacrum*

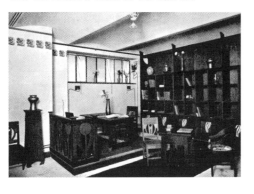

Cat. 15 1898

Exhibition design: "Viribus Unitis" room
"Education" Pavilion of Jubilee Exhibition, 1898,
on the Rotunda Grounds in the Prater park, Vienna
Opening: 7 May

The room was devoted to displaying the sumptuous volume *Viribus Unitis* for which

Hoffmann also designed binding, endpapers, and 19 vignettes. The architect articulated the walls and ceiling with a partially pleated white fabric with green stripes, and a patterned cretonne. The books were displayed on slanted lecterns supported by consoles carved in openwork. Like the overdoor panels and a group of four stools and table, these featured curved Secessionist forms. Furniture and paneling are executed in green-stained alder wood.

Bibl.: *DK I/2*, 1898, 206.

Cat. 16 1898

Second exhibition of the Vereinigung bildender Künstler Österreichs (Secession)
(First exhibition in the new Secession building)
Opening: 21 November

Hoffmann contributed to Olbrich's design of the exhibition rooms, and designed the editorial room of *Ver Sacrum* with anteroom, and the secretarial office which was completed in 1899 (see Cat. 24). In this exhibition Hoffmann designed the stenciled wall decoration in the left side hall, the so-called green hall. In addition he furnished two rooms in the basement of the Secession building where he also made ample use of stenciled patterns on the walls. In the editorial office he placed a low podium below an elevated horizontal window; its balustrade is carved with stylized floral forms in openwork. The wall behind has built-in open storage shelves. For the anteroom Hoffmann designed a checking facility.

Bibl.: Catalogue, *2nd Exhibition VBKÖ*; Hevesi, *Acht Jahre*, 72; *DK II*, 1899, vol. IV, 6, 36ff.; Nebehay, *Klimt*, 179.

Cat. 17 1898

Furniture for the studio of the painter Kolo Moser

A well-known photograph of Hoffmann (fig. 299) shows him in the studio of his friend Moser on a backless upholstered seat with high circular armrests. This proves that these "cart-like chairs," as Hevesi called them, found their way from the Secession to Moser's home, or that Moser lent them to the Secession where they stood in the Pointillist Room at the 3rd Exhibition.

There are also smaller stools with round unupholstered seats and armrests. Their pierced design resembles the "cart-like chairs." To these seats belong a chaise longue and a studio cabinet with a rectilinear, one-door lower section, and an upper with two doors and a drawer. Both sections have lateral compartments open in front with pierced side walls. The upper section is also crowned by a small open superstructure. The copper mountings are designed in very dynamic

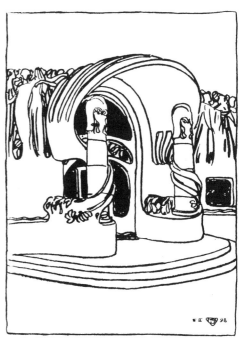

Cat. 18/1. Study for entrance to a house
(cf. text fig. 24)

Secessionist forms. The greenish wood stain was later changed to black; the form of the studio cabinet was also somewhat altered.

Bibl.: *DK I*, 1898, 203ff.; *DK II*, 1899, vol. IV, 38; Hevesi, *Acht Jahre*, 101; Nebehay, *Klimt*, 129; *Katalog Wiener Möbel des Jugendstils, Neuerwerbungen and Leihgaben*, ÖMAK, Vienna, 1971, no. 1; W. Fenz, *Kolo Moser*, Salzburg, 1976, 30, shows the studio cabinet in its original state.

Cat. 18 1898

Architectural sketches

During 1898, Hoffmann published perspective sketches that showed parts of imaginatively designed buildings. The following explanation in *Ver Sacrum* applies to them: "Architects originating in or adhering to earlier periods of art confronted new tasks, at least in regard to language of form, with the intentions of a compiler; by contrast, architects of modern outlook seek to approach a new problem with their artistic sensibility, and from this primary architectural sensitivity grows the invention of appropriate form. We have long been accustomed to view the sketches of painters and sculptors with serious interest. Why should we not bring the same to the fugitive jottings of the very first, the most personal thoughts of architects? The architectural sketches in this issue should be regarded as such notations of the very first architectural ideas . . ." (*VS I*, 1898, no. 7, 27).

1. Three studies for the decorative design of the entrance to a house:

Three variations on the theme of the entrance

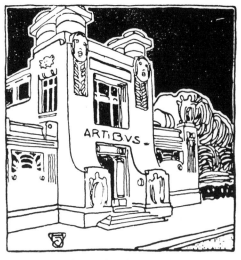

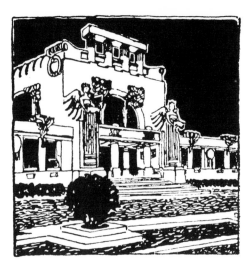

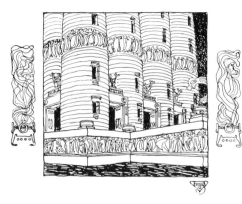

Cat. 18/3. Perspective sketch of a monumental building

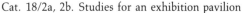

Cat. 18/2a, 2b. Studies for an exhibition pavilion

Cat. 18/4. Perspective study, Hall of Knowledge

to a house with covered entry, modeled freely in strongly curved forms and including the curving front steps. In all cases vegetal forms are part of the composition; the richest design also includes a frieze of figures along the wall of the house. Hevesi probably had these designs in mind when he wrote: "Some of these Hoffmanniana are only conceivable in cast cement . . ." (*Acht Jahre*, 68). One design is dated 5 February 1898.

2. Five studies for an exhibition pavilion:

These design sketches probably originated in connection with the plans for the new Secession building; in any case, one of the sketched buildings bears the inscription *ARTIBUS*. All are symmetrical designs whose monumental entrances lead to a high central structure with lower lateral wings. In each case sculptural enrichment with anthropomorphic forms is planned, and in some places sculpture and architecture tend to merge. One of the central pavilions is topped by a steep pyramidal roof; the others have flat roofs surmounted by various crowning elements. Two buildings have ground plans with rounded corners and three have facades with horizontal grooves.

3. Architectural sketch for a monumental building:

Perspective view of a monumental building consisting of towerlike cylindrical elements with horizontal grooves and several entrances. The structure stands on a podium with a frieze and monumental braziers.

4. Architectural study for "Hall of Knowledge":

Perspective sketch of part of a barrel-vaulted hall in stone construction. The wall is articulated by a composite pier, matched in the vault by an arch with richly sculptured mascherone and leaf decoration. In front of the pier stand two round pillars with large stylized apple-tree tops instead

of capitals. Eve sits between the pillars holding the apple. On both sides of the pier the wall is replaced by a colonnade of round pillars without capitals. A straight entablature bears a barrel vault with coffering in the lower zone and relief figures in the middle zone.

5. Architectural sketches for tombs:

Two perspective sketches for monumental tombs. One shows a building in ashlar; its roof is a stepped pyramid with crowning bronze basin. Sculptured figures are envisaged at both sides of the building and on the tops of the round corner pillars. The other sketch shows a tomb precinct bordered by pylons with seats in front, and enclosed at the rear by a wall pierced in its upper part. The landscaping is kept severe in its forms.

6. Study for a park entrance:

Perspective sketch for a grillwork gate, reached by several steps, flanked by fluted pillars topped by finials with stylized leafy wreaths. At two thirds of the height the pillars are joined by a straight lintel with a mascherone as a kind of keystone. The railings flanking the gate have stone pillars topped by lion heads.

7. Garden entrance and path (see vignette at end of Chapter IV):

A straight path between hedges leads from a tree in the left foreground to a simple garden gate in a wall; trees and bushes are indicated next to and behind the wall. The highly decorative drawing gives less the impression of an architectural sketch than that of a design for a stencil or for stained glass. It might also have been planned as book decoration.

Bibl.: 1. *VS* I, 1898, no. 7, 14; S. T. Madsen, *Sources of Art Nouveau*, New York, 1956, 124; P. Selz, M. Constantine, eds., *Art Nouveau*, New York, 1959, 137; *Finale*, 171; H. H. Hochstätter, *Jugendstil Druckkunst*, Baden-Baden, 1968, 239; Nebehay, *VS*, 92.
2. *VS* I, 1898, no. 7, 15; Nebehay, *VS*, 93; Catalogue, *1st Exhibition VBKÖ*, Vienna, 1898, 6, 16, 40, 56.

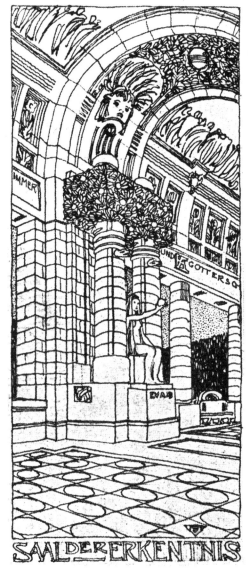

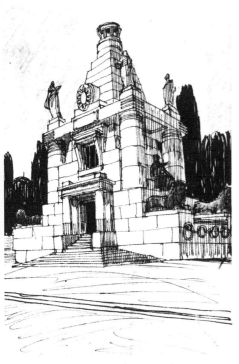

Cat. 18/5. Perspective of a mausoleum

Cat. 18/6. Perspective sketch of a park entrance

3. *VS* I, 1898, no. 2, 26.
4. *VS* I, 1898, no. 7, 23.
5. Ibid., 19; *Architekt* IV, 1898, 33, 44; Original drawing: Estate.
6. *VS* I, 1898, no. 7, 19; *Architekt* IV, 1898, 33.
7. Nebehay, *VS*, 93.

Cat. 19 1898

Design for a study

Perspective drawing of a room with wood wainscoting in Secessionist forms. Above a door with straight lintel a wooden basket arch is applied to the wall. It intersects with the tall decorative framing of the door, and its apex touches the overdoor panel. On both sides of the door flower holders are set into the upper part of the wainscoting. Below, built-in furniture projects from the wall forming a bench, a desk, and tall towerlike bookcases.

Bibl.: *Interieur* 1, 1900, pl. 2.

Cat. 20 1898

Study for a simple living room

Two perspective sketches of a cross-vaulted, wood-paneled room with a window niche containing built-in benches and a curtained bed niche. In the overdoor panel above a curtained opening is a landscape picture; above the bed is the inscription "Good sleep is half a life." The study is related to the "Bergerhöhe" adaptation (Cat. 32).

Bibl.: *VS* I, 1898; no. 4, 29.

Cat. 21 1898

Book decoration

Numerous vignettes, decorative rules, picture frames, and other decoration for *Ver Sacrum* (complete list in Nebehay, *VS*). The catalogue of the 1st Secession Exhibition also contains additional book decoration by Hoffmann.

Cat. 22 1898

Third Exhibition of the Vereinigung bildender Künstler Österreichs (Secession)
Opening: 12 January
Complete design of exhibition including presentation of Klinger's *Christ on Olympus*

The design of the principal rooms used highly effective contrasts of brightness and color. Klinger's large painting was placed in a flood of light beyond the central hall in such a manner that the visitor had to walk the full length of the hall to reach the picture, first crossing an area made darker and lower by a dark blue can-

Cat. 19. Perspective of a study

Cat. 20. Perspective of a simple living room

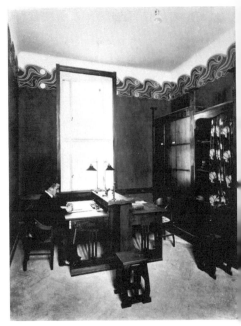

Cat. 22. Main room of the 3rd Secession Exhibition

Cat. 24. Anteroom, Secretariat of the Secession

opy and clearly defined at the sides by small laurel trees and sculpture on pedestals. Then followed the very bright hall in yellow and white with Klinger's work in the middle, the yellow robe of its principal figure, Christ, in the greatest possible contrast to the blue of the approach. Comparable to the small laurel trees, variously grouped plants, together with draperies, played an important part in other halls. This is particularly evident in the rest hall where, however, two free-standing round pillars carrying symbols were also prominent. In the Pointillist Room, Hoffmann exhibited his "splendid cart-like chairs" (Hevesi) and a dark blue cabinet.

Bibl.: Catalogue, *3rd Exhibition VBKÖ*; *VS* II, 1899, no. 8, 25; Catalogue, *10th Exhibition VBKÖ*; *DK* II, 1899, vol. IV, 6, 36, 38; *DKuD* II, 1899, 374; Hevesi, *Acht Jahre*, 101; *Studio* XXII, 1901, no. 98, 264ff.; Nebehay, *Klimt*, 129, 195; Waissenberger, 60; *KuKhw* II, 1899, 78.

Cat. 23 1899

Room design for the auction of the Theodor von Hörmann Estate in the Secession building
February 1899

Arrangement of a brief exhibition of the remaining works of the artist prior to auction on 27 February.

Bibl.: Catalogue, *10th Exhibition VBKÖ*; Hevesi, *Acht Jahre*, 119ff.

Cat. 24 1899

Anteroom and room for secretary in the Secession building
Execution: Friedrich O. Schmidt

Two not very large rooms, each 3.5m x 7m, functionally furnished with desks, seats, and cabinets; the wood was stained "in the most delicate nuances between green and gray that are possible" (Hevesi) while the walls for a while remained yellow. The anteroom was temporarily furnished with two cabinets, a table, and seats that were then taken by Hoffmann for his own apartment. Later the room received a large built-in cabinet with open central section and two lateral sections. There was also a double desk with matching armchairs and stools, their lower sections sawed out in Secessionist forms. At the top of the monochrome walls a stenciled, curvilinear, multicolored frieze formed a strong color accent with the floral-patterned curtain of the built-in cabinet.

The principal room was more richly furnished. It was dominated by built-in furnishings opposite the window wall, including a gas fireplace in chased metal, and a combination of seating niche with towerlike cabinet. The fluted side walls and ornamental top of the latter are reminiscent of the design for a study of 1898 (Cat. 19). The walls were at first monochrome with a stenciled frieze above (stylized blossoming branches); later they were covered by wainscoting below, and a leaf pattern above.

In contrast to the semimatte furniture in the anteroom, the darker wood of this room was polished to a high gloss. The desk and chair had bright metal casings at the feet. Strongly patterned curtains again played an important part in the total effect.

Bibl.: *DK* II, 1899, 37, 38; *Interieur* I, 1900, 134, 135; Hevesi, *Acht Jahre*, 102; *Altkunst*, 243; *KuKhw* II, 1899, 393.

Cat. 25. Left side hall, 4th Secession Exhibition

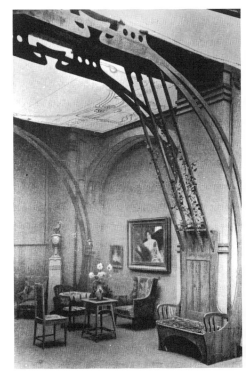

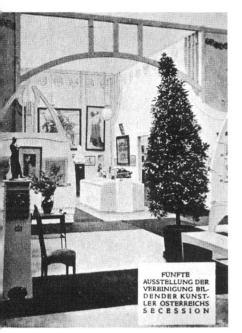

Cat. 26. Room at the 5th Secession
Exhibition

Cat. 26 1899

*Design of the exhibition halls I, II, V, VII, at
the Fifth Exhibition of the Vereinigung bildender
Künstler Österreichs (Secession)*
Opening: 15 November

This exhibition was devoted to the graphic
arts. Several small rooms in an appropriate scale
for graphics were created around the central hall,
including one with the dramatic accent of opa-
lescent Tiffany glass. The walls were covered
with whitish flannel stenciled with light—in-
cluding silvery—patterns. Among the numer-
ous light, curving wood constructions for frames,
corners, and room dividers, screens ending in
lyrelike pierced forms were prominent. In this
exhibition, characterized as a "triumph of the
art of interior design" (Richard Muther), potted
plants and flower arrangements were again in-
tegral parts of the total composition. Hoffmann
also designed the catalogue with cover and vi-
gnettes.

Bibl.: Catalogue, *5th Exhibition VBKÖ*; Catalogue, *10th Ex-
hibition VBKÖ*; *VS* III, 1900, no. 1, 4, 9, 15, 20, 23; *DK* IV,
1901, 110; *Interieur* I, 1900, 25, 136; Muther, *Studien* I, 9;
Hevesi, *Acht Jahre*, 196ff.; Nebehay, *Klimt*, 198ff.

Cat. 27 1899

*Design of the Ver Sacrum Room at the Fifth
Exhibition of the Vereinigung bildender Künst-
ler Österreichs (Secession)*
Opening: 15 November

In the *Ver Sacrum* Room (which is not iden-
tical with the editorial room of the magazine;
see Cat. 16) the walls (except in the entrance
area) are very simply articulated by dark stained
boards into vertical compartments, sparingly
decorated with dark linear patterns reminiscent
of the book decoration in *Ver Sacrum*. Only the
entrance area has a strongly effective surface
pattern with light lines on a dark ground. The
entrance area is also separated from the rest of
the room and the central seating group by a
curtain and a two-part divider, the upper part of
which is formed by wooden grillwork with
strongly stylized floral forms.

Bibl.: See Cat. 26.

Cat. 28 1899

Furnishings of Hoffmann's apartment
Vienna VI, Magdalenenstraße 12

Two rooms; one uses the same stenciled frieze
as the anteroom to the secretariat in the Seces-
sion but in a different color scheme. Some of
the furniture was also originally used to furnish
the secretariat in the Secession, including the
two taller closed cabinets that now flank a lower

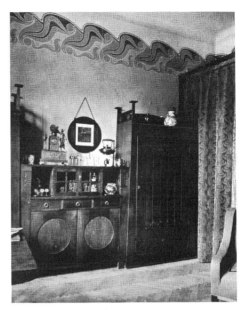

Cat. 28. Room in the architect's apartment

central section serving as a buffet. The curtain
closing the room carries the "Trout Dance" de-
sign by Kolo Moser.*

In the adjoining room are the stools and table
from the Secession. A low upholstered bench
along the wall is flanked by two small low cab-
inets with glazed doors, each divided into eight
square panels; circular motifs also appear several
times, as openings in the bases of the stools, as
picture frames, on panels in the doors of the
buffet, and at the top of the tall cabinets.

* "Trout Dance" and even more the contemporaneous "Salmon
Migration" pattern (both published in *Ver Sacrum* II, 1899,
no. 4) show how the artist experimented with the interchang-
ing effect of figure and ground, startlingly anticipating the
interlocking puzzle pictures Konrad Escher created about half
a century later.

Bibl.: *Interieur* I, 1900, 139; *DK* IV, 1901, 113.

Cat. 29 1899

Furnishings, Max Kurzweil studio
Vienna IV, Schwindgasse 19
Execution: A. Pospischil

The furnishings consisted of a simple built-in
set of red stained soft wood by the window: a
hard-edged, fabric-covered sofa bench, flanked
by small square cabinets on top of each other.
There were also a stool, an upholstered armchair,
and a low armchair of the kind used on the Ber-
gerhöhe (Cat. 32).

Bibl.: *Interieur* I, 1900, 137; *VS* III, 1900, 71; *DK* IV, 1901,
111; F. Novotny and H. Adolph, *Max Kurzweil*, Vienna, 1969,
25.

Cat. 25 1899

*Fourth Exhibition of the Vereinigung bildender
Künstler Österreichs (Secession)*
Opening: 18 March
Design of side halls and the Room of Arts and
Crafts

The left side hall, or gray hall, was divided
into two spaces by a light, built-in, bridgelike
construction of soft wood; one contains a large
fireplace by Engelhart. At the foot of the room
divider is a built-in bench; its arms flow directly
into the curving parts while the back supports
struts with growing plants. Top light is filtered
through a flat canopy with linear ornament
matching the curves of the divider. The lines of
the entire room with their curves, interlacings,
and countercurves are reminiscent of comparable
book decoration in *Ver Sacrum*.

In the Arts and Crafts Room, Hoffmann ex-
hibited six pieces of furniture executed by Wen-
zel Hollmann, including a buffet in gray maple.
Except for the horizontal base line its outline is
completely curvilinear, with a three-quarter-cir-
cle cutout in the upper part. In the appendix of
the catalogue designed by Kolo Moser the vi-
gnettes may also be by Hoffmann.

Bibl.: Catalogue, *4th Exhibition VBKÖ*; *VS* II, 1899, no. 4,
28; *DK* II, 1899, 5; *Interieur* I, 1900, 150; Hevesi, *Acht Jahre*,
139, 144; H. Bahr, *Secession*, Vienna, 1900, 195; Nebehay,
Klimt, 196; *KuKhw* II, 1899, 395.

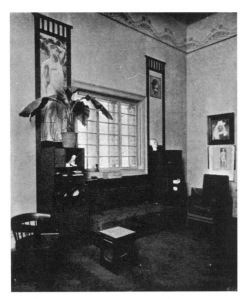

Cat. 29. Studio of Max Kurzweil

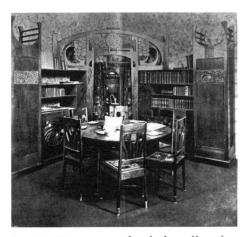

Cat. 30. Main room with safe, law office of Dr. Brix

Cat. 31. Front, Apollo candle shop (cf. text fig. 25)

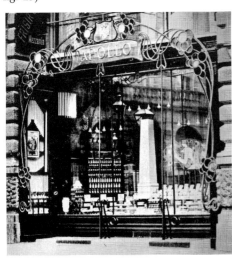

Cat. 30 1899

Office of the attorney Dr. Walter Brix
Vienna I, Walfischgasse 14

Furnishings of two rooms in green stained oak with flat carvings. In the anteroom the wall was painted red and sprayed with gold; the main room has a leaf pattern. Besides diverse individual pieces of furniture and a set of chairs, the main room has a built-in corner. Its centerpiece is a safe concealed behind a curtain with a large leaf pattern. It is surrounded by a carved frame with a richly decorative, widely projecting superstructure and clock. The framing joins two built-in bookcases which end in taller locked cabinets crowned with three-quarter circles. The flat carvings are on bandlike panels in the upper third of the cabinets and show flower and leaf forms. The design probably dates from 1898, since Hevesi mentioned this interior in March 1899.

Bibl.: *Interieur* I, 1900, 26, 27, 51, pl. 3; Hevesi, *Acht Jahre*, 145.

Cat. 31 1899

Entrance and furnishings of Apollo Shop
Vienna I, Am Hof 3, Corner of Irisgasse
Client: Erste Österreichische Seifensiederei Gewerksgesellschaft Apollo

The entrance was built in a prominent section of Vienna, opposite the former Ministry of War. The opening between the massively rusticated piers of the existing building was entirely glazed, and an eye-catching metal and glass construction in the form of an arch of flowers was erected in front of it. Tendrils and blossoms seem to climb up to the shop sign and the shield of a supplier to the Imperial Court. A stained glass window by Kolo Moser provides a glowing accent of color for the interior. In the interior it is particularly striking that the curving arch motif around the show window is repeated on all sides of the room. The arches at the right and back wall start at the floor and are doubled to enclose a showcase similar to the built-in bench at the 3rd Secession Exhibition. Above the built-in shelves and showcase the arches are joined to the wall by a kind of console, richly carved with stylized leaf motifs. The wall stucco repeats sylized plant motifs.

Under the large arch is a kind of small mock-portal that displays the sign "Perfume Department" and the lyre, symbol of Apollo and trademark of the firm. The effect of this composition is enhanced by eleven large light bulbs hanging from the large wooden arch. Numerous other light bulbs with bell-shaped glass shades hang from the other arches. They provide brilliant lighting that brings out the contrast between the warm shimmer of the polished, red stained wal-

nut, the white stucco, and the subdued tone of the carpeting.

The sales counter runs parallel with the left wall to the back of the shop, then makes a 180 degree turn around the back pillar. The curve of the counter, the shelves forming a kind of apse, and the seeming penetration of pillar and arch all emphasize the visual continuity of the total design. The customers are seated on stools with round lateral cutouts and on tall colorfully upholstered easy chairs under round mirrors. Between these is a glass case with an organlike composition of candles. The shop is no longer extant.

Bibl.: *Architekt* V, 1899, 44; *KuKhw* II, 1899, 397-401, 403; *Interieur* I, 1900, 24, pl. 5; *Studio*, 1901, no. 98, 267; *Ausgeführte Kunstschmiedearbeiten der Modernen Stilrichtungen in Wien . . .*, Vienna (A. Schroll), n.d., 6th series, pl. 29.

Cat. 32 1899

Remodeling of a country house, Bergerhöhe
Near Hohenberg, Lower Austria; for Paul Wittgenstein
Building permit: 13 July 1899
Execution of woodwork: A. Pospischil

The architect remodeled a small farmhouse on a rise in a forest. The client, director of the nearby Iron Works in St. Aegyd, had a quotation from Luther placed over the entrance, which conveyed the desired atmosphere: "The house of peace in stillness." The remodeling added to the existing rectangular building a small bathroom with sunken tub, a wooden veranda, a small porch, and included alterations in the interior.

The external stucco is roughcast on the base and on parts of the facade; the rest is smooth. The smooth areas are white, the base greenish, the other roughcast areas blue. All exterior woodwork and the interior of the porch are painted green; the adjoining staircase, red. The existing wood stairs received a new railing with flat sawed-out balusters painted with stylized, triple-blossomed flowers. The motif of a flower with three blossoms also appears in openwork carving on a wooden window surround opposite the bed niche.

In the finished top floor, the stair hall is separated from the attic by a wooden wall with square glazed lights, door, and decorative overdoor panel. The adjoining smoothly stuccoed walls are violet. The original furnishings of the attic bedroom are extant. The most important room in the house is on the first floor to the left of the staircase. It consists of two spaces divided by an opening with flat arch; the front area is the approximately square (5.30m by 5.55m) living room, heated by a green tile corner stove; the back section houses a bed niche and can be closed off by a heavy curtain.

The living room is about 2.95m high and is

paneled in green stained spruce to about three-quarters height. The paneling contains wall niches and built-in closets. Decorative friezes with curved tops rise above the windows and doors. The overdoor panel above the entrance has the initials of the owner, while the base next to the door is engraved with the architect's initials and the date 1899.

Above the paneling the walls are light gray and white and stenciled with linear Secessionist motifs in red orange. The annex with bed niche is paneled only up to the parapet and covered above with a strongly patterned reddish fabric to the wooden molding at the white ceiling. The same fabric is used on the inner side of the dividing curtain; the other side has a patterned blue green material.

At each side of the flat-arched opening in the wall, the paneling merges with the woodwork on the inner face of the arch. This consists of openwork étagères bordered by slender, stalklike forms with crowning blossoms. On the opposite wall the paneling merges with an arched window surround that forms a niche with a folding table and two leather-covered window seats. A sofa next to the niche is also upholstered in deer skin.

The window arch and the flat arch dynamize the room with their curves as do the many curvilinear copper mountings. The architect used these in several places—for example, on a desk of oak, stained green, like the table and chairs. A third large arch as a compositional element is in the grillwork that divides the bed niche from the rest of the room.

The door to the bathroom terminates in concave "horns." Here and on the entrance the upper part of the door has square wood-framed panes; their light blue glass provides a particularly impressive effect of light and color. The bathroom has a sunken tiled tub and a striking washstand in Secessionist forms. Most glazed openings are divided into small square panes; exterior iron gratings are painted green. They do not run parallel to the wall but are slightly concave.

There have been no major alterations except modernization of Hoffmann's original kitchen and removal of the worn green felt floor covering in the sleeping niche. Thanks to enlightened owners, the Bergerhöhe is a rare instance of an interior of around 1900 that has come down to us almost unchanged.

Bibl.: *VS* III, 1900, no. 5, 80, 81; *Interieur* I, 1900, 143; *DK* IV, 1901, 115; *AUMK*, 1970, no. 113, 29; *Architectural Review* CXLIX, no. 888, February 1971, 75; submitted plan: ABBH.

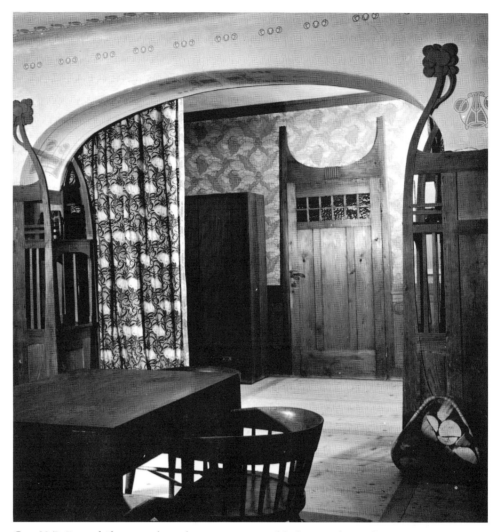

Cat. 32/I. Bergerhöhe, view from dining room toward bedroom (cf. text figs. 27, 28)

Cat. 32/III. Bergerhöhe, exterior with veranda (cf. text figs. 27, 28)

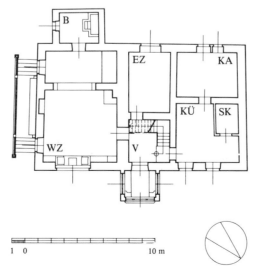

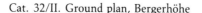

Cat. 32/II. Ground plan, Bergerhöhe

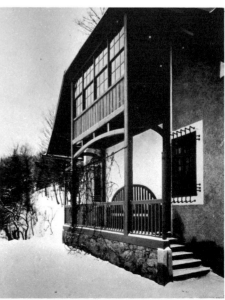

Cat. 33 1899

Interiors, furniture, book decoration

Interiors and furniture, very probably already designed by 1899, are among the works published in the first year of the periodical *Das Interieur* in 1900. They will be discussed together with the works dating from that year (Cat. 42). A complete listing of book decoration by Hoffmann for *Ver Sacrum* in 1899 is in Nebehay, *Ver Sacrum*. Further illustrations of furniture and a design sketch are in *KuKhw* II, 1899, 392ff.

Cat. 34 1899-1900

Smoking room, Gustav Pollak Villa
Atzgersdorf near Vienna, Wienerstraße 117
Execution: Wenzel Hollmann

An existing room is redesigned with complete furnishings in wood stained gray green. Light wood constructions with shelving were set in front of door openings; the upper parts and overdoor panels were executed as grillwork with stylized plant forms. The emphasized verticality of these constructions also recurs on a desk and cabinets with narrow panels between slim friezes.

In the corners between the cabinets and door frames sit a round bench and a built-in stove. On the other side of the doors are bookcases with irregularly divided fronts; their largest feature is decorative glazing with linear plant motifs. The walls are stenciled with stylized trees, and the treetops are repeated on the ceiling. The wall-to-wall carpeting has a leaf pattern in the manner of Kolo Moser.

Bibl.: *Interieur* I, 1900, 140, 141, 151; *DK* IV, 1901, 108, 109; *VS* III, 1900, 82.

Cat. 35 1899-1900

Study for Ministerial Secretary, Dr. Gustav Pollak
Execution: W. Hollmann & L. Loevy

A room with alcove is executed in green polished ash. The upper part of the alcove is divided from the main room by an openwork wooden construction on which stylized plants seem to grow from a flat segmental arch. At the longer wall is a bookcase with built-in sofa; there is also a desk and table with chairs. The carpet is striking with a dynamic abstract linear pattern designed by Kolo Moser for J. Backhausen and Sons, called "Föhn" ("Spring Wind").

Bibl.: *Interieur* I, 1900, 142; *VS* II, 1899, 30; *VS* III, 1900, 82.

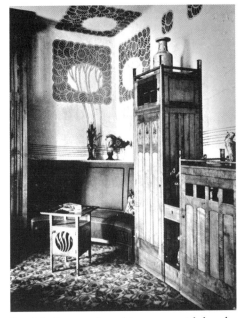

Cat. 34. Corner of smoking room with bench

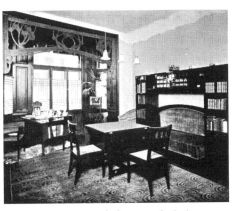

Cat. 35. View toward alcove with desk

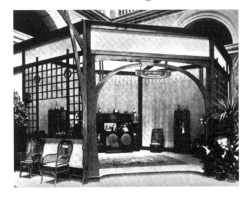

Cat. 37. Pavilion with dining room

Cat. 36 1899-1900 (?)

House of the artist Fernand Khnopff
Involvement as consultant in the design of the interior(?)
Brussels, 41 Avenue des Courses

The interior of the house, no longer extant, built by the Belgian symbolist Fernand Khnopff in 1900 is reminiscent of Hoffmann's manner. Furthermore, Robert Von der Mühll wrote to Hoffmann in 1924 that "the present residents of the house respect the rooms you created." The residents were members of the Dewaerde family in which there is still a tradition that Hoffmann had some role in the house. Khnopff was in Vienna around 1898 and could have become friends with Hoffmann at that time. He published a favorable article about Hoffmann in *The Studio* XXII, 1901, no. 98, 261ff.

Bibl.: R. L. Delevoy et al., *Fernand Khnopff*, Brussels, 1979, 47ff.; Hevesi, *Acht Jahre*, 30ff.; letter from Robert Von der Mühll of 28 July 1924; Estate.

Cat. 37 1899

Exhibition design: Pavilion and dining room of the Anton Pospischil firm for the Paris Universal Exposition 1900
Winter Exhibition 1899/1900
Austrian Museum of Arts and Crafts, arcade court

In a hexagonal pavilion of light wooden construction, three sides are closed off to serve as a background for furnishings; two sides allow views into the interior through wooden grillwork over parapets, and one is the open entrance. In contrast to the intentionally light and unassuming temporary architecture, the furnishings are very costly and massive—polished mahogany with shiny gilt metal mountings and brilliant cut glass. Typical Secessionist forms appear only on the sides of a large buffet; there are also two smaller sideboards with drawers.

Bibl.: *Interieur* I, 1900, 33, 132, pl. 19; H. Bahr, *Secession*, Vienna, 1900, 189; *DK* III, 1900, 470, 471; *ID* XI, 1900, 126, 127; *KuKhw* III, 1900, 21.

Cat. 38 1900

Exhibition design: Room of the Vienna School of Arts and Crafts
Paris Universal Exposition 1900

In a corner of a room 5.75m high and about 11.50m square is a 3.50m wide inset that serves as a vestibule to display graphic works, as an entrance portal, and to delimit the niche in the main room. On the niche's back wall is a large painting on wood representing the Triumph of

Music, which suggests the intended use of the entire space. The painting, the centerpiece of a large-scale decorative composition, is of female figures (Muses?) in a stylized grove seen through a curved frame.

In the first design the curves on the wall appear as stylized plant forms, but they became more abstract in the execution. The rectilinear articulation of the wall by dark moldings serving as base, thin pilaster-strips, and cornice unifies a tight and clear composition. Not only the entrance portal but all other door openings are partially decorated with rich carving; these forms and those of the exhibited furniture and pedestals harmonize with the stenciled curves on the walls. The published first design allows insight into the architect's method of proportioning: the door opening has the same height-to-width ratio in the clear as the width-to-height ratio of the entire wall, so that the respective diagonals are at right angles.

The *Handbuch der Architektur* proves that this method of proportioning was an architectural commonplace at the beginning of the 20th century. Furthermore, relations on one side of the room are repeated on the other, so that, for example, the front of the vestibule corresponds exactly to the opposite compartment with door and framing.

Bibl.: *Interieur* I, 1900, 53, 54, 123-125; *Studio* XXI, 1900, no. 92, 112, 113; *DKuD* VI, 1900, 460; *Die Kunst* II, 1900, 470; *DK* IV, 1901, 9ff.; *ID* XI, 1900, 90, 91; *KuKhw* III, 1900, 112-122; Muther, *Studien* I, 302.

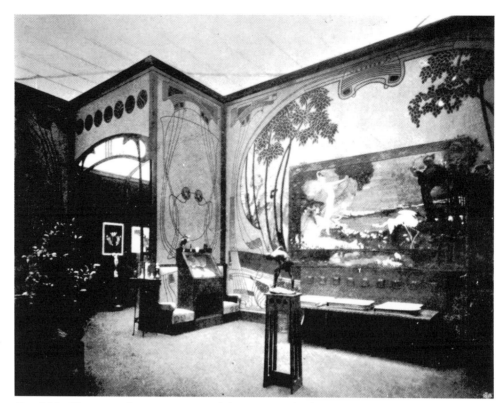

Cat. 38/I. View toward entrance, room of the Vienna School of Arts and Crafts, Paris 1900

Cat. 39 1900

Exhibition Design: Rooms of the Secession
In the Grand Palais, Paris Universal Exposition
1900
Execution: J. Müller and C. Giani Jr.

Hoffmann was responsible for designing the entrances to the Austrian art exhibition and two rooms with polygonal ground plans. Using flat wooden boards, he divided the walls into compartments in which uniformly framed pictures hang at eye level. In the smaller room for the exhibition of watercolors and drawings, the narrow white frames stand out clearly from the bluish green background, which harmonizes with the light maple furniture and wall articulation. The latter incorporates a decorative openwork divider next to the entrance.

In the second room for large works, dominated by Klimt's *Philosophy*, the pictures are in narrow gold frames. Richard Muther remarked: "It is wonderful how the pictures harmonize with each other and with the brownish green wall." The wall articulation and carved overdoor panels are reddish brown stained oak polished to high

gloss. The canvas-type wall covering has delicate linear patterns in yellow and white appliqué above the overdoor panels and at the top and bottom of all wall compartments. The yellow and gold silk fabric for door curtains and sofa covering was designed by Kolo Moser.

Bibl.: *VS* III, 1900, 287ff.; *Studio* XXI, 1900/1901, no. 92, 114-119; XXII, 1901, no. 98, 261; Muther, *Studien* I, 331; *DK* IV, 1901, 16.

Cat. 40 1900

Exhibition design: Dining room
Paris Universal Exposition 1900
Execution: W. Hollmann

Hoffmann designed this dining room for the Universal Exposition in addition to the dining room executed by the Anton Pospischil firm and shown at the winter exhibition of the Austrian Museum (see Cat. 37). It is a long rectangular room with an alcove and a table with armchairs for fourteen people. The roughcast white walls are articulated by wainscoting, narrow listels, and a carved openwork frieze. Doors and frames and overdoor panels, as well as the arched portal of the alcove, match this composition. Buffet cabinets, window bench, and stove are also integrated with the whole design. The gray green stained oak is complemented by yellow tiles on

Cat. 38/II. Elevation, Room of the School of Arts and Crafts, Paris 1900

Cat. 39. Room of the Secession, Paris 1900

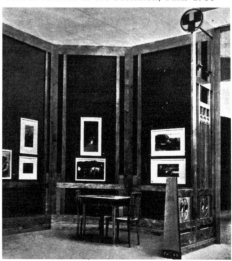

the stove and yellow leather on the chairs, as well as ceiling lights, mountings, and hanging flower baskets of gilt brass.

Bibl.: *Interieur* I, 1900, 129-132.

Cat. 41 1900

Anteroom
Execution: Bernhard Ludwig

Das Interieur illustrated this anteroom with the above dining room at the Paris Universal Exposition with the caption "From the same apartment," without further information. It could well have been designed with the dining room. The door frames with their inner faces and overdoor panels are enameled white, as are the china cabinets with brilliant cut glass that are integrated with the wainscoting. These cabinets are symmetrically composed in three or four parts. The lateral sections are higher, forming an unglazed compartment with a curved open front below the flat top shelf. An unusual lighting fixture is above the built-in gas fireplace with round opening. It consists of light bulbs fixed to decorated cables that are obliquely suspended from the wall. Seating is provided by the kind of armchairs in wickerwork Hoffmann employed on other occasions (for example at Secession exhibitions).

Bibl.: *Interieur* I, 1900, 133.

Cat. 42 1900

Designs for rooms and pieces of furniture

In 1900 *Das Interieur* published two groups of such designs; they are supplemented by sketches in *Ver Sacrum*. One group corresponds in its forms to the curving pieces of 1899, and probably dates from that year. Here the wall articulation, stenciling, and individual furniture designs are typically Secessionist, while the pieces in the other group are more quiet and rectilinear.

The design for a room in a coffee house (billiard room) is representative of the first group. This design pulls walls and ceiling together, and utilizes curved wooden struts to form a seating niche and a tiled buffet niche with shelves and small cabinet. A small flower table stands before a wall projection; its plants correspond to the picture of a wooded landscape above. The design is characterized by much movement, fusion of parts, and obscuring of connections.

Two representative designs of the second group were published not only in *Das Interieur* but also in *Ver Sacrum*, where they were identified "Bed- and living room" and "Corner in a living room." They scarcely use multiple curves, show

clear formal and spatial connections, and already relate to the simplicity Hoffmann achieved in his sketches for Lichtwark's publication (see Cat. 43).

Bibl.: *Interieur* I, 1900, 52, 53, pls. 7, 8, 32; *VS* III, 1900, 68-70, 79; Nebehay, *VS*, 87.

Cat. 43 1900

Architectural sketches for Alfred Lichtwark's publication "Palastfenster und Flügelthür" ("Palace Window and Two-leaf Door"): Hall and high window bench

In the hall a straight stair of two flights leads to a gallery above an area usable as a seating niche with a large window. The stairs and gallery have simple wooden railings with straight bars; the low wainscoting also consists only of straight boards. In the foreground is a tile stove with slightly tapering sides and a widely projecting base. A potted plant at the gallery railing and a few pictures are the only decorative elements. As the walls are also without stenciling, the total effect is severely simple. The same applies to the window seating with two facing benches (text fig. 30), referred to as "high window bench." They stand between slender vertical struts in a room of straight lines and flat planes except for the curved sides of the benches and a restrained stenciled frieze.

Bibl.: Original sketches: ÖMAK; *VS* III, 1900, 72, 73.

Cat. 44 1900

Sketch for a Moravian country house

Perspective view of the entrance facade of a broad country house with projecting half-hipped roof and small entrance block. The front joins a wide round-arched entrance, the curve of the arch rising from the ground. The opening is closed by two low barriers that allow a view of the house and garden beyond. Next to it is a smaller round-arched gate at a right angle to the facade; it opens onto a small front garden with the entrance porch.

Bibl.: *VS* III, 1900, 67.

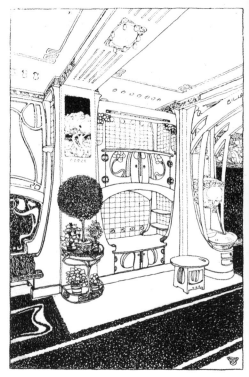

Cat. 42/I. Perspective, café interior

Cat. 42/II. Perspective, corner of a living room

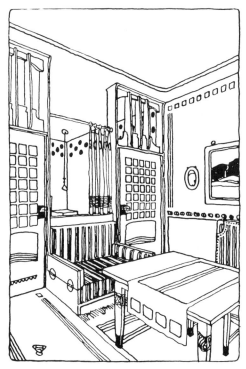

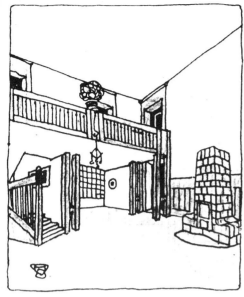

Cat. 43. Perspective, hall with gallery (cf. text fig. 30)

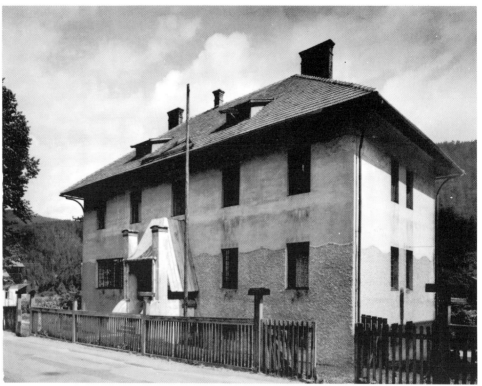

Cat. 45/I. Forestry office, street view (1965)

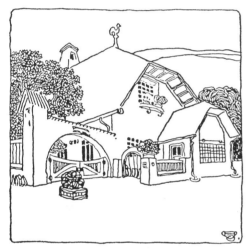

Cat. 44. Perspective sketch, country house

Cat. 45 1900

Forestry office of the Wittgenstein Forestry Administration
Hohenberg 105, Lower Austria, for Karl Wittgenstein
Building permit: 26 March 1900
Completion: 26 October 1900
Execution: Franz Gröbl, Builder, Hohenberg
Building cost: 27,817 crowns

This rectangular building (11.75m × 19.90m) is located on the main street, somewhat outside the built-up section of the settlement. It has a basement and two upper stories, in stuccoed brick construction, with widely projecting tile-covered hip roof and straight dormer windows. The base-ment is covered by segmental vaulting between steel beams; the upper stories have floors constructed with wooden joists.

The facade is divided into three zones, corresponding to base, middle portion, and cornice. The base zone has a surface of roughcast with a slightly wavy upper edge ending just below the top of the first floor windows. The middle zone is smooth stucco, enriched by a decorative frieze from the corners to the first windows. The up-permost cornice zone is enlivened by stenciled Secessionist ornament.

The entrance (text fig. 35) is set in the center of the facade. Its open stairs are partly shielded by a construction of idiosyncratic design, con-sisting of two curved parapets surmounted by pylonlike pillars with segmentally arched tops. These flank a sheet metal roof curving up to the second-floor window; its lateral parts reach down behind the pillars. The horizontal gutter and downspouts play a not inconsiderable part in the total conception. Parts of the curved parapets, downspouts, and the pillars below their tops are grooved or fluted. This entire construction looked somewhat different in the submitted plan.

The entrance leads to a vestibule and central staircase with U-shaped wooden stairs; the rail-ings are rich in form but designed with geometric severity. To the left is the forestry office with built-in file cabinets and map drawers, desks and

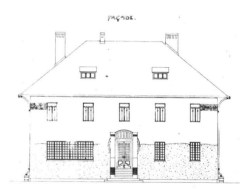

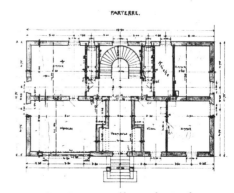

Cat. 45/III. Forestry office, submitted ground plan

drawing tables designed by Hoffmann, and an adjoining large room. To the right are service apartments of two rooms and kitchen. Other apartments for forestry personnel are on the second floor. All woodwork on the facade is painted blue.

This building and the adjoining dwelling (see Cat. 46) still serve their original functions. After restoration in 1978 it is in excellent condition. The entrance was somewhat altered by removal of the downspouts and the addition of new lower stair parapets. The painted woodwork was changed to green in 1949.

Bibl.: Submitted plan in the archive of the forestry office; *Architekt* VII, 1901, 26, 47.

Cat. 46 1900

Dwelling for personnel of the Wittgenstein Forestry Administration
Hohenberg, Lower Austria, for Karl Wittgenstein
Building permit and execution as for Cat. 45
Building cost: 24,363 crowns

Next to the forestry office is a dwelling with full basement; it consists of a two-story wing (13.70m x 10.45m) with finished attic, an adjoining one-story wing (5.45m x 11.35m) with finished attic, and covered entrance stairs.

The facade is divided into two zones. The socle zone has roughcast up to the middle of the first-floor windows. The smoothly stuccoed zone above with inset wooden framing gives the impression of half-timbering; the construction is actually in load-bearing brick, like the adjoining building. The lintels of the first-floor windows are enriched with a simple stenciled pattern, the woodwork above the second-floor windows with visible square dowels, and the corners of the building with stylized leaf forms in cut stucco. All woodwork is painted green.

The steep roof (47 degrees) is tiled; the rear main wing has a dormer window, added later for additional lighting of the finished attic. The widely projecting roof of the main wing is gabled, with visible struts in the upper part of the gable, while the lower wing has a half-hipped roof.

Open stairs along the left side, under a roof added in 1948, lead to the raised first floor and the well-lighted wood staircase with decorative railings. On both floors, rooms and apartments for forestry personnel open from the stair hall. A veranda, originally at the left corner in the upper story, was converted into an additional room in 1948.

Bibl.: See Cat. 45.

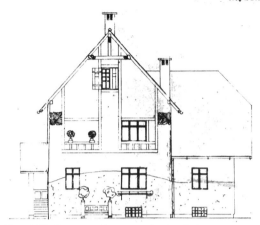
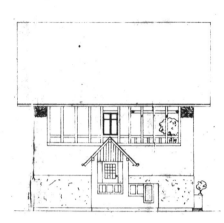

Cat. 46/I. Foresters' house, submitted elevation

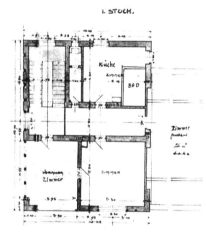

Cat. 46/II. Foresters' house, submitted ground plans

Cat. 47 1900

Eighth Exhibition of the Vereinigung bildender Künstler Österreichs (Secession)
Opening: 3 November
Design of the central room, and the halls, IV, V, VII, VIII, using furnishings of Hoffmann's design.

This exhibition focused on crafts, with strong foreign participation. Hoffmann designed a high, light, central space with rectangular forms in forceful contrast to an adjoining darker corridor-like area with a tentlike ceiling. Low framed partitions with stenciled panels and vertical grill-work at the ends subdivided the central space. They had polychromed tall uprights crowned by widely projecting abaci as outer terminations. In the central gallery a massive secretary by Charles Ashbee occupied the place of honor.

Hoffmann showed numerous pieces of furniture of his own design. These included a group for a garden salon enameled white and sealing-wax red, a "matte dark blue cabinet for a gentleman's linen," a mantelpiece and buffet in white maple, a cabinet for musical scores, a cabinet in brown stained soft wood with iron mountings, consisting of three straight-lined elements on top of each other, and more costly pieces made of rare woods with intarsia or metal inlays. The lines are very restrained and generally without the curves that were still characteristic of the 5th Secession Exhibition in the previous year. Hoff-

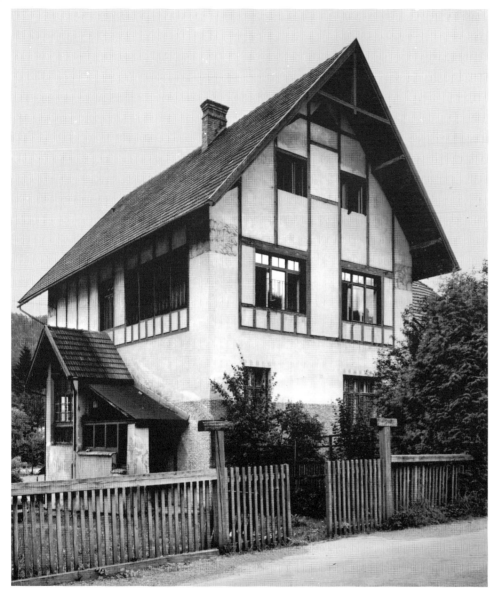

Cat. 46/III. Foresters' house, street view (1965)

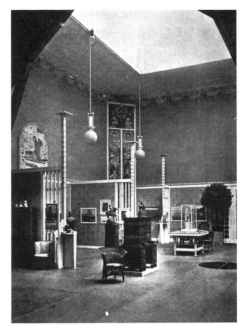

Cat. 47. Central room, 8th Secession Exhibition

mann now stressed effects of color and texture: "In a highly individual manner Hoffmann uses multicolored patterns for inlaid woods that seem to be inspired by the endpapers of old books. A jewelry cabinet of this kind in light green, white and matte blue . . . is of uncommon effect" (Hevesi). Besides furniture, Hoffmann showed numerous hand-crafted objects and a binding for a large bible. For the catalogue he drew seven vignettes (see Cat. 48).

Bibl.: Catalogue, *8th Exhibition VBKÖ*; Catalogue, *10th Exhibition VBKÖ*; *VS* III, 1900, 375-386; *Interieur* II, 1901, 17ff., 72, 154; *DK* IV, 1901, 171ff., *Studio* XXIII, 1901, no. 98, 264ff.; *ID* XII, 1901, 30ff.; Hevesi, *Acht Jahre*, 284ff.; *KuKhw* III, 1900, 467-469.

Cat. 48 1900

Pieces of furniture and book decoration

Das Interieur published seventeen finished pieces of furniture from designs by Hoffmann, from a small shelf and a music stand to upholstered armchairs and case furniture of all kinds, in a variety of forms and materials. Some were seen at the 8th Secession Exhibition. *Ver Sacrum* contained book decoration by Hoffmann including designs for ornaments and bindings.

In the catalogue of the 8th Secession Exhibition there were vignettes of which three showed details of furniture or interior design. One vignette showed two vessels, one with flowers. Three presented simplified views of houses. One of the houses has a half-timbered second story; one seems to be round or oval; the third has a loggia in front of a main facade dissolved into square window openings. Hoffmann used the latter also as a signet on his stationery. Most of these vignettes were also reproduced in *Das Interieur*.

Bibl.: *Interieur* I, 1900, 50, 80, 138, 147-151; II, 1901, 155, 194, 195, 202, 203; Catalogue, *8th Exhibition VBKÖ*, 8, 9, 18, 19, 30, 31, 40; for Hoffmann's contributions to *VS*, see Nebehay, *VS*, 219.

Cat. 48/I-III. Vignettes with houses

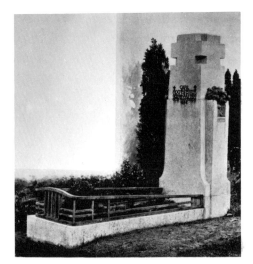

Cat. 49. View of Carl Hochstetter grave

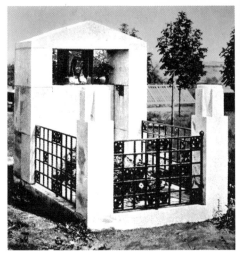

Cat. 51. View of grave in Mauer

Cat. 49 about 1900(?)

Tomb of Carl Hochstetter (1850-1899)
Vienna, Grinzing Cemetery, Group 3, 24
Date: The tomb was published in 1903 but probably dates from around 1900 as is evident from the treatment of formal details.

The grave has a rectangular stone border with a low metal railing of markedly horizontal lines. The border is higher in front than at the rear where it touches the tombstone. The central stone has slightly inclined sides with curves at the bottom and a cross-shaped top. It is flanked by lateral projections topped by stylized flower insets of metal.

The tomb is preserved although the railing is missing; a new plaque has replaced the original inscription.

Bibl.: *Architekt* IX, 1903, 42.

Cat. 50 about 1900(?)

Tomb of Philipp Knoll (1841-1900)
Vienna, Grinzing Cemetery
Date: The tomb was published in 1903 but could date from 1900.

A stone about the height of an adult man has lightly sloping sides and an inscription. Low stone walls border the grave; at the front of the enclosure is a square opening with a grillwork door of black metal in restrained decorative forms. Not extant.

Bibl.: *Architekt* IX, 1903, 42.

Cat. 51 about 1900(?)

Tomb
Mauer, near Vienna

The tomb of light stone consists of an aedicule and an area in front bordered by a dark metal railing with square panels that include flat decorative insets. The two front pillars have sculptured tops for flowers. The wall bearing the inscription is recessed between the sides of the aedicule; a windowlike opening below the pediment contains a girl's bust framed by two vertical elements. The monument cannot be found in the Mauer cemetery.

Bibl.: *Architekt* IX, 1903, pl. 2; *Hohe Warte* I, 1904/1905, 367.

Cat. 52 1900-1901

House for Kolo Moser on the Hohe Warte
Vienna XIX, Steinfeldgasse 6
Approval of submitted plans: 24 October 1900
Certificate of occupancy: 14 August 1901
Builder: Franz Krásný (not Krasnik, as erroneously indicated in *Der Architekt*)

This and the neighboring house for Carl Moll (Cat. 53) were planned, built, and completed at the same time. Both are on the east-west Steinfeldgasse so that the street facades face north and the gardens south. The Moser lot of 12.5m x 35.5m is about half as large as the corner lot of the Moll House. Both houses are of traditional construction in stuccoed brick, with floors of wooden joists over the main stories.

The disposition of rooms is as follows: on the top story where the walls merge with the sloping roof are the large studio of the owner with bedroom and bath and a large terrace on the north side with a view of the Leopoldsberg and Kahlenberg. These rooms can be reached by a circular stair at the southwest from the basement or by a stair beginning in the room below. On the opposite side this room opens wide into a large corner room with polygonal bay window. Then follows an approximately square room on the street side, marked as a bedroom in the certificate of occupancy, which opens into an alcove in the middle of the house. Beyond is a second bedroom with bath on the garden side.

Access to the main floor is by stairs inside an annex along the outer west wall leading to an anteroom with circular stair and toilet. Kitchen, laundry, storage rooms, and a maid's room are in the basement. The basement is so close to

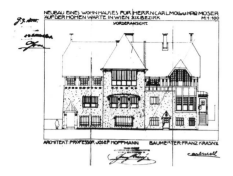

Cat. 52/I. Moll-Moser House, submitted elevation (cf. text fig. 40)

Cat. 52/III. Moser House, submitted cross-section

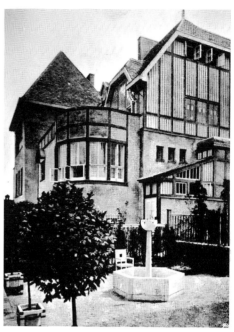

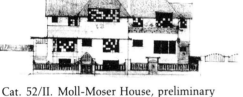

Cat. 52/II. Moll-Moser House, preliminary study, view

Cat. 53/I. Moll House, submitted side elevation

Cat. 52/IV. Moser House, side view with entrance (cf. text fig. 40)

grade level that its floor is only three steps down from the garden.

By using different devices, the exterior of the house is so varied that it seems larger than it actually is. In this respect the execution went beyond the preliminary plan. The separate half-hipped roof over the large studio window on the north side and carrying up the newel staircase into a towerlike projection at the southwest corner contribute as much to the creation of a dynamic outline as the polygonal alcove and the enclosed entrance stairs on the west side.

Further enrichments include the apparent half-timbering of the upper story, the support of the box gutter on the main cornice by curved, light metal consoles, the half-round metal roof over a window on the street front, and the flat metal roof with rounded edges at the entrance. There are also strong contrasts of texture and color between rough stucco, metal, painted wood, and the tiles of the tall roof. In many cases windows and doors are subdivided into small squares. On the garden front is a small veranda that was not in the original plan.

The building has undergone considerable alteration, most recently during restoration in the 1970s, but the original general effect is still recognizable.

Bibl.: Plans: ABBH; *ID* XIII, 1902, 29; *Architekt* IX, 1903, 85ff.; *Interieur* IV, 1903, 121ff.; J. A. Lux, *Das moderne Landhaus*, Vienna, 1903, 96, 98.

Cat. 53 1900-1901

House for Carl Moll on the Hohe Warte
Vienna XIX, Steinfeldgasse 8/Corner Geweygasse
Approval of submitted plans: 24 October 1900
Certificate of occupancy 14 August 1901
Builder: Franz Krásný

The house forms a visual unit with its smaller neighbor, the Moser House. A passerby on the northern street side could easily mistake them for one long house rather than two paired buildings. They have the same basic plan organized around a central stair accessible from a living hall. Another common feature is the entrance by a stair at the side wall; in the Moll House the stair is inside the building. The house can be entered by a secondary entrance on the east side leading to the basement or by the main entrance at the corner of the Steinfeldgasse. A small projecting entry with separate roof protects the straight staircase leading to a vestibule which opens into the central hall; next to it is a toilet. The main stair is at the opposite side of the hall, next to which a passage leads to the basement stair and to a small pantry between the dining room and the bedroom. The bedroom opens onto a veranda with exit to the garden. Next to the bedroom is a room and bath and next to the dining room is the salon with a small raised corner niche.

Cat. 53/II. Moll House, side view with entrance

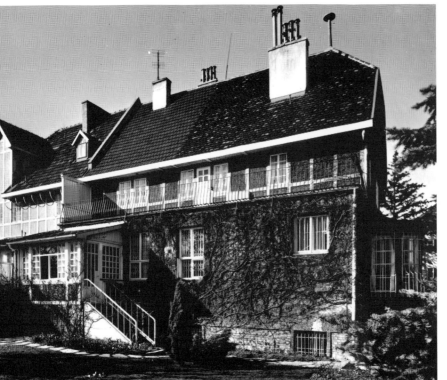

Cat. 53/III. Moll House and Moser House, garden view (1965)

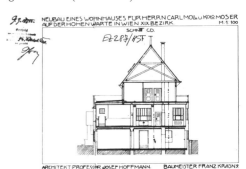

Cat. 53/V. Moll House and Moser House,
garden view (about 1902)

Cat. 53/VI. Moll House, submitted section
(cf. text fig. 44)

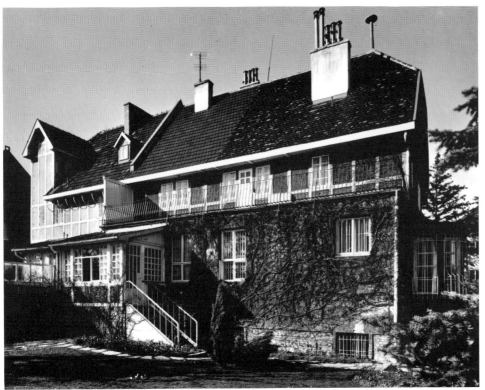

Cat. 52/V and 53/IV. Moll House and Moser House, ground plan

On the upper story, as in the Moser House, are a large studio on the north side with terrace and a vestibule, and two rooms and a bath. The basement contains the kitchen and laundry plus two storerooms and a servant's room.

The exterior design is closely related to the Moser House with its highly articulated and varied appearance. On the street side this is achieved by the studio block which projects as a somewhat higher pavilion with its own towerlike pyramidal roof. On the garden side the projecting veranda on the ground floor and the recessed upper story with its terrace produce the three-dimensional articulation. There are further details, such as the half-hipped roof on the gable side and the half-timberlike walls of the upper story echoed by the four posts rising above the terrace railing. Above the basement entrance on the east facade and above a sculpture near the corner are curved metal protective roofs. The wide overhanging box gutter is designed like that of the Moser House, but without the metal supports. Windows and doors are again often divided into smaller squares.

The building was extensively altered and merely suggests the original total impression.

Bibl.: Like Moser House, Cat. 52.

House for Dr. Hugo Henneberg on the Hohe Warte
Vienna XIX, Wollergasse 8
Entered in the land register: 27 July 1901
Builder: Franz Krásný

Hoffmann conceived the first four houses built on the Hohe Warte as a unit of four related buildings. Their ground plans, however, had to conform to the street layout. Unlike the Steinfeldgasse with the Moll-Moser double house, the Wollergasse runs approximately north-south. The Henneberg House, along with the other three houses, has the usual brick wall construction, a studio on the upper floor, and a basement story only partially below grade resulting in a raised ground floor. Considerable difference in level between street and ground floor had to be overcome. In the Henneberg House the visitor approaching from the garden gate must first walk uphill along the whole length of the north front to reach the main entrance. One then enters a vestibule with a short open stair, at the head of which one makes a 90 degree right turn into the great hall. This is the central element of the building and extends through two floors. On the ground floor it is lighted by a large north window and on the upper story by a strip window on the south. The hall connects with a loggia with steps to the front garden. It also leads directly into the dining room with adjoining smoking room and to a boudoir with a bow window. The dining room has access to a wide corridor which can serve as a pantry and which connects to a secondary stair of three flights, a toilet, and a small room. In the garden facade the walls of the staircase project considerably.

Kitchen, laundry, servant's room and caretaker's apartment, plus furnace and storerooms are in the basement. The upper story contains living quarters reached either by the open stair from the hall and a gallery or by the secondary stair. Clockwise around the hall, starting at the southeast corner, are a small room, a terrace, two guest rooms, the lady's dressing room, the main bedroom, and a bath. The finished attic houses a photographic studio with its subsidiary rooms and a large study; in front of the studio with its large windows facing north is a terrace which, like the terraces of the Moll-Moser House, offers a view of the Wienerwald hills.

On the lower floors the house appears as a rather compact, cubical building, except for the loggia on the street side; in the upper stories it appears much more varied due to the terraces and towerlike corners, except on the garden side where it remains closed and cubical to its flat terminations. These contrast with the high roofs that repeat the gable with half-timber motif of

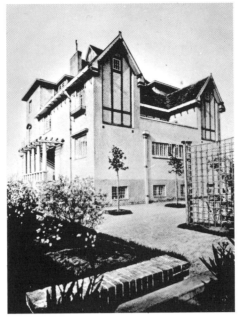

the Moll-Moser House. The Henneberg House also shares the widely projecting box gutter with slim metal brackets.

The exterior is finished in roughcast. A white coarse-grained stucco also predominates in the interior; it is in contrast to the sparingly used, colored stucco decoration, and the colors of the paneling, furniture, and floor coverings. The hall woodwork is stained greenish black to match the owner's artistic photographs; the open fireplace of marble, iron, and gilded brass, with the portrait of the lady of the house by Klimt above, provides the main accent.

The rooms are in different colors and furnished with custom-designed pieces, many of them built in. Thus, the study is designed around a cabinet by Mackintosh in dark stained wood. In the dining room the white lacquered wood of the buffet contrasts with black marble and the ebony of table and chairs. The studio displays brownish red wood and a dark red floor; the lady's dressing room has red polished furniture, red fabric on the walls, and a red floor. The master bedroom has woodwork lacquered in light

Cat. 54/I. Dr. Henneberg House, garden view (cf. text fig. 42)

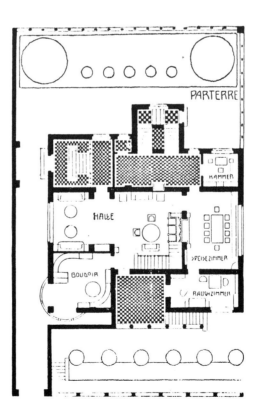

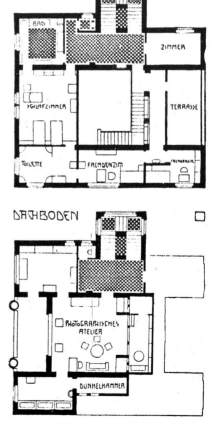

Cat. 54/II-IV. Design for Dr. Henneberg House, ground plans (cf. text figs. 43-48)

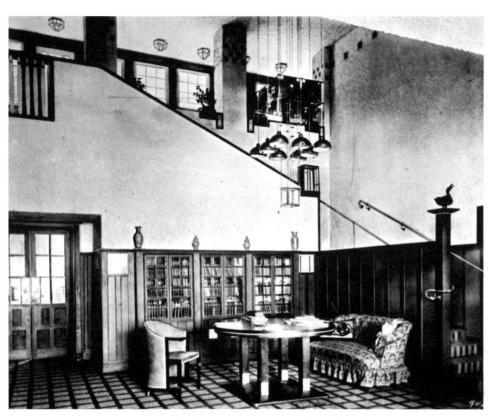

Cat. 54/V. Dr. Henneberg House, hall, view toward stair (cf. text fig. 46)

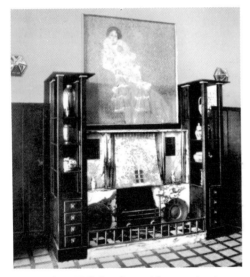

Cat. 54/VI. Hall fireplace with portrait of Marie Henneberg by Gustav Klimt

bluish gray with brass mountings, mirrored panels, and stenciled walls with restrained color accents. In the secondary staircase, the carefully designed kitchen, and all subsidiary rooms, black and white predominate as colors, and the square as form.

Cat. 55. Calendar page with study of a country house

The design of the garden is severely geometric with clipped hedges and axial symmetry in the main part. A central path leads to an exedra cut out of the enclosing hedge. Opposite the south facade are trelliswork niches with Baroque garden sculpture.

The house was heavily damaged in World War II and then reconstructed as a rental building, so that it is impossible to visualize the original state.

Bibl.: *Architekt* VII, 1901, pl. 51 (preliminary design); *Interieur* IV, 1903, 124-152; *Studio* XXXII, 1904, 124ff.; N. Powell, *The Sacred Spring*, London, 1974, 67; *Art-Revival*, C16, C27; M. Paul, *Technischer Führer durch Wien*, Vienna, 1910, 508.

Cat. 55 1901

Architectural sketch entitled "Landruhe" (Country Calm)

Perspective view from a garden entrance to a country house set among trees. The house has a wide hip roof projecting over a terrace on the gable front, and a tall chimney. The facade, with a small wall fountain, is linked to a courtyard wall with gate and decorative niche for a ceramic vessel. The drawing was used as a calendar page for the month of June.

Bibl.: *VS* IV, 1901, 12; Nebehay, *VS*, 99.

Cat. 56 1901

12th Exhibition of the Vereinigung bildender Künstler Österreichs (Secession)
Opening: 22 November
Design of exhibition rooms

The exhibition was devoted primarily to Scandinavian, Russian, and Swiss artists, and to Jan Toorop; it was designed by Hoffmann as follows: "In the center a large rectangular hall, which at the back has entrances to somewhat raised side galleries. The main hall is covered like a tent with white fabric; the walls are also covered with white folded fabric, framed with yellow stripes and articulated by identical triple vertical stripes" (Hevesi). The covering of the walls and ceiling and the raising of the side halls were done in the course of preparation for the 14th Secession Exhibition, as Marian Bisanz-Prakken has shown.

The entrance hall was also altered by installing a box office newly designed by Hoffmann, who chose a white and gold color scheme for it.

Bibl.: Catalogue, *12th Exhibition VBKÖ*; *VS* V, 1902, 29, 35, 36; *Studio* XXV, 1902, 38; M. Bisanz-Prakken, *Gustav Klimt, Der Beethovenfries*, Salzburg, 1977, 13.

Cat. 56. Central room, 12th Secession Exhibition

ENTWURF FÜR EIN GLASFENSTER

orliegende Skizzen, die ungefähr vor einem Jahre entstanden sind, bilden Studien zu dem berüchtigten Schlagworte »Einfache Möbel«.
Vielleicht ist es überflüssig, sie zu publiciren. Sie zeigen nichts Neues. Jedoch was wird in diesen schweren Zeiten nicht alles gedruckt und was muss man sich nicht alles gefallen lassen!
Ich will mich daher nicht erst entschuldigen, sondern nur noch über Einiges sprechen, was, obwohl oft genug gesagt, immer wieder ins Gedächtnis zurückgerufen werden sollte.

Cat. 57/I. Title page of the article "Einfache Möbel" ("Simple Furniture")

Cat. 57 1901

Designs for simple furniture

More than thirty designs, accompanied by a polemical text (Appendix 4) and vignettes, were published in *Das Interieur*. The free-standing and built-in furniture shown is simple in form and construction but not in purpose. There are luxury pieces such as cabinets for small objects, salon furniture for precious objects, cases for mineral collections, plus toilet tables, writing desks, bookshelves, a piano, and many other pieces. Hoffmann showed examples of the three types he distinguished in his text: board, pillar, and case pieces. The design for a glass window executed for Helene Hochstetter (see Cat. 60) is also illustrated. Wood is handled mainly in straight lines; Secessionist curves are eliminated.

Bibl.: *Interieur* II, 1901, 193-208, pls. 85-92; drawing for pl. 85: ÖMAK, illustrated: Mang, 99; M. Fagiolo, M. G. Messina, *Hoffmann, i "mobili semplici," etc.*, Galleria dell'Emporio Floreale, n.d.

Cat 58 1901

Pieces of furniture and book decoration

For the 9th Secession Exhibition, Hoffmann designed the endpaper for the catalogue. At the 10th Exhibition, for which he designed the catalogue cover, he exhibited individual pieces of furniture; in this context Hevesi singled out a cabinet in red and white maple with brass mountings, and a red showcase. For *Das Interieur* and *Ver Sacrum*, Hoffmann drew decorations including the frame for a page of music "*Kleinstadt Idyll*," an abstract composition mainly of straight lines. For industrial production, he designed bentwood furniture, and for the firm E. Bakalowits Sons he drew glass vessels.

Bibl.: Hevesi, *Acht Jahre*, 324; *VS* IV, 1901, 12, 68, 97, 157, 164, 411; *Interieur* II, 1901, 193-208; Nebehay, *Klimt*, 235, 236, 238; St. Asenbaum, J. Hummel, editors, *Gebogenes Holz*, catalogue, Vienna, 1979, 37ff.

Cat. 57/II. Furniture from "Einfache Möbel"

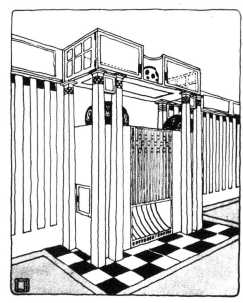

WANDKÄSTCHENO
V. SITZGELEGENHEIT

COMMODE AUS
ZWEIERLEI □
HÖLZERN □
DIE FLÄCHEN
FOURNIRT □

□ EIN SALONMÖBEL
FÜR KOSTBARKEITEN
UND KLEINPLASTIK

Cat. 57/III-VI. Furniture from "Einfache Möbel"

regular polyhedrons. Two other rooms show the same basic design throughout.

In 1905 a bentwood bed after a design by Hoffmann was exhibited in London.

Bibl.: *Art Revival*, C14, C17; *Jahrbuch der Gesellschaft Österr. Architekten*, Vienna, 1908, 69ff.; St. Asenbaum, J. Hummel, editors, *Gebogenes Holz*, 45, 46; *Die Form*, VII, 86.

Cat. 60 1901-1902

Furnishings for Helene Hochstetter, Vienna
Execution: A. Pospischil

A bedroom and a living room/study for a young woman. The living room, with cabinets, desk, pedestal for a statue, and seats, has coarse-grained plaster walls and wainscoting in walnut with inlaid linear patterns in white maple. In the upper part of the window is a lightly colored stained glass inset, the design for which Hoffmann used as the opening of his article on "Simple Furniture" in 1901 (see Cat. 57). The furniture and wainscoting in both living room and bedroom are in the "board style," i.e., their effect rests largely on the harmony of almost equally wide stiles and panels.

In the bedroom, the bed, sofa, washstand, and cabinetry are integrated with the wainscoting at a uniform height. The wall is covered with a green gray patterned fabric within a framework of maple stained light blue. The cabinets have square maple panels stained dark blue and polished with mountings of hammered iron. Dark blue wall-to-wall carpeting covers the floor.

Bibl.: *ID* XIII, 137-140.

Cat. 61 1901-1902

Furnishings for Director Dr. Hugo Koller
Vienna IV, Argentinierstraße 26
Execution: W. Müller

Furnishings for a connecting corridor, anteroom, and salon with existing pilaster decoration. The connecting corridor is kept light, except for a black marble stove, and furnished with white lacquered furniture, while the anteroom is darker, with dark blue floor covering and woodwork in stained alder. The walls are covered to door height with large panels of stenciled gray fabric. The upper termination is formed by a frieze of decorative square panels framed in wood; this frieze is interesting because its motif, a geometricized rose, in somewhat changed form later appears as the trademark of the Wiener Werkstätte.

To remodel the salon, the areas between the existing pilasters were divided into squares by slim wooden frames painted white, which contained either mirrors or light patterned fabric

Cat. 59 about 1901(?)

Furnishings of three rooms in bentwood
Execution: Jacob and Josef Kohn

As consultant for the firm Jacob and Josef Kohn and also for Thonet, Hoffmann, like Kolo Moser, made several bentwood furniture designs. At the Christmas exhibition of the Austrian Museum for Art and Industry in 1901, "three complete interiors in modern style" for the Kohn firm were exhibited. Illustrations of a dining room, salon, and bedroom were also published at a later date.

In the dining room the motif of the rounded corner, typical of bentwood, is displayed in every possible way. The panels of the low wooden wainscoting have bentwood frames with such corners, the decorative frame and the casing of the door opening are bent at the corner, and even the tile stove repeats this motif at the top. On the dining table the edge of the thick top is thus framed, and in the case of the leather seats and backs of the chairs their almost shell-like overall form shows definite consideration for the curve of the wood. The walls are stenciled with light decoration. The light fixtures are designed as

Cat. 60. View toward window of Hochstetter living room/study; the window corresponds with the design in Cat. 57/I

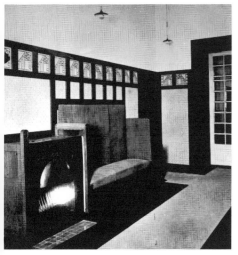

Cat. 61. Anteroom with gas fireplace and bench, apartment of Director Dr. Hugo Koller

Cat. 62. Dining room, apartment of Gustav Pollak

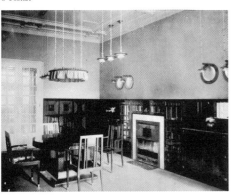

harmonizing with the large carpet in gray, white, and gray blue. A strongly patterned fabric with leaf motifs was chosen for the upholstered furniture; the chairs were executed in polished rosewood. A white marble fireplace in a wooden surround with ogee arches completes the furnishings. Hoffmann also designed a small standing clock and other decorative art objects for Dr. Koller.

Bibl.: *ID* XIII, 1902, 130, 131, 144, 145, 151, 152.

Cat. 62 1901-1902

Furnishings for Gustav Pollak
Vienna IV, Brahmsplatz 2(?)
Execution: Portois and Fix

Three rooms—a vestibule, study, and dining room—are related by the consistent use of straight lines. The vestibule with cabinets and dresser, bench, table, and easy chairs is kept in tones of white and gray blue. The study repeats the gray tone in walls and floor but achieves a strong contrast by the use of polished dark rosewood with ornamental inlays of zerigatti wood for furniture and low wainscoting, and of yellow leather upholstery for the seats. The dining room, finally, with yellow gray walls and light-colored paneling differs from the other rooms in its generally lighter tones. The wood used for furniture and paneling is pitch pine with inlays. Built-in sideboards beside the fireplace are largely glazed. The seats around the large round brass-trimmed extension table are upholstered in dark red leather.

In the archive of the Secession is an undated letter from Hoffmann to the secretary, Hanke, in which he sends a key to Mr. Gustav Pollak and asks to be excused because of illness adding, however, "say nothing to Moll, etc., so I don't get visitors."

Bibl.: *ID* XIII, 1902, 133, 134, 146-150.

Cat. 63 1901-1902

House for Dr. Friedrich Victor Spitzer on the Hohe Warte
Vienna XIX, Steinfeldgasse 4
Approval of submitted plans: 4 May 1901
Certificate of occupancy: 14 May 1902
Builder: Franz Krásný

The Spitzer house, whose preliminary design was published, was the last of the four houses on the Hohe Warte and shares various essential features with the other three. In its exterior design, it relates well to the neighboring Moll-Moser House. As in the latter, the ground floor is high above grade; rather long stairs are there-

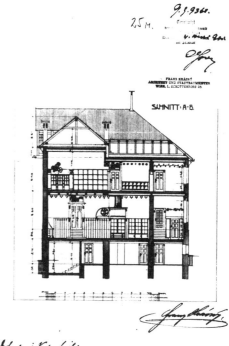

Cat. 63/I. House of Dr. Spitzer, submitted section

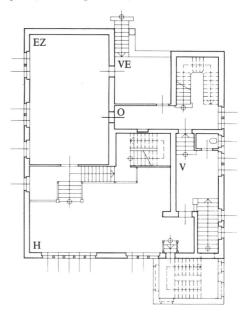

Cat. 63/II. House of Dr. Spitzer, ground plan (cf. text figs. 49-53)

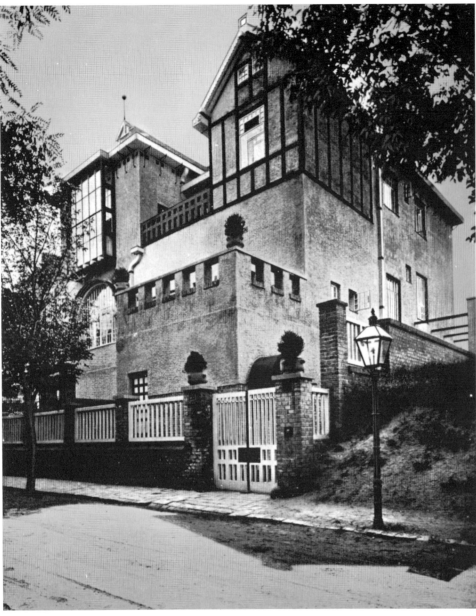

Cat. 63/III. House of Dr. Spitzer, street view

fore necessary for the entrance from the street and the exit to the garden at the south facade.

Access from the street is at the northwest corner by a projecting stairway with a flat roof that doubles as a terrace for the great hall. The stair ends in a vestibule which opens into the back of the house on the garden side and into the great hall. The hall takes up almost the whole length of the street front and lies more than three feet below the rooms on the garden side.

From the vestibule, three elements dominate the hall: a large round-headed window on the left, the fireplace opposite, and, on the right, the open staircase with its landings and subsidiary spaces. These include a large podium that can be used as a concert stage and, not visible from the hall, a library niche with a built-in wall fountain under the stairs. The hall has low paneling in wood stained black with coarse-grained white stucco above. A yellow and gray carpet covers the dark gray stained floor, producing a contrast similar to that of the light upholstery of the furniture and the dark wood of the chairs and tables. In addition to the open fireplace in lead and copper with its curved hood, a large hanging chandelier of transparent cubes is prominent.

The first stair landing opens into the dining room on the garden side with access to a spacious loggia and pantry; open stairs lead from the loggia to the garden. The pantry in black and white connects directly with the subsidiary staircase to basement and upper story.

Kitchen, servant's room, and utility rooms are in the basement; in the upper story are a pantry, corresponding to the one on the ground floor, a large photographic studio with subsidiary room, a study or writing room, and the bedroom with bath, toilet, and dressing room. The studio can be reached from the pantry or by the main stair directly from the hall; it has a glazed alcove and a terrace with a view of the Wienerwald hills. A staircase to the guest rooms in the finished attic starts in the pantry.

The guest rooms project from the facade under steep gabled roofs and with the mock half-timbering of their outside walls provide a strong accent on the street and east facades; they also establish a clear relation to the nearby Moll-Moser House. This is also achieved by the use of the same type of box gutter with metal brackets. Otherwise the garden facade is very simple with large unbroken surfaces. It consists essentially of two sections: a somewhat higher corner pavilion on the right, crowned by an overhanging gable, and the almost square section on the left which houses the deep loggia with its garden stair; the roof of that section is hipped toward the side.

The east facade is unarticulated with the exception of the attic story where the overhanging guest room projects strongly. The windows below appear on the facade as they result from the ground plan and vary in size. The west facade is freely treated in a comparable manner and is plain except for a section at the northwest where the upper story appears as if it were half-timbered. Of all the facades, the street front is most strongly articulated owing to the projections and recesses of the entrance block, studio alcove, and studio terrace. The half-round large hall window with its protective metal hood also plays an important role.

The interior is carefully and richly furnished, using an existing dining room, adjoining music room, and other elements from Dr. Spitzer's city apartment designed by Olbrich. In the upper story, the study or writing room with its built-in furniture, kept in white and gray, is especially noteworthy. The wall-to-wall carpeting has a square grid pattern in two tones of gray. Flanking a window are a desk lacquered white with black lines and a matching bench. It can be said that one sits *in*, not *at*, the desk, because it has its own housing in the room; with its upper glazed compartments it corresponds to a bench upholstered in gray suede and a matching cubical armchair.

The house was greatly altered by different

owners, but the exterior is still very similar to the original state. In 1920 a garage was built in the front garden, later the glazed alcove was replaced by a balcony, and additional windows were opened on the garden facade. The present owner had the balcony and a disturbing chimney on the garden side removed and the alcove restored. On the right side new outside stairs lead to a porch on the facade. The original stairs on the interior of the northwest corner were removed, and a kitchen was installed in the space. The hall no longer has stairs, and only the library niche with the wall fountain still conveys the original effect. Everything else was altered in most rooms, especially through remodeling in historicizing forms by one of Dr. Spitzer's first successors. The open loggia is now glazed and combined with the space formerly occupied by the pantry; a new dining room was formed in this way replacing the old one which now serves as the library. After careful restoration by the present owner the house is in a good state of preservation but the facades are largely overgrown with climbing plants. The building is protected as a historic monument.

Bibl.: *Architekt* VII, 1901, pl. 50; IX, 1903, 88; *Interieur* IV, 1903, 153-183; *DK* VII, 1904, 2-11; J. A. Lux, *Das moderne Landhaus*, Vienna, 1903, 52ff.; *Studio*, XXXII, 1904, 125ff.; *Art-Revival*, C13; Hevesi, *Altkunst*, 217.

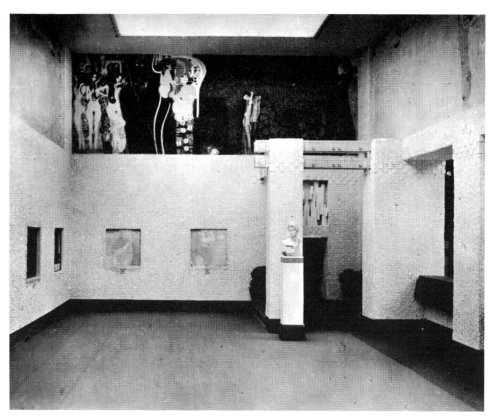

Cat. 64/I. Left side gallery with Hoffmann's *sopraporta* (cf. text figs. 62, 63)

Cat. 64 1902

14th Exhibition of the Vereinigung bildender Künstler Österreichs (Secession), Klinger's Beethoven

Opening: 15 April
Artistic direction, design of all rooms except reading room, cut stucco of two *sopraportas*

The catalogue as well as contemporary reviews make it clear that all participants considered this exhibition especially significant. In the words of Ernst Stöhr in the catalogue, ''. . . the accustomed periodic exhibitions of pictures were to be interrupted by an event of another kind. . . . A unified room should be created first and painting and sculpture should then serve to decorate it in the service of the spatial idea.''

Hoffmann also explained the principles he followed:

''To fulfill their function and to create a worthy frame for the center of the exhibition, Klinger's Beethoven, the exhibition rooms must have a monumental character. The limitation of available means, and the self-evident duty to use genuine material throughout, to energetically

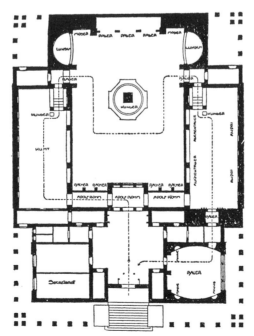

Cat. 64/II. Ground plan of 14th Secession Exhibition

avoid sham and falsity, likewise demanded the greatest simplicity in material and form. Therefore, the roughcast of the walls, which also enlivens them, offered the most obvious means. Its alternation with smoothly stuccoed surfaces produced the architectural articulation of the walls. The rooms were to be precious only by the artistic value of the painted and sculptured decoration borne on the walls.''

Work on the room design was being carried on while other exhibitions were still taking place (see Cat. 56, 12th Secession exhibition). It is conceived as a sequence of spaces familiar from the aisled naves of sacred architecture. The visitor is first prepared for the principal work, then faces it under the most favorable conditions, and finally leaves it as if accompanied by fading resonance. To achieve this, a barrier of small laurel trees makes it impossible to enter the central hall directly from the entrance hall. Instead, one is first led behind a parapet with high pillars into the left side gallery with the mighty prelude of the frescoed Beethoven frieze, especially created for the exhibition by Klimt. Since the level of the side galleries is higher than that of the central

and entrance halls, the visitors have to ascend a short stair before they enter the room. Here, as elsewhere in the exhibition, decorative plaques by members of the Secession are set in the walls, without, however, diverting attention from the Klimt frescoes below the ceiling.

The entire lower zone of the right wall is dissolved into piers and three wide openings, providing a view into the central hall and a first impression of Klinger's work before leaving the Klimt gallery by corner stairs and a small high door. Because of its importance as the last stage of preparation for the principal work, the exit from the side gallery is as monumental as the egress into the central hall. The steps are enclosed in a kind of porch which is not built but defined spatially; a pier projects from the right side wall corresponding to a free-standing pillar on the left. This is connected with the walls in pergola-fashion by two parallel horizontal beams with decorative nails. At the upper ends, the pier and pillar bear a simple stucco decoration of rows of alternating squares which is also used elsewhere. In front of the pillar stands the only full round sculpture, a girl's head by Klinger—again a preparation for the principal work. Instead of a masonry parapet between pillar and wall there is a taxus hedge matched by another at the other side of the exit stairs. Above the door, Hoffmann placed another preparatory element—a completely abstract cut stucco *sopraporta* of his own creation. The exit portal into the central hall is not by Hoffmann but by Leopold Bauer; it does not quite fit into the total design because it uses oblique and curved forms in a setting in which the square and right angle predominate.

While the side galleries have flat ceilings with top light, the central hall, with Klinger's sculpture behind a low circular barrier on an octagonal podium, is barrel vaulted. From its apex, ample top light falls on the sculpture. It is seen against the background of Alfred Roller's mural *Nightfall* on the back wall, which corresponds to Adolf Böhm's *Daybreak* on the front wall. There are no other important works to divert attention from the Beethoven statue. At the end the hall widens like a transept into two fountain niches with strongly stylized high reliefs by Richard Luksch. At the front of the hall four pillars rise above the parapet walls which mask the doors to the side galleries; the pillars carry figures by Rudolf Bacher of women bearing wreaths. Next to them are two armchairs carved by Ferdinand Andri. There are other decorative elements, but they are so sparse and restrained that the strongest impression is of a white room enclosing sculpture. The spatial experience is enriched by the views into the side galleries with their works of art. The connection between the central hall and the right side gallery is analogous to the one

on the left, but Hoffmann's cut stucco is of different design, and another work by Klinger stands before the pillar.

Bibl.: Catalogue, *14th Exhibition VBKÖ*; *VS* V, 1902, 166-170; *Studio* XXVI, 1902, 141ff.; *DKuD* V, 1902, 475ff.; Hevesi, *Acht Jahre*, 390ff.; F. Novotny, J. Dobai, *Gustav Klimt*, Salzburg, 1967, 325ff.; P. Vergo, *Art in Vienna 1898-1918*, London, 1975, 67ff.; M. Bisanz-Prakken, *Gustav Klimt, Der Beethovenfries*, Salzburg, 1977, *AUMK* XXVII, 1982, no. 184/185, 24ff.; *Structurist* 1981/1982, no. 21/22, 25ff.

Cat. 65 1902

Exhibition design, Rooms of the Vienna Secession, Art Exhibition in Düsseldorf
Opening: 1 May

Hoffmann designed several rooms using pictures, decorative art objects, and furniture including inlaid pieces after his own designs. In a sequence of three rooms with top lighting he created an optical relationship between two especially striking pieces: at one end a large, lavish, three-part glass case by Kolo Moser in the room next to Leopold Bauer's tearoom; and at the other end, two rooms further on, a decorative fountain of his own design (see Cat. 66).

In the center room the walls are articulated by the use of a delicate framework which includes the door frames. This produces dark-framed wall areas for the pictures which hang at eye level. The upper wall zone has a restrained stenciled decoration of dots forming geometrized female figures and the inscription Ver Sacrum. Small square elements in cut stucco also appear. Above the doors are painted triangles with curved sides resembling roofs, and in front of the door frames, which are dark rosewood with inlays of coral wood, stand slim, rodlike columns of maple with strongly curved shafts and inlays of Macassar ebony. The base is a torus of polished bronze. Instead of a capital, tooth- or rootlike bronze forms cap the shaft. A board serves as architrave and forms a rooflike projecting lintel over the door opening.

Bibl.: *VS* V, 1902, 302ff.; *DK* VI, 1903, 27, 30; *ID* XIII, 1902, 234ff.; *Katalog Deutsch-Nationale Kunst-Ausstellung Düsseldorf*, 1902.

Cat. 66 1902

Decorative fountain, art exhibition, Düsseldorf
Opening: 1 May
Execution: Friedrich Otto Schmidt
Sculptural work: Richard Luksch

The fountain, which was also shown at the 17th Exhibition of the Vienna Secession (Cat. 75), consists of a central part in strongly veined, multicolored marble and a canopy of wood and metal. The canopy stands on a smooth octagonal base covered with sheet metal; there are four

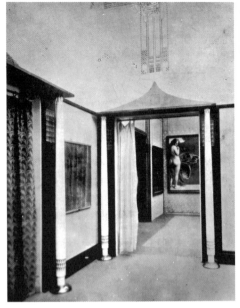

Cat. 65. Door frame treatment at the Düsseldorf exhibition

Cat. 66. Perspective of Düsseldorf exhibition rooms, drawn by Max Benirschke (cf. text fig. 66)

slim, rodlike columns with strong entasis, made of light maple polished to high gloss and inlaid with ebony. Spherical elements above a platelike flat echinus carry the circular roof of hammered copper with a mask as waterspout on its underside. The marble section consists of a gently hollowed-out cylindrical base (diameter 1.07m, height 0.44m) and a goblet on a tall stem; it

bears a circle of six lead figures, representing three nude couples with outspread arms.

The fountain (without the canopy) is now in the Museum of the City of Linz.

Bibl.: *Katalog Deutsch-Nationale Kunst-Ausstellung Düsseldorf,* 1902; *VS* V, 1902, 302ff.; *ID* XIII, 1902, 235; *DK* VI, 1903, 25; *Interieur* IV, 1903, 82, 84; J. Heusinger v. Waldegg, *Richard Luksch,* Hamburg, n.d., and "Ein Zimmerbrunnen von JH, etc.," in *Kunstjahrbuch der Stadt Linz,* 1973, 71, 72.

Cat. 67 1902

Furnishings for Dr. Hans Salzer
Vienna VI, Gumpendorferstraße 8

A large apartment furnished for a physician in the Wittgenstein family circle. Dining room, salon, study, and bedroom, plus anteroom and kitchen were executed. The rooms are related in color and texture.

The white anteroom is furnished with wall cabinets, a table, and chairs; these have unusually high backs and a striking construction. Their legs rest on a U-shaped frame which gives the effect of a sled. All other chairs in the apartment are constructed on this "sled" principle.

The gentleman's room or study (consulting room) has dark wall areas divided by delicate lines and furniture in brown wood with glued-on black elements. Between two wall cases a portrait of Mrs. Salzer by Rudolf Bacher is hung above an upholstered bench. Another upholstered bench is built into a corner. In addition, a writing desk with a small armchair as well as several small tables and stools are provided. The upholstered furniture is covered by a colorful vividly patterned fabric. In the salon the furniture has been executed in a polished dark, reddish brown wood. In a corner by the window, a screen forms a small alcove with a round marble-topped table and a cubical armchair upholstered in the same material as the inside of the screen. Diagonally across from this group are a gas fireplace built into the corner and two showcases joined to it. The cases have faceted glazing and are lined with a reddish material.

The dining room has a sideboard and a fireplace surround painted white with brown insets. The metal fireplace is painted black; next to it is an armchair upholstered in gray suede. The round extension table and the chairs are in light brown wood.

The bedroom has wall-to-wall carpeting with a grid pattern of squares; the wall is patterned with very narrow vertical stripes. The furniture is executed in light and dark wood with square inlays. Opposite the built-in beds, night tables, and cabinets is another built-in unit consisting of toilet table, washstand, and, between them, a

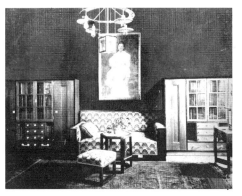

Cat. 67/I. Apartment of Dr. Salzer, view into study (cf. text fig. 60)

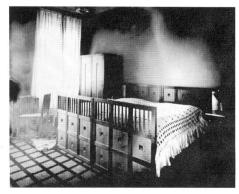

Cat. 67/II. Apartment of Dr. Salzer, view into bedroom

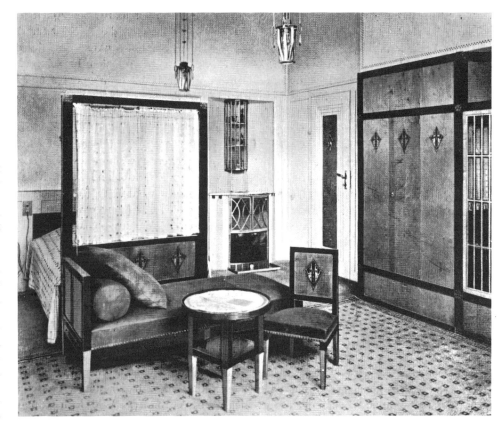

Cat. 68. Mautner-Markhof apartment, bedroom with gas fireplace

small glass case. In all the rooms, light fixtures and curtains are part of the total design.

The bedroom is almost unchanged; in other rooms some original furnishings are preserved.

Bibl.: *Interieur* IV, 1903, 1-8.

Cat. 68 1902 and later(?)

Furnishings for Baroness Magda Mautner-Markhof
Vienna III, Landstraßer Hauptstraße 138

The living room walls are paneled in wood up to about 1.30m; the area above is framed into large panels covered by matte gray fabric. All furniture is executed in polished mahogany with shiny brass mountings, none of it reaching higher than the paneling, thus giving a unifying effect.

The cabinets have round corner posts at the front, which keep the cases off the floor. In addition to a sofa with light-colored upholstery and matching corner bench, there are a writing desk and a side table with marble top.

The bedroom, which was probably finished later, has waist-high wood paneling; the inlaid footboard of the bed is linked to a tall curtained frame which shields the sleeper from disturbing light. The inlay motif of the bed is repeated on a small desk and on the multipartite wall cabinet. Next to the bed, a gas stove and a small showcase above it are built into a flat wall niche.

Bibl.: *ID* XIII, 1902, 135; XVI, 1905, 180ff.

Cat. 69. Biach apartment, fireplace in card room (cf. text fig. 68)

Cat. 69 1902

Remodeling and furnishings for Max Biach
Vienna IV, Mayerhofgasse 20

Hoffmann remodeled and furnished the interior of a three-story historicizing town house for an industrialist; the living quarters and bedrooms are on the two upper stories. Hoffmann designed a new entrance with door, lobby, and ground floor hall as well as the staircase, and he furnished several of the rooms.

The entrance door, constructed with stiles and square panels, opens into a lobby with black-and-white floor tiles; the walls are white tile up to the height of the door, with coarse-grained stucco above. A partition wall painted white, with decorative glazing above the door, separates the lobby from the hall, which is at a slightly higher level.

The staircase at the rear of the hall has two straight flights and winders. The walls are finished, above a dark base, in coarse-grained stucco with occasional small applied metal ornaments.

The straight-barred handrail is not continuous but is divided into stepped segments except in those panels where the verticals reach the level of the next story. The railing is painted white and ornamented with spare black motifs. The tall windows have ornamental leaded glazing in simple geometric forms. A decorative light fixture hangs from the top story.

Of the living quarters it is known that the living room, dining room, card room, several bedrooms, and a bath were remodeled.

The living room is paneled in white and stenciled above with a light pattern. A very simple rectilinear fireplace is set into the wainscoting of one wall; built into another is a high bench upholstered in dark leather, its tall sides ending in light fixtures. Between them, above the upholstered back, are two glazed bookshelves. A dark table, white armchairs of "sled" construction, and the upholstered bench form a seating group.

The dining room is dominated by a built-in tripartite buffet, decorated by slim sunken colonnettes. Its lower center section has a top, and wall paneling of light arabescato marble with a small mirrored super-structure in the middle. While the whole unit is rectilinear, the door panels are treated as lozenges with curved sides. The sidechairs and armchairs in "sled" construction around the rectangular dining table have bars in the form of lozenges with crossed axes. Like all of the woodwork, they are painted white with a touch of black in the geometric ornament. The walls are light bluish gray with a restrained delicate pattern.

In one bedroom, a washstand is built into the wall paneling, and the bed forms the center of a built-in unit with cabinets and night tables. An upholstered bench with back rest is in front of the bed. The cabinet doors have triple, lightly recessed stiles. The lower wall sections are covered with dark patterned fabric in white wood framing; above the level of the cabinet tops, the walls are painted white and divided into panels by a stenciled dot pattern. Above the headboard is a niche with a small inset cabinet between slim colonnettelike bars with strong entasis. Hoffmann left the furnishing of another bedroom to his student Franz Messner.

The card room has a wood-paneled niche with flat coffered ceiling, spherical light fixtures of frosted glass, and a built-in gas stove or fireplace under a round-headed arch. The polished marble facing of the surround and the shiny metal of the chimney piece form a strong contrast to the rough stucco. Under the arch is a small cabinet with decorative glazing. Cabinets, compartments, and a bench are built into the side walls.

The building is now an apartment house. The entrance and the staircase are preserved—except

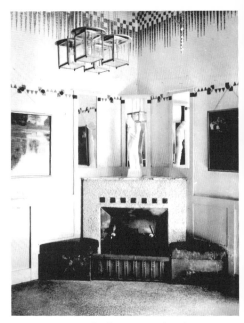

Cat. 70/I. Wärndorfer House, fireplace corner in smoking room

for overpainting, some missing details, and the removal of the decorative glazing on the stair windows—but they show clear signs of wear and tear.

Bibl.: *Art et Décoration* XVI, 1904, 69; *ID* XVI, 1905, 47ff.; *Art Revival*, C12, C23; Le Corbusier, *L'Art décoratif d'aujourd'hui*, Paris, 1925, 149; W. Fenz, *Kolo Moser*, Salzburg, 1976, 99 (discusses a wall unit from the girl's bedroom in connection with Moser, but this is by Hoffmann; on the other hand, decorative leaded glazing in the bedroom by Franz Messner is attributed to Moser in the catalogue *Koloman Moser*, Vienna, 1979, no. 154).

Cat. 70 1902

Furnishings for Fritz Wärndorfer

Vienna XVIII, Weimarer Straße 59 (formerly Karl-Ludwig-Straße 45)
Dating: A letter from Wärndorfer to Hoffmann proves that the dining room was largely finished by Christmas 1902.

For his friend, later the co-founder of the Wiener Werkstätte, Hoffmann modernized the smoking room with a new corner fireplace flanked by low seats upholstered in leather. The roughcast front has an inset of chased copper with a spherical hood. Small square metal elements are set into the stucco and the whole unit is covered by a thin marble slab. Above the fireplace three mirrors in white wood frames are arranged so that objects on the mantel are triply reflected. The room has low paneling and the edge line of the mirror frames is continued by a stenciled pattern of squares and triangles. Further up, the

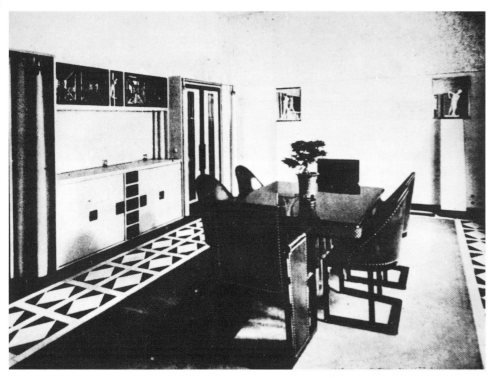

Cat. 70/II. Wärndorfer House, dining room with buffet (cf. text fig. 67)

Cat. 71/1,2. Perspective design sketches

walls are similarly patterned. The chandelier is a composition of four transparent cubes.

More important than this work and small alterations in the children's room are the furnishings of a small gallery and a new dining room (in black, white, and silver) next to the salon furnished by Mackintosh. The rectangular room is well lighted by a large triple window in the long side; this window does not have casements but a lowering sash. The walls are roughly stuccoed in shiny silver above the height of the door; below they are paneled in white marble with a black base and dotlike insets. The floor is designed with black and white marble in a lozenge pattern around a central carpet on which stand the dark dining table and matching chairs. The chairs have "sled" bases and cylindrical backs cut at a slant.

Opposite the window is a built-in buffet unit, closely related to the door frames, of white painted wood with square divisions, dark insets, and a glazed upper section supported by flat side pieces and round bars. The adjoining door frames project as far from the wall as the buffet. The transition to the plane of the door is by a wide S-shaped cyma profile with slim inset tapered columns with shiny crowning features of metal resembling the columns used at the Düsseldorf exhibition (Cat. 65).

On the short side of the room two tall sculpture pedestals project from the wall; they are topped with black marble. Mirrors are set into the wall so that the backs of the sculptures can be seen.* A door frame next to the window matches that next to the buffet but is not as wide; it frames a glazed showcase and is flanked by two built-in light fixtures, each divided into nine glazed squares.

The Hoffmann interior, like that by Mackintosh, was sold in 1916 and is lost. Parts of the entrance to the house designed by Hoffmann are still extant.

* Ludwig Hevesi, *Altkunst—Neukunst*, p. 216, reports: "When Gustav Klimt saw the [mirrors] in the dining room . . . in which rooms and people are depicted as such a picturesque unit, he exclaimed: 'What remains for us painters to do?'"

Bibl.: *ID* XIII, 1902, 136; Hevesi, *Altkunst*, 221; *Art et Décoration* VIII, 1904, 68; *AUMK* XXVI, 1981, no. 177, 33ff.; *Burlington Magazine* CXXV, July 1983, 402ff.

Cat. 71 1902(?)

Two architectural sketches for a small church

1. The perspective sketch shows a building with high steep roof and two-towered facade. The towers have slanting sides and terminate in open belfries and domes. The gable front has a large crowning crucifix and a central window above a recessed round-arched entrance. Three windows are drawn in the side wall. Joints indicate that the building was planned for masonry execution.

2. This sketch also shows a facade with two towers but they are straight-sided and terminate in free-standing bell yokes. Below this open bell story the towers are joined by a roofed segmental arch so that the front of the church becomes a tall portal. The boatlike roof juts out below the connecting arch and covers a small entrance porch with curved ground plan. Two columns or piers support its front. The windows in the curved side wall are arranged as a strip below the cornice.

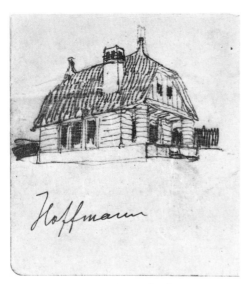

Cat. 72. Perspective design sketch

The sketches may have originated in connection with the competition for a country church criticized by Karl Kraus (*Die Fackel*, no. 101, April 1902) or while working on the church for St. Aegyd (Cat. 74). The roof design of sketch 2 recalls the roof in a vignette on p. 8 of the Catalogue of the 8th Secession Exhibition (Cat. 48).

Bibl.: The sketches were acquired by ÖMAK from the estate of Kolo Moser.

Cat. 72 1902(?)

Architectural sketch: Wooden house with half-hipped roof and large chimney

The perspective sketch shows a small one-story house with large, steep half-hipped roof. The building stands on a low base and has an open veranda in front with several steps leading to the center entrance. The attic story, with two windows in the front gable, projects over the veranda and is supported at the corners by two strong round piers. On the side are three grouped windows reaching from base to cornice. A large square chimney pierces the roof near the front corner and suggests a corner fireplace in the interior.

Bibl.: The sketch was acquired by ÖMAK from the estate of Kolo Moser; it obviously comes from the same sketchbook as those for the small church (Cat. 71).

Cat. 73 1902

Pieces of furniture and book decoration

Furniture: compare St. Asenbaum, J. Hummel, editors, *Gebogenes Holz* (catalogue), Vienna, 1979, 38.
Book Decoration: *VS* V. 1902, 60.

Cat. 74 1902-1903

Protestant church and parsonage
St. Aegyd am Neuwald, Lower Austria
Start of building: 15 September 1902
Consecration: 7 June 1903
Builder: Franz Gröbl, Hohenberg, Lower Austria
Cost: 19,000 crowns

The small church (120 seats) with adjoining parsonage was built for the Protestant community of St. Aegyd outside the village in heavily wooded mountainous country. The building stands by itself on a small outcropping at the foot of a slope; a fieldstone retaining wall forms a plateau and half-round front yard. The effect of this arrangement and location is that the small church appears more monumental from the valley than one would expect.

The building in stuccoed brick construction consists of a single nave with altar niche, and adjoining parish offices and apartment of the parson. The church has a steep tile-covered saddle roof. At the back it is hipped over the somewhat wider parsonage. The front of the church projects laterally beyond the side walls of the nave and terminates in a pointed gable; behind it is an octagonal bellcot with a cupola crowned by a tall cross. The central entrance is protected by two wall piers bearing a segmental roof. Above the entrance two narrow slit windows are interrupted near the upper end by horizontal masonry so that they are perceived as the "ground" for the appropriate "figure" of a cross.

Behind the outer wooden door is an inner door with simple decorative glazing. In addition to the slit windows, the interior is lighted by seven windows on each side. Each windowpane has a slanting bar in the upper quarter, creating a linear zig-zag effect. The lintels of the window frames curve upward at the center, leaving room for four inset squares which again form a cross.

The tie beams of the visible roof trusses across the nave dominate the space, and their repeated occurrence intensifies the perception of depth. A stuccoed ceiling intersects about halfway down from the apex of the roof; thus, the section of the nave appears as a rectangle with a superimposed trapezoid. All woodwork, including the benches, is painted blue in strong contrast to the white stucco. The bench terminations are de-

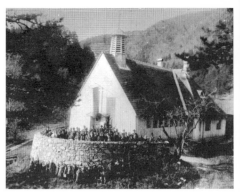

Cat. 74/I. Exterior view soon after completion

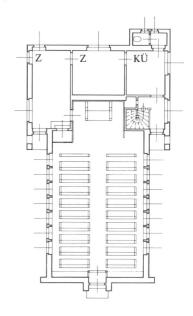

1 0 10 m

Cat. 74/II. Ground plan of Evangelical church (cf. text fig. 70)

signed as crosses. Altar and lectern are of wood in plain form and an old crucifix forms the center of a simple linear composition painted on the wall of the presbytery.

The building is still used and is in a good state of preservation. The attic story of the parsonage was finished in 1923; the presbytery was radically altered in 1952/1953, and the color of the walls was changed to light ochre. A new parsonage was built next to the church in 1937.

Bibl.: *Hohe Warte* I, 1904/1905, 40; F. Mauer, *50 Jahre evangelisches Waldkirchlein St. Aegyd a. N.* (Festschrift), 1953 (published by the author); *Der Aufbau* XIX, 4/5, April-May 1964, 156.

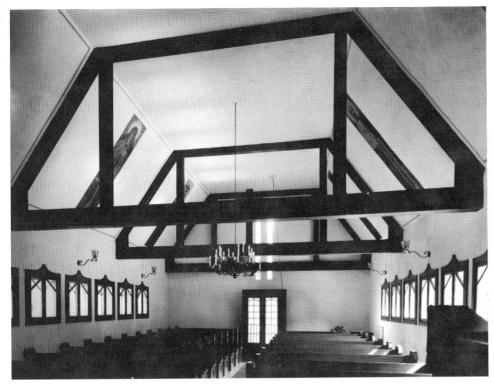

Cat. 74/III. Church interior, view toward entrance (1965)

Cat. 75 1903

17th Exhibition of the Vereinigung bildender Künstler Österreichs (Secession), Austrian Art
Opening: 26 March
Design of a room for Richard and Elena Luksch; design of the Jettmar room

A square room was transformed into an octagon by two polygonal niches with slightly recessed back walls. In one of the recesses is the entrance door, in the other is a portrait by Elena Luksch-Makowsky on a stenciled background.

The glass doors with glazing bars that form cross- and lozenge-patterns and the baseboards are painted white. The lower two-thirds of the walls are articulated by overlapping vertical boards, alternately stained a matte bluish and matte yellowish gray. The recessed boards which continue into the polygonal niches have decorative dark red nails below the upper edge.

In the recessed areas of the niches, white pedestals with busts by Richard Luksch are dramatically lighted from above. Other pedestals with sculptures stand elsewhere in the room;

the walls here are higher than in the niches and accommodate a Japanese frieze by Franz Hohenberger, brightly lighted through the transparent ceiling. The decorative fountain is the same one that was shown in Düsseldorf (Cat. 66), except that four white stone colonnettes were added below the goblet.

In the Jettmar room the color was "harmoniously adjusted to the pictures." The floor is gray, the woodwork whitish gray, and the four large wall areas for the paintings are dark violet. In the center of the room four simple chairs were placed back to back in a square.

Bibl.: Hevesi, *Acht Jahre*, 419, 424; *Interieur* IV, 1903, 81ff.; Catalogue, *17th Exhibition VBKÖ*.

Cat. 76 1903

18th Exhibition of the Secession, Gustav Klimt
Opening: 14 November
Design of the anteroom

A small octagonal room with a gridlike skylight has niches in its diagonal sides with ivy plants arranged under irregularly hung spherical lights. The walls are articulated by black and white vertical wainscoting; both the black stiles and the white panels have borders of dotlike square elements. The panels also have four decorative nails with spherical heads at their upper ends.

Decorative easy chairs with carvings by Andri from the main room of the 14th Secession Exhibition are placed at the side walls; square mirrors are inset above.

Bibl.: Hevesi, *Acht Jahre*, 442; Nebehay, *Klimt*, 313; *Studio* XXXII, September, 1904, 352.

Cat. 77 1903

"Gewerkschaftshotel" of the Poldihütte steel plant
Kladno, Přičná Ul., Czechoslovakia

The building (15m long, 12.20m wide, 7.20m high up to the gutter) is about two meters above street level in a lightly built-up residential district outside the core of the city near the plant. The lot is separated from the street by a retaining wall of random ashlar topped by slabs on which sit low brick pillars and a white wooden railing. A black door with a white center grille opens to stairs parallel to the retaining wall that lead to the main entrance. The main door with ornamental leaded glazing is in a niche flanked by two projecting spurs of wall. On these and on two free-standing masonry piers rests a flat roof. In this manner a kind of small, open, entrance pavilion is created which houses the few steps leading to the door.

Cat. 75. Room of Richard and Elena Luksch with decorative fountain (cf. Cat. 66)

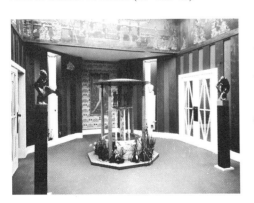

Cat. 76. Anteroom, 18th Secession Exhibition

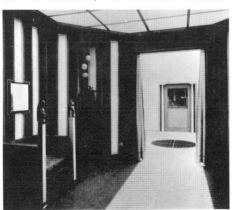

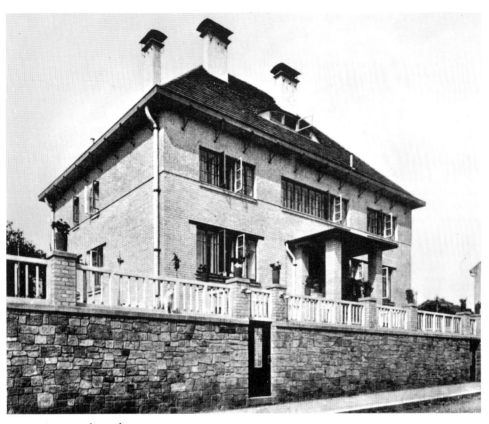

Cat. 77/I. View from the street

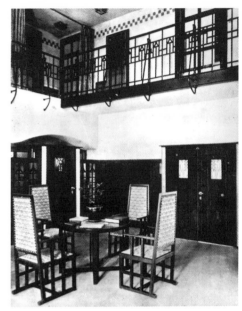

Cat. 77/III. Hall with gallery

Cat. 77/II. Ground plan of the "Gewerkschafts" Hotel, Kladno (cf. text fig. 56)

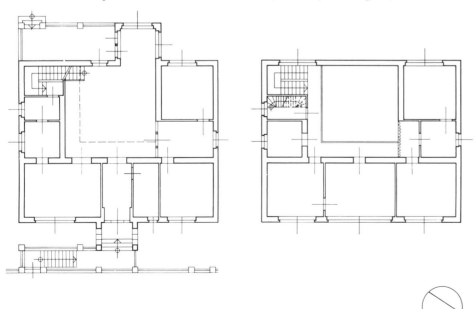

1 0 10 m

A vestibule, with a checkroom and toilet on the right, leads to a large, two-story, approximately square, hall, the core of the building. It gives access to rooms on three sides and widens into a square alcove on the garden side. At the left corner straight stairs lead to a gallery that gives access to the other rooms on the upper floor. In this manner three rooms on the ground floor and four on the upper floor, with subsidiary rooms, can be reached.

The gallery has a decorative rectilinear iron railing stiffened by curved struts. Another curve occurs in the hall above one of the doors. Otherwise square forms predominate in the ironwork, the door panels on the upper floor, and in the border cut into the white coarse-grained stucco of the walls.

On the ground floor the hall has dark wooden paneling and, on the stair side, there are built-in showcases for the display of company products. An open fireplace is in the center of this unit, in front of which two wicker chairs and a round table form a group. A second larger group of high-back chairs and round table stands near the center of the hall. In and near the alcove, which has a parapet with white panels and dark stiles, stand an upholstered bench, a desk with easy chair, and a grandfather clock. The upper door panels have decorative leaded glazing. Above the showcases decorative light fixtures hang from the gallery.

Hoffmann also furnished a breakfast room but left the execution of a small meeting room and the bedrooms to his student Franz Messner.

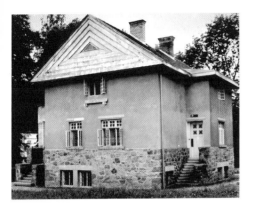

Cat. 78/I, II. Knips Country House views (1966) (cf. text figs. 58, 59)

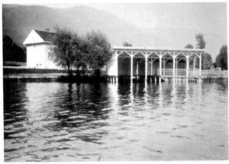

Cat. 78/III. Ground plan of Knips Country House

The exterior of the "Gewerkschafts" Hotel looks like an ordinary home with a high hip roof and projecting box gutter supported by curved metal brackets. The windows are strikingly large, especially in the upper story on the street and garden side. Their exterior woodwork is painted dark in contrast to the light gray bricks and white stucco of the facades. On the garden side is a terrace next to the hall alcove bordered by a white wooden fence with brick pillars. An electric wall fixture provides lighting. The tiled roofs are broken only by three tall chimneys and a curved dormer atop the center of the entrance front.

In 1928 the building was enlarged to almost double its original length with skillful use of the old materials and forms; a few years ago the interior was refurbished so that only the glazed entrance door, the original railing, some doors, and the stucco border are preserved. The building is to be razed because of a new traffic plan.

Bibl.: *Die Kunst* X, 1904, 23ff.; Plans: Archives of the Poldihütte.

Cat. 78 1903

Country house and boathouse for the Knips family

Seeboden, Wirlsdorf 39, Carinthia

A summer house with boathouse on a large lot at Seeboden on Lake Millstatt. Above a random ashlar basement containing the kitchen and servants' rooms are two stories in stuccoed brick construction; the saddle roof has wood siding on the gables. The building consists of a rectangular block (9m x 15m) with a veranda topped by a terrace on the south side, and a 1.5m x 6m projection with a lightly sloping metal roof on the north side.

An open stair on the short side of the projection leads to a wood entrance door with two

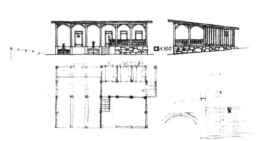

Cat. 78/IV. Design sketch of boathouse

Cat. 78/V. View of boathouse and house (about 1903)

vertical panels topped by four square windows. The vestibule is lighted by a triple window; opposite the entrance are doors to toilet and bath, and on the left, doors to basement stair and central hall; in the entrance wall is a door to the children's bedroom.

The central hall also serves as a dining room, 5m x 6m, which opens via a three-leaf French door to the veranda. The hall also gives access to the large bedroom, which has a south window and connects with bath and adjoining dressing room, and to a small reading room next to the children's room. On the exposed western side, the outer wall is half a brick thicker than the other walls, which are one and a half bricks in thickness. A hall stair leads up to further living quarters. The largest room, in the center, opens onto a terrace above the veranda. Like the hall below, it has a floor of black and white square tiles. The veranda is closed to the west, open to the south and east where there is a flight of stairs to the garden. The piers standing on the parapet instead of capitals have incised linear patterns with nine squares on each side.

The windows are informally arranged and on the upper story are subdivided into ten panes.

The ground floor windows have four panes above and vertical leaves divided into two panes below. Two upper-story windows have consoles and flower boxes. The concrete lintels of the basement windows are left visible.

The roof projects beyond the walls on all sides; there is no cornice but only a flat overhang with wood siding. A box gutter is in the slope of the roof. The siding of the large gables has wide boards which follow the outline of the gable in five stepped-back fascias leading to a small triangular window in the center. However, the preliminary design called for a flat or lightly sloped roof.

Rich interior and garden furnishings were made for the house. The boathouse on the lake shore is a light six-bay wood structure painted white, partly on piles in the water and open to the lake. The house was razed in the early 1970s; the boathouse had disappeared earlier.

Bibl.: Design sketches and photographs; Estate.

Cat. 79 1903

Furnishings of apartment for Mrs. S. K. (Sonja Knips)
Vienna VI, Gumpendorferstraße 15

A living room-study and adjoining music room were newly furnished, with the walls of the music room stenciled in a delicate dotlike pattern. A glazed double door designed to connect the two rooms has multiply recessed stiles and panels with two rows of glazed squares.

In the study this door forms part of a wall unit of square elements in gray maple with black and white inlays and silvered mountings. The unit also incorporates a gray upholstered bench inside a niche which is flanked by slender columns on small low cabinets. Klimt's painting *Fruit Trees* of 1901 hangs in the niche. Like all walls, the back of the niche is covered by a gray fabric in a white frame. Not only the square cabinets but all major surfaces in the room are conceived as framed areas. This strongly determines the total effect, as does the ceiling executed as a barrel vault in coarse-grained stucco. A remarkable mantelpiece with a black veined marble surround and silvered fittings also belongs to the furnishings. Its metal and glass overmantel consists of a base with colonnettes and a glazed showcase with upper sides that slant in rooflike fashion.

Two easy chairs with stoutly nailed upholstery are related to the built-in bench, as is the round inlaid table; its square base with dark legs has white decorative colonnettes like those of the wall unit. Three white spheres above the table serve as light fixtures; the floor has a gray carpet. The surfaces with a predominance of black, white, gray, and silver provide an effective backdrop to the colorful accents of Klimt's painting.

Bibl.: *Interieur* IV, 1903, 50-53; *DKuD* XXIV, 1909, 216, 217.

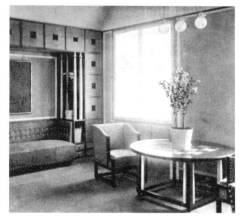

Cat. 79. Seating niche with the painting *Fruit Trees* by Klimt

Cat. 80 1903

Architectural sketches for a villa(?) and a monumental pavilion

Two perspective sketches, of which one shows a villa(?) with garden wall and entrance; the outer wall of the building and the garden wall merge without articulation or offset. A loggia with convex back wall is set into the upper story of the facade, a pergola crowns the middle. The roof is flat or very lightly sloping. The second sketch shows a pavilion, also linked to a garden wall. It has a square ground plan, recessed corners, and a tall superstructure in four steps. Niches with sculptures are above the door and on the sides.

Bibl.: Catalogue, *17th Exhibition VBKÖ*, 34, 46.

Cat. 81 1903

Furnishings for the Wiener Werkstätte
Vienna VII, Neustiftgasse 32-34
Jointly with Kolo Moser
The Wiener Werkstätte was entered into the commercial register on 19 May 1903 and moved into its new quarters in October of the same year.

Several stories of an existing factory building in a courtyard contain the office and sales department, the workshop rooms for metal- and precious metalwork, bookbinding, leatherwork, and the carpentry and paint shop. A separate architectural office is in a side wing of the upper story reached by an outside steel stair. The workshops are high, well-lighted and ventilated halls, with built-in case furniture. In each workshop a particular color is stressed and also used for the ledgers of the respective department.

The spacious drafting room, also used as an exhibition hall (as for an exhibition of garden designs in Spring 1907), has tables along the window side while cabinets for plans are on the opposite wall on each side of a white tile stove. A screen at the door defines the entrance area.

The office and the rooms of the sales department are entered by a door with a *sopraporta* by Richard Luksch containing a panel with the initials WW and a girl and boy with expressive gestures (fig. 69). The offices and exhibition rooms are arranged as a varied sequence of large halls and smaller, more intimate rooms with built-in seating nooks and half-open partitions with wood grillwork. The walls are carefully articulated, in

Cat. 80/1, 2. Vignettes with architectural studies

part by built-in furniture. Finally, a large hall is divided into booths for the display of furnishings. Furniture and exhibits are treated as parts of the total composition.

This is particularly evident in the reception and exhibition room with its built-in fireplace and wall mirror in a multiply stepped niche. The side walls have half-round niches with showcases; a display case occupies the center; its low octagonal base with open compartments bears a wood-framed glass cube on four supports. Between this and the fireplace of veined marble and polished metal, two chairs face each other on a strip of carpet. Elsewhere the black and white tiled floor is visible. The window niches with pebbly glazing in the upper section are extended by projections into the room; although translucent, the glazing does not allow a clear view, which consequently heightens the concentration on the interior. There is a small built-in cabinet in the parapet and a curved showcase between the two windows. Large decorative nails for hanging pictures are evenly spaced below the ceiling. The stuccoed edge of the ceiling repeats the motif of multiple stepping of the doors and fireplace niche. Numerous small hanging light fixtures decorated by glass spheres heighten the sparkling and glittering effect of the showcases, shimmering exhibits, and metal mountings.

Another sales hall has a large chandelier by Kolo Moser consisting of glass crystals on strings hung in such a way that they form volumes stepped in three stages. The walls are plain and have built-in cabinets and shelves over 2m high; in the center is a large dark table top on two cubical bases.

The Wiener Werkstätte was liquidated in 1932; the workshop building and former architectural office with its exterior stairs still exist and now serve other functions. Except for some woodwork, the furnishings have disappeared.

Bibl.: WWA: ÖMAK; *Hohe Warte* I, 1904/1905, 268; *DKuD* XV, 1904/1905, 1ff.; XXIII, 1908/1909, 155-157; Brochure of WW, Vienna, 1905; *Art-Revival*, C15, C18; Hevesi, *Altkunst*, 231; *Die WW 1903-1928*, Vienna (Krystall Verlag), 1929; *AUMK* XII, no. 92, May/June 1967, 20ff.; G. Feuerstein, "JH und die WW," in *Der Aufbau* XIX, April/May 1964, 177ff.; W. Mrazek, *Die WW*, exhibition catalogue of ÖMAK, Vienna, 1967.

Cat. 82 1903

Book decoration

For the last year of *Ver Sacrum*, Hoffmann drew book decorations which included strongly stylized elongated figures and the terminal vignette on page 402. He also provided book decoration for the catalogue of the 17th Exhibition of the Secession (pp. 34, 46, 52; see Cat. 75).

Bibl.: Nebehay, *VS*, 220, with complete listing.

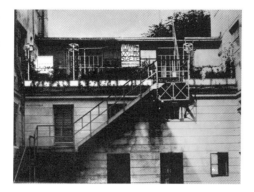

Cat. 81/I. Architectural office in the courtyard of Neustiftgasse 32

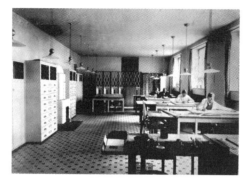

Cat. 81/II. Drafting room toward entrance

Cat. 81/III. Reception-showroom (cf. text fig. 69)

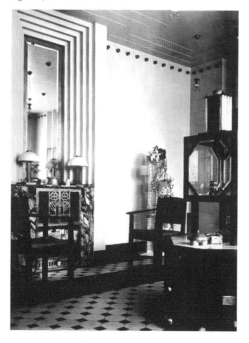

Cat. 83 1904

Furnishings of dining room for Editha Mautner-Markhof
Vienna III, Landstraßer Hauptstraße 138
Jointly with Kolo Moser

The dining room of a large apartment in the garden wing of a house is richly furnished. The floor has a marble border reminiscent of that in the Wärndorfer dining room (Cat. 70). One wall is almost entirely taken up by a large buffet with rich inlays, very similar to contemporaneous designs for buffets by Kolo Moser (for example, the dining room of Dr. S., *DKuD* XVI, 1905, 539; *ID* XVI, 1905, 179), while the chased metal panels on each side of the buffet recall works by the Luksches. The wall above the buffet is frescoed in a mixed technique with cut stucco and rich gilding, representing birds in tree tops.

The long walls have built-in framed showcases above dark wainscoting. In the center the painting *Alpine Pasture* by Segantini occupies a place of honor facing the entrance door. Under it is a richly inlaid serving table related to the buffet. The long rectangular dining table is surrounded by chairs with entirely straight legs, backs, and seats; instead of the usual arms they have triangular sides connecting seats and backs. The furnishings are not preserved, but a desk attributed to Hoffmann is extant.

Bibl.: *DKuD* XV, 1904/1905, 123ff.; Photo: WWA; Information courtesy Mrs. Hilde Glück and Prof. Dr. Hanns Jäger-Sunstenau.

Cat. 84 1904

Purkersdorf Sanatorium
Formerly Westend Sanatorium, Purkersdorf, Lower Austria, Wienerstraße 74

The building with basement, ground floor, and two upper stories was planned for the director Viktor Zuckerkandl as a sanatorium for curative baths and physical therapy. It was erected on a large wooded lot on which there were already several older villas; a covered glazed passage provides a connection. A preliminary project in several variations preceded the executed design. The original plan shows a slimmer rectangle and the main stair at one end rather than in the center. There the stair would have been closely connected with the passage. The published facade of the preliminary project also shows that the building was originally planned with a hip roof.

The building was executed in stuccoed brick construction with reinforced concrete ceilings and stairs; a flat wood cement roof serves as the termination. The short sides of the building face north and south. Apart from the ground floor addition on the south and the central projection

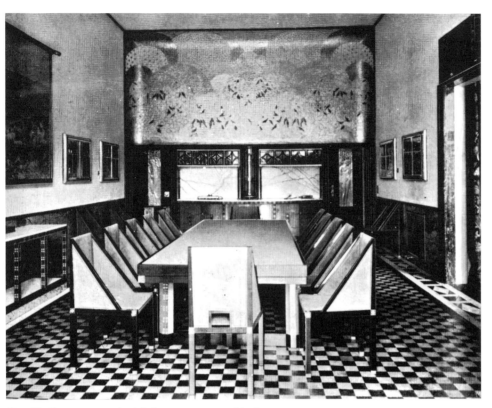

Cat. 83. Dining room for Editha Mautner-Markhof

Cat. 84/I. Purkersdorf Sanatorium, dining room (cf. text figs. 72-81)

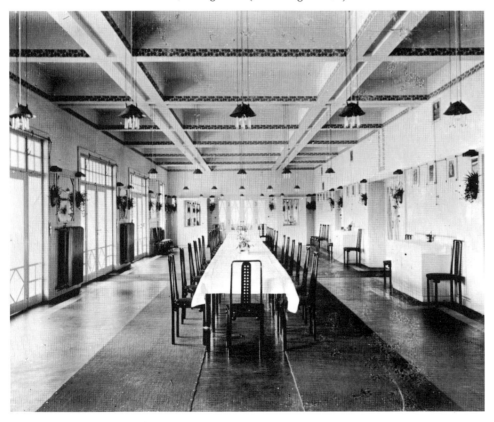

for entrance, porter, and office, the ground plan in an early version fits exactly into a rectangle with the sides in a 1:3 ratio. In the execution this changed. The plan is also worked out in relation to the two symmetrical main axes of this rectangle. The shorter axis passes through the main entrances, reception hall, and staircase; the longer axis through the wide access corridor from the entrance hall to the outer north and south walls.

Entering the building from the east, the difference in level between outside and the ground floor is overcome by two open stairs, one under a canopy in front of the facade and the other in the lower front of the hall. A half-turn stair with landings connects directly with the higher back part of the hall; the western exit is reached under this stair. A covered drive passes in front of the exit.

Various treatment rooms extend along both sides of the access corridor; on the northeast end a subsidiary staircase leads to the basement with employees' rooms, kitchen, and other utility rooms.

The second floor containing the dining room and social rooms has complete bilateral symmetry except for the secondary stairs on the north end. Like the ground floor, it has a central access corridor. On the east side next to the secondary stairs is a pantry with dumb waiters; then follow the large dining room with glazed veranda and an adjoining music room. On the west side the central portion is recessed to the depth of the main staircase so that only the corner portions retain the full depth of the ground floor rooms and project on the facade. They contain rooms for table tennis and billiards, each with toilet facilities. Also on the west side are a ladies' salon, a reading room, a writing room, and a card room.

On the third floor, both the east and west facades are shallower at the center, thus forming projections on both sides. There are balconies off the rooms on the center east facade. On this third story the central corridor does not extend to the outer walls so that the entire perimeter of the building can be used for patient accommodations. In this manner a large service room and thirteen rooms for patients are provided including single and double bedrooms and living rooms for two-room suites.

The exterior of the building impresses by its bold three-dimensional modeling with straight planes and precisely defined projections and recesses, and by the clearly expressed and varied rhythm of fenestration. All upper portions of windows are subdivided into small squares. The flatness of the wall surfaces is stressed by the framing of all planes and openings with a thin border of blue and white tile and by the absence

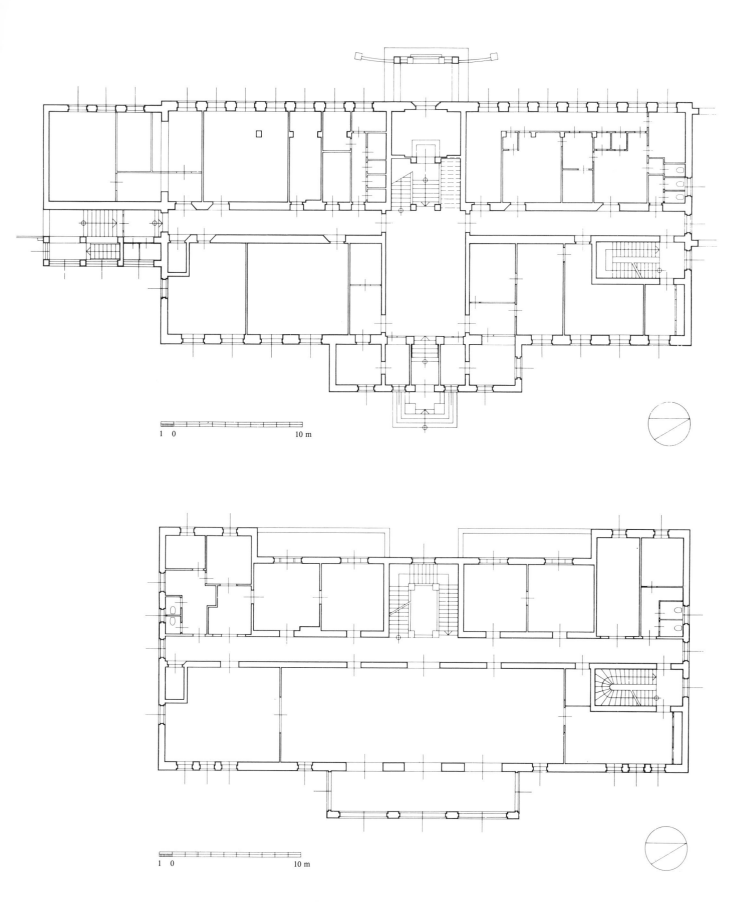

Cat. 84/II. Purkersdorf, ground plans (*top*: ground floor; *bottom*: 2nd floor) (cf. text figs. 72-81)

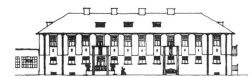

Cat. 84/III. Preliminary project, elevation

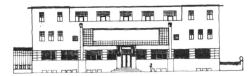

Cat. 84/IV. Preliminary project, elevation

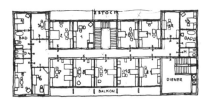

Cat. 84/V. Sketch of ground plan for third floor (cf. text figs. 73-75)

of any tectonically articulating strips or pilasters. On the contrary, projecting sections on the upper story are not set off from the facade on the lower story but remain undifferentiated in the wall plane; no differentiation is made between outer bearing walls and walls that are merely parapets of a balcony. As upper terminations there are only overhangs of thin or shallowly recessed slabs instead of tectonically profiled cornices.

At the entrance, pedestals for plants relieve the severe geometry of the total effect, as do the sculptures by Richard Luksch. On the west side, reliefs flank the entrance; on the east, two blue and white faience figures are placed over the drive. Above this entrance a tablelike canopy of glass and metal hangs by miniature lattice girders (fig. 76). This facade has the most glazing.

The building was furnished by the Wiener Werkstätte. With Kolo Moser collaborating, the interiors, room design, and furniture were carefully coordinated. This is immediately evident in the high entrance hall, which is divided into three spaces by slim, square pillars—entrance

area, central area, and open staircase. These areas are coordinated through form and color. The pattern of the black and white floor tiles repeats the lines of the concrete ceiling coffering; these in turn match the woven pattern of black and white squares on the cubiform seats* and the five square openings set into the white wall tiles. Black and white squares also form the pattern of the floor tiles in the corridors visible from the hall through glazed two-leaf doors. Above the doors are windows with decorative leaded glazing. Comparable glazing appears in many places in the interior, including the staircase windows; in the staircase the motif of square coffers occurs again on the massive parapet and in the reinforced concrete beams of the ceiling.

The second floor contains the most elaborate interiors. Here, other colors join the predominant black and white, for example, in contiguous rooms "three kinds of green with a continuous red carpet" (Hevesi). The large dining room, optically enlarged by mirrors and vistas, has a stenciled frieze with leaf pattern on the upper walls and concrete ceiling beams. There are also flowers in mirrored holders flanking all doors. Upholstered bentwood chairs in a warm brown tone were chosen as the seating. The walls in all rooms were framed and divided by delicate stenciled friezes of dotlike elements wherever they were not paneled or covered by built-in furniture. The furniture often approximates a cube in outline; in the music room an unusual hardedged form was preferred even for the grand piano. A variety of ceiling lights, wall fixtures, and standing lamps was used.

A story was added in 1926 by Leopold Bauer against the wishes of the architect, largely robbing the building of its character. The sculptural decoration and ceramic framing also disappeared, and a wooden enclosed porch was added to the front entrance. In the interior, the use of the building as a hospital required numerous alterations, especially on the ground floor, including the erection of two glazed compartments in the entrance hall. Parts of the original woodwork and decorative glazing are preserved, but very little survives of the original furniture, some of which found its way into the art market. The fate of the building is in doubt, as it is no longer used. It is therefore barely maintained and no longer heated. Ground dampness and condensation are dramatically evident in many places, and the facades show many traces of water damage and general decay. It is apparent that only speedy and thorough restoration can assure the continued existence of this building though it is under protection as a historic monument.

* Kolo Moser used these chairs in 1903 in the design of the Klimt exhibition in the Secession.

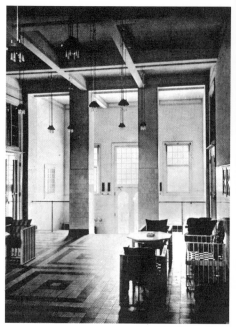

Cat. 84/VI. Hall with main entrance

Bibl.: *Hohe Warte* II, 1905/1906, 70; *DKuD* XVIII, 1906, 421-443; Hevesi, *Altkunst*, 214ff.; *ID* XVII, 1906, 318, 319; *The International Studio* XLIII, 1911, 193; *Architekt* XVIII, 1912, 15; *Art-Revival*, B3, C7-9, 21, 22, 24; F. Ahlers-Hestermann, *Stilwende*, Berlin, 1956, 76; N. Pevsner, *Pioneers of Modern Design*, Harmondsworth, 1960, 197; O. Breicha, G. Fritsch, editors, *Finale und Auftakt Wien 1898-1914*, Salzburg, 1964, 212; *Der Aufbau* XIX, no. 4/5, April/May 1964, 147, 183, 185; I. Cremona, *Die Zeit des Jugendstils*, Munich, 1966, fig. 159; P. Vergo, *Art in Vienna 1898-1918*, London, 1975, 134ff.; Mang, 100, 101; Design sketches, Estate: 1st Preliminary Project: 2 ground plans; 2nd Preliminary Project: 2 ground plans, 1 facade; 3rd Preliminary Project: 1 ground plan; Executed Project: site plan, ground plan of basement, ground floor, second floor, third floor, 2 facade studies, 2 variations of perspective of west facade.

Cat. 85 1904

Design for a room of the Vienna Secession, International Exhibition, St. Louis, Missouri

The design shows a room largely devoted to works by Klimt, including two of the large pictures destined for the University of Vienna. Hoffmann employs majolica strips to divide the walls, above a low base of black tiles, into large framed panels of white coarse-grained stucco. Sculptures by Franz Metzner stand on framed pedestals beside Klimt's pictures. Colored and gilded sculptures are planned above the doors, and works in chased silver in connection with the door frames. The floor has a black, white, and pink tile pattern; the ceiling, a dark wooden grid with silver-plated mountings which admits light from above through milk glass panes.

The design was not executed.

Bibl.: *VS*, special issue, *Die Wiener Secession und die Ausstellung in St. Louis*, Vienna, 1904; Nebehay, *Klimt*, 346, 347.

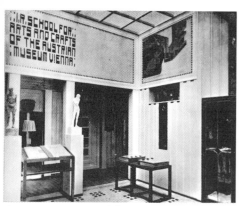

Cat. 86. St. Louis Exhibition 1904, view into the room of the Vienna School of Arts and Crafts

Cat. 86 1904

Design of room of Wiener Kunstgewerbeschule (Vienna School of Arts and Crafts), International Exhibition, St. Louis, Missouri

In this exhibition design black and white predominate and two pillars provide the transition from a lower, darker annex for the display of graphics to a higher main room lighted from above. The walls are divided into panels and there is a frieze of interwoven ribbons that, "by combining two tone values create a third one on the retina in a decorative painterly manner related to Neo-Impressionism, and achieve a lively vibrant impression" (Max Creutz). Sculptures on high pedestals stand in front of the two pillars. The display cases built into the walls, lecterns, and tables are executed in black wood. Two carpets are on the floor: one with stripes is in the annex, the other with square pattern is in the higher room. Among the exhibited student designs is a country house strongly reminiscent of works by Hoffmann.

Bibl.: *DK* VIII, 1905, 125-128; *DKuD* XV, 1904/1905, 211.

Cat. 87 1904

Special Exhibition of the Wiener Werkstätte, Hohenzollern-Kunstgewerbehaus, Berlin
Fall 1904
Jointly with Kolo Moser

Effective room design was considered as important as the display of individual arts and crafts objects. The entire wall is articulated in black and white; dark wooden ledges trace a fine net of lines on the white wall, dividing it into panels and strips of different proportions. The variously shaped rooms are connected by wide openings with lintels that have a shorter rising element right and left and a horizontal element in the center. The effect of this repeated "bent" lintel is an important part of the total design. The entrance (fig. 71) is flanked by pedestals for pots of leafy branches. Behind them is a shallow wall projection, topped by a flat cornice and bordered by two framed strips on each side.

The next room is given an octagonal shape by oblique corner showcases; then follows the most important exhibition room and climax of the composition—a long gallery, glazed at the end, with a stuccoed barrel vault. A lozenge pattern in the stucco has glittering elements emphasizing the center of each rhombus. Under the vault a horizontal showcase is set into the wall, interrupted only by the entrance and the niche opposite; below extends a surface of coarse-grained stucco with additional built-in vertical showcases. All elements of the composition are divided by dark half-round roll moldings, sometimes designed as frames within frames. Abstract dip paintings in narrow black frames hang next to the vertical showcases. Equally abstract, anthropomorphic black and white compositions by Kolo Moser are displayed in the horizontal showcases. A carpet with a square grid pattern and a few exhibition objects and pieces of furniture complete the total image.

Bibl.: *DKuD* XV, 1904/1905, 205-206; Photographs: WWA.

Cat. 88 1904

Room Design of Ceramic Department, Hohenzollern-Kunstgewerbehaus, Berlin

For the exhibition and sale of a large selection of ceramic products, Hoffmann transformed an existing long rectangular room by creating shelving, display units and an entrance screen that extends between a window pier and a wall pier.

The screen is constructed in wood with dark stiles and light-colored panels and contains shelving units. It is articulated with high lateral portions flanking a lower central unit whose main feature is a square display opening in the middle. The stiles of the lateral portions are carried higher than those of the central unit and, on flat abaci, support segmentally arched tympana of unequal widths. The wider one, at the left, spans the entrance opening like a baldacchino. Passing underneath it and walking along the window wall, visitors can view well-lighted display units and shelves on the right with high and low elements alternating. The upper walls of the room have a stenciled dot pattern of stylized flower forms.

Bibl.: *DKuD* XV, 1904/1905, 178, 179.

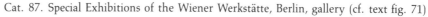

Cat. 87. Special Exhibitions of the Wiener Werkstätte, Berlin, gallery (cf. text fig. 71)

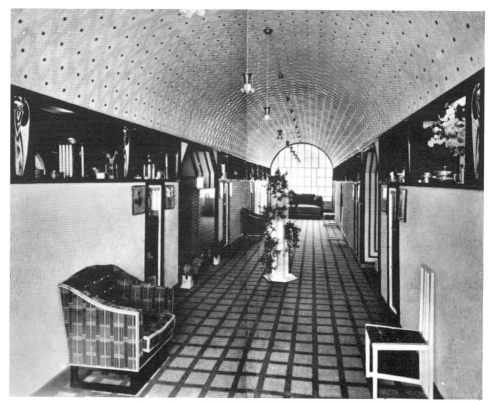

Cat. 89 1904

Furnishings of the Flöge Sisters fashion salon
Vienna VI, Mariahilferstraße 1c
Jointly with Kolo Moser

A reception room, office, and fitting room are
furnished, with Moser responsible for the re-
ception room, and Hoffmann for the office and
fitting room. Their contributions are not easy
to distinguish as there is, for example, a design
signed by Hoffmann for chairs very similiar to
the ones with high backs in Moser's reception
room.

In the fitting room and the office the white
walls are divided into different-sized areas by
wooden ledges painted dark while the floor is
covered with dark wall-to-wall carpeting. White
wooden stools, armchairs with curved forms, and
low open shelves serve as furnishings.

Bibl.: *DKuD* XVI, 1905, 522, 523; *Hohe Warte* I, 1904/1905,
28; Nebehay, *Klimt*, 275; *AUMK* XXVIII, 1983, no. 190/191,
54ff.; Drawing for three chairs; Inv. no. 8819/1 ÖMAK;
Drawings for two wall treatments in office, with Hoffmann's
initials: Estate; Mang, 102.

Cat. 90 1904

*Furnishings of salon for Dir. P. (Director Paz-
zani?)*

A formal richly furnished living room with
large-patterned curtains and a matching fabric
on the framed wall areas, which are of different
sizes. There are low glazed corner showcases,
narrow cabinets with drawers, an open display
shelf, and two seating groups. One has a free-
standing round table with upholstered easy chairs;
the other, in a niche, contains a polygonal table,
bench, and two upholstered cubiform chairs with
inlaid wooden backs and sides that are further
enriched by slim pillars at the corners.

Bibl.: *Interieur* V, 1904, 9-12.

Cat. 91 1904

Hunting lodge (?) for Director Pazzani
Gröbming, on the Brandmoos, Styria

A small, unpretentious log cabin in a wooded
hunting region with a steep, shingled saddle roof
and an adjoining low, boarded lean-to. The log
cabin stands on a whitewashed fieldstone base
that projects to form a seating platform on the
entrance side. The house has a small basement

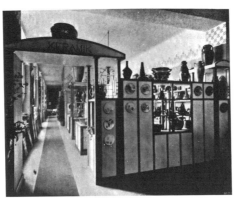

Cat. 88. Entrance to ceramics department

Cat. 89/I. Flöge fashion salon, design of
wall unit

Cat. 89/II. Flöge fashion salon, office

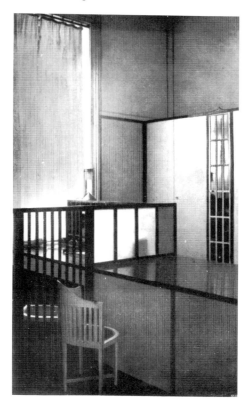

on one side and the simplest of interior fur-
nishings.

The building was razed in 1933.

Bibl.: The building remained unpublished, probably because of
its insignificance, but a set of photographs with date and
client's name was found in Hoffmann's estate.

Cat. 92 1904(?)

Wittgenstein Tomb
Vienna, Central Cemetery, Group 32b
Attributed to Hoffmann

An octagonal roofless burial chapel of ocher
granite, with sides about 1.90m high and 2.70m
wide, stands on a low base of gray granite. The
walls are designed as framed panels, topped by
a cornice which projects widely inside and out.
The panels inside the octagon have inscriptions.
One side of the pavilion is an open entrance with
two steps to the interior. In the center, a large
stone slab marks the actual burial place. It is
flanked by two flower beds and two lights at the
head consisting of glass octahedra with metal
frames affixed to a cubiform stone with quad-
ruple-stepped base. Four small supporting stone
balls are around the lower point. A large cross
is chiseled into the wall panel opposite the en-
trance. In the interior to the left of the entrance
is a small stone bench.

Bibl.: Hevesi, *Altkunst*, 236.

Cat. 93 1904

Furnishings
Small apartment with softwood furniture painted
white.

A vestibule wardrobe, buffet, washstand,
dresser with three drawers and mirror, and a bed
and chair are illustrated in *Hohe Warte* as proof
that "the lower-middle-class apartment and the
worker's apartment . . . can also be a little jewel
box."

Bibl.: *Hohe Warte* I, 1904/1905, 5-7; J. A. Lux, *Die moderne
Wohnung*, Vienna, 1905, 169ff.

Cat. 92. Wittgenstein Tomb

Cat. 94 about 1904 and later

Room furnishings
For Ladislaus and Margarete Remy, August Lederer, and others

As soon as the Wiener Werkstätte became known and established, numerous furnishings for apartments were ordered. Hoffmann and Kolo Moser were responsible for the designs. The artistic collaboration of the two friends took various forms: glass paintings and other works of decorative art by Moser were used, as in the apartments of August Lederer (Vienna I. Bartensteingasse 8) or Dr. Hermann Wittgenstein (Cat. 106), or furniture by both artists was in the same apartment, as in the Remy interior of 1904.

The original owners of some of the apartments known from publications have not been identified. There is, for example, an as yet unidentified apartment furnished by Hoffmann, of which details from three rooms were published: a dining room and adjoining bedroom related through their form and color (white). A double bed stands in the center of a symmetrical wall unit with wardrobes. The upper part of the footboard has openings with wooden St. Andrew's crosses instead of panels. All of the dining room furniture is of "sled" construction. The formal motif of the segmental arch occurs in the chair backs, the panels of the buffet, and the decorative glazing bars. The salon is made into a polygon by a diagonally placed fireplace and is unified by wall fabric in multiply recessed framing. A bench, armchair, and stool around a round table of "sled" construction form the seating group.

In the Lederer apartment, Hoffmann is responsible for the design of the setting for Klimt's painting *Philosophy* of 1905. He also designed furnishings for colleagues such as Czeschka, Metzner, and Roller (see Cat. 124).

Bibl.: *DKuD* XV, 1904/1905, 126, 129; *ID* XVI, 1905, 164; Nebehay, *Klimt*, 191, 223.

Cat. 95 1904

Country house for Dr. Wilhelm Figdor, addition and alteration
Baden near Vienna, Weilburgstraße 67
Approval of submitted plans: 14 April 1904
Builder: Anton Breyer, Baden

An existing neoclassical two-story house is connected with a new triaxial building of the same height. The new flat-roofed connecting wing contains a two-story hall. In the new wing a vestibule with subsidiary rooms and a large room connected with the hall occupy the ground floor; in addition there is a children's playroom on the garden side. In the upper story, accessible only from the hall gallery, are bedrooms and related rooms. The addition is aptly related in form and proportion to the old building but avoids direct imitation of historicizing forms. A gardener's house was also built.

The large hall, with a connecting corridor on the street side, is 7m x 7m square and 5.7m high. An open timber stair with one right turn leads to the gallery which runs around three sides of the hall. On the garden side a veranda fronts the gallery from which an open stair leads to the garden. Under the veranda at the juncture of hall and new building is a fireplace niche with benches on each side in the manner of an English inglenook. Simple square wooden posts with plain

Cat. 95/I. Figdor Country House, inglenook

capitals support the unadorned wall above the niche. Above the fireplace is a framed panel, flanked by six book shelves.

Hoffmann's building is no longer extant.

Bibl.: Submitted plans: ABBH; Photograph: Estate.

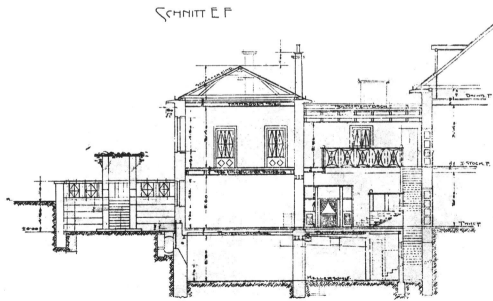

Cat. 95/II. Figdor Country House, section through new building (cf. text fig. 151)

Furnishings of the Stoneborough apartment, Berlin
Jointly with Kolo Moser

For this interior, Hoffmann designed the dining room, study, guest room and servant's room; Moser, a living room and dressing room. In the dining room, the chairs with angular backs, the square extension table with octagonal legs, and the buffet with three units of equal height are striking.

The study is executed in dark stained wood with the grain rubbed white. Next to a glazed bookcase is a massive cubical desk unit connected at the back to two towerlike bookshelves containing compartments and drawers which face the writer. The large surfaces of the desk and the sides and backs of the suede upholstered armchairs are designed so that multiply recessed stiles frame the plain central panel. In a corner of the study is an open fireplace. Its opening is placed in a shallow oval niche flanked by pilaster strips with small dark inlays at the top.

The furniture in the guest room and servant's room is generally blocky and restrained in detail; in the servant's room the motif of multiply recessed framing is used again. In the guest room, half-round bars are used as framing elements on the furniture, comparable to the cabinet on rollers for Klimt (see Cat. 96).

Bibl.: *DKuD* XVIII, 1905/1906, 149ff.; *Art-Revival*, C20.

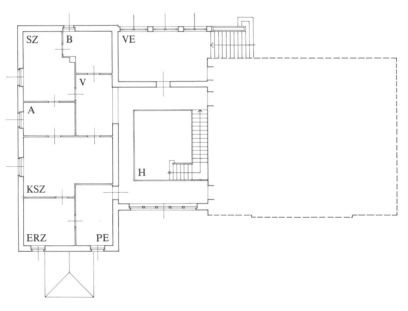

Cat. 95/III. Figdor ground plans (*top*: ground floor, *bottom*: upper floor)

Cat. 97. Fireplace in the study, Stoneborough apartment

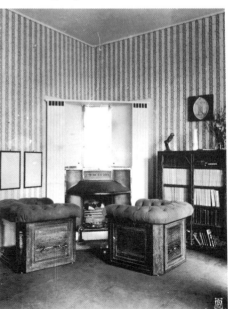

Cat. 96 1904-1905(?)

Furnishings for the studio of Gustav Klimt

Hoffmann designed a three-piece wall unit for his friend Klimt. The side units with single doors below a glazed bookshelf serve for storage of costly silk garments while the center unit is designed with five drawers and a glass case for art objects. There is also a matching seating group consisting of a square table, two armchairs with upholstered seats and unusually high backs, and a cabinet on rollers for painting implements, all in black stained wood. It is not certain if all furnishings were made at the same time.

Bibl.: Wien 1900-1918, special issue of the magazine *Du*, April 1963, 16; Nebehay, *Klimt*, 109, 462, 465, 470; Catalogue *Vienna Moderne: 1898-1918*, Cooper-Hewitt Museum, New York, 1979, 36, 76.

Cat. 98. Miethke Gallery, main room

Cat. 98 1905

*Design of gallery, Exhibition of the Wiener
Werkstätte, Galerie Miethke*
Vienna I, Graben 17
Jointly with Kolo Moser

For the Galerie Miethke, whose artistic adviser
was the painter Carl Moll, a square main room
in white, lighted from above, with side exten-
sions, was created in a new building. The wide
opening to a darker side room houses the two
sculptures Luksch created for the Purkersdorf
Sanatorium; on a pedestal between them is the
model for the Palais Stoclet (see Cat. 104) under
glass. In the center of the main room is a square
showcase with glazed upper section; pieces of
furniture, ivy-stands and metal flower-stands are
placed along the walls. The pictures hang from
two rows of round black nails that form a frieze
below the ceiling, as in the reception room of
the Wiener Werkstätte. Five showcases with tops
slightly curved in a bell shape stand along one
wall; between them the ivy-stands provide relief
and animation.

Hoffmann also designed an entrance portal for
the gallery consisting of a two-leaf door within
a multiply recessed, richly bordered frame. The
outermost step of the frame contains the in-
scription "H. O. Miethke, Werke Alter u. Neuer
Kunst."

Bibl.: *Hohe Warte* II, 1905/1906, 68; *Studio* XXXVII, 1906,
no. 156, 166-170; *DKuD* XVIII, 1906, 444; Nebehay, *Klimt*,
345ff.; Hevesi, *Acht Jahre*, 505.

Cat. 99 1905

Tombs (design sketches)

Five perspective sketches for mausolea in stone
and wrought iron:
1. A rectangle is bordered on three sides by
tall square stone piers bearing an architrave; be-
tween the piers the walls are articulated by flat
stepped recesses. A richly ornamented wrought
iron gate closes the front. The whole structure
is open to the sky.

2. An approximately square substructure with
deeply recessed side windows and entrance door
carries a cylindrical drum with narrow slit win-
dows between masonry piers which support a
spherical stone dome.

3. Four slim polygonal pillars bear a pyramidal
roof; between them rich wrought iron grilles
enclose the tomb. The tripartite entrance has a
central two-leaf gate, reaching up to about two-
thirds of pillar height. The roof is crowned by
a finial with stylized plant ornament.

4. A square ashlar building with a stepped-
back window story; the window openings are in
deep, angled recesses. The door, also angled back,
sits in a projection; wreath holders are on the
wall at each side. The keystone of the door lintel
is treated as sculpture. The roof is a low dome
crowned by a four-legged metal stand resem-
bling an ancient tripod.

5. Eight square piers carry a flat roof slab over
the rear portion of a rectangular stone build-
ing. In front, the side walls project to create a
precinct which is divided into three sections; the
two side sections contain a spherical clipped tree
or bush; in the center an open stair rises between
low walls bearing lanterns. The short fronts of
the side walls are sculptured at the top (compare
Cat. 467).

Bibl.: *Hohe Warte* II, 1905/1906, 6, 7; Original drawings of
2, 4: Estate.

Cat. 100 1905-1906

*Monuments (design sketches), including Johann
Strauß Monument and concert podium*
Thirteen perspective design sketches for mon-
uments with landscaping; eleven were published
in 1906, but like the designs for tombs (see Cat.
99) they might have originated in 1905.

1. A wall on a U-shaped ground plan circum-
scribes a covered precinct with a wide gatelike
opening. The rear wall of the U is lower and
crowned by a relief or grillwork. The front and
rear portions of the side walls are treated as
panels articulated by shallow recessing. The very
wide entrance is framed by short walls with rec-
tangular openings near the top.

2. A massive masonry building is flanked by
tall cylindrically clipped trees. The front is con-
cave with a figural relief in the upper part of a
niche; below it a widening jet of water falls into
a basin.

Cat. 99/1. Design for mausoleum

Cat. 99/2-3. Designs for mausolea

Cat. 99/4-5. Designs for mausolea
(cf. Cat. 467)

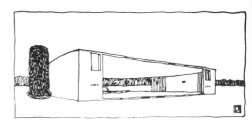

Cat. 100/1-2. Designs for monuments

Cat. 100/3. Design for concert podium

Cat. 100/4. Design for a monument

perhaps containing water, planted with small flowering trees (perhaps roses). Larger spherically clipped bushes grow to the right and left.

6. A three-niched structure is formed from the espaliered, clipped hedges and trees: two smaller side niches with a group of statues on an approximately cubical base, and a larger central niche with another sculpture behind a circular water basin.

7. A flight of steps flanked by two figural sculptures leads to a round domed building, the outer shell of which is entirely plain. Supporting the dome is a wall articulated by openings near the bottom and by slightly projecting multiple framed piers. A central projection accommodates the large entrance door.

8. Between two stone benches a portal rises consisting of two tall piers inscribed "Johann Strauß," a sculpture-ornamented central section, and a tympanumlike stone roof block. The center has a statue in a niche above a sculptured lintel that spans a tall opening.

9. A monument in a round niche is bordered by trimmed hedges; the inscription on the base reads "Johann Strauß." His statue appears on a slim polygonal pillar in a niche with gently curved side faces, hollowed out from a tall rectangular block. The pillar stands on a decorative base flanked by flowering bushes.

10. An octagon with alternating long and short sides forms the ground plan of a small open garden pavilion partially covered by a slightly curving polygonal roof. Extensions of the octagon are treated as nichelike stone benches; next to them grow small clipped trees.

11. Another design for a Johann Strauß monument. A polygonal courtyard defined by wall segments opens toward a garden path. The rear wall carries an ornamental relief and inscription; the front walls are pierced by rectangular openings with statues. Low hedges adjoin the side walls and link the structure to the surrounding vegetation. Roses bushes are planted in selected locations inside the walled area.

12. Piers standing on three sides of a rectangular platform base carry an architrave with three fasciae. Decorative grilles fill the narrow spaces between the piers. The back wall holds an obelisk, more than twice as high as the piers. In the side walls one wide pillar provides space for a wreath. The shaft of the obelisk bears the inscription "Family Vault" (name illegible) below the pyramidion.

13. Memorial oak. A circular wall on a square podium encloses a large oak growing in the center. The tree is reached by a flight of low steps between parapets and through a gate within the wall, which is flanked by piers that are somewhat higher than the wall and have a simply molded lintel. The floor level within is slightly lower

3. This structure is integrated into a park by a garden wall with plant pots, and is flanked by two tall clipped trees. It consists of a paved forecourt with side walls forming the backs of benches, and a concert podium in the form of an apse with a thin half-dome shell. The side walls project forward and are crowned by sculptures. The stone benches display additional sculptural ornament. A conductor's lectern stands at the edge of the podium.

4. A statue court and fountain, open in front, with a background of bushes. The back wall runs parallel to a skirting path while the side walls stand at an angle, forming a truncated V-plan. Four tall polygonal pillars topped by figures divide the back wall into three sections; the center is designed as a fountain niche; statues stand in the other two sections and on the tops of the angled walls.

5. Four tall cruciform pillars set on a platform bear statues. They surround a circular element,

than the level of the podium outside. A circular hedge is behind the monument.

Bibl.: *Hohe Warte* II, 1905/1906, 287-289; J. A. Lux, *Der Städtebau, etc.*, Dresden, 1908, 56-60; Original drawings of 3, 6: Estate; *Jahrbuch der Gesellschaft Österr. Architekten*, Vienna, 1908, after p. 16; *DKuD* XXV, 1909-1910, 390, 391; *Architekt* XVIII, 1912, 9, 15; Hevesi, *Altkunst*, 100.

Cat. 100/10. Garden pavilion

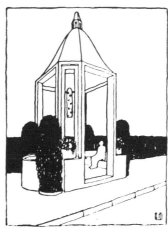

Cat. 100/12. Family tomb

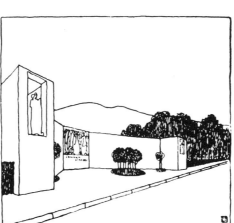

Cat. 100/11. Design for Johann Strauß monument

Cat. 100/13. Memorial oak

Cat. 100/5-7. Designs for monuments

Cat. 100/8-9. Designs for Johann Strauß monument

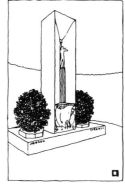

Cat. 101 1905-1906

House for Alexander Brauner on the Hohe Warte
Vienna XIX, Geweygasse 11
Approval of submitted plans: 17 June 1905
Certificate of occupancy: 20 January 1906
Builder: O. Laske & V. Fiala

The fifth house of the "Villenkolonie Hohe Warte" was built on a lot next to the Moll-Moser House. It is a free-standing building but placed for semidetached arrangement at the left edge of the lot on the Geweygasse, which runs approximately north-south. The Geweygasse slopes toward the north, and the lot is considerably higher than the sidewalk so that a retaining wall in random ashlar is required. At the lowest point—the garden entrance—there is a difference in level of more than 3m between sidewalk and garden. An open stair parallel to the sidewalk leads from a grillwork gate at the right to the front garden where a loggia leads to the entrance of the house.

The loggia, of four bays, has a slightly inclined metal roof on roughcast piers. The bays are glazed above parapets on the north but open on the south and only partially bounded by low barriers with flower boxes. Balancing the loggia on the opposite side of the lot is a sort of pergola, also of four bays, with a group of garden furniture. The pergola, loggia, and parapet of the retaining wall border the graveled front yard of the house; it is not visible from the street. Besides the seating group, there are two garden chairs and several laurel trees in wooden containers.

The house has a partial basement, ground floor, upper floor, and finished attic plus a lookout tower on the roof. The house is executed in traditional brick masonry, stuccoed or with wood siding, and with wood floor construction, except in the basement. Covering the basement are flat vaults between steel beams. The ground floor is 3.4m high; the upper story, 3.2m. The steep (about 45 degrees), partially hipped roof is tiled.

Except for the alcoves and terraces, the ground plan is approximately square—14m wide and 15m deep. From the entrance a short stairway leads to the vestibule, approximately at the center of

the north side. From the vestibule there is access to the kitchen with its garden-side alcove, to a winding central staircase, and to the study. The living room has an alcove in the manner of a segmental English bow window; the dining room with terrace is linked to the kitchen through a pantry and subsidiary room.

On the upper floor the wooden stairway ends in an interior hall with access to living quarters and related service rooms. There is a large bedroom and—in the northwest corner—a large bathroom with a balcony above the kitchen alcove. On the street side are a children's room, the room of the lady of the house, and a wardrobe. Behind the center of the north facade a stair artfully turning in several directions leads to the attic. The central stair from the second floor ends in a large room called the gymnasium. On the garden side are a laundry and wardrobe, on the street side is a library; from its northwest corner a circular stair of about 1.5m in diameter leads to the lookout or belvedere. This structure, glazed on four sides, abutting a high chimney and crowned by a weathervane in the form of a ship, dominates the exterior of the house.

The facades are clearly articulated in each story. The basement is treated as a base in hard brick, the ground floor is in smooth white marble stucco; and the upper story has horizontal wood siding painted white. Windows, gutterboards, and vertical boards which subdivide the siding on the south facade are painted ultramarine blue. The roof has a box gutter supported by curved metal brackets; box dormers break the roof planes on all sides.

All windows on the ground floor are hung sash windows with bars dividing only the upper half into squares, whereas the upper story and the dormers have casement windows. For the street facade the shallow bow window of the living room is decisive, while the large kitchen alcove and the bathroom balcony above are the dominating elements in the west facade. The manner in which the parapet of the garden terrace is treated and integrated with the whole is also striking. On all facades the windows are freely placed according to the demands of the rooms within, and informal relations rather than strict symmetries prevail.

The front yard and the main garden beside and behind the house are carefully treated in a composition which conceives of house and garden as a coherent whole. Hevesi mentions a "lawn with choice roses, then a basin between two selected horse chestnut trees bending over it, finally a pergola . . . the white walls all with copings of black concrete which results in a great tranquillity for the eye."

There are more than a dozen published perspective drawings of interiors for the Brauner

Cat. 101/I. Brauner House, ground plan (cf. text figs. 119-126)

House; they prove that Hoffmann succeeded in this case in coming very close to the ideal of complete coordination between architecture and furnishings. Photographs show how similar execution and design are in most cases.

The living room/reception room, which also functions as a hall, consists of two segments, divided by two spurs of wall jutting into the room. When coming from the vestibule, one first enters the rear section and sees the impressive fireplace niche opposite with built-in benches in the manner of an inglenook. This and all built-in units, including numerous glazed bookcases, match the height of the wainscoting. The chimney piece has a surround of strongly patterned dark marble and a multiply framed metal plate with the year 1905 above the fireplace. Above the wainscoting the room is stenciled with a delicate, colorful pattern. While the fireplace niche has black and white floor tiles, and the remainder of the rear section shows varnished floor boards, the front section is covered mostly by a large carpet. This section is well lighted by the five openings of the shallow bow window; and the predominantly white furniture contributes to a general effect of luminosity. Seats, a built-in desk, and even the piano near the window are painted white.

White also predominates in the adjoining dining room; its approximately square ground plan (5.2m x 5.6m) is converted into an octagon by built-in buffets in all corners.

In the study the walls are also white and divided into unequal segments by black lines, but the furniture is dark. In addition to a large desk there are several bookcases with doors and some with drawers. A Tudor arch is a prominent motif in the glazing. The bedroom on the upper floor is again all in white, except for the patterned carpet and stylized roses painted above the marble headboard. The beds stand in the center of a built-in unit in which all doors have panels in the form of lozenges with slightly curved sides. The footboards show the motif of multiple framing.

Among the other striking rooms are the children's room with motifs of equilateral triangle and tetrahedron, and the guest rooms, one in white and yellow, the other in white and red. Above all, the large gymnasium in the attic, with visible roof beams, makes a strong impression. In this room Hoffmann uses polyhedra as lights; their sides are formed of glass squares and equilateral triangles in metal frames.

The building was heavily damaged in World War II and had to be razed.

Bibl.: *Hohe Warte* II, 1905/1906, 133-146; *DKuD* XIX, 1906, 42-53; *Architekt* XIII, 1907, pl. 63; *Jahrbuch der Gesellschaft Österr. Architekten*, Vienna, 1908, 22; Hevesi, *Altkunst*, 217ff.; A. Karplus, *Neue Landhäuser*, etc., Vienna, 1910, pl. 38; Photographs: Estate, WWA; Submitted plans: ABBH.

Cat. 102 1905-1906

Beer-Hofmann House
Vienna XVIII, Hasenauerstraße 59/corner Meridianplatz
Approval of submitted plans: 16 September 1905
Certificate of occupancy: 4 October 1906
Builder: O. Laske & V. Fiala
Building cost: 133,712 crowns

For the poet Dr. Richard Beer-Hofmann a detached house was built on a corner lot with a frontage of 24.5m. The building has a basement, ground floor, second story, and finished metal-covered mansard roof. It is built of stuccoed brick and has wood floor construction in the upper stories and concrete slabs between steel beams above the basement. The stories are 3.9m high.

The ground plan, a rectangle in a proportion of 11:15 (16.5m x 22.5m), is divided longitudinally into three sections of unequal width. In each story except the basement the central section contains a large hall with access to the rooms along the outer walls. All staircases are very

Cat. 101/II. Brauner House, view from garden

Cat. 101/IV. Brauner House, design for study

Cat. 101/III. Brauner House, submitted elevations

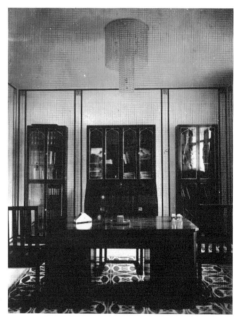

Cat. 101/V. Brauner House, study

directly connected with the central hall. The facades are exactly in the cardinal directions with the Hasenauerstraße on the north. The entrance is at the northeast corner; a secondary entrance leads from the east facade to the basement which is barely below grade and contains storerooms, central heating, kitchen with dumb waiter, and a porter's apartment.

On the ground floor a lobby gives access on the right to a staircase and on the left to a toilet. Next a vestibule leads to the large central hall from which an open stairway between high parapets leads to a gallery. Hall and vestibule extend to the height of one and a half stories; this is achieved by lowering the floor of these rooms by half the height of the basement. The visitor first enters the blue salon (music room) on the garden side with a double door on axis with vestibule and stair. A study in the southwest corner adjoins the salon, then follows the library and finally, in the northwest corner, the dining room with pantry and dumb waiter.

On the garden side a straight alcove is placed in front of both the music room and the study

while an open loggia occupies the center of the facade between the alcoves. A terrace with two descents into the garden extends along the entire garden facade.

The staircase between vestibule and pantry leads up to living quarters accessible from the central hall. In the center of the garden side is the lady's bedroom with a large polygonal bay window. On the west side is the gentleman's bedroom; on the east the children's room. Next to it is the nursemaid's room while the gentleman's bedroom is followed by a dressing room and bath.

The finished attic is reached from the central hall by a straight staircase; around a great hall, serving as gymnasium and roller skating rink, are guest rooms, servants' rooms, laundry and ironing room. These rooms are lighted by oval dormer windows which play a significant role in the exterior appearance of the house.

The facades in coarse-grained stucco are articulated by strips and panels in smooth stucco which enclose windows and shallow coffers. A general impression of flatness prevails; only the garden facade is more strongly articulated by its alcoves, balconies, and loggia. The run-off from the mansard roof is by a suspended gutter all around the edge of the roof. The vertical windows have four casements, each divided into small lights.

In the Hasenauerstraße facade the entrance with its round-headed window above stands out. In the center of the window is a pane with a Star of David. The door sits within a projecting surround with wide cyma profile and a glazed lantern in the center of the lintel. Being on the weather side, the west facade, of which a design drawing is extant, has only a few windows in a vertical strip in the center except that the basement has additional windows for the porter's apartment. The south or garden facade is entirely symmetrical with an interplay of projecting and receding elements. A deeply recessed loggia with windowless back wall is below the projecting alcove on the upper story with its large windows; next to the loggia on the ground floor are straight alcoves. They project as much as the central alcove on the upper story, and the facade above is recessed to form wide balconies. Visually the parapets are combined with the outer walls; the area between the window lintel and the parapet-coping above is filled by a single shallow coffered panel.

Near the terrace, between the parapets of the two garden stairs, is a seating area with garden furniture. The remainder of the rather large site is richly planted with flowers. The garden is enclosed by a fence with base, piers, and squared grilles painted black.

Inside, many existing antique furnishings were used, especially on the ground floor, but numerous designs remained to be done by Hoffmann for execution by the Wiener Werkstätte. The hall stands out because of its function and size. On the ground floor it measures about 8m x 9m with a height of over 5m. On the north side the hall at gallery level is widened by an arcade of round arches which allows a view into the brightly lighted staircase. The hall receives light mainly from a group of large windows in the east wall; the straight stairway to the gallery is especially well lighted. The wood parapet of the gallery repeats the motif of shallow coffering from the facade; like the paneling below, it is painted white. The rest of the hall is also white; only the floor is tiled black and white, and the stair is painted black. In the center of the west side a short section of the gallery projects like an alcove or pulpit; below the overhang here a fireplace with green tiles has been placed. The projection was perhaps intended for a musical instrument (organ?); in any case, it provides space for a cabinet at the gallery level. Among the other rooms on the ground floor, the library is of major interest. It is well lighted by a double window; the built-in glazed bookcases are painted white. They have upper and lower glass doors, and three drawers at the bottom. In the center of the room a sculpture by Gianbologna stands on a specially designed pedestal.

Noteworthy in the upper story are the central hall with black and white tiled floor, a built-in cabinet under the paneled stair to the attic, and the lady's bedroom. This white room, designed entirely by Hoffmann,* has, in addition to the bed, a double secretary placed in the brightly lighted bay window, a dresser with mirror, and a showcase containing a collection of fans.

In 1939 the building was taken over by Dr. Kuno Grohmann, who installed a garage and made alterations in the interior. After the war it briefly became the property of the Beer-Hofmann family again, who sold it in 1966 to Simone Gininger. After some years of neglect leading to complete dilapidation, the house was demolished in 1970.

* According to a daughter of the client, Hoffmann commented about furnishing such a modern house with antique furniture. Beer-Hofmann then remarked to his wife: "Now we must let Hoffmann have his pleasure too," and asked him to design the bedroom.

Bibl.: *DKuD* XXII, 1908, 76-79; XXV, 1909/1910, 388, 389; *Architekt* XV, 1909, 33; J. A. Lux, *Das neue Kunstgewerbe in Deutschland*, Leipzig, 1908, pls. 9ff.; *Interieur* XII, 1911 29; Photographs: WWA; Submitted plans: ABBH; Drawing of facade: Estate.

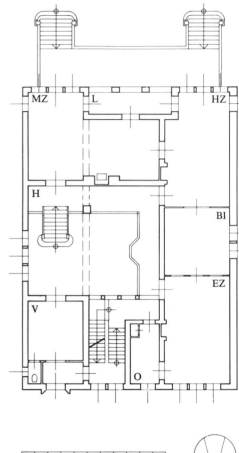

Cat. 102/I. Beer-Hofmann House, ground plan (cf. text figs. 134-139)

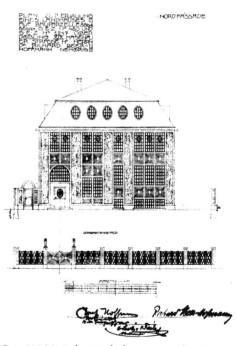

Cat. 102/II. Submitted plan, street elevation

298

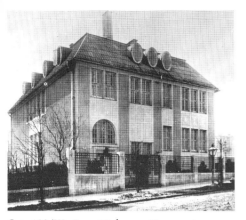

Cat. 102/III. Beer-Hofmann House, view from street

Cat. 102/IV. View from garden

Cat. 103/I. Legler House, view from street

Cat. 102/V. Hall and stair

Cat. 103 1905-1907

House for Margarethe Legler
Vienna XIX, Armbrustergasse 22
Approval of submitted plans: 31 October 1905
Certificate of occupancy: 27 February 1907
Builder: Stadtbaumeister Karl

The small house (10.5m x 10.5m) is on an irregular lot; the street front faces northwest. The building with full basement is of traditional construction with brick bearing walls and wood floor construction; the basement has flat vaults between steel beams. The semidetached building is paired with its neighbor on the right. It is entered on the left up a flight of steps in an enclosed lateral porch, alongside of which one enters the garden.

The entrance leads to a vestibule with adjoining paneled staircase. Beyond is the living room connected by a large opening with the dining room. On the street side are the kitchen, and—accessible from the vestibule—a pantry and toilet. On the second floor a servant's room and the gentleman's bedroom with adjoining bathroom are arranged on the street side. On the garden side the spacious lady's bedroom is connected to both the other bedroom and the nursery, with the latter also directly accessible from the stairs. The finished attic houses the studio of the owner, the painter Wilhelm Legler, lighted by large dormers at the front and back. The roof is hipped toward the left side.

The exterior design is as simple as possible. The tiled roof has a box gutter painted white. The exterior is treated in coarse-grained stucco with smooth bands to frame or unify the facades and window openings. The windows are painted white and have upper casements divided into four square panes. Inside only the wainscoted staircase with inset square picture frames is of some formality.

In 1914 a wooden veranda with a terrace above, not designed by Hoffmann, was added on the garden side. In 1934 the house was divided into three small apartments, but the exterior still shows the original state to a remarkable degree.

Bibl.: Drawings: Submitted and revised plans, signed by Paul Roller for Josef Hoffmann: ABBH.

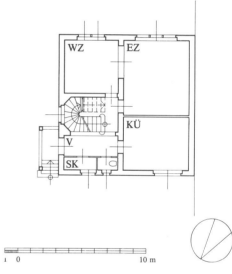

Cat. 103/II. Legler House, ground floor plan

Cat. 104 1905-1911

Palais Stoclet
281 (formerly 303) Avenue de Tervueren, Brussels, Belgium
Beginning of design: 1905
Submitted plans: 2 April 1906 with later supplements
Building permit: 29 July 1906
Completion: 1911
Local building supervision: Emil Gerzabek
Builder: Ed. François et Fils, Etterbeek
Interiors and furnishings: Wiener Werkstätte (see figs. 84-118)

The Palais Stoclet lies at the edge of the city of Brussels, parallel to the Avenue de Tervueren,

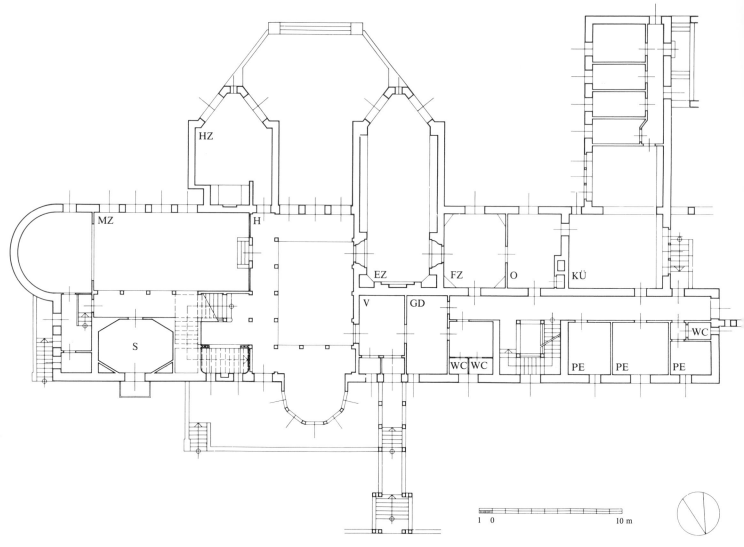

Cat. 104/I. Stoclet House, plan of ground floor (cf. text figs. 84-118)

an important artery. The avenue here runs approximately northwest-southeast and slopes slightly to the southeast. The site was graded by extensive fill. In the following description the street side is simply designated as north side, and the garden side as south. The building stands about 12m from the street and consists of two principal parts: the large residence and the service wing with garage yard adjoining in the west.

The residence is a two-story building with a full basement and gently sloping hip roof; the finished attic provides virtually a full third story. Because of the high attic parapet into which the topmost windows are cut, the slope of the roof is hardly noticeable on the interior. Measured on the second floor the ground plan rectangle of the main building measures about 37.5m x 13.5m, without the projections. The height of the facade

from the upper edge of the base, which is about 1m high on the street side, to the uppermost molding measures about 9.6m; then there are about 10m more to the top of the tower.

On the street side the lot is closed off by a fence. A stone base takes up the slope of the site and supports horizontal panels of rich wrought iron grillwork between low stone piers. In front of the service wing the railing is executed more simply with straight vertical bars. The entrance gate to the garage yard is flanked by coupled stone piers bearing lanterns; these are also used at the entrance pavilion. The passage between the door of the house and the open entrance pavilion on the street is made by a loggia of piers. The first bay is open while the succeeding bays with steps to the entrance have stone parapets and glazed panels above. The garden gate, flanked

by the coupled piers of the pavilion, has a flat metal roof with curved consoles and a *sopraporta*. The roof of the entrance pavilion is crowned by a bronze statue of Pallas Athene by Michael Powolny, on a high pedestal.

The ground plan of the residential wing is designed with two main axes in such a manner that one axis is at once the longitudinal axis of the large central hall and the approximate symmetry axis of the whole building.[1] The other axis, at a right angle to the first, coincides with the line of the central wall. Parallel to it on one side is the longitudinal access corridor; on the other side it is the axis for the enfilade of formal rooms on the ground floor—to the east of the hall the music room and to the west the dining room and breakfast room. Pantry and kitchen follow, with the latter located at the juncture of

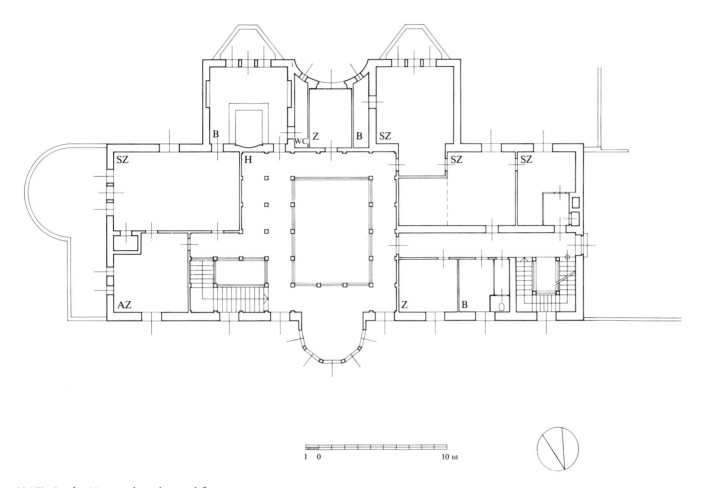

Cat. 104/II. Stoclet House, plan of second floor

1 0 10 m

the main building with the service wing. On the access corridor are the secondary staircase to basement and upper story, and the exit to the service yard and garage.

The visitor enters the vestibule from a small lobby; next to it the cloakroom with its subsidiary rooms is arranged so that the western access corridor can also be reached from here. The corridor, however, does not run through to the great hall, which is entered directly from the vestibule. Entry is at the northeast corner of the central segment of the hall, which is 7.2m high and extends through two stories. In the opposite corner a very wide and comfortable (ratio of riser to tread: 13.5cm x 31.5cm) open main staircase of three flights leads to the upper story where a gallery widens the hall on all sides. The first flight of the stairs runs in the axis of the western

corridor and is continued by a shorter, eastern corridor; to the north of it is an octagonal ladies' salon. The south wall of this corridor is designed in such a manner that its four bays open to the music room with parapets between piers. Thus, the corridor can serve as a spectators' gallery. The second flight of stairs rises at a right angle to the outer wall, the third parallel to the wall, reaching a level that permits the arrangement of a small sitting room with a fireplace niche and benches under its slope.

At the east end the building extends on the ground floor in two projections; one, on the garden side, houses a stage in the half-round, the other contains the performers' dressing room with a separate entrance on the street side. On the garden side projections flank the wide opening of the hall entrance. These have rectangular

ground plans terminating in bay windows in the shape of truncated V's. One houses the study; the other is part of the dining room. On the second floor the flat roofs of all projections serve as terraces for adjacent rooms.

On the second floor the very spacious (5.8m x 9.7m) master bedroom with views into the garden is accompanied by a dressing room on the street side, and on the garden side—in the projection—by an unusually large bathroom, 6m x 5.8m. Then follows a workroom with a concave facade, flanked by two narrow subsidiary rooms, and in the second projection a children's bedroom with terrace. Next to this is another two-part children's room with an adjoining maid's room; a third room, furnished as a small library, is on the street side next to a bathroom.

In the top story, which is reached by a com-

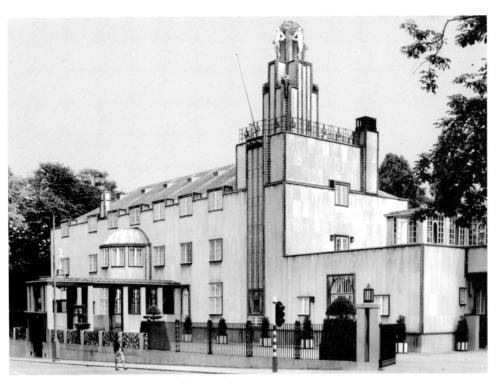

Cat. 104/III. Stoclet House, view of street side

fortable stair (ratio of riser to tread: 13.5cm x 31.5cm) in the northwest corner, are numerous other bedrooms plus storerooms, housekeeping rooms, and baths along a central corridor. On the garden side there is a large terrace over the projecting segment of the lower story. As on the other terraces, a beautiful view of the distant wooded parkland gently sloping to the southeast can be enjoyed from here. The tower is accessible by a wooden stair above the area of the secondary stairwell.

The building is constructed of brick walls with massive ceilings throughout. The facades are clad with slabs of white Norwegian Turili marble. Above a low base and paved gutter the facades are framed by gilded and blackened chased-metal moldings. The linear pattern in the moldings is developed by concentrically repeating several times the outline of an elongated hexagon. The resulting half-round metal bands are parallel at the juncture of surfaces and are carried around windows like garlands. On the street side it is easy to overlook the fact that the overall dimensions of the main building and the fenestration of the central part are designed with almost exact bilateral symmetry around an axis that runs through the large bay window. For the observer, an impression of asymmetry prevails because of the eccentric tower, the unequal pro-

jections at the ends of the ground floor, and the off-center entrance. Left of the bay window low parapets enclose a garden terrace reached by steps and guarded by a Romanesque lion as sculptural enrichment at the entry. On this side a small balcony on two pillars, accessible from the salon, also projects beyond the facade and forms a unit with a wall lamp and a window above, and a wooden bench below. In the west half of the facade the dominant element, aside from the bridgelike loggia atop the entry to the garage yard, is the tower with its tall, continuous, tripartite staircase window. Between this window and the basement window is an inset relief panel by Emilie Schleiss-Simandl representing two strongly stylized women carrying flowers in an attitude of sacrifice. Above the window three sculptured heads project from the facade.

The tower rises in two stages to a crowning metal dome in the form of a floral group. The corner elements of the first step bear flower baskets with hanging garlands; the central elements of the second stage support four heroic male figures in chased metal by Franz Metzner. All surfaces of the tower are framed and articulated by the facade moldings, which seem to descend like hanging garlands from the crown. The same moldings also form the uppermost horizontal termination of the whole facade, where they frame

the upper outline of the raised windows. All the windows project slightly; they have dark painted frames and white casements and glazing bars. On the ground floor the size and form of the windows vary according to the function of the rooms; on the second floor the windows are square.

The appearance of the east facade is determined by the following elements: the half-cylindrical stage, the rectangle above with tripartite opening, and the horizontal parapet of the stairs to the stage door. Next to the corner pier of the parapet is a shallow niche, in front of which is a stone structure with a sculpture of the enthroned elephant-headed Hindu god Ganesha. As the copper roof is hipped above this facade, it is even less evident than on the long facades; there it makes little or no visual impression because of its comparatively slight incline, its rise behind an attic parapet, and the fact that the windows are higher than this parapet.

The half-cylinder in the east facade provides a seamless transition to the south facade, which seems symmetrical when viewed frontally from the garden, though it is no more so than the street facade. On the garden side the asymmetrical stair tower is less evident and the irregularities caused by the strip-window of the music room and the ground floor projections are less prominent than the actually symmetrical projecting center section. This section consists of three main elements: the concave wall and deep entrance niche in the middle, and on either side, rectangles of plane wall with wedge-shaped bay windows projecting on the ground floor. The roof terraces on top of these projections are accessible through French doors flanked by windows in a tripartite arrangement framed by moldings and articulated by fluted piers. The concave wall has a tripartite central window with a small vertical window on each side. The narrow front panels of the bay windows also have such small windows enclosed by the framing molding, while the oblique sides have large framed windows with four casements. The outer walls of the bay windows continue upward to serve as the parapets of the second-floor terraces. The upper-story terrace, which extends across the entire central projection, has grillwork of straight bars alternating with panels of decorative scrollwork.

The garden and residence are carefully related in many respects so as to form a coherent whole. Between the bay windows of the south facade a garden terrace is bordered by low stone parapets. Three steps between stone vases and pedestals lead into the garden; in the center a rectangular water basin with a stone border contains a fountain bowl on a high columnlike shaft. Beginning some distance from the house, paved pergolas, partially with parapets between the pillars, lead

at a right angle from the house to the garden and tennis court. Behind stands a small garden house on an elevation. It is designed as a pavilion with a flat roof and a wide central opening between two narrow glazed areas. The architrave/cornice is recessed in three fasciae; the piers have narrow framed panels with floral decorations. The pavilion is flanked by two sculptured female figures on pedestals by Richard Luksch.

The inclined roof of the west facade is barely visible since it is masked by the tower terrace; at its south corner is a chimney which repeats the vertical emphasis of the tower. In front of it the terrace extends over part of the service wing and terminates on the west end in a loggia of pillars extending like a bridge over the entry to the service yard. Between the pillars the loggia is divided into panels of squared white trellis-work with arched openings in the center. The loggia and terrace are landscaped.

After crossing the entrance pavilion and ascending amidst the piers of the glazed loggia, the house is entered through a black door with gold framing and small oval windows; the two leaves of the door are relatively high and narrow. Then a white, windowless narrow zone leads to a second set of doors—an arrangement that gives one the impression of having passed a very thick wall—before entering the vestibule, the first important room.

The vestibule is not very brightly lighted. The predominant color is the dark green of the verde antico marble walls, which forms an effective contrast to the white ceiling that is gently vaulted in a segmental arch curve, as if hollowed out by the same impulse that carved white segmentally arched niches into the upper part of the walls. They recall the segmental arch motif of the concave recess in the garden facade, just as the molding under the ceiling vault is reminiscent of the framing moldings on the facades. In the niches are gilded vases lighted from above, designed by Hoffmann himself. With the thin gold stripes on the ceiling and the mosaic by Leopold Forstner they project an atmosphere of festive dignity. The two main axes of the room are inlaid in black on whitish veined marble. This reinforces the impression that nothing is left to chance: the furniture, the sculptures by Michael Powolny on built-in pedestals flanking the doors, and the pictures in gilt frames—all take their predestined place with the same inevitability with which the visitor must follow a prescribed path.

At each side of the vestibule are glazed double doors. One leads to the all-white cloakroom with its subsidiary rooms, and the other into the great hall. The hall has enough in common with the basic mood and the handling of detail in the vestibule as to leave no doubt about the close relationship between the two rooms. At the same

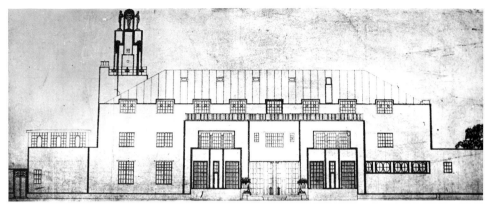

Cat. 104/IV. Stoclet House, garden facade

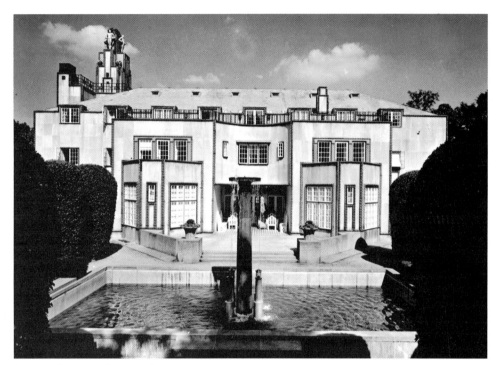

Cat. 104/V. View from garden

time there is an overwhelming contrast created by size and height in addition to lighting, color, and spatial design.

The hall extends through the full depth of the building and at the center rises to the height of two stories. This center section is defined by slim marble piers reaching from floor to ceiling. They would form a rectangle of 4 by 3 bays if the piers were not omitted on the garden side. On the second floor the hall is widened by galleries on all sides but only two sides are supported by piers. The gallery on the garden side spans from one wall to the other without supports; the gallery on the western, long, side rests directly on the wall, which has inset pilaster strips. It is

Cat. 104/VI. Garden pavilion

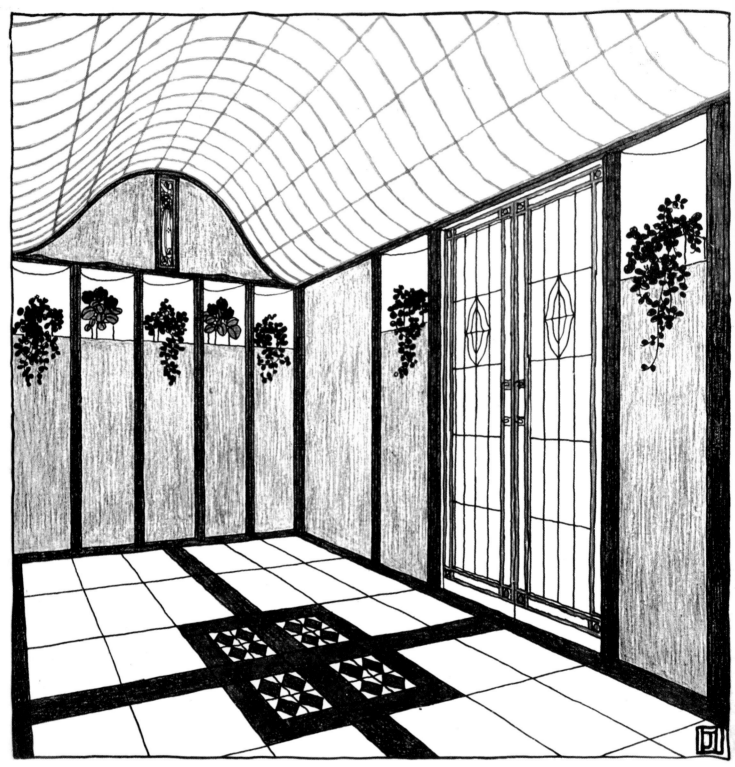

Cat. 104/VII. Stoclet House, design for vestibule

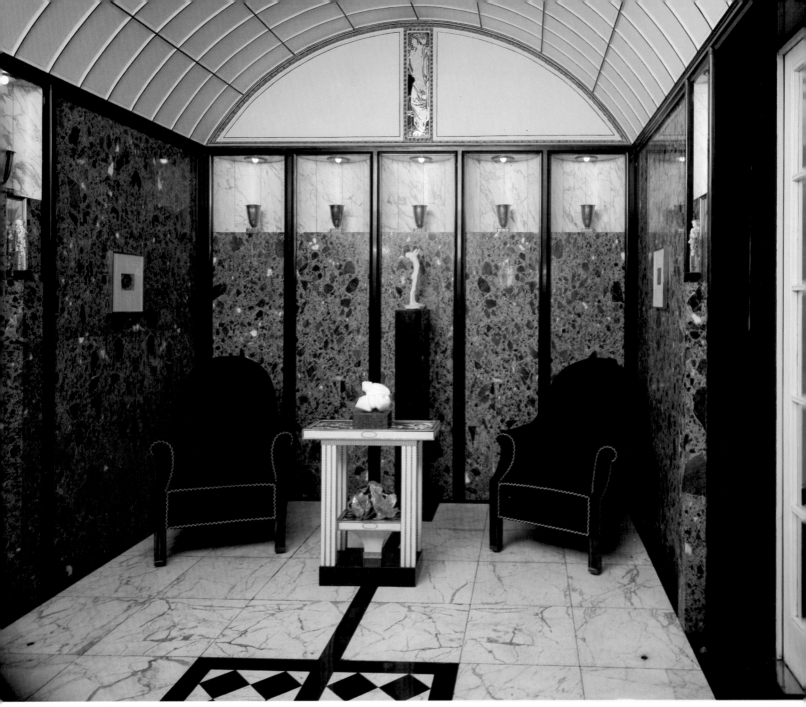

Cat. 104/VIII. Stoclet House, vestibule, view from entrance

understandable that the space of the great hall with its various extensions and recesses seems difficult to grasp because its defining boundaries are so varied and because its profile changes in section: it is obviously narrower on the ground floor than on the second floor where the ground plan of the hall is a square.

If the hall space has its elusive aspects, it is never confusing. Among other features, the strict axiality of all main vistas and the way in which every juxtaposition of two materials is considered and formalized give assurance that a feeling of order is not lost. All surfaces are framed by moldings, as on the facades, and, as on the exterior, this creates a special effect.

In the large bay window on the street side is a marble fountain with a sculpture by Georges Minne; standing in front of some piers are dark marble pedestals for sculptures from the collection of the owner; showcases for smaller objets d'art are built in between other piers. Their faceted crystal glass panes, along with the glass chandeliers, polished marble and wood surfaces, and inlaid floors contribute to making the room especially suitable for use with artificial illumination. Among the furnishings, a massive seating group upholstered in suede plays an important role.

The open main staircase is both integral to and an extension of the hall. Underneath the top

Cat. 104/IX. Stoclet House, design for hall

Cat. 104/X. Cloakroom on ground floor

flight is a seating area in the tradition of the Anglo-Saxon inglenook with open fireplace. Above the fireplace a large translucent onyx slab, flanked by two smaller ones, is placed so that it can be illuminated from behind to bring out the impressive effects of its cloudy streaks.[2] Two decorative plaques by Carl Otto Czeschka enrich the marble walls above the upholstered seats at each side. A relief of Saint Michael in the niche below the stair is also by Czeschka. A similar niche with a marble fireplace and leather upholstered benches takes up the back wall of the study. Like all other rooms on the ground floor which are accessible from the hall, the study is darker than the high central room: the paneling, built-in cases for books and collections, and a large low cabinet with drawers are executed in matte oak stained black and with the motif of multiple framing. The room receives light through two large windows with decoratively treated glazing bars in the angled end-walls, and by a small window between them; in front of the latter stands a sculptured head on a slim pedestal.

The music or theater room is four steps below the great hall; on the stage with its half-round end stands an organ. The wall surfaces are black, strongly veined Portovenere marble polished to high gloss; the floor is teakwood parquet with strips of coral wood. The carmine red of carpet, curtains, and upholstered furniture, the golden luster of carvings and framing moldings, the colorful inlays of glass and enamel on the gallery and window piers stand out all the more strongly against the dark wall and floor surfaces. Two aedicules framed with gilt moldings next to the entrance stairs are very effective settings for a Chinese grave relief and a painting especially created for Adolphe Stoclet by Fernand Khnopff.[3] Ten glass windows with representations of Apollo and the Muses by Carl Otto Czeschka complete the rich interior of the theater. Its gallery opens onto the octagonal ladies' salon, where Czeschka also played a determining role in the furnishings. In this room the delicately stuccoed ceiling, colorful flowered wall fabric, soft carpet with a wreath motif, and richly carved and gilded upholstered furniture with embroidered decoration are all coordinated to form a sumptuous ensemble.[4]

Opposite the entrance to the music room, glazed double doors open into the great dining room, which Klimt's mosaics made the most magnificent room in the house and one of the most famous interiors of the 20th century. The room is darker than the hall since the only daylight comes from the bay window at its outer end, about 14m from the rear wall. Though the same honey-colored Paonazzo marble as in the hall is used on the walls, the remainder of the interior is kept in dark materials: Portovenere marble,

Cat. 104/XI. Stoclet House, design for staircase with inglenook

Cat. 104/XII. View toward stairs

Cat. 104/XIII. Fireplace in inglenook

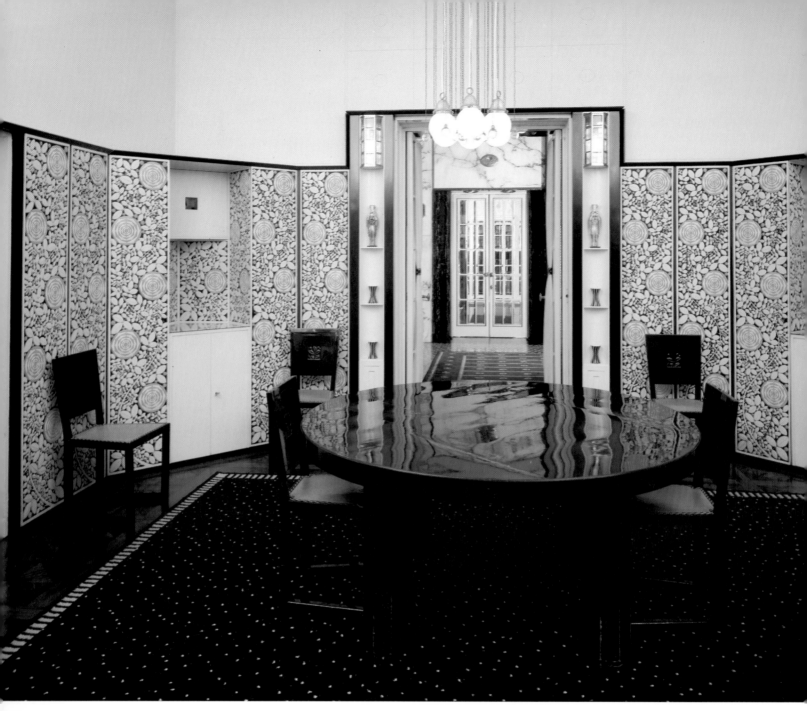

Cat. 104/XIV. Stoclet House, breakfast room, view toward hall

Macassar wood, and black leather with gold tooling. The sparkling mosaics are all the more effective and for them this interior, with its subdued natural and carefully arranged artificial lighting, is as ideal a setting as it is for the luster of precious metal, porcelain, and crystal. Spatially, the dining room consists of three areas, although one's first impression is one of a completely unified whole. At one end the windows form a wedge of light; between them a small raised window like the one in the smoking room is placed above a small black marble fountain with fish mouth, crowned with a sculpture by Michael Powolny. Four ceramic versions of the same work are displayed in the vestibule. By day the three windows create an area of brightness and transparency in this segment of the room. At the opposite, entrance, end of the room, there is again a kind of spatial wedge—in this case achieved by built-in showcases which can be illuminated artificially. The walls are also recessed here—the side walls to receive the entrance doors, the back wall to frame Klimt's central mosaic with its strong colors and largely abstract forms. By setting the image in a stepped-back niche, it assumes a special, almost hieratic, character.

Engaged marble piers delimit both the entrance and the window areas. Between them the two lateral mosaics *Expectation* and *Fulfillment* extend over the whole length of the wall. They are set back slightly behind the marble cladding which separates them from the sideboards below. These have alternating open marble compartments and square wooden doors with gilded framing moldings. The squares are about half as high as the mosaics. It is striking how well the rest of the room holds its own with the mosaics. All elements, from the dark speckled and white squares of the marble floor with its brownish olive carpet, and the square wooden doors of the buffets, to the row of wall fixtures and ceiling chandeliers, are coordinated to enhance each other. The surfaces polished to a high gloss and the mosaics and elements of precious metal create, in the gleam of reflected light, the exact atmosphere of festive brilliance desired.

In contrast to the courtly formality of the great dining room, the adjoining breakfast room is characterized by a light, bright atmosphere. It has an octagonal ground plan, formed by oblique corner showcases, and receives ample daylight. Flat carved floral decor in white and yellow on a black ground covers the walls. Black, white, and yellow (with some blue) are also the colors of the carpet; its spotted pattern was said to have been chosen so that crumbs falling on the ground during a meal would not be visible.[5]

The marble staircase from the hall to the second floor is covered by the same colorful runner as is found along the main traffic lanes; it is also

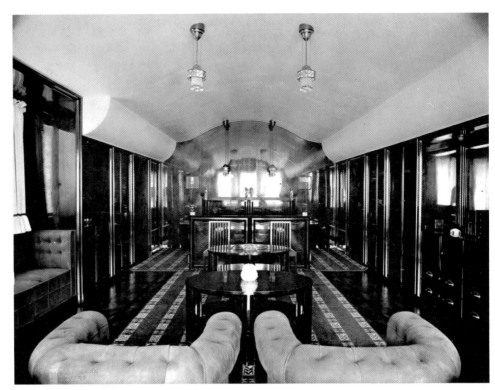

Cat. 104/XV. Stoclet House, master bedroom

used in the galleries, where there is a seating area with bentwood furniture in the polygonal bay window. Among the numerous rooms in the upper story, those connected with the main bedroom form a special group. The bedroom itself is planned so that the beds are opposite the triple opening to the terrace and face east to the morning sun. The room has a vaulted white ceiling in multiple curves, and built-in cabinets and paneling in polished rosewood with inlays. Tables and chairs are executed in the same material and are supplemented by leather upholstered furniture. The headboards are crowned by carved statuettes. Doors in the long walls lead to the lady's dressing room on the street side and to the bathroom on the garden side. The dressing room has paneling and built-in cabinets with plain white surfaces framed by black moldings. The other furniture, including a dresser, large mirror, clothes racks, and a seating group, is also kept in black and white; even the upholstery of the small easy chairs was originally striped black and white. There is a light gray carpet with a grid of black stripes. The bathroom with its own terrace is dominated by a large rectangular marble tub on a low podium; in front of it are placed a sofa in green upholstery and a matching white table. The walls are fluted in the

upper third, and covered with white, strongly veined marble below, and articulated by black linear inlays and decorative insets in malachite and mosaic. A washbasin and dressing table with mirrors are built into niches; two free-standing decorative soap dishes are next to the tub.

Among the children's rooms, the room with two beds on the garden side deserves special mention. It was painted by Ludwig Jungnickel with a largely black and green animal frieze and has a built-in unit of white lacquered wood which includes cabinets and a wall bench. In the center stand a rectangular table and chairs with earlike raised posts in the form of strongly stylized birds.

The other rooms on the second and attic floors, including a schoolroom and several guest rooms, are less sumptuous but planned and detailed with the same care as the interiors discussed above. This also applies to the corridors, the secondary staircase in dark gray marble, and the housekeeping rooms, of which the spacious kitchen with built-in cabinets and a bright dining room for the servants are noteworthy. In all cases the Wiener Werkstätte supplied not only mountings and light fixtures but furniture, curtains, and carpets. Furthermore, all the table silver, china, and glass were made from Hoffmann's designs.

The building is in a very good state of pres-

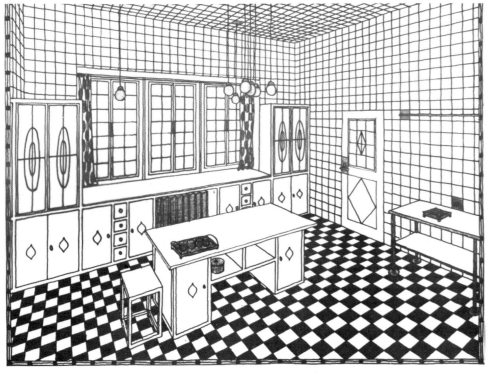

Cat. 104/XVI. Stoclet House, design for kitchen

Hochreith Hunting Lodge near Hohenberg, Lower Austria
Remodeling and furnishings for Karl Wittgenstein
Dating: According to a letter to Hoffmann, the work was completed in the middle of July 1906
Cost: 88,670 crowns

Design and furnishings for a vestibule and a two-part main room in an existing log house on a sloping lot with a splendid view in a densely wooded area. Access is along the narrow side of the house below the wide overhang of a hipped shingled roof and up a short wooden stairway to the corner veranda. The entrance consists of an iron security gate and behind it a partially glazed facade element painted white, with a door, a vertical window, and three upper lights. The lower part of the door is designed with a multiply recessed, approximately square panel; the upper part, like the adjoining window, has decorative leaded glazing of many segments. The composition includes the monograms KW and PW, and, in the window, an octagonal mirror.

Entering the vestibule, there is a cloakroom at the right and, further back, a door to the kitchen; another door is in the rear wall, and a third is in the center of the left wall. The door at the back leads to the part of the house not altered by Hoffmann and to the secondary entrance; the left door opens onto the main room. Next to it on the right, in a completely tiled wall, is the fire door to a stove in the next room. Except for a tiled area at the fire door a carpet covers the floor. It is patterned with wide longitudinal stripes, creating a directional emphasis corresponding to the parallel dark green wooden moldings on the ceiling. The white walls are also divided into striplike areas by green and black painted bars. In the upper part are square insets with colorful designs of birds by Carl Otto Czeschka, who also painted the *sopraportas* with flower baskets. The tiled area of the back wall has a colored ceramic relief by Richard Luksch of two huntresses. Lighting is provided by a ceiling fixture with rows of hanging glass spheres and light bulbs in curved mountings.

The back door and the two side doors are treated differently. The back door swings within a narrow plain casing. The lower part has a multiply recessed panel; the upper part is filled by a colorful glass painting (by Kolo Moser?) in an abstract composition of blossom and flower motifs. The two side doors are in frames with a wide cyma profile. These doors have only a single vertical panel, painted in a linear stylized composition of scrollwork and birds by Hoffmann; at the top is a square opening with decorative

ervation and has undergone only minor changes and necessary modernization. The copper roof, which had been removed during the First World War, was restored in the recent past. Some panels in the ceiling of the entrance loggia and the entry to the garage yard were renewed in white glass. At the entry to the garage area the fence was altered and extended to the west to enclose a lot acquired later. The garden house is badly damaged, and the two flanking figures now stand in the great hall of the house. Some signs of beginning decay from age are also noticeable in the garden and its furnishings and on the upper terraces, which are no longer landscaped, but this does not compromise the positive total impression. Inside, the ladies' salon has been altered by built-in showcases, and the pictures have been removed from the vestibule. Elsewhere, other works of art have been removed from their original places of display. Numerous carpets and upholstery have had to be replaced, as in the great hall; the wall painting by Jungnickel is beginning to separate from the wall in places.

1. The ground plan is only approximately symmetrical; the longitudinal axis of the hall is not exactly in the center of the building.
2. On a visit in 1955 the architect commented on this *tour de force*: "You can see that I was young when I did that, and not afraid of anything."
3. This is *Une recluse*, a version of the painting *I lock my*

door upon myself; see *Fernand Khnopff 1858-1921* (exhibition catalogue), Brussels, 1979, 129.
4. A drawing for upholstered furniture is illustrated in the catalogue of the *Jugendstilsammlung* I, Museum für Kunst und Gewerbe, Hamburg, 1979, 264.
5. Edmond de Bruyn, "Adieu à Monsieur Adolphe Stoclet," *Le Flambeau*, no. 6 (1949), 2.

Bibl.: *MBF* XIII, 1914, 1ff.; *Studio* LXI, 1914, 189ff.; Hevesi, *Altkunst*, 220; *Belfried* (Leipzig) III, 1918, 230-232; *Wendingen*, August/September 1920, 4ff.; *L'architecte*, I, 1924, 21ff.; Platz, 311; *Architect and Building News*, 13 March 1931, 382ff.; *Maandblad voor beeldenden Kunsten* XVIII, 1941, 278ff.; H.-R. Hitchcock, *Architecture 19th & 20th Centuries*, Baltimore, 1958, 350; L. Benevolo, *Storia dell'architettura moderna*, Bari, 1960, 429; *AUMK* VI, 1961, 7ff.; VII, 1962, 22ff.; XV, 1970, 32ff.; E. F. Sekler, "The Stoclet House, etc.," in D. Fraser et al., ed., *Essays in the History of Architecture Presented to Rudolf Wittkower*, London, 1967, 228ff.; W. Hoffmann, *Gustav Klimt und die Wiener Jahrhundertwende*, Salzburg, 1970, 28ff.; Nebehay, *Klimt*, 381ff.; N. Powell, *The Sacred Spring, etc.*, London, 1974, 74ff.; P. Vergo, *Art in Vienna 1898-1918*, London, 1975, 143ff.; Drawings and photographs: *Museum des 20. Jahrhunderts*, Vienna; WWA; Estate; Archive of the author; Plans: ABBH and archive of the owners.

glazing in a network of squares with an inscribed heart shape.

The left door leads to the main room, which provides a strong color contrast to the vestibule, where white and bold colors predominate. Here—except for the white tile stove with a decorative ceramic sculpture by Luksch and the black marble fireplace—only a few coordinated warm tones play a role: reddish brown Maracaibo wood polished to a high gloss with flame moldings, lighting fixtures similar to those in the vestibule, gilt mountings and plaques, faceted plate glass, yellow tiles behind the stove, and a light carpet of very subtle coloration: violet and black on a predominantly dark yellow ground, mixed from light and dark threads, which accounts for a curiously vibrant quality.

The main room (4.62m x 6.55m) is in two sections connected by a very wide opening, reaching almost to the ceiling, which can be closed by an embroidered yellow silk curtain. The back section, with a fireplace as the main accent, can be entered only from the front room, which has the entrance from the vestibule and the door to the rear of the house. Both doors are veneered in the same wood as the ceiling beams and wall paneling, which means that the inner and outer surfaces of the entrance door are treated quite differently.

The overall design is based on a square grid, visibly expressed by the almost square wall panels and tiles (height, 33 cm; width, 30 cm). In the rear room this is also expressed on the ceiling so that the simple relation of length to breadth to width can be directly read as 11:8:9. In the front room the relation is 15:12:9 (5:4:3). The individual panels are divided by narrow black strips. All the furniture fits into the grid system: in the front, a window unit, low wall cabinet with marble top, and buffet; in the rear room, the built-in glazed bookcases, a folding sleeping bench, a "wash stand with fire gilded silver fittings," and a secretary with several compartments and a hinged desk top. The units are vertically articulated in a 1:2 relation; later the upper sections of the glass doors in the rear room were backed with Japanese screen paintings, which enriched the total effect. The third wall of this room is paneled throughout except for two sash windows with decorative glazing on each side of the fireplace. The fireplace is executed in black, strongly veined marble. Its opening is set into the concavity of a half-oval niche, with the convex marble floor paving in front completing the oval symmetry. The resulting outline matches the plaque over the fireplace opening. Two small light fixtures illuminate the mantelpiece from above. The dining table and a smaller gaming table are in black stained and polished wood with gilt flame moldings; they are in the same mas-

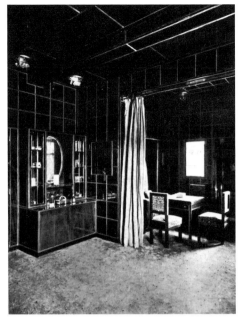

Cat. 105/I. Hochreith Hunting Lodge, main room (cf. text figs. 82, 83)

Cat. 105/II. Hochreith Hunting Lodge, fireplace in main room

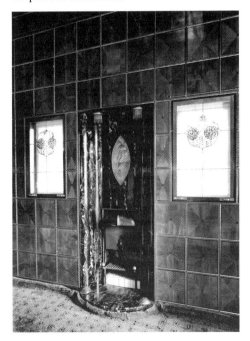

sive rectangular forms as the upholstered seats with hand embroidered, vividly patterned fabric (designed by Czeschka). Details and execution of the entire interior are of the highest precision and quality. The contrast between the very simple rural exterior of the house and the rich, sophisticated interior is unusually effective.

Except for the seats, the furnishings and decoration are preserved and in excellent state. The floor covering in the vestibule was replaced, and the washstand and dividing curtain in the main room were removed.

Bibl.: *DKuD* XIX, 1906/1907, 79, 443-445; *AUMK* XII, 1967, no. 92, 28ff.; Photographs: WWA.

Cat. 106 1906

Furnishings for Dr. Hermann Wittgenstein
Vienna III, Salesianergasse 7

For the physician Dr. Hermann Wittgenstein, a son of Paul Wittgenstein, Hoffmann designed an apartment, largely in black and white. The study, salon, children's room, bedroom(?) and kitchen(?) were published. Perspective designs for salon and children's room are extant.

In the study the white walls are either divided into tall vertical areas by superimposed dark wooden strips, or articulated by built-in furniture of equal height, treated in white with black moldings. On a side wall are two built-in bookcases, each consisting of a base with drawer, a two-door glazed case with book shelves, and a smaller glazed case on top with horizontal doors and bars in the form of diamonds. The upper part of the opposite wall has the same type of glazed cases with horizontal doors and inscribed diamonds; here 16 such units run in two rows from one end to the other. Below them two mirror niches and cabinets flank a built-in upholstered bench, in front of which is a seating group consisting of a round table and upholstered armchairs. They have a U-shaped plan and curved armrests and backs. In front of a window, a desk and an armchair in massive "sled" construction are diagonally placed.

The most important element in the salon is an inglenook: a fireplace niche with dropped paneled ceiling and upholstered benches on each side. The longer side of the niche is articulated by piers into three sections; the center section is wide and open; the side sections are narrow and have a parapet which also serves as the side piece of the built-in upholstered bench.

The benches are high-backed, the one on the right serving as the lower enclosure of the whole niche. The back of the niche is also articulated by engaged piers into three sections, analogous to the front wall. The center section contains the

fireplace with hammered metal hood and surround of black-veined marble. The side sections are plain except for a decorative motif in the center. Above the benches are open shelves for bric-a-brac and objets d'art; two of these hold insets in chased metal by Kolo Moser. A small round table and a large cubiform armchair complete the furnishings of the niche. The floor has dark tiles. The rest of the room has wall-to-wall carpeting. Next to the inglenook is a secretary with armchair; other armchairs and a bench and hexagonal table form a seating group in a corner.

In the children's room the walls are stenciled with a colorful pattern of birds and blossoms. The furnishings, painted white with dark moldings, consist of bed, washstand, a three-part cabinet with glazed center, and a table with rounded corners and matching chairs. The chairs are of "sled" construction with insets of a chalicelike form in the back frame. Insets and seats are upholstered with the same colorful fabric used for the window curtains.

In the bedroom the walls have fabric-covered panels in white wood frames as wainscoting; it is coordinated with the furniture along the wall. This includes a four-door cabinet, a dresser with a mirror, and the bed with the headboard in a shallow niche. Next to the foot of the bed is a stand reaching to the ceiling and supporting a curtain for shielding the bed against light from the window.

Parts of the furnishings were acquired by ÖMAK.

Bibl.: *DKuD* XVIII, 1906, 454-460; XXV, 1909/1910, 403; *Art-Revival*, C11, 12; *Kunst in Wien um 1900* (exhibition catalogue), Darmstadt (Hessisches Landesmuseum), 1965, 166 (chased works by Kolo Moser); Photographs: WWA.

Cat. 107 1906

Studio addition and furnishings for Magda von Mautner-Markhof (See Cat. 68)
Vienna III, Landstraßer Hauptstraße 138
Certificate of occupancy: 6 August 1906

For "the multitalented Miss Magda von Mauthner-Markhof [sic]" (Hevesi), who was active in arts and crafts, a studio room was added to an existing building, and furnished. The walls are white, with a frieze of "nails" below the ceiling to hang pictures, and low wainscoting in dark polished wood with picture frames in the upper part. The wainscoting is coordinated with wall cabinets of equal height. In the middle of a long wall is a white rectangular tile stove with niches, somewhat lower than the wainscoting. In front of the stove a seating group consists of two upholstered easy chairs and a bench with wooden sides of the same material as the wainscoting.

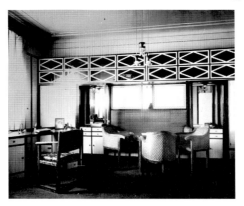

Cat. 106/I. Apartment for Dr. Hermann Wittgenstein, study

Cat. 106/II. Design for children's room

Cat. 106/III. Children's room

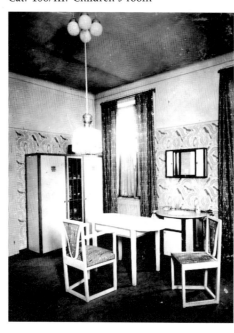

At the large studio window is a desk, and at the side wall a glazed bookcase, repeating the height and construction with round bars of the small wall cabinets on the other side of the room. The hanging light fixtures have glass cubes with metal frames and round sheet metal covers.

Bibl.: *DKuD* XIX, 1906/1907, 490; *Interieur* XII, 1911; Hevesi, *Altkunst*, 314.

Cat. 108 1906

Exhibition Design, Kosmanos
Reichenberg (Liberec), Czechoslovakia

Cat. 109 1906

Tomb for Leopoldine Hoffmann
Pirnitz (Brtnice), Moravia, Czechoslovakia

Josef Hoffmann designed a simple tomb for his mother who died on 8 August 1906. It consists of a simplified aedicule with two side piers and a slightly rounded gable enclosing the inscription tablet. In the tympanum, four square recesses form a cross. The grave is covered by a slab on stone sills forming steps on all three sides. At the front, low piers bear lanterns. Simple side railings border the grave. The grave is not cared for but still well preserved (1970).

Cat. 110 1906

Kohn Tomb
Vienna

Cat. 110a 1906

Shop front and furnishings of the salesroom for the bentwood firm Jacob & Josef Kohn
Berlin, Leipzigerstraße 40
Jointly with Kolo Moser

The well-known bentwood firm, for which Hoffmann and Moser had been active for some time (see Cat. 59), acquired premises for its Berlin branch with rooms on the first and second floors and accordingly needed a two-story shop front. This is executed in metal painted in a dark tone and extensively glazed. Slender uprights articulate the facade into three vertical sections, with the central one somewhat wider and more richly decorated. There is also a tripartite horizontal articulation with a mezzanine zone showing richer spatial and decorative treatment, including a convex central projection, a division into small segments by thin bars, and two glass paintings by Moser.

The shop is no longer extant.

Bibl.: *Berliner Architekturwelt* VIII, 1906, 403-405; J. Posener, *Berlin auf dem Wege zu einer neuen Architektur*, Munich, 1979, 103.

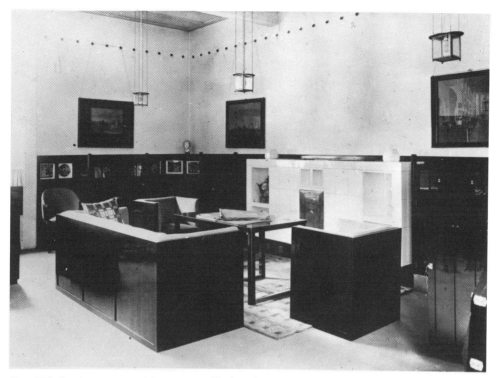

Cat. 107. Seating group in Mautner-Markhof studio

Cat. 109. Grave of Leopoldine Hoffmann

Cat. 110b 1906

Project for an extension to the School of Arts and Crafts
Vienna I, corner Kopal (Oskar Kokoschka) Platz and Schallautzerstraße

The existing building on the Stubenring and a projected new building on the Wien River at the little Marxer Bridge are connected by a new wing on the Kopalplatz. Each new element receives individual architectural treatment. The connecting wing is somewhat lower than the older building, with five bays of equal width and two narrow staircase elements. The bays are divided by piers which on the street side carry sculptured figures and on the courtyard side have only finials. In addition the two last piers, framing the narrow staircases on the courtyard side, are connected by arches that project above the facade.

The bays of the wing on the Kopalplatz are designed with successively recessed stories, so that the facade appears stepped back from bottom to top. The stepping back is achieved by giving the shape of glazed quarter-cylinders to the up-

Cat. 110a. Shop front of J. & J. Kohn, Berlin

313

Cat. 110b. Project: School of Arts and Crafts extension. View of new section, old section and courtyard.

per termination of the continuous workroom windows on all floors. The walls between the glazed portions are treated as plain surfaces articulated in square and rectangular panels without reference to an expression of the floor levels.

While in the connecting wing horizontality prevails despite the piers, the three-story river front is characterized by verticality. This facade, which can be viewed from a considerable distance, is slightly angled toward a narrow center section with the entrance. On each side are eight facade bays separated by continuous plain stucco strips. At the end of the facade these strips are wider, and at both sides of the central section they are doubled, reinforcing the effect of rhythmic articulation. At the outer ends there are additional slightly projecting piers which have horizontal joints like the piers of the connecting wing, and are crowned by tall, slightly conic elements. Sculptures crown the piers at the entrance bay.

On the river side the window spandrels show the motif of multiple, slightly recessed framing. On the courtyard side the stucco panels at the base have double frames; the remaining vertical panels have a kind of inset strut with decorative top. A widely projecting thin slab is used in lieu of a cornice on both the street and the courtyard sides.

Bibl.: *Architekt* XIV, 1908; *KuKhw* XXI, 1918, 342, 343, with dating of 1906; Print of perspective drawing: Estate.

Cat. 111 1906-1907

House for Helene Hochstetter on the Hohe Warte
Vienna XIX, Steinfeldgasse 7
Approval of submitted plans: 31 May and 10
July 1906
Certificate of occupancy: 17 June 1907
Builder: Eduard Ast & Co.

Five years after he had done her city apart-
ment, Hoffmann designed a house for Helene
Hochstetter. The lot is on the north side of the
Steinfeldgasse opposite the Kolo Moser House
and is about 33m long, dropping sharply to the
north where it borders the Kühn park. The slope
location gives the house the appearance of a two-
story building on the street side and a three-
story building on the garden side, and it provides
an especially fine view from the upper story and
finished attic to the Wienerwald. The house is
carried out in traditional construction with room
heights of 2.8m; the facades have coarse-grained
stucco on the upper story and very light-colored
bricks below. The hip roof with a 45 degree angle
is tiled. Except for the alcoves and other projec-
tions, the ground plan can be inscribed into a
rectangle; the long side is 14.9m and parallel to
the street; the depth is 12.2m.

Four perspective views of the preliminary de-
sign, slightly different from the executed build-
ing, were published. The building is reached from
the Steinfeldgasse by an open entrance loggia or
gallery. A flat roof is supported by piers and
engaged piers in brick; steps within lead from
street level to the entrance door, which opens
onto a corridor that gives access to a hall on the
garden side. On the left is the cloakroom with
anteroom and toilet; on the right, the butler's
pantry for the dining room on the street side.
Just before the hall, a short corridor branches
off on the left, giving access to a staircase from
basement to upper story. The kitchen, porter's
apartment, servants' rooms, storerooms, and
furnace are in the basement.

The hall extends toward the garden in a straight
alcove. At the inner end is a wooden staircase
with decorative openwork. Next to this a door
opens onto a small terrace. To the right of the
hall is the spacious living room with a bow win-
dow at the east end. The room is separated by
three piers from a narrow "aisle," which con-
nects to the dining room and to an open stair
along the garden facade. In the upper story a
corridor, reached from the hall stairs, gives ac-
cess to the bedrooms with subsidiary rooms and
terraces. There are additional bedrooms in the
attic.

The appearance of the exterior is determined
by comparatively few elements: the roof with
box dormers, overhanging box gutter and sep-
arate roofing of the west staircase; the horizontal

Cat. 111/I. Hochstetter House, street facade

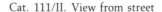

Cat. 111/II. View from street

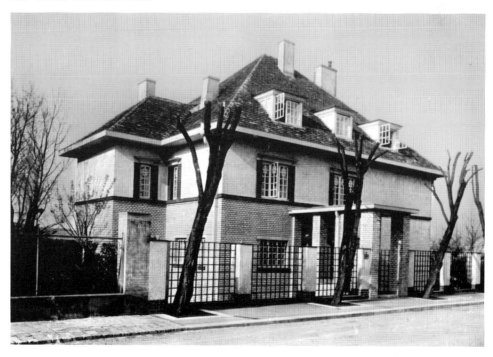

315

division of the facades; the plastic enrichment resulting from projecting alcoves and terraces, and not least of all, the enrichment from the use of variously colored bricks—window jambs, sills, and a belt course are of dark bricks which stand out against the light facades. The window heads in the upper story have a straight cavetto molding; the eastern bow window is divided by plain strips into panels, into which, above the ground floor windows, dark bricks are inset as centered accents. The straight alcove of the north facade is articulated by vertical brick strips. All windows have multipaned casements; in the upper story decorative bars are inset in the four upper lights of each casement.

Inside, all the formal rooms on the ground floor have wainscoting; they are either painted white as in the cloakroom which—like the pantry—has black and white floor tiles, or stained dark, as in the hall, living room, and dining room. In the hall, built-in cabinets and the staircase are coordinated with the paneling of the wainscot; the openwork stair railings with diagonals and two lozenges contribute to a dynamic effect. In the living room, built-in cabinet inlays repeat motifs from the city apartment and a sculpture and pedestal were actually transferred from the apartment. In the bow window four small upholstered armchairs and a round table form a seating group. The dining room has wainscoting divided into square panels. In the long wall this division is interrupted by a large oval mirror in the middle while built-in buffet cabinets are placed on each side of the entrance. These, like the door frame, are bordered by multiply recessed cavetto moldings. The upper walls are stenciled in a colorful, rather dynamic pattern; the ceiling is white. The perspective design of the dining room was published.

After some alterations, including the installation of a garage, and after damage in World War II, in 1960 the house came into the hands of the Weinwurm family, who remodeled it into a *pension* and added a third story. The changes were so great that the original state is no longer recognizable.

Bibl.: *Architekt* XIV, 1908, 122; XV, 1909, pl. 61; *DKuD* XIX, 1906/1907, 38-41, XXIV, 1909, 202-209; *Interieur* XI, 1910, 90; Photographs and prints of plans: Estate; Photographs: WWA; Submitted plans (incomplete): ABBH.

Cat. 111/III. Hochstetter House, plan of ground floor (cf. text figs. 130-133)

Cat. 112 **1906-1907**

Second house for Carl Moll on the Hohe Warte
Vienna XIX, Wollergasse 10
Approval of submitted plans: 29 September 1906
Certificate of occupancy: 13 September 1907
Builder: Eduard Ast & Co.

The lot, purchased by Moll in May 1906, is near the Brauner House (Cat. 101) and next to the Henneberg House (Cat. 54); the street side faces approximately west. A first project, completed in July, did not meet with the approval of the client. The building would certainly have looked unusual, with walls of random ashlar masonry in decided contrast to a stuccoed bow window with brick piers, and with a sheet metal roof of almost semicircular form. The L-shaped ground plan is organized around an approximately square staircase in the angle of the L. On the second floor, which is the ground floor on the garden side, the stairs connect with a large living room on the street side. A wide opening leads to the dining room, which has a large bow window. On the garden side are the child's room and the woman's bedroom separated from the man's bedroom by a common bathroom. The governess's room and a toilet are between the child's room and the staircase. The man's bedroom has a bow window.

The executed project retains the L-shaped plan around a straight staircase in the angle of the L, but the room layout was considerably changed. There is a partial basement. On the ground floor a few steps lead to a central entry and a small vestibule.

At the far end the vestibule opens to the staircase whose center four piers reach from the ground floor to the attic. To the right of the vestibule is the kitchen, to the left the living room, dining room, and veranda on the garden side. Pantry and laundry are also on the garden side. A toilet is arranged under the stairs. On the second floor are two bedrooms on the garden side; the larger on the north has a terrace. A second contiguous bedroom has a north window, and a third smaller bedroom is on the street side. In the finished attic are Moll's studio and storerooms.

On the street side there is a towerlike element with a gently curved sheet metal roof; it is carried one story higher than the level of the roof gutter, which is designed as a large box gutter with a prominent pattern of five rows of alternating black and white rectangles. Similar patterns border window frames on the facades, which are partly stuccoed, and partly covered by asbestos cement shingles. The entrance door with two flanking windows forms a recessed group that finds its correspondence in the second-floor

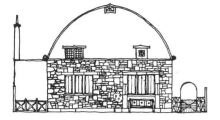

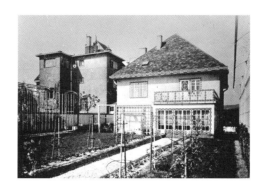

*Exhibition design for room of Gustav Klimt and
the Wiener Werkstätte*
International Art Exhibition in the Kunsthalle,
Mannheim
Opening: May 1907
Execution: Wiener Werkstätte

Three large pictures and about twenty draw-
ings by Klimt, together with arts and crafts by
the Wiener Werkstätte were to be exhibited in
a long rectangular hall with large windows and
two doors. Complications resulted from the fact
that one of the doors was not on the same level
as the exhibition hall but on the level of a lower
room, so that the hall had to be entered on this
side by a staircase cut into the floor.

Hoffmann's treatment unified the various ele-
ments of the hall. He framed both doors with
the same elements but in a different combina-
tion. The opening of the door at gallery level is
framed by two projections which carry a flat
lintel. The framing is painted in a pattern of
rectangles and triangles, which is also used in
the second, more complicated, door arrange-
ment. There, the entire flight of entry stairs
including the massive parapets is included in the
composition, and the flat lintel becomes a larger
slab to form a kind of small pavilion. The door
also has a stucco *sopraporta* with the multiply
recessed framing motif and a bas-relief in the
center. All wall panels are framed by light linear
borders. Two large ladies' portraits hang on the
walls next to the doors, facing each other, while
The Three Ages of Man occupies another wall.
This work is flanked by rows of drawings hung
at eye level, interrupted only by two showcases
for craft exhibits. One of the portraits is flanked
by two Minne sculptures on black pedestals; an-
other sculpture stands in the opposite corner of
the room. Furniture, flower stands, and small
tables with vases are placed along the window
wall. Flowers in floor containers also stand in
front of the portrait of Adele Bloch-Bauer. The
floor is a checkerboard pattern of black and gray
squares. Two small seating groups consisting of
a table with two chairs are placed in the long
axis of the room; they are black like the show-
cases.

Bibl.: *DKuD* XX, 1907, 328–333; Nebehay, *Klimt*, 517; Pho-
tograph: Estate.

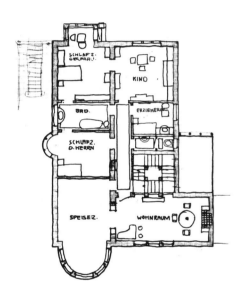

Cat. 112/I. Second house for Carl Moll,
first project, elevation and ground plan
(cf. text fig. 128)

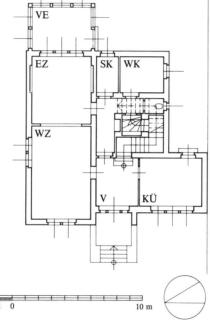

Cat. 112/II. Executed project, view and
ground plan (cf. text fig. 129)

loggia. The pillar at the southwest corner of the
loggia is octagonal with an interesting geometric
capital design. The effect of the garden side is
enhanced by the repetition of the border motifs
from the gutter on the wooden trellis and the
terrace railing. Some of the furnishings were
executed by the Wiener Werkstätte. A pavilion
with curved roof stands in the garden.

In 1928 the building was altered by additions
and later by interior changes. In 1971/1972 it

was restored with style by Erich Boltenstern,
although the restoration included the installa-
tion of a dumb waiter.

Bibl.: 1st project: *Architekt* XVII, 1911, 16, pl. 12; *Finale*,
182; Original drawings of ground plan and three facades:
Estate; 2nd project: *DKuD* XXIV, 1909, 210; Submitted and
altered plans signed by Paul Roller (Architectural office of the
Wiener Werkstätte): ABBH; Photograph of facade: WWA;
Restoration: *AUMK* XIX, 1974, 24ff.

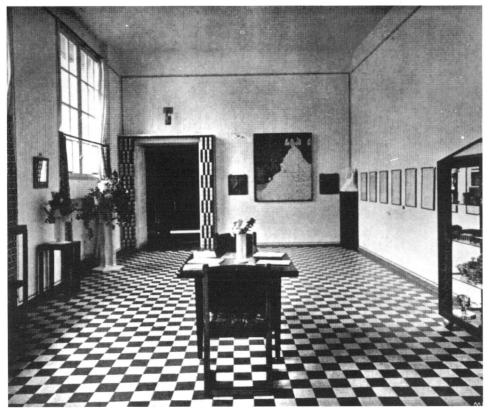

Cat. 113. Klimt Room in Mannheim

Cat. 114/I. "Die Fledermaus" Cabaret, anteroom and bar

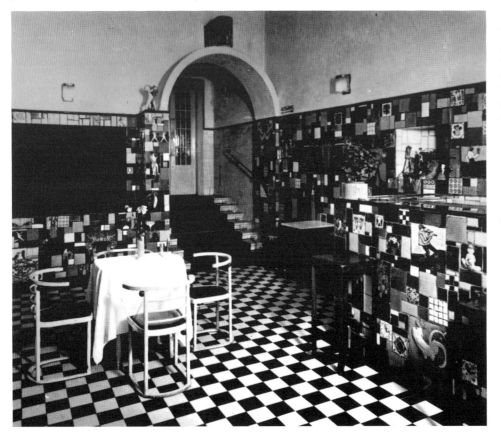

Adaptation and furnishings of the Cabaret "Die Fledermaus"
Vienna I, Kärntnerstraße 33/corner Johannesgasse 1
Approval of submitted plans: 20 September 1907

An entertainment place is created in the basement of a new building. The ground plan is complicated since a rich spatial program must be housed in an approximately square area of about 440 sq. m, not very large for its function, considering the thick wall piers and space required for emergency stairs. The program includes two main rooms for the public—a lobby with bar and an auditorium with gallery—plus the necessary cloakroom, performers' dressing rooms, inspector's room, kitchen, and toilets. Access is from the Johannesgasse by a stair; the walls are designed with vertical black and white marble stripes. The lobby and bar, and a curtained cloakroom next to the main stair, have black and white floor tiles and ceramic tiling on the walls. The ceramic treatment of the lobby, which also extends over the bar counter, employs colorful tiles of varied sizes, many also patterned or pictorial, with "drawings, vignettes, symbols, caricatures, modernistic follies, portraits, satiric ideas" (Hevesi). The execution was by the "Wiener Keramik" (Berthold Löffler and Michael Powolny).

"The colorful den of horrors is followed . . . by a blossom white theater auditorium" (Hevesi). This hall, which is actually black (dark gray) and white, has a gallery with eight boxes opposite the stage; the boxes are separated from each other only by parapets. The rear wall of the gallery has vertical relief strips with a grape ornament cut into the white stucco. A plain white parapet with two inset mosaics and slim, nonbearing pillars between the boxes separates the gallery from the parterre. In the parterre two curved parapets, joining the convex curve of the stage podium, border two tiers of raised boxes. The parapets and the wall under the gallery are covered with dark gray veined marble. This is also used on the pillars underneath the gallery so that there is a dark zone below the gallery above which the upper parapet appears as a continuous white strip without visible support. In contrast to the bar, the auditorium has a carpet, dark and patterned with squares. Specially designed small tables and chairs are placed around. In view of the cellar location, there is a plant for forced ventilation. Wall fixtures, spherical ceiling lights, and table lamps with cloth shades on the gallery parapet provide the lighting. The Wiener Werkstätte also supplied the furnishings, including vases and tableware. Even the designs for some posters are by Hoffmann.

The cabaret was remodeled several times, fi-

nally into a movie theater; today nothing remains of the original furnishings.

Bibl.: *Theater und Kabarett Fledermaus*, Vienna, n.d. (a small program brochure published by the Wiener Werkstätte); Hevesi, *Altkunst*, 240; DKuD XXIII, 1908, 159; M.P.M. Sekler, *The Early Drawings of Charles Edouard Jeanneret, Le Corbusier*, Ph.D. thesis, New York, 1977, fig. 239 (architectural sketch of the cabaret by Ch. E. Jeanneret of 16 April 1908).

Cat. 115 1907

Salesrooms of the K. K. Hof- und Staatsdruckerei (Imperial-Royal Court and State Printing House)
Vienna I, Seilerstätte 24/corner Johannesgasse 19

Hoffmann designed salesrooms for the products of the State Printing House on the ground floor of a new building, "where Hoffmann's suggestions were everywhere decisive" (Hevesi). It was a corner store consisting of sales- and other rooms, including a director's office and a conference room.

Around the entrance and show windows the facade is covered with polished black Swedish granite laid in vertical slabs so that the rounded corner becomes a many-sided polygon. The main entrance is in a deep recess in the corner with show windows on each side. Window and door openings are framed with a rich rope molding of chased copper. The entire group of entrance and windows is further enclosed by a frame with the same molding. As there is a third molding between the frame and the door opening, three moldings thus run parallel above the entrance. Moldings, escutcheon with state arms, and inscription are gilded so that, appropriate to the official character of the enterprise, the color contrast of black and yellow—the Habsburg colors—was created. The entrance door has glazing with Hoffmann's motif of a rhombus with crossed axes and slightly S-curved sides.

Inside, black also predominates as all woodwork is in oak stained black with the grain rubbed white. The counter in the main room is divided into square panels. A built-in unit along the main wall has rows of open shelves for printed forms arranged above batteries of drawers. An open bookshelf is at the top. Above this unit the wall is divided into vertical panels with stenciled dot borders; a network of such panels also extends over other wall surfaces where they are not covered by the woodwork of the show windows and the structure at the entrance door. The floor has square tiles. Hanging fixtures provide light. In the customer area there are striking small tables with round tops and straight bases; a seat is permanently attached to each table unit.

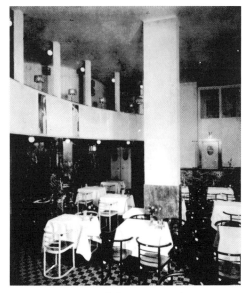

Cat. 114/II. "Die Fledermaus" Cabaret, auditorium (cf. text fig. 141)

Cat. 115/I. State Printing House, design drawing of facade

Cat. 115/II. State Printing House, view of facade

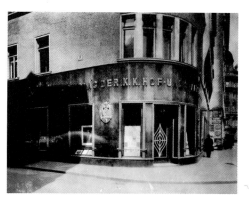

The salesroom for art prints, approached from the room for printed matter by a glazed two-leaf door, is furnished with a large display desk in the center. Large fabric-covered wall panels serve as background for the pictures on exhibit. In the conference room the walls are fabric-covered in wooden frames. In a corner an upholstered bench with small glazed cabinets at each side is built in; in front stands a round table with wooden armchairs of U-shaped plan. The floor has wall-to-wall carpeting.

Remains of the facade design are still recognizable, but the interior is completely changed. Some furniture is now in the Austrian federal furniture depot (Bundesmobiliendepot).

Bibl.: Hevesi, *Altkunst*, 241; DKuD XXIV, 1909, 211-215; *Interieur* XII, 1911, pl. 27; *Architekt* XIV, 1908, 21; Perspective drawings of the facade design, the salesroom, and two subsidiary rooms plus two photographs: WWA.

Cat. 116 1907

Shop front and furnishings of salesrooms of the Wiener Werkstätte
Vienna I, Graben 15
Approval of submitted plans: 4 November 1907
Opening: November 1907
Builder: Eduard Ast & Co.

An existing shop only 3.38m wide, but of considerable depth and height, is remodeled. It is divided into two stories by an intermediate ceiling. At the back of the shop where the plan shows a slight break a stair is built, and a work-storage room is partitioned off. The shop walls are rhythmically articulated horizontally and vertically by wooden showcases, taking into account existing wall projections. There are three zones: a plain base with drawers; a glazed showcase; and an open zone above for large objects. The showcases have alternating, approximately square, panes and vertical panes. In the latter the glazing bars form a pattern. In the upper zone are multiply recessed stucco frames with mirrors in the center. A low counter with glass top and rounded ends is placed in the center of the shop. Like the base zone, it is dark, while the showcases, stucco, and ceiling lights are white.

The appearance of the shop window reveals the interior division into two stories. At the top is lettering framed by existing moldings, with two monograms and the firm's name between them in white letters. Then, below the original dark molding, garlandlike metal moldings frame the new front. There is a slightly concave midsection with vertical bars and a patterned curtain behind the glass, followed by a white horizontal beam, enclosed by metal profiles, repeating the

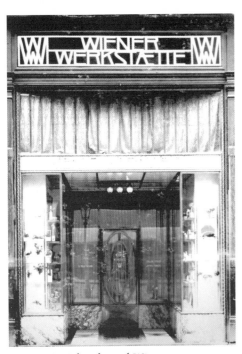

Cat. 116/I. Sales shop of Wiener Werkstätte, front

Cat. 117. Design for Stoclet tomb, perspective

Cat. 116/II. Sales shop of Wiener Werkstätte, interior

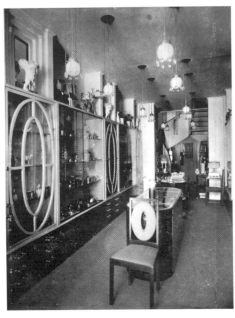

Wiener Werkstätte inscription. Below are glazed show windows on light-veined marble bases at each side of the passage. The lateral show windows extend back more than 3m to the glazed entrance partition with door in the middle. The door shows the same double oval motif of glazing bars as the interior of the shop. The ceiling of the passage is divided into panels matching the showcases below. Three spherical lights are mounted in the center panel. The floor of the passage has an inlaid pattern on both sides of the built-in doormat.

The shop is no longer extant.

Bibl.: *AUMK* XII, 1967, no. 92, 27; plan drawings and photographs: WWA.

Cat. 117 1907-1911(?)

Stoclet tomb
Brussels, Cemetery of Boisfort Watermael

The original design for the tomb consisted of a low wall, like the rest of the tomb in random ashlar, enclosing a somewhat higher grave area. It is entered by three stone steps flanked by stone pedestals with flat bronze bowls. The side walls have recesses for three trees. Next to the pedestals are two stone piers with bronze wreaths and the inscription "Familie Stoclet." The back of the tomb is closed off by a curved ashlar wall which houses a niche with the portrait bust of a young man on a pedestal. In front of it, three superimposed stone slabs form a low step pyramid. Finally, backless stone benches are situated between the niche wall and the tall piers.

Several decisive changes were made in the executed project. Entry is by a gate opening with slightly inward-leaning faces; these and the lintel are twice recessed at the inner front edge. The back wall is eliminated, and a stone-framed flower bed takes the place of the low pyramid. Instead of individual trees, the green wall of a high evergreen hedge now encloses the grave.

Bibl.: Design drawing: Estate; Information courtesy of Mrs. Elisabeth Hauser, Brussels; Hevesi, *Altkunst*, 236, mentions a design of 1907.

Cat. 117a 1907

Apartment furnishings Hamburger, Vienna

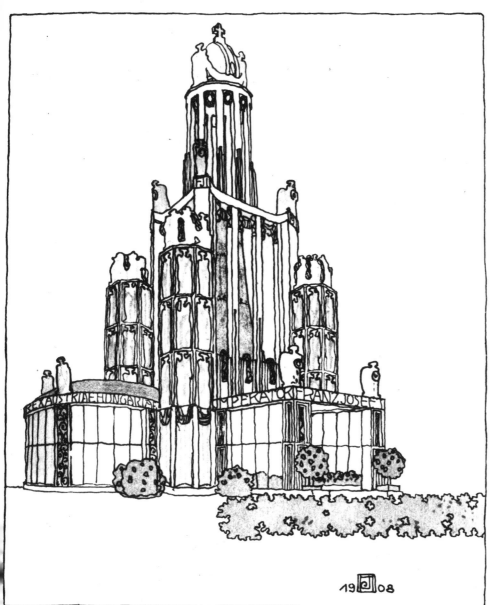

Cat. 118. Design for Emperor Pavilion 1908

Project for the Emperor Pavilion for the Jubilee Festival Parade 1908

Above a cross-shaped ground plan* a pavilion with a towerlike superstructure rises. The plan is organized around a square central room; on the four main axes are extensions which are apsidal at the back and sides while the front has an open arm with straight walls and a flat ceiling. In the reentrant angles between the cross-arms are four-story octagonal elements built so that five sides of the octagon remain visible on the ground floor. In the upper parts of these structures seven sides of the octagon are visible; the eighth coincides with a diagonal and projecting face of the central block. This block is designed so that in plan short diagonal buttresses join the corners of the basic square in the manner of Gothic corner treatments. In the three upper stories of the polygonal elements figures stand in niches between vertical piers. Other figures crown the side structures and the cornices of the cross-arms on the ground floor, which are designed as bands for inscriptions.

The square central block with its diagonal buttresses also has ornamental figures at the corners. The highest part is a central cylinder with pierced walls and wreaths at the top of the openings; it bears the symbol of the Habsburg crown towering above all. At the entrance are small spherical trees in containers; low bushes are planted in the reentrant corners and opposite the entrance.

* According to the present perspective drawing, the ground plan could also be T-shaped, but this is most unlikely in view of the complete symmetry of the upper parts of the composition.

Bibl.: *Architekt* XVII, 1911, pl. 17.

International Architecture Exhibition, Vienna
Vienna I, Horticultural Halls
Jointly with Josef Hackhofer
Opening: 19 May

This exhibition was held in conjunction with the 8th International Congress of Architects. Hoffmann was responsible for the main room where the international section was shown; he also drew the vignette for the catalogue.

Bibl.: *Katalog der Internationalen Baukunstausstellung Wien 1908; Bericht über den VIII. Internationalen Architektenkongress Wien 1908*, Vienna, 1909, 415; *HW* IV, 1908, 256.

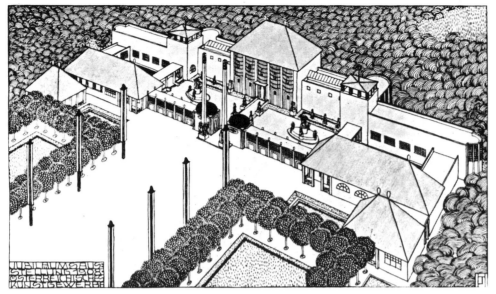

Project of a building for the Jubilee Exhibition of Austrian Arts and Crafts, 1908

The exhibition building stands in a wooded landscape like the Vienna Prater; an alley, flanked by tall flagpoles, leads to a forecourt. The building is designed in bilateral symmetry to the axis of this alley. The essential parts are grouped around a court of honor; its four sides are bordered as follows: The back is occupied by the rectangular main pavilion with steep hip roof and by adjoining somewhat lower galleries. Toward the front these galleries have towerlike elements with an open loggia under a flat roof. The two short sides of the court of honor are bordered by low covered walks with a view to a rectangular pond beyond. The pond is in another court which forms a lateral extension of the main court. Opposite the walk is a short, low wing connected to a pavilion with hip roof. Pylon-flagpoles on bases surrounded by figures flank the central entrance to the main courtyard.

At the extreme front edge of the whole complex are two more smaller free-standing corner pavilions with tentlike hip roofs. They are loosely connected to their neighbors by a loggia, and fronted by sunken garden parterres. From their central doors run alleys of trees in the same direction as the alley bordering the central axis.

It is noteworthy that the walls of the main building are plain but framed by rope moldings. Only the piers of the roof loggias on the towers are treated decoratively. The main pavilion has a wide flat roof overhang; below it six piers, treated as framed wall panels, run through from bottom to top. Between them, on ground floor level, are panels with multiple framing. Above these, tall, slightly convex, windows, divided into numerous smaller vertical panes, extend to the roof.

Bibl.: *Jahrbuch der Gesellschaft Österr. Architekten*, Vienna, 1908, after p. 20; *DKuD* XXII, 1908/1909, 81; Photograph of a perspective drawing: Estate; Drawing: HFAK.

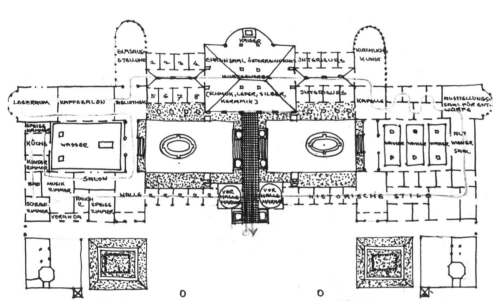

Cat. 120/I, II. Project: Jubilee Exhibition of Austrian Arts and Crafts, bird's-eye view and sketch plan (cf. text fig. 144)

Kunstschau, Vienna: Overall architectural design; entrance pavilion and small court
Opening: 1 June
Builder: Ing. Eduard Ast & Co.
Carpentry: Joh. Österreicher
Stuccowork: H. Heydner
Painting: A. Falkenstein

Hoffmann planned a group of exhibition buildings of temporary construction on the irregular lot at the corner of the Lothringerstraße, where the Concert House and Academy Theater stand today. He was responsible for the entire

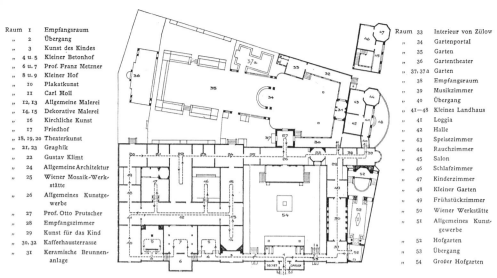

Raum 1 Empfangsraum
" 2 Übergang
" 3 Kunst des Kindes
" 4 u. 5 Kleiner Betonhof
" 6 u. 7 Prof. Franz Metzner
" 8 u. 9 Kleiner Hof
" 10 Plakatkunst
" 11 Carl Moll
" 12, 13 Allgemeine Malerei
" 14, 15 Dekorative Malerei
" 16 Kirchliche Kunst
" 17 Friedhof
" 18, 19, 20 Theaterkunst
" 21, 23 Graphik
" 22 Gustav Klimt
" 24 Allgemeine Architektur
" 25 Wiener Mosaik-Werkstätte
" 26 Allgemeines Kunstgewerbe
" 27 Prof. Otto Prutscher
" 28 Empfangszimmer
" 29 Kunst für das Kind
" 30, 32 Kaffeehausterrasse
" 31 Keramische Brunnenanlage

Raum 33 Interieur von Zülow
" 34 Gartenportal
" 35 Garten
" 36 Gartentheater
" 37, 37a Garten
" 38 Empfangsraum
" 39 Musikzimmer
" 40 Übergang
" 41—48 Kleines Landhaus
" 41 Loggia
" 42 Halle
" 43 Speisezimmer
" 44 Rauchzimmer
" 45 Salon
" 46 Schlafzimmer
" 47 Kinderzimmer
" 48 Kleiner Garten
" 49 Frühstückzimmer
" 50 Wiener Werkstätte
" 51 Allgemeines Kunstgewerbe
" 52 Hofgarten
" 53 Übergang
" 54 Großer Hofgarten

Cat. 121/I. Ground plan of Kunstschau building 1908 (cf. text figs. 145-148)

Cat. 121/II. Kunstschau 1908, entrance building

planning and some individual designs, which will be discussed below. He left most of the rooms and the garden design to others, including some of his students. An extant plan, dated 28 February 1907, lists next to the identification of the room the name of the artist responsible for the design. This design basically corresponds to the execution but differs from it in some essential points. Above all, it is noteworthy that all of Hoffmann's rooms with curved walls—an exedra and an oval hall—were replaced by rooms with straight walls, perhaps an economy measure. The elimination of a large square annex of about 100 sq. m originally planned at the left edge of the site can perhaps be explained the same way.

At the front of the site, which is about 73m long on the Lothringerstraße, are the exhibition galleries and the entrance pavilion, connected with a small garden court, a large court, and four smaller courts. At the back of the site is a small country house designed by Hoffmann, joining a large garden court with café terrace and a garden theater along the Heumarkt. The entrance pavilion, which dominates the complex by its greater height and richer design, is in the center between the simply treated gables of two wings. It is joined to them by windowless connecting wings the walls of which are filled with inscriptions of appropriate quotations in large block lettering by Rudolf Larisch. The left wing can be seen not only in relation to the symmetry axis of the entrance pavilion, but also as part of a second bilaterally symmetrical composition centered on the wing that projects into the Lothringerstraße. Thus, two systems interlock in this facade, and one wing is part of both systems.

The facade design results from the ground plan which articulates the wings as follows: at the right edge of the site the irregular obtuse angle between the Lothringerstraße and Lisztstraße is occupied by a small garden court. All galleries run either parallel to the Lothringerstraße or at a right angle to it. One gallery wing is at the left edge of the site; two others follow at a distance of 14.8m, measured from room center to room center. The arrangement is such that 7.4m wide courts remain between 7.4m wide wings. Thus, this portion of the ground plan is developed in five 7.4m wide strips. The strips in the other direction are of unequal width; that along the Lothringerstraße is the narrowest, consisting of three exhibition rooms connected by covered corridors which open into small courts. Beyond these courts follow a transverse wing with the sculpture hall, two more courts, and another transverse wing. Thus, a cross is inscribed in a square, resulting in four courts. Between this large gallery block and the wing that borders on the small garden court at the extreme right lies the large court of more than 20m in width, dominated by the entrance pavilion.

The entrance pavilion, covered by a bell-shaped hip roof, has a two-story facade. On a simple low base, wide wall piers run through to the cornice, without articulation except for modeled masks at the top. Between them on the ground floor are wall panels, and in the upper story half-round niches for statues. The two lateral panels on the ground floor are recessed in three steps toward a kind of false door: a triangle rests on two narrow pilaster strips like a steep tympanum. The actual entrance in the middle of the pavilion is reached by two steps and a podium. In the niches of the upper story stand three blocky abstracted figures as embodiments of Painting, Sculpture, and Architecture. The pavilion is flanked by tall masts with colorful flags.

In contrast to the street side, the garden side of the entrance pavilion is treated as a single story. A group of five windows extends through the full height of the facade. The wall surfaces are entirely plain except for masks below the main cornice. The windows are divided into numerous small panes; the middle ones in the second row from the top have an oval inset.

The interior of the entrance pavilion is divided by slim pillars which, like the walls, are painted with a decorative pattern after Hoffmann's design. The side walls also have a large panel with a decorative painting by Hoffmann's pupil Anton Kling. In close cooperation with Hoffmann, who designed the garden benches, Wagner's pupil Otto Schönthal designed the large courtyard with an over-size sandstone figure in the center. In front of the courtyard's rear wing is a garden terrace with flowers and trees in containers; in the center is the entrance to the room for general arts and crafts.

The planned visitor's tour, however, does not lead from the entrance pavilion across the courtyard but from the main entrance left through a

Cat. 121/III. Kunstschau 1908, reception room with decorative painting by Josef Hoffmann and Anton Kling

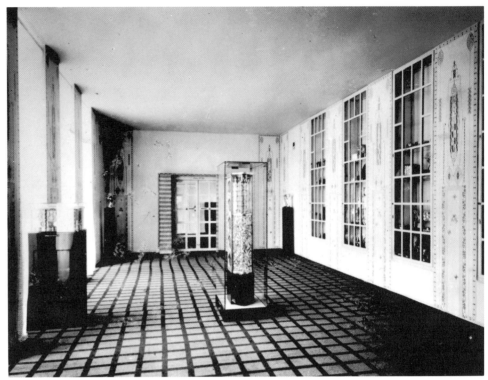

Cat. 122. Kunstschau 1908, room of the Wiener Werkstätte (cf. text fig. 146)

corridor designed by Hoffmann to a small room where Franz Cizek exhibited "Children's Art," through an open loggia past the small "court in concrete architecture" by Wagner's pupil Emil Hoppe, and into the gallery with sculptures by Franz Metzner. Then follows a walk through an open loggia, part of a court designed by Hoffmann. The loggia is divided by piers into three sections with the central section open and wider than the lateral ones, which have parapets and trellised plants. Hoffmann articulated the court walls very simply by pilaster strips and a continuous architrave which bears an inscription. On the side opposite the loggia is a niche with a seating group. In the center of the court and set into walls are ceramic sculptures and reliefs by Berthold Löffler and Michael Powolny.

The adjoining left gallery wing and the other wings house toplighted rooms of varied sizes. In a "wild cabinet" (Hevesi) works by the young Oskar Kokoschka, working for the Wiener Werkstätte, were on view. In the center of the sequence of rooms the pictures in the Klimt gallery under the care of Kolo Moser received special emphasis. The room for architecture was designed by Wagner's pupil Robert Farsky, using the sculptures for the commercial academy

by Richard Luksch. Here Hoffmann himself also exhibited several projects.* He was also represented by textile designs in the room for general arts and crafts; from there the visitor went either straight through several rooms to the "small country house" (see Cat. 123) by Hoffmann, or to the café terrace with view of the garden theater.

The U-shaped café terrace was designed by Otto Schönthal as a loggia with coupled pillars, and furnished and painted by Hoffmann's pupil and collaborator Eduard J. Wimmer. In a small structure in front of the terrace is a colorfully tiled ceramic fountain by Fritz Dietl and opposite the fountain Wagner's pupil Karl Maria Kerndle erected an impressive garden entrance of concrete. Behind it is the garden theater by Hoffmann's pupil Franz Lebisch, with a stage by another Hoffmann pupil, Gustav Siegel. The treatment includes two concrete vases designed by Hoffmann and typical Hoffmann details like multiply recessed wall panels. Returning from the garden by way of the café terrace to the galleries, the last stage of the visit leads through the room of the Wiener Werkstätte (see Cat. 122). Its windows open onto the adjoining garden court which was entrusted to Hoffmann's

close collaborator and manager of the Wiener Werkstätte architectural office, Paul Roller.

Leaving the building the visitor enters the small garden court on the narrow end through a front yard in black and white tile. When looking toward the wider end, inverted perspective naturally makes the court look shorter than it is. Next one descends, flanked by two of Hoffmann's concrete vases, under a flat roof on polygonal pillars to the actual garden. Its walls are articulated into panels by piers with thrice-recessed fronts. At the end of the garden a few steps on each side of a half-circle lead to the terminal element of the whole composition, a large niche.

In 1909 the Kunstschau was again held in the same exhibition building with new material and various changes. In the architecture gallery a memorial exhibition for Olbrich was shown; in the arts and crafts hall a selection of works by Ashbee and Mackintosh. The "small country house" was furnished by the German Workshops for Handicraft with machine-made furniture.

* Studies for tombs, the Beer-Hofmann and Brauner houses, sketch for the Emperor Pavilion, design for a dining room, project for an exhibition building.

Bibl.: *Katalog der Kunstschau*, Vienna, 1908 and 1909; *Hohe Warte* IV, 1908, 214; *Studio* XLVII, 1909, 239ff.; *MBF* VII, 1908, 361-408; *Erdgeist* III, 1908, 541ff.; *DKuD* XXII, 1908, 338; XXIII, 1908/1909, 33-39, 74, 75; *DK* XI, 1908, 513-518; Hevesi, *Altkunst*, 311; *The International Studio* XLIII, 1911, 196; *Architekt* XIV, 1908, 161-163; Nebehay, *Klimt*, 393ff.; N. Powell, *The Sacred Spring*, London, 1974, 125ff.; P. Vergo, *Art in Vienna 1898-1918*, London, 1975, 179ff.; R. Muther, "Die Kunstschau," in *Die Zeit*, 6 June 1908; Print of the ground plan: Estate; plans: ABBH.

Cat. 122 1908

Kunstschau: Room of the Wiener Werkstätte

A long rectangular room with five windows between piers extending to the ceiling; on the opposite wall are five matching built-in showcases which also reach to the ceiling. At each end the room is entered by glazed two-leaf doors; their decorated projecting lintels are carried on bulky supports of ceramic(?) construction. The floor has wall-to-wall carpeting of dark stripes and light squares. The ceiling is white like the walls and woodwork. Only a few costly objects are placed in the room engendering a feeling of spaciousness.

Walls and piers have delicate linear decorative painting in black designed by Hoffmann; the end panels of the long walls have slim black pedestals with colorful ceramic figures by Berthold Löffler and Michael Powolny.

Bibl.: As for Cat. 121.

Cat. 123/I. Design sketch, small country house for the Kunstschau 1908

Cat. 123 1908

Kunstschau: Small country house with furnishings for the bentwood firm Jacob & Josef Kohn

Hoffmann designed a villa to serve as a showcase for the utility and inexpensiveness of bentwood furniture from the firm J. & J. Kohn; "with complete furnishings it should cost only 7,000 crowns" (Hevesi). However, in the execution the kitchen, pantry, and toilet of the original plan were omitted.

The visitor enters the small country house by a ground floor loggia, two steps above grade, which opens onto a small garden court. Since the two-story facade is conceived in skeleton construction with a clear separation of bearing and infill elements, the loggia is created without difficulty by simply leaving out the infill panels on the ground floor or by replacing them (in the two lateral panels) by low parapets. These parapets have inset decorative grilles in the center and, like those under the windows of the upper story and the architraves above the ground floor, they are painted with delicate borders. The architrave under the roof has painted parallel horizontals while the piers have a linear decoration made up of three nesting frames in an inverted U-shape.

On the right, the tripartite facade joins an octagonal towerlike flat-roofed building which has windows on the three sides facing the garden court. The hall of the main house, extending through two stories, is square and is entered by a door in the loggia. On the right wall stairs run along to a gallery on the upper story. The steps and newel post are dark; the stuccoed parapet is white like the gallery parapet and ceiling. On the gallery side of the hall are four dark wooden pillars placed so that the gallery parapet is a little behind the front edge of the pillars.

Underneath the gallery a fireplace with two built-in upholstered seats is arranged in a niche; in front of it is an adjustable mahogany-colored reclining armchair with cushions. Next to the stairs are a round small table, bench, and up-holstered armchairs. The chairs are constructed on the "sled" principle with curved backs over U-shaped plan.

The dining room next to the hall is an irregular figure in ground plan because it is contiguous to the octagonal smoking room. The ceiling and walls of the dining room are white; the walls also show a delicate linear design composed of small dotlike elements. In the center of the room is a carpet with the same pattern as that in the hall; on it stands the round dining table with four bentwood chairs. Along the walls are a buffet, two shelves for decorative art objects and two showcases, all below eye level; the cases are supported by high slim legs, giving an impression of graceful lightness.

The adjoining octagonal smoking and card room has three horizontal windows with high parapets opening on the garden court, flooding the room with light. As in the dining room, the dark furniture polished to high gloss contrasts to the light-colored walls and white ceiling. It includes stools with balls at the juncture of leg and seat like the chairs in the *Fledermaus* cabaret (see Cat. 114) and the reclining armchair in the hall.

On the upper floor the visitor goes from the hall gallery into a corridorlike salon above the loggia. It has windows in both long walls and, in keeping with its character as a connecting room, is furnished only with seats and small tables. Like the doors and windows, these are painted a glossy white. A double door leads into the master bedroom where the walls are darker than in the other rooms and have a design based on small rectangles, diamonds, and ovals. Large circular forms decorate the headboards of the twin beds. An oval table and two chairs with cushions stand in front. On the night tables are lamps with fabric shades; a washstand is placed at the oblique wall. In front of the window stands a small dressing table with circular mirror; another circular mirror hangs above a four-drawer dresser which is flanked by high wardrobes. In the adjoining children's room the furniture is painted a glossy white, the floor is covered by wall-to-wall carpeting, and the walls show a diamond pattern of floral effect. Next to the crib with drawers in the base are a baby chair and a low oval table, a bench, and two small armchairs.

In all rooms it is striking that the paintings, largely portraits, are far removed from the avant-garde tendencies evident in the other parts of the Kunstschau.

Bibl.: As for Kunstschau; also, *DK* XI, April 1908, 538ff.; *MBF* VII, 1908, 368-375; St. Asenbaum, J. Hummel, eds., *Gebogenes Holz*, 78-81; Original drawing: Estate.

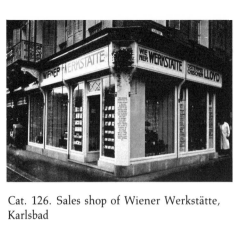

Cat. 126. Sales shop of Wiener Werkstätte, Karlsbad

Cat. 125 about 1908

Study for a hall

The lower half of the walls of this large room is wainscoted in vertical framed panels with fabric coverings; the upper half is stuccoed, with the surfaces enclosed by thin moldings and enriched by decorative insets. As in the salon of Dr. Hermann Wittgenstein (see Cat. 106), a fireplace niche with dropped ceiling and built-in benches is arranged in a corner of the room.

Bibl.: *MBV* VII, 1908, pl. 55.

Cat. 126 about 1908

Salesrooms of the Wiener Werkstätte
Karlsbad (Karlovy Vary), Czechoslovakia

A corner shop in the building of the Hotel *Auge Gottes* (Eye of God) is adapted for the Wiener Werkstätte. An information office of the Austrian Lloyd's is housed in the same shop and has one show window. Show windows and entrance are very simple and executed in wood painted a glossy white with the sparing use of green decoration. The corner near the entrance is chamfered. It is interesting that the resulting oblique surface bears an English-language inscription.* Above it is a niche with ivy growing in a basket. The interior is furnished with pieces from the Wiener Werkstätte.

* "The Wiener Werkstätte (Vienna Artshop) is the only organisation of artists and artistical workmen who from strictly original and constantly new ideas of their own design build and furnish houses throughout as well as producing all articles in gold, silver, and all other metals, wood, leather, glass, china material etc.''

Bibl.: *Jahrbuch des Deutschen Werkbundes,* 1913, 95; Photographs: WWA; F. Wärndorfer wrote to C. O. Czeschka on 8 May 1909: ''. . . in Karlsbad a shop (WW) as it has never been done. The side walls of the show windows white wood likewise the ceiling . . . across walls and ceiling always four carved wooden bars, painted green and black. Back wall white-green fabric curtain—Inside all quite white and the most grass green carpet'' (Estate Czeschka).

Cat. 123/II. Kunstschau 1908, small country house of J. & J. Kohn, garden court

Cat. 123/III. Kunstschau 1908, small country house of J. & J. Kohn, hall

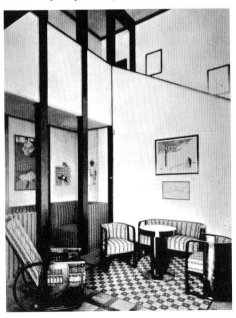

Cat. 123a 1908

Dedication drawing with architectural elements in the manner of a pavilion or monument

A triangular form should probably be understood as a saddle-back roof or pyramid; two tall pillars flank a multiply framed arched opening; the word *ARS* (art) can be read above the apex. A parapet of alternating grilled and solid units connects the high pillars with lower piers or pavilions. On all architectural elements, except the ''pyramid,'' multiple framing or stepping plays an important role. Below the architectural composition is an inscription with the years 1858-1908, flanked by two decorative panels. The decoration of these panels is formed of stylized tendril, leaf, and floral shapes.

Bibl.: *Österreichische Kunst 1880-1945* (Auction catalogue, Galerie Hassfurther), Vienna, May 1979, no. 104 (from dedication portfolio Sturm-Skrla).

Cat. 124 about 1908

Furnishings for Carl Otto Czeschka

Czeschka, a collaborator of the Wiener Werkstätte, moved to Hamburg in 1907 and furnished his home there with furniture by Hoffmann, including a large table and chairs in ''sled'' construction, a side table, secretary, chest of drawers, and two high, glazed bookcases in black stained oak. These pieces are now in the Museum für Kunst und Gewerbe in Hamburg.

Bibl.: *Jahrbuch der Hamburger Kunstsammlungen* XXI, Hamburg, 1976, 284; H. Spielmann, *Räume und Meisterwerke der Jugendstilsammlungen, etc.,* Hamburg, 1977, 38.

Cat. 127 1909

Exhibition design: Austrian Room
10th International Art Exhibition, Glass Palace, Munich
Opening: 1 June

The room receives top light from a translucent ceiling with a square grid; there is a painted cornice. The walls are divided into large framed panels; on one side small sculptures on pedestals and two built-in showcases flank a door. The cases are set into the wall and have arched tops;

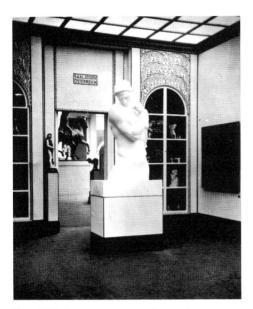

Cat. 127. Austrian Room, Glass Palace, Munich 1909

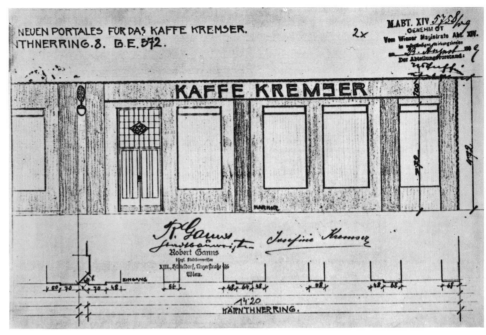

Cat. 128. Facade for Kremser Café, submitted plan

the wall segments above are decorated with curving foliate patterns. Sculptures on pedestals, including the *Athlete* by Franz Metzner, are placed freely about the room.

Bibl.: Photograph: Estate; Catalogue, *X. Internationale Kunstausstellung München*, Munich, 1909, 297ff.

Cat. 128 1909

New street facade for the Café Kremser
Vienna I, Kärntnerring 8
Approval of submitted plans: 23 August 1909

The entire street front has a marble cladding and is framed with a chased metal molding in the manner of the State Printing Office (Cat. 116). Shallow pilaster strips provide the irregular articulation. The two-door café entrance is very simple. Its high upper window is divided into small panes and in the center a decorative emblem is formed by the letters KJK (Kaffe Josefine Kremser) inscribed in a diamond with curved sides. The café was closed and the portal altered.

Bibl.: Copy of plan: Estate.

Cat. 129 1909

Furnishings for the dining room in the Knips apartment

Hoffmann furnished a new dining room in the same apartment where he had been active

six years earlier (see Cat. 79). The room is paneled in black oak with the grain rubbed white and has furniture of the same material. The wainscoting consists of five rows of rectangles with moldings covering the joints; the white wall above is divided into three horizontal strips by light, stenciled decoration. Various built-in units fit into the wainscoting. At the window wall a high pedestal for a sculpture by Minne has a mirror behind it and a clock in a decorative housing above it. Along one wall are high narrow showcases and a long buffet. Along the opposite wall is a cabinet above a heating unit cased in black veined marble. Its front is closed by a metal grille which shows the same motif as the faceted glass doors on all the cases—an outer and an inner ellipse, crossed by axes, inscribed in a rectangular frame.

Spherical lights hang from the ceiling, and there is a central hanging lamp with silk shade, plus decorative wall fixtures with three candles each. Behind the latter are mirrors with richly molded frames of gilded metal. There is a wall-to-wall carpet patterned in rectangles and diamonds and a seating group including extension table, chairs, and armchairs of "sled" construction.

Bibl.: *DKuD* XXIV, 1909, 216; *Interieur* XI, 1910, pl. 42; Photographs: WWA.

Cat. 130 1909

Apartment furnishings for H. Böhler
Vienna IV, Belvederegasse

Cat. 129/I, II. Dining room, Knips apartment, design sketch and view

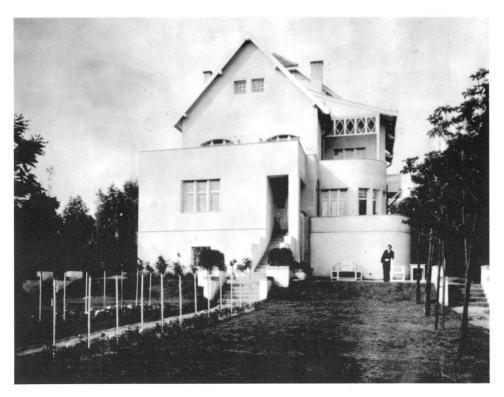

Alteration and furnishings of a villa for Prof. Pickler
Budapest II, Trombitas ut 19
Jointly with the architect Karl Bräuer, a pupil and collaborator of Hoffmann

An existing house is enlarged and modernized; hall, study, dining room, guest room, and kitchen are newly furnished. Rich decorative patterns on the walls play a part in all the rooms except the kitchen.

In the study, the walls are stenciled with a pattern of vertical panels with a central motif. The furniture is simple. Next to a large bookcase an upholstered corner bench, a small round table, and two chairs are grouped. On the other side of the room, a desk is placed before a window. In the dining room the furniture is painted a light color. It includes a round table and chairs in "sled" construction; their backs consist merely of a frame and two diagonal struts. There is also a large buffet with mirror and glazed lateral doors. In the bedroom the bed fits into a wall unit with open bookshelves interrupted by a three-door wardrobe. The chairs here are U-shaped in plan with backs upholstered in a large pattern. Their outline, seen from the side, recalls the triangle created by the diagonal in a square. Similar chairs are used in the guest room, which also has a desk and an upholstered bench-sofa.

On the exterior it is striking that the forms are strictly geometrical and very simple, with no ornamentation on the plain stuccoed walls. From the garden a long stair with stepped parapets leads to the door in a cubical entrance block. This cube contrasts with the roundness of a cylinder in the adjoining part of the building.

In 1925 Hoffmann altered the interior; it was damaged in World War II and later remodeled into small apartments; a terrace was removed on the exterior. In the staircase, remnants of the original state are still extant.

Bibl.: *DKuD* XXV, 1909/1910, 396; *Interieur* XII, 1911, 25, 26, pl. 25; Photographs: WWA; Information courtesy of Prof. Anna Zador, Budapest.

Cat. 131/I, II. Villa for Prof. Pickler, exterior and corner in lady's bedroom

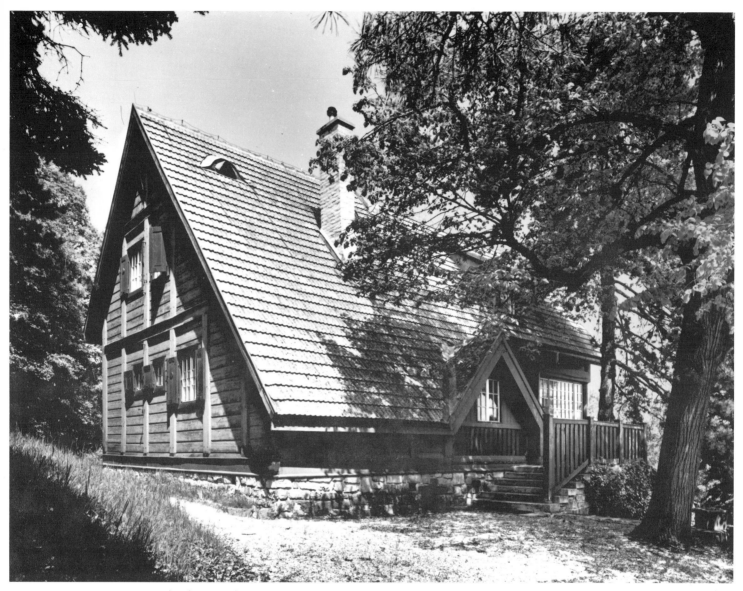

Cat. 132/I. Pazzani Hunting Lodge from southeast

Cat. 132 1909-1910

"Transportable Hunting Lodge" for Alexander Pazzani
Klosterneuburg-Weidling, Wolfsgraben 66, 68, Lower Austria
Approval of submitted plans: 12 August 1909

The Wolfsgraben is a narrow valley on the side of the Kahlenberg facing away from Vienna, and opens into the valley of the Weidlingbach. When Alexander Pazzani acquired a large lot of about 160m x 150m on the rather steep eastern slope of the Wolfsgraben, the district was still a region of woods and meadows without buildings and offered opportunities for hunting. He had

two buildings erected, a service building at the foot of the slope and a residence below the highest point, plus subsidiary buildings, such as a hutch for hares and a hay barn.

The residence, facing approximately north-northeast by south-southwest, is a prefabricated wooden frame building with panels of horizontal siding; Hoffmann had to take into account the given system of construction. Only the front of the building has a full basement. Because of the steep slope the lower story appears as a very low base at the back of the house while it becomes the ground floor in front, containing a darkroom (later furnace room) plus a large wine cellar. The cellar is open at the front like a loggia to form

a grottolike room entered from the outside by steps and a wide central opening. The wooden portion of the house has two stories; on the eastern, long, side the steep roof is carried so low over part of the facade that both ground floor and second floor are under the slope of the roof. The house is approached on this side by open stairs running alongside the facade to a podium at the entrance door where the building is set back. The house is considerably wider at the rear, 9.30m, than at the front where it measures only 6.80m.

The entrance door leads to a vestibule; next to it are the stairs and a corridor with access to the kitchen, to a bedroom, and to the bath and

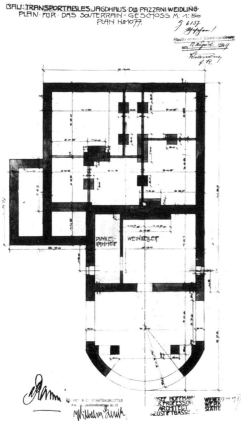

Cat. 132/II. Pazzani Hunting Lodge,
submitted plan of basement

Cat. 132/III, IV. Pazzani Hunting Lodge,
bedroom on second floor, sketch of wall
elevation, and perspective

Service building for Alexander Pazzani
Klosterneuburg-Weidling, Wolfsgraben 66, 68,
Lower Austria
Approval of submitted plans: 12 August 1909

On the Wolfsgraben property, the residence
and service building are connected by a serpentine path carefully adjusted to the terrain; its
lower end leads into the yard behind the service
building. This one-story, one-room-deep building lies north-south on the road in the valley
bottom. Two years after completion it was extended at the south end, including a cellar in the
slope of the hill.

The white, smoothly stuccoed building with
steep tiled hip roof is entered by an arched door.
On the right are the three large round-headed
windows of the stables; on the left, the four
windows of the original building and one window of the addition. The four original windows
have protective grilles bulging from edge to center. The entrance door has two leaves with superimposed obliquely set boards and is painted
green; the grooves between the boards are painted
white. In the center is a small inset pedestrian
door with a window. The window has a remarkable decorative grille with a motif of five
squares, each divided into sixteen smaller squares.

On the side away from the road is a paved
yard bordered on the north by a low wall with
an arched opening that marks the beginning of
the path to the house. The apex of the arch is
considerably higher than the top of the flanking
wall, a portion of which is carried up in a concave
curve so that the gate is enclosed in a bell-like
outline. Wall and arch have a coping of bricks,
laid like roofing. Most of the service building
facade toward the yard has trelliswork for climbing plants. North of the entrance door is the
stable; to the south is an apartment with an
entrance door leading to a small anteroom with
access to the living quarters. Both outer and
inner doors are treated decoratively with stiles
and panels painted an alternating green and white.

The building is well maintained and in the
original state except for renovations and small
alterations.

Bibl.: Photographs: WWA; Plans: Archive of the owners and
ABBH.

toilet at the back of the house. These rooms have
high wooden wainscots painted white. The kitchen
also has a wall unit with built-in sink. The front
part of the house is taken up by the large living
room with open fireplace and adjoining glazed
veranda. In front of it is an open terrace from
which a splendid distant view can be enjoyed.
The same is true of the veranda. Even the connection between living room and veranda takes
advantage of the view; it consists of a four-leaf
French door, which can be entirely opened so
that the two spaces merge. In the finished attic
are additional bedrooms (maid's room, forester's
room, guest rooms); two of them can be heated
by decorated tile stoves with hemispheric tops.
Hoffmann's design drawing for such an attic room
is preserved.

In the facades the timber framework with its
horizontal siding is the most striking feature.
The symmetrical front facade is chiefly determined by the veranda and balcony, with two

windows in the gable above. In the rear facade
with its irregular fenestration the high asymmetrical gable is the decisive element. The side
facades have not only dormers but also low projections separately roofed at a right angle to the
main roof, which results in a varying outline.
The projection at the entrance has vertical instead of the usual horizontal siding. Matching
the facing stair railing, the boards below the
window are painted an alternating brown and
white. The metal rainwater head near the entrance is decoratively treated with a simple, chased
dot pattern. All exterior woodwork is brown;
only the windows, shutters, and the vertical boards
of the stair railing are painted white.

The state of preservation is good, with most
of the interior woodwork still in the original
state. Outside the color scheme was changed,
and the open loggia was enclosed.

Bibl.: Photographs: WWA; Plans: Archive of the owners and
ABBH; *Interieur* XI, 1910, pl. 46.

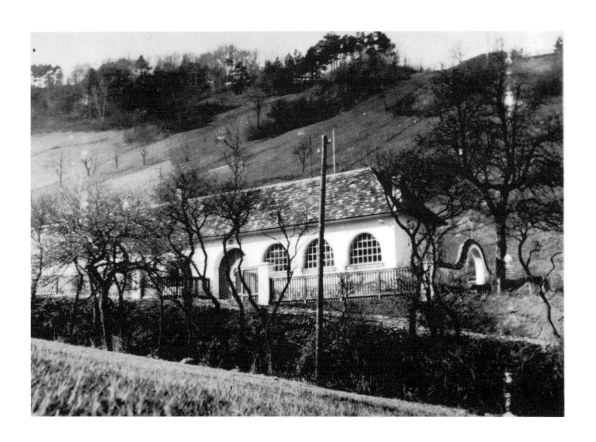

Cat. 133/I, II. Pazzani Service Building, street view and plan

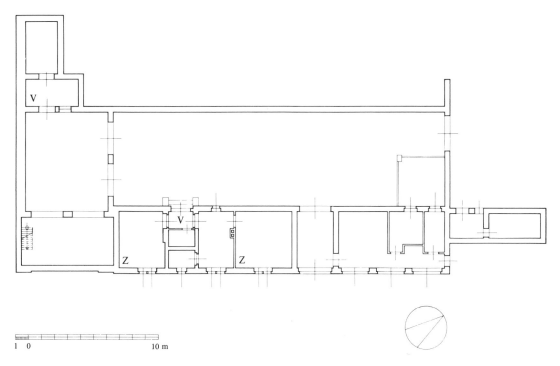

1 0 10 m

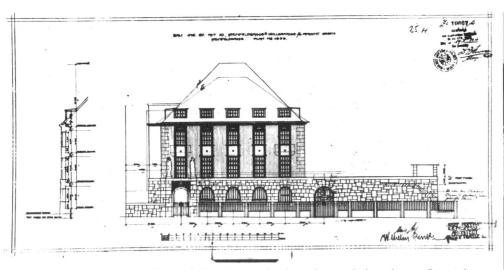

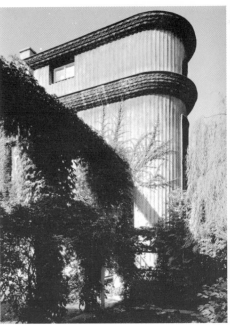

Cat. 134/I, II. Ast House, submitted plan of street facade, and ground plan of main floor (cf. text figs. 168-177)

Cat. 134/III. Ast House, stair tower

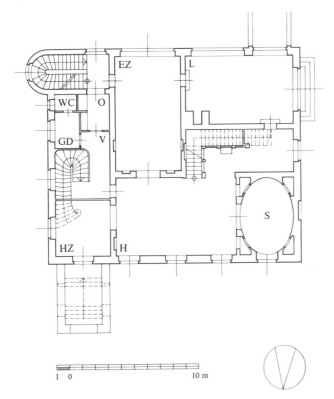

1 0 10 m

Cat. 134 1909-1911

House for Eduard Ast on the Hohe Warte
Vienna XIX, Steinfeldgasse 2/Wollergasse 12
Approval of submitted plans: 29 October 1909
(1st version) / 19 May 1910 (2nd version)
Certificate of occupancy: 3 March 1911

This was the last house to join the group on the Hohe Warte on a corner site of almost 1,680 sq. m remaining between the lots of Dr. Spitzer

(Cat. 63) and Carl Moll (second house, Cat. 112). The house is situated on the northeast corner of the irregularly shaped site, taking into account the prescribed 5m depth of the front garden and the setback of 3m at the side. The built area is 322.5 sq. m. A comparison of the published preliminary design with the executed project shows important changes in the facades, which were originally planned to be plain above the random ashlar base, except for corner quoins. French

windows with balconies were to flank the row of windows in the upper story. A west facade in the submitted plans proves that the first version was retained for some time before deciding on the final design.

Approaching from the city one sees first the secondary, west, entrance in the Wollergasse; behind it open stairs lead past a statue niche to the raised garden level. Next, beyond the black rectilinear iron grillwork fence with stone base and piers, a small, set-back raised garden pavilion or belvedere catches the eye before, from the Steinfeldgasse, the house itself attracts attention. The facades are a warm gray merging into beige. From the street the house presents itself as a three-story building because the basement appears as the ground floor. The base is built of the same coarse conglomerate used on the fence, and has round-headed windows. In the last bay a projection with arched openings forms both a protective roof in front of the entry and a terrace above. The arched opening to the street is closed by a richly decorated wrought iron gate.

Except for the projection at the entrance and the stair tower, the Ast House is mainly a large, closed block with powerful cornice, high hipped tile roof with dormers, and uniform facade design on all sides. The compositional scheme of the facade is comparatively easy to grasp: over a base, varying in height according to the terrain, follow the two-storied wall zone and the main cornice with the metal box gutter above. The decorative articulation of wall and cornice in a

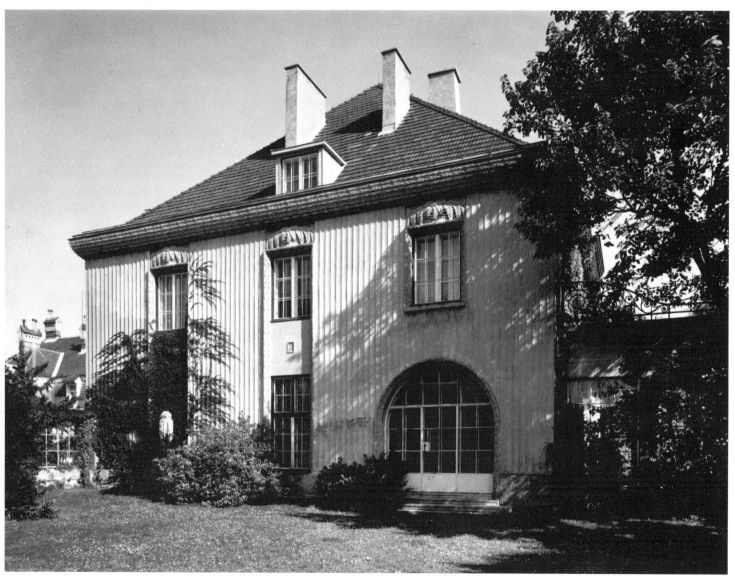

Cat. 134/IV. Ast House, west garden facade

special stucco that resembles artificial stone is applied to brick bearing walls. The cornice as a whole has a convex overhang consisting of three superimposed moldings of the same kind, characterized by the double curve of the cyma reversa. This molding also occurs on the facades as one of the main motifs. It bears undulating scrollwork made up of elongated spirals, smaller spiraling tendrils, and gently curving five-pointed leaf forms. The strong modeling of the sculptural forms produces a clear, rhythmical modulation of light and shade. The cornice is bordered by a small straight plinth and a cavetto molding.

The wall zone is sectioned into flat, fluted strips which give the impression of pilasters. The win-

dow panels are framed by a single molding giving the effect of a garland hanging over the window and never carried around under the sill. The panels between the ground floor windows and second story windows are left plain, except for a central decorative motif of plant forms. More strongly modeled are the horizontal segments between the upper window and the main cornice. Here the architect placed various dynamic compositions of vegetal forms.

Except for the entrance, the five-axis street facade is strictly symmetrical. For the ground floor windows the ratio of width to height is 1:2 (1.4m: 2.8m) and they are divided into five equal parts. The upper story windows repeat the lower part of the ground floor windows, as do the dor-

mers, although their rectangle is horizontal rather than vertical. On the base story all arched openings are designed with emphasis on large springers, voussoirs, and keystones, and the windows are divided by bars in a decorative lozenge pattern.

The east facade is the most irregular, resulting from the varying disposition of smaller rooms, the location of side entrance and service stair, and the strong break in the terrain which necessitates a retaining wall. The service staircase, with a half-round end, juts out from the facade and terminates with its own cornice, well above the level of the main cornice. It gives a towerlike impression; the vertical dimension is emphasized by a strip window. The stair tower also

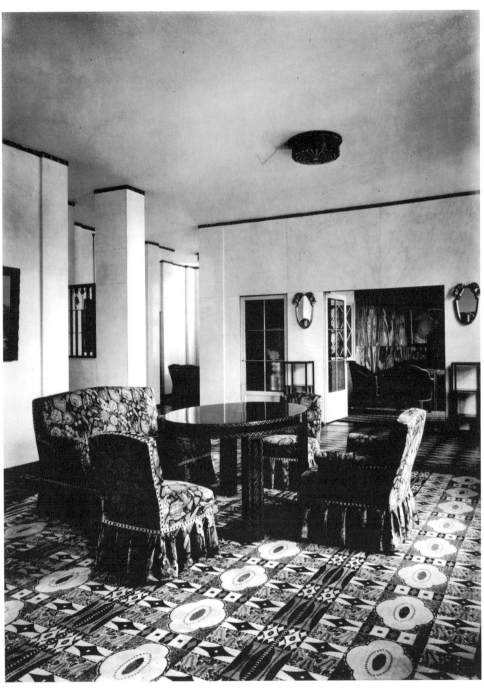

Cat. 134/V. Ast House, living hall with view into salon

plays an important part in the garden facade. Without it, and the western loggia, the garden facade could have been designed to be as symmetrical as the street facade, although with the additional enrichment of the dining room window and the veranda opening. Both are treated with separate garland framing, as is the exit from staircase to garden. There is another door to the garden in the west facade where it forms part of the large glazed arched opening of the veranda. This opening has no symmetrical match on the facade; instead there is a sculpture of a stylized flower container with garlands, which can be read as a floral offering on a garlanded altar.

From the street entrance the visitor reaches a vestibule of yellowish marble; the floor is tiled in black and white, and there is a black wooden staircase. The basement has its own access through a secondary door; it houses the usual housekeeping and servants' rooms plus a spacious, well-lighted, white tiled kitchen with built-in, partially glazed cabinets painted glossy white. On one side is a podium with three steps protected by a tiled parapet providing a better view of work in the kitchen.* Similar to the kitchen, the service rooms on the upper floors, connected with the basement by a dumb waiter, have well-planned features for efficient housekeeping. These include sideboards and numerous built-in cabinets.

The main staircase from the vestibule reaches an anteroom; from there is access to a toilet with anteroom and a pantry with dumb waiter on one side, and to the suite of formal rooms on the street side. The rooms are organized so that the oval ladies' salon is on the right of the hall, and the smoking room on the left. On the side of the hall opposite the windows the open main staircase starts on the right, while the door to the dining room is on the left. Next to the dining room is a spacious veranda with exit to a garden loggia.

On the street side the upper story houses a bedroom, dressing room, and boudoir suite; on the garden side two children's rooms follow the governess's room. Between them is a wide corridor. On the left end of the corridor is a large bathroom, toilet, and anteroom with a curved wall, and a short corridor to the service stair. This leads into a finished attic where there are two studios, storage rooms, laundry, plus bathroom and toilet, and access by a separate stair to the upper attic.

The formal rooms on the ground floor are 3.45m high and designed with great care and considerable lavishness. The colors of the individual rooms are related. Thus, the dark smoking room makes an effective contrast to the light hall, with which it is linked by glazed two-leaf doors. The smoking room has French doors to a terrace. It is square (4.2m) with fabric-covered

walls of "saturated green." Baseboard, carved cornice, all free-standing furniture, and the built-in corner bookcases are in dark oak. The glazed bookcases reach from floor to ceiling.

The great hall is a rectangular room with three windows (9.30m long x 5.70m wide, which approximates the golden section). The hall is enlarged and enriched by the enfilade of the smoking room and ladies' salon in one axis, and by the open staircase and adjoining area, which merge without a break, in the other axis. The walls are white Laas marble, lightly articulated at decisive points by pilaster strips. A dark baseboard marks the transition to the lozenge pattern of the parquet floor; a gilded, chased molding is below the ceiling. An oval table and upholstered furniture with large floral designs stand on a strongly patterned carpet.

The staircase and its adjoining area are especially impressive. Walls and piers are covered with the same marble as the hall and the marble steps are covered by a runner of the same material as the hall carpet. The same runner is also used in the stair hall on the upper story. That hall is treated in white stucco. The woodwork, painted glossy white, consists of a carved openwork parapet and pillars with square capitals and cyma moldings. The richly furnished rooms on the second floor include a bedroom paneled in rosewood and a living room with "yellow wood" furniture.

In the center of the brightly illuminated stair landing visible from the ground floor, a small niche for the display of a work of art is fitted between the pilaster strips. In addition, to the right of the person ascending, a small vitrine with decorative, partially gilded glazing bars is set into the marble wall, which serves as a parapet (see fig. 177). Above the level of the vitrine, the wall dissolves into openings and piers, thus unifying the space of the stairs with that of the hall extension.

This extension contains a fireplace, flanked by pilaster strips, below the second flight of the stairs. The fireplace with its dark marble framing and decorative inset with fire basket is visible from the hall but also clearly defines its own zone. In the background is an adjoining room with seating, separate but not closed off by doors, and only loosely linked to the hall. Flanking the large doorway to the ladies' salon are smaller doors. Their high thresholds show that they do not serve as connecting doors for daily use but rather give access to wall closets in the wedges behind the rounded walls of the oval. On the opposite side of the wall they are matched by built-in showcases.

The oval salon takes one of its dimensions (4.20m x 5.70m) from the smoking room and the hall. Like the smoking room, it is darker

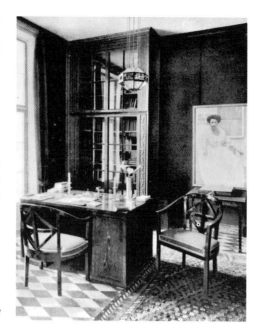

Cat. 134/VI, VII. Ast House, smoking room with portrait of Maria Ast by Josef Auchentaller; stair to upper story

than the hall, as it is covered in greenish gray, strongly veined Cipolino marble. The marble is interrupted only in the diagonals of the room where there are wall panels with three horizontal zones. Above a low wall niche with black veined marble are inset showcases, and above these white stucco panels with an inscribed oval and decorative motif. The seating group in this room is upholstered in black silk rep and is placed on a dark carpet. The contrast of the shimmering, iridescent skin tones and golden gleam of Klimt's *Danae*, hung in this room, is all the more dramatic, and the painting is the high point of the whole spatial composition. Approaching from the vestibule, the work—seen instantly through the length of the hall either directly, framed by the doorway, or somewhat strangely because of the refractions and reflections in the glass doors—appears to occupy a place not unlike an apse.

The execution of the dining room (5m x 8.5m) is the closest to Hoffmann's original designs. A multiple window, taking up most of one of the room's short sides, opens onto the garden, where, opposite the window, a sculpture by Metzner is mirrored in a pond. The other short side of the room is divided into three sections by pilaster strips rising to the triply articulated cornice. The center section has glazed two-leaf doors to the hall. The narrower lateral sections have inset wall cabinets, which are slightly recessed and bordered by a gilded molding. The hall door is in a niche bordered by a marble molding. The same brownish black Portovenere marble with dramatic veins in orange and white is used in the window casing and parapet. It also serves as an important element on the long wall with the pantry door. This wall is designed for a buffet and related built-in units. All niches and doors in the room have stucco over-panels with shallow fluting. The parquet floor has lozenges in ocher and chestnut brown. The wood of the cabinets, the gilding, the brown and orange marble hues, and the light champagne stucco produce a warm, appealing tone which is especially effective by candlelight from the great chandelier.

A door opposite the pantry door leads from the dining room to the spacious open veranda (5.05m x 8.35m) at the southwest corner, from where another door leads to the hall extension. Both doors are set into a kind of aedicule that has a steep, triply framed gable with a central leaf motif. The fluted walls and the triple cornice echo motifs from the dining room. The floor is black and white tile. Here, as in the garden, there is specially designed massive garden furniture, painted white. The veranda opens to the south in the width of two window bays, then follows a masonry pier and another opening which corresponds to a window bay and gives access to a loggia running from the house into the garden.

Near the end the loggia is closed off by decorative grillwork. On the west side the veranda has a large arched opening, later glazed because it is on the weather side. The loggia, designed with piers, is also glazed at the west, but is open on the other side. A parapet above the loggia borders a terrace which is accessible from the upper story. Near the house a curved wrought iron grille on the parapets serves as additional protection. The loggia defines a garden court in front of the south facade; its other sides are formed by a pergola of equal height. In the garden court a pond with a curved border and flanking concrete vases has been arranged.

The building is in good condition but has undergone some changes, especially in the interior. The veranda and entry, originally open, were glazed. An apartment in the attic, an elevator, and a new garage were installed; furniture was exchanged; and the interior décor was altered in some respects. Yet the building still gives a good impression of the original intentions, especially on the ground floor.

* Thomas Chorherr reported in the newspaper *Die Presse* of 31 December 1963: "Down in the kitchen the housekeeper resided on a throne for which a special niche was built, a podium constructed, and a telephone line laid. From here she directed the servants."

Bibl.: *Architekt* XVII, 1911, 46, 47, pl. 48; XVIII, 1912, 10-13; XXIII, 1920, 75; *Interieur* XI, 1910, 44; XIII, 1912, 10, 11, pls. 9, 10, 12; *Moderne Bauformen* XII, 1913, 1ff.; *Jahrbuch des Deutschen Werkbundes*, 1912, Jena, 1912, 90, pls. 12, 13.

Cat. 135 1910

Design for an exhibition building
Dated: 13 January 1910

The strictly symmetrical ground plan for a building in frame construction shows that this exhibition building was intended to present the layout of a large residence. The individual rooms in the U-shaped plan with a large central terrace are designated as living spaces throughout: a reception room, hall and stairs, kitchen with pantry, dining room, and two bedrooms are indicated. This could be a drawing in connection with the Austrian Exhibition held in 1910 in Buenos Aires. A design for this was attributed to Hoffmann (see Cat. 136).

Bibl.: Copy of plan: Estate.

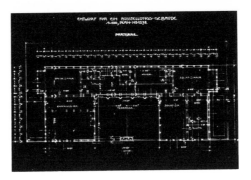

Cat. 135. Design for exhibition building, ground plan

Cat. 136 1910

Exhibition Project for Buenos Aires, Argentina
Execution: Höfler, Mödling

The actual exhibition apparently was not designed by Hoffmann.

Cat. 137 1910

Adaptation and furnishings of country house for Heinrich Böhler
Baden near Vienna, Pelzgasse 11
Approval of submitted plans: 1 March 1910

An existing two-story house with a hip roof was adapted through additions and alterations; the character of the old one-room-deep building was largely respected. It stands on an irregular lot at a mill stream and is separated from its neighbor on the left by a fire wall.

A triaxial arcaded section of the building projects from the side facade to form a covered drive at the main entrance. From there the visitor enters a corridorlike vestibule where a staircase of two flights with winders begins. Next to it is a glazed partition symmetrically articulated with two doors, fluted pilaster strips, and multiply recessed panels. On the street side a large room adjoins the entrance hall; it takes up the entire width of the house (almost 8m). Hoffmann created the room by demolishing a partition and by adding new openings. On the street side three windows are combined into one group; on the garden side there are two double French windows. On the upper floor there are only two single windows on the street side; on the garden side two French doors open onto a balcony supported by two piers. Its iron railing consists of vertical bars and panels with a scrollwork motif. Similar grillwork is on the balcony at the back of the house.

The large room on the ground floor serves as the living room. The floor has square black tiles interrupted at regular intervals by white squares.

A solid color carpet covers the center of the room from the entrance wall to the window where there are two chairs, a table, and a built-in upholstered bench with rounded corners and low upholstered cabinets at the sides. The same upholstery fabric used on the bench is used on the wall cabinets. The walls are treated with a pattern of vertical stripes and ornament at the top. The ceiling is rimmed with numerous spherical light fixtures. In a corner stands a fluted white tile stove. The wall treatment and the form of the armchairs show clear echoes of the Biedermeier style which is so widely represented in Baden.

At the back of the house is a large, carefully designed garden divided by a wall with an arched entry. In the further part are a square wooden summer house and a larger pavilion with sun terrace (see Cat. 138). A covered garden seat with flat roof is built against the garden wall. The roof slab, supported on two broad piers, has a cyma recta as edge molding and a dark lattice grid as soffit. Underneath, a mosaic is set into the center of the rear wall. In the garden design ample use is made of plants in decorative wooden containers and espaliered on wooden fences. The walls of the house, especially the fire wall, have trellises for climbing plants.

In the area bordered by the fire wall and the neighboring house, a symmetrical garden court is formed by one-story buildings with hipped lean-to roofs. The court is separated from the rest of the garden by a wooden fence with growing plants. Two separately roofed small pavilions mark the points of juncture of the rear wing with the side wings of the courtyard.

The house has had several owners and was long occupied by the military after World War II. Most of the house has been restored, but the interior is entirely changed except for the staircase, and the original large room on the ground floor is no longer extant. The appearance of fences and garden was also lost. Of the original furnishings only a few are preserved.

Bibl.: *Architekt* XVII, 1911, 12, 13; *Interieur* XII, 1911, pl. 28; *DKuD* XXXIII, 1913/1914, 310; Photographs: WWA; Plans: ABBH.

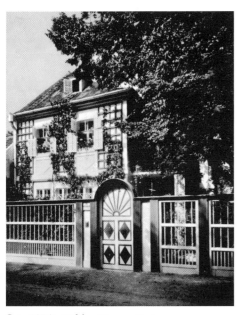

Cat. 137/I. Böhler House, Baden, street view

Cat. 137/II. Böhler House, Baden, vestibule

Country house for Heinrich Böhler, garden pavilion
Baden near Vienna

The small corner pavilion is at the end of the garden. It is integrated with the design of the garden so that its outer walls are aligned with the wooden fences. The smoothly stuccoed building consists of basement, ground floor and projecting terrace with parapet, and a roof terrace for sun bathing behind a high parapet. Access to the ground floor terrace and to the roof terrace is by a straight open side stair ending at a door between two piers linked by a flat cornice. The solid parapet wall of the stair merges in a curve with the outer pier. The solid parapet of the roof terrace, running to the inner pier, has a simple cornice and is not read as a parapet because there is no differentiation between the outer wall below and the parapet. Owing to the optical unification of the outer wall and the parapet, the built volume of the pavilion approximates a perfect cube.

The corners of the block are emphasized by shallow projections, surmounted by polygonal containers for plants. On the entrance side, three French doors open onto the terrace. They are flanked by pilaster strips supporting a cornice with triple cyma curve. The two strips in the center carry polygonal wall lights. The overdoor panel has a ceramic floral wreath which is also repeated in the adjoining facade. This facade, like the rear facade, has a continuous band of three square windows, so that the square interior (5.2m) of the pavilion can be opened and aired on three sides.

The building is in a very ruinous state.

Bibl.: *Architekt* XVII, 1911, 12, 13.

Project for a theater in Kapfenberg, Styria

The project is thoroughly worked out in ground plans, section, and facades; even an interior perspective with an indication of the color scheme was drawn. There are two variations for the design of the auditorium. About 750 seats in parterre, boxes, and gallery are planned. The slightly wedge-shaped ground plan is designed with a convex front with five entrance doors giving access to a spacious vaulted vestibule. From here there is access to toilets at the sides and to the staircases. According to building regulations, separate staircases lead to the tier of boxes and to the gallery. Three doors lead to the horseshoe-shaped passage with access to the cloakrooms and the parterre. Between the auditorium and stage are more stairs; then dressing rooms and work-

Cat. 138. Böhler House, Baden, garden pavilion

rooms follow on a corridor; finally, another staircase at each end. The stage has a curved back wall and two large entrances for stage sets at each side. In the upper story this plan is repeated in principle except for foyers instead of the vestibule, inspector's and doctor's offices, and different locations of toilets and cloakrooms. The plan calls for bearing wall construction with steel trusses over the auditorium.

The auditorium of the first plan has rectangular wall panels and decorative parapets in gray, making a contrast to the white ceiling and deep red seats and boxes. All doors have lozenge-shaped panels. In the second plan the bluish gray ceiling is divided into strips, and the ochre yellow walls and parapets are articulated by vertical strips. In contrast to the first variation, there are now slim square pillars of dark brown veined marble under the gallery. The same marble is also used on the walls under the gallery, the high base in the auditorium, and for the frame of the stage opening. The floor covering is blue gray; edges and joints between materials are covered by decorative metal moldings. Above the gallery doors are rich *sopraportas*. Below the large molding between wall and ceiling are lighting fixtures placed at regular intervals.

The design of the facades clearly distinguishes between the high stage house, which is treated simply like an office or industrial building, and the richer auditorium. This has a base story articulated by horizontal strips, doors and a canopy over the main entrance, and three upper stories. The side facades have three rows of windows, the front has only two. There are tall windows above the base story and low windows in the upper part of the facade. This gives rhythmic articulation to the facade, as does the arrangement of wide side panels in contrast to the nar-

rower panels of the central section. The side facades have decorative stucco panels between the windows. Various sculptural decoration is planned for the front, including sculptural groups on the upper part of the facade and statues in niches bordering the central section.

Bibl.: *Architekt* XVII, 1911, 6, 7, pls. 1, 2; XVIII, 1912, pl. 49.

Cat. 140 1910

Designs for apartment furnishings

In 1910 *Das Interieur* published several perspectives of rooms after designs by Hoffmann. Some can be recognized as parts of known projects (Knips, Pazzani, Hochstetter); the others could not be identified. Among these is the design for a living room with marble chimney, bay window, and two cabinets with very small panes (pl. 45); a smoking room with seating group in front of a fireplace decorated with rich metalwork (pl. 43); and the design for a dining room with a long, low buffet (p. 91).

The detail of a sideboard with rounded ends (p. 89) belongs to a dining room in mahogany which was published after completion (*DKuD* XXV, 1909/1910, 406, 407). It shows chairs in "sled" construction and backs with V-shaped insets and a round table. This dining room has the same carpet that appears in the smoking room for Dr. H. (ibid., p. 405), which is furnished with strongly curved upholstered club chairs. It cannot be established whether a child's room with diaper chest and cabinet (ibid., p. 404) is from the same apartment.

Bibl.: *DKuD* XXV, 1909/1910, 404ff.; *Interieur* XI, 1910, 89ff., pls. 43ff.

Cat. 139/I, II, III, IV. Project for theater in Kapfenberg: exterior perspective, plan of upper story, section, and interior perspective (cf. text fig. 184)

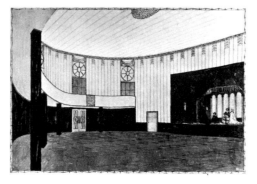

Cat. 140a 1910

Exhibition design for the galleries of the Klimt group in the Art Pavilion of the First International Hunting Exhibition, Vienna
Opening: 7 May 1910

Two galleries were designed. The smaller one contains showcases with arts and crafts objects; the larger one is devoted to monumental painting. Hoffmann divided the walls by stenciled verticals and hung pictures in uniform dark frames.

Bibl.: *Die erste Internationale Jagd-Ausstellung, Wien 1910: Ein monumentales Gedenkbuch*, Vienna, Leipzig, 1912, 30, 31.

Cat. 141 1910-1911

Austrian Pavilion at the International Art Exhibition, Rome
Opening: Spring 1911
Design of building and exhibition
Local supervision: Karl Bräuer
Sculptural work on the facade: Anton Hanak
Two-headed eagles on the two pylons: Franz Barwig
Small decorative wall insets: Oskar Strnad
Sculpture of the Archangel Michael (on the central wing): Ferdinand Andri

The beautiful but very steep grounds of the Valle Giulia were made available for the exhibition; they required considerable terracing. The lot for the Austrian pavilion in a prominent location next to the main entrance lies on a terrace, formed by high rubble stone retaining walls. It is reached by steps under an entrance arch. The terrace of the pavilion area is landscaped.

There are various preliminary studies for the pavilion and an early design, which differs from the final execution but shows the same basic composition, namely a bilaterally symmetrical building with U-shaped ground plan, open toward the front and the view. The court is devoted to sculpture; painting and some graphics and arts and crafts are shown inside. The first design shows the central room for paintings as an octagon, although that is not apparent in the external modeling of the building. This remains compact, determined by a simple large rectangle with the sides in a 3:4 ratio. The executed ground plan is more richly articulated. It seems that its wall axes were developed on a squared grid of 3.4m units. At the back of the large central hall is a semicircular apselike projection; on each side the plan shows a suite of lateral galleries, the last of which, next to the central hall, projects from the main block like the transept of a church.

The whole pavilion stands on a plain base. The outer wall is raised to form a parapet for the court of honor. At the start of the stairs are engaged piers bearing sculptures. The retaining wall and parapet are set back in front of the court of honor by the width of the stairs, which rise from the center outward, parallel to the retaining walls, leaving ample room between for the monumental sculpture *Austria (The Creative Forces)* by Hanak and plantings at the wall. Hanak's group is very important, not only because of its position in the center of the main view, but because, flanked by two tall flagpoles and his two female figures *Between Heaven and Earth* on the edge of the terrace, it contributes substantially to the spatial definition of the court of honor.

A portico of pillars, one step higher than the court itself, is placed in front of each wing of

the pavilion. The fluted pillars have neither base nor capital and a very low architrave, also fluted on the underside. Pilasters, corresponding to the pillars, articulate the remaining two lateral sections of the front facades with their high multiply framed windows. The left wing is further divided by a kind of low set-in portico, corresponding to the two stories of the interior. The wall of the central wing remains entirely plain, except for the central slightly projecting panel with the monumental sculpture of the Archangel Michael by Ferdinand Andri. Designed to impress from afar, it is placed high above a curved fountain basin. Laurel trees complement the composition. The entire court and the porticoes are paved with marble. Across the court, under the stern gaze of the Archangel and the silent ranks of monumental sculptures, one reaches the entrance to the exhibition rooms at the center of the portico.

All the large galleries are top lighted, and the exhibits are carefully coordinated to avoid any impression of overcrowding. The central hall is arranged in such a manner that it cannot be entered directly from the outside but is experienced as the culmination of a sequence of spaces. It begins with the ascent from one terrace to the next, continues in the courtyard and under the high loggia, and ends with a rectangular room and then a semicircular one, which are linked by a low, elegantly framed triple opening, so as to be closely related but not completely fused. Flowers are placed at the entrance to the semicircular room, whose spatial character is reminiscent of an apse, with walls that have, in contrast to the other galleries, discreet stenciling. Here the pictures are hung at wider intervals than elsewhere in the exhibition. The hall is devoted to Klimt; his *Jurisprudence* is hung in the central axis.

In similar ways, though perhaps with less marshalling of artistic means, the other galleries achieve characterizations matching their contents. Thus, the Waldmüller Room, at the beginning of the exhibition, is furnished with Biedermeier furniture, wallpaper, and curtains. At the end of the presentation a stair with a curving parapet leads from the Arts and Crafts Gallery to a low room for small-scale graphic work and sculpture. As this room on the upper story opens with a triple arcade into the full-height Arts and Crafts Gallery, there was sufficient guarantee that no visitor would overlook the graphics room. A spatial enrichment of the total experience of the exhibition is also achieved. Furniture is used with great restraint. Very elegantly curved wicker furniture and two cabinets in the room for decorative arts are especially noteworthy. One is an inlaid cabinet; the other, in black oak with white rubbed grain, is a showcase for the display

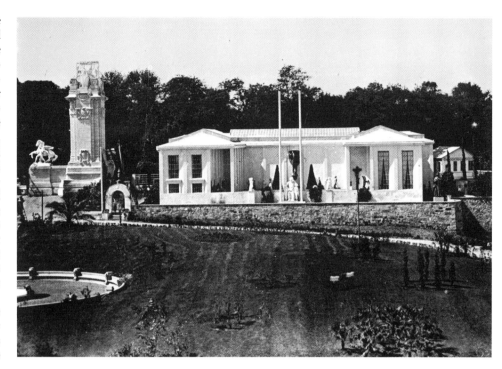

of small decorative objects, especially from the Wiener Werkstätte.

The building was taken down after the close of the exhibition.

Bibl.: Drawings: Albertina and Estate; F. Dornhöfer, *Rom 1911, Internationale Kunstausstellung Österreichischer Pavillon*, Vienna, 1911 (with list of all participants in design and execution); *Architekt* XVII, 1911, 41-48, pl. 41; *Die Kunst* XXV (*Die Kunst für Alle* XXVII), 1912, 77ff.; *Zeitschrift für bildende Kunst*, n.s. XXII, Leipzig, 1911, 273ff.; *Der Cicerone* III, 1911, 421ff.; Photographs: WWA and Österreichische Galerie des 19. and 20. Jahrhunderts; E. F. Sekler, "Hoffmanns Österreichischer Pavillon auf der Internationalen Kunstausstellung in Rom 1911," in *Österreichische Künstler und Rom vom Barock zur Secession* (exhibition catalogue, Vienna, Academy of Fine Arts), 1972, 81-84.

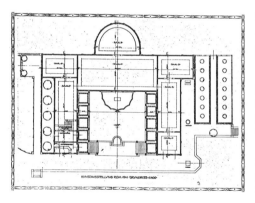

Cat. 141/I, II. Austrian Pavilion in Rome, view and plan (cf. text figs. 185-189)

Cat. 142 1910-1911

Villa for Dr. Otto Böhler
Kapfenberg, Mariazellerstraße 32, Styria

A villa was erected on a level lot, about 60m x 100m opposite the Böhler Works plant; the street front faces almost south. Two extant perspectives of the preliminary designs differ somewhat from the final execution.

The house has stuccoed brick walls and timber floor construction, a deep basement story, two main stories, and a steep (55 degree) hip roof with double tile covering. The height of each floor is approximately as follows: basement, 2.6m; ground floor, 3.3m; upper story, 3.2m; and finished attic, 2.9m. The ground plan measures roughly 21.3m x 13m, without the projections. The south facade is entirely symmetrical around a central axis while the north facade is roughly symmetrical. The asymmetrical ground plan is structured in three sections running east to west: in the east are the entry with stair and kitchen; in the center, the hall and dining room with terrace; in the west, two large formal rooms.

The house has two main entrances. A formal one is in the right wing of the south front, while a side entrance is in the east facade. The front entrance leads into a long vestibule; in it a short stairway on the west wall rises to a space on ground floor level with openings between pillars

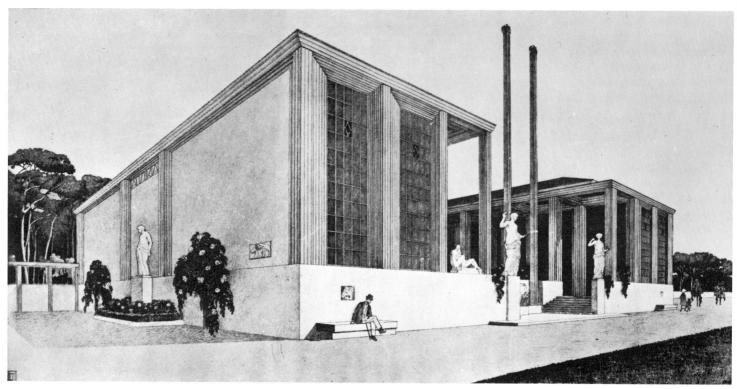

Cat. 141/III. Austrian Pavilion in Rome, perspective

at the back. The central opening is wider than the lateral ones, which are partially closed by railings. This gives a view which intensifies the experience of space, as does another opening, to the right, into the main staircase. Next to it a door leads to a cloakroom and toilet; the opposite wall has doors to the pantry and to the great hall.

The side entrance, reached by a small open stairway, is protected from the weather by a bell-like sheet metal roof whose projecting cornice rests on two corner piers. The entrance opens onto an anteroom that extends at a right angle to the outside wall. At the right are the doors to a toilet and to the kitchen and larder. The left wall entirely dissolves into openings; one leads to the main staircase; three, with the above-mentioned pillars, connect with the large vestibule of the front entrance.

The great hall (6m x 9.75m) extends to two stories in height (about 7m). It receives light from three large windows which extend to the full height of the room. Beyond them a terrace screened by a parapet gives egress to the garden. On the west, the great hall opens into two large rooms which end in polygonal alcoves. In the south wall, below the gallery reached by an open

wooden staircase, is the entrance to the dining room which runs parallel to the great hall and has its pantry, reached from the kitchen by way of the anteroom and vestibule, adjacent at the east. The dining room with its three windows and the pantry with one are set back in the facade between the two lateral wings.

The rooms in the upper story can be reached from the hall gallery and also by the east staircase, which opens into a vestibule. Next to it are a toilet with anteroom, a bathroom, and a large room. Two other rooms lie at the south front. The hall gallery leads to a suite of rooms in the west wing connected by an inner corridor. In the northwest is a large room with a polygonal alcove, then a spacious bathroom and finally another large room with three windows. The whole north side of the finished attic story is occupied by a large space lighted by three dormer windows with hip roofs. In the west is another large room, and in the south are three smaller rooms. At the southwest corner is a bathroom, and a toilet has been placed next to the staircase. Storage, housekeeping rooms, and heating plant are in the basement.

The steep roof plays a dominating role in the exterior appearance. Its height, 9.5m, is greater

than that of the house itself, which measures only 7.8m to the top of the main cornice. The facades are articulated by a horizontal base, a string course below the second-floor windows, and the main cornice with large cavetto molding and hanging gutter. The base and cornices are smooth, the wall planes are coarse-grained stucco. The fenestration and various projections provide vertical articulation. On the second story of the south facade, there are eight openings, including two French doors to the terraces. On the ground floor there are two projecting alcoves with oblique sides. Both doors and windows have wooden shutters with simple painted motifs emphasized in green and white.

In contrast to the front, the east facade is entirely asymmetrical, strongly articulated in three dimensions, and formally restless, since its design is not restricted to the use of forms with predominantly straight outlines. The idea of a picturesque side entrance is already clear in the preliminary design. Here and in the executed design the projecting staircase tower is the most prominent element. It is crowned by a mansard roof, and has a round-headed central window. The windows of subsidiary rooms in the east wing are arranged irregularly, and at the lower

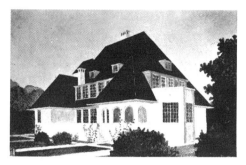

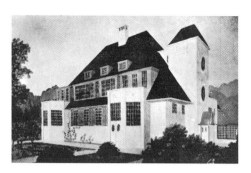

WV 142/I, II, Villa Böhler, Kapfenberg, Vorprojekt

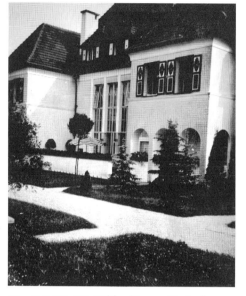

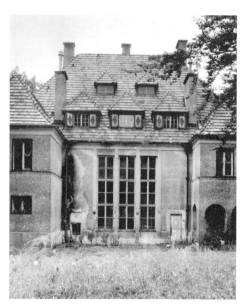

Cat. 142/III, IV. Böhler House, Kapfenberg, exteriors (about 1912 and 1966)

Cat. 142/V. Böhler House, Kapfenberg, plan

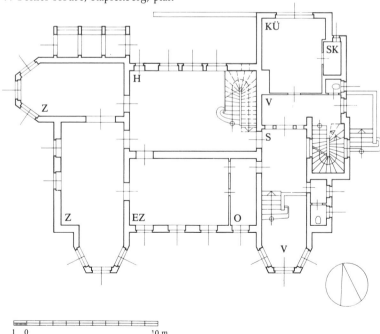

staircase window the upper edge of the base is continued as a frame around the window. There is a similar treatment on the north facade where the two flat niches next to the central windows are linked to the base. The center section with the three hall windows unified by stucco strips is the dominating element. This is further emphasized by two rows of dormers and the tall flanking chimneys.

At each side of the center section are projections of equal width but unequal depth. On the ground floor there are small horizontal windows in the east wing and a triple arcade in the west wing. The arcade has openings partially closed by parapets and also an opening on the west facade, which is otherwise windowless. Then follows a polygonal projection, corresponding to the alcove on the interior, with a pyramidal roof and windows on all sides.

The building became the property of the State. In the late 1960s it was razed by fire because of fungus infestation.

Bibl.: *Architekt* XVII, 1911, 12ff., pl. 12; Photographs: Estate; Measured drawings in archive of Böhler Works, Kapfenberg; Photographs (1966) by the author.

Cat. 143 1910-1911(?)

Figdor Tomb

In front of an upright rock left in its natural state is a stone tablet with five horizontal framed panels. The uppermost panel has a foliage relief; the lower ones bear inscriptions.

Bibl.: Photographs: ÖMAK.

Cat. 143. Figdor grave

Cat. 144/I. Service building of Knips Country House, exterior

Cat. 144 1911

Service building of the Knips Villa
Seeboden, Carinthia
Submitted plan dated: 4 April 1911

A stuccoed building one room deep (6.9m x 25.65m) in brick construction with a slightly inclined hip roof was erected on a small road leading to the Knips Villa of 1903 (see Cat. 78). On the ground floor it accommodates garage, wagon shed, stable with harness and fodder room, coachman's room, laundry, anteroom, and the toilet in a projection. The upper story does not extend over the whole length of the ground floor. It is reached by an open stair along the short side of the building and contains three rooms on a corridor leading to a drying loft. Since the single-story section with the garage and wagon shed is roofed separately, and the upper story has a roof of varying heights, the outline of this small building is remarkably changeful. Inside, simple furniture is painted a different primary color in each room.

Bibl.: Design sketch and photographs: Estate; Submitted plans: ABBH.

Cat. 145 1911

Furnishings for Hugo Marx
Hinterbrühl, Lower Austria

Several rooms in an existing building were furnished for an art-loving industrialist and his wife, Marie, who had studied painting and was close to the Wiener Werkstätte.

A high buffet dominates the dining room. It is white with a black base and has black marble slabs and wide fluted side-pieces flanking the serving areas, drawers, and glazed doors. The rectangular extension table and the chairs are painted black. The upholstered seats and the wall covering have the same colorful stylized floral pattern of the Wiener Werkstätte.

In the beige, brown, and black living room the wallpaper creates an unusual effect because of its rhythmic pattern of horizontal rather than vertical stripes. The furniture has fabric upholstery with diagonal stripes in a contrasting herringbone pattern. The same fabric is used on a built-in corner bench and a second bench, on armchairs, as a tablecloth, and for the curtains in a low sideboard. The sideboard is veneered brown, as is the bookcase and a desk with hinged top. Moldings and glazing bars are polished black. Two rows of small pictures in uniform dark frames hang above the corner bench.

In addition to the above rooms, a bedroom and breakfast room were also furnished. After leaving the house in the Hinterbrühl, the family used some of the furnishings in other apartments. Various pieces have found their way into the art market.

Bibl.: Eisler, 15; *ID* XXVII, 1916, 130ff.; *Die Bildenden Künste vereinigt mit Architekt* I, 1916/1918, 20; ÖBWK II, 1925/1926, 52; Photographs: Family property and Galerie bei der Albertina, Vienna.

Cat. 145. Marx apartment, living room

Cat. 144/II. Service building of Knips Country House, plans (*top*: ground floor; *bottom*: upper story)

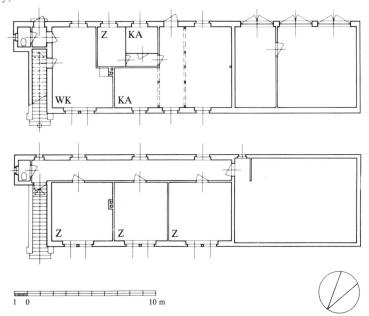

Cat. 146 1911

Remodeling of rooms in Josef Hoffmann's paternal house
Pirnitz (Brtnice), Moravia, Czechoslovakia

Hoffmann rearranged the newly painted and papered rooms of his family home dating from the 18th century in a very restrained manner with good antique furniture owned by the family, old pictures, and suitable additions of his own design. These include a three-part upholstered corner bench and furnishings for his bedroom. There is a tall four-poster bed enclosed by curtains, with the upper ledge of the bed canopy carried around the paneled walls. A hexagonal shelf for decorative arts objects, a night table, a small secretary, and a dresser complete the interior.

The house is extant and in good condition except at the back (1970). Of the old furnishings, only some stoves and a few pieces of furniture are preserved.

Bibl.: *Interieur* XII, 1911, 30-32; *Uměni a Řemesla* (Prague), 1970, no. 4, 11ff.

Cat. 147 1911

Furnishings for apartments

Das Interieur published a bedroom of the K. (Knips?) apartment in Vienna, consisting of a wall unit with a double bed, night tables, and two-door cabinets. Over the headboard seven vertical wall panels are covered with a floral fabric. A crucifix hangs in the center. Multiple framing and an elongated lozenge are employed as motifs. The walls are articulated by delicate stenciled patterns. The "sled" chairs have high backrests divided into a grid of nine openings. The effect of the white room is one of great clarity and unity. The formal elements would fit a date before 1911—perhaps 1909, the year of the Knips dining room.

In the same year *Das Interieur* published a kitchen and a second bedroom in dark, highly polished wood. This would match the mahogany dining room (Cat. 140) published a year earlier. In this case the bed is not built-in but has a solid headboard and a vertically barred footboard.

A dining room in black stained oak with white rubbed grain is noteworthy for its rich decoration of flat geometric carving on the table and buffet. Parts of this interior are now in the Austrian Museum for Applied Art.

A design for a library is marked by built-in bookcases and decorative painting above, in which climbing branches alternate with figures. The ceiling is either white or wood paneled.

Bibl.: *Interieur* XII, 1911, 26, 27, pls. 29, 30, 59; Photograph: WWA.

Cat. 148 1911

Project for a villa on the Semmering for Gustav Mahler

Hoffmann worked out two variations, but the plans are lost, and Mahler's death precluded execution of the project.

Bibl.: Entry in the outgoing mail register of the Hoffmann office for January 1911, Haerdtl estate.

Cat. 148a 1911

Zuckerkandl Tomb
Vienna, Döbling Cemetery, Jewish Section, Group I, Row 2, Grave 11

The grave is covered by stone slabs and at its head has a low fluted cylindrical stone container for flowers. Behind this a tall stele carries the metal inscription panel in the top of its twice-recessed front. The state of preservation is good.

Cat. 148b 1911

Project for the addition of a studio in the courtyard of the School of Arts and Crafts

Bibl.: See Cat. 148, May and July 1911.

Cat. 149 1911

Reception room in the Exhibition of Austrian Arts and Crafts 1911/1912
Austrian Museum for Art and Industry
Opening: December 1911
Cabinetmaker: J. Soulek

In this exhibition designed by his pupil Karl Witzmann, Hoffmann showed arts and crafts objects and did a black and white reception room. Above a low black marble base the walls have delicate fluting and a narrow cornice; there are a few small graphics in black oval frames. The floor has a carpet, designed by Hoffmann and executed by the firm of Joh. Backhausen & Sons, which has an overall effect of vibrating gray. A ceiling fixture has strings of glass pearls and a white fabric shade in the form of an inverted truncated cone. Underneath it is a seating group with an oval table, upholstered bench and two upholstered armchairs with skirted legs. The group is placed in front of a partition glazed in square compartments, which is draped with curtains of the same striped and floral pattern found on the furniture. In the center of the partition is a white glazed door with a slim palmette motif.

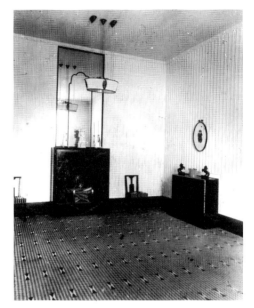

Cat. 149. Reception room

Opposite the seating group is a simple black marble fireplace surmounted by a mirror reaching to the cornice. The mirror has an outer frame and a second inscribed frame with an arched multifoil top of five curves. Chairs with upholstered seats and straight backs with carved central splats flank the fireplace. On the long wall are chests on black marble bases, unornamented except for mother-of-pearl inlay on the front. Like all woodwork of this interior, they are pearwood stained black and polished.

Bibl.: *Interieur* XII, 1911, pls. 92, 93; *DK* XV, 1912, 261ff.; *DKuD* XXIX, 1911/1912, 397, 398; *KuKhw* XIV, 1911, 631ff.

Cat. 150 1910

Tomb of Gustav Mahler
Vienna, Grinzing Cemetery, Group 7, Row 2

Hoffmann first designed a tomb based on the multiple framing motif with a stele which would have ended in the manner of a stepped pyramid. Next, he designed a rather high enclosure with spheres at the corners and inside he placed a slender stele with slightly projecting cornice. The last design, executed, also has a stele, at the rear of a grassy enclosure with a simple stone border. The stone employed is a coarse-grained conglomerate. The stele is a rectangular block, twice as high as wide, with Mahler's name carved at the top of a slightly recessed panel. A cornice block rests on the stele; the transition to its slightly projecting abacus is made by a cyma of barely noticeable curvature. The tomb is in good condition.

Bibl.: Drawings: Estate.

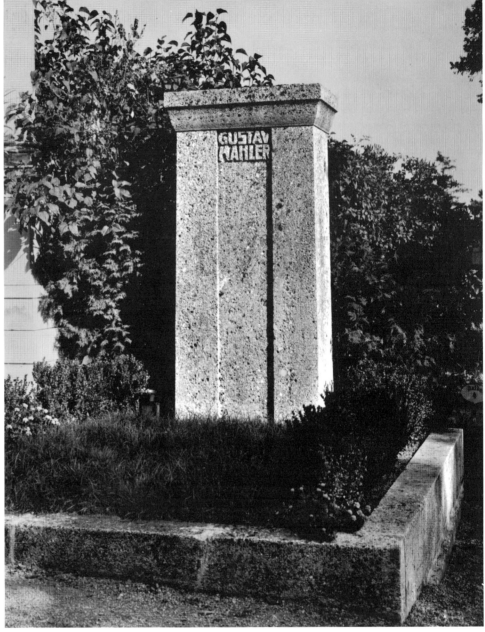

Cat. 151 **1911-1912**

Apartment furnishings for Lisbeth Steckelberg
Vienna III, Esteplatz 7

Dining room and salon, in contrasting colors,
were designed for a successful young actress.
The dining room has black oak furniture; the
windows and doors are also painted black. The
carpet is dark gray, and the painted walls are
designed with black-white vertical borders on a
violet ground. The same printed fabric from the
Wiener Werkstätte is used for curtains, sofa,
chair cushions, and the tablecloth. Heavy dark
tones predominate here, while the opposite is
the case in the salon. Here the walls are yellow
and gray, the furniture is white and gold, and
the carpet is blue and green. The walls are di-
vided by delicately bordered rectangles; every
third one contains a small graphic work in a
white frame. On one wall is a low vitrine, at
another a black piano. There is also a built-in
corner bench with a small round table. The bench
and the piano stool are covered with the same
colorful large floral fabric. Lighting is provided
by a ceiling fixture with a spherical white ribbed
fabric shade.

Cat. 150/I, II. Grave of Gustav Mahler, design sketch and view

Bibl.: *Interieur* XIV, 1913, pls. 33, 34; *DKuD* XXXIII, 1913/
1914, 307; Photograph: Estate.

344

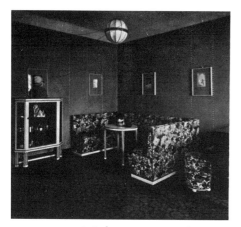

Cat. 151. Steckelberg apartment, salon

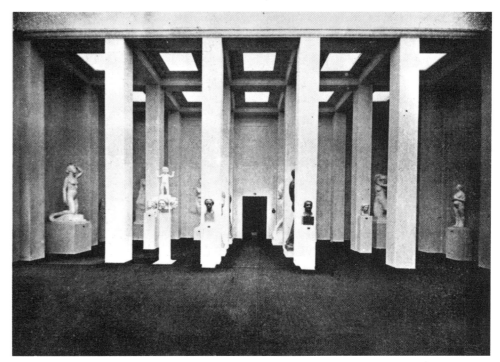

Cat. 153. Art Exhibition, Dresden 1912, Hanak Hall

Cat. 152 1911-1912

Furnishings of apartment for Mimi Marlow, Vienna

Vienna VI, Köstlergasse 3
Design jointly with Eduard Josef Wimmer
Wall paintings by Wimmer, furniture by Hoffmann

For a well-known Viennese musical comedy actress, of whom there is a photograph in a Wiener Werkstätte dress, Hoffmann furnished an anteroom, dining room, salon, and bedroom. The vestibule and dining room show the same contrast between dark gleaming furniture and white

Cat. 152. Marlow apartment, salon

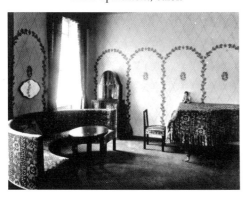

walls. The vestibule furniture includes chests with standing mirrors, an upholstered bench, and a wardrobe. The dining room has a low buffet, a side table, and a center table with matching chairs.

The walls in the salon have a delicate, lightly curved linear network of lozenges painted over with airy arcades of flowers and leaves. In addition to a piano, the room contains an upholstered semicircular bench, a mirror with lively outline, and a small vitrine with a bell-like top. A colorful fabric with large floral pattern is used for the piano cover, the round bench, and the piano stool. A wall-to-wall carpet has a small, densely patterned design which appears almost monochrome but vibrant in tone.

The bedroom has a large-patterned carpet. Walls, window and bed curtains, and the bell-shaped bed canopy have the same décor of delicate tendrils and large flowers. A pair of white cabinets with plain doors stand at the wall next to the bed, in front of which is a small round table. There is also an upholstered rocking chair and a dressing table with a white "sled" chair. Its upholstery and the dressing table skirt are in the same pattern that elsewhere dominates the room. There is a ceiling light with a white ribbed spherical shade.

Bibl.: *Interieur* XIV, 1913, pls. 1-4; *ID* XXVII, 1916, 22; Photograph: Estate.

Cat. 152a 1912

Project for a factory and house for Rosenbaum Brothers, Vienna

Bibl.: See Cat. 148, April, June 1912.

Cat. 153 1912

Design of the Austrian Section for monumental Art (Hanak Room) at the Art Exhibition, Dresden 1912
Opening: 1 May

As a setting for Anton Hanak's predominantly monumental sculpture, Hoffmann created a hall of pillars more than twice as high as the largest of the pieces on exhibit. The walls are divided by engaged piers into panels, each with two recessed fasciae at the sides and across the top. The hall is five bays wide and two bays deep. While the open front is crowned by a cyma profile, architraves, supporting a flat coffered ceiling, span the longitudinal and transverse bays inside the hall. Top lighting falls on the sculptures through the open-center panel of each coffer.

Bibl.: *Architekt* XVIII, 1912, 68, 69; H. Steiner, *Anton Hanak, Werk, Mensch und Leben*, Munich, 1969, VI; *DKuD* XXX, 1912, 209-220.

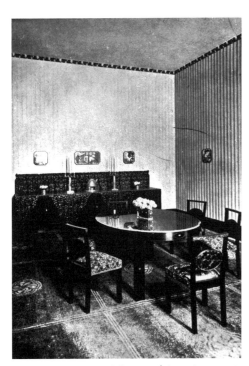

Cat. 154. Spring Exhibition of Austrian Arts and Crafts, dining room

Cat. 154 1912

Design of a dining room at the Spring Exhibition of Austrian Arts and Crafts
Austrian Museum for Art and Industry
Cabinetmaker: J. Soulek

The Exhibition was held on the occasion of the meeting of the German Werkbund in Vienna, and its overall design was entrusted to Hoffmann's pupil Karl Witzmann. Hoffmann designed a dining room in black polished pearwood; its dark gleaming surfaces stand out from a gray carpet and yellow walls with vertical fluting. The walls are articulated by a black base, and a small decorative cornice, and are decorated with sparingly placed Japanese woodcuts in narrow black frames. In addition to two upholstered armchairs with table, the room contains a low buffet and a round table with four chairs. The three-part buffet is executed in post construction with richly profiled edge moldings; each section has two doors, which, like the bearing posts, have flat elaborate decorative carving. The wall board that serves as superstructure is covered with a heavy hand-printed silk fabric from the Wiener Werkstätte. The same colorful fabric is used on the chair cushions. The chairs have fluted legs, and backs with slightly oblique lateral struts, joined in the center by an oval plaque with flat carving. A mother-of-pearl inlay borders the edge of the round table.

In the same exhibition Hoffmann showed designs and plan drawings for various buildings and an entire room was devoted to the Palais Stoclet (Cat. 104). He was also represented by various decorative arts objects, in addition to those from the Wiener Werkstätte.

Bibl.: *Die Kunst* XXVI, 1912, 480; *KuKhw* XV, 1912, 332-334, 345; *Interieur* XIII, 1912, 57ff., pl. 57; *DKuD* XXXI, 1912/1913, 182ff.; *The International Studio* XLVIII, 1912/1913, 217ff.; *WAZ*, 25 May 1912, 3.

Cat. 155 1912

Graben Café
Vienna I, Graben 29a/ corner Trattnerhof
Execution of the kiosk: Ludwig Biber

The rooms for a well-known Viennese coffeehouse were furnished on the ground floor of a new building, and a wooden kiosk for an outdoor café was erected in front. Designs for the interior of the café were published.

Hoffmann faced the walls and piers of the top-lighted room with light colored, slightly veined marble; and by the use of built-in upholstered benches created niches. The upholstery fabric of the benches, which hangs in ruffles to the floor, is printed with a floral pattern from the Wiener Werkstätte. A special effect is created by wall mirrors arranged at the eye level of seated guests; the mirrors can be covered by curtains. Above the niches are hanging wall lights that spread a subdued warm light, filtered through their silk fabric. In addition to rectangular tables with rounded front corners in the niches, there are free-standing round tables with center supports on massive bases. Additional small side tables and chairs with curving backs are in bentwood.

In front of the café a rectangular kiosk with flat roof, two bays wide and five bays long, was erected. A planned roof terrace was not executed. The construction consists of fluted posts bearing beams; between them are the multiply framed panels of the flat ceiling. The ceiling projects widely on all sides and plants hang down over the edge of the roof. A short side and the last bay of the long side have a wood siding with round-headed windows and doors. The openings of the long sides have parapets of horizontal wooden bars and horizontally striped gathered curtains. In the center of each parapet is a built-in pedestal for flowers.

The cafe was modernized in 1928 after Hoffmann's designs (see Cat. 303); it is no longer extant.

Bibl.: *Interieur* XIV, 1913, pls. 5, 35, 36; *Ausgeführte Zimmermanns- und Bautischler-Arbeiten aus Wien und Umgebung*, Vienna (A. Schroll), n.d., pl. 13; Photographs: WWA.

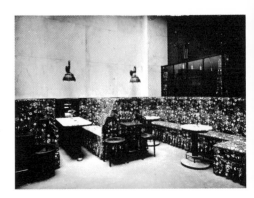

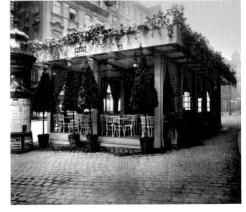

Cat. 155/I, II. Graben Café, interior and view of kiosk

Cat. 156 1912

Volkskeller in Hotel Pitter, Salzburg
Murals by Berthold Löffler

A long, not very high, room with windows on one long side was designed so that tables stand at a right angle to the window wall while the tables along the opposite wall are in niches with built-in benches. Wooden wainscoting to the level of the backs of the benches, is carried around the room. The wainscoting as well as all other wood-

Cat. 156. "Volkskeller," Hotel Pitter, Salzburg

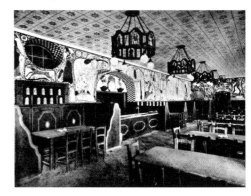

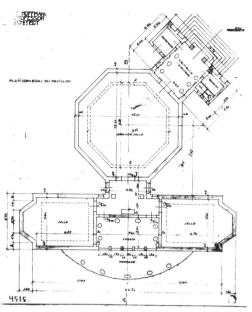

Cat. 157/II. Perspective of gallery wing

Cat. 157/I. Project: Pavilion in Venice, plan

work, including the bar and the door- and window frames, is black with green borders. The contours of the panels and the benches have multiple curves. The upper walls have colorful paintings by Berthold Löffler with scenes from Salzburg's legends and past history. On the ceiling is a painted square grid with a star pattern. Several rustic chandeliers provide lighting.

The *Volkskeller* was completely altered in the course of modernization.

Bibl.: *KuKhw* XVII, 1914, 65ff.

Cat. 157 1912

Project for an Austrian Pavilion at the Art Exhibition (Biennale) in Venice

A pavilion was planned for the exhibition gardens consisting of an entrance hall, an octagonal main hall, and a gallery wing with two additional exhibition halls. Because of the conditions of the site, the axis of the entrance hall forms a 45 degree angle with that of the gallery wing.

In front of the entrance is a flight of eight steps leading to an open entrance hall, 4.40m wide. On one side is the secretariat; on the other a guard's room and toilet. The octagonal central room is 12m wide; it is considerably higher than the entrance hall, and has a still higher octagonal cupola. The gallery wing was planned so that the visitor goes from the central hall through a short connecting space into a transverse vesti-

Cat. 157/III. Design for entrance facade (cf. text fig. 190)

Cat. 158/I. Design for a villa, plans and view

bule. On its short sides doors lead to the exhibition rooms on the right and left. These are rectangular (5.6m x 6.85m) with toplighting and with large niches at the end. Adjacent to the vestibule, between the two galleries, is a loggia with five openings, fronted with a terrace.

There are two variations for the exterior. One shows the entrance hall with eight fluted pillars and a triangular pediment reminiscent of classical models; the cupola of the main hall has round arches. The other, later, design shows the walls of the raised central section glazed with square panes and the entrance hall with a flat roof; the facade has plain wall surfaces with circular windows flanking a wide central opening, which is subdivided by four slender pillars. In both variations, the loggia in the gallery wing has an arcade of pillars. On the eight sides of the central volume figure sculptures were envisaged. The whole complex is embedded in a rich growth of trees and plants.

Bibl.: *Architekt* XXIII, 1920, 67; Drawings: Albertina and Academy.

Cat. 158 1912(?)

Design for a villa
(Perhaps intended for Josef Hoffmann himself)
Published 1912; Date of origin unknown

The original design came close to an arrangement of rooms in a cube with sides of 8m, but it was later reworked so that the street facade appears not as a square but as a rectangle with the height somewhat larger than the width.

The lot is entered through a portal in a garden wall which has a window with decorative grillwork. The portal has an oval inset with the initials JH. A paved path through the formal front garden leads to the entrance in a projection at the left corner of the facade. The projection extends only to the height of a roughcast first floor and serves as the base for a small second-story terrace. As the main door is recessed into the projection, an open covered porch results, framed by two wide, richly profiled moldings; above them is a panel with figural sculpture in a U-shaped triple frame. This decorative panel also extends over the part of the wall surface that is not an outer bearing wall but functions as the terrace parapet, and which in turn is bordered by a richly molded horizontal strip. This and the other articulating strips on the facade were probably planned for execution in the manner of the moldings of the Ast House (see Cat. 134). A decoratively designed door opens onto the terrace. Next to it are three ornamentally framed windows and below, on the first floor, three unframed openings of the same size. The facade also has a framed triangle with decorative

Cat. 158/II. Design for a villa, section

inset placed above the terrace door, and some smaller decorative plaques.

From the covered entry the visitor goes through the outer and inner door into a long vestibule. On the left side a straight staircase begins; on the right side, next to an open fireplace, is the door to the large living room. At the rear a door opens to a small kitchen. It forms the link to a single story rear annex with a double bedroom, and a small, largely glazed, garden room accessible only from the living room.

The second-story stair hall gives access to two bedrooms and a bathroom, plus a terrace and a pergola, which extend above the ground floor annex. The small front terrace can be reached from the bathroom. A straight stair at the entrance to the back bedroom leads to the third story where there is a studio running from front to back, another small workroom, and a bedroom.

Bibl.: *Architekt* XVIII, 1912, 16; Drawings: Estate.

Cat. 159 1912

Project of a house for Paul Poiret, Paris

A report "on the reasons for the separation of the Architectural Office from the Wiener Werkstätte" reveals that the Parisian fashion designer Poiret commissioned Hoffmann in the summer of 1912 to build and furnish a house, and that the design was actually begun. However, Poiret had difficulties acquiring the lot and gave up the project. Yet, in 1913, Hoffmann asked his friend, the Hungarian architect Béla Lajta, about the most favorable placement of a Buddha statue in connection with this project.* Because of an excessively high bill for this design, which Fritz Wärndorfer had sent to Poiret without Hoffmann's knowledge, there was a dispute between Wärndorfer and Hoffmann. Later, Le Corbusier made proposals to Poiret about building a villa by the sea, and Robert Mallet-Stevens designed a house for him in Mézy in 1924.

* Information courtesy of Dipl.-Ing. Ákos Moravánszky.

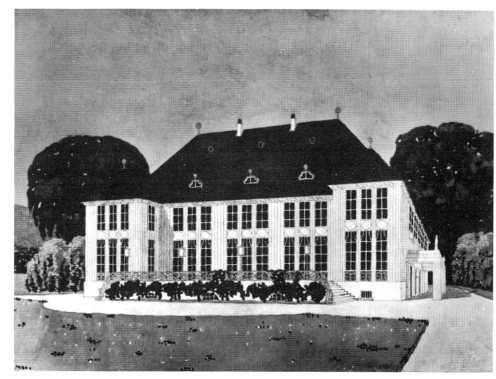

Cat. 160. Design for a country house in Pötzleinsdorf, perspective

Bibl.: Report on the reasons for the separation of the Architectural Office from the Wiener Werkstätte: Estate; *Le Corbusier et Pierre Jeanneret, Oeuvre complète 1910-1929*, 7th ed., Zurich, 1960, 27.

Cat. 160 1912

Design for a country house in Vienna-Pötzleinsdorf

A published perspective in watercolor shows a substantial country house which has much in common in size and design with the approximately contemporaneous houses for Dr. Otto Böhler in Kapfenberg (Cat. 142) and Josefine Skywa in Vienna-Hietzing (Cat. 185). The rendering represents the front and the lateral entrance facades. The entrance porch has a triple-stepped flat roof and corner pillars with crowning statues. The front facade shows a two-story building with basement and high finished hip roof. It consists of a nine-bay central section with terrace in front, and two three-bay side pavilions with their own smaller hip roofs. The central section is divided into three parts by broad striated masonry piers. The main cornice is richly ornamented; the spandrels between the ground floor and second floor windows are enriched with a curved rhombic motif; and the terrace balustrade is also decoratively treated.

Bibl.: *Architekt* XVIII, 1912, pl. 10.

Cat. 161 1912

Design of a service building and dormitory for farm workers

This is a long one-story building with a hip roof. The facade has 15 bays, of which three are entrances while the others have tall windows which are carried up into the roof-zone. The covered entrances have curved metal roofs; a trellis runs below the windows along the entire facade.

Bibl.: *Architekt* XVIII, 1912, 9.

Cat. 162 1912

Design for a house designated as the Director's Residence

Two published design sketches show a single-story country house with a finished attic. The ground plan shows the entrance at the right front corner in an arched loggia, in which a stair leads to the door of an anteroom where more steps rise to a landing on the ground floor level. On the right the stair continues to the upper story; on the left, a large hall with windows on the front facade connects with the salon, which projects in a semicircle beyond the front facade, and with the dining room, which projects beyond the side facade. A corridor at the end of the hall

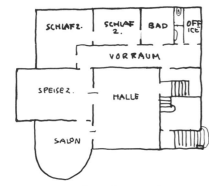

Cat. 162. Design for a director's house

gives access to two bedrooms, bathroom, toilet, and pantry. The kitchen must be in the basement, since only dining room and pantry are planned on the ground floor.

While the room in the attic above the hall receives light from dormer windows, the rooms above the salon and dining room are not under the pitched roof but covered by their own flat metal roof. The facade of this projection is articulated by engaged piers.

Bibl.: *Architekt* XVIII, 1912, 14; Drawing: Estate.

Cat. 163 1912

Tomb of Helene Hochstetter
Vienna, Grinzing Cemetery, Group 9, Row 5

At the head of a rectangular grave with a simple granite enclosure lies a rectangular slab, 0.25m thick, 1.20m high, and 1.40m wide, bearing the inscription "Paul Wittgenstein, Helene Hochstetter, Terminus vitae sed non amoris" in bronze letters. At each side of the ivy-covered grave are grass strips about 1.2m wide, which are closed at the back by railings joined to the tombstone. They consist of square iron bars forming grids of eleven by eleven squares. The tomb is well preserved, but the left railing has become detached.

Cat. 164 1912

Furnishings for a bedroom
Execution: Deutsche Werkstätten Hellerau

This bedroom, which was exhibited at the Wertheim department store in Berlin, has white furniture of simple, large planes, with half-rounds only as moldings. In addition to the double bed with solid headboards and its night tables, Hoffmann designed a closed washstand, a two-door wardrobe with drawers in the lower part, and chairs of "sled" construction with upholstered seats.

Bibl.: *DK* XXI, 1912/1913, 342; *DKuD* XXXIII, 1913/1914, 82; *ID* XXX, 1919, 283.

Cat. 165 1912

Furniture for the apartment of Director Dr. Hugo Koller
Vienna IV, Argentinierstraße (formerly Alleegasse) 26 (?)

A "silver cabinet" and a desk with a matching armchair are carried out in dark, highly polished wood. The cabinet consists of a case unit and a vitrine. The case has lateral doors flanking drawers and a smaller door in the center; it is bordered by grooved moldings and its top has a chamfered edge; the base, which projects beyond the case, has the same chamfer. The square feet have quadruple grooves and project somewhat outside the case. The vitrine is about half as wide as the base unit and rests on four oval turned feet. It has glazed sides and two glass doors, which, like the sides, are divided into eight panes. The desk has side sections with simple doors and a central drawer. The lateral sections have fluted low bases and a lozenge pattern in the center of the side walls. The top edge is also fluted and slightly set back from the lower section.

Bibl.: *DKuD* XXIV, 1914, 142ff.; *ID* XXVIII, 1917, 242, 243.

Cat. 166 1912-1913

Furnishings of study for Prof. Dr. Otto Zuckerkandl
Vienna I, Reichsratstraße 13

This room, for which a published design is extant, has a polygonal alcove with three windows, a white ceiling, dark wall-to-wall carpeting with light squares, and walls which are largely wainscoted or have built-in bookcases in black oak with white rubbed grain. The walls are articulated by a low base, fluted pilaster strips, and a large cornice with three superimposed cavetto moldings. The areas above the doors are smoothly paneled, those next to the doors contain built-in bookcases. The wall opposite the windows has

a covering with a predominantly geometric-abstract pattern, which also appears on the window and door curtains.

The upper sections of the bookcases have two glazed doors; the lower section is vertically divided into three compartments. The outer compartments have glazed doors with a decorative motif in the center. The central compartment has the lower shelves filled with books, while the upper shelves, which have a curved top forming a decorative campanulate opening, are reserved for the display of art objects.

A centrally placed table has six square legs with fluting and a thick top recessed at the edge. The armchairs also have massive fluted legs connected to the sides by grooved stretchers. Seats and backs are upholstered; the outline of the back at the upper corners is enriched by a composite curve that echoes the outline of the central opening of the bookcases.

Bibl.: *DKuD* XXXIV, 1914, 140, 141; *Interieur* XIV, 1913, pl. 17.

Cat. 167 1912-1913

Kaasgraben "Colony" of villas
Vienna XIX, Kaasgrabengasse and Suttingergasse
Builder: Adolf Micheroli

A site plan was approved on 16 July 1912 dividing a property in the XIXth District belonging to Emil and Yella Hertzka into lots, most of them 13m wide by 40m deep. The lots were newly laid out on sloping ground in a largely unbuilt district. Plans for eight semidetached houses were approved between 28 May and 13 November 1912. Certificates of occupancy were issued between 10 June and 6 December 1913. Several preliminary studies were published which differ considerably from the execution.

The houses have numerous similarities in design, construction, and interiors. All have basements and two full stories plus a finished attic; the room heights are 2.4m in the basement, 2.6m in the attic, and between 3m and 3.2m in the full stories, except for rooms with dropped floor levels. Construction is traditional with brick bearing walls and wooden ceiling constructions throughout except for the basement which has flat vaults between steel beams. The basement stairs are concrete; all others are wood. Heating is by hot air, among the first such installations in Vienna. The hipped roofs with 45-degree slopes are covered with tiles. The facades are finished in a light gray, high-quality stucco. The attic windows are placed in dormers with flat or saddle roofs. Water run-off is by roof gutters and downspouts with rainwater heads on the facades. The facades have a string course with cavetto

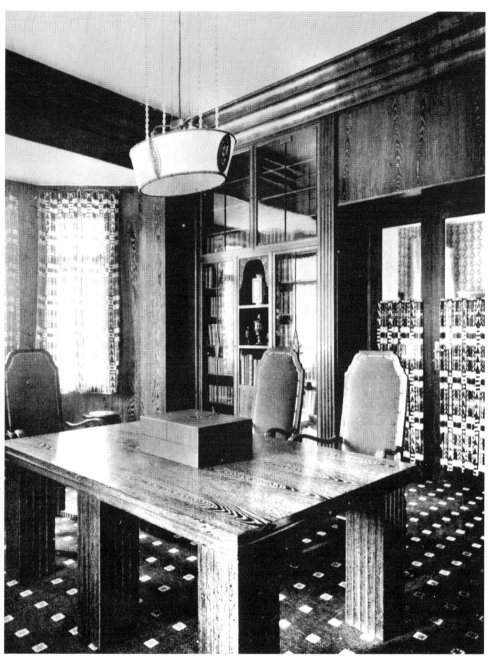

Cat. 166. Study for Prof. Zuckerkandl

molding below the level of the upper story windows and strongly projecting main cornices with horizontal fluting. The parapets of terraces and open stairs continue without differentiation in the same plane as the bearing walls. The front yards are separated from the street by fences with bases, piers, and horizontal beams of concrete; the openings have wire fencing. As the houses are rather close to the street (the front yards are 5m or 6m deep), there are comparatively large rear gardens which form an extensive, virtually unbroken green area.

The ground plans of the four pairs of houses vary according to the size of the house and the special needs of the client, but all have a compact layout with a minimum of corridor area, and access to the living quarters from a central stair or hall. All the stairs wind in some way to save space. Terraces, verandas, and loggias play a significant role—on the ground floor mainly in connection with the dining room, and on the upper floor with respect to a bedroom. The formal rooms on the ground floor frequently are linked to each other by double or sliding doors or doorless

openings. There is no special orientation to the rooms, but there is a planned relation to the gardens.

The floors are of boards, parquet or planking, or tile, according to the function of the room. Tiles are often in dark reddish brown and also occur in front of doors and on the terrace. The white stuccoed interior walls are partially painted or papered with a rich selection of patterned motifs and have many built-in cabinets, often glazed. In the Vetter House (see below) the original wall pattern can still be examined (1970). Doors and windows are painted glossy white and have massive mountings of cast brass. The parapets are covered in wood and sometimes have built-in metal flowerboxes. The windows open outward.

1. Kaasgrabengasse 30, built for Dr. Hugo Botstiber, is the first house seen when approaching from the city. The entrance is at the right, reached by an open stair with a slightly curved parapet. The ground plan is almost square (12m wide by 11.5m deep) with a corner projection on the garden side containing the kitchen, which is reached from the right of the vestibule. On the left of the vestibule is the usual cloakroom and toilet. At the far end is the hall with winding stairs. The hall also serves as dining room; it has a terrace with exit to the garden. On the street side follow two rooms connected by a sliding door; the larger room (5m x 7m) serves as a music room and lies one step lower.

2. Kaasgrabengasse 32, the neighboring house of Yella Hertzka, is comparable, with its side entrance and the arrangement of a projection and terrace on the garden side. The solutions for the stair and vestibule with cloakroom and toilet are different, resulting from a shorter front of only 10m, which also determines the somewhat different arrangement and size of the three rooms on the ground floor. Here the staircase is visible on the side facade through a tall continuous window. Despite variations, the street and garden facades of the two houses are so similar as to leave no doubt about the unity of the block. On both houses the upper parts of the facades between the string course and the main cornice have flat vertical fluting.

Alterations

In the Botstiber House as in the Hertzka House a garage was installed in the basement. During renovation in 1979/1980, alterations were made on the interior, of which raising the level in the music room is the most important.

In the Hertzka House an enclosed porch was built in front of the entrance, and a terrace was added on the upper story. Alterations of the interior required the building of two additional dormers in the attic story.

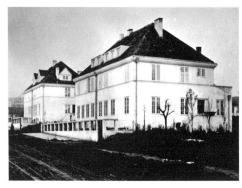

Cat. 167/I. Kaasgraben Colony, houses in the Kaasgrabengasse (cf. text figs. 178-182)

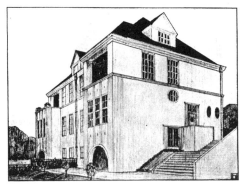

Cat. 167/II. Houses at Suttingergasse 12 and 14, preliminary study

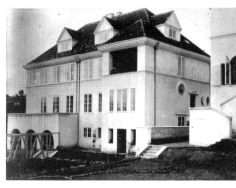

Cat. 167/III. Houses at Suttingergasse 12 and 14, garden view shortly after completion

3. Kaasgrabengasse 36, built for Dr. Adolf Drucker, is 10m wide and 12m deep, with an additional ground floor projection of 3m in depth on the garden side. As in the neighboring houses entry is from the side by a flight of steps with a curved parapet, but, at the client's request, this house has a small lateral projection directly adjoining the podium of the open stairs. It contains a toilet and pantry, accessible from the vestibule onto which the entrance opens. As one comes in, the kitchen is on the right; on the left, past the basement staircase, a few steps lead down to the library on the street side. Opposite the entrance is another anteroom which opens onto the dining room on the garden side and also serves as an annex to the living hall, which, like the adjoining library, is below the level of other first-floor rooms. Next to the steps between anteroom and living hall begins the main staircase.

From the dining room a small terrace opens to the garden. Its open stair starts at the party line where it is paired with that of the adjoining house (see fig. 178). Thus the two stairs, with their curved parapets and fluted piers, form a unified composition, especially since the piers at the top of the two stairs are connected by a flat slab. On this and the contiguous house the facades do not have vertical fluting on the upper story. The street facade was originally planned for richer treatment with a balcony in front of the library, but its place was taken by a tall French window, a motif also used in the adjoining living hall.

4. Kaasgrabengasse 38, the adjoining house for Dr. Egon Wellesz, has standard rather than French windows, but they are combined in a triple unit in the music room, exactly as the French windows on the Drucker House. By this device, as well as by the analogous rhythm of the window spacing, the two houses are un-equivocally unified in their architectural treatment. In the same spirit, the two houses also have the main cornice and string courses at the same height, although the slope of the Kaasgrabengasse might have suggested staggering. The entrance on the west facade is like that of the other house but has a flat canopy. The entrance opens on a long vestibule. On the left are the doors to a toilet and to the kitchen, which projects somewhat on the garden side, and, on the right, the doors to the basement stairs and to the main staircase. The latter gives access to the dining room with its garden veranda and, on the street side, to a corner room linked with the large music room by a wide doorless opening. There are sliding doors between the music room and dining room. Finally, dining room and veranda are connected by three openings between pillars. This arrangement forms a continuous sequence of spaces on the ground floor.

Alterations

On the Drucker House several alterations were made on the interior and exterior. Additional kitchens and baths were built, a veranda and a garage were built in, and the entrance was altered. On the street side, the French windows were reduced to normal window size.

On the Wellesz House a partially glazed porch was installed at the entrance, a garage was built in the basement, and the large bath on the upper story was divided to install a kitchen. The original exit to the garden was removed, and a terrace was added in front of the veranda which was made accessible by glazed doors replacing the veranda windows. The window in the dormer was enlarged.

5. Suttingergasse 12, for Dr. Leo Sokolowski, has a frontage of 10m and a depth (without the projection) of 10.5m. The Suttingergasse rises rather steeply, and the terrain also slopes away toward the rear of the lot. Thus, the house ap-pears two-storied from the street and three-storied from the garden. Entry is at the side where a flight of steps with an oblique parapet leads down to the basement level house door. The entrance opens onto an anteroom with access to the kitchen with pantry and to the staircase. On the first floor, the stair hall leads to the study on the street side and to the living-dining room on the garden side where a terrace extends the full width of the house. The street facade with regular fenestration is kept as simple as possible, while the side and especially the garden facades are enriched by the projecting terrace which, in the basement story, opens in a triple arcade.

6. Suttingergasse 14, for Hans Küpper, has a frontage of 10m. The entry with a straight parapet is at the side; next to it a stair leads down to the garden. Below the podium in front of the entry is a small room for garden tools. The stair hall on the ground floor is reached from the entrance by a small anteroom adjoining a toilet with oval window. The stair hall also opens onto the kitchen, the dining room and adjacent study, and onto the living room and large veranda. On the upper story a deep open loggia is above the veranda. The street facade is very similar to that of the contiguous house, but there is one less ground-floor window. On the garden side the projection is treated differently; in contrast to the contiguous house, it is carried up through the whole height of the house and is separately roofed.

Alterations

In the Sokolowski House, the entrance was newly designed with an enclosed stair, the arrangement of ground floor and interior stair was altered, and the kitchen was divided to provide an additional bathroom. The arched openings on the garden facade were glazed.

The interior of the Küpper House was divided into two apartments. The opening of the garden

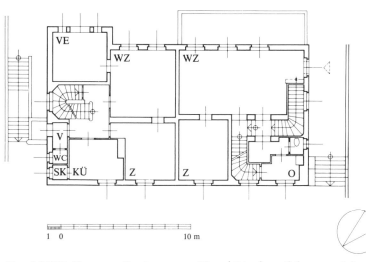

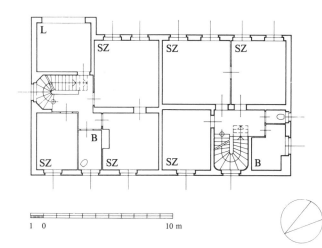

Cat. 167/IV. Houses at Suttingergasse 12 and 14, plans (*left*: ground floor; *right*: upper floor)

Cat. 167/V. Drucker House, interior view

loggia was closed by windows. A wooden pergola in the garden was removed.

7. Suttingergasse 16, for Dr. Adolf Vetter, has a frontage of 10m and a depth of 12m. The entrance, like that of its contiguous house, is on the front, not on the side as in all other houses of the colony. The upper stories of both houses are again fluted, as are the houses at Kaasgrabengasse 30 and 32. A polygonally shaped flight of steps leads to the entrance which opens onto an anteroom with cloakroom and toilet on the right and kitchen with an iron circular basement stair on the left. A door opposite the entrance leads to the hall where the main staircase begins, lighted by a strip window extending through two stories. In the hall the opening for the first flight of stairs forms a compositional unit with the doors on either side of it (see fig. 180). In each case a *sopraporta* with a carved openwork flower basket and decorative glazing bars is provided. On the garden side of the staircase is a smaller room with a built-in niche under the stairs and two windows, one of them with Palladian motif. This room connects with the large dining room; the partition is almost entirely dissolved by glazing, including a large glazed door with built-in showcases on each side. A loggia off the dining room has three arched openings to the garden (see fig. 181), which on the facade appear as parts of an arcade of engaged piers supporting the parapet of the terrace above. The coping of the parapet continues the cavetto molding of the string course. By contrast, the parapet of the loggia has a flat coping carried over from the oblique parapet of the garden stair; both the coping and the wall surface are set back behind the plane of the arcade. The basement wall has an oval window below each arch.

8. The house at Suttingergasse 18, for Captain Robert Michel, has a frontage of 11.5m and the entrance is on the street side. The door opens onto an anteroom with cloakroom and toilet on the left; then follows a hall with the staircase that receives light from a tall window on the side facade and continues enclosed to the garden door in the basement. The hall gives access through a storage room with built-in cabinets to the kitchen on the street side and, through two doors in the spine wall, to the two large rooms on the garden side: a dining room with terrace and a living room which projects beyond the dining room and has a segmental bow window with three openings. Living room and dining room are connected by a four-leaf door. Upstairs a small terrace is above the bow window. There are three rooms on the garden side and a smaller room and a bath on the street side. In the attic are three rooms, one of which is a studio with a small terrace cut into the roof slope. The garden of this house is designed with a pergola and a water basin.

Alterations

In the Vetter House the attic was finished and the attic stair relocated. In the Michel House additional rooms in the attic and a garage were built. In addition, the hall was enlarged and a large flower window was placed on the garden facade. The pergola was removed.

Bibl.: *Architekt* XIX, 1913, pls. 8-12; *DKuD* XXXV, 1914/1915, 308, 309; *Interieur* XV, 1914, pls. 115-121; Photographs and perspective sketch: Estate; Submitted and substituted plans: ABBH; *Döblinger Bezirksblatt* II, 1914, no. 25 (15 May), 1-3.

Villa for Dr. Edmund Bernatzik
Vienna XIX, Springsiedlgasse 28
Approval of submitted plans: 9 July 1912
Certificate of occupancy: 8 May 1913
Builder: Carl Höllerl & Co.

A house for the Professor of Constitutional Law, Court Councillor Dr. Edmund Bernatzik, and his large family is placed on a garden lot 21.5m wide by 55m deep on the Springsiedlgasse which runs approximately north-south. The house is set back 25m from the street and, disregarding the projections, is almost square (14m x 13.5m). The basement is only 0.80m below grade; there are two full stories, and a finished attic. The room heights are: basement 2.8m, first floor 3.3m, second floor 3m, attic 2.8m. The building is executed in brick masonry with wooden ceiling constructions in the main stories and massive ceilings in the basement.

The entrance is on the left side near the northeast corner below ground level and is protected by a small pavilion, open in front and back but closed on the outer side. The pavilion's light cornice slab with cyma rests on piers and is covered by a flat sheet metal roof; inside, steps lead down to the entrance at basement level. The door opens onto an anteroom, from which a winding wooden stair with solid parapet leads to the first floor. Opposite the stair is the cloakroom with toilet and lavatory and the porter's apartment, which occupies the entire western part of the basement and contains another entrance on the south side. Behind the cloakroom is the kitchen with its subsidiary rooms. Heating, housekeeping, and storage rooms are also housed on this level.

On the first floor the stair from the basement ends on a podium from which a second stair with three flights and winders rises to the second floor. A deep arch with bell-shaped profile at the foot of the stair gives access to a short corridor with toilet and storage room below the stair; the end of the corridor leads to the pantry on the garden side. The staircase was planned on a greater scale but had to be reduced at the request of the client.

A loggia originally planned in the center of the south facade was omitted; thus, a single large room, destined for musical performances, in addition to the staircase, fills the west side of the first floor. In the east section is the dining room with pantry and dumb waiter from the kitchen, and a study with segmental bow window. The dining room gives access to a veranda with garden stairs. The veranda has such large windows on three sides that its walls appear largely dissolved. Above it, on the second floor, there is a similar room closely linked with a bedroom. The plan of the second floor is very clearly organized

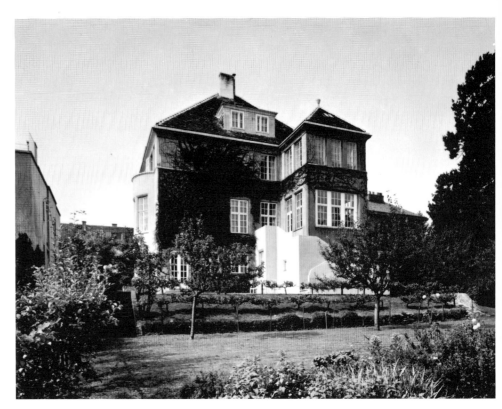

Cat. 168/I, II. Villa for Dr. Bernatzik, garden view and plan of raised ground floor (cf. text fig. 183)

in three strips. On the top floor a central hall gives access to the attic rooms. Among these is a room with a terrace on the south.

The appearance of the house from the street is approximately that of a cube and pyramid. The ridge of the tile-covered hip roof with 45 degree slope is so short that the effect is that of a pyramidal roof. On the street side is a box dormer with three windows terminating in a cornice with cyma profile. Wall strips with sunken panels border the windows. The facade is entirely symmetrical (except for the entrance pavilion). It is composed so that there are corresponding windows on the first and second floors, but not in the basement. Basement and first floor have profiled window frames while the windows on the second floor are set between main cornice and string course in a wall surface that is fluted. Below the string course all facades are framed by edge moldings in stucco. The main cornice is a boldly projecting cavetto molding with a narrow fillet; it carries the metal roof gutter.

If the rear facade had received the planned loggia and adjoining windows, it would have produced a richer three-dimensional effect. In its present form, it is without any opening in

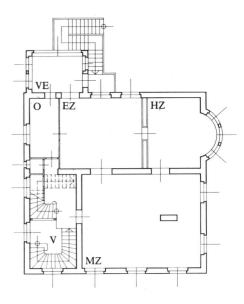

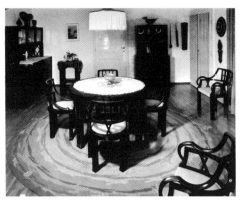

Cat. 168/IV. Villa for Dr. Bernatzik, dining room

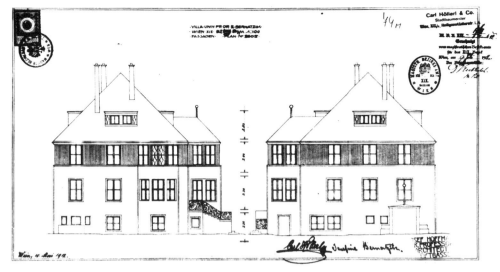

Cat. 168/III. Villa for Dr. Bernatzik, submitted plan, facades and section

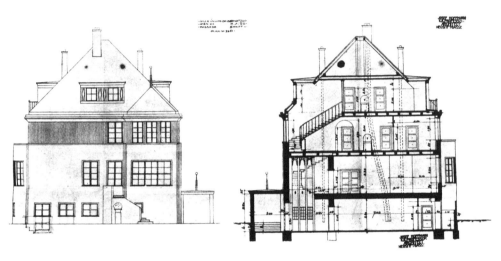

with the former study, which was turned into a bedroom. After war damage the house was restored during Hoffmann's lifetime. An additional door to the garden was opened on the south facade, and the division into panes on the dormer was altered. Further smaller alterations occurred in 1965.

Bibl.: *Architekt* XX, 1914/1915, pls. 1, 2; *DKuD* XXXV, 1914/1915, 304-309; *L'amour de l'art*, September 1923, 637; *Josef Hoffmann, 1870-1956, Architect and Designer* (exhibition catalogue, Fischer Fine Art Ltd.), London, November/December 1977, 22-25, 49. Plans, also for the (unexecuted) building of a garage annex from 1942: ABBH.

Cat. 169 1912-1913

Böhler Tomb
Kapfenberg, Styria

The tomb is no longer extant.

the western half, except in the basement. There is strong articulation only at the east, where the projecting bow window and the triple opening of the terrace above stand out. The east facade is dominated by the towerlike veranda-projection and the open stairs from the dining room to the garden. With their straight and oblique parapet walls, they provide a rich play of lines and intersections.

The north facade has three axes (disregarding the veranda-projection) and is symmetrical in the upper stories with one window per axis and story. In the basement the plan requires a more irregular fenestration.

The garden is designed in relation to the house, with a seating area, sunken parterre, and various flights of steps. The fence on the street side has a base and pillars of concrete with a molded

wooden coping and a wooden grillwork of vertical bars. The garden entrance is arched.

For the interior, Hoffmann designed furnishings not only at the time of building but on various occasions in later years. These range from the simple white painted seating group on the veranda and the black polished furniture with custom-made round carpet in the dining room, to the eggshell finished red furniture in the salon, which took the place of the former large hall after a remodeling in 1932. A desk by Dagobert Peche is in the salon.

The house has been protected as a historic monument since 1959 and is in very good condition. During the remodeling under Hoffmann's direction in 1932 a bathroom and dressing room were separated from the hall on the south side of the first floor; they form a unit

Cat. 170 1912-1914

Design for entrance and interiors (adaptations) in the office of the "Poldihütte"
Vienna III, Invalidenstraße 7/Ditscheinergasse

Extensive adaptations and interior design work are done in a new building for the Poldihütte steelworks, one of the most important industrial enterprises of Austria-Hungary. Hoffmann designed not only formal rooms, such as the reception room or the waiting room of the director general's office, but also the general offices, the employees' kitchen, dining room, and washrooms, and the corridors and stairs in addition to the entrances for the director general's office and for the sales office.

The entrance to the director general's office through a large reception room in the center of

355

the building is the most important part of the adaptation. The entrance from the Invalidenstraße is a symmetrical tripartite composition of great severity. At each side of the tall entrance door are windows of equal height above a plain base. The piers next to and between the openings are left plain; only their edges above the base are beveled. Strong bars divide door and windows in the same way: five horizontal lights and eight—nine in the door—vertical lights. The entrance door also has a fluted base and a pushbar across the three lights of the swinging door so that there is no need for a handle, which would have disturbed the symmetry. Above the door are the words "Poldi Hütte." Two other short inscriptions in smaller letters are at eye level on the center piers. These also bear octagonal lanterns, which have triple-stepped tops.

A large hall (see fig. 191) is entered through the door and a small entryway with a second similar door. The floor is tiled, the walls are clad with whitish gray, strongly veined marble. The hall is divided into two sections by a heavy reinforced concrete beam on engaged masonry piers. It is parallel to the window wall and bent downward at the ends. The hall's front section is lighted by the entrance windows; there are low lateral marble benches for display of the firm's products. In front of the engaged piers, underneath the beam's oblique soffits, a pair of polygonal marble pedestals supports two striking exhibition pieces, between which every visitor must pass: two mighty artillery shells, polished to high gloss. The rear of the hall has a single milk glass window which occupies the entire wall; its dark frame repeats the bent outline of another beam parallel to the one in the middle of the hall. The large window area is divided and subdivided to provide relief and scale for the total composition.

In front of this window stands a seating group on a black and green carpet, consisting of a massive polished black table and club chairs in green

Cat. 170. Office building of Poldihütte Steel Works, entrance (cf. text fig. 191)

Cat. 171. Facade design for "Graphic Industry" printing house

leather. The very heavy legs of the chairs are fluted, the table top is triple-stepped like the tops of the wall lights outside. The plan of the club chairs is polygonal, repeating the motif of an angular broken outline from the hall divider and shell pedestals. In the rear section are black built-in showcases containing the products of the steelworks. The showcase on the left wall is shorter because the hall widens for doors, a reception desk, and another polygonal pedestal for flowers. Artificial illumination is provided by milk glass bowls hanging close to the ceiling.

The rooms now serve other functions, but the great hall is largely preserved. The entrance is no longer extant; of the furnishings only some in the upper story are preserved, mainly those in a room with low, black-stained wall cabinets and framed photographs of the steelworks.

Bibl.: *DKuD* XXXV, 1914/1915, 306, 307; *ID* XXIX, 1918, 147; Eisler, 128, 129; Photographs: Estate.

Cat. 171 1912(?)-1914

Facade design for the printing plant "Graphische Industrie"
Vienna V, Stolberggasse
Entered into the register of plans: 25 July 1914
Drawn by Max Fellerer

A symmetrical fifteen-bay facade of six stories with finished attic is proposed. The entire facade is bordered by a triple-recessed frame, open at the bottom, forming an inverted U-shape. Each vertical bay of windows in turn is enclosed by an analogous triple frame, with the vertical frames separated from each other by plain strips of wall. The spandrels between the windows are also plain wall surfaces, set back behind the level of the frames and thus appearing as parts of continuous horizontal strips. In this manner the verticality of the frames is countered by an equally strong horizontality. All windows are four lights wide but their heights vary in divisions of four, five, or six. Glazed entrance doors with projecting, multiply stepped frames, are in the second and thirteenth axes. They are topped by architraves in the shape of a slightly curved cyma inscribed with the name of the firm. Next to the main

doors are small pedestrian entrances with top lights. A railing of vertical and diagonal bars fronts the slanting windows on the attic story.

Bibl.: *Architekt* XIX, 1913, pl. 68.

Cat. 172 1912-1914

Remodeling and furnishings of a country house for Director Dr. Hugo Koller
Oberwaltersdorf, Lower Austria
Builder: Ratzman & Pick, Klagenfurt

An old water mill, later converted to a factory, was remodeled and enlarged. A set-back upper story in the new addition was joined to the old building so that a spacious loggia and two new rooms were formed at the juncture. The new roof continues the slope of the old mansard roof and contains three rooms with built-in cabinets and large dormer windows. A spacious terrace with a decorative railing is on the second story. An arched loggia opens below this while the second story of the new facade is articulated by fluted pilaster strips. The new and the old buildings are unified by the formal treatment of the facade.

Other parts, carried out in reinforced concrete, were added to the factory wing. We do not have evidence whether they were determined by the client and his builder or by the architect. In any case, Hoffmann did not publish illustrations of the factory part, and the details of the facade do not prove attribution to him. There can be no doubt that he designed the interior of the residential part. Here, a former kitchen was remodeled and furnished as a hall, and the former stove is used as a flower carrier. The adjoining dining room was enlarged by taking down a partition, and was linked with neighboring rooms by opening up a single and a double arch, with a see-through vitrine built into the single arch. Furniture by Hoffmann was placed in other rooms.

In 1923, a high-ceilinged workshop room on the second story was remodeled into a library with gallery; it was built by the cabinet-making firm Johann Jonasch; the design is attributed to Hoffmann's student Wilhelm Jonasch. The built-in library units are now in the Museum for Arts and Crafts in Hamburg. After the war the building was badly neglected and fell into partial ruin; it was restored by sympathetic new owners, and the hall with its furnishings and light fixtures now matches Hoffmann's design quite accurately.

Bibl.: Building plans and old photographs in the archive of the owners; BAV; *DKuD* XXXVII, 1915/1916, 401; *ÖBWK* II, 1925/1926, 51; *ID* XXIX, 1918, 146, 401; XXXV, 1924, 310ff.

Cat. 172/I, II. Country house for Dr. Koller, exteriors before and after remodeling (cf. text fig. 154)

Cat. 173 1913

Hospital of the Bosnische Elektrizitäts A. G.
Jajce, Bosnia, Jugoslavia

The one-story, seven-bay building with slightly sloping hip roof is unassuming. The building is articulated by a high base, windows in the wall plane, and a simple main cornice. Open stairs with solid parapets lead to entrances and an attic door.

The building is rather neglected (1979).

Bibl.: Photographs courtesy Dr. Anica Cevc, National Gallery, Ljubljana.

Cat. 174 1913

Furnishings of an apartment for Councillor Moriz Gallia
Vienna IV, Wohllebengasse 13
Cabinetwork: W. Hollmann, L. Loevy, J. Soulek

For an industrialist and well-known patron— Klimt had portrayed Hermine Gallia—Hoff-

mann furnished five rooms in a large apartment that had French windows: hall, dining room, smoking room, salon/music room, and boudoir/ ladies' salon. Several perspective design drawings were published.

The hall at the center of the suite is divided into two unequal sections by pillars forming a tripartite screen open in the middle and with low grilles in the narrower sides. Walls parallel to the screen repeat its triadic rhythm in their articulation. They are covered above the dado with fabric in a blossom pattern. In the larger section of the hall, which serves as a seating area, the wall articulation is especially rich and includes built-in floor-to-ceiling vitrines with decorative glazing bars and multiply recessed frames. The furniture is ebonized wood with carved floral appliqués and with wide fluting as the main motif. A seating group is composed of armchairs with seats upholstered in leather and an extension table with massive legs and a triple-recessed top.

The motif of fluting also occurs on the sides of the large dining room table in dark walnut. The upper areas of the dining room walls are stuccoed and divided into panels by moldings; the lower ones are covered with dark, vividly veined marble, which is carried around windows and doors and is also used on the buffet. A hand-knotted carpet of Hoffmann's design covers the floor.

The smoking room in ebonized wood is a large room with a ceiling divided into wide shallow coffers, partly containing recessed lights. The wallpaper is lively but traditional; wide fluted boards with carved decoration run along the top of the walls and frame the windows and doors. There are low glazed bookcases with richly carved uprights and square panes. In addition to a large desk with two upholstered armchairs and a small table with chairs, there is a table with high wing chairs upholstered in green. The room was also used as a living room by the family.

In the music room the black and white brocade upholstery of a seating group repeats the tone of the black piano while the walls and ceiling are in yellowish and white stucco, articulated by moldings and a multiply stepped cornice. The curtains are gathered and draped in the traditional manner; chandeliers with glass pearls also recall traditional models. A large carpet with floral motifs covers most of the parquet floor.

The red, blue, and white boudoir or ladies' salon has an inglenook between piers, with built-in seats flanking a fireplace. The walls are covered in blue silk and are articulated by fluted pilasters and a stepped cornice. Low upholstered furniture covered in red corded silk forms the main seating group; other pieces of furniture are enameled white, with some gilding. The cur-

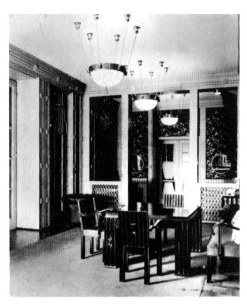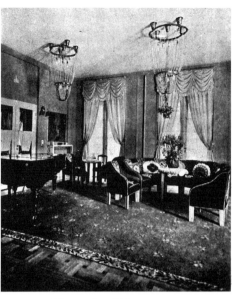

Cat. 174/I, II. Gallia apartment, living hall and music room (cf. text fig. 194)

Cat. 175. First room in Exhibition of Austrian Wallpaper, "Linkrusta" and Linoleum Industry

tains and chandeliers again recall traditional designs, and there is a blue wool carpet.

After the death of Hermine Gallia in 1936 the apartment was taken over by other tenants. Today a significant portion of the furniture is in the National Gallery of Victoria, Melbourne, Australia.

Bibl.: *Interieur* XIV, 1913, pls. 37-42, 49; *DKuD* XXXVII, 1915/1916, 405-408, 600; *ID* XXVII, 1916, 23, 343; Eisler, 125-127.
Information courtesy Terence Lane, Curator of Decorative Arts.

Cat. 175 1913

Design of two rooms for the Exhibition of Austrian Wallpaper, Linkrusta and Linoleum Industry
Austrian Museum for Art and Industry

For the first room Hoffmann designed a Linkrusta embossed wallpaper in a lozenge diaper pattern. Wall surfaces utilize a linear version of this pattern with vertical and horizontal dots; in the corners is another version of the same pattern with color added to the lines. This creates a strong rhythmic articulation, and the effect is greatly heightened by an impressive cabinet with inlaid edges and stepped setbacks, which is perceived as a distinctive three-dimensional object in space.

The second room displayed vivid wallpapers with large patterns by Ludwig Jungnickel and Franz von Zülow; Hoffmann here limited the use of wallpaper to lateral niches. Thus, their restless papered walls form a contrast to the quiet white of the main room. The walls and ceiling have delicately framed panels with small center motifs. A small ceramic sculpture stands on a pedestal in a round niche.

Bibl.: *Interieur* XIV, 1913, pl. 113; *DKuD* XXXIII, 1913/1914, 157; *ID* XXIV, 1913, 353.

Cat. 176 1913

Tomb of Henny Hamburger
Vienna, Grinzing Cemetery, Group 9, Row 3

The rectangular grave site has a simple low stone border and a sunken oval stone basin in the center for flowers. A shell limestone stele is topped by a cornice block with cyma profile. The sides and front edges are fluted. The front panel between the fluted strips bears the name in two lines. The grave site is well preserved although the stele leans to one side.

Cat. 176. Hamburger grave

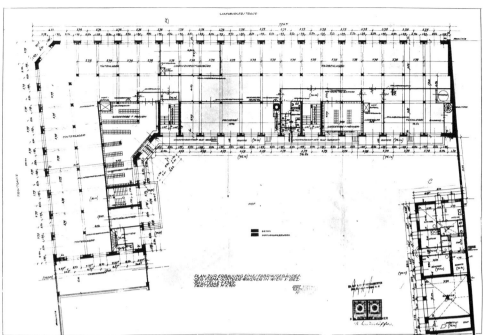

Cat. 178/I. Günther Wagner factory, submitted ground plan

Cat. 177 1913

Förster Tomb
Vienna, Döbling Cemetery(?)

Cat. 178 1913-1914

Factory building for the Günther Wagner firm
Vienna X, corner Laxenburgerstraße and Trost-
gasse
Builder: Ing. Eduard Ast & Co.
Approval of submitted plans: 18 August 1914

Project for a four-story factory building with finished attic and basement on a corner lot about 77m x about 71m. There is a second basement under one part of the building. A one-story garage was planned in the courtyard at the south edge of the lot. The building has an L-shaped ground plan, with the longer arm on the Laxenburgerstraße; it has two main staircases and two freight elevators. The staircases are on the courtyard side of the Laxenburgerstraße wing. Next to them are cloakrooms, washrooms, and toilets. All other areas are open and subdivided by light partitions according to manufacturing and storage needs. The attic houses rooms for the employees: showers, baths, warming room and canteen.

The building is of reinforced concrete with beam ceilings and two rows of square pillars; each story is 4.2m high; the width of the wing is 17m. The axial distance between pillars in longitudinal direction is 3.79m. As the entire facade was planned in concrete, it is not a pure skeleton building but consists of concrete bearing walls combined with skeleton construction on the interior. The builder's cost estimate refers to T-shaped reinforced concrete piers on the outer wall.

A letter of 29 May 1914 from the builder to the architect states expressly ''. . . that our facade is actually constructed in concrete . . . not added and no parts affixed.'' Previously, several variations for the facade were offered in the bidding document: ''a 5 centimeter Dolomite bush hammered layer built simultaneously with the concrete according to plans including moldings . . . ,'' or ''a 2.5 centimeter shell-limestone-artificial stone layer added afterward, as a variation''; finally, a possible execution in high-quality stucco is mentioned. The whole interior concrete construction was planned for rendering both in rough and fine cement-lime mortar. The roof was to be reinforced concrete frame construction with a visible four-post frame, 4cm cork insulation and copper sheet metal covering.

Hoffmann designed the 19-bay facade on the Laxenburgerstraße and the matching facade on the Trostgasse without base and with a simple main cornice consisting of a small fillet and a quarter round. It is mitered at the end and carried to the ground so that it has both a crowning and framing function. The facade is divided into bays by narrow moldings. The windows are of iron. The basement windows have segmentally arched heads; the top story windows are round-headed; the others are square.

All windows are framed by small-scale decorative moldings; sills and lintels are emphasized, the latter with small stylized sculptures of a pelican, the firm's trademark. The windows in each bay are enclosed in an arched frame; the resulting effect of a tall arcade is decisive for the total impression of the facade. A railing stands above the main cornice; behind it are the large attic windows in the roof slope. The name of the firm appears in the center of the roof.

The courtyard facade is designed in an analogous manner but enriched by doors and the continuous staircase windows; here the pelican sculptures are omitted.

The single-story building in the courtyard for a garage, storage of solvents, and two small apartments was planned in stuccoed brick with ceiling and roof construction in wood. The low hip roof is covered in sheet metal. The simple facade is articulated with a 1.20m base and a twice-recessed slab above an inclined fascia as main cornice. The sides of the entrance door are

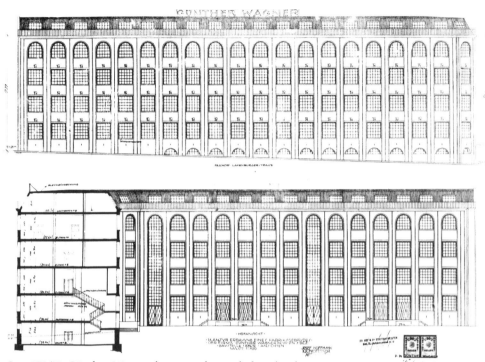

Cat. 178/II. Günther Wagner factory, submitted plan, facades

also recessed. The windows run from base to cornice.

The building was begun but stopped at the foundations by World War I and never completed.

Bibl.: Plans: ABBH; Günther Wagner Archive, Vienna.

Cat. 179 1913-1914

Primavesi Country House
Winkelsdorf (Kouty), Czechoslovakia
(Compare figs. 155-164)
Dating: According to entries in the register of plans, details of the interior were drawn at the end of 1913 and the beginning of 1914; smaller utility buildings for the same site were drawn in 1915, 1916, and 1921.

Winkelsdorf (Kouty) is about 47 miles north of Olmütz (Olomouc) in the beautiful valley of the Tess (Desná) in the Altvater (Praděd) Mountains. The village was once the terminal of a local railroad. Here the Primavesi family acquired a large lot (about 230m x 350m) on a beautiful site on a southeast slope. Hoffmann built the house at the highest point with a view, near the left edge of the lot.

Coming from the valley a narrow, steadily rising road leads to a high gate. The simply designed grilled wooden gate sits in a wall of random ashlar. The road then winds in two serpentines up the slope, past a garage in random ashlar and other outbuildings such as stables, dairy, and turbine house on a creek; then follow a sunbathing area, swimming pool, and tennis court with decorative fence. Drawings for the dairy cellar with barn above and for a small shed have survived.

The main house faces southeast and forms the center of a layout with several outbuildings and gardens. A pavilion is connected to the house by a glazed walkway at the southwest. The house and outbuildings have high random ashlar bases and wooden walls like a loghouse with alternating natural and dark stained courses. The roofs are thatched in straw, supposedly at the suggestion of Anton Hanak.

The house has two stories, basement, and a hip roof with finished attic. The roof has a faintly bell-shaped profile. The central section of the symmetrical block projects about 2.5m at the front and rear. At the front the central section opens in a loggia with round oak posts as pillars. Their capitals, originally beveled round wooden slabs, were replaced by square abaci with inclined faces. It was intended that Hanak should later cover them with carvings. The central section

has three semicircular dormers. Each lateral wing has three windows in the second story, and two taller barred windows on the first floor. The basement has only a few round-headed windows but has a large arched opening in the center. Shutters are painted green and white with floral enrichment.

The entrance is at the southwest. As the road comes from the north and consequently runs along the rear of the house to the entrance, the great view from the loggia is likely to come as a surprise. The two lateral wings are almost square (about 8.5m x 9m), while the central section measures about 9m x 12m. The loggia is 5m deep. An extant design shows that the ground plan, with wide central section and loggia and two approximately square lateral sections, was conceived early and retained. A still earlier published design also calls for a large central hall and open loggia but shows some substantial differences, such as three front gables and three large openings in the basement story. The early designs also call for a lookout or belvedere with cupola in the center; this idea was dropped.

The entrance, protected by the glazed passage to the pavilion, opens onto a 2m-wide corridor which leads straight to the main room—the great hall. Like all other important rooms, this entry corridor is richly decorated. The tiled floor is

360

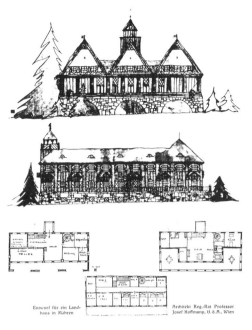

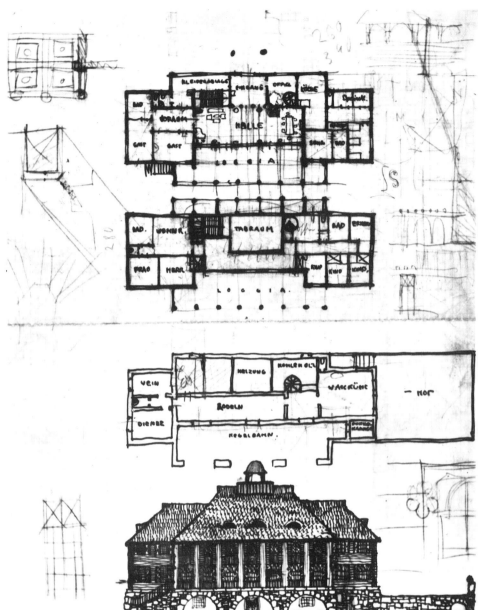

Cat. 179/I. Primavesi Country House, first design

dark, but the basic tone of the walls and ceiling is white. As in most other rooms, the predominant effect is bright. The white surfaces are strongly relieved and articulated by a grillwork of dark ceiling laths and by painted woodwork, especially by the dynamic form of the lozenge pattern used in repetition. Strips of the lozenge pattern divide the wall areas into sections for doors and low cabinets. The glazed cabinet doors and glazed doors to the guest rooms and bath have diagonal bars. Next to the basement stairs a tripartite pillared opening with lateral parapets leads to an anteroom with cloakroom and adjoining toilets. Here and in the corridor there are lights with colorful bell-shaped fabric shades.

The great hall, with stair, loggia, and adjoining dining room with pantry, takes up the entire central part of the house; 12m long, its sheer size is impressive. Furthermore, it is richly articulated in white, green, and black. The carpet is divided into square panels by borders of squares. The ceiling beams are painted white and rest on a dark, slightly grooved architrave. The perspective foreshortening of the regular intervals between the beams reinforces the experience of depth. The ceiling is further subdivided into square panels by thin strips. The walls are divided in a comparable manner, with a decorative element painted in the center of each panel.

Cat. 179/II, III, IV. Primavesi Country House, second design; ground plan; large hall (cf. text figs. 155-164)

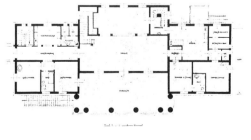

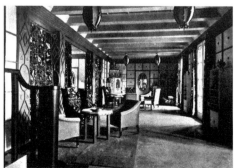

The room receives light through glazed double doors; another door with an oval light leads to the service zone housing the kitchen, painted in light blue and gray, the service stair, and two additional rooms with bath. The high point of the hall is the large colorful tile corner stove with sculptural decoration by Hanak. Other heating is provided by radiators covered by grillwork doors. One seating group with a floor lamp is by the stove; a comparable one is on the other side of the room where the stairs begin. One wall has three curtained openings separated by pillars, which forms the connection to the dining room. The pillars are carved and painted with lozenge and circle motifs, and all curtains in the hall have colorful patterns. The connection between hall and dining room reinforces the spacious effect. Hall ceiling fixtures are of an elongated egg shape, faceted and covered with fabric.

The dining room (about 7m x 4.5m) repeats the ceiling treatment of the hall, but the walls are sectioned into rectangles rather than squares. Below the windows there are glazed cabinets with glazing bars arranged in the same lozenge pattern that recurs in the carvings of the heavy colorfully upholstered chairs. There is a massive table with square fluted legs and inlaid edge, above which hangs a lamp with a colorful fabric shade. A large white three-part buffet with dark moldings is built into a niche at one end of the room.

The wooden stair from the hall to the upper story begins with an open flight of four steps to a landing and then continues in two parallel enclosed flights. The walls of the staircase repeat the treatment of those in the hall. A central area corresponding upstairs to the hall contains a day room with loggia or veranda, colorfully done in white, light blue, and red, and intended for the children. The ceiling is beamed and coffered and there is a carved and painted cornice carried by wooden pillars, pilasters, or painted strips. These are decorated with geometric and stylized figural motifs in the folk art tradition. Similar treatment is found in many richly furnished living rooms and bedrooms on this floor and in the attic. The parents' living room, for example, has walls and ceiling in green with accents in other colors. The master bedroom is in light yellow and red while the lady's bedroom is in light blue, gray, and black. Each of the several children's and guest rooms has a different color scheme: pink with multi-colored carvings, light blue and dark blue upholstery with variegated painting, white with green, white with violet, etc. The motifs of lozenge, zig-zag, and crisscrossing diagonals are again repeated; polychromatic fabrics with large patterns supplement the decor of painted and carved flowers and tendrils. The total effect is one of strong articulation in detail

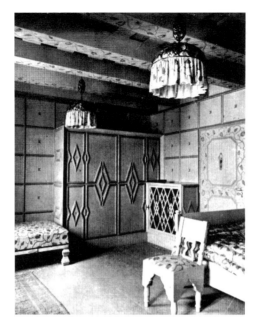

Cat. 179/V. Primavesi Country House, gentleman's bedroom

and an overwhelming play of color.

In 1921, Hoffmann designed an additional building with porter's apartment (Cat. 236), but the Primavesi estate burned down in 1922, and Hoffmann sketched a small, one-story house as a possible replacement (Cat. 240). Today, the base of the main house, on which a new convalescent home was erected, and the garage are extant.

Bibl.: *Interieur* XV, 1914, pls. 65, 66, 114; *Architekt* XX, 1914/1915, pl. 80; *DK* XVIII, 1915, 233-241; *ID* XXVII, 1916, 49, 179-181; *DKuD* XXXVIII, 1916, 199ff.; Eisler, 8-10, 14, 123, 124; *Wendingen*, August/September 1920, 13, 14, 24; *L'amour de l'art*, 1923, 637, 638; *Art et Décoration* XLVI, 1924, 63; *Journal of the American Institute of Architects*, XII/10, October 1924, 422; *ÖBWK* II, 1925/1926, 49, 50; Platz, 313; *The Architectural Forum* XLIX, November 1928, 707; Design sketches and photographs: Estate and WWA.

Cat. 181. Remodeling of Primavesi Banking House, front

Cat. 180 1913-1914(?)

Furnishings of an apartment for Ferdinand Hodler
Geneva, 29 Quai du Montblanc
Cabinetwork: J. Jonasch, J. Soulek

These furnishings include a light, richly carved lady's salon with oval table, desk, flower table and chairs, and a group of furniture in black stained oak with white rubbed grain. A table with massive fluted legs, triple-stepped top and carved appliqués, a credenza and buffet, a silver and china cabinet, and upholstered armchairs were made. The chairs with the high backs and a seating group of sofa and upholstered easy chairs are decorated with colorful embroidery.

Some of these furnishings with later fabric coverings are now in the Musée d'art et d'histoire of the City of Geneva; others are in the Düsseldorf Museum and in the Jura Brüschweiler Collection in Chêne-Bourg, Switzerland.

Bibl.: *Interieur* XV, 1914, 91; *DKuD* XXXVII, 1915/1916, 408, 409; XXXIX, 1916/1917, 208ff.; *ID* XXVII, 1916, 225, 226; XXVIII, 1917, 334; Eisler, 130, 131; H. Ankwicz-Kleehoven, *Hodler und Wien*, Zurich, 1950, 18, pl. 5.

Cat. 181 1913-1914

Remodeling of the Banking House Primavesi
Olmütz (Olomouc), Niederring 6, Moravia, Czechoslovakia

The ground floor of an existing building was modernized. The facade with three large arches was newly designed, with the glazing sectioned into tall rectangular lights. The building was razed in 1935.

Bibl.: Information courtesy Dr. Pavel Zatloukal, Olomouc.

Cat. 182 1913-1914

Austria House at the German Werkbund Exhibition, Cologne 1914
Opening: 16 May 1914
Local supervision: Philipp Häusler

The exhibition plan provided a preferred site on the main square, opposite the festival hall by Peter Behrens. Thus, an especially effective monumental building was indicated. Hoffmann worked out several preliminary designs, taking as point of departure his exhibition building for Rome 1911. What he finally created was a powerful building, 7.5m high to the top of the main cornice, with a triple-stepped attic and a steep pediment. The ground plan is 29.4m wide by 52m long, U-shaped and open in the center front. The open end of the U, however, contains several rows of pillars. The interior courtyard has open arcades at each side. At the back is a fountain niche flanked by two large openings.

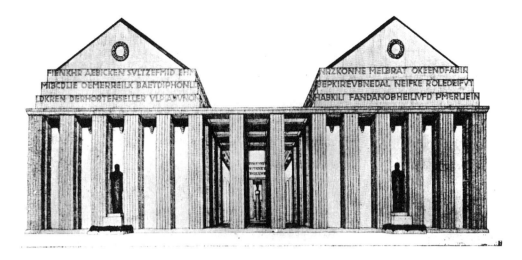

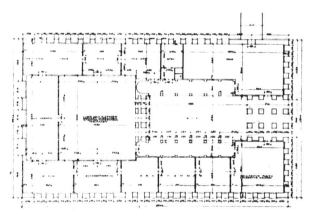

Cat. 182/I, II. Austria House at German Werkbund Exhibition, Cologne 1914, perspective, plan, and view (cf. text figs. 207-209)

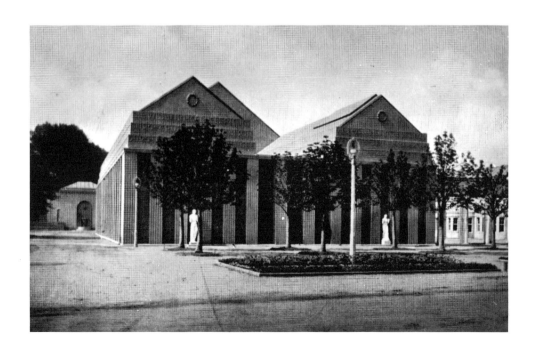

The facades are rendered in coarse-grained gray Terranova stucco; the front and sides of the building are articulated by square pillars (0.95m diameter), which carry the main cornice profiled with a cyma and a fillet. The distance between pillars is 1.7m in front, 1.1m at the sides. Each wing has six pillars in front, two more stand in the opening to the courtyard. Behind these are three more pairs, resulting in an almost square hall of four by four piers. The outer walls are set back far enough from the pillars to create strong shadows. The word "Austria" in capital letters appears over the entrance cornice. The steppings of the high attic have inscriptions in flat relief taken from Grillparzer. Rudolf Larisch designed the lettering. Setback gables in both wings rise above the stepping of the attic; the tympanum carries a wreath. The slope of the roof is about 35 degrees. Another gable of the same slope rises to considerable height above the rear wall of the courtyard. The roof is hipped at the back.

The open hall of pillars before the courtyard has a flat roof. Sculptured fruit baskets are in niches between the pilasters. The facade is otherwise plain. Two over-life-size gleaming white statues by Anton Hanak, *Man* and *Woman*, are placed in front of the lateral wings.

Oskar Strnad designed the courtyard as part of Hoffmann's total concept. Inside, the rooms were entrusted to various designers, most of them close to Hoffmann. He is responsible only for a reception room and the Poldihütte room, but many arts and crafts objects after his designs were shown in other rooms.

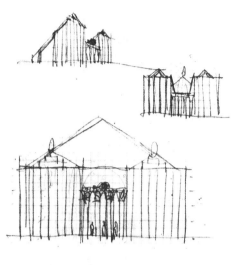

Cat. 182/IV. Perspective sketches, Werkbund Exhibition

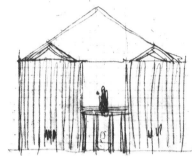

Cat. 182/III. Reception room, Werkbund Exhibition

Cat. 182/V. Room of the Poldihütte Steel Works, Werkbund Exhibition

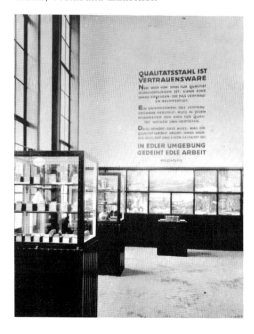

The Reception Room

The second room in the left wing approximates a cube with sides of 7m. It has three high windows and two doors, one in each lateral wall. The color scheme is restricted to black and white plus gray tones for carpet and textiles. Walls and ceiling are painted matte white and articulated by black wooden members. The ceiling is divided by delicate laths into large panels related to the wall articulation; the largest is a central square with inscribed diagonals. The walls have a low, grooved base and a cornice with two superimposed cavetto profiles. Slim pilaster strips, their sides covered by wood, divide the walls into unequal panels.

The wall opposite the window has a wide center panel flanked by two narrow panels. The strips here project so far from the wall that they become engaged piers separating flat niches. Two light fixtures hang in the central niche; below are a built-in bench and a richly carved table with two chairs. Tall, arched showcases stand in the lateral niches. A landscape by Egon Schiele, *The Houses by the Sea*, is the only painting in the room, a special distinction.

The lateral walls are divided unevenly; in front of the narrow panels at the window side stand low chests with oblique glazed tops. In the wider main panels sit single, richly molded doors and arched recessed *sopraportas* with white carvings on a black ground. Small built-in showcases with curved tops flank the doors.

Poldihütte Room

This is the first room to the right at the end of the courtyard. It is well lighted by three tall windows. Hoffmann's design is simple and severe. Showcases in dark wood stand in front of the window piers; their fluted bases are as high as the parapets. The upper part is a metal and glass cube of the same height as the base. The fluted wood surface continues as wainscoting around the room.

On most of the walls a wooden framework for photographs is set above the dado. In one corner is a built-in lecternlike showcase; another exhibit on a low pedestal is in the opposite corner. The upper walls are plain except for a programmatic inscription which ends: "Noble work thrives in a noble environment."

Bibl.: *Architekt* XX, 1914/1915, pls. 41, 81, 82; *Die Kunst* XXX, 1914, 465ff.; *DKuD* XXXIV, 1914, 349ff.; *Kunst und Künstler* XII, 1914, 615ff.; *Interieur* XV, 1914, pls. 53, 58; Eisler, 51-66; Drawings: Estate.

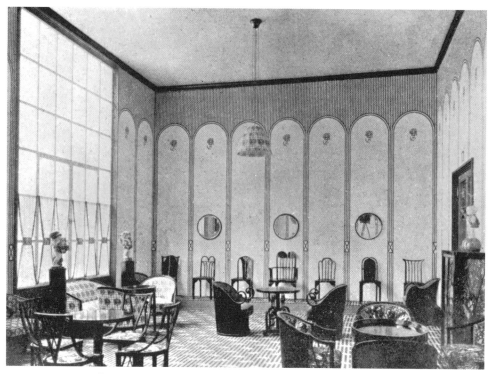

Cat. 183. Room of J. & J. Kohn, Werkbund Exhibition

Cat. 183 1913-1914

Exhibition design: Room of the bentwood firm Jacob & Josef Kohn
Werkbund Exhibition, Cologne, Main Hall
Opening: May 1914

The high room is lighted by a large glazed opening on one side. The walls are painted with a slim arcade and, above it, with vertical lines. Ceramic putti on pedestals flank a seating group in front of the window; on the opposite wall two showcases are flanked by additional seating groups. Other seating groups are placed throughout the room. A different type of chair stands in each of the seven painted arches. The second, fourth, and sixth arches also have mirrors in round bentwood frames. The room gives an impressive survey of the varied design possibilities for chairs in bentwood and bent plywood.

Bibl.: Eisler, 30; *ID* XXVIII, 1917, 164.

Cat. 184 1913-1914

Addition to house and erection of two small wooden garden pavilions for Josefine Skywa
Vienna XIII, Trauttmansdorffgasse 56
Approval of submitted plans: 30 July 1913 and 7 February 1914 (garden pavilions)
Certificate of occupancy: 14 November 1913
Builder: Ing. Eduard Ast & Co.

A small addition to a house built in 1897, and two small pavilions in the back garden. These are square wooden structures (2m x 2m) with pyramidal roofs and about 3m high. The walls are light frame construction and divided into three panels with a 0.8m high parapet and glazing above. The cornice has three superimposed, slightly projecting cavetto moldings. The well-preserved house was altered several times; one garden pavilion that may date back to Hoffmann's design is extant.

Bibl.: Submitted plans: ABBH.

Cat. 185 1913-1915

Villa for Josefine Skywa (Robert Primavesi)
Vienna XIII, Gloriettegasse 18
Approval of submitted plans: 29 May 1913
Certificate of occupancy: 22 January 1915
Builder: Ing. Eduard Ast & Co.

A sumptuous villa on a large lot (about 58m x 75m) that was formed by combining several lots after the demolition of an old building. The length of the street front is almost 30m, the depth about 24-27m; the house is set back 8m from the property line. The Gloriettegasse runs east-southeast to west-northwest, and the site slopes toward the rear. In the following description, the street facade will be designated as south and the rear facade as north.

Construction is in brick with reinforced concrete floors, and facades are rendered in yellowish high-quality stucco. In addition to the raised first floor, which is the main floor, and finished attic, there is a basement; it is about 1m below grade on the street side, but above grade on the garden side. The ground floor is 3.75m above the basement, the attic story is about 4.6m above the ground floor. Access to the lot is at the right edge; the entrance to the house is at the rear of the east facade.

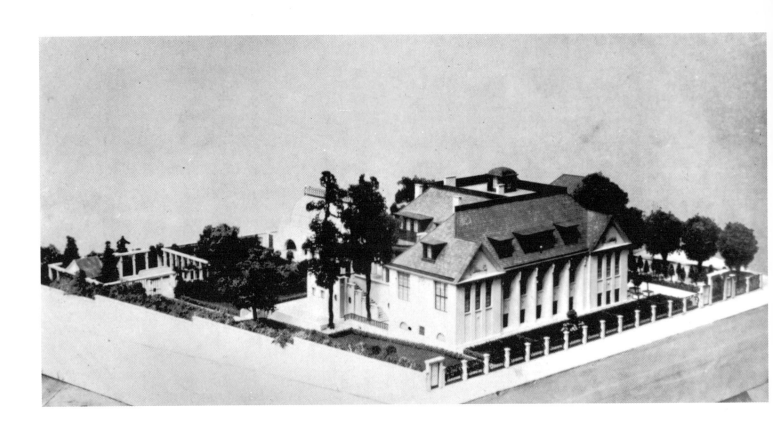

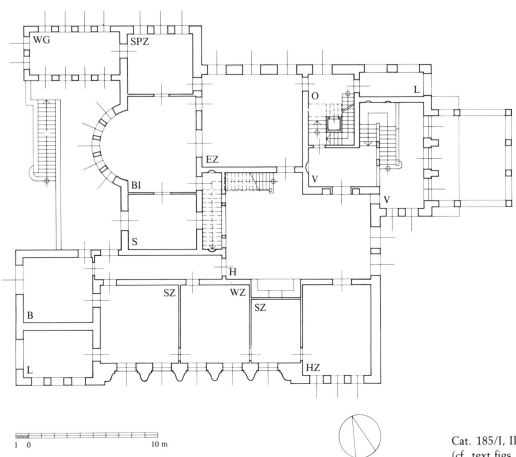

1 0 10 m

Cat. 185/I, II. Skywa-Primavesi House, model and plan
(cf. text figs. 195-206)

The ground floor plan is organized in two functionally differentiated zones that meet in the great hall. The public, or formal, zone begins at the entrance with porch, steps, and vestibule. It includes the great hall, dining room with pantry, salon, library, card room with winter garden, and garden terrace. From the great hall one can reach either, via a staircase, the guest rooms and service rooms in the attic, or, on the same level, the private, residential, section of the house along the south facade, which includes a large bath with loggia, two bedrooms, a dressing room, and a study. Cloakroom and toilets at the entrance, and additional service rooms are in the basement. The servants' rooms are on the south facade, the kitchen and its numerous subsidiary rooms at the north facade. There are also various storerooms and pantries.

The south facade, facing the street, is bilaterally symmetrical with eleven axes, five in the central section and three each in the projecting pedimented lateral wings. The entire facade is on a base with rounded upper edge, and is articulated by pilasterlike fluted engaged piers. On the central section the piers have rounded fronts and sides and project far beyond the recessed wall. They also carry on consoles six sculptured figures by Anton Hanak. Two reclining figures by the same artist are placed in the pediments: *Man* and *Woman*. The flutings have a complex profile—concave-convex-concave between flat fillets—assuring a rich modulation of light and shade. The cornice has, above a fillet and astragal, a large cyma with floral appliqués, followed by a vertically grooved fascia, crowned by a double ovolo with distinctive foliage which looks almost like an inverted egg-and-dart. Windows or loggia openings fill the upper half of the area between the piers, with the lateral windows narrower than those of the central section. On the lateral projections the outer pilasters are three times as wide as the inner ones, which produces a strong rhythmic effect. There are three box dormers of dark-stained copper above the main cornice. The surfaces of the dormers are fluted, and the moldings repeat motifs of the main cornice. The dark red tiled roof with roof gutter rises above the dormers and gables to the fluted and richly molded parapet of a sun terrace in the center of the building.

Despite its strong modeling, the south facade is restful compared to the west facade with its projections, setbacks, and changes of grade. The west facade consists of three parts: a south wing with the living quarters, a recessed central section with terrace, and a north wing with winter garden. The system of articulation is taken over from the south facade and is continued throughout. Because of the terrain, the south wing is on a higher base than the street facade. The

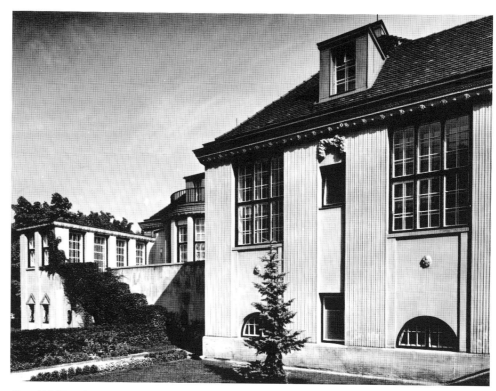

Cat. 185/III. Skywa-Primavesi House, view from west, winter garden wing in background

facade of this wing has an uneven tripartite spacing with larger openings on either side of a more constrained middle bay. A dormer, two small windows, and a festoonlike decoration of fruit and flowers with a squirrel are aligned in the central axis.

At the corner of the south wing the west facade is taken back some 8.5m, permitting the arrangement of a terrace of some 5m depth in front of the central facade section. The north wall of the south wing has no openings except a door to this area. From the garden the terrace is reached by a flight of steps parallel to the retaining wall. The most important element in this portion of the facade is the large bow window of the former library with its five openings. Above it is a roof terrace accessible from a triple dormer.

The northernmost part of the west facade is the flat-roofed winter garden. It is somewhat lower than the main house and continues only the lower molding of the main cornice as its own upper termination. This wing juts out to the line of the parapet wall of the terrace stairs. On the terrace side it is glazed to the ground. Seen from the west, it has the effect of a towerlike structure and its engaged piers appear pronouncedly slender.

In contrast to the west facade, the north facade is less articulated and fundamentally consists of only two parts: the main house which continues the articulation of the south facade, and the projecting, somewhat lower, winter garden wing. On the north side of this wing the articulation of the west side continues for seven axes, enriched by a decorative floral motif below every window. The main house has four windows in the center of the raised ground floor with dormers above; then follows a fluted section which is so wide that it looks like a strip of wall rather than a pilaster, and finally a two-bay open loggia at the corner. The basement story is windowless in the four axes on the right of the facade; then follow large rectangular openings with parapets. On the left, enclosed in a projecting glazed annex, is a staircase which bridges the change in level between the garden and a large terrace in front of the last three window axes.

The east facade has two parts: a south part of five bays, and a north part of four bays projecting 3.7m. The south part begins with three blank panels between fluted pilasters; then follow two panels which have the usual large rectangular windows on the raised ground floor and smaller windows in the basement, with floral wall decoration between. The adjoining projecting north

part has two windows in its south wall; they run from base to main cornice and light the stair hall. On the east wall, below a central triple dormer, are three windows on the raised ground floor, a wide wall strip similar to the one on the north facade, and a flanking corner panel. Below the three windows the entrance porch is arranged.

The visitor first sees the entry from the garden gate, which begins a spatial sequence ending with the formal rooms. The gate and fence play an important preparatory role. The fence has a low base and piers, with decorative grillwork painted black. The gate is a triple portal with two lateral pedestrian doors. Two tall gate posts are connected by an architrave richly articulated with a thrice-repeated cyma reversa molding; on the outer pillars the same profile is used for capital-like tops. The gate posts bear tall lanterns. A wide, flagged path leads, past the east wall of the south wing and a lawn with a flagpole, to the entrance porch which receives the visitor with smaller versions of the fluted piers and cornice moldings of the main house. The flat porch roof is supported by four engaged piers on the facade and four matching piers at the other side of the driveway. The opening between the outer pairs of piers is divided into two unequal parts to form a narrow pedestrian passage closed by a decorative door. The windows on the driveway facade run from floor to ceiling, and have frames painted glossy black with white window bars. The two-leaf entrance door with its decorative carving is also painted black.

The entrance hall and stairs are parallel to the east wall of the house, at a right angle to the movement of the visitor. Upon entering, one can turn right to the cloakroom and toilets, or left, where a stream of light floods the hall from two windows about 6m high. Here, the visitor makes a 180-degree turn to mount steps to a landing where one turns again, mounting to the entrance of the great hall. The repeated changes of direction in the ascent to the raised first floor give ample opportunity to view the stair hall (fig. 202) with its works of art in niches and to appreciate the impressive combination of spatial complexity and simplicity, richness and austerity. Design sketches for the stair hall are extant (see figs. 200, 201). The impression of complexity results from the ambiguity of some elements and the spatial interlocking of the extremely high entrance hall and the considerably lower vestibule of the great hall. The stair parapet in front follows and expresses the slope of the first flight of the staircase, but the slope of the second flight is hidden behind a horizontal parapet that merges seamlessly with the adjoining wall surface; bearing wall, nonbearing parapet and the faces of pillars here are all in the

Cat. 185/IV. Skywa-Primavesi House, stair hall

same plane and covered with the same marble.

The wall that separates the two flights of steps is vertically divided into three zones; two are open, thus permitting vistas, the third accommodates a showcase but otherwise is filled by a stuccoed wall. Thus, the marble strips, which here barely project from the wall yet correspond to the neighboring free-standing pillars, can be read both as wall surfaces and as engaged piers.

Apart from the colorful carpet runners, there are very few colors: the stucco, marble steps, and painted wood are white or whitish gray; other wooden parts and radiator grilles are black. The only other color is the light brownish gray of the strongly veined Belgian marble, but its surface shimmers with the most unexpected reflections. The marble reaches from floor to ceiling only on the entrance wall, window wall, and on pillars and strips. Elsewhere it ends at parapet level. This produces a very effective rhythmization of the wall surfaces while at the same time respecting their planarity. Only the parapet-copings, delicately raised strips at important points of the stucco, and moldings below the ceiling project from the wall planes. In a few places there is also decorative enrichment by small heads in stucco relief; Ceres, Dionysos, Pan, Flora. Other small sculptures are placed on the strip of masonry between the upper and lower openings of the entrance wall.

After the high, luminous stair hall the vestibule of the great hall is more muted in form and brightness. Marble is used only on the base and door frames. On the right, a mirrored chest gives the visitor an opportunity to inspect himself before entering the hall by a two-leaf door. The contrast to the stair hall in color, texture, and quality of light is most effective. The predominant material is dark polished oak, and the light from two large windows with light-colored stained and slightly streaked clear glass is subdued.

The hall (see fig. 206) is a large rectangular room (6.60m x 11.65m without the stairs) which expands in several places. There are published design drawings for the hall. The wall panels are completely coordinated with the wooden ceiling coffers and the grid of the parquet floor, but without monotony because each wall is articulated differently. The viewer facing the entrance wall sees on the left the first flight of the staircase and next the glazed double door to the dining room. Then the wall projects and continues to the window wall, with the entrance door in the third and fourth panel from the corner. At each side of the door a showcase is substituted for one panel.

Opposite is the study which is one of the points of juncture between the private and formal rooms. Further on, the wainscoting is interrupted by a fireplace niche with built-in upholstered benches, creating an accent of space and color, heightened by a colorful carpet as well as two large upholstered easy chairs and richly carved round side tables in front of the niche. Opposite the window an equally strong accent is created by the pillared opening of a deep niche with half-round ends and doors to the salon and the original library. The niche is arranged under the second flight of the staircase, which here runs behind the paneling. The panels of the wainscoting generally measure 0.75m x 0.95m and repeat the motif of multiple framing within an inverted U. The changing floral motifs of the panels show a great wealth of forms, and the craftsmanship of the carving and other woodwork is outstanding; the firm of J. Soulek was responsible.

The salon (see fig. 203) was originally planned as an oval but was executed as a rectangle; it is the first of the enfilade of formal rooms entered from the hall. Compared with the latter, it is intimate in scale (4.15 x 5.2m). It is adequately lighted by a French window, and the color scheme is so light that the wealth of delicate detail can be appreciated. The walls are articulated by slight projections at the corners, producing a plan in the form of a cross with very short arms. Each projection has a built-in radiator with cover, and a showcase above. The parquet floor is of lemon wood with black inlaid strips; the baseboard and

door casings are of strongly veined *arabescato* marble. The walls and ceiling are in a delicate cream tone; the pure white of door, windows, and stuccowork stands out in contrast. The decorative grillwork with floral motifs is in a golden tone, while the wood of the showcases resembles that of the floor and also has contrasting black strips. Above the doors and on the surfaces of the projections is a flat stucco decoration with flowers, foliage, tendrils, and figural motifs. The ceiling cornice also carries repeated floral motifs.

Similar stucco décor is in the dining room, but the wall decoration shows more use of veined marble on baseboards, cornices, flat strips, radiator covers, and the boldly projecting cornices above the doors. The light gray wall panels between the marble elements are framed by white, grooved strips. White, glazed doors have dark brown frames and diagonal glazing bars.

The other formal rooms as well as the private living quarters are of similar sumptuousness. Even the bathroom is unusually large, with decorative painting above the tiled wall and an open loggia. The direct connection between the bath and outdoor space corresponds to an attitude that also finds expression in the provision of a private sun terrace. Only the utilitarian rooms, such as the large tiled kitchen with built-in cabinets and the winter garden with black-and-white floor tiles, sliding windows, and uncovered radiators, are simpler, though still of careful design and the highest quality.

The garden is an important part of a total conception, involving everything from the smallest detail to the extended environment in the creation of an ambience for a way of life. The garden* of the Skywa villa was planned to incorporate the difference in level of about 3m between the Gloriettegasse and the rear of the site, and to preserve existing trees. "The trees closest to the house also contributed to determining the outline of the house" (Max Eisler). The terrain resulted in a row of terraces; the largest supports the glass half-cylinder of the greenhouse. The basement under the greenhouse opens to the garden in three wide semicircular arches. Between these openings are projecting wall strips, crowned by putti which Hanak completed in 1915.

A pergola with a small pavilion or "tea temple" and water basin dominate the lower part of the garden. The pergola encloses a courtyard entered on small stone bridges across two narrow arms of water basin. A 1929 replica of Hanak's fountain sculpture *Kind über dem Alltag* was later placed in the center of the basin. The garden pavilion is rectangular and has a steep gable (40-degree slope) on the courtyard side; its tympanum has a shallow semicircular recess with a wooden sculpture of a female figure by

Cat. 185/V. Skywa-Primavesi House, greenhouse in garden with sculptures by Anton Hanak

369

Cat. 185/VI. Garage and porter's lodge, view

1 0 10 m

Cat. 185/VII. Garage and porter's lodge, plan of ground floor and upper floor

Ferdinand Andri. The walls of the pavilion are articulated by fluted pillars and display openwork decorative carving. Like the entrance wall, the rear wall is divided into three bays; the central one is plain while the two lateral bays have mirrors that reflect the courtyard.

Near the northeast corner of the house, at the rear of the entrance yard, the garden design integrated an outbuilding with garage and gardener's apartment above. It is a two-story structure with basement, 9.2m x 12m, with tiled hip roof and roof gutter. The building is stuccoed brick with reinforced concrete ceiling construction. The main cornice has a large cavetto molding with fillet. Centered eyebrow dormers are at the long sides. The basement houses storerooms and heating, the first floor has a two-door garage, tool storage room, and straight stair to the upper story. The apartment has three rooms, kitchen, and toilet. All facades have trellises for climbing plants; the front facade, visible from the main entrance, is particularly rich in decorative articulation with a linear architecture of trelliswork.

In 1929 the interior of the main house was partially refurnished for the attorney Dr. Bernhard Panzer, who had acquired it. This included a guest room in the attic, a silverware storage room, a cloakroom corridor with built-in cabinets next to the great hall, and the hall vestibule, which received a late Gothic Madonna on a pedestal. The most important changes were the furnishing of a smoking room paneled in walnut and a new library, a corner room next to the original library with built-in bookcases and smooth paneling in flaming Zebra wood. During and after World War II the house and garden were damaged. After acquisition by the Austrian

Labor Federation, they were restored, except for the razed greenhouse, and are now in excellent condition. Little is preserved of the original furnishings, and there were also substantial changes in the course of several remodelings, the last in 1976/1977. The alterations were required for the use of the house as a training school. The former open loggias are now glazed, and the opening of new doors and windows changed the north facade especially. The fireplace was removed in the great hall; adjoining rooms were divided or combined. Numerous functional changes were also made in the basement and attic. At the gardener's house the trellises and planting were removed, and the ground floor was altered. A bowling alley was installed in the basement of the destroyed greenhouse. In the garden court the layout of the pavilion and pergola was changed and both elements have started to deteriorate. The crowning lanterns of the garden gate are missing.

* "Hoffmann himself designed only the part close to the house, the adjoining part on the left was added later." M. Eisler, *DK* XIX, 1916, 7.

Bibl.: *DK* XIX, 1916, 1ff.; *DKuD* XXXVII, 1915/1916, 228ff.; LXVIII, 1931, 31ff.; *Architekt* XX, 1914/1915, pls. 4, 5; XXIII, 1920, 71, 72; *Interieur* XV, 1914/1915, pl. 50; *ID* XXVII, 1916, 48; Eisler, 120-122; *L'amour de l'art*, September 1923, 635; *Journal of the American Institute of Architects* XII, 1924, 427; *The Architectural Forum* XLIX, November 1928, 707-710; *Studio* CV, no. 481, April 1933, 244; Platz, 315; N. Powell, *The Sacred Spring*, London, 1974, 71; Design sketches: Estate; Plans: ABBH; Photographs of model from estate of E. Wimmer: ÖMAK.

Cat. 186. Exhibition of Austrian Arts and Crafts, hall, seating niche (cf. text fig. 193)

Cat. 186 1914

Exhibition design: Hall in the Exhibition of Austrian Arts and Crafts 1913/1914
Austrian Museum for Art and Industry
Execution: Ludwig Schmidt

There is a published color perspective for this room and its black-stained oak furniture. The hall has a high, boldly projecting cornice; above it are dark ceiling beams between which the white ceiling is visible. The panels between the beams above the cornice are decorated. The cornice itself has five equal cyma moldings separated by

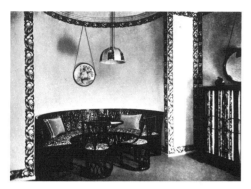

Cat. 187. Ladies' salon

delicate black dotted lines. While ceiling and cornice are white, the walls, except for a low black base, are a brownish violet, in contrast to the greenish gray carpet.

A large niche with a plain wall and coffered ceiling contains a built-in upholstered bench with a black fluted base and colorful fabric. A large table stands on a carpet patterned with small squares. The six square fluted legs with small carved decoration are so massive and so close together that they give the effect of three transverse bases which support the table top. This too is unusually thick; the edge has a profile similar to that of the cornice. A round decorative panel with floral decor is on the rear wall of the niche, and two lamps with fabric shades hang above the table.

A matching credenzalike piece of furniture stands at one wall of the hall (see fig. 193). It has a lower section with square fluted legs and a thick table top with four superimposed cavetto moldings; the lower section also has a rear wall which, like the legs, bears carved decoration in the center. The tripartite upper section, within a frame recessed five times, has a niche and two flanking compartments with doors. Above the niche is a somewhat wider open superstructure in the shape of a steep gable. Its sloping sides have the same moldings as the case below, and combine with the oblique edges of the lower section in a dynamic composition. Opposite the seating niche is a small group with two armchairs and a window with decorative glazing.

Bibl.: *Interieur* XV, 1914/1915, pl. 12; *ID* XXV, 1914, 103ff.; XXVII, 1916, 223; *MBF* XIII, 1914, 512.

Cat. 187 1914

Exhibition design: Ladies' Salon in the Exhibition of Austrian Arts and Crafts 1913/1914
Austrian Museum for Art and Industry
Execution: Jacob & Josef Kohn, Vienna

This room was planned to demonstrate the artistic potential of bentwood. Hoffmann placed

a group with a half-round bench, round table, and two chairs in a large niche. The round niche and other wall surfaces in the room are framed by a stenciled floral border. The bentwood chairs are U-shaped with the U opening in front; they have an upholstered seat with fluted vertical edge, and four straight legs. Diagonal struts form an inscribed X at the chair backs; within the upper and lower triangle thinner bars crisscross. Curved struts run to the sides. The semicircular bench has matching struts and crisscrossing bars at the back. The same fabric is used in the upholstery and on the curtains behind the glass doors of a cabinet with several doors, which are designed with a zone of delicate bentwood ovals; circular mirrors in bentwood frames hang on the walls.

Bibl.: *Interieur* XV, 1914/1915, pl. 7; *ID* XXV, 1914, 103ff.; *MBF* XIII, 1914, 511.

Cat. 188 1914

Design of rooms in the Austria House at the International Exhibition for Book Trade and Graphics (BUGRA)
Leipzig
Carpentry and cabinetwork: J. Soulek

The rooms of an existing building were to be designed to create a unified overall effect despite the variety of materials on display. Hoffmann solved the problem by providing both built-in and free-standing showcases and glazed lecterns in addition to displaying on the walls posters and framed works of graphic art. He limited the color scheme to white and the colors of the Habsburg Monarchy—black and yellow—and used a single principal motif—the arch—in various forms. Perspectives drawn by Karl Bräuer for Hoffmann's two most important rooms were published. They essentially agree with the execution, but the hall, originally planned with a barrel vault and distinctive mural painting, was simplified. The paintings, which anticipated works of the 1920s, were replaced with wallpaper. The barrel vault was eliminated, and bands with inscriptions, which would have been on the arched surface, were placed on beams below the flat ceiling. On the long sides of the room are multifoil arches with wooden edge moldings and horizontally striped casings between piers with low recessed bases. The other exhibition galleries are also articulated by bases, moldings, cornices, and striped casings, always forming clearly outlined areas.

Especially important is the "hall of honor," a long gallery with wide, arched central openings. On the long walls built-in showcases with arched tops flank these openings. A boldly projecting cornice with cyma profile and floral decoration provides the transition between wall and ceiling.

Cat. 188. International Exhibition for Book Trade and Graphics, Leipzig, gallery (cf. text fig. 210)

In one of the galleries the way in which lateral extensions join the main space is especially noteworthy. The two piers flanking the opening have a decorative cladding and edge molding, which rises from the base and runs across the opening, as on a door. One would expect that the wall plane would start above the edge molding, but this is only partly the case. The wall plane begins next to the pier, but then a semicircular arch is spared out allowing a view into the adjoining room. Then follows a wall surface, another arch, etc. All in all, the wall above the horizontal molding is interrupted three times by open lunettes.

A similar but simpler solution recurs several times in this room, where an opening with a lunette above the center of a lintel was inserted.

Bibl.: *Internationale Ausstellung für Buchgewerbe und Graphik, Leipzig 1914, Österreichisches Haus,* catalogue, Vienna, 1914, 26, 27; *Architekt* XX, 1914/1915, 17, 18, pls. 49, 50; Eisler, 67–72.

Cat. 189 1914

Design of an automobile for Director General A. Pazzani

Cat. 190 1914

Furnishings of rooms for Otto Primavesi, Olmütz (Olomouc), Czechoslovakia

Cat. 191/1-4. Designs for soldiers' graves

Cat. 191 1915

Soldiers' graves and war memorials, sample designs

Toward the end of 1914 it was decided that the teachers and their classes at the Vienna School of Arts and Crafts should submit designs for dignified war memorials. In 1915 selected examples were published and in the Winter 1916/ 1917 an exhibition *Kriegergrab und Kriegerdenkmal* (Warrior's Grave and Warrior's Memorial) was held at the Austrian Museum for Art and Industry. Hoffmann worked out a number of designs but not all were published.

1. Two typical stone forms, about 1m high, if possible in limestone or granite, chiseled, lettering incised, lightly colored.

Both forms are based on rectangular blocks about 20cm thick with oblique edges: in one case they run inward so that the side of the block resembles half of an irregular X; in the other they run outward so that the outline of the block looks like a hexagon with elongated horizontal sides.

2. Grave marker of wooden posts in dovetailed construction, nailed with wooden nails, 1.8m high.

Two thick boards with plain edges are joined to form a steep roof with a cross on the ridge. The lower half of this ∧ is filled by a panel which bears name and year below a cross and a carving above. The memorial stands between two small trimmed bushes on a low grassy platform with sloping sides.*

3. For repeated use in a forest cemetery. The grave is of squared wood, 1.4m high, rough hewn, lightly cut with spoon chisel.

A rough wooden pillar with simple incised articulation at the base and a central band with the name of the fallen; at the top is a border and knob worked into a cross. The manner recalls the grave of Carl Hochstetter (see Cat. 49).

4. A grave of brick. The tablet for the inscription is of terra cotta. A type for repeated use in a small cemetery. Height 1.5m.

A stele with a top consisting of two large sloping bricks which form a gable; its triangle is left open. Below the pediment is the inset tablet for the inscription. The design is related to a somewhat more monumental one in stone for which Hoffmann's sketch is extant (see fig. 212).

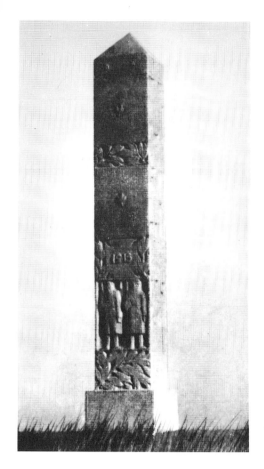

Cat. 191/6-11. Designs for soldiers' graves and war memorials (cf. text fig. 212)

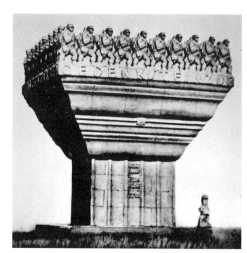

5. On the same sheet with the sketch of the above stele, Hoffmann suggested a steep pyramid—almost an obelisk—as a single tombstone. In 1919 he designed the Knips family tomb with a pyramid (see Cat. 219).

6. *Memorial for a hillock in flat terrain, surrounded by trees. The hillock is about 50m in diameter. The memorial is 6m high. The obelisk measures 80cm x 50cm, limestone.*

An obelisk with straight sides and pyramid top stands on a straight base. The front has low reliefs: soldiers with rifles on a base of laurel leaves, above them the year in a cross between leaves, further above a strip of leaves and single leaves and crosses.

7. *Group tomb on the battlefield. A typical form which can also be enlarged.*
The tomb in the sketch is intended for six men. The stone should be placed along a highway or better just outside the town parallel to the house fronts or in the town parallel to the front of the church. The inscription tablet is of cast iron. The whole stone is 2.2m high.

A huge plain block with beveled front edge. Six square cast iron tablets in two rows are set into the upper half of the front; they bear the inscriptions under crosses. The lower half bears the incised year.

8. Memorial in the form of a stone pillar which bears a four-sided capital with four superimposed cavetto moldings and a crowning low pyramid. The year is carved in relief high on the front of the capital. The pillar has five relief panels. One with a soldier and one with leaves and cross are at the top. A horizontal panel with a messenger dog is in the middle; the bottom panels contain a soldier and a sword with leaves.

9. *(War) cemetery within a country cemetery. The single grave markers are of iron, 1.3m high, the tablets of sheet iron, the spears, which also serve to stiffen the tablets, about 3m high. The dedication appears on an inscription tablet on the enclosing wall.*
The grave markers are tall rectangles with oblique gablelike tops, raised borders, and inscriptions under a center cross. Behind the markers, uhlans' lances rise skyward.

10. *Memorial stone. A simple memorial stone placed under oaks where the trees either show some natural order or where order has been imposed by some felling. The stone is 3m long, 2m high, 1m deep.*
The huge block, which would weigh about 17 tons, rests at each end with about one quarter

Cat. 193. Knips apartment, living room

of its undersurface on a flat block. The front has a simple molding at the edge and bears the inscription. On each side is a chiseled wreath.

11. Monument in the form of a giant pillar capital, about as high as a four-story house. The lower third of the monument is a fluted rectangular pillar with an inscription in the center. The capital is made up from repeated cyma moldings and has a large inscription on the abacus. Marching soldiers are represented at the top.

12. An unpublished monument, related to the above design, in the form of an oversize capital on a pier but enriched by a second smaller pillar which rises above the center and supports a statue on its capital.

*A related form was given to the tomb of Fritz Schwarz on the Grinzing Cemetery, Group 14.

Bibl.: *Architekt* XX, 1914/1915, pls. 91, 93; *KuKhw* XVIII, 1915, 284-291; *DKuD* XXXVII, 1915/1916, 181; *Soldatengräber und Kriegsdenkmale, herausgegeben vom K. K. Gewerbeförderungs-Amte*, Vienna (A. Schroll), 1915.

Cat. 192 1915

Furnishings for apartment Gödl-Olajossy, Linz, Upper Austria

Cat. 193 1915-1916

Furnishings for Anton and Sonja Knips
Vienna VII, Gumpendorferstraße 15
Start of planning: June 1915

An existing apartment (Cats. 79 and 129) was enlarged by the addition of rooms so that it occupies the entire second floor of an apartment house. Newly furnished are anteroom, living room, smoking room (library), boudoir, dressing room, bedrooms, and sons' studies. Especially noteworthy are the anteroom wainscoted with square wooden panels enameled white, the richly furnished living room, and the rooms for the client and his wife.

In the living room a showcase with rich openwork carving and high fluted legs stands next to a door with a triangular *sopraporta*. Above the showcase hangs a landscape by Klimt, flanked by two small lamps. Opposite the door a matching wainscoted panel with triangular top provides the background for a small sculpture on a fluted pedestal. The wall opposite the windows is divided into five rectangles containing mirrors or a showcase. In the center is a fireplace with a round table and upholstered chairs in front. The rooms of the client and his wife are wain-

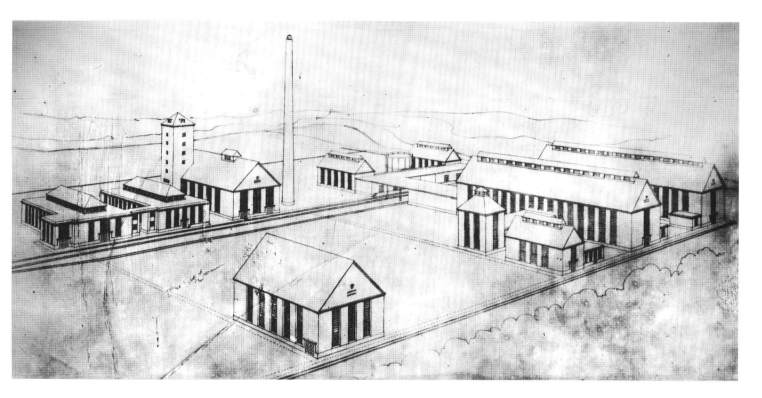

Cat. 195/I, II. Wacker Works Burghausen, perspective (cf. text fig. 214). Key: 1. Workshops
2. Boiler house 3. Carbide storage 4. Oxygen plant 5. Electrolysis plant 6. Main hall I
7. Main hall II

scoted, with bookcases replacing part of the paneling in the man's room.

Bibl.: *Architekt* XXI, 1916-1918, pls. 14, 15; *ID* XXVII, 1916, 233; XXVIII, 1917, 394; *DKuD* XLI, 1917/1918, 120; *ÖBWK* II, 1925/1926, 53.

Cat. 194 1915-1916

Furnishings for Heinrich Böhler, Munich, Germany, and St. Moritz, Switzerland

Cat. 195 1916

Dr. Alexander Wacker Company for electro-chemical industry, plant in Burghausen on the Inn, Bavaria

Dating: According to the plan book, design drawings were made in Vienna at the end of January 1916; the plans based on them were completed by the Munich architectural firm of Rast Brothers up to the end of March or the beginning of April. A photo of the works in November 1916 shows all the buildings on Hoffmann's perspective of the entire layout completed except the large Hall II. Hall II and several additional large buildings were erected by the end of 1917; Hoffmann had nothing to do with their planning although they follow his general forms. It is significant that the plans submitted

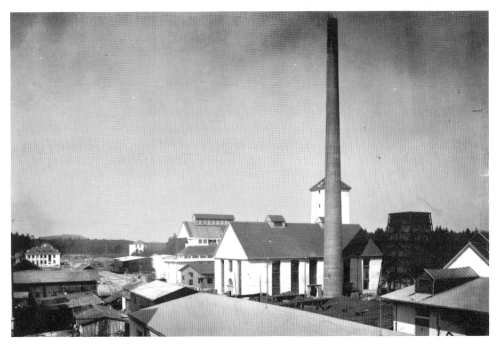

Cat. 195/III. Wacker Works Burghausen, view

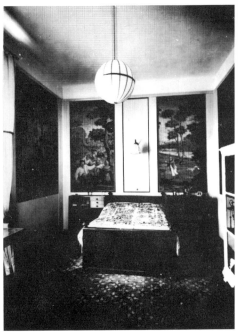

Cat. 196. Berta Zuckerkandl apartment, bedroom

by Rast Brothers bear the note "Architecture: Prof. J. Hoffmann-Vienna"; plans for the entrance and administration building completed in 1917 no longer bear this note.

Layout: The site is a level wooded area; the neighborhood is not built up. It is divided by east-west railroad tracks. The first building in the southern section is the oxygen plant(4). Then at a distance are Halls I(6) and II(7) and the smaller electrolysis building(5). In the northern section the first building is the workshop(1), then the machinery- and boiler house(2) with its tower and tall chimney, and finally the two-wing carbide storage(3) with loading ramp and nearby gasometer.

For the *Buildings* the architect created a type he varied according to the requirements of each work place. It is a rectangular hall in stuccoed brick with a 40-degree gabled roof. The main cornice with hanging gutter has cavetto moldings; the profile is carried around on the rake of the gables. The roof ridges frequently bear a ventilator with windows and a pyramidal roof. The fenestration strives for regularity and symmetry. The oxygen plant, for example, before it was enlarged, was a building in which all facades were symmetrical. The south front has one window; the north has three. The sides have five windows and, like the gable facades, wide wall surfaces at the corners. The only difference between east and west facade is that there are three entrance doors on the east. The windows are mostly uninterrupted, tall openings (12m in Hall I) from base to cornice, set back and framed by a simple cavetto molding with fillet. Metal bars hold the glazing. Entrance doors are set into a narrow stuccoed strip in the plane of the base; a projecting cornice forms the top.

Required additions or annexes have flat roofs but are otherwise of matching design. Only the tower at the northwest corner of the machinery house interrupts the scheme. It is 9m square and about 35m high and has three small windows on each of the three lower stories, and one each in the five upper stories. It terminates in a cornice and pyramidal roof with a dormer on each side. The tower serves no obvious practical use. Some of Hoffmann's buildings are extant, but have been modernized.

Bibl.: Plans and photographs in the archive of the Burghausen Works of Wacker Chemie G.m.b.H.; Photo of the perspective view: WWA.

Cat. 196 1916

Furnishings for Berta Zuckerkandl
Vienna I, Oppolzergasse 6

The interiors of medium-sized rooms in a corner house on the Ringstraße include a salon with upholstered furniture, a small dining room, and a bedroom decorated with tapestries from the owner's collection. In the salon a wall is divided to about midway into framed panels for the display of Japanese fans and color woodcuts. The same foliage-and-blossom pattern as in the Fashion Department of the Wiener Werkstätte (see Cat. 197) is used for walls, ceiling, curtains, and lamp shades in the dining room. It suggests a symbolic "arbor," furnished with an oval table and six bentwood chairs and a plain buffet with a stepped, glazed top.

Bibl.: Photographs: Estate.

Cat. 197 1916

Fashion Department of the Wiener Werkstätte
Vienna I, Kärntnerstraße 41
In collaboration with Eduard Wimmer

An inconspicuous entrance and two show windows adapted to the historic facade were built on the street side of the former Esterházy Palace, whose interior had been remodeled in the 19th

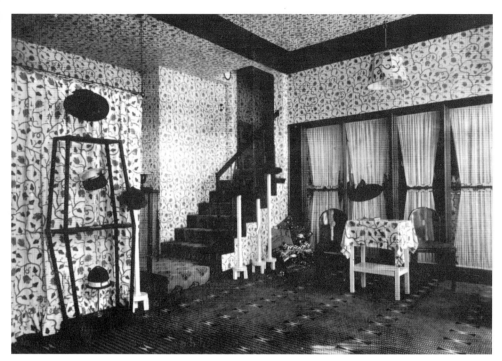

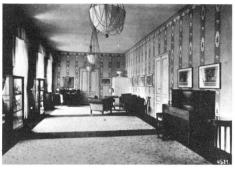

Cat. 203. Living room and study of Paul Wittgenstein, Sr.

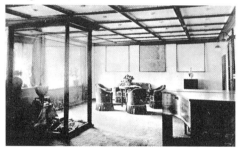

Cat. 197. Fashion department of the Wiener Werkstätte, reception room

Cat. 204. Studio of Heinrich Böhler

century. Behind them is a reception room; the walls and ceiling are covered with a foliage-and-blossom pattern while the floor has typical Wiener Werkstätte carpeting in black and gray. Built-in showcases are along two walls. On the rear wall a stair leads up to the display and dressing room arranged in a historic salon with adjoining gallery. In the room of the artistic director, Eduard Wimmer, also on the second floor, there is the same high-back chair that was used in the Flöge fashion salon (Cat. 89).

On the ground floor a sales- and dressing room adjoins the reception room. Walls, vaults, and cabinets are stenciled with a design of slim pointed leaves. A contemporaneous review praised "the harmonious manner in which the new has been integrated with the distinguished historic old." The rooms were altered after the dissolution of Wiener Werkstätte.

Bibl.: Photographs: WWA: ID XXVII, 1916, 340ff.

Cat. 198　　　　　　　　　　　　　　1916

Furnishings for the salesroom of the Wiener Werkstätte
Marienbad (Mariánské Lázně), Czechoslovakia

The same foliage pattern as in the Vienna shop was used on the walls of the salesroom and for the curtain of the dressing room. The sales table

in the center and a large showcase with higher triangular center have rhythmic fluting.

Bibl.: Photograph: WWA.

Cat. 199　　　　　　　　　　　　　　1916

Project: House for Director Hatianek, Poldi-hütte

Cat. 200　　　　　　　　　　　　　　1916

Kevevára tomb

Cat. 201　　　　　　　　　　　　　　1916

Tomb for Olga and Gustav Steiner, Vienna

Cat. 202　　　　　　　　　　　　　　1916

Stross tomb, Vienna, Central Cemetery(?)

Cat. 203　　　　　　　　　　　1916-1917

Furnishings for Paul Wittgenstein, Sr.
Vienna VIII., Friedrich-Schmidt-Platz 6
Execution: Wiener Werkstätte

A very large room with four windows was furnished as a living room and study, incorpo-

rating some existing Biedermeier furniture. Walls and carpets are in pink tones. The apartment also includes a dining room in light brown wood with a display case for porcelain, and chairs with an arcade motif. A bedroom with case furniture and rectilinear "sled" chairs, and furniture for subsidiary rooms complete the furnishings, which were divided among the heirs after the owner's death.

Bibl.: A set of original photographs with the stamp of the Wiener Werkstätte in possession of the family.

Cat. 204　　　　　　　　　　　1916-1917

Furnishings of studio for Heinrich Böhler
Vienna I, Schwarzenberg Palais

A large room with wide window opening on the park was furnished with upholstered furniture, resembling the Hodler furniture (Cat. 180), a grand piano, and a free-standing show-case reaching to the ceiling. The ceiling is divided by dark moldings into square panels with small stucco decorations in the center. On one wall hangs the painting *Castle Pond in Kammer(?)* by Gustav Klimt. The interior is not extant.

Bibl.: *Décoration Moderne*, Paris (A. Morancé), 1929, pl. 83; the illustration is not designated, and the present identification is made on the basis of the Klimt painting visible in the background, which was owned by Heinrich Böhler.

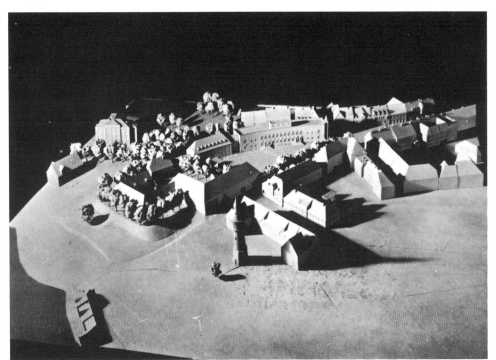

Cat. 206/I. Town planning project Ortelsburg, model

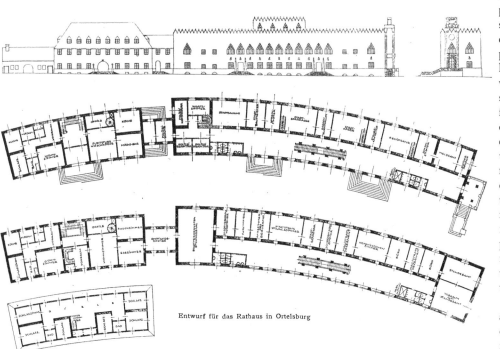

Entwurf für das Rathaus in Ortelsburg

Cat. 206/II. Design for Ortelsburg City Hall (cf. text fig. 213)

Office furnishings for Rudolf Weinberger
Vienna IV., Schwindgasse 10(?)

*Project for the rebuilding of Ortelsburg
(Szczytno), East Prussia*

Dating: Hoffmann began work in 1916 on projects for the rebuilding of the East Prussian town of Ortelsburg, destroyed by the Russians and adopted by Vienna; plans for "courthouse, Baptist chapel, water tower, Gorfinkel house, etc.," are mentioned in the register of plans. At the beginning of 1918 plans at a scale of 1:200 for a new town hall were made after "detailed studies on the site" (Dagobert Frey); the collaborator on the project was Philipp Häusler.

Town planning: Hoffmann proposed a solution with a spacious, enclosed main square at the end of the slightly curved main street. He integrated the existing castle with the rear wall of the square and curved the right side of the square with the town hall in the opposite direction from the existing curve of the street, which creates better visibility and spatial effect. Just before the site of the former town hall the main street divides into two arms, one of which leads to another important building behind the town hall. At this fork Hoffmann placed a bell tower, dominating the urban design.

The town hall, together with the adjoining officials' house on the left, forms the most important front on the main square. It is a two-story building with high base and flat roof concealed behind a high parapet. The symmetrical plan is divided into two longitudinal strips. Behind the spine wall are the offices. In front is a wide corridor hall, with a straight monumental staircase in the center. At the left end of the first and second floors, the corridor hall does not continue, so that here the rooms take up the full depth of the building. Toilets are built in near the ends of the corridor hall. Main entrances are right and left of a seven-bay central section. Another entrance is on the right in the open bell tower adjoining the town hall. On the ground floor are the traffic-generating public offices—registration office, cashier, building office, and police—while the upper story houses meeting rooms and ceremonial spaces. On the left of the town hall a narrow connecting wing gives access to the officials' residence.

The plan of the officials' residence is organized around a central entrance hall and large staircase. On the left are identical apartments on the first and second floors, containing living room, bedroom, kitchen, maid's room, and subsidiary rooms; on the right is one larger apartment which

extends over both stories and includes bedrooms in the finished attic. The house has a high hipped roof with pointed dormers. The windows reach almost to the cornice. A three-sided open stair leads to the arched main entrance flanked by free-standing candelabra. Another entrance gives access to the separately roofed connecting wing.

The symmetrical main facade of the town hall has seventeen bays. Eleven of them, spaced more narrowly, form a central group. On the ground floor seven square windows in the center are flanked by entrances with their open stairs and obelisklike candelabra; at each end is one more window. The window above it, on the second floor, is topped with an equilateral triangle. Heraldic escutcheons appear above the windows and entrances on the first floor. The facade is rendered in plain stucco, only the basement story with its half-round windows is ashlar. The first-floor windows rest directly on the base. The top of the building is parapeted with pointed battlements, giving a saw-tooth effect. A crenellated superstructure with small triangular windows rises above the center of the building.

The lateral facade, visible at a great distance from the main street, is almost square above the base, and the windows match those on the main facade. An open, free-standing, octagonal bell tower is part of the facade composition. It stands on a masonry podium with balustrade, reached by a comfortable open stair. Here an arched gate, framed by relief figures, gives access to the building. From the podium compound corner pillars rise above roof height where they carry a platform with coffered soffit and oblique parapets decorated by figure relief. Below, on the second-floor level a balcony with multiply curved, ornamented parapet is set between the pillars. At the outside of the pillars round shafts bearing sculptured figures rise beyond the balcony. The balcony door is treated as one of the windows; it is surmounted by a large clock. On top of the tower a pyramidal roof, supported by columns, shelters a large bell. The architraves between the columns rise steeply on either side of each capital, giving the eaves a zigzag line.

The square in front of the bell tower holds an over-life-size replica of the statue of a knight from the top of the Vienna city hall. In the last version of the project the bell tower appears greatly simplified.

Bibl.: *Architekt* XXIII, 1929, 65ff.; *ÖBWK* II, 1925/1926, 41ff.

Cat. 207. Project for World Peace House (cf. text fig. 215)

Cat. 207 1917

Project sketch for a World Peace House

Prof. Erwin Hanslik wanted international attention for his "place of cultural cooperation, as a way out of national struggles, and World Peace House." At his request and based on his data, Hoffmann sketched a large symmetrical plan, measuring about 90m x 140m. The main rooms are linked by a system of pillared halls, corridors, and loggias, which is based on a square grid. The description assumes that the front of the building faces south.

The building has a base with a wide, open central stair flanked by two smaller stairs. Pillars with an axial spacing of 4m carry a flat roof which shelters an open passage extending around the entire complex. Wings of various sizes and heights are grouped around several courtyards. At the right and left of the deep lobby in the center of the building's front are the two-story galleries of the World Economy Show. Parallel to them runs a corridor to two groups of cloak rooms and toilets, and to two large halls in the east and west. These halls and the central hall behind the lobby rise high above the rest of the building. The central hall is equipped with stage, film, and broadcasting facilities; the left hall is

intended for art exhibitions(?); the right hall as a reading room(?). Between are two large courtyards; masts over 40m high stand in the centers. Office wings are north of the courtyards between the two lateral halls.

The facade treatment is only suggested, but it is evident that the gallery for the World Economy Show has rectangular windows, while the large halls have hipped roofs and wall arcades.

Bibl.: Originial drawings: Estate; Photograph: BAV.

Cat. 208 1917-1918

Wiener Werkstätte Shop, Department for Fabrics, Lace, and Light Fixtures
Vienna I, Kärntnerstraße 32/Führichgasse

The fabric department of the Wiener Werkstätte is in a building at the corner of the Kärntnerstraße and Führichgasse (Hotel Astoria) with a shop front on each street. A salesroom for light fixtures and other rooms are on the second floor.

Access from the Kärntnerstraße is by a narrow reception room which at its rear has a stair of three flights with a massive parapet. Walls, parapets, and ceiling are painted with scattered scenes and motifs consisting of flowers and birds, cupids, amorous couples, mythological figures, etc. On the upper flights of the staircase, two pointed niches are set into the wall and painted with figurines by Hilde Jesser. The pointed motif recurs in the salesroom at the top of the stairs. The ceiling of this long, narrow room is twice stepped obliquely. Ceiling paintings by Felice Rix continue in the manner of the staircase. The side walls have built-in cabinets with closed shelves below and showcases with multiply curved decorative bars above, whose pattern is repeated on the windows and stands out effectively against the daylight. A long table with rounded ends and cabriole legs is in the center. Three light fixtures with ribbed fabric shades hang from the ceiling; similar ones are also used in the other second-floor rooms.

In addition to subsidiary rooms, there is a large salesroom for fabrics and a smaller one for light fixtures. The latter has a coffered ceiling for the display of chandeliers; the former has a ceiling with an oblique cut-off, recalling the double stepping in the smaller neighboring room. The walls here are also entirely lined by built-in cabinets. These and the ceiling are painted with inconspicuous floral motifs by Reni Schaschl. Large tables with thick, vertically grooved tops, colorful upholstered chairs, and an oval mirror complete the furnishings. The parquet floor is bare.

Bibl.: Photographs: Estate and WWA; *DKuD* XLIII, 1918/1919, 373ff.; *Die Wiener Werkstätte 1903-1928*, Vienna, 1929.

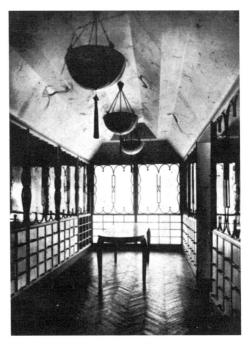

Cat. 208/I, II. Wiener Werkstätte, shop front on Führichgasse; salesroom of textile department in upper story

Cat. 209 1917-1918

Furnishings for Erwin Böhler
Vienna I, Parkring 4

Several rooms were newly furnished in an existing *palais*. In the salon are tall upholstered armchairs and a table with a thick grooved top and cabriole legs, enameled gray. A long low buffet with rhythmic fluting was made for the dining room, and a mirrored wall with dressing table for the lady's dressing room. The rhythmic fluting is repeated on the base of low glazed bookcases. Their shelves, sides, and upper parts are richly carved with foliage forms. The bedroom is in walnut.

Bibl.: Photographs: Columbia and Estate.

Cat. 210 1917-1918

Exhibition design: Exhibition of Austrian Art in Copenhagen and Stockholm

Hoffmann was commissioned to arrange exhibitions in two Scandinavian capitals as part of an Austrian cultural program in neutral countries.

Cat. 211 1917-1919

Changes on buildings at the Poldihütte steelworks in Kladno and Komotau (Chomutov), Czechoslovakia

Cat. 212 undated (before 1918)

Small industrial or workshop building for the Marx paint factory(?)

An undated facade design shows a small building consisting of a main hall about 7m high and 10m wide, and an annex, about 5m high and also about 10m wide. The buildings are brick and have a slightly projecting soldier course as cornice below a flat roof. A second soldier course marks the base and forms the window sills.

The facade of the main building is bordered by two lateral wall strips and slightly projecting bases. Over the windows are multiple (probably stepped) frames in the shape of an inverted U, resting on the lintels. The lintels in turn rest on light colored (probably stone) impost blocks; this treatment is repeated in the annex. Rhombs with cross axes are formed by the glazing bars of the lower panes in the main building. Above the roof of the main building a ventilator with three small windows is flanked by two sheet-metal chimneys, about 8m high, with exhaust tops, protective roofs, and guy wires.

Bibl.: Drawing: Estate.

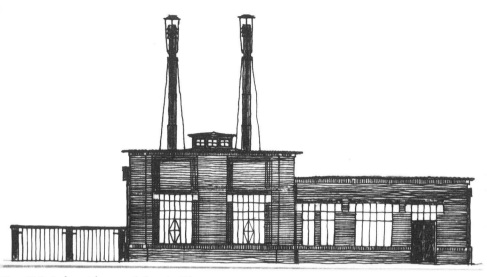

Cat. 212. Industrial or workshop building

Cat. 213 1918

Project for Pazzani Palais, Vienna III

with two lateral projections and an open stairway at the main entrance. A turret with broken outline is at the center of the roof. The plan is conceived with a large entrance hall giving access to all other rooms. The high windows have shutters; above them oval elements (ceramics?) are set into the stucco.

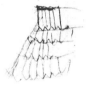

Cat. 214 1918

Furnishings for apartment of Dr. Berstel
Wiener Neustadt, Promenade 4, Lower Austria

An alternate elevation is indicated at the left of the sketch.

Cat. 217. Pazzani estate manager's building, sketch for project

Bibl.: Drawing: Estate.

Cat. 215 1918

Furnishings for Primavesi apartment
Vienna I, Tegethoffstraße 4

Cat. 218 1919

Preliminary project: Office building for Poldi-
hütte

Cat. 219. Knips Tomb

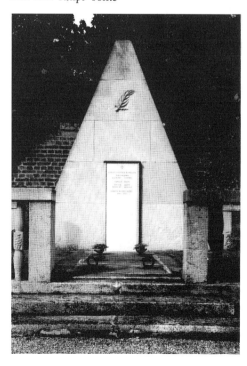

Cat. 216 1918

Exhibition design: Wiener Werkstätte Shop at
the Leipzig Fair

Cat. 219 1919

Knips Tomb
Vienna-Hietzing Cemetery, Group 32, B-Vault

At the cemetery wall, large stone slabs form a trapezoid symbolizing a pyramid. The inscription tablet is in the lower part and a branch is chiseled in the upper part. In front of the inscription tablet is the lid of the vault with four rings. The grave with two standing lanterns is bordered by a low stone balustrade. The tomb is in good condition.

Cat. 217 1919

Project: Manager's house for Director General
Alexander Pazzani
Pichl near Schladming, Styria

A preliminary design for a one-story manager's house with basement and steep roof was sketched for Director General Pazzani, owner of the Pichlmayr Estate (see Cat. 224) near Schladming. The building is conceived in the manner of a country house, strictly symmetrical

Cat. 221. Tomb for Egon Schiele, design sketch

Cat. 224. Pichlmayr Estate, addition and remodeling, elevations

Cat. 225. Groß Ullersdorf (Velké Losiny) Spa, view 1971

Cat. 220 1919

Design for the tomb of Kolo Moser, Vienna

Cat. 221 1919

Design for the tomb of Egon Schiele

A band of lettering is placed above a torus molding on a low stone base that forms an approximate square about 2.20m x 2.40m. Above it rises an earth or turf pyramid with a 50-degree slope.

Bibl.: Original sketch: Estate.

Cat. 222 1919

Pazzani Tomb

Cat. 223 1919

Tomb of Dr. Hamburger, Freudenthal (Bruntal), Czechoslovakia

Cat. 224 1919-1920

Addition and alterations to the Pichlmayr Estate for Director General Alexander Pazzani
Pichl near Schladming, Styria

An addition of five bays with glazed veranda was joined to the south facade of the main building of the Pichlmayr Estate, a former Salzburg official estate in a prominent location on a south slope. The new wing harmonizes fully with the old building; only certain decorative details and, above all, the new entrance door with lantern show Hoffmann's touch. This two-leaf door, drawn by Eduard Wimmer, has a carved ledge strip at the rebated joint, small windows with a grillwork of olive branches, and, in the transom window, a grille with plant motifs and the initials

of the client: A.P. A Madonna with child in glazed ceramic is set in between the two windows above the lantern.

Various smaller farm buildings and alterations for the Pichlmayr Estate were also planned, including a tool shed and a garden house, which were drawn in November 1920 by Gabriel Guevrekian.

The building now houses a tourist facility; it was remodeled and enlarged in 1966 and Hoffmann's contributions were greatly altered.

Bibl.: Print of Plan 4453 (views 1:100): ÖMAK.

Cat. 225 1919-1920

Alterations and additional stories for a sanatorium
Bad Groß Ullersdorf (Velké Losiny), Czechoslovakia

An existing building received additional stories and other parts. Alterations were made on the interior; a new music pavilion and glazed veranda were planned. After completion, the building had an additional wing with a gently curving sheet-metal roof and a ribbon of large windows on the upper facades; engaged piers articulate the central section, and above the windows there are lozenge-shaped elements.

Bibl.: Register of plans, *Vlastivědný věstnik Moravský* XXXV, 1983, 68; Photographs courtesy of Ing. Arch. Vladimir Šlapeta.

Cat. 226 1919-1922

Sigmund Berl House
Freudenthal (Bruntal), Hussova Ulice, Czechoslovakia

The house is located at the edge of a small industrial city; Max Fellerer drew the submitted plans. The lot slopes away from the street and

on the garden side the house stands on a large terrace of random ashlar that has three large arched openings toward the garden. A second, smaller terrace with railing sits atop the first terrace from which it is reached by two lateral stairs. On the street side the ground floor is reached by a long flight of steps to an entrance porch with pillared roof. The steps are required because the basement is partly above grade, i.e., the sills of the semicircular basement windows are just above street level.

The plan can be inscribed in a rectangle (about 12m x 20m) to which is added a three-bay central projection on the garden side. The front entrance is off-center at the right in the otherwise symmetrical street facade. It leads to a vestibule with cloakroom and toilet. Through a vestibule door on axis with the entrance the great hall with the main staircase is reached. Next to the hall are a salon and smoking room on one side and on the other the dining room, pantry, and kitchen with storeroom and a circular stair. The kitchen can also be reached from the vestibule by way of the cloakroom.

Access to the bedrooms and subsidiary rooms is from the upstairs central hall with built-in wardrobes. The light-filled breakfast room is in the garden projection; below it is an open loggia with pillars. The white stuccoed main block and the projection have gray slate hipped roofs and equally hip-roofed box dormers that play an important role in a total effect which is characterized by a feeling of closure. The upper-story windows, except those in the central projection, have artificial stone flower boxes. These boxes and the convex main cornice have rich floral decoration applied in stucco. The corners of the house, window surrounds, and pilasters in the projection also have stucco decoration. Slim ornamental moldings divide the facade vertically, and there are small stars next to the windows and blossom motifs below the flower boxes. The

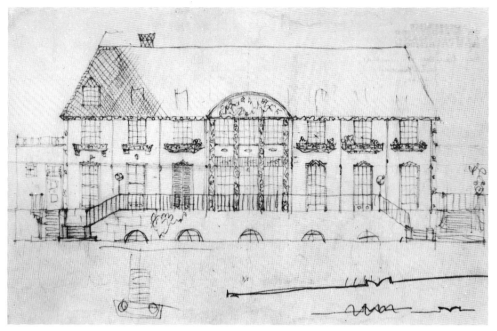

Cat. 226/I. Berl House, early facade design

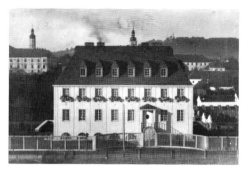

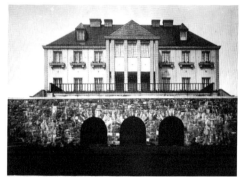

Cat. 226/IV, V. Views of street and garden side shortly after completion

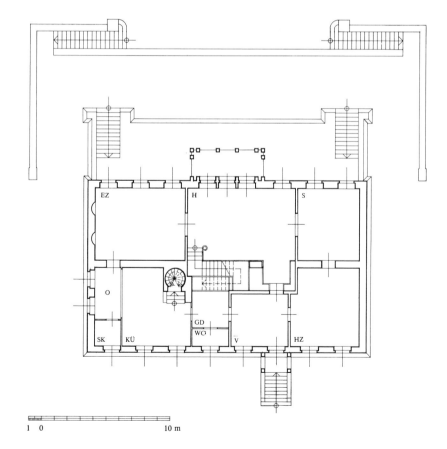

Cat. 226/II, III. Plan of ground floor; design sketch for ground floor and upper floor (cf. text figs. 219-220, 223-227)

Cat. 226/VI. Berl House, facade detail

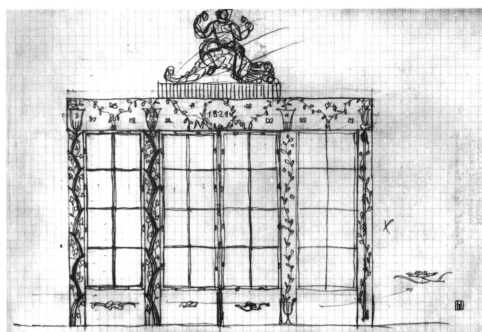

Cat. 227. Café-restaurant Laxenburg, facade design for garden pavilion (cf. text fig. 217)

Cat. 226/VII, VIII. Hall with easy chair; sketch for furniture

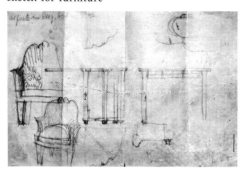

corners and pilasters have a strongly horizontal articulation, contributing to the rich total effect. An earlier design shows a segmental pediment over the projection and French windows with pedimented tops. A detail study of the facade reveals that even richer decorative possibilities were considered.

Inside, white and tones of gray blue eggshell finish, relieved by colorful upholstery, predominate. The dining room is rosewood; the smoking room is walnut against light yellow walls. In the hall the horizontal panels of wainscoting are painted gray like the furniture. The upholstered seating has strong curves and a strong multicolored pattern on a black ground; a design is extant. It is noteworthy that the doors to the salon and dining room have circular glazed openings with multiply curved edges (see fig. 220) instead of panels. The radiators are covered with latticed wooden grilles.

The house now serves as a maternity center and children's clinic. The interior is entirely changed, and the facades have lost a large part of their decoration, including the flower boxes. The entrance and dormers on the street side were also altered. It could not be determined whether any furnishings remain.

Bibl.: *MBF* XXIV, 1925, 289ff.; Fries, 190ff.; Design sketches, facade details and photographs: Estate and Estate Max Fellerer.

Cat. 227 1920

Project for a café-restaurant in Laxenburg, Lower Austria

Hoffmann designed a main building and small garden pavilion. The main building has a symmetrical facade with a terrace in front and lateral projections crowned by steep gables. The two-story facade has tall round-headed French windows with shutters on the first floor, and shuttered squarish windows on the second floor. Decorative sculptures were planned in the gables and between the windows, and slender pilaster strips were to provide vertical articulation.

The flat-roofed garden pavilion has four bays, with sculpture on a base above the coupled central windows. The slender piers are richly ornamented with stylized plant motifs. Walls above and below the tall windows also bear decorative motifs, creating a rich and lively overall effect. The date 1821 within a wreath is centrally displayed on the facade.

Bibl.: Drawings: Estate and Estate Max Fellerer.

Cat. 228 1920

Project for hotel and bank building for Srbska Zadruzna Banka in Novi Sad, Yugoslavia

Cat. 229. Bernatzik Tomb

Cat. 231/I, II. Fritz Grohmann House, view and ground plan

Cat. 229 1920

Bernatzik Tomb
Vienna-Heiligenstadt Cemetery, Group I

The actual grave of this tomb in front of an
overgrown retaining wall was designed with a
low stone enclosure and slab with rings, like all
graves in this part of the cemetery. The tomb-
stone of unpolished granite consists of a base
and double upper part. Total height is 1.55m,
width is 1.1m, depth about 39cm.

While the base has a simple rectangular sur-
face, the upper part is more complex. Its two
halves consist of rectangles (55cm x 47cm)
topped by isosceles triangles (height, 30cm). All
surfaces are enclosed by simple moldings; the
upper sections have inscriptions and stylized
leaves. The lower one has only four inscriptions.
The block lettering projects from the stone. The
tomb is well preserved.

Cat. 230 1920

Tomb of Louise Gomperz-Auspitz (1832-1917)

Cat. 231 1920-1921

House for Fritz Grohmann
Würbenthal-Pochmühl (Vrbno pod Praděd),
Czechoslovakia

For an industrialist who also had his office
designed by Hoffmann, a spacious but simple
house was built on a flat parklike lot near his
factory. The plans were worked out in Hoff-
mann's office by Fellerer and Weirather.

The house is of traditional construction with
basement, two stories, and steep hipped roof.
The plan is rectangular (15.5m x 25m) except
for a recess of about 3.5m x 10.3m on the en-
trance side enclosing a terrace reached by an

Cat. 231/III. Fritz Grohmann House, view of garden side (cf. text fig. 222)

open flight of steps. The plan is organized in three strips. The central strip, behind the recess, contains a vestibule and a large hall with stairs and egress onto a semicircular terrace. One wing contains the dining room with pantry and kitchen plus a corridor and staircase; the other a smoking room, corridor, and guest room with bath and toilet. On the second floor, one wing houses the parents' bedrooms with bath and toilet, the other a child's bedroom and guest room with bath. In the central strip are two more children's rooms and a hall. Restrained stucco décor is found above the doors and on the cornice in the vestibule. It also occurs between the windows on the otherwise very plain facades. The smooth stuccoed light ochre wall surfaces run without a break from the base with its half-round windows to the cavetto molding of the main cornice. The projecting upper story window surrounds reach to the cornice and are painted in the same dark ochre as the cornice. In a similar manner the round-headed first floor windows are integrated with the base. The parapets and the window woodwork are white. On the garden facade a French window connects terrace and hall. The dormers have individual hipped roofs.

A fountain with one version of the sculpture *Kind über dem Alltag* by Anton Hanak stands in the garden.

The first floor now serves as a club for the employees of the nearby factory; the upper story is divided into three apartments. The building

is well preserved, but the furnishings seem greatly altered. The Hanak fountain is damaged.

Bibl.: Facade sketch, detail of basement window, and photographs: Estate; Fries, 196; H. Steiner, *Anton Hanak*, Munich, 1969, XIX.

Cat. 232 1921

Exhibition bedroom in cherry wood
Special exhibition of elegant apartment interiors at the Austrian Museum for Art and Industry
Opening: 11 September
Execution: Johann Jonasch

Bibl.: *Katalog der Sonderausstellung vornehmer Wohnungseinrichtungen*, Vienna, 1921.

Cat. 233 1921

Apartment furnishings for Dr. Robert Baru
Vienna XII, Schönbrunnerstraße 217 (see Cat. 242)

Cat. 234 1921

Bernatzik apartment furnishings in the Ast House (Cat. 134)

Cat. 235 1921

Apartment furnishings (two rooms) for Ernst Gallia
Vienna XIII, Einwanggasse 15

The living room has seating and a table, bookcases, and a desk in black oak with white rubbed grain; the dining room, with a large and a small buffet, was furnished in rosewood.

Cat. 236. Design for Primavesi porter's house

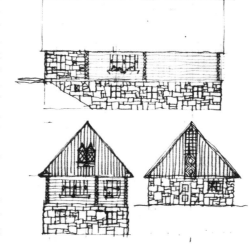

Cat. 236 1921

Project for an addition with porter's apartment to the Primavesi Estate
Winkelsdorf (Kouty), Czechoslovakia (see Cat. 179)

A small house (about 7m x 15m) on a slope, in random ashlar and log construction, with finished attic under a steep roof, matching the existing buildings. On the entrance side the house has one story, on the slope side it has a stone basement and wood upper story.

Bibl.: Design sketch: Estate.

Cat. 237 1921

Project for new hotel in Zagreb, Yugoslavia

Cat. 238 1921

Project for war memorial, Pirnitz (Brtnice), Czechoslovakia

This project and a later version of 1937 (see Cat. 469) were not executed.

Bibl.: *Uměni a Řemesla* 1970, no. 4, 10ff.

Cat. 238a 1921-1922

Alteration and furnishings of house for Dr. Kuno Grohmann
Würbenthal-Pochmühl (Vrbno pod Pradĕd), Czechoslovakia

With this project, supervised by Max Fellerer, an existing two-story house (11m x 12m) was adapted for a newlywed couple and furnished with partial reuse of antiques. A living room, dining room, and kitchen on the first floor were newly furnished. The second floor, especially the wife's bedroom, was richly appointed. A U-shaped built-in upholstered bench and a small oval table are the most important pieces in the living room. The dining room is reached from the living room through a wide opening flanked by built-in vitrines (see fig. 221); it has a low buffet and several additional showcases. The wife's bedroom has a canopy bed and a large built-in wardrobe. The furniture is executed with an eggshell finish. The cornices are carved, painted wood instead of stucco.

Some of the furnishings were taken to Vienna when Dr. Grohmann moved and are in the possession of the family.

Bibl.: Plans, photographs, and correspondence: Archive of Josef Grohmann; Fries, 198, 199, 200 (right picture; the left picture is of the Fritz Grohmann House, Cat. 231; Fries marks it erroneously as Dr. Kuno Grohmann's).

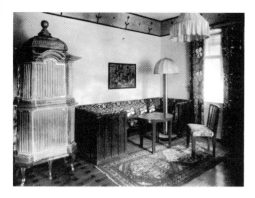

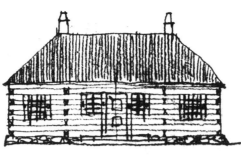

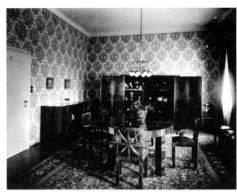

Cat. 242. Dining room for Dr. Robert Baru

Cat. 240. Design sketch for small Primavesi House

Cat. 243. Bachofen von Echt House, facade sketch

Cat. 238a/I, II. Remodeling of Dr. Kuno Grohmann House, seating niche in living room and lady's bedroom with closets

Cat. 239 1922

Furnishings of room for Dr. Taussig

Wolfgang Hoffmann worked on this project.

Cat. 240 1922

Design sketch for a Primavesi house
Winkelsdorf (Kouty), Czechoslovakia (see Cat. 179)

Hoffmann probably made this sketch, for a small one-story house (about 5.5m x 11m) with steep hipped roof, after the destruction of the large house by fire. Two broad steps lead to the house, which has a low fieldstone base. A square living room (about 5m wide) is in the center,

flanked by two square bedrooms (about 3m wide) at the right and left front. In the rear are a bathroom and a dressing room.

Bibl.: Design sketch: Estate.

Cat. 241 1922

Design for Pinell grave

A rectangle of gray granite slabs (about 2.7m x 2.9m) is bordered on three sides by a massive parapet, 60cm high and 30cm thick; in front is a rectilinear two-leaved grillwork door. At the rear is a wall, 2m high, with a tablet for the inscription and a small gilded inset panel. At the right and left are half-round niches for evergreen trees. In the parapeted precinct a narrow path, paved with black slabs, encircles the central area, which is planted with low shrubs.

Bibl.: Drawings and letter in the archive of the owners of the Koller House, Oberwaltersdorf (Cat. 172).

Cat. 242 1922(?)

Dining room for Dr. Robert Baru
Execution: Johann Jonasch

This room was richly furnished in book matched walnut veneer. The furniture includes a tall wall

cabinet, a low buffet, and an oval table with chairs. The table and chairs have square legs with horizontally grained veneer. The table has a massive top; the leather upholstered chairs have square open backs with inscribed crosses and diagonals. The room was part of Cat. 233.

Bibl.: *Festschrift*, 67; Weiser, 47; *MBF* XXVII, 1928, 68.

Cat. 243 1922-1923

House project for Baron Bachofen von Echt
Vienna XIX, Springsiedelgasse

Hoffmann worked on this project for the well-known industrialist and president of the Austrian Werkbund several times, but the house was not built. An extant elevation design shows a two-story house with high basement and hipped roof, the facade articulated by a large string course, and a small main cornice. The upper-story windows, bordered by string course and cornice, create a strip effect. The first-floor windows have steep triangular pediments and are integrated into one unit with the basement windows. An open stair leads to a terrace and projecting element with horizontally striated pilaster strips and small obelisks.

Bibl.: Facade sketch: Estate.

Cat. 244/I. House for Karl Dunckel, submitted plans

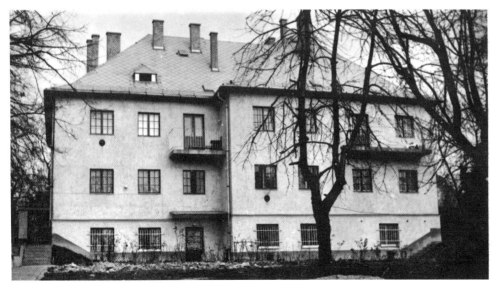

Cat. 244/II. House for Karl Dunckel, 1980 view

388

Cat. 244 1922-1923

House for Karl Dunckel
Budapest I, Ürge ut 3 (now: Tapolcsányi ut 3)
Building permit: 24 January 1923

A house with basement, two stories, and high hipped roof for the director of the Ungarische Stahlwarenfabrik A. G. (Hungarian Steel Products Factory). It consists of two parts, one 9.25m x 11.8m and one 12.75m x 15.05m. The entrance is in the center of the left lateral facade, protected by a small porch.

A short stair leads to the vestibule and service rooms including the kitchen. A two-story stair hall with gallery follows; it precedes the formal rooms consisting of salon or library, living room, and dining room. The second story contains six rooms, bath, and access stairs to the attic. The plain facade is divided into four horizontal zones by strips of stucco.

Furnishings for several rooms were designed for the house. It has now been divided into apartments, which entailed various alterations.

Bibl.: Submitted plan no. A 12762, in ABBH, where it was found thanks to Prof. Anna Zador and Joseph Sisa, Budapest.

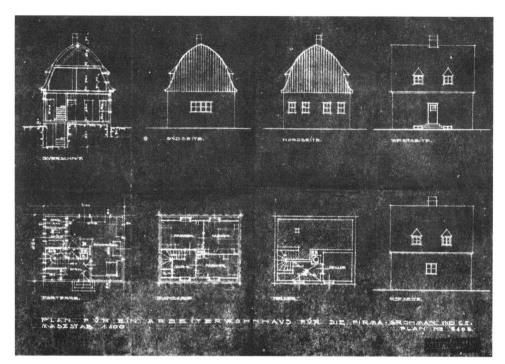

Cat. 246. Project for worker's house of the Grohmann firm

Cat. 245 1922-1924

Shop front and interior for the art dealer Gustav Nebehay
Vienna I, Kärntnerring 7

In the remodeling, Hoffmann flanked the deeply recessed entrance by showcases and thus created maximum display space for a shop with a narrow front. The show windows are divided into smaller square panes; the portal and name are painted gray.

Inside, the narrow front room of the shop opens onto an inner court with a skylight and milk glass ceiling which was remodeled into an exhibition room. The walls are covered with coarse light gray fabric and have hinged panels which form display booths. A contiguous second exhibition room has walls covered with red silk damask or painted in a matching tone. An office and library adjoin the exhibition rooms.

Bibl.: C. M. Nebehay, *"Wie gewonnen, so zerronnen"—Das Leben meines Vaters Gustav Nebehay,* unpublished ms.

Cat. 246 1922-1923

Project for workers' houses of the Grohmann textile firm
Würbenthal (Vrbno pod Praděd), Czechoslovakia (see Cat. 336)

When young Dr. Kuno Grohmann entered the family firm in 1922 he wanted to reform the workers' housing conditions. The Hoffmann office sent him proposals for three types of one-story, single-family houses with finished attic and slate-covered facades. A local builder associated with the Grohmann firm was consulted on the designs; an economical twin house design was developed; and wood or wood-clad houses were also considered. Dr. Grohmann commented on the designs, pointing to the Hellerau colony as a model, and asked whether "quite round houses" could not also be built. In an appeal to his staff he wrote in 1923: "If we cannot achieve . . . within 10 years that every coworker [should] receive his own house and garden . . . I shall not remain here." Finally, three twin houses were built as models and Dr. Grohmann as well as his brother Theo tried out one house by living there.

Bibl.: Plans and correspondence: Archive Josef Grohmann; K. Grohmann, *Emil-Grohmann-Siedlung,* Troppau (brochure, published by the author), 1931.

Cat. 247 1923

Exhibition boudoir
Exhibition of Austrian Arts and Crafts in the Austrian Museum for Art and Industry
Opening: September
Execution: August Ungethüm

The walls and ceiling are in burnished walnut. A French window faces the entrance, and in the right wall is a small built-in showcase. Next to it is a deep, stagelike divan niche with a softly upholstered bottom surface about 40cm above the floor. The lowered ceiling in the niche has a recessed light. Wall cabinets with arched tops are built into the side walls of the niche. The rear wall contains a "cult niche for souvenirs," which consists of a panel painted by Maria Strauss-Likarz in imitation of intarsia with scenes around a standing Venus(?). Similar paintings enrich the two cabinets. Scattered pillows complete the furnishings of the niche, which is framed by carved openwork ornament "reminiscent of Chinese motifs." A ceramic draped female nude by Susi Singer stands on a large table at the window. A very comfortable upholstered armchair with orientalizing curved legs stands at the foot of the divan; next to the entrance is a work basket. The upholsteries are black and brownish red.

Cat. 247/I, II. Boudoir, design sketch for wall elevation, and view toward niche (cf. text fig. 240)

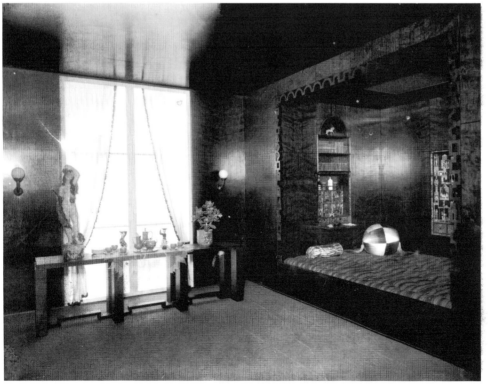

The same room was shown with a few variations in Paris in 1925 and in New York in 1928 (see Cats. 267 and 292).

Bibl.: *DKuD* LIV, 1924, 19ff.; *ÖBWK* 1, 1925, 360ff.; *Art et Décoration* XLVII, 1925, 128; *MBF* XXIV, 1925, 268; Drawing, ÖMAK.

Cat. 248 1923

Furnishings for apartment of Dr. Robert Baru
Schloss Neudorf, Styria

Cat. 249 1923

Furnishings of Hoffmann's own apartment
Vienna IV, Schleifmühlgasse 3

Extant furniture from this apartment shows that it included a living room in oak, painted black, and a bedroom in light green eggshell finish with brown fluted cornice moldings. No photographs of the interior have been found.

Cat. 250 1923

Furniture designs for the U. P. Works, Brünn (Brno), Czechoslovakia

Cat. 251 1923

Furnishings of offices for the Grohmann firm
Würbenthal (Vrbno pod Praděd), Czechoslovakia

Bibl.: *125 Jahre Grohmann & Co.*, Troppau, n.d., 18.

Cat. 252 1923

Project, villa for Dr. Hans Heller
Vienna XIII, Reichgasse

The two-story house on a wooded lot was destined for newlyweds, interested in the arts, who wanted a flat roof for sunbathing. The plan is a long rectangle with slight projections on all sides. Vestibule, living room, music room, dining room with pantry, terrace and a servant's room are on the first floor; bedrooms are above. Kitchen, laundry, other servants' rooms, and storerooms are in the basement. The house was planned with fluted stucco walls and white painted windows; at the corners are small crowning obelisks.

Bibl.: *DKuD* LIII, 1923/1924, 36, 37.

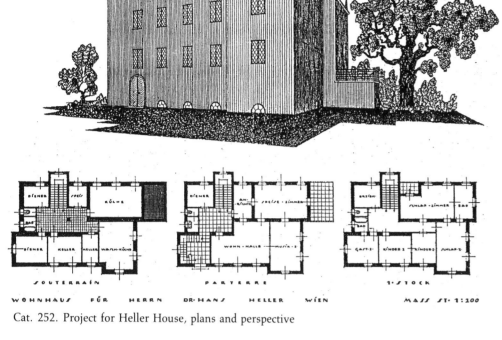

Cat. 252. Project for Heller House, plans and perspective

Cat. 253. Eduard Ast Tomb

Cat. 253a. Project for Kurt Grohmann
House, plans and elevation

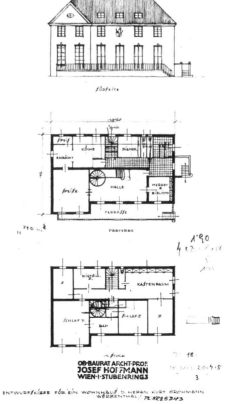

Tomb of Eduard Ast
Vienna XIX, Heiligenstadt Cemetery

The grave is covered by a large slab. The high stele with artificial stone surface consists of a rectangular pillar slanting outward at the top in the shape of an inverted truncated pyramid. The inscription is designed with an intertwined decorative branch of leaves and blossoms.

Bibl.: According to register of plans, October 1923, drawn by M. Fellerer; Hoffmann may have designed an earlier grave for Ast in 1912.

Cat. 253a 1923

Design sketch: House for Kurt Grohmann
Würbenthal (Vrbno pod Pradĕd), Czechoslovakia

A sketch for the project drawn by Hans Welz on 5 December shows a two-story house with hipped roof. On the front side, facing south, are the dining room, smoking room, and hall with circular stair. The north side contains cloakroom and toilet, servant's room, staircase, and kitchen with subsidiary rooms. Upstairs in front are bedrooms; at the rear, subsidiary rooms and a large room with built-in closets which also serves as a hall. The south facade with a pedimented projection and terrace has tall French windows with small triangular decorations above the lintel. This project, for a brother of Fritz and Kuno Grohmann, was not executed.

Bibl.: Plan: Archive Josef Grohmann.

Cat. 254 1923-1924

Country house for Eduard Ast
Aue near Velden on the Wörthersee, Carinthia

A preliminary design is extant; it has the same basic concept as the executed building, but differs substantially in ground plan and facades. A large site on a slope was available for this country estate. It consists of a flat section for the house and extensive garden, and a wooded section sloping down to the road and the lake. The house is not visible from the road; a porter's lodge in fieldstone (see fig. 167) is at the fence on the road.

The porter's lodge is a two-story house on a steep slope; in the front, the basement and first floor are above grade; at the rear a level courtyard had to be excavated, otherwise the first floor would have been partly buried within the slope.

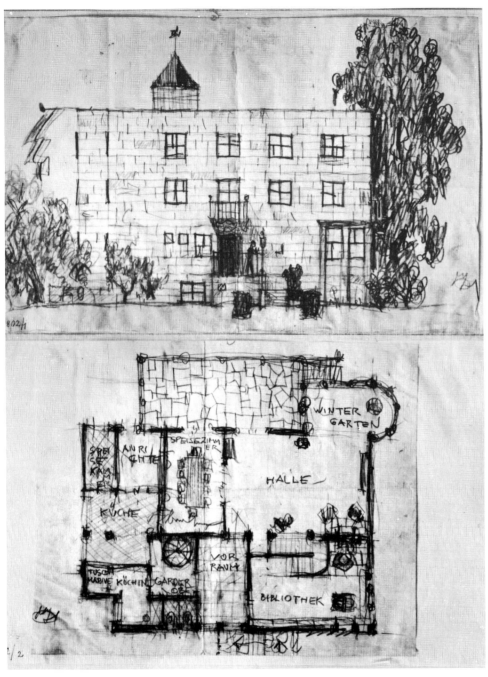

Cat. 254/I. Ast Country House, first project

This courtyard is bordered by a high retaining wall. The almost square house (9.60m x 9.05m) has a basement, two stories, and a steep pyramidal roof. A short open stair leads from the road to the entrance at the center of the left facade. The wide white entrance door opens to a corridor; on the right are two rooms; on the left a toilet, circular stair (diameter 2.15m), and another room with wash basin. The layout of the upper floor is identical, but the room with the wash basin was later remodeled into a bath accessible from the corridor. The circular stair leads to the attic, while a concrete stair gives access to the basement. The exterior effect is determined by the unarticulated block and pyramidal roof, the color and texture of the masonry, and the distribution of the rectangular windows; only the toilet windows are round.

Beyond the road is another lot which drops in successive stages to the lake; a small bath house was later built there, and water lilies were planted at the suggestion of the architect. Coming from the lake, past the porter's lodge and over a steep stair, the approach leads uphill on a forest path until one reaches a spot where the house is first visible above a long sloping lawn, with a garden stair leading to the main entrance. From this approach, the main effects are the cubical forms of the main block and the entrance block, both with flat roofs, and the penthouse at the left corner with bands of windows and a sheet-metal hipped roof. The horizontal striation of the facades and a small entrance porch are also striking. The fenestration is as simple as possible with 2 by 3 windows in the main block and a French window above the entrance. A few round porthole windows are not conspicuous.

The house stands on a baselike pavement, and the striation of the facades is formed by simple stucco moldings profiled with an angular band forming an arris between two half-rounds. These moldings also appear on the pillars of the arched entrance porch. A zone above the arches of the porch carries a frieze of female figures by Hanak. This frieze of cast cement tilts forward, providing a clearer view and also a larger area for the small terrace. The terrace has a glazed door and a simple iron railing with vertical bars. Approached from the garden at the rear, the simplicity of the striped cubic house makes an even stronger impression. The sides have few windows, and those at the rear are clearly subordinate to the wall. Only at the northeast corner does a projection with exit to the garden provide some three-dimensional enrichment for the facade.

The main entrance on the lake side opens to a vestibule lighted by a window on the left. On the right wall a small door leads to a toilet. At

the rear, two short flights of steps, separated by a landing, rise to the first floor. Their simple black railing begins with a tall upright that carries a lantern of milk glass. The vestibule has a richly molded cornice.

From the top landing a door in the side wall opens to a corridor and service rooms; another door, in the rear, leads to the largest room, the living room/hall, first viewed from a corner. Diagonally across the space, the room expands to a verandalike alcove with large windows and exit to the garden. Here, the most light falls into the rather dark room. Within the hall a stair begins, with the first two steps projecting into the room. The first flight, after a landing, runs parallel to the central wall which has two arched openings, one for the stair to pass through, the second providing a view of the rising balustrade. The outlines of the multifoil arches recall Moorish prototypes. These, like all lines of juncture in the room, are emphasized by painted wooden moldings. The light cornice is also painted and decorated with carvings. The floor is covered with dark brown cork tiles. Just as a view is possible from the hall/living room into the stair-

Cat. 254/II. Ast Country House, view from garden with concrete pergola (cf. text figs. 228-232)

Cat. 254/III. Ast porter's house, plan of ground floor

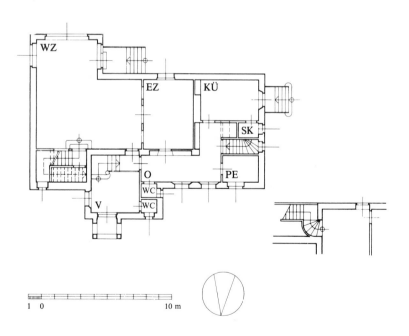

Cat. 254/IV. Ast Country House, plan of ground floor with inset of remodeled staircase (*bottom right*)

case, so the adjoining dining room can also be viewed through a door and two round window openings in the partition wall. These repeat the motif of round windows from the facades. In the corner between partition and outside wall is a seating group consisting of a round table and chairs upholstered with the characteristic "shaded" pattern from the Wiener Werkstätte. The dining room furniture with buffet, dining table, side table and chairs is in soft wood painted blue; the buffet and table legs have rich carvings. Built-in cabinets in the pantry and the kitchen furniture are white and light green. The floors of these housekeeping rooms are black and white tile.

Taking the staircase to the upper floors, one first enters a long, light green-gray-blue hall with furniture painted blue and in part built-in. This area has a cork floor and serves as a breakfast room. It opens onto a terrace above the entrance loggia and gives access to two baths and four bedrooms on the south side. These have painted, partially built-in furniture, with color changes from room to room. In each room one tone predominates on the walls, the painted, frequently built-in furniture, and the fabrics. The largest room is warm reddish brown and has horizontally striated walls, like the facades. A smaller room with built-in cabinet and bed niches is predominantly light and dark green and has "shaded" fabrics. The guest bedroom with bed niches and striated walls is in harmonizing light and dark blues.

The main stair continues to a penthouse with numerous windows and access to a flat roof from which the landscape and garden can be viewed. In the garden Hoffmann created not only a remarkable pergola of reinforced concrete arches, but garden furniture of steel pipe.

In 1934 Hoffmann remodeled the house for a new owner, Director General Friedrich Meyer-Hellbeck. He added a steeply roofed story with a hall giving access to bedrooms and baths. The entire southwest end of the top story is occupied by a large children's room. The remodeling also included the provision of direct access from vestibule to main stair, additional windows, and a kitchen entrance. Franz Cizek collaborated on the interior decoration; his murals and most of Hoffmann's original furniture are extant. The general condition of the house is excellent, but the color scheme was altered in several rooms.

Bibl.: *ID* XXXVIII, February 1927, 55-74; Plans in archive of owners; Drawing (preliminary design): ÖMAK.

Cat. 254/V. Ast Country House, entrance hall with stairway

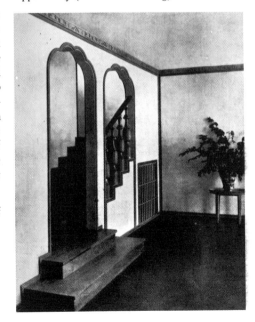

Cat. 254/VI. Stair from living room to upper story (before remodeling)

Cat. 255　　　　　　　　　　1923-1925

Municipal apartment building, "Klosehof"
Vienna XIX, formerly Felix-Mottl Straße, now Philippovichgasse 1; 140 apartments.
Building permit: 9 May 1924
Certificate of occupancy: 17 September 1925

The building is on a slightly sloping, almost square, lot (about 60m x 65m) between the Philippovichgasse in the north and the Fickertgasse in the south, adjoining the old Währing Cemetery and Währing Park. It consists of a five-story outer building with a saddle roof, which encloses a courtyard, and a towerlike, flat-roofed six-story building, originally planned to be higher, in the center of the courtyard. The ground floor of the center building contains children's rooms; the upper floors each have four apartments. The courtyard is accessible by a high tripartite main gate from the Werkmanngasse and by a pedestrian entry from the Philippovichgasse. There are ten staircases on the courtyard side with the entrances in shallow projections. An earlier plan proposed deeper projections that contained entire apartments.

The facades have no bases and terminate in a richly articulated cornice consisting of a half-round, cyma, cavetto, and one more cyma. Such composite profiles also occur on the main gate and on the pedestrian entry. Both are flanked by fluted pilasters, which at the entrance are crowned by Hanak sculptures of women bearing fruit. Between them is a window with projecting molded frame and top. The wooden windows, originally painted red, project slightly beyond the wall plane. The ventilating windows in the toilets are round.

The shallow courtyard projections are crowned by triangular gables with semicircular windows. The center building on the first floor has tall prominent openings in groups of three. The outer building in its south facade has uniform windows and its only rhythmical subdivision is by dark downspouts. On the other facades the staircase windows are in shallow recesses with arched cornices. A model photograph of an earlier design shows that a straight termination was also considered. All attic windows are in box dormers covered with sheet metal. On the east and west facades balconies in deep niches provide strong shadow effects. The east facade also has a shop at its north corner. Small fruit and flower decorations in stucco, scattered over the facades, are hardly noticeable.

The building is well preserved and has undergone few alterations. These include removal of the stucco decorations and downspouts, the addition of bases and outside lights, and change of

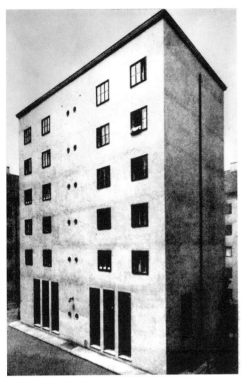

Cat. 255/I. "Klosehof" municipal apartment complex, building in central courtyard

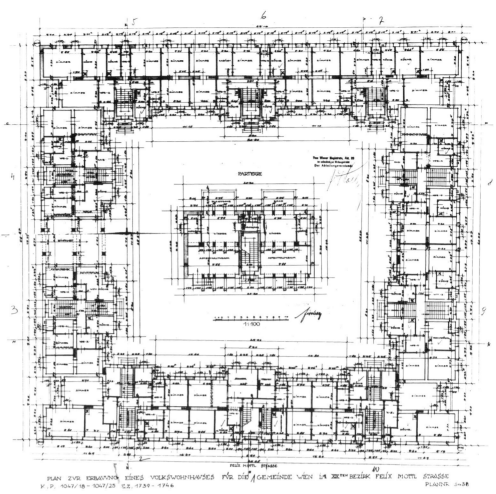

Cat. 255/III. "Klosehof" municipal apartment complex, plan of ground floor

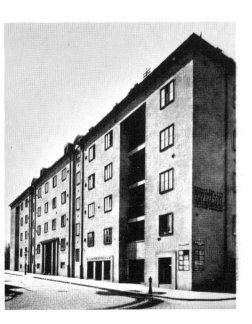

Cat. 255/II. "Klosehof" municipal apartment complex, east facade (cf. text fig. 266)

color on the windows. Flagpoles were mounted at the entrance, and the built-in shop is now more prominent.

Bibl.: Photographs: Estate; Drawings: Estate and ÖMAK; Plans: ABBH; *MBF* XXV, 1926, 240ff.; Wasmuths *MFBK* XI, 1927, 258ff.; *Der Tag*, 19 July 1925, 5; *Arbeiter Zeitung*, 9 August 1925, 11; Mang, 104.

Cat. 256 1923-1925(?)

Project for a Russian exhibition pavilion in Vienna

One project shows a centralized building; another, a longitudinal building with an apse and high tower; a third project has a row of four towerlike pavilions. All buildings were planned for polychromed wood architecture with a prominent zigzag motif. The longitudinal building has an arrangement of parallel galleries which lead to a square tower for the display of arts and crafts as a climax. The tower is capped by a pyramid roof which tops a succession of two more roof zones of increasing size, separated by open stories. A similar but smaller tower crowns the entrance of the building. The galleries of the centralized building enclose a square inner space with a tower above. The entrance is in a small annex connected by a short wing to the main

Cat. 256/I, II. Project for a Russian exhibition, design sketch for facade and plan

building. In front of the four linked pavilions is a vestibule flanked by small towers.

Bibl.: Drawings: ÖMAK and Estate; they are co-signed by Franz Schuster and Dr. Otto Neurath as representatives of the Austrian Association for Housing and Small Gardens; this dates them between 1923 and 1925 when Schuster was architect of the Association.

Cat. 257 1924

Housing estate project "Neustraßäcker" for a housing cooperative of the City of Vienna
Vienna-Stadlau, between Erzherzog-Karl-Straße and Langobardenstraße

The paired two-story row houses are opposite an "entrance building with continuous pillared passage on the ground floor." They have L-shaped plans which form a protected garden court with terrace. Flat roofs also serve as terraces. Living room, dining room, kitchen, and stair are on the ground floor of the main wing; a utility room and a stable are housed in the short wing. On the second floor are two larger and a smaller bedroom, a bath, and a terrace above the stable. The cubical blocks are quite plain with flush windows.

After several variations of the design were rejected by the client or the building authority, Hoffmann resigned the commission at a dramatic session, according to Viktor Winkler, who worked on the project in Hoffmann's office. The estate was then built by Franz Schuster and Franz Schacherl in the more familiar forms of vernacular architecture.

Bibl.: *MBF* XXVI, 1927, 373ff.; Lecture by Viktor Winkler, 1970.

Cat. 258 1924

Project for facade remodeling of the Österreichische Central Boden Credit Bank
Vienna I, Kohlmarkt 8-10 / Corner Wallnerstraße

Three different solutions were submitted for a new facade; they retain the fenestration of the existing building. In all designs the tall banking room on the street floor is almost completely glazed. In the first project the facade was horizontally articulated by large moldings above the plain ground floor. The moldings consist of alternating concave and convex forms recalling those for the Austrian pavilion at the International Exhibition of Decorative Arts in Paris (see Cat. 266). A powerful cornice and low parapet form the upper termination. The moldings are recessed at the corners. The vertical articulation

Cat. 257. Project for "Neustraßäcker" housing estate, perspective view of assembly court

of the existing facade by paired windows is emphasized by the ground floor pillars and small balconies on the second floor. By placing corner balconies and closely spaced pillars under the paired windows Hoffmann achieves the effect of symmetry on this actually asymmetrical facade.

Several preliminary studies for the second project are extant. Fluted pillars are spaced in such a manner that no supports occur between the corner and the second pair of windows. The remaining portion of the facade is fully glazed between the flanking entrance bays. In this way the axis of the central window becomes the symmetry axis for the whole composition in this part of the facade. The overall effect is almost that of two independent contiguous facades. They are unified by the decorative treatment, consisting of framing and crowning motifs for the windows, floral motifs on the walls, and round-headed merlon-shaped elements above the delicate main cornice. Paired windows on the second and third floors form decorative units with their balconies. Four central windows are also treated as unified, framed elements. This design treatment and the stucco decoration in vegetal forms create a certain verticalism on the entire facade. The corner is planned with a sculpture on the second floor and with alternating large and small diamond-shaped elements above. One of the preliminary studies envisaged as a main motif a thrice-stepped element, also repeated in the battlements.

The third project retains more pillars on the

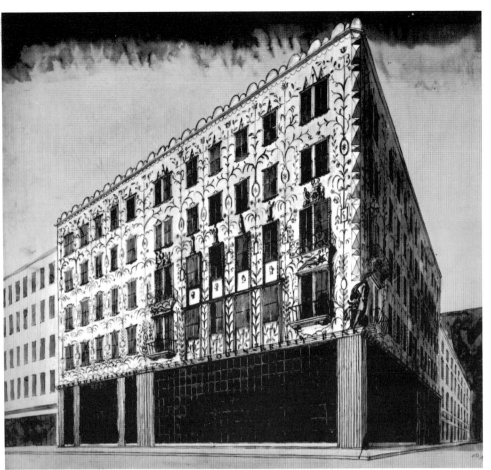

ground floor, shows a balustrade above the main cornice, and unifies superimposed windows by a common frame as vertical facade elements. Stucco decorations are scattered over the walls, and a decorative sculpture was planned at the corner.

Bibl.: Elevation sketches: ÖMAK and Estate; two perspectives: Academy; *OBWK* I, 1924/1925, 20ff.; *MBF* XXIV, 1925, 289.

Cat. 259 1923-1924

House project for Dr. Kuno Grohmann
Würbenthal (Vrbno pod Praděd), Czechoslovakia

A first project drawn by Max Fellerer was worked out at the end of 1923. It shows two facade variations with the same plan. One has a steep saddle roof, the other a flat roof with a small hip-roofed penthouse in the manner of the Ast Country House (Cat. 254). The house has two entrances: one opens onto a vestibule with steps, cloakroom, and access to the kitchen; the other leads directly to the hall which occupies most of the ground floor. The hall expands to a dining nook next to the stairs and to an alcove on the garden side. On the second floor are a hall, three bedrooms in front, and a fourth bedroom and bath at the rear.

Cat. 258/II. Austrian Central Real Estate Credit Bank, facade project

Cat. 258/III, IV. Austrian Central Real Estate Credit Bank, facade variants

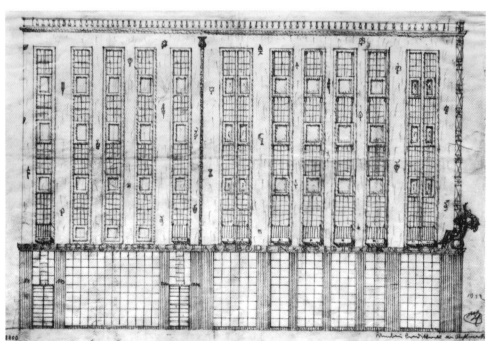

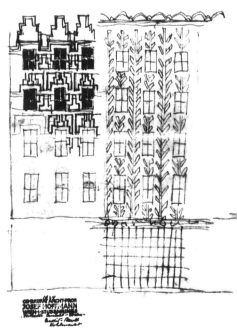

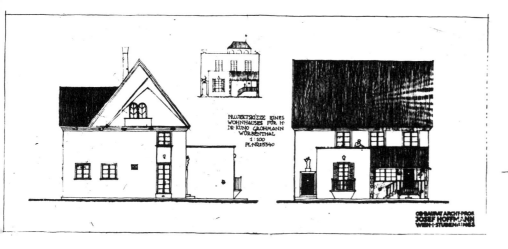

Cat. 259/I. Dr. Kuno Grohmann House, first project

Cat. 259/II. Dr. Kuno Grohmann House, second project

Another project was sketched about two months later. The program is sharply reduced so that the entire house covers about the area of the former hall. The plan shows a small two-story, single-family house with hip roof. The ground plan is a rectangle of 5.5m x 9m; the first floor has a vestibule with cloakroom and toilet, kitchen, and living room with lateral veranda. An enclosed newel staircase rises to the upper story with corridor, larger and smaller bedroom, and bath. Above the veranda is a deep balcony which, reduced in depth, continues at the front. The exit to the front balcony is recessed to form a niche. The balcony and main cornice have moldings; the facades are otherwise plain. All principal windows have numerous small panes.

Bibl.: Drawing: ÖMAK; Plans: Archive Josef Grohmann.

Cat. 260 1924

Exhibition design of two rooms
Jubilee exhibition of the Viennese Association for Arts and Crafts at the Austrian Museum for Art and Industry
Execution: A. Pospischil and J. Soulek

Hoffmann designed Rooms XII and XVI for the exhibition arranged by Otto Prutscher. These were later shown at the International Exhibition of Decorative Arts in Paris (see Cat. 267).

Bibl.: *Katalog der Jubiläumsausstellung*, Vienna, 1924.

Cat. 261 1924

Stand of the Grohmann firm, Reichenberg Trade Fair

Cat. 262 1924

Dining room furnishings for Willner, Reichenberg (Liberec), Czechoslovakia

Cat. 263 1924

Project for remodeling of Molineus Villa, Reichenberg (Liberec), Czechoslovakia

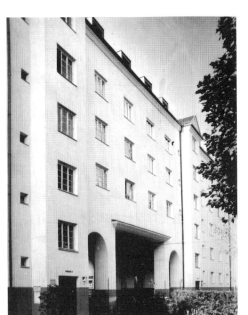

Cat. 264/I. "Winarskyhof," courtyard view
1980 (cf. text fig. 267)

AVSWECHSLVNGSPLAN

WOHNHAVSBAV DER GEMEINDE WIEN, IN WIEN

Cat. 264/II. "Winarskyhof," plan of upper story

Cat. 264/III. "Winarskyhof," facade study

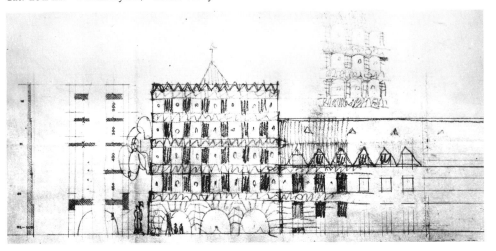

Cat. 264 1924-1925

Municipal apartment building "Winarskyhof"
Vienna XX, Stromstraße 36-38, 76 apartments
Submitted plans: April 1924

Hoffmann was responsible for a 117.5m long,
five-story wing of a large complex for which the
City of Vienna also employed the architects Beh-
rens, Strnad, Frank, Wlach, Schuster, Loos, Li-
hotzky, and Dirnhuber.

The design of the facades is strikingly simple.
On the street side the facade is plain except for
two shallow projections with triangular gables
flanking the center part with its gate for the
driveway through the block. The gateway con-
sists of a two-story portal with a rectangular
central opening accompanied by two lower arched
pedestrian passages. On the garden court side
there are shallow one-bay projections with the
entrances and windows of every staircase. The
facade is horizontally articulated by a high base
and a multiple cornice below the roof with 40
degree slope. An extant preliminary study shows
that a more monumental and decorative solution
was considered.

The building was somewhat altered by finish-
ing the attic story with dormers, building a to-
bacco shop in the passage, and simplifying the
entrances. After renovation in 1979, it is in good
condition.

Bibl.: Submitted plans: ABBH; *Die Wohnhausanlage der Ge-
meinde Wien Winarskyhof, etc.*, Vienna, 1925 (brochure pub-
lished for the opening); K. Mang et al., *Kommunaler Wohn-
bau in Wien*, Vienna, n.d. (1978); Facade study: Bauhaus
Archive, Berlin.

Cat. 265 1924-1925

House for Sonja Knips
Vienna XIX, Nusswaldgasse 22
Preliminary design: March 1919
Approval of plans: 24 June 1924
Certificate of occupancy: 27 November 1925
Builder: Ing. Eduard Ast & Co.

The house is built on the site of an old building
belonging to Berta Zuckerkandl; the large gar-
den lot (3,733 sq. m) has a wealth of old trees
and a considerable change in level between front
and rear. The street facade faces north. The pre-
liminary design (fig. 218) called for a two-story
main building with slender cast iron columns,
cast iron cornice, iron window frames, and a one-
story wing; the perspective was drawn by Max
Fellerer. On the garden side, in front of the
retaining wall, open stairs were planned. The
project was executed five years later, retaining
the basic concept but with significant modifica-
tions in detail. The house is sited so as to permit
a grassy forecourt with a large tree on the street
side; on the garden side a graveled forecourt
provides the transition between house and gar-
den. It is bounded by the parapet of a high (more
than 5m) concrete retaining wall, at the foot of
which the lower garden begins. A vaulted niche
in the middle of the wall serves as a garden hall.
A long but comfortable open stair connects the
lower garden with the graveled forecourt.

The house is built of stuccoed brick with rein-
forced concrete floor construction and a hipped
slate roof. The two-story main house (14.4m x
17.4m) with full basement and finished attic
dominates the one-story lateral wing. The main

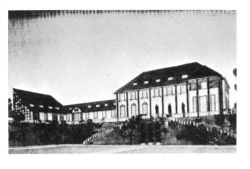

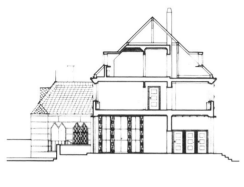

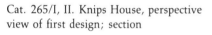

Cat. 265/I, II. Knips House, perspective
view of first design; section

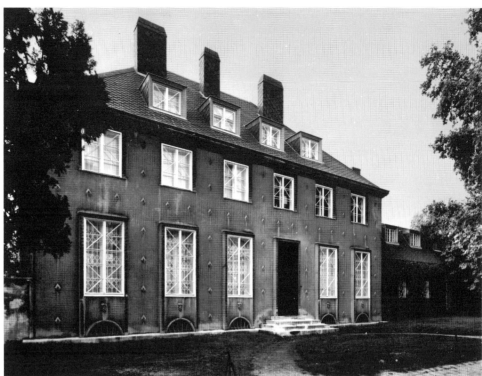

Cat. 265/III, IV. Knips House, street view; plan of ground floor

house has a forcefully molded cornice and four
box dormers in the center. The windows on the
second floor are recessed within richly molded
surrounds while the taller ground floor windows
project 20cm beyond the facade. Their surrounds
also enclose the lunette-shaped basement win-
dows. The stuccoed facades are enriched by rows
of small diamond-shaped elements, and on the
street side there are bunches of grapes under the
first floor windows. The glazing bars of the win-
dows form simple decorative patterns. On the
garden facade a cubical alcove with boldly molded
cornice and the parapet of the adjoining garden
terrace play an important role. The parapet no
longer exists.

The side wing has dormers similar to those in
the main house but no prominent cornice, only
an overhang with hanging gutter. The paired
facade windows have oblique tops resembling an
inverted W. This zigzag line is accompanied by
a wooden trellis along the entire facade. This
wing has a corner ell and, at the reentrant angle,
a passage for a driveway, closed by a double gate
on the street side.

The tall main entrance door was flanked by
two lanterns (now missing) and opens to a large
white vestibule with black tile floor; at the right

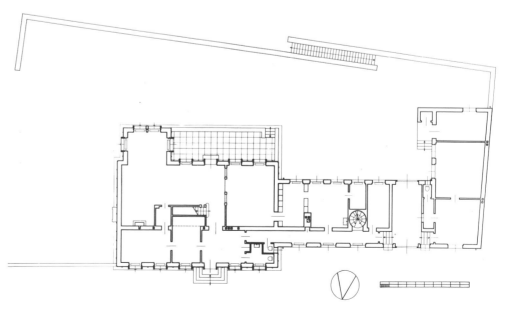

401

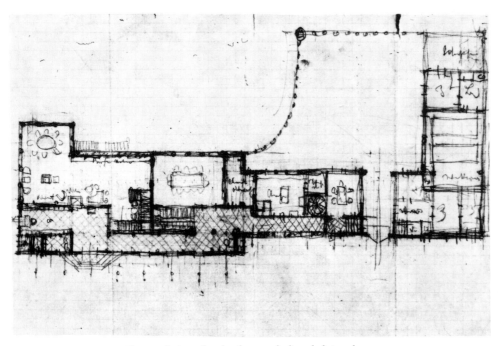

Cat. 265/V, VI. Knips House, design sketch of ground plan; lady's salon

is a lavatory, a closet, and the corridor to the wing; at the left are two guest rooms. Ahead, a large door opens to the hall and main staircase.

The living hall (3.5m high) has a large alcove on the garden side and a fireplace opposite, and a central portion connected to the dining room through tall glazed doors between glazed floor-to-ceiling vitrines. Accordingly, the dining room and the living hall tend to form a visual unit. Both rooms have tall windows looking onto the garden, and a French door opens from the hall to the terrace. Under the second flight of main steps is the bed niche of the guest room; under the landing is a short corridor to the second guest room. In the hall the stairway begins with two pilaster- or pillarlike elements with painted stucco decoration by Christa Ehrlich. Similar elements are on the showcases; their decoration matches that on the cornice and fireplace. The doors are painted a dark pink, the floor is covered by a purple and dark green carpet (designed by Julius Zimpel). The furniture is black oak (executed by Johann Jonasch); upholstered armchairs stand in front of the fireplace; a round table and red leather armchairs form a group in the alcove. There are also a cabinet and side tables. The dining room furniture in pink eggshell finish is dominated by a large table with upholstered chairs and a low buffet. Large, spherical, faceted fabric light fixtures hang from the ceiling.

In the first floor side wing are, next to the dining room, the pantry, kitchen, larder, and cook's room. Next to the cook's room is a black metal newel staircase for the servants. The white kitchen and pantry are connected, like the living hall and dining room, by a floor-to-ceiling vitrine with center door. The contents of the compartments of the vitrine are visible from both the kitchen and the pantry. The shelving of the vitrine is repeated in a built-in cabinet on the opposite side of the pantry. At the end of the corridor three steps descend to the level of the driveway from the street to the garden. The adjoining ell has two rooms, a kitchen, and two toilets.

The second story of the main house (2.75m high) contains on the north side a library paneled in dark oak, a bath, and the lady's dressing room in delicate light blue with mirrored wall and built-in dressing table; on the south side are the gentleman's bedroom paneled in walnut, a living room (the so-called pink salon) and the lady's bedroom, paneled in orange colored lemon wood, fronting on a balcony. The color and texture contrasts of the rooms are highly effective.

The finished attic in the wing contains the master bathroom and three servants' rooms, and the laundry and ironing room in the ell. The main attic contains a living room, bedroom, and bath, partially under the roof slope; some of these rooms have an unusually high wooden cornice with repeated double cyma moldings. Fittings and appurtenances, such as cornices, framing and paneling, radiator covers, sanitary appliances, and mountings, are detailed and executed with great care throughout and match the decorative character of the whole.

The building is in excellent condition, but some original furnishings are no longer preserved and some sanitary facilities were modernized. The garden terrace was altered by removal of the parapet wall, and a swimming pool was built in front of the house.

Bibl.: *DKuD* LIII, 1923/1924, 38, 39; *MBF* XXV, 1926, 353ff.; XXVI, 1927, 161ff.; *Studio* XCVII, 1929, 383ff.; Platz, 311, 312; Drawings: Estate and ÖMAK; Mang, 104; Submitted plans: ABBH.

Austrian Pavilion at the International Exhibition of Decorative Arts (Exposition Internationale des Art Décoratifs et Industriels Modernes), Paris

Quai de la Conférence, east of the Pont Alexandre III
Opening: 28 April 1925
Collaborator: Oswald Haerdtl
Local supervision: Max Fellerer

Within the framework of Hoffmann's overall concept, Peter Behrens, Josef Frank, and Oskar Strnad were responsible for individual parts of the building. A large number of Austrian artists and craftsmen contributed to the interiors. The building was one of the few that were essentially completed on opening day.

An early (1924) design of a pavilion with wings on each side of a tall, pillared loggia takes up ideas from earlier exhibitions (Rome 1911, Cologne 1914). The executed building is, however, entirely different. With an asymmetrical informal layout of buildings and connecting corridors, it is designed both to be seen at a distance from the Seine and to blend with the existing rows of trees along the river. The neighboring pavilions are those of Japan on the west and Monaco on the east.

The Austrian Pavilion consists of two main parts parallel to the river and connected by a loggialike corridor. On the river side the building is supported by concrete pillars and has two parallel wings. One ends in an important accent, the organ tower by Strnad; the other ends in the glasshouse by Behrens. Between the wings, partially on the water, are the café terraces. The most striking feature of the exterior is the modeling of the walls—rhythmic horizontal moldings. Small sculptures and inscriptions about Austrian artists are loosely arranged on these moldings.

The entrance porch with fluted pillars opens onto a light gray stuccoed entrance hall with the sculpture *Burning Man* by Anton Hanak in the center. The walls are lined with four narrow artificial stone showcases for ceramics. Behind the statue is the door to offices; on the right the exhibition begins with a long, toplighted gallery with glazed showcases for arts and crafts along the walls and low showcases in the center. All woodwork is black with decorative white painting; all backgrounds are covered with yellow fabric. At the end is a second, parallel gallery with colorful showcases; here a showcase is built into the outer wall so that the exhibits receive natural light. After dark they are brightly lighted for viewing from the outside. At the end of this gallery are two smaller rooms, one with glass

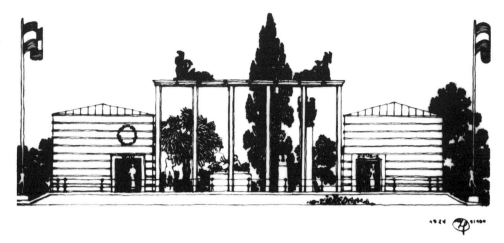

Cat. 266/I. Austrian Pavilion in Paris, plan and facade of an early design (cf. text figs. 241-248)

Cat. 266/II, III. Perspective and plan of the executed design

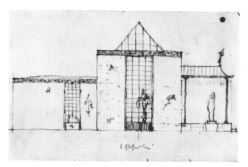

Cat. 266/IV. Austrian Pavilion in Paris, design sketch

latter clearly recalling the walls of the Austrian Pavilion. At the back of the room is a fireplace with a colorful ceramic surround by Hertha Bucher. The moldings of the cornice are painted.

The tearoom in elm wood (executed by Anton Pospischil) also has a piece of horizontally molded furniture—a high buffet. A small round table and upholstered chairs stand in the center. The ceiling in tent shape is colorfully painted by Camilla Birke.

Bibl.: *L'Autriche à Paris*, 35; *MBF* XXIV, 1925, 267ff.; *L'Amour de l'Art* VI, 1925, 319ff.

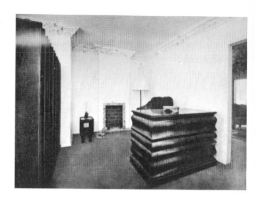

Cat. 267/I, II. Austrian furniture exhibition in Paris, smoking or writing room and tearoom

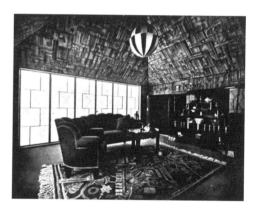

Cat. 268 1925

Exhibition room of the Austrian publishing and reproduction firms at the International Exhibition of Decorative Arts
Paris, Grand Palais

In the Grand Palais, Hoffmann created a room for the graphic industry with a velum hung in the manner of a tent roof, walls divided by projecting strips, and display tables with slanted surfaces. A strong pattern of stripes is the visual motif for the room. Hoffmann was also represented in the Grand Palais in the Austrian architectural exhibition and by student work in the room of the School of Arts and Crafts.

Bibl.: *L'Autriche à Paris*, 33; *Art et Décoration* XLVII, 1925, 129; *MBF* XXIV, 1925, pl. after 268.

from the Lobmeyr firm, the other with paper products.

Leaving the first building the visitor proceeds through the connecting loggia with views to the outdoors before continuing the tour to the second building. There one can view the interior of the organ tower and the "cult room" with chased metal sculpture before enjoying the first view of the Seine—framed by an arched opening—and a café terrace above the water. At the west end of the terrace, the glasshouse by Behrens protects one from the wind and terminates the riverside of the pavilion.

Bibl.: *Exposition Internationale des Arts Décoratifs . . . , Rapport Général*, Paris, 1928, vol. II, 59; *L'Autriche à Paris, Guide*, Vienna, 1925; *ÖBWK* I, 1924/1925, 296ff.; *MBF* XXIV, 1925, 249ff.; *DKuD* LVII, 1925/1926, 69ff.; *L'Amour de l'Art* VI, 1925, 295; *L'architecte*, n.s. II, 1925, 102; *L'Illustration*, June 1925 (special issue on the Exhibition); *Art et Décoration* XLVII, 1925, 120ff.; *Department of Overseas Trade; Reports on the . . . International Exhibition of Modern Decorative . . . Art*, London, n.d., 45; Platz, 314; Photographs: Estate; ÖMAK and Museum of the 20th Century, Vienna.

Cat. 267 1924-1925

Exhibition design of the Austrian furniture section at the International Exhibition of Decorative Arts
Paris, *Galérie des Invalides*
Collaborator: Oswald Haerdtl

An 18m long gallery with niches for the display of individual pieces of furniture gives access to furnished rooms, three of which were designed by Hoffmann. The gallery has broad horizontal stripes in the Austrian national colors of red-white-red.

One of the rooms is the boudoir Hoffmann showed in Vienna in 1923 (Cat. 247). The two others "lighted from small winter gardens," are a tearoom and a smoking room or writing room in walnut (executed by J. Soulek); the desk and chest are rhythmically articulated with vertical and horizontal strongly curved moldings, the

Cat. 268. Exhibition room of the Austrian publishing and printing firms

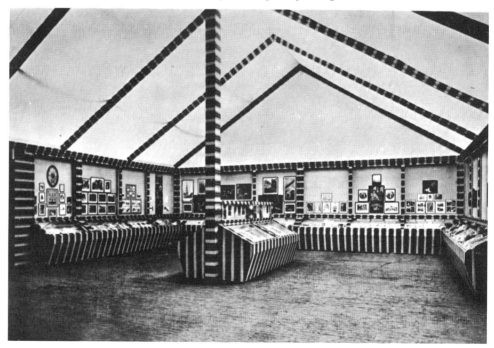

Cat. 269 1925

Sketch of a facade design for a six-story building

Over a ground floor in random ashlar rises a four-story building of skeleton construction with horizontally striated walls. On the second floor three sections are spared out to form an open hall with a terrace. On the three following stories the first section is left open. On the top story is a penthouse with a hipped roof; it has a balcony in front and a terrace in the back. A small simple pavilion or pergola stands at some distance next to a willow tree. The complex gives the impression of a summer resort.

Bibl.: Drawing: Estate.

Cat. 269. Sketch of a facade design for a six-story building

Cat. 270 1926

Furnishings of apartment for Dr. K. Reinhold
Vienna VII, Siebensterngasse 42

A smoking room, dining room, hall with a seating niche, and bedroom were furnished; Franz Nebenführ was responsible for the working drawings. The bedroom in pink eggshell finish has a free-standing bed and an asymmetrical dressing table with a large mirror in a corner. Preliminary sketches for this project are extant and show that richer decorative treatment was originally planned.

Bibl.: Drawings: Estate and HFAK; DK XXXII, 1929, 39ff.

Cat. 272 1926

Architectural fantasy, perhaps for a wallpaper design

On a four-story building with multiple overhangs is a tower with four supports in the lower story and two supports in the upper story, crowned by a column and statue. The insubstantial structure is flanked by two columns with statues which give the same airy impression. Potted plants grow between, and at the edge of the composition stand a potted poplar and another lower column with statue. The design recalls the fantastic architecture of Pompeiian murals.

Bibl.: Photograph: ÖMAK.

Cat. 273 1927

Furniture for the Exhibition of Austrian Arts and Crafts, Essen, Hotel Königshof
Opening: 20 January

The cabinetmakers Anton Pospischil and August Ungethüm exhibited furniture from designs by Hoffmann; Pospischil, a walnut buffet with horizontal moldings, matching the one shown at Paris in 1925 (Cat. 267); Ungethüm, an armchair and a secretarylike cabinet with massive legs supporting a slender recessed tabletop surmounted by a recessed case with open front and three small drawers. A much smaller, stepped top crowns the piece.

Bibl.: Katalog Ausstellung Österr. Kunstgewerbe Essen; ÖBWK III, 1926/1927, 227.

Cat. 271 1926

Project for remodeling of the Kornfeld House
Vienna XVIII, Julienstraße 38 (now Dr.-Heinrich-Meier-Straße)

Remodeling project for an existing villa of a culturally and politically avant-garde client, whose wife was a singer. A new terrace was built on the ground floor, and a sequence of living room, dining room, library, and rehearsal room was planned, with some newly designed furniture. Finishing the attic with a bedroom and new stair was also planned.

The terrace with exit to the garden is extant.

Bibl.: Drawings and plans: Archive Prof. Rudolf Steinböck.

Cat. 270. Dr. Reinhold apartment, design sketch for hall

Cat. 272. Architectural fantasy

Cat. 274. Exhibition of European Arts and Crafts, Austrian section, Leipzig 1927, view toward entrance of main room

Exhibition of the Italian Chamber of Commerce at the Vienna Fall Trade Fair
Collaborator: O. Haerdtl

Cat. 277 1927

Exhibition design of two rooms at the Kunstschau 1927
Austrian Museum for Art and Industry

The exhibition was arranged by Oswald Haerdtl. Hoffmann, who was also represented by designs in the Architecture section and by works of his students, designed a living room (executed by Anton Pospischil) and the room of the Wiener Werkstätte next to a small paved winter garden. In the living room the informal arrangement of the furniture is noteworthy. Except for a fluted buffet, the forms are without decoration. There are a low open cabinet on two X-shaped wooden supports with a metal connecting link, a cabinet with compartments and drawers, a round table with three legs of which one is extended to bear a lampshade, and various seats.

Bibl.: *Katalog der Kunstschau Wien 1927*, Berlin (G. E. Diehl), 1927; *DKuD* LXI, 1927/1928, 69ff.; *ÖK* I, 1926/1927, 121; *MBF* XXVI, 1927, 389ff.

Cat. 274 1927

Exhibition design of Austrian section at the Exhibition of European Arts and Crafts 1927
Leipzig, Grassi-Museum
Opening: 6 March
Local supervision and decorative wall painting: Christa Ehrlich

On the occasion of the opening of a new museum building the Austrian rooms were designed as parts of an international exhibition. The main room is entered through a wide entrance flanked by two narrower see-through showcases. The left side wall and the right rear corner also have built-in floor-to-ceiling showcases. Walls and ceiling are white; the slight cornice is decoratively painted in red, light yellow, and gold; the showcases have silvery metal moldings. The floor covering is gray. A large table on three massive pedestals veneered in walnut stands in the center. Table and showcases are brightly illuminated, and the colorful decorative art objects exhibited form a contrast to the tranquillity of the plain walls in subdued light.

In a side room stand three other showcases. They are square and have four massive legs sup-

porting a thin slab on which rests a metal vitrine with a pyramidal top.

Bibl.: R. Graul, *Europäisches Kunstgewerbe 1927*, Leipzig, 1928; Information and photographs courtesy of Christa Ehrlich; Weiser, 22; Catalogue of the Exhibition, Leipzig, 1927.

Cat. 275 1927

Furnishing of a model interior for apartment buildings of the City of Vienna
Exhibition: *Vienna and the Viennese*, Vienna, Messepalast, May/June (text fig. 274)

With other architects Hoffmann participated in the creation of model interiors for Vienna's municipal housing projects. He designed a folding bed, low eggshell finished case furniture, as well as a corner seating arrangement consisting of a round table, simple chairs, and sofa with joined chest.

Bibl.: *MBF* XXVI, 1927, 399; *Catalogue, Wien und die Wiener*, Vienna, 1927.

Cat. 278 1927

Furnishings of apartment for Director General Ernst Bauer
Vienna I, Biberstraße 11

Anteroom, master bedroom, and children's bedroom were newly furnished in an existing apartment. The anteroom received a dark carpet with a rhythmic linear pattern and wall covering with the patterned Wiener Werkstätte fabric "Viola" (designed by Dagobert Peche). Floor-to-ceiling closets were given a green eggshell finish.

The children's room has pink walls and eggshell finished furniture. It includes three low chests with folding beds, a glazed toy cabinet, a child-sized seating group, and a small upholstered chair. A richly decorated cylindrical stove of ceramic grillwork (by Flora Bauer) and informal decorative wall painting (by Mathilde Flögl) complete the interior. Next to it is a "built-in cabin" for the oldest son, who has his own furniture, including a desk painted matte pale blue.

The adjacent parents' bedroom is especially rich. The walls and tentlike ceiling are linked by painted geometric motifs and superimposed de-

Cat. 278/I, II, III. Bauer apartment, children's room; design sketch; bedroom (cf. text fig. 252)

signs in a yellow tone by Maria Strauss-Likarz. A matching curtain extends across the entire window wall; light red "shaded" upholstery also fits into the overall effect. Upholstered chairs face each other across a small table and flank the dressing table, above which hangs a large round mirror. Opposite the window wall is a fireplace corner with upholstered bench. The bed niche is occupied by a tripartite cabinet with a fold-out bed in the center. All furniture is walnut; its warm, light tone contrasts with the black carpet woven with colorful flower accents.

Bibl.: *DKuD* LXI, 1927/1928, 445ff.; C. G. Holme, ed., *Decorative Art*, London, 1931, 41; Drawing: ÖMAK.

Cat. 279 1927

Project for a Music Festival House or World Concert Hall for the World Music and Song Society of Gustav Mäurer
Vienna II, Augarten Park

A monumental building of about 100m x 130m, comparable in size to the Vienna Opera House, consisting of a concert hall with foyer and subsidiary rooms, plus cloakrooms and meeting rooms grouped around two courts. The exterior is simple and shows a number of tall entrances reached

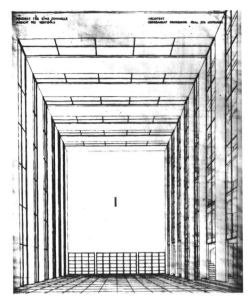

Cat. 279/I, II, III. World Concert Hall, design sketch; interior of vestibule; model (cf. text fig. 254)

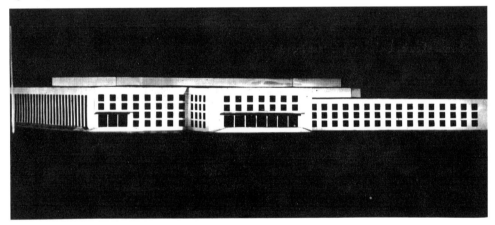

by a flight of steps, but Hoffmann's drawing looks less severe than a published perspective and the representation on the 1930 letterhead of the World Music and Song Society.

Bibl.: Drawing: Estate; Photograph: ÖMAK; *MBF* XXVI, 1927, 168, 169; *Architectural Forum*, November 1928, 712.

Cat. 280 1927

Design sketch of row house for Ing. Scharf

Cat. 281 1927

Design of a light column for the Wiener Werkstätte

Illuminated advertising in the form of a pillar, 6m high, with a pronounced downward taper. It bears a winged lantern carrier on a thin vertical support, the lantern hanging from his hands by a long cable. The pillar has a composition of letters and decorative motifs with the inscription "Wiener Werkstätte modern arts and crafts in all genres." This composition may have been intended for illumination from within, perhaps with cut-out metal forms against a background of milk glass.

Bibl.: Drawing: ÖMAK.

Cat. 282 1927

Design for a soldiers' monument in Kapfenberg, Styria

O. Haerdtl was responsible for working out this design, but it was not executed immediately and about five years later a greatly altered monument was built on the outer wall of the parish church in Kapfenberg.

Cat. 283 1927

Steiner family tomb, Vienna, Central Cemetery(?)

Cat. 284 1927-1936

Interiors of cars for the Austrian Federal Railroad

Jointly with O. Haerdtl (who was especially interested in this project and must be credited with much of the actual design work)

The interiors are developed for regular and express cars built by the Simmering railroad car factory in Vienna. Passenger compartments, corridors, washrooms, and sanitary facilities are designed for the respective types of cars. Perforated metal is used as wall covering in several places; there were also experiments with corrugated aluminum. The compartments of the express trains have paneling in precious wood; the upholstery has a pattern developed from the state coat of arms and the letters ÖBB. The regular cars are not divided into compartments but have pairs of wooden benches with two or three seats on an open central corridor.

Bibl.: *DKuD* LXVII, 1930/1931, 420ff.; Haerdtl, 127; Archive photographs of the ÖBB.

Cat. 285 1928

Competition project for Synagogue in Sillein (Žilina), Czechoslovakia

The facade sketch shows the main building and a column with the Lion of Judah in front; it is connected with a secondary building by a glazed passage. The main building has walls with battlementlike tops and a steep glazed polygonal roof in the center. There are at least fourteen preliminary studies for this final version, which Max Eisler has arranged in convincing order. The first sketch showed a building with low segmental dome, then follows one with rich exterior articulation and a slightly pointed dome, then three designs with pointed or parabolic domes on a high drum. Another series explores a pyr-

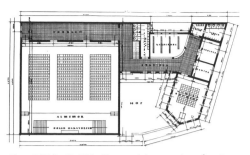 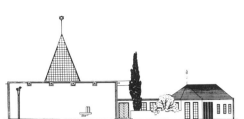 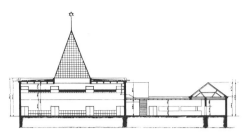

Cat. 285/I, II, III. Competition project for Synagogue in Sillein, plan, view, and section (cf. text figs. 258, 259)

amid roof instead of a dome and an outer wall with several gables. Finally, the pyramid roof is not set back but rests directly on the outer walls, and the idea of folding the surface of the roof also occurs.

Bibl.: Drawings: Estate and Academy; *Menorah* VII, 1929, 86ff.; *MBF* XXVII, 1928, 463, 464.

Cat. 286 1928

Project for Goeritz House
Chemnitz (now Karl-Marx-Stadt), Saxony, East Germany

The owner of a lot invited several architects to submit designs. Hoffmann's design was not executed.

Cat. 287 1928-1929

Project for Art and Exhibition Hall in Vienna
Vienna IV, Karlsplatz
Shown at the Exhibition *Neues Bauen* (New Building), Vienna (6-28 April)

Hoffmann proposed a multipurpose building with function, exhibition, sales rooms and guest rooms on the site of the Resselpark between the Wiedener Hauptstraße and the Church of St. Charles. Parts of the park were to be preserved, with buildings only at the perimeter. The buildings are arranged to provide a framed approach to the Technical University and a court of honor in front of the Church of St. Charles. The tracks of the metropolitan railroad are built over or paralleled by buildings.

The buildings have three stories except for a tower at the Wiedener Hauptstraße. The ground floor is in stone and forms a base for upper stories in steel and glass construction. The slightly

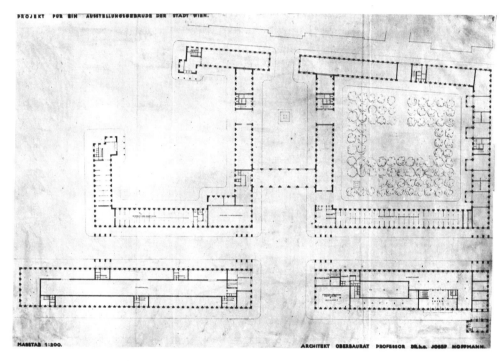

Cat. 287/I, II. Project for Art and Exhibition Hall in Vienna, Karlsplatz, plan and perspective toward Karlskirche (cf. text figs. 255-257)

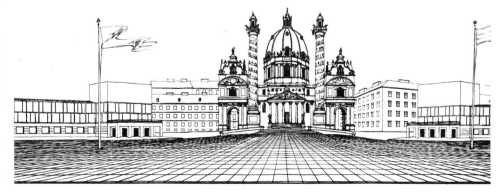

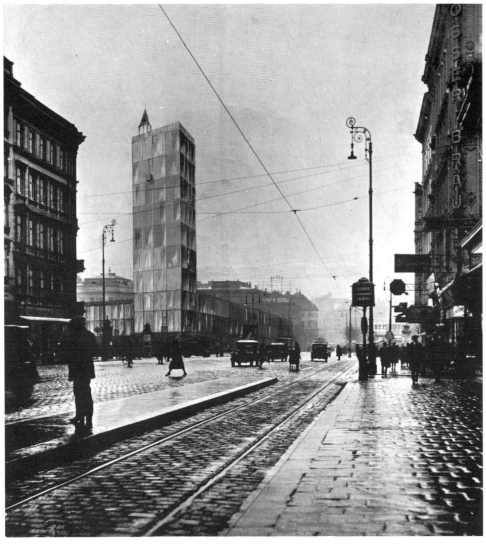

Cat. 287/III. Project for Art and Exhibition Hall in Vienna, view from Kärntnerstraße toward exhibition building (photo montage)

sloping roofs are set back from the facades so that they are barely visible. The architect also conceived the building as "a great shining glass lantern at night." There are several facade studies that show various possibilities of decorative enrichment.

Bibl.: Drawings: Estate and Historical Museum of the City of Vienna; Photographs: Estate; *DKuD* LXIV, 1929, 317ff., LXV, 1930, 409ff.; B. Taut, *Die Neue Baukunst, etc.*, Stuttgart, 1929, 213; *Die schönen Künste*, 1946, 169, 170.

Cat. 288 1928

Project for a hotel in Vienna and "Kurhaus" competition, Salzburg

The two projects are closely related as shown by comparing the very similar perspectives of hotel and "Kurhaus." The five-story hotel in skeleton construction houses reception and dining rooms on the glazed ground floor; on the upper stories are 160 guest rooms with balconies. A three-story wing at a right angle accommodates a café terrace on the ground floor, function rooms on the second floor, and exhibition rooms on the third floor; in the center is a large hall seating 500 people, with stage and foyer. Besides Hoffmann, four other architects, including Peter Behrens, were invited to the competition for the "Kurhaus."

Bibl.: *BUWK* V, 1928/1929, 193; *DKuD* LXVI, 1930, 412.

Cat. 289 1928

Exhibition "Tearoom"
Exhibition *Die neuzeitliche Wohnung* (The Modern Apartment) at the Austrian Museum for Art and Industry
Opening: May
Wall painting by Mathilde Flögl
Seating furniture by Bernhard Ludwig
Buffet and showcase by J. Soulek

The room is in a preferred location at the end of the center hall of the museum addition. On a dark carpet stand a few graceful pieces of furniture, all on slim, shimmering metal legs. Only a bench and low buffet have additional wooden curved supports. The rectangular table has a glass top, the upholstery fabric has a "shaded" pattern. There are also chairs with only an empty rectangular frame as back. Everything is geared to achieve the greatest possible effect of transparency and a feeling of lightness, of hovering. A large spherical light fixture with white silk shade hangs from the dark ceiling. The walls are painted with widely spaced horizontal elements and stylized plant, animal, and human forms.

Bibl.: DK XXXII, 1929, 15; *DKuD*, LXII, 1928, 311ff.; Catalogue, *Die neuzeitliche Wohnung*, ÖMKI, Vienna, 1928; Catalogue, *Neus Wohnen, Wiener Innenraumgestaltung 1918-1938*, OMAK, 1980, 48.

Cat. 290 1928

Exhibition design within the section "Austrian Arts and Crafts then and now" at the International Press Exhibition PRESSA, Cologne

Hoffmann designed a group of furniture in yellow eggshell finish, executed by Anton Pospischil, and another one in dark, polished wood.

Bibl.: Catalogue, *PRESSA*, Cologne, 1928, Rooms 67, 68; *MBF* XXVII, 1928, 465; Weiser, 54.

Cat. 291 1928

Exhibition design for Düsseldorf
Collaborator: O. Haerdtl

Cat. 292 1928

Exhibition design of two rooms for the exhibition "Art in Industry" at Macy's department store, New York
Collaborator: O. Haerdtl

Besides the Boudoir of 1923 (Cat. 247), a room of showcases with a completely mirrored wall was shown. Wolfgang Hoffmann took over the local supervision.

Bibl.: *The Arts* XIII, 1928, 378.

»PROJEKT FÜR EIN HOTEL IN WIEN« 1927

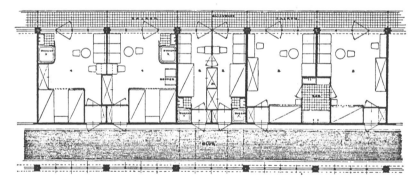

Cat. 288. Project for a hotel in Vienna, perspective and plan of room types

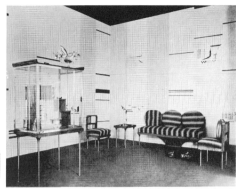

Cat. 289. Exhibition "Tearoom"

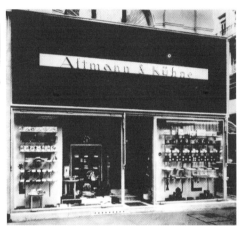

Cat. 295/I, II. Altmann & Kühne
confectionery shop, front and interior

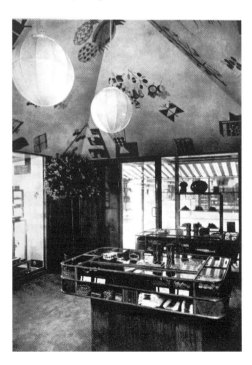

Cat. 293 1928

Design for contribution to an exhibition, Chicago, Illinois

Cat. 294 1928

Project: Building for Dr. Georgewitz, Belgrade, Yugoslavia

Cat. 295 1928

Shop window and furnishings of Altmann & Kühne confectionery shop
Vienna I, Kärntnerstraße 36/corner Maysedergasse
Collaborator: O. Haerdtl

The corner shop window is divided into two horizontal zones of about equal height; the lower includes the entrance from the Kärntnerstraße and the large plate glass windows; the upper bears the name of the firm. On the Kärntnerstraße the lettering on a cream colored strip contrasted with a large vermilion panel; on the Maysedergasse the color scheme is reversed: the in-

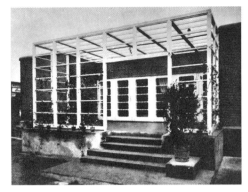

Cat. 296/I. Steel house for Vogel & Noot, view

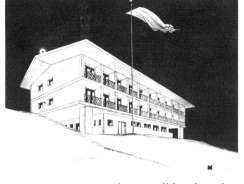

Cat. 297/I, II. Project for a small hotel on the Schneeberg, perspective and plan of ground floor

scription is in a red strip against a light background. Inside, the walls have wood wainscoting or shelving up to the oblique, tentlike ceiling with painted decoration. There are free-standing sales tables with rounded tops and massive bases; the sides and surfaces are partially glazed and divided into compartments.

When the painting of the ceiling became worn, it was replaced by a flat white ceiling. The shop is no longer extant.

Bibl.: Photographs: Estate; *DKuD* LXV, 1929-1930, 338; *MBF* XXVII, 1928, 465ff.; *Die Form* VII, 1932, 663.

Cat. 296 1928

Steel house for the firm Vogel & Noot
Wartberg, Styria, and Vienna
Collaborator: O. Haerdtl

This is a prefabricated house with wall and ceiling elements of pressed steel; the manufacturer offered several models. Hoffmann designed a solution with flat roof and terrace with pergola in front of the living room. On a 9.3m x 12.3m area he included a living room of about

Cat. 300. Decorative design for a high-rise building

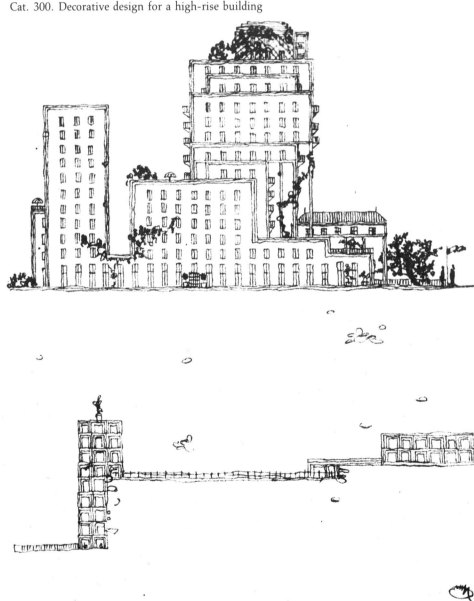

Cat. 296/II. Steel house, ground plan

4m x 7m, two bedrooms, a small room, plus vestibule, kitchen with larder, and bath. The central living room runs from one outer wall to the other; on one side are the bedrooms, on the other the housekeeping rooms with entrance and kitchen. Hoffmann commented on this design: "As I am exceptionally interested in every progressive method of building, it was a matter of course for me, upon introduction of the steel house in Austria to give it a new form." Some houses of this type were actually made and partly exported to Italy; a sample house was exhibited near the Secession building in Vienna.

Bibl.: *MBF* XXVIII, 1929, 77, 78; B. Taut, *Die neue Baukunst*, etc., Stuttgart, 1929, 173; Records in the archive of Vogel & Noot, including a letter from Hoffmann of 19 November 1928.

Cat. 297 1928

Project for a small hotel on the Schneeberg, Lower Austria

A three-story building with low saddle roof has massive piers at each corner of the ground floor; on these rests a slab which projects beyond the side walls. The outer walls of the ground floor are set back from the piers. On the ten-bay front, the wall of the upper stories is also set back to make room for balconies, separated by vertical slabs. On the ground floor are the lobby and staircase, the dining and function rooms plus the kitchen and its subsidiary rooms. The building seems to have been planned for reinforced concrete construction.

Bibl.: *MBF* XXVII, 1928, 461, 462.

Cat. 298 1928

Remodeling for Dr. Döll

Cat. 299 1928

Exhibition room of the Wiener Werkstätte at the Christmas Show in the Vienna Künstlerhaus
Opening: December

A large showcase with built-in shelving at the rear center takes up one wall. The other walls have wide multicolored bands enriched by silhouetted stenciled motifs. There are also selected pieces of furniture and ceramic sculptures, of which a contemporary critic singled out those by Gudrun Baudisch.

Bibl.: *DKuD* LXIV, 1929, 63; *BUWK* V, 1928/1929, 98, 99.

Cat. 300 about 1928

Decorative design of a tall building

Probably drawn for publication in the jubilee book of the Wiener Werkstätte 1903-1928, this

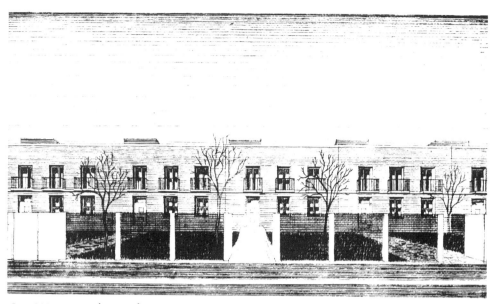

Cat. 302. Project for row houses, perspective of garden side

fanciful design shows a thirteen-story building with penthouse, and a second building complex with terraces in frame construction. The taller building has numerous framed projections and setbacks, terraces and balconies, and is enlivened by plants.

Bibl.: Drawing: ÖMAK; Mang, 106; *Wiener Werkstätte 1903 bis 1928*, Vienna, 1928.

Cat. 301 1928

Project: Exhibition hall for Ludwig Geyer
Collaborator: O. Haerdtl

Cat. 302 undated (at the latest 1928)

Project for row houses

A published perspective of the garden side shows flat-roofed, two-story houses with small balconies on the upper floor. The facades seem to be intended for brick construction. The roofs are designed as terraces, the parapets of which merge with the outer walls.

The drawing may be connected with Cat. 280.

Bibl.: *MBF* XXVII, 1928, 462.

Cat. 303 1928-1929

Remodeling of the Graben Café
Vienna I, Graben 29a
Collaborator: O. Haerdtl

The interior of Hoffmann's café of 1912 (Cat. 155) was remodeled and a new entrance front created. A new music podium had been installed in 1926. On top of the recessed entrance the

Cat. 303/I. Remodeling of Graben Café, front (cf. text figs. 272, 273)

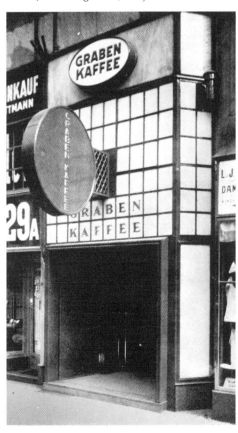

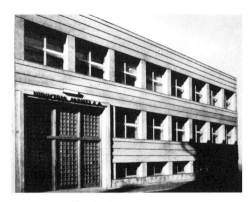

Cat. 304. Office building of Industria Sarmej S.A., street view

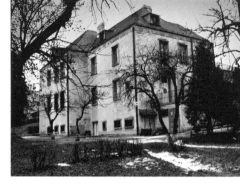

Cat. 305/I, II. Diamant House, street and garden views (cf. text fig. 270)

portal is divided into white metal-framed squares, with an oval name plate above. Another oval shield with the name projects from the facade. A wood-paneled vestibule leads to the café rooms of whitish gray marble. Most of the original bentwood chairs and marble tables were retained, but the upholstery was renewed. Large, white, balloonlike ceiling fixtures and—in the large hall—crystal chandeliers provide lighting. The card rooms are green, a "French Bar" is white and red. The bar is especially lively with its thrice-stepped ceiling painted by Mathilde Flögl. This room has high wing chairs in addition to the usual upholstered chairs.

Bibl.: Brochure published for the opening; *MBF* XXVII, 1928, 468ff.

Cat. 304 1928-1929

Office building for Industria Sarmej S.A.
Klausenburg (Cluj-Napoca), Str. 6 Martie 25, Romania
Collaborator: O. Haerdtl

A flat-roofed structure with basement, in stuccoed brick construction on an L-shaped plan, is placed between neighboring buildings. The street wing is two rooms deep while the courtyard wing has only one row of rooms along a corridor. The two-story street facade, originally planned for three stories, has eight axes. Except for the window piers it is articulated into horizontal bands by strips of stucco; as the windows are also horizontal, the effect is of continuity and broad extension.

The tripartite wooden entrance divided by a transom is at the left beneath two windows. It is subdivided into small glazed squares. Steps lead to a corridor with a staircase on the court side; approximately in the middle of the courtyard wing a second staircase projects slightly and, together with another projection, helps to give it some articulation.

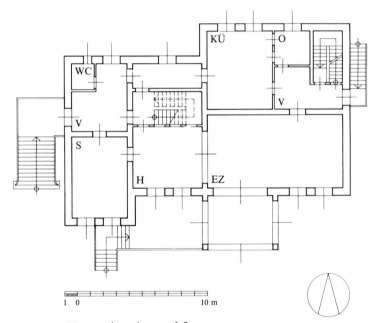

Cat. 305/III. Diamant House, plan of ground floor

The building now serves as a student home; it is in good structural condition but needs renovation. The color of the facade has been altered. A few remnants of the original built-in furniture are extant.

Bibl.: *Festschrift*, 45; Haerdtl, 15.

Cat. 305 1928-1929

House for Isidor Diamant
Klausenburg (Cluj-Napoca), Str. I. Creana 4-6, Romania

Designed for an industrialist who also commissioned an office building (Cat. 304), the two-story house with basement and partially finished attic is on a hilly wooded lot in a neighborhood of villas. The house is built in stuccoed brick with a tiled hip roof.

The house is oriented to the cardinal directions; the main entrance, reached over steps and a terrace, is on the short (west) side. It opens onto a vestibule which connects to a salon or smoking room, the main staircase, and a corridor to kitchen and pantry. Next to the salon there are, on the south side, the hall and, closely linked, the large (10m) dining room with glazed alcove and adjoining garden terrace. The staircase opens toward the hall through an arcade. A service entrance on the east side leads to a secondary staircase. On the second floor are a large bedroom with terrace over the first-floor alcove and a dressing room and bath, plus additional bedrooms and another large room on the north side.

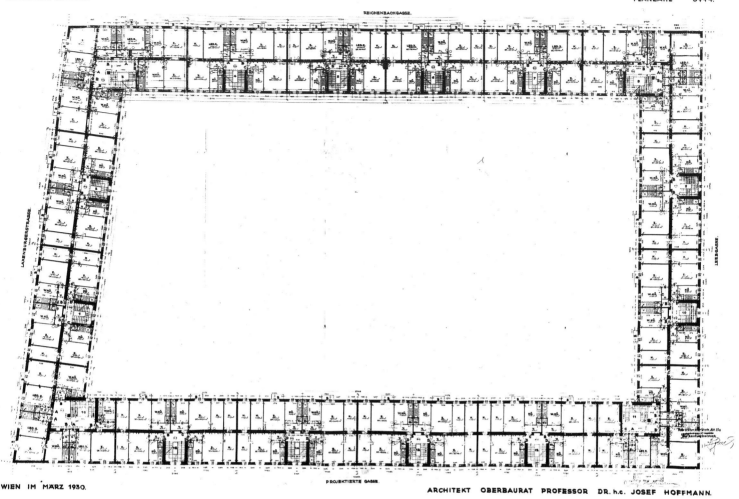

WOHNHAUSBAU DER GEMEINDE WIEN – WIEN, X. LAXENBURGERSTRASSE – REICHENBACHGASSE – LEEBGASSE – PROJEKTIERTE GASSE.
GRUNDRISS 2. STOCK.

MASSTAB 1:100.
PLANZAHL 6944.

Cat. 307/I. Laxenburgerstraße municipal apartment building, plan of third floor (cf. text fig. 268)

The facades, above a low base, have an irregular stucco pattern of horizontal and vertical grooves and strongly projecting window and door frames. The entrance forms a unit with the balcony and French door above. Delicate irregularly distributed glazing bars—horizontal, vertical and diagonal—are used in the windows. A flat, ochre stucco strip ornamented with linear geometric and plant forms takes the place of a cornice.

The building now serves as a kindergarten and has been altered inside. It is structurally in good condition. Remnants of the built-in furniture are extant. The color scheme of the facades was somewhat altered.

Bibl.: Plans in the possession of the kindergarten; Information courtesy of Prof. Stefan Lakatos, Cluj.

Cat. 306 1928-1929

Furnishings of the millinery salon "Tosca"
Vienna IV, Margaretenstraße 9
Collaborator: O. Haerdtl

At the back of the shop are booths with large mirrors. The show window is closed by a colorful patterned curtain; next to it a round mirror hangs above a perforated radiator cover. A large picture by Mathilde Flögl, with a low table and two upholstered chairs in front, takes up one side wall. The other wall is entirely taken up by a painted built-in cabinet with several doors.

Bibl.: *DKuD* LXV, 1929/1930, 333ff.; Haerdtl, 94.

Cat. 307 1928-1929

Apartment building of the City of Vienna
Vienna X, Laxenburgerstraße 94; 332 apartments
Building permit: 17 July 1931
Certificate of occupancy: 12 February 1933

The 5-story building with large interior court has a frontage of 76m on the slightly rising Laxenburgerstraße and is surrounded by streets on all sides. The maximum depth between the Laxenburgerstraße and the Leebgasse measures 123.55m. The entrances to the 16 staircases are in the court, which has vehicular access from two streets. On the Laxenburgerstraße there is a shop near each end of the building. The shorter wings are divided into four stepped segments to accommodate the slope of the Laxenburgerstraße and Leebgasse; each segment is enclosed on the

415

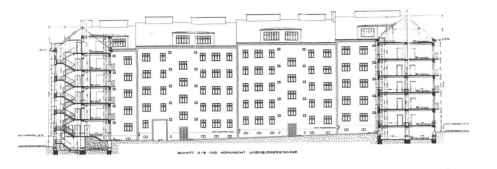

SCHNITT A-B UND HOFANSICHT LAXENBURGERSTRASSE

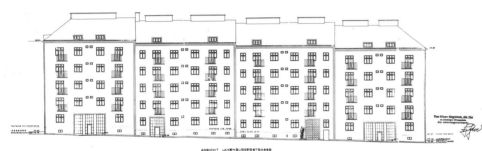

ANSICHT LAXENBURGERSTRASSE

WIEN IM MÄRZ 1930 ARCHITEKT OBERBAURAT PROFESSOR DR. h.c. JOSEF HOFFMANN

Cat. 307/II, III. Laxenburgerstraße municipal apartment building, sections and facades; view of Dieselgasse corner

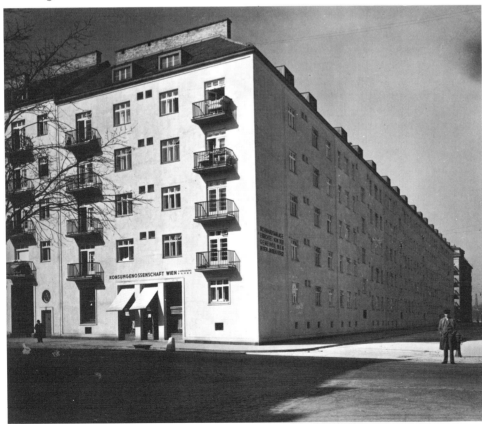

facade by a stucco strip. The side facades are also articulated into segments for each staircase. The building has a low base of brown ceramic slabs, smooth stucco above, and a simple cornice with cyma molding under a ridge roof with dormers. The facades on the Laxenburgerstraße and Reichenbachgasse are enriched by balconies with rectilinear grilles. The windows are painted white. A sculpture was to be erected next to the driveway from the Laxenburgerstraße, but it was placed in the center of the court instead.

The complex is structurally in good condition but formally changed in many respects. Only the court facades still show the architect's intentions; on the street facades the stucco strips were removed, the bases changed, and the balconies enclosed with thin slabs. The attic stories were finished later; the staircases received elevators. A third shop was built into the Laxenburgerstraße facade.

Bibl.: Photographs: Estate and ÖMAK; *MBF* XLI, 1942, 278-280; Plans: ABBH.

Cat. 308 1929

Project for an exhibition hall of the Wiener Werkstätte

A glazed hall measuring about 10m x 16m, with the outer walls designed as showcases, encloses large showcases in the center. Entrance and exit door are in a small front porch, designed as a turret with balcony and flagpole. The facades are divided into rectangles and bear decorative motifs and the dates 1829-1929. A superstructure behind the facade projects beyond the side walls; it bears the inscription "Wiener Werkstätte" and linear decorative motifs.

Bibl.: Drawing: Academy; Mang, 110.

Cat. 309 1929

Project for the Wiener Werkstätte in New York

Cat. 310 1929

Exhibition design for pavilion of "Jerske Zakladie Przemyslowo Handlowe"
Collaborator: O. Haerdtl

Cat. 311 1929

Design of exhibition stand for Zawercie, Poznan, Poland

Cat. 312 1929

Design of exhibition pavilion for Gottlieb Taussig, International Exhibition, Barcelona, Spain

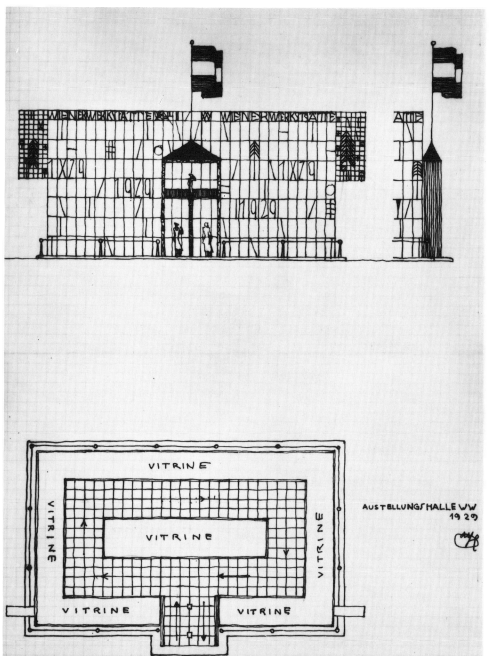

Cat. 308. Project for an exhibition hall of the Wiener Werkstätte, design sketch

Cat. 313 1929

Remodeling and partial new furnishings for Dr. Bernhard Panzer in the former Skywa House (Cat. 185)
Vienna XIII, Gloriettegasse 18

See Cat. 185.

Bibl.: *DKuD* LXVIII, 1931, 31ff.

Cat. 314 1929

Furnishings of a villa for Dr. Lengyel
Bratislava, Podtatransky Ul. 3, Czechoslovakia

At the wish of the art-loving wife of the client, an attorney, Hoffmann designed the interiors for a new house built from the designs of a local architect; in some rooms existing furnishings had to be used.

The two-story house is at a slope so that the basement story is above grade in front. This houses the apartment of the porter. The main story contains the function rooms, vestibule, living hall, dining room, and salon (or music room). The upper story houses the kitchen and bedrooms grouped around a hall, both with built-in cabinets. One of these rooms was furnished by Hoffmann's student Jordan.

The vestibule with coat niche has a light green eggshell finish; in it an older seating group was covered with a Wiener Werkstätte fabric. The Wiener Werkstätte also supplied light fixtures, mirrors, and mountings. A glazed door opens to the living hall, which extends through the entire width of the house. The walls and the ceiling with its oblique edge in the hall and adjoining dining room are entirely paneled in walnut. The book matched finely figured, partially knurled veneer gives the effect of horizontal striping on the walls. The wooden stair begins with six steps in the hall. Above the steps a showcase with diagonal bars is set into the wall; the radiators also have latticed grillwork covers. Next to the stair a quadruple folding door to the dining room matches a two-leaf glazed door between showcases on the opposite wall. When the doors are open, the three function rooms form a unit. The hall is lighted by a tripartite glazed wall with a balcony door in the center. In front of it stands a voluminous seating group with two easy chairs and a semicircular bench upholstered in brown fabric. Later, a piano designed by Hoffmann was placed in the hall between entrance and stair.

On the dining room wall opposite the entrance stands a buffet of the same wood as the paneling, flanked by two decorative wall lamps. The extension table, with massive legs rounded on the outside, stands in the center. The matching chairs have curved upholstered seats and backs with blue "shaded" pattern fabric. Two rows of four

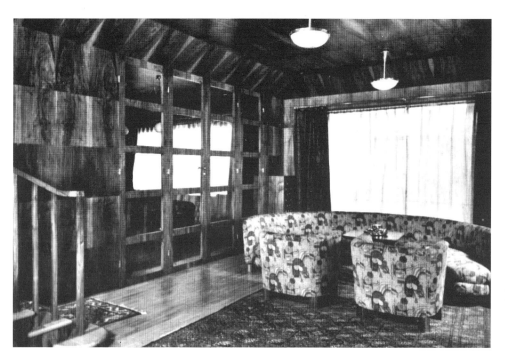

Cat. 314. Villa of Dr. Lengyel, hall (cf. text fig. 271)

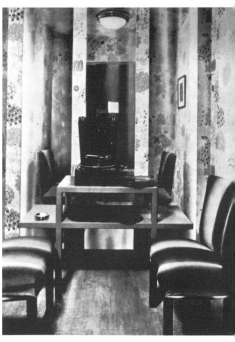

Cat. 315. Doblinger (Herzmansky) phonograph shop, salesroom (cf. text fig. 269)

Cat. 317. Branch of Wiener Werkstätte in Berlin, shop front

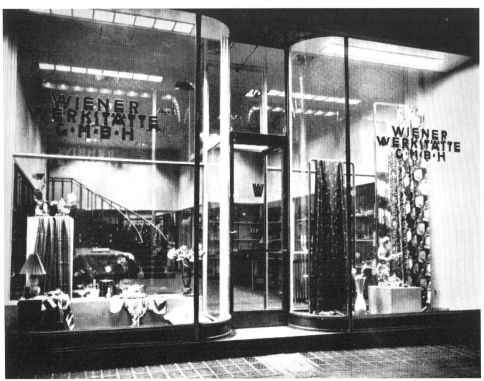

spherical milk glass lights hang from the dining room ceiling, while flat bowls are on the hall ceiling. The salon is furnished with older pieces.

After the war the house was remodeled for use by four families, but substantial parts of the furnishings are extant.

Bibl.: Drawing: HFAK; *DKuD* LXVIII, 1931, 31ff.; *MBF* XXX, 1931, 494, 496; Photographs in possession of family; Information courtesy of architect Ing. Ján Bahna.

Cat. 315 1929

Phonograph shop Doblinger (Herzmansky)
Vienna I, Dorotheergasse 10
Collaborator: O. Haerdtl

The salesroom is entirely paneled in luster finished rare wood veneer and has blue carpet and "shaded" pattern upholstery. Sales tables have shimmering metal legs and two superimposed tops with rounded corners. The luminous ceiling is designed with square milk glass panels. A side wall is taken up by two record cabinets with many compartments. On the rear wall is a large mirrored metal showcase flanked by veneered doors to the listening booths. The booths

are papered with a Wiener Werkstätte pattern and optically expanded by mirror effects; they contain two upholstered chairs and a phonograph table.

Bibl.: *DKuD* LXV, 1929/1930, 332ff.; *Die Form* VII, 1932, 663; Haerdtl, 95; Photographs: Estate.

Cat. 316 1929

Project for Ungethüm House

Cat. 317 1929

Furnishings for a branch store of the Wiener Werkstätte
Berlin W 9, Friedrich-Ebert-Straße 2-3
Collaborator: O. Haerdtl

The shop front is symmetrical with a central entrance flanked by two convex show windows. It is entirely transparent with large plate glass panes in slim metal frames so that both the window display and the lighted interior are visible in the evening. Lighting is by recessed ceiling fixtures. Brass showcases stand at the slightly rose-tinted walls, brass sales tables and upholstered chairs are in front. They are covered with a red "shaded" pattern fabric that harmonizes with the light red carpeting.

At the rear of the room an open quarter-circle stair with slender brass railing leads up to another room; in contrast to the ground floor color scheme it has a blue carpet, showcases with blue eggshell finish, and blue walls.

Bibl.: Photographs: Estate; *DKuD* LXV, 1929/1930, 327ff.

Cat. 318 1929

Music Room for an Exhibition
Exhibition of Viennese interior designers at the Austrian Museum for Art and Industry
Opening: December
Execution: Anton Pospischil

Hoffmann showed a large room in blue gray with an entirely glazed wall permitting a view into a winter garden. He was also represented by furniture in the first room of the exhibition. A row of strongly curved upholstered easy chairs stands along the wall opposite the winter garden. A four-door cabinet for sheet music is covered with the same blue white patterned rep from the Wiener Werkstätte as are the seats. In front stands a Bösendorfer grand piano with two chairs, floor lamp, music stand, and a low holder for sheet music. L. W. Rochowanski said about the room that it is ". . . for festive feelings, a room

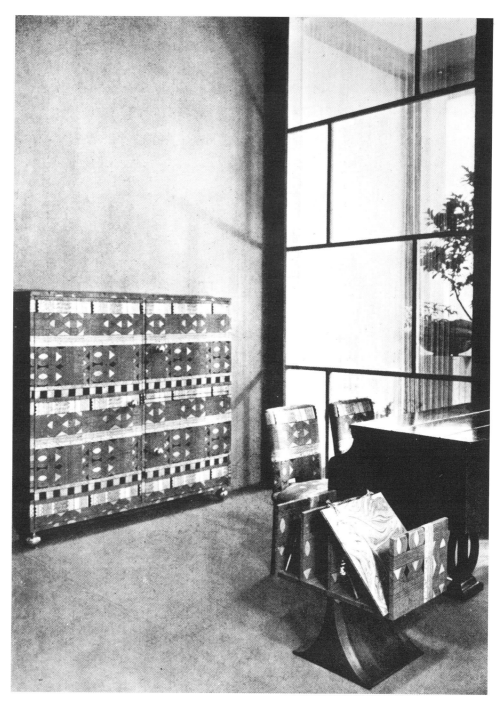

Cat. 318. Exhibition music room, view toward winter garden

419

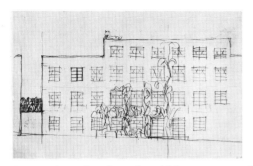 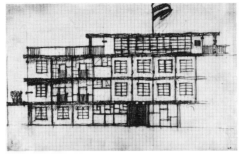 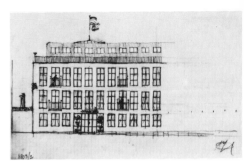

Cat. 320/I, II. Facade studies, 12-bay apartment house

Cat. 321. Facade study, apartment house

of creative hours, over which the blue toga of Klimt is spread.''

Bibl.: *Katalog Wiener Raumausstellung*, ÖMKI, 1929/1930; *DKuD* LXVI, 1930, 417; *MBF* XXIX, 1930, 78ff.; *Decorative Art, The Studio Year Book* XXIX, edited by C. G. Holme, London, 1934, 88.

Cat. 319 1929

Facade study for an apartment building of the City of Vienna

The four-story, 12-bay building on a slightly sloping site has a roof terrace and closely spaced horizontal windows with three vertical casements. Only next to the entrance is the regular rhythm interrupted by smaller windows. Delicate parallel lines on the facade may indicate planned stucco decoration. Decorative motifs are scattered over the wall in some places, and sculptured enrichment is shown above the entrance.

The study probably belongs to the same project as Cats. 320 and 321.

Bibl.: Drawing: ÖMAK; Mang, 108.

Cat. 320 Undated (1929-1930)

Facade studies for a 12-bay apartment building

The studies assume a three-story building with a higher six-bay center. In one variant there is a roof terrace with railing next to the center; in another, one with a solid parapet. In the first case the superstructure is largely glazed, the facade divided into panels, articulated by recessed loggias, and enriched by decorative stucco bands. In the second case the facade is without decoration and relieved only by climbing plants. The drawing, however, may not represent actual plants but decorative plant motifs. In both cases the building stands on a sloping site and is connected with neighboring buildings by a decorative portal.

Bibl.: Drawings: Estate and National Gallery of Art, Washington, D.C.

Cat. 321 undated (1929)

Facade study for an apartment building

A facade for a three-story apartment building with penthouse; on the ground floor there are only casement windows, on the upper stories French windows or balcony doors. The penthouse, sheathed in sheet metal and with small horizontal windows, is set back to form a terrace. The glazed entrance extends over three axes and has a sculpture above. A flag waves from a low hipped structure on the roof. A decorative portal connects with the neighboring building. A low stone base makes up for the slight slope in level (compare Cats. 320 and 325).

Bibl.: Drawing: ÖMAK.

Cat. 322 1929-1930

Exhibition design: Room of the Wiener Werkstätte
Austrian Arts and Crafts Exhibition at the ''Nordiska Companiet,'' Stockholm
Opening: end of January 1930
Collaborator: O. Haerdtl

Bibl.: Haerdtl, 179; *Die Form* V, 1930, 113.

Cat. 323 1929-1930

Monument for Otto Wagner
Vienna I, Heldenplatz (present site: Makartgasse, next to the Academy building)
Unveiled on the occasion of the Werkbund meeting in Vienna, end of June 1930 (see figs. 260-261).

Hoffmann created many designs for the monument which was eventually executed as a simple 9m high pillar with the inscription at eye level. Four are related to the executed version since they are pillar- or obelisklike, variations of the ancient motif of the triumphal column. Two of these have capital-like tops, two even support figures. One of the ''capitals'' serves as a basin with sacrificial flame. Another solution

Cat. 323/I, II. Monument for Otto Wagner, design sketch, view (photo montage) (cf. text figs. 260-261)

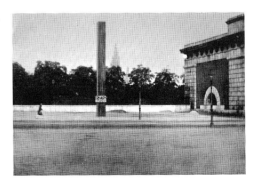

addresses a theme as old as the triumphal column: the triumphal arch, in this case of concrete with parabolic profile. Another concrete design is a pillared hall with flat roof and twelve slender pillars enclosing a square with a round basin and fountain. The whole is crowned by a sculpture on a tall support, not unlike a weathervane. Two other designs propose portal-like monuments instead of a roofed hall. One has a quadripartite portico of concrete frames; four closely spaced pillars are connected by beams at the top. The lettering is in the upper part of the monument between the pillars below the beams. For the other design Hoffmann created a tall portal of pillars with horizontal lintel, with a neighboring bench and tall concrete basin. There are also benches at the foot of another monument where a vertical central concrete slab, about 10m high and 2.5m wide carries a projecting horizontal slab and three more parallel slabs which are symmetrically cantilevered below. The inscription is on the short side of the central slab.

Bibl.: Drawings: ÖMAK and Estate; ÖK I, 1929, 43ff.

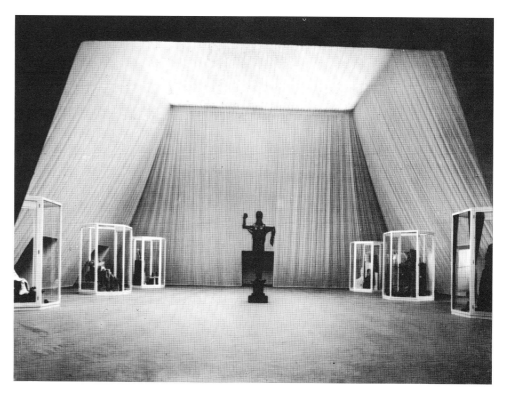

Cat. 324 1929-1930

Exhibition: Austrian Werkbund 1930
Austrian Museum for Art and Industry, Vienna
Opening: June 1930

Hoffmann was responsible for the entire layout of the exhibition, which included the museum garden. He designed the great central room for Fashion and Sport in the main axis of the museum entrance, the adjoining main room of a café with large terrace, and the show windows for arts and crafts along the corridors with tentlike roofs on either side of the central room. The entire plan is based on the idea of presenting solutions for actual design problems from the economic realm, namely shops and public establishments. Werkbund members were employed; they include Hoffmann's old collaborators, colleagues, friends, and former students such as Oswald Haerdtl, Oskar Strnad, Josef Wimmer, Alfred Soulek, and Walter Sobotka. Wagner's pupil Ernst Lichtblau stands out by the elegance of his contribution, and Clemens Holzmeister by the emphatically rustic character of his wine tavern in loghouse construction.

Hoffmann designed the large central room in a grand but restrained manner, by means of a pleated white velum (execution by Max Schmidt) with tentlike oblique side walls and flat lighted ceiling. In the center of the room stands a strongly stylized female figure by Rudolf Reinhart, the only work of art, visible from afar. A few hexagonal glazed showcases for sports and fashion displays stand at the long walls; the café with a

Cat. 324/I, II. Exhibition of Austrian Werkbund, view of central room; design sketch (cf. text figs. 262-263)

wide striped awning over its terrace adjoins the transversal rear wall.

Hoffmann designed the large room of the café (execution by August Ungethüm; see fig. 262) with two seating groups, and strongly patterned upholstered benches along part of the walls. Two large buffet tables of zebra wood with massive bases and rounded corners are free-standing. In the smoothly stuccoed walls are round niches with colorful ceramic figures—said to be portraits of well-known Viennese beauties; flat light fixtures are set into the ceiling.

Bibl.: Drawing: HFAK; ÖBWK VI, 1929/1930, 225ff.; *MBF* XXIX, 1930, 333ff.; *DKuD* LXVI, 1930, 317ff.; *Die Form* V, 1930, 329ff.; *Katalog der Werkbundausstellung 1930*, ÖMKI.

Cat. 325. Facade study for apartment house

Note for the years 1930-1939

During these years Hoffmann worked with Oswald Haerdtl as his partner. Projects on which Haerdtl had substantial influence in design and execution are listed here in parentheses. Projects which were demonstrably worked on by Haerdtl alone are not included in the Catalogue.

Cat. 325 1930

Facade studies for apartment building

Facade solutions for four-story, flat-roofed apartment buildings are studied. Stairs parallel to the facade are visible in the glazed staircases. The facades are planned in strong colors—light blue, violet, and light green in one case, and violet in the other—and have decorations on the cornice and staircase window surrounds, or as scattered motifs. A decorative gateway connects with the neighboring building. One of the gateways bears the inscription "Werkbund."

Similar portals occur on other studies for apartment houses (see Cats. 320 and 321).

Bibl.: Drawings: ÖMAK.

Cat. 326 1930

Project for an apartment building in Vienna XIX
Jointly with O. Haerdtl

A symmetrical 12-bay, three-story building, shown in a model photograph, stands on a slightly rising street; it has a roof terrace and set-back open shelters on the roof. The first and third axes at each end are emphasized by triple French windows; the entrances are in the third axes. All other axes are identical, with almost square windows.

This scheme was probably developed from earlier studies for a 12-bay apartment building (see Cats. 320 and 321).

Bibl.: *Festschrift*, illustrated part; *DKuD* LXVII, 1930/1931, 278; Haerdtl, 15.

Cat. 327 1930

Project for rental villas in Vienna XIX
Jointly with O. Haerdtl

The published model photographs show a pair of detached triple-stepped, flat-roofed houses. On the street side is a garage in a high basement; its entrance and the door to the house are placed on the side facade. Above the entrance are round staircase windows. Three other round windows per story are the only openings of the main stories on the garden side. On the street side of the first floor a triple French window and the balcony door form a unit set in a niche so as to enlarge the terrace. On the two next stories two triple French windows separated by a masonry pier open onto the terrace.

Bibl.: *Festschrift*, illustrated part; *DKuD* LXVII, 1930/1931, 278; Haerdtl, 15.

Cat. 326. Project for apartment house, Vienna XIX, model

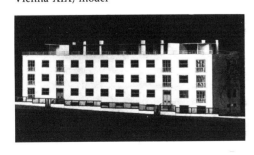

Cat. 327. Project for rental villas, Vienna XIX, model

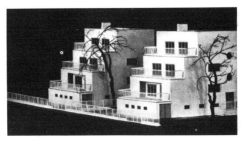

Cat. 328 1930

Project for a rental villa in Vienna
Jointly with O. Haerdtl

A published model photograph shows a flat-roofed three-story building with a 4-bay facade and set-back open shelter on the roof. The stories are identical and have horizontal windows with

round portholes in between, plus a triple French window opening to a small balcony.

Bibl.: *Festschrift*, illustrated part; Haerdtl, 15, where the project is dated 1928.

Cat. 329 1930

Design for Humhal House
Jointly with O. Haerdtl

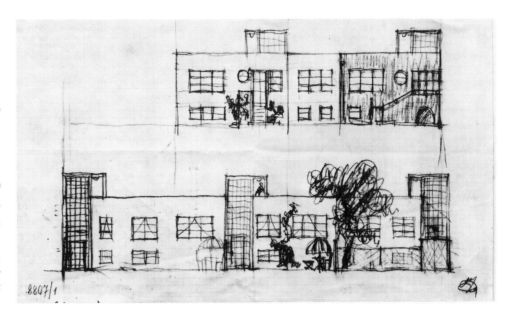

Cat. 330 1930

Project: Single family house and apartment building for the Phoenix Insurance Co., Vienna
Jointly with O. Haerdtl

Some previously listed studies (Cats. 320ff.) may refer to this project, as might some of the numerous studies for single-family houses that are not identified or dated (Cats. 405ff.).

Cat. 331 1930

Project: Apartment building for Dr. Grete Magg
Jointly with O. Haerdtl

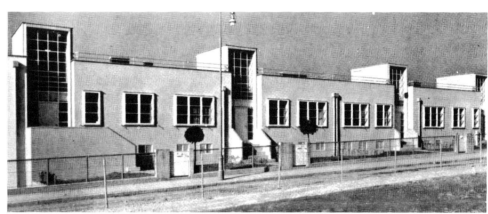

Some of the previously listed studies (Cats. 320ff.) could also refer to this project, as might studies for urban apartment buildings that are not identified or dated (Cats. 439ff.).

Cat. 332 1930

Design for the Exhibition of the Austrian Werkbund in Chicago, Illinois
Jointly with O. Haerdtl

Cat. 333 1930-1932

Four row houses of the Werkbund Housing Estate
Vienna XIII, Lainz, Veitingergasse 79-85
Opening of the exhibition: 4 June 1932
Builder: GESIBA

The houses are part of the Werkbund Estate planned under the direction of Josef Frank and were originally intended for another site. Hoffmann designed two types of houses which are arranged as mirror images, achieving compositional unity particularly on the garden side. In the execution, he himself furnished only one house of each type and left the second house to others.

The houses for which preliminary studies exist, are one-story buildings with unusually high basements and flat roofs used as terraces. Like most of the houses in the Estate, they are of conventional construction with hollow stuccoed brick walls. With a depth of 8.5m, Type I at the

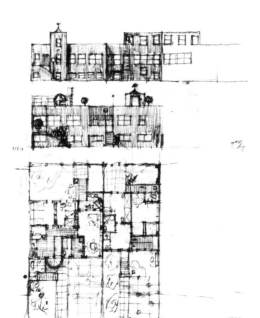

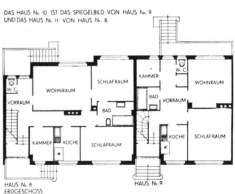

Cat. 333/I, II, III, IV. Row houses of the Werkbund Estate, facade studies, views from the Veitingergasse, preliminary project, and ground plans (cf. text fig. 264)

end has a built over area of 84 sq m; Type II in the center covers 66 sq m. Storerooms and laundry are in the basement. Type I has a vestibule, staircase, and central corridor with a bath at the end; living room and bedroom are on the garden side; another bedroom, kitchen, and a small room are on the street side. The more compact Type II has no corridor, and only a small room on the garden side instead of the second bedroom.

On the plain facades it is noteworthy that the casements project slightly beyond the wall. The towerlike staircases are glazed on the street side and provide the strongest accent. On the garden side the terraces or landings with their stairs and solid parapets and the double facade setbacks on Type I provide effective three-dimensional articulation. The living room of the larger type has white walls, a low chest at the inner wall, and a seating corner with upholstered bench and chairs. The adjoining bedroom has a clothes cabinet from floor to ceiling. The parents' bedroom is "saturated blue, the second bedroom, intended for a daughter, pink, and the small room green . . ." (Wolfgang Born).

The structural condition of the houses is good, but all have undergone changes ranging from improper facade colors and small additions (fences) to major design changes. The house at Veitingergasse 79 was affected most; here an entry was added on the street side, and the garden side was greatly altered by a garage, new terrace steps, and new windows. The built-in garage at no. 85 and the glass canopy on the street side of no. 81 have a less disturbing effect. An overall rehabilitation of the Werkbund Estate is planned.

Bibl.: Drawings, ÖMAK; *Katalog der Werkbundsiedlung Internationale Ausstellung Wien 1932*; J. Frank, *Die Internationale Werkbundsiedlung Wien 1932*, Vienna, 1932, figs. 32-38; *Die Form* VII, 1932, 84, 212; W. Dreiholz, "Die Internationale Werkbundsiedlung, etc.," in *Bauforum* 61, X, 1977, 19ff.; *Decorative Art, The Studio Year Book*, London, 1934, 24; *ID* XLIII, 1932, 287; *MBF* XXXI, 1932, 438; A. Sartoris, *Gli elementi dell'architettura funzionale*, 2nd ed., Milan, 1935, 79, 80.

Cat. 334 1931

Type design for a housing estate of the GESIBA
Jointly with O. Haerdtl

There are design sketches which may refer to this project (Cats. 408ff.).

Cat. 335 1931

Project for sound film theater in Vienna VII
Jointly with O. Haerdtl

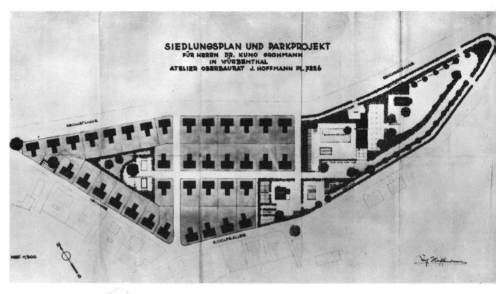

Cat. 336/I, II. Project: Housing estate and house for Dr. Kuno Grohmann

Cat. 336 1931

Project for housing estate and residence for Dr. Kuno Grohmann
Würbenthal, (Vrbno pod Pradĕd), Czechoslovakia

A site plan drawn by O. Haerdtl shows houses and a central children's playground in the western section of a large site about 500m long, or about 45.000 sq m. The eastern section is planned for a park. The residential section consists of 34 twin houses and the residence for Dr. Grohmann with its own large garden; a church, restaurant, swimming pool, and monument are planned in the park.

The two-story house for Dr. Grohmann was first planned compactly with the central staircase starting in a living room with square veranda. The ground plan is related to an earlier project (Cat. 259). A second project was worked out (see Cat. 422) with a different staircase solution; comparison of its facade with the earlier project

(Cat. 259) shows how Hoffmann's style changed: plain, largely glazed surfaces with horizontal emphasis predominate in the later project.

A brochure by Dr. Grohmann indicates that a Czech law for the promotion of housing was the impulse for this project, and that Hoffmann's design was modified by a local architect and a landscape architect. The project was not realized.

Bibl.: See Cat. 246.

Cat. 337 1932

The growing house
Exhibition house on the Rotunda grounds at the Vienna Spring Trade Fair
Jointly with O. Haerdtl

Hoffmann and Haerdtl won one of two second prizes in a competition; the first prize was not awarded; the other prizes went to Erich Boltenstern and Franz Schlacher. The task was to design a core house which could be expanded by gradual additions, and which comprised no more than 30 sq m and cost no more than 5,000 schillings.

Hoffmann and Haerdtl designed two variations: a one-story house of hollow brick construction which could be expanded on the same level, and a house of wood frame construction with Heraklith cladding, stuccoed on both sides, a second story to be added later. Only the latter house was actually erected. The almost square (6m x 6.5m) house with slightly sloping roof has a cubical effect. A flat canopy projects over the entrance; on the garden side a small terrace is in front of a triple French window, sheltered by a flat canopy on two slender supports. On the street side the toilet and basement entrance are on one side of the vestibule; on the other are the kitchen and small bath. The living room with open fireplace and folding beds which disappear into a closet are on the garden side.

In case of expansion a staircase to the upper story was to be built above the basement stairs, and the bath relocated to make the kitchen more

Cat. 337. The "growing house," view of street side

Cat. 338. Altmann & Kühne confectionery shop, front

spacious. Three bedrooms and a balcony were planned. The latter takes over the function of the former canopy over the terrace.

Bibl.: *Die Kunst* LXVI (*Angewandte Kunst*), 1932, 202ff.; *MBF* XXXI, 1932, 292, 293; *Studio* CV, no. 480, March 1933, 155ff.; Haerdtl, 18; *Sonderkatalog: Das wachsende Haus,* Vienna, 1932, 18ff.; L. W. Rochowanski, *18 wachsende Häuser,* Vienna, 1932.

Cat. 338 1932

Portal and furnishings of Altmann & Kühne confectionery shop
Vienna I, Graben 30
Jointly with O. Haerdtl

The designs of shop front and interior strongly recall the branch of the same firm on the Kärntnerstraße furnished a few years earlier (Cat. 295). The shop front is again divided into two optically equal zones; the upper one is a large white panel with the name of the firm. Inside, the walls are again covered by shelving or are paneled, but the design makes use of more glass and metal than in the earlier shop, and the wood surfaces are highly polished. The free-standing sales tables have glazed, projecting tops.

The shop is preserved without major alterations.

Bibl.: *Forum* (Bratislava) III, 1933, 174; Haerdtl, 97; G. W. Rizzi, "Josef Hoffmanns letztes Wiener Geschäft," in *Steine sprechen,* no. 43/44, December 1973, 3.

Cat. 339 1932

(Alteration and furnishings of Hartmann Restaurant)
Vienna I, Corner Kärntnerring and Akademiestraße
Jointly with O. Haerdtl

The work comprised three parts of a restaurant establishment: on the Ringstraße, left of the main entrance, the café, also called the French Restaurant with Bar; right of the entrance, the large two-part dining room, and finally a cellar with two dining rooms and separate entrance from the Akademiestraße.

In the café a transverse wall above a bench and the bar niche opposite were entirely mirrored; the bar shelves were black and red while the bar front was stainless steel. Nickel-plated steel furniture was upholstered with red leather, the window curtains were red-flowered Wiener Werkstätte fabric—probably the last product delivered before its collapse.

The dining room is entered through a metal entryway. One wing is along the Ringstraße, the other, with a free-standing marble chimney, is on the Akademiestraße. The chairs are Thonet-Mundus bentwood armchairs from Hoffmann's design, enameled black, with caned backs and patterned cushions.

A large fresco by Ernst Huber defines the character of the vestibule leading to the cellar. The other walls are in a light terra-cotta in contrast to the black floor tiles. The stairs are screened by a glass wall. The cellar has gray green bentwood furniture and a cabinet unit and buffets of cherry wood. The walls and the gently vaulted ceiling are painted a yellow tone. Pictures by contemporary artists hang in all rooms.

Bibl.: *ID* LXIV, 1933, 174ff.; *Forum* (Bratislava) III, 1933, 169ff.; Haerdtl, 76, 77; *ÖK* III, 1932, no. 8, p. 25.

Cat. 340 1932(?)

Project for a small country house

The extant ground plan and facade show a two-story house with slightly sloping hipped roof. The plan is inscribed in a square about 10m wide. On the left a courtyard wall joins the street facade. A door leads to a paved, covered forecourt. If we assume the street to face north, the entrance from the forecourt is at the north end of the east facade. It opens on a vestibule with steps leading to a corridor with cloakroom; on the east is a toilet, on the west the main staircase. A servant's room and kitchen are on the street side; a large living room with dining nook and terrace are on the garden side. The facade is simple and

with its window surrounds achieves a rustic effect.

Bibl.: Drawing: Academy (dated 1932[?] in the catalogue).

Cat. 341 1932

(Portal and furnishings of Ritz [Chanel] perfume shop, Vadasz Brothers)
Vienna I, Kärntnerstraße 22
Jointly with O. Haerdtl

The walls of the shop are largely covered by built-in cabinets with veneered doors below, showcases or open shelves above, and closed compartments at the top.

Bibl.: *Forum* (Bratislava) III, 1933, 174; Haerdtl, 99, shows the state after remodeling by Haerdtl in 1947.

Cat. 342 1932

Competition project for buildings on the Arenberggründe, Salzburg
Jointly with O. Haerdtl

Three built-up zones were proposed for the site at the foot of the south flank of the Kapuzinerberg. At the west end a multistory complex of several wings includes a tower building and a terrace establishment on a neighboring hill reached by an elevator. Behind it are seven four-story apartment houses in a row, and finally rows of three-story, single-family houses on the

Cat. 342. Competition project for Arenberg grounds, model

east. The single-family houses recall the project for a villa of 1930 (Cat. 327).

Bibl.: Photograph: Estate; *ÖK* III, 1932, no. 6, 30.

Cat. 343 1932

Project for Wertheim/Wiener Country House
New City, New York

The designs were worked out in the Hoffmann office in October and November, based on a commission originally meant to be given by Alma Morgenthau-Wertheim, sister of the United States Secretary of the Treasury, to Wolfgang Hoffmann through his wife, Pola. Alma eventually married Wolfgang's friend Paul Lester Wiener, who had become involved in the matter and who reworked and altered the designs sent by Josef Hoffmann and named the house "Contempora" after a decorative arts firm in New York in which he was a partner. Several publications of the completed house name Hoffmann as the source of inspiration.*

Two two-story cubical blocks are connected by a bridge on slender supports. The residence is in the larger block, a studio above a garage in the smaller. The house is almost entirely surrounded by terraces; the plan is organized around a central stair hall. On one side is the large living room with rounded corner, on the other, the dining room and housekeeping rooms. A square library is fitted between living and dining room. On the upper story are the parents' bedroom with bath and dressing room, and the daughter's

bedroom with another bath; above the housekeeping rooms are a second daughter's bedroom, a guest room, and a third bath.

The ground floor of the garage was planned in ashlar; the walls are otherwise stuccoed and have a decorative string course. A variation of the design shows the main house with an indication of masonry joints and with a small penthouse on the flat roof. The windows are divided into horizontal panes and carried around one corner.

* There is an exchange of letters between Wiener and Hoffmann in 1935 about the misleading publication of the house in *Die Pause*. Hoffmann's plans and Wiener's altered facades were shown together under the title "Josef Hoffmann Builds in America" without mentioning Wiener's contribution to the design.

Bibl.: Drawings: Estate; *Die Pause* I, 1935/1936, no. 1, 24ff.; *Architectural Record* LXXVII, July 1935, 22ff.; *Decorative Art, The Studio Year Book*, edited by C. G. Holme, London, 1935, 25, 45; *Bau* XXV, 1970, no. 1, 22ff.; *Domus*, December 1972, 12, 13.

Cat. 340. Project for small country house, plan and entrance facade

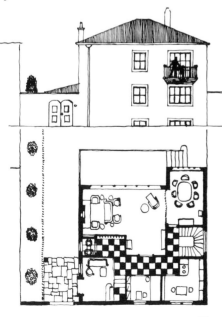

Cat. 343/I. Project for Wertheim/Wiener Country House, facade (cf. text fig. 280)

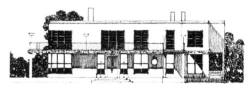

426

Cat. 343/II, III. Project for Wertheim / Wiener Country House, elevation; section

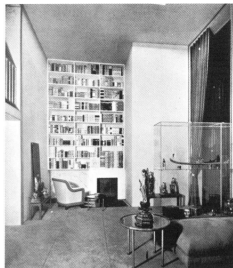

Cat. 344. Fireplace corner in a living room at the Exhibition "Room and Fashion"

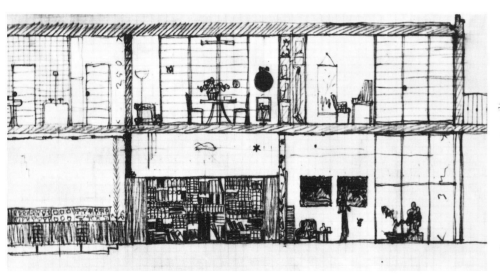

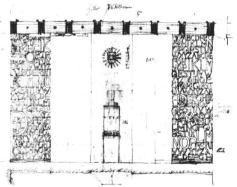

Cat. 346. Design sketch, setting for a bust of Engelbert Dollfuß

Cat. 344 1932

Exhibition design of fireplace corner in a living room

"Room and Fashion" Exhibition at the Austrian Museum for Art and Industry, Vienna
Opening: 29 November

Hoffmann participated in the artistic direction jointly with Josef Wimmer and Oswald Haerdtl, who was the chief architect. He designed a high narrow room with an undecorated fireplace of lightly veined marble in a niche. Ceiling-high bookshelves are on the wall above; an upholstered armchair and a small round three-legged table stand in front. Numerous decorative objects were displayed on other tables and in a showcase.

Bibl.: Catalogue, *Raum und Mode*, ÖMKI, Vienna, 1932; *ID* XLIV, 1933, 41, 42; *Domus* VI, February 1933, 76.

Cat. 345 1932-1933

(Furnishings of Tailor Salon of Adolf Huppert)
Vienna I, Opernring 15
Jointly with O. Haerdtl

A reception room for customers had walls covered with rare wood veneers, a fireplace of polished marble, and nickel-plated tubular steel furniture. The shop is no longer extant.

Bibl.: *Forum* (Bratislava) III, 1933, 174.

Cat. 346 undated (1932-1935?)

Design sketch for the placement of a bust of Engelbert Dollfuß

A shallow white niche, 1.40m wide, is recessed in a red wall panel; the bust is in front on a pedestal 0.54m wide by 1.86m high, with a red-white-red coat of arms in a silver wreath of rays on the wall above. Around this group is a square

white area, 5.20m wide, flanked on the right and left by shallow niches, again 1.40m wide, with inscriptions in silver letters of different sizes on a white ground. A dark brown and silver frieze with eight triglyphlike panels and stars tops the composition.

Bibl.: Drawing: Estate.

Cat. 347 1933

Project for remodeling of Café Bristol
Vienna I, Opernring
Jointly with O. Haerdtl

Cat. 348 1933

Design of various stands and the café at the Culinary Exhibition, Vienna
Jointly with O. Haerdtl

Cat. 349 1933

Site plan and house type for project of Trazerberg housing estate, Vienna XIII
Jointly with O. Haerdtl

Cat. 350 1933

*Design sketch for single-family house with approximately square ground plan**

The ground plan of this two-story house with basement and hipped roof measures 11m x 10.5m. Assuming the entrance to be at the north, there is a toilet in the northeast corner and a staircase in the northwest corner, reached from an entrance in a niche, and a vestibule. The vestibule opens to the living room with dining nook and terrace. The kitchen adjoins a pantry and a short access corridor to a small bedroom and the dining nook. The facades are plain; the roof is somewhat set back from the coping of the wall.

* From the entries in the register of plans for 1933, this could be a house type for the Trazerberg project (Cat. 349).

Bibl.: Drawing: Estate.

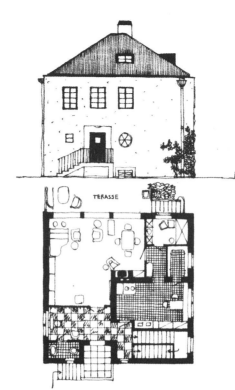

Cat. 350. Design sketch for a single-family house with approximately square ground plan

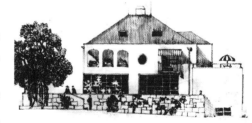

Cat. 351/I, II. Project for Sinaiberger Country House, plan and east facade

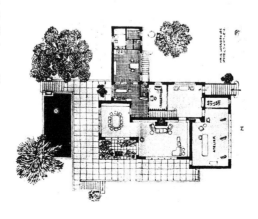

Cat. 351 1934

Project for Sinaiberger Country House, Spotezow, Poland

A house with north-south axis on a level lot. A large, high, random ashlar terrace at the south and east is accessible by several flights of steps. On the south it adjoins a small pool.

The main entrance is at the northwest by an open stair running parallel to a large painter's studio. The entrance opens to a hall with cloakroom, toilet, and staircase. The large living room with fireplace opens wide on the east terrace. Next to it is the dining room with window on the south terrace, and a winter garden on the east. The service wing has its own entrance, and contains pantry, basement stairs, large kitchen, servants' and subsidiary rooms.

Above this wing and the painter's studio are terraces, and above the winter garden, a loggia accessible from a bedroom. The east wing contains a double bedroom, a single bedroom, two baths, and a large hall with exit to a terrace.

The house has a hipped roof and large horizontal windows on the first floor while the second-floor loggia has arched openings. The design includes plantings and trees.

Bibl.: Design drawings: Estate (mentioned in register of plans in March).

Cat. 352 1934

Design for the Arts and Crafts Gallery of the Exhibition "Austria in London"
Dorland Hall, London
Opening: 16 April

The exhibition, directed by Clemens Holzmeister, contained several sections for the display of fine arts, arts and crafts, industrial and handicrafted products, tourism, etc. Hoffmann designed a long gallery for arts and crafts on the second floor. White painted showcases were built into red walls along a central corridor. The floor is light colored, and the ceiling with recessed lights was painted silver. Among the exhibits were products from the Max Welz firm designed by Hoffmann, including a dressing table in eggshell finish with partial gilding.

Bibl.: Design drawings: Estate; Catalogue, *Austria in London*, 1934; *Profil* II, 1934, no. 3, VIII; no. 5, 144ff.; *ÖK* V, June 1934, 14.

Cat. 352/I, II. Room for Arts and Crafts at the "Austria in London" Exhibition, design for portal; view into hall

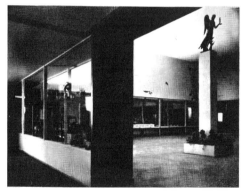

Cat. 353. Exhibition, "50 Years Viennese Association for Arts and Crafts," view into main room

Cat. 357. Exhibition, "Liberated Handicraft," view toward entrance

Cat. 353 1934

Room design for the Exhibition "50 Jahre Wiener Kunstgewerbeverein" (50 years of the Viennese Association for Arts and Crafts)
Austrian Museum for Art and Industry
Opening: May 1934

The walls of the main room have built-in showcases and, above these, are plain except for some decorative painting by women students of the School of Arts and Crafts. In the center is a sculpture by Herta Bucher on a high pillar. In the adjacent rooms, which are lower than the main room, the wall surfaces slope backward above the showcases. Many vitrines are glazed on both sides, providing vistas between the exhibition rooms. Originally the walls above the showcases were to be stepped outward and upward several times.

Bibl.: Drawing: Estate and HFAK; Catalogue, *50 Jahre Wiener Kunstgewerbeverein*, Vienna, 1934; *Profil* II, 1934; *ID* XLV, 1934, 254, 255; *ÖK* V, November 1934, 22.

Cat. 354 1934

(Shop window for Viktorin shop)
Vienna I, Burgring 2
Jointly with O. Haerdtl

The ground-floor piers of a building on the Ringstraße are covered with veined travertine. The name of the firm is in large fluorescent tubing letters above windows glazed without bars.

Shop and shop window are no longer extant.

Bibl.: *Profil* II, 1934, 268.

Cat. 355 1934

Design of a room for the wine tavern of Hans Böhler
Baden near Vienna, Pelzgasse 17
Decorative wall painting: Franz von Zülow

The small room, furnished with a corner bench, table, and simple, three-legged stools, takes its character largely from the decorative painting of the walls and of a pillar next to the bench. The wall behind the bench is painted in trompe l'oeil with arcades that seem to provide a view into a hilly landscape.

Bibl.: *Profil* II, 1934, 464. Identification courtesy Dr. W. G. Rizzi.

Cat. 356 1934

Project for Italian trade fair pavilion

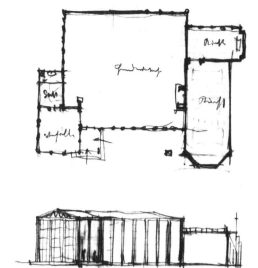

Cat. 359. Design study for Austrian Pavilion in Brussels, plan and elevation

Cat. 357 1934

Exhibition design "Das befreite Handwerk" (Liberated Handicraft)
Austrian Museum for Art and Industry, Vienna
Opening: 7 November

The exhibition was organized by the Arts and Crafts section of the Viennese Federation of Trades Associations and conceived as a reply to the "Neue Sachlichkeit" (New Objectivity). Hoffmann was responsible for the artistic direction, the design of numerous pieces of furniture, and one room, a "kind of men's bar, with mounted photographs by Jela Wilfan." He divided the exhibition hall by showcases into two large and several smaller rooms, and had the walls colorfully painted with patterns recalling Minoan painting. Among the specially designed furniture are a screen and a waste basket, a home bar, several gilded or polychromed cabinets executed by Max Welz, a free-standing map cabinet, and an especially striking showcase in walnut with carved caryatids (executed by Franz Konečný).

Bibl.: *Das befreite Handwerk, Geschmack und Wohnkultur* (catalogue), Vienna, 1934; *Neues Wohnen* (catalogue), ÖMAK, Vienna, 1980, 54, 78; *Profil* II, 1934, 392ff.; *ÖK* V, December 1934, 25ff.; *ID* XLVI, 1935, 132ff.

Cat. 358 1934

Project: House for Dr. Kertész

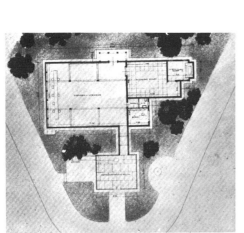

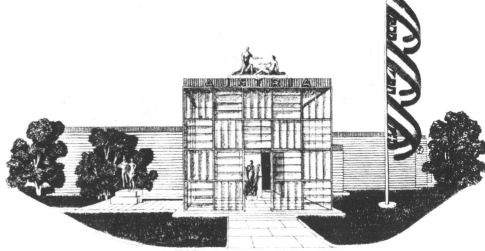

Cat. 360/I, II. Competition project for Austrian Pavilion in Brussels, plan and perspective

Cat. 361/I. Austrian Pavilion in Venice (cf. text figs. 275, 276)

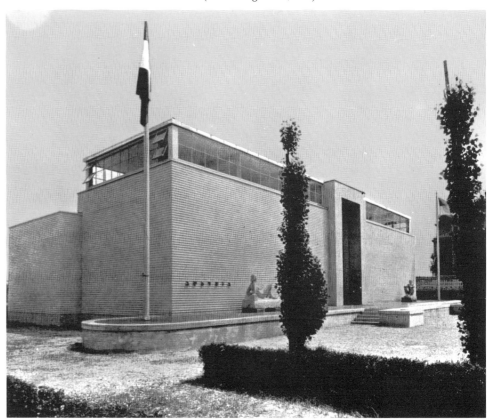

Cat. 359 1934

Design studies in the Competition for the Austrian Pavilion in Brussels

Hoffmann studied several solutions in addition to the competition project, which was awarded honorable mention (Cat. 360). In one case he sketched a large hall with a pillared facade, gabled entrance, and a low annex. Another study was of a flat-roofed building with an asymmetrically placed second story, designed as a chapel, to house religious art. The second story also has a projecting corner supported by a caryatid (at this time Hoffmann also exhibited a piece of furniture with caryatids; see Cat. 357). At the rear is a covered terrace, and a part of the flat roof was also designed as a terrace. One side of the pavilion is entirely glazed, with the glass carried around both corners. Part of the roof is also glazed. Next to the building stands a tall flagpole. Two other design sketches attempt a symmetrical main facade or an especially high entrance portico.

Bibl.: Designs: Estate.

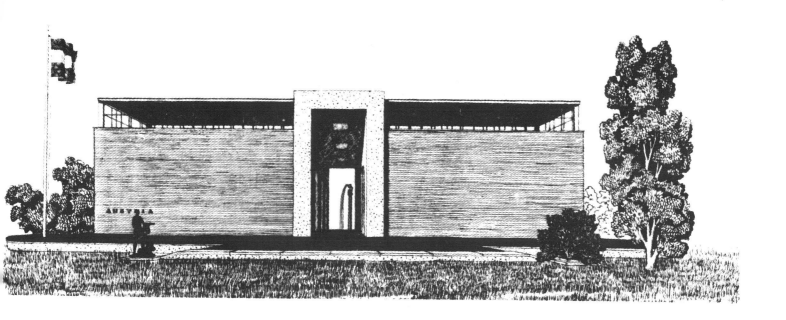

Cat. 361/II, III. Austrian Pavilion in Venice, perspective view and plan

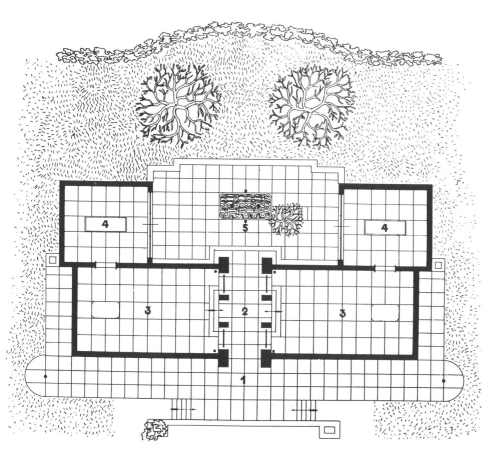

Cat. 360 1934

Competition Project for the Austrian Pavilion at the Brussels Universal Exposition 1935 (honorable mention)

The pavilion has horizontal grooves in the manner of the Venice pavilion (Cat. 361); it is connected by a glazed corridor with a glazed formal reception room at the front. The walls of the reception pavilion are divided into square panels with alternating horizontal and vertical panes of glass. The vertically grooved cornice bears the inscription "Austria"; above is a crowning sculpture group.

The entrance opens to a main room devoted to tourism. Next to it is a small office, and then the room for modern art, with a chapel-like annex for religious art. The exit is through a portico at the rear.

Bibl.: Drawings: Estate; *Profil* III, 1935, 10.

Cat. 361 1934

Austrian Pavilion for the Biennale in Venice
Collaborator for the execution: Robert Kramreiter

The Education Ministry organized a limited competition and then entrusted the joint execution of Hoffmann's design to him and Robert Kramreiter.

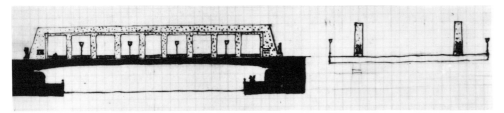

Cat. 363/I, II. Project for architectural design of Rotunda Bridge, view; partial view of a variant

Hoffmann planned a symmetrical complex with flat roofs and a rectangular (26m x 6.8m) main building 6.8m high on a flagged terrace. At the rear two small lower halls flank a sculpture terrace with a fountain. These annexes are glazed facing the terrace and windowless elsewhere. The main block is also windowless but is lighted by a clerestory; the toplight can be filtered through a velum or transparent ceiling.

The stuccoed outer walls have horizontal grooves; the high portals are travertine at the entrance and decorated with sgraffito on the courtyard side. Inside, the passage from front to rear is framed by tripartite arcades which permit a view into the two lateral galleries, sunken somewhat below the corridor.

After World War II the building was renovated with minor alterations and without sgraffito, and is in fair condition.

Bibl.: Drawings, prints of front and rear facades: Estate; *Profil* II, 1934, 76, 77; *Architettura*, October 1934, 577ff.; *ID* XLV, 1934, 28; *Forum* (Bratislava) IV, 1934, 190ff.

Cat. 362 1934-1935

(Furnishings and shop front for Opera perfume shop, Vadasz)
Vienna I, Kärntnerstraße 53
Jointly with O. Haerdtl

A small shop with an entirely glazed front has the entrance door in a strong metal frame which does not reach the lintel of the shop front. Thus, glazing without bars continues above the door for maximum transparency. The shop name in Roman letters is on the glazing while neon tubing flashes the name of a perfume brand in two different ways on the stone surface above.

The shop is no longer extant.

Bibl.: *Profil* III, 1935, 555.

Cat. 363 1935

Project for architectural design of the Rotunda Bridge, Vienna III

Hoffmann, assuming a high reinforced concrete truss, designed several variations for the

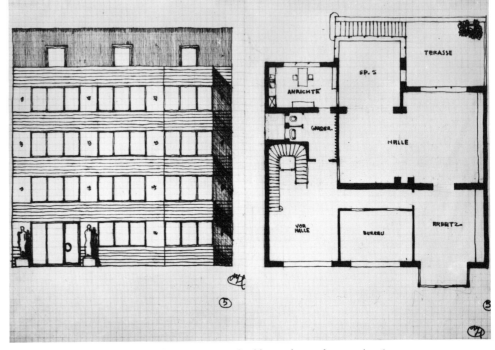

Cat. 364. Project for a small urban apartment building, plan and street facade

remodeling of a bridge that was eventually remodeled after a design by Clemens Holzmeister. Hoffmann paid special attention to the formal treatment of the end member that bears the name of the bridge by placing a sculpture in front of it or a relief on it.

Bibl.: Drawings: Estate (the bridge is shown against a black background as if at night).

Cat. 364 1935

Project for a small apartment building, Vienna III

Plan and elevation show a building of three bays with four stories and finished attic on a lot with a 18m frontage. The entrance at the left, flanked by two sculptures, opens onto a large entrance hall. At the rear is a half-turn stair with the elevator in the well and a door leading to a cloakroom with toilet and lavatory, and to a pantry with dumbwaiter. On the right is a short corridor with access to an office and study with a glazed alcove. A double door in the study opens to a large living hall with terrace and exit to the garden. A wide opening connects the hall with the dining room.

The facade has horizontal windows throughout. The panels between the windows have a small stucco decoration while the bands between stories are horizontally striated. Above the study alcove are similar alcoves on the upper floors.

Bibl.: Drawing: Academy (dated 1935 in the Catalogue).

Cat. 365 1935(?)

Design for the tomb of Gustav Klimt

On the grave site stands a rectangular stone trough with sloping, slightly swelling, ribbed sides, recalling the lower part of a sarcophagus. It contains low-growing plants; at the head a weeping willow stands. Near the foot is a ribbed metal fire basin on a slender support. The flat upper edge of the trough bears the name.

Bibl.: Drawing: Estate and Academy (dated 1935 in the Catalogue); Emil Pirchan, *Gustav Klimt*, Vienna, 1942, 90.

Cat. 366 1935

Brück Tomb, Vienna

Cat. 367 undated (about or before 1935?)

Project for a row house with 7m frontage

There are two variations for this two-story house with basement and ridge roof; they differ in the depth of the building and the layout of the upper story, but the designs of the ground floor are very similar. In both cases the entrance leads to a vestibule with toilet, a small bedroom on one side, and the kitchen on the other. The living room with the beginning of the stairs is on the garden side.

In both variations the living room is largely glazed toward the terrace and garden, and the upper story has three windows. The garden facade bears an inscription with the year 1935, which does not exclude the possibility that the designs were made somewhat earlier. The facade treatment is extremely simple.

Bibl.: Drawings: Estate.

Cat. 365. Design for tomb of Gustav Klimt

Cat. 367. Project for row house on 7m. wide lot, plans and facade

Cat. 368 1935

Project for Italian Exhibition(?)
Jointly with O. Haerdtl(?)

Cat. 369 1935

Design of Larisch Exhibition(?)
Jointly with O. Haerdtl

Cat. 370 1936

Competition project for the Palace of the Great National Assembly of Turkey, Ankara

Hoffmann designed a monumental group of buildings along an axis running approximately north-south on a site sloping to the north. The complex, extending over a length of some 600m, consists of two parts and is bordered on the north by an existing six-story building. Only the south part is designed in detail; general massing only is indicated for the north complex. Three terraces were planned, with the south part standing on the uppermost terrace. From the middle terrace two broad ramps lead to the forecourt of the monumental buildings on the upper terrace.

The north complex measures 150m (north-south) by 174m (east-west). It consists of a five-story range of buildings around a court and two short wings on each side, which project into the court at a right angle to the north-south wings. The complex is open to the north, permitting a view above the existing buildings and access through a grand flight of steps. The south center is also open, and here two towerlike buildings flank another flight of steps; additional stairs were planned in the lateral passages.

The south complex measures 190m (north-south) and 120m (east-west). The east and west wings run the entire length of the building and house the two great assembly halls in approximately square blocks at the north; one is for 600, the other for 300 deputies. Between these blocks stands the national hall of honor, the Pantheon. Behind this building is a garden with a pond which forms the centerpiece of a great paved court for mass meetings. The center of the adjacent middle wing forms a large entrance hall with portico and access to a smaller landscaped court open to the south. This is flanked by two buildings enclosing small inner courts; they house assembly halls for 200-300 people each. In addition to the assembly halls with their subsidiary rooms, the buildings house a variety of rooms along single-loaded corridors. In the east wing are recreation and dining rooms for the deputies as well as kitchen and security rooms. The library with reading rooms and lounges is arranged around the southeast inner court; a post

Cat. 370/I, II. Competition project for the Palace of the Great National Assembly of Turkey, Ankara, design sketch of longitudinal section; site plan (cf. figs. 281-287)

office and offices are around the southwest inner court. In the central wing are waiting rooms, conference rooms, and medical services.

The buildings were planned with two main stories throughout and have flat roofs except for the large assembly halls with their segmentally arched roofs. Otherwise only the higher volume of the hall of honor interrupts the dominant horizontality. The facades are in ashlar, the sub-structures in random ashlar. There are no wide cornices; instead the low perforated roof parapet plays an important role. The main facade facing north is designed with special care. Here the architecture is enriched by sculpture; the hall of honor with its base and high upper story is especially rich in this respect. It has a portico with sculptured supports and a roof parapet with sculptured figures. Inside, a flight of stairs rises from the comparatively dim ground floor to a high, light-flooded upper story with busts of national heroes on pedestals between the windows. In the parliament halls with their two galleries the ceiling is raised in the center so that a glazed clerestory provides ample light.

There are numerous design sketches and detailed studies for this project. Notable among them are designs for a pillared portico between flanking towers; in the submitted design this building was apparently replaced by the hall of honor. Preliminary sketches also include studies for nearby buildings (Palace of the President, police barracks, printing plant, etc.).

Bibl.: Design sketches: Estate; Drawings: Academy; Competition drawings: Estate O. Haerdtl.

FAÇADE PRINCIPALE

Cat. 370/III, IV. Competition project for the Palace of the Great National Assembly of Turkey, Ankara, view of main facade, section, and plan of ground floor

Cat. 370/V, VI. Ankara project, studies for Propylaea; facade of hall of honor

PALAIS DE LA GRANDE ASSEMBLÉE NATIONALE DE TURQUIE

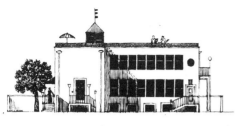

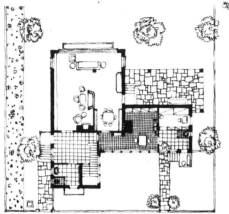

Cat. 371. Design for single-family house, plan and facade

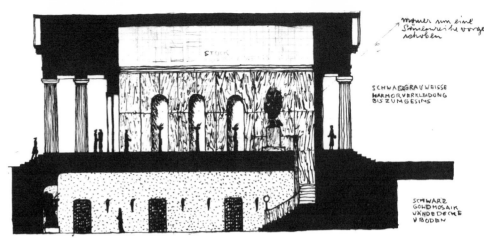

Cat. 373. Project for Hall of Fame and Vault of Austrian Composers, section through Theseus Temple and crypt

Cat. 371	1936

Design for a single-family house

Hoffmann designed a two-story house with basement and roof terrace. There are two entrances from the street. Assuming that the street runs along the west side of the site, the main entrance is near the west end of the north facade and the secondary entrance near the south end of the west facade. From the main door, one enters a staircase hall with cloakroom and toilet. The secondary entrance opens onto a small lobby with toilet and a small room. Between the lobby and the staircase hall lies the spacious kitchen; it is connected to the dining nook of the large living room that, along with a covered veranda, occupies the garden side of the ground floor.

On the second floor, above the veranda, is a terrace, accessible from two bedrooms. A third bedroom is in the middle of the north facade. All bedrooms have their own bathrooms; the master bedroom, in addition, has a dressing room with built-in closets.

On the street side the windows in both stories are pulled together so as to form a continuous strip. In the center of the staircase hall projection a small first-floor balcony provides an accent. On the garden facade, the wall of the living room is largely glazed; the resulting wide window projects somewhat and has a flower container. The roof exit is treated as a small glazed turret with pyramidal roof.

Bibl.: Drawings (one dated 1936): Estate.

Cat. 372	1936

(Installation of a bar in the Hartmann Restaurant)
Jointly with O. Haerdtl

A bar was added to the restaurant, which had been redesigned a few years earlier (Cat. 339).

Cat. 373	1936

Hall of Fame and Vault for Austrian Composers
Vienna, Volksgarten, Theseus Temple

Hoffmann designed several variations of a project for the Theseus Temple (Pietro Nobile, 1823) at the suggestion of his old friend Carl Moll.* The sarcophagi, or cenotaphs, of twelve great Austrian musicians are chronologically arranged in pairs in a crypt; above them is the hall of fame and a monument to Mozart, conceived by Moll as an open sarcophagus and an apotheosis.

On each side of the marble-covered interior are candelabra in three niches. A stair of three flights descends to the crypt along the relocated rear wall of the cella; a sculpture stands on a high base at the top of the stair. The vault has a niche with another sculpture and three grilled openings in each lateral wall which provide views into the chapel-like rooms with the sarcophagi. The possibility of a separate entrance pavilion next to the Theseus Temple was also considered.

* Moll hoped to obtain required financing by pointing out that the Capuchin Vault (burial place of the Habsburg Imperial family) was Vienna's most popular museum.

Bibl.: Drawings: Academy and Estate; Letters from Carl Moll: Estate.

Cat. 374	1936

Projects for Hall of Fame and Vault of Austrian Composers
Vienna, Volksgarten

In connection with Cat. 373, Hoffmann worked out several variations of the same theme without use of the Theseus Temple. All have spaces above and below ground, but the number of sarcophagi is smaller than in the first project. One project places an 11m high ashlar building with truncated gabled top in the center of a 2m high podium with the windows of the crypt. Metal sculptures are indicated on the entrance side. The interior is centered on a tall, top-lighted columnar sculpture group on a base that forms the core of a circular stair to a barrel-vaulted crypt with eleven vaulted niches. Other projects experiment with a tall, square, or round pillared structure, with a sculpture on a tall support in the center, on a podium above a crypt. Access to the crypt is by a straight stair under a pillared structure in one case, by two separate stairs in another.

Bibl.: Drawings: Academy and Estate.

Cat. 375	1936

Designs for the Austrian Pavilion, Paris Universal Exposition, 1937

In one design Hoffmann chose a glazed tent, or pyramid, form for the main building; its monumental portal is flanked by two flagpoles. Two smaller annexes connect with the main building by passages. The right one with its slender ar-

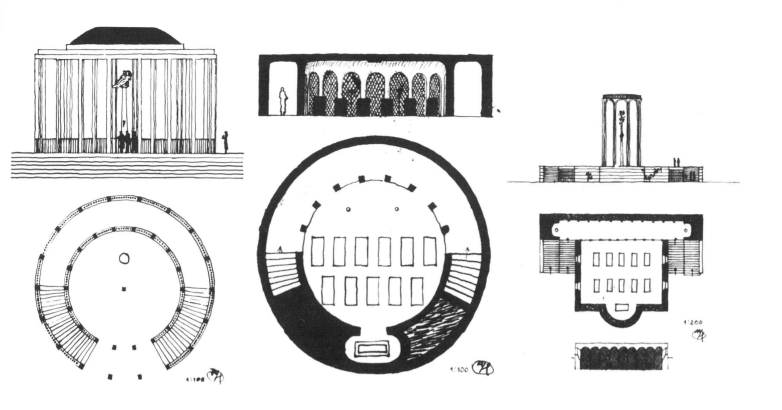

Cat. 374. Projects for a Hall of Fame and Vault of Austrian composers in the Volksgarten

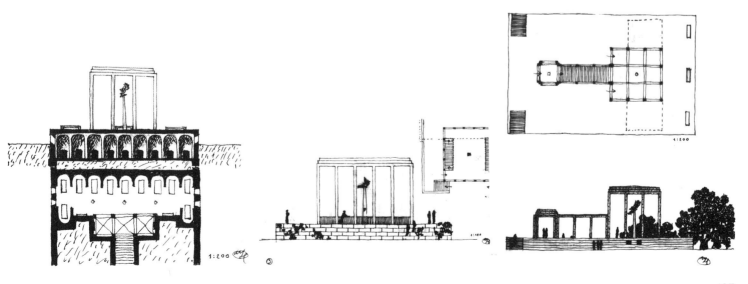

Cat. 375/I, II. Design sketches for the Austrian Pavilion, Paris 1937

cade and crowning sculptures is probably meant for an art exhibition; the left one houses a café. In a second design the boxlike main building is placed on high supports and reached only by two flights of steps at the sides; next to them stand flagpoles. Two other designs indicate a large pavilion with a completely glazed front, through which an oversize map of Austria is visible. In one case a second glass building with steep roof is joined to the first pavilion by a pillared loggia.

Bibl.: Drawings: Estate; *Magnum*, no. 32, October 1960, 46.

Cat. 376 1937

Exhibition room "Boudoir d'une grande vedette," Paris Universal Exposition, 1937
Execution: Max Welz

An upholstered sofa and chair stand on a white Angora goat fur rug in a bright room with a mirrored floor. The coffee table surface is also mirrored. Foliage appliqué serves as decorative articulation of the walls. A wall niche with mirrored sides and ceiling holds a built-in dressing table with an upholstered stool. The furniture is carved and silvered, with upholstery in wool embroidery (dark gray with silver threads, light gray, and pink).

Bibl.: *Die Pause* II, 1936/1937, no. 12, 48; Catalogue: *Neues Wohnen*, ÖMAK, Vienna, 1980, 54, 79; Catalogue: *L'Autriche à l'exposition internationale de Paris*, Paris, 1937; *Art et Décoration* XLVI, 1937, 221; *ID*, XLVIII, 1937, 318.

Cat. 376. "Boudoir d'une grande vedette"

Cat. 377 1937

Design of smoking room and bedroom for Director General Meyer-Helmbeck
Vienna I, Walfischgasse 13

The extant elevations for the smoking room show that the walls and doors were wainscoted in rare wood veneer. A fireplace of veined white marble was placed in a corner and a built-in low cabinet stood along the window wall.

Portions of the bedroom furniture were transferred to another apartment.

Bibl.: Drawings: Academy and Estate.

Cat. 378 1937

(Casino Baden near Vienna)
Room design in the *cercle privé*: entrance hall, gaming hall, fountain niche, restaurant, bar.
In collaboration with O. Haerdtl

On the basis of a competition two groups of architects were commissioned to remodel and refurbish the gambling casino. The Hoffmann-Haerdtl partnership was assigned the redesign of the *cercle privé* consisting of a group of rooms with a separate entrance and especially luxurious furnishings to complement the evening dress required of the guests.

The entrance hall is in a new annex and consists of a vestibule with cloakroom and the actual hall two steps below. A tripartite portico of pillars, wider at the center and with two glazed showcases at the sides, divides the square hall from the vestibule. The pillars are covered with brownish yellow marble. The inlaid marble floor repeats the divisions of the deep coffered ceiling. Two two-leaf doors in the center of the side walls lead to the gaming room or to the restaurant.

The adjoining rooms are blue or vermilion; the restaurant has flower-patterned fabric on the walls and a parquet floor. The walls of the bar are paneled in walnut veneer or, behind the counter, mirrored. The motif of a pillared portico recurs in these rooms. Lighting is recessed or indirect. Irregular flower containers in rubble masonry and upholstered bentwood armchairs by Thonet-Mundus complete the interiors.

The rooms are extant although considerably altered.

Bibl.: *Offizielle Casino-Zeitung* IV, no. 93, 15 December 1937; *Neue Freie Presse*, 12 December 1937, 13; *ÖK* IX, February 1938, 24; *MBF* XXXVIII, 1939, 78ff.; Haerdtl, 81.

Cat. 379 1937

(Project for Opera Restaurant and Cellar)
Jointly with O. Haerdtl

Cat. 380 1937-1938

(Alterations and furnishings of rooms in the Hotel Imperial)
Vienna I, Kärntnerring 16
Jointly with O. Haerdtl

The café with its front garden was newly furnished and a reading room and cloakroom were added. The café interior makes use of the effect of multiple mirrors and strongly veined marble. Bentwood chairs and armchairs with caned backs and flowered cushions provide seating. The garden has metal tables painted white and natural wicker armchairs.

The furnishings were redesigned again after the war.

Bibl.: Haerdtl, 79.

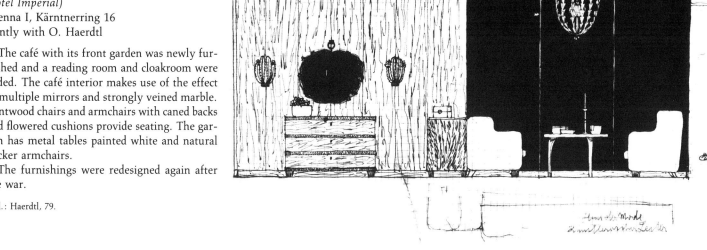

Cat. 381 1938

(Furnishings of a shop for the fashion magazine and dress pattern department of the publisher Otto Beyer)
Vienna I, Singerstraße 12
Jointly with O. Haerdtl

The long narrow shop has a lower front section and a higher rear section lighted by a wide frosted window on the courtyard. The rear section is also articulated by a large masonry pier joined to a cabinet of showcases. In the front is a long oval table with a stand at which the customers can select patterns. Upholstered stools with low backs serve as seating. They are also used with other tables at the rear of the shop and along a wall. On another wall is a cabinet with several compartments for patterns. Mirrors with richly gilded and carved frames line the walls. Light walnut was chosen for the furniture, gray linoleum for the floor, and grayish white marble for sheathing the pier. The upholstery fabrics are light gray and red on a brown ground. Walls and ceiling are white. A decorative frieze runs along the ceiling at the rear.

The shop is no longer extant.

Bibl.: *MBF* XLI, 1942, 281-284.

Cat. 382 1938

Remodeling and furnishings of the "House of Fashion" in the Lobkowitz Palace
Vienna I, Lobkowitzplatz 2
Collaborator: Josef Kalbac

Parts of a former aristocratic palace dating from the 17th century were remodeled and furnished

Cat. 382/I, II. "House of Fashion," design sketch and perspective view, room of the artistic director (cf. text fig. 290)

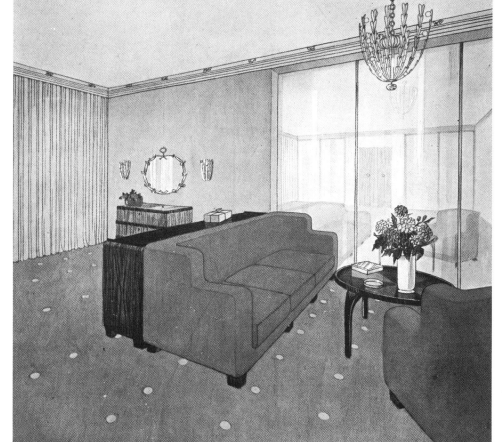

for a fashion information and publicity center. Showroom, library, and dining room, rooms for the artistic director and directress, the business manager, and the models were furnished.

The room for the artistic director is partially paneled with book-matched finely figured rare wood veneer, and has built-in showcases and mirrors; at one side a floor-to-ceiling curtain closes the space. In addition to a drawerless desk with caned armchair for the director, there are gray plush chairs and a small round table. An inlaid chest of Caucasian walnut stands below an oval mirror with richly carved and gilded frame. By contrast the room of the business manager is simpler and more robust, with light oak paneling, built-in bookcases, a beamed ceiling in the desk niche, and oak furniture. The library has built-in walnut bookcases and a Kelheim stone floor.

The building now serves other functions; the furnishings of the House of Fashion are not extant.

Bibl.: Drawings: Academy and Estate; *MBF* XLI, 1942, 285ff.

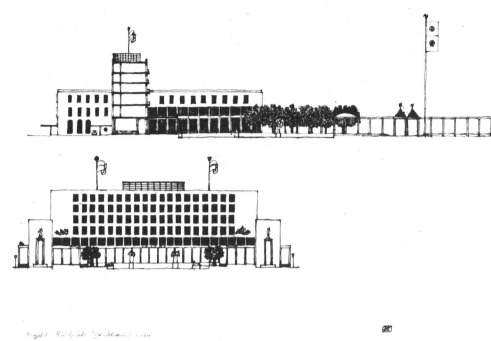

Cat. 383 1938

(Competition for buildings on the trade fair grounds)
Jointly with O. Haerdtl

The landmark at the entrance—a tall pillar with a winged figure—recalls earlier designs for monuments by Hoffmann, while the free layout suggests Haerdtl's manner.

Bibl.: Haerdtl, 119.

Cat. 384 1938 or 1939(?)

Project for a guest house of the City of Vienna
Vienna I, Stadtpark

The complex consists of three buildings, which in plan form an H-shape, and small pavilions and arcades loosely joined to the verticals of the H. The lateral wings have three stories; they house on one side a café, on the other, galleries and exhibition rooms. The six-story connecting central wing houses the "Club Wien," with foyer and cloakroom on the ground floor. On the inner side of the lateral wings are wide terraces around a pond which continues between pergolas and rows of trees. The small pavilions at the pergolas serve various refreshments; they are designated as pump room, "fruit restaurant," confectionery, bar or wine shop.

The buildings are flat roofed and have essentially open, high ground floors. The lateral wings have entrances with tall framed portals crowned

Cat. 384/I, II. Project for a guest house of the City of Vienna, main facade and section; ground plan

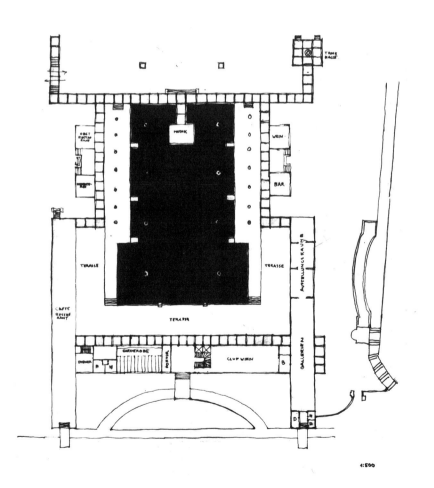

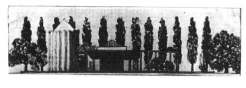

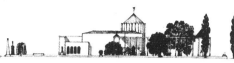

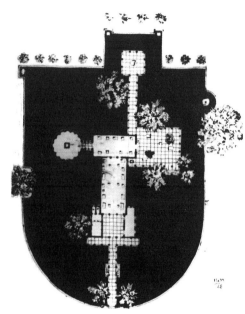

Cat. 385/I, II, III. Project for Hanak Museum, plan and two elevations

by sculptures. Sculpture is also indicated for the entrance facade of the main building with the hotel rooms. The main building has a glazed penthouse with a terrace on the garden side. The guest rooms also have small balconies on that side.

The outbreak of the war prevented following up this project, which was initiated by Dr. Hermann Neubacher, Vienna's first National Socialist mayor.

Bibl.: Drawings: Estate; The project was shown in the Hoffmann Exhibition in the State Museum of Arts and Crafts (ÖMAK) at the beginning of 1941, and mentioned in a review of 1 February 1941 in the *Neues Wiener Tagblatt*; Neubacher mentioned it in a letter to Hoffmann of 17 May 1955 (compare Cat. 403).

Cat. 385 1938-1940(?)

Project for a Hanak-Museum
Vienna II, Augarten

The complex consists of several buildings and high, pillared loggias on terraces, all on an artificial island in a U-shaped pond with small bays,

one of which has a fountain jet. The museum island is entered from the south by a bridge or dam with two benches at about midway.

The actual museum building consists of two high galleries at right angles. The slightly sloping hipped roofs must be glazed since the walls are windowless. The long, north-south, gallery has a square foyer with lower flanking blocks and a transverse entrance loggia with eight slender pillars. The shorter, east-west, gallery is connected by a corridor to a high, round building with undulating outer wall and conical glass roof. East of the gallery is a larger flat-roofed terrace bounded by slender pillars; at its corner a narrow loggia of pillars leads to the end of the complex, a small square platform with a pyramidal roof and a monumental sculpture in the center. Poplars along the pond and various other trees at selected points play an important part.

Bibl.: Drawings: Estate; Mentioned in the review of the Hoffmann Exhibition 1941 (compare Cat. 384).

Cat. 386 1939

(Festive decoration for the Opera Ball)
Jointly with O. Haerdtl

The ballroom is entered by a festive portal in the form of a very high pillared hall; four rows of four pillars each carry a gallery and coffered ceiling with a light in each central coffer. The pillars are painted with multiple frames. The gallery, which occupies the lowest quarter of the total height of the ballroom, is reached by flights of steps at the sides with richly curved balustrades. Similar balustrades divide the central dance floor from the tables and chairs. Walls and ceiling are covered and draped with pleated fabrics. Stylized plant forms on the walls, numerous potted plants, spherical ceiling lights, and large crystal chandeliers contribute to the festive character.

Bibl.: Photographs: Estate.

Cat. 387 1940

Remodeling and furnishings of salesrooms for the Meissen Porcelain Manufactory
Vienna I, Kärntnerring 14
Collaborator: J. Kalbac

A restrained shop front was inserted into a palais on the Ringstraße of 1865, retaining the existing neoclassic pilasters. Plain, slightly projecting frames enclose arched windows. Above are the Meissen mark modeled in stucco and the name of the firm in small dark letters.

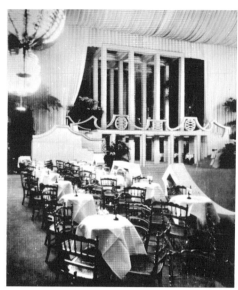

Cat. 386. Festive decoration for opera ball 1939

Cat. 387/I, II. Store of Meissen Porcelain Manufactory, wall elevation and view into large salesroom (cf. text fig. 291)

The large salesroom for the costliest wares runs the full width of the store. It is paneled and furnished in mahogany. The lower paneling of the rear wall has built-in showcases and a gilded molding as upper termination; the upper portion has oval niches for the display of colorful porcelain parrots. On one side is a large mirror with carved frame; the other is occupied by a closed mezzanine reached by a circular stair. Next to it is the descent to the salesrooms in the basement. A sales desk with upholstered stools and a row of tables set with the firm's wares stand in the main salesroom. Showcases are built in between the windows. A blue passageway with tall showcases leads to the rear salesroom with its oak ceiling and paneling and delicately patterned light green wallpaper. This room also has a built-in mezzanine. Another, barrel-vaulted, salesroom in the basement contrasts light blue eggshell finished wall units with dark floor covering. Here, the simpler porcelain of rustic effect is displayed. In addition to the salesrooms, offices and subsidiary rooms were furnished.

Shop and furnishings are no longer extant.

Bibl.: Drawings and photographs: Estate; *ID* LIII, 1942, 202-208.

Cat. 388/I. ''House of the Armed Forces,'' view from forecourt toward main entrance (cf. text figs. 292, 293)

Cat. 388 1940

Remodeling the former German Embassy as a ''House of the Armed Forces''
Vienna III, Metternichgasse 3
Collaborator: J. Kalbac

A historic building of the 1870s was remodeled into an officers' club, retaining the existing block and fenestration. Hoffmann removed the rich facade articulation, with its cornices, pilasters, pediments, and rustication, and instead used a slightly projecting strip, with an epaulette pattern in place of a meander, to divide the facades into two zones: a grooved base with the basement and ground floor windows, and the upper story with the tall pedimented second-floor windows or two superimposed rows of smaller windows. In each case an unrelieved high wall section is formed above the windows. The roof is barely visible, especially from close up. A cornice supported by consoles forms the upper termination of the facade. All windows, except for those in the basement, have straight, slightly projecting surrounds.

The main entrance is in the center of a three-bay recess and is emphasized by a balcony on fluted pillars. The balcony door is surmounted by a sculpture of an eagle and swastika. A similar

Cat. 388/II. German Embassy before remodeling

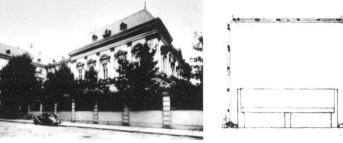

Cat. 388/III. Drawing for pergola in forecourt

Cat. 388/IV. Study of a facade variant

sculpture was placed above the central French window on the garden facade. The entrance below is reached by a terrace with flights of steps.

Numerous sketches prove that Hoffmann dealt carefully with the problem of remodeling a historic building, and that he gave special care to every detail of the facade and garden design. Most of the interior design was entrusted to a German architect.

After war damage, the building was razed to make room for a new German Embassy.

Bibl.: Drawings and photographs: Estate; Plans: ABBH; *Die Pause* V, 1939/1940, no. 12, 50ff.; *MBF* XLI, 1942, 277.

Cat. 389 1940

Furnishings for a model apartment of the Vereinigte Werkstätten (United Workshops) Munich

Munich, Briennerstraße

The design indicated, for the walls, part wood paneling and part stucco with rich decorative door frames, cornices, and modeled blossoming branches as *sopraportas*. A small chest with rounded corners and a round mirror with decorative frame resemble the decorative furniture Hoffmann designed in the 1930s for the firm of Max Welz in Vienna (Cat. 352).

Bibl.: Drawings: Academy and Estate.

Cat. 390 1941

Project for front and furnishings of a store for velvets, silks, woolens

Vienna I, Bauernmarkt

There are two studies for the front. One is quite plain; the other, not illustrated here, has six large show windows enclosed by a slightly tilted decorative frame. The entrance door is in the third window from the left; above it is the emblem of the staff of Hermes. A rich decorative cornice runs above the show windows and store

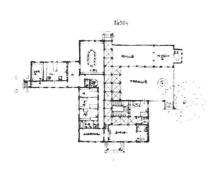

Cat. 392/I, II. Project for Baron Wieser House, two variations of design

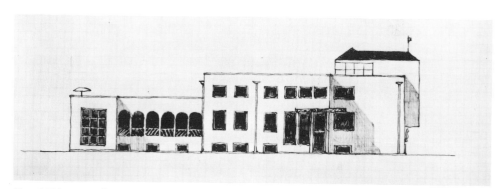

Cat. 392/III. Facade study for the Baron Wieser project

Cat. 390. Design sketch for a shop front

Cat. 391. Design for a tomb for the Flöge family

name. The interior is furnished with simple tables and with shelving as high as one can reach; the space above is covered by curtains.

Bibl.: Drawings: Estate.

Cat. 391 1943

Design for a tomb of the Flöge Family

Hoffmann designed for urn burial a great prismatic stone sarcophagus on a set-back base. The upper edge is beveled. The tomb has five arched panels; one bears the inscription. Wreaths—probably of bronze—are on the sarcophagus and base. A fire basin on a tall fluted support stands beside the tomb.

Bibl.: Drawing: Academy.

Cat. 392 1943(?)

Project for Baron Wieser's House

Hoffmann worked on several variations of this project for the client, for whom he also designed a signet ring. Two of the designs—here identified as I and II—share the basic plan to connect the house and garage by an arcaded passage. A third variant was conceived without a garage; two unidentified drawings probably belong to a fourth variant.

I shows an 11-bay, two-story, flat roofed building with the rooms mainly along a central corridor, on one side of which are, on the ground floor, small bedrooms and baths, and on the other, a large stair hall, oval dining room with terrace, pantry, and kitchen. The corridor is extended by an exterior arcade connecting with a stair tower. On the other side of the house an arcaded quad-

rant connects with the garage and chauffeur's room.

II shows a building of only eight axes with the staircase moved into the body of the house. Instead of a tower and arcade, a small glazed penthouse with a hipped roof provides a vertical accent. The connection with the garage is shorter and straight; the garage has two stories and a hipped roof. The layout of bedrooms, hall, dining room with terrace, pantry, and kitchen is the same as in I. II is probably a version of I reduced at the request of the client.

III is also a two-story, flat-roofed house, but with a different ground plan. The house is entered at the center of a front with seven axes. A large entrance hall gives access to a study and to a cross-vaulted, 10-bay corridor to the rear. On one side are the staircase, a 4-bay arcade and terrace, and the living hall with music room. On the other side are the dining room and a parallel inner corridor to the maids' rooms. Next to the dining room is a single-story ell with kitchen, pantry, storerooms, and roof terrace. A circular stair is at the juncture of main building and ell.

IV shows a building which is not expressly identified as a house for Baron Wieser but shares so many features with I-III that the identification seems justified. Like I and II, it has a connecting arcade to a garage and a staircase along one short side, and like III, a cross-vaulted arcade through the full depth of the building.

Bibl.: Drawings I-III: Academy; IV: National Gallery of Art, Washington, D.C.

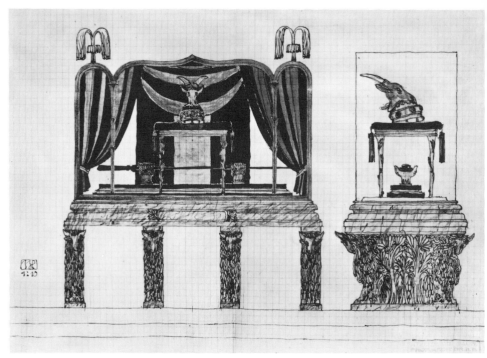

Cat. 393/I. Design for a showcase for the helmet and sword of Skanderbeg (cf. text fig. 294)

Cat. 393 1944

Project for a ceremonial gift to Albania: Design of a mausoleum at Krujë, Albania, and of a showcase for the helmet and sword of Skanderbeg

At Krujë, where Skanderbeg, national hero of the Albanians, had his citadel, a mausoleum and a showcase to be displayed inside it were to be placed.

The bronze showcase rests on a marble base consisting of a richly molded rectangular slab (about 1m x 2m x 0.25m) supported by four short slabs which are 0.65m high, 0.2m thick. These stand parallel to the shorter side of the rectangular slab; they are richly decorated with plant forms and their narrow sides have carvings of the skulls, manes, and forelegs of rams—establishing a relation to the crest of Skanderbeg's helmet, a ram's skull. The vitrine has short sides richly engraved in bronze and tripartite glazed long sides, with the outer segments topped by round-headed arches, and the wider central segment crowned by a flat ogee arch. Pairs of horse-

Cat. 393/II, III. Design of a mausoleum in Krujë, exterior, plan and section

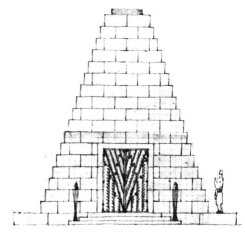

444

tails atop the apex of each lateral arch provide the terminations. On the inside the vitrine is lined with velvet and draped with silk. The helmet rests on a velvet cushion supported by a four-legged gilded stand; the sword rests on two decorative gilded supports.

The small mausoleum is designed in the form of a truncated stone pyramid with stepped courses and a top-lighted interior. A list of materials submitted to the Cultural Office of the City of Vienna indicates that 485 pounds of cast bronze and 10 cubic meters of marble would have been required.

Bibl.: Drawings and photographs: Estate; Letter to the Cultural Office of the City of Vienna, 6 June 1944; Letter from Hermann Neubacher to Hoffmann, 12 August 1954: Estate.

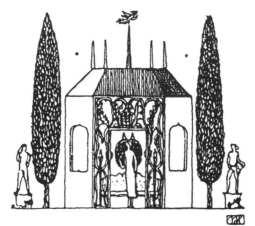

Cat. 394 undated (before 1947)

Sketches of imaginary garden pavilions

In these variations on a theme the architect played with various possibilities for garden pavilions. A small polygonal structure with ogee-arched windows flanked by poplars and garden sculptures is just large enough for a bench. A larger building with doubly curved roof, draperies, and awning is placed at the end of a garden terrace against a clipped hedge and a weeping willow. The largest of the three garden houses is treated as an arbor. A central pavilion with latticed trelliswork and a steep roof contains two rooms; one with a bench; one on an upper level reached by two footbridges. They lead across to free-standing turrets with steep stairs for ascent and descent. The turrets are lower, more slender, and more pointed than the central pavilion. This garden pavilion is in a densely wooded site so that the upper story floats among the tree tops.

Bibl.: *Die schönen Künste* II, 1947, 91, 92.

Cat. 394a 1949

Project for restoration and refurnishing of rooms in the Vienna Secession Building

Hoffmann designed simple furniture of the greatest economy for rooms in the Secession Building, which had been plundered at the end of the war, but nothing was executed.

Bibl.: Plans: ABBH.

Cat. 394/I, II, III. Sketches of imaginary garden pavilions

Cat. 395 1949-1950

Apartment buildings of the City of Vienna
Vienna V, Blechturmgasse 23-27; 81 apartments
Building Permit: 8 September 1949
Certificate of occupancy: 22 December 1950
Collaborator: Josef Kalbac

A 6-story wing with four staircases and a 6-story courtyard wing with one staircase were built on an approximately rectangular lot with over 69m frontage on the northwest-southeast Blechturmgasse. The courtyard wing adjoins a neighboring building and bears a hipped roof. At each end of the street facade is a courtyard entrance with coffered ceiling and simply decorated grillwork gate.

The front is in four segments, lightly stepped, following the slope of the street. In the center units the staircase windows face the courtyard; in the outer units they face the street, thus giving rhythmic relief to the otherwise uniform facade. The street facade is stuccoed above a low concrete base and divided by vertical and horizontal grooves between the windows. Instead of a cornice it has only a coping, while the courtyard facade has a convex concrete cornice. The windows with six panes have projecting stucco sills and white woodwork. The staircase doors and the courtyard entrances have concrete surrounds and projecting canopies with multipaned openings spared out above. The width of the staircase is indicated on the facade by a shallow niche.

The building is in good condition.

Bibl.: Plans: ABBH.

Cat. 396 undated (about 1950?)

Ground plan study, municipal apartment building in a gap

Three apartments per story with a staircase on the courtyard side; the room layout matches the norms for public housing.

Bibl.: Drawings: Estate.

Cat. 397 undated (about 1950)

Preliminary design for a 4-story municipal apartment complex

A U-shaped building with rounded corners on a lot with access from three sides and an adjoining building on the south. The apartments match the type of public housing common in the City of Vienna in the 1950s. The ground floor has stores. The floors above have identical windows and small stucco decorations in between.

Bibl.: Drawings: Estate.

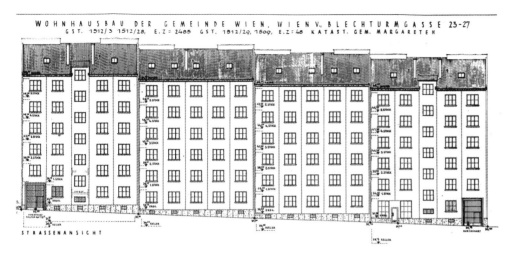

WOHNHAUSBAU DER GEMEINDE WIEN, WIEN V., BLECHTURMGASSE 23-27

Cat. 397. Ground plan study of municipal apartment complex

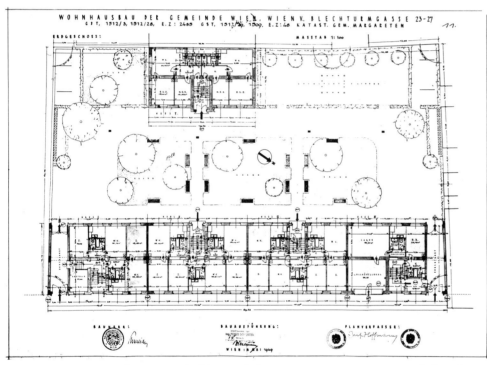

Cat. 395/I, II. Municipal apartment buildings, Blechturmgasse 23-27, street view and plan of ground floor

Cat. 398 undated (about 1950)

Project for an urban apartment building
Vienna III, Salesianergasse(?)

A 7-story building, with a 6-bay facade worked out in several variations. Two show a set-back attic. The ground plan is symmetrical with a staircase on the courtyard side and four apartments on each floor.

Bibl.: Drawings: Estate.

Cat. 399 undated (about 1950?)

Urban design sketch of plan for a semicircular apartment building

In a hasty sketch the architect dealt with the possibility of arranging six staircases with two apartments per staircase unit in a semicircle, 50m inner diameter.

Bibl.: Drawing: Estate.

Cat. 400 1951-1952

Apartment building complex of the City of Vienna
Vienna XIX, Silbergasse 2-4; 70 apartments
Building permit: 8 February 1951
Certificate of occupancy: 28 August 1952
In collaboration with Josef Kalbac

A symmetrical group of three buildings on an irregular, trapezoid lot, bordered by the Krottenbach Creek, the Silbergasse, and Nußwald-

446

Cat. 398/I, II. Project for a municipal apartment building, street facade and plan of upper story

Cat. 400/I. Municipal apartment building complex, Silbergasse 2-4, elevations (submitted plan)

gasse. The main axis runs through the center of a five-story building, 15.7m x 10.67m, with a hipped roof and two apartments on each floor at the rear of the lot.

In front of this central block two flanking three-story buildings with hipped roofs form a forecourt arrangement. Two further buildings, off-set and angled outward in successive stages are attached to each of these flanking elements. Their entrances open to the forecourt. The angle of the two rear buildings permits optimal use of

447

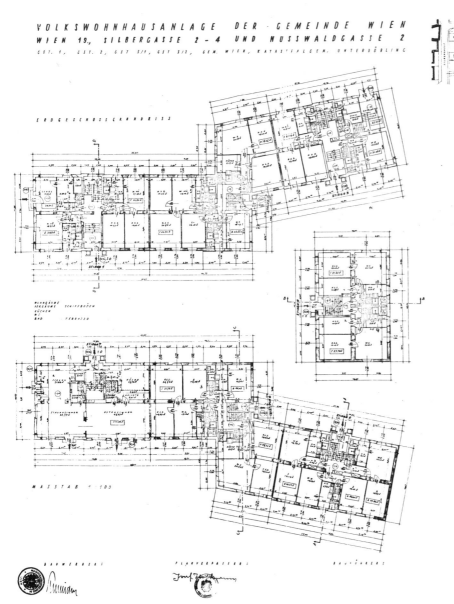

ERDGESCHOSSGRUNDRISS

MASSTAB 1:100

Cat. 400/III. Municipal apartment building complex, Silbergasse 2-4, plan of ground floor

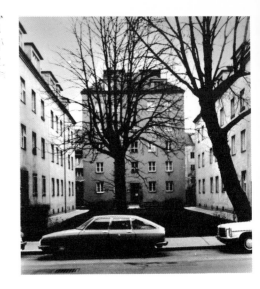

Cat. 400/II. View from the Silbergasse into the garden court after loss of pergola

Cat. 401 1953

Project for an Arts and Crafts Museum

Hoffmann dealt with the idea of a modern arts and crafts museum in a series of ground plans. In each case the building consisted of individual structures or pavilions informally connected by corridors and arcades; some are at the water's edge or are designed as islands or peninsulas. Terraces and garden courts play an important role. In addition to exhibition and administration rooms with service apartments, a café-restaurant and a sales shop were planned. (See Appendix 19.)

Bibl.: Drawings: Estate.

Cat. 402. Municipal apartment building complex, Heiligenstädter Straße, street view

the lot, which is wider at the back than at the front. In the north building are a toolroom and a store, in the south is a restaurant (now occupied by two shops).

The stuccoed facades have a low, slightly set-back base and a triple-stepped main cornice. The finished attic story has dormers. Shallow projections indicate the staircases on the facades of the lateral buildings and articulate the facade along the creek valley. The staircase windows, except in the central building, have transoms and vertical bars; the other windows have two casements with horizontal bars. The woodwork is painted white. The entrances have simple concrete frames; doors and transom windows are largely glazed with rhythmic division by bars.

A sculpture by Fritz Wotruba is in the forecourt with a pergola on the Silbergasse. The building is in good condition, but the pergola is missing. A disturbing store front at the southwest corner extends for the first five bays on the creek facade.

Bibl.: Plans: ABBH.

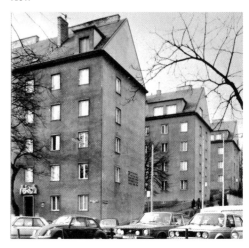

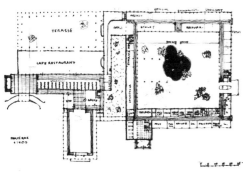

Cat. 403/I, II. Project for Addis Ababa City Hall, perspective sketch and plan

Cat. 402 1953-1954

Apartment building complex of the City of Vienna
Vienna XIX, Heiligenstädter Straße 129; 46 apartments
Building permit: 15 May 1953
Certificate of occupancy: 11 August 1954
In collaboration with Josef Kalbac

Three buildings on the (north-south) Heiligenstädter Straße on a steeply sloping lot are echeloned according to height. The building on the Heiligenstädter Straße has five stories, the next one, four, and the one at the top of the slope, three. Each has a central staircase, ridge roof with box dormers, and a main cornice which continues across the gables. Casement windows are painted white. The facades are grainy stucco above a concrete base. Entrances have simple artificial stone frames and six slender glazed panels. The Heiligenstädter Straße entrance also has a transom window and a relief sculpture by Heinz Leinfellner.
The buildings are in good condition.

Bibl.: Plans: ABBH.

Cat. 403 1954-1955

Project for City Hall, Addis Ababa

Through his old friend Hermann Neubacher, who held an administrative position in Addis Ababa, Hoffmann received the commission to plan a city hall for Addis Ababa, jointly with Anton Ubl and Franz Hubert Matuschek.

Hoffmann was given a comprehensive program for about 6,000 sq m required by the various departments of the municipal administration. On this basis he made ground plan studies and eventually decided on a multipartite plan centered on a four-story main building enclosing a landscaped inner court 50m x 55m. Assuming north at the top, the north and south wings are two rooms deep, the other wings one room deep. At the southwest corner is a projecting tall building; at the northwest corner the north wing projects beyond the west facade. From this corner a passage runs south to meet a second building complex west of the main building. This is connected in turn with the main building by another passage. The west complex houses a hall, cloakrooms, and a café-restaurant with a large terrace. The area between the main building and the west complex is designed as a long garden court. The facades show a largely glazed skeleton structure; and a detail study of the tall building suggests a reinforced concrete frame. The project was not pursued after 1955.

Bibl.: Drawings and letters from Neubacher to Hoffmann: Estate.

Undated Designs and Sketches

The following entries are based on drawings from the Estate of the architect, unless otherwise indicated. They are grouped by theme in the following groups:

Cats. 404-416 Small one-story houses and residences for housing estates
Cats. 417-430 Two-story residences
Cats. 431-437 Large villas and country residences
Cats. 438-445 Urban one-family houses and apartment houses
Cats. 446-452 Special types of residential buildings
Cats. 453-463 Exhibition buildings and rooms
Cats. 464-466 Interiors
Cats. 467-469 Memorials and tombs
Cats. 470-493 Various designs and sketches
Cats. 494-501 Works from the period of collaboration with Josef Kalbac
Cats. 502ff. Various projects

Cats. 404-416

Small one-story houses and residences for housing estates

Cat. 404 undated

Design for a small wooden house

The house is built in wooden frame construction on a 8m x 8m square plan, with 1m distance between posts. It has a slightly sloping pyramidal roof with wide overhang. It contains an anteroom with toilet, a kitchen, and two rooms.

Bibl.: Drawing: Estate.

Cat. 405 undated

Ground plan sketch for an almost square single-story one-family house

The ground plan is divided into three unequal segments; the right one houses the living room; the left one, the bedrooms with bath and toilet; the center, the vestibule and kitchen. The living room and kitchen have terraces.

Bibl.: Drawing: Estate.

Cat. 406 undated

Design studies for single-story one-family houses

Two designs which have some features in common deal with the problem of a very compact ground plan, assuming a building depth of about 7.5m. In both cases a segment along the right facade contains vestibule with toilet, kitchen, and bath. One design has a transverse, the other a longitudinal combined living and dining room. Two bedrooms adjoin in each case, and each has a small terrace on the garden side. The buildings are entered by a short flight of steps along the street facade, its solid parapet continuing as a garden wall. A decorative motif is indicated above the doors; the hipped roofs start behind the attic parapet.

Bibl.: Drawings: Estate.

Cat. 407 undated

Facade studies for small row or semidetached houses

The front and rear views of two very small houses with L-shaped ground plans show one-story buildings with high basements, garden courts, and simple facades.

Bibl.: Drawings: Estate.

449

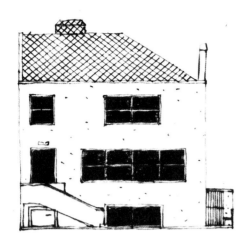

Cat. 409. Design for studio house, section

a bedroom and subsidiary rooms. To the right of the studio is an annex with stairs, vestibule, and outdoor seating. The building is covered by a gently pitched shed roof; the studio facade has one large window.

Bibl.: Drawings: Estate.

Cat. 410 undated

Two ground plan studies for a one-story single-family house with kitchen in the basement

Two different alternatives for combining the living and dining rooms, and two bedrooms and bath are explored. Both have a garden court, and next to the dining room, a pantry close by the basement stairs.

Bibl.: Drawing: Estate.

Cat. 410. Ground plan study for one-story single-family house

Cat. 411. Design for a one-story house with large living room and loggia, plan and two elevations

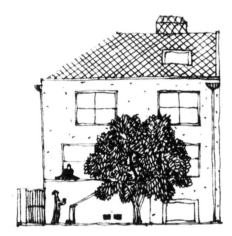

Cat. 408. Facade studies of small semi-detached residence, front and back

Cat. 408 undated

Facade study for a semidetached residence with about 10m frontage

The simple front and rear facades show a two-story house with a basement and a hipped roof with the eaves recessed behind the coping of the facade. At the rear is a terrace with a solid parapet and descent to a garden. The windows are predominantly horizontal.

Bibl.: Drawings: Estate.

Cat. 409 undated

Design for a studio house

The main room of this house, without a basement, is a 6m x 10m studio which is almost 6m high. The building's rear section has two stories. On the ground floor a firing room and library niche adjoin the studio. On the second floor are

Cat. 411 undated

Design for a one-story house with large living room and loggia

The ground plan of this one-story house with hipped roof is a rectangle about 9m x 10m. The entrance at the left corner opens to an anteroom with toilet. A large living room or studio in the entrance axis has a curtained annex with two sofa beds. At the left is a long, narrow area for kitchen and bath. On the garden side the living room is entirely glazed but sheltered from direct sunlight by a loggia with three pillars. Seven steps behind a solid parapet lead along the street facade to the entrance. The garden gate is between the parapet and an equally high garden wall, which continues to the right, closing off the street facade in contrast to the open garden facade. The sheet metal roof begins behind the coping of the wall without a cornice.

Bibl.: Drawing: Estate.

450

Cat. 412 undated

Design for a small single-family house with finished attic

The house has no basement; the entrance opens onto a hall with a straight attic stair. On the right is the door to the parents' bedroom, on the left are pantry, toilet, and bath. The right (garden) side also contains a kitchen-living room, with terrace and a second bedroom. The entrance door forms a unit with the window above and a flower box. At the left is a small round window into the hall, and on the right a horizontal bedroom window. The 45-degree gable is flanked by two small obelisks; the attic story has a dormer with hip roof and a small roof terrace.

Bibl.: Drawing: Estate.

Cat. 413 undated

Two studies for small two-story residences for housing estates

Both houses are designed for the utmost economy on lots of only 39 and 43 sq m. The ground floor contains vestibule with toilet, kitchen, and living room. The larger house also has a dining nook. Bedrooms and bath are on the second floor; the smaller house has a spiral stair. The simple facades are topped by hipped or pyramidal roofs.

Bibl.: Drawings: Estate.

Cat. 414 undated

Design sketch for a semidetached residence with gable

The house with basement and steep finished ridge roof has an entrance on the gable side. The vestibule opens onto a staircase, toilet, and living room, next to which on the garden side is the kitchen with dining nook. The attic with two large dormers contains two bedrooms and a bath. The simple facade has a door with shiplap siding and square windows.

Bibl.: Drawing: Estate.

Cat. 415 undated

Design sketch for two two-story semidetached houses

These small houses (7.5m x 8.5m) with inclined hipped roofs have contiguous entrances with broad surrounds grouped with a balcony above. A second balcony on the upper story gives relief to the facade.

Bibl.: Drawing: Estate.

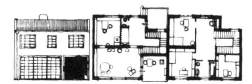

Cat. 416/I, II. Project for row house on a 10m-wide lot, plans and facades

Cat. 416 undated

Row house project on a 10m wide lot

Several facade designs are studied on the same ground plan for a two-story row house with a basement and hipped roof. The entrance is in a deep niche on the right. Behind it, in the entrance hall, next to the kitchen, is a staircase lit by a window about midway. On the garden side a loggia joins the living room. There are three bedrooms and a bath on the second floor.

The living room is glazed toward the garden. Windows are invariably subdivided in many panes and have surrounds. There is sparing use of stucco decoration. Hoffmann explored a solution in which the roof is carried through over the entrance niche, and another, in which the niche is unroofed.

Bibl.: Drawings: Estate.

Cats. 417–430

Two-story residences

Cat. 417 undated

Design for a small single-family house with two round alcoves
Said to be intended for Hoffmann*

This two-story house with hipped roof has semicylindrical projections with conical roofs on the street and garden sides. The street alcove is on the left, the garden alcove is diagonally opposite at the rear. The entrance is reached through a narrow pillared porch in the center of the triaxial facade; a small balcony is above. The entrance hall houses stairs, cloakroom, and toilet, and gives access to the dining room. Below the stair is the door to the living room with its half-round front

alcove. The rear of the room adjoins a veranda on the garden side. The kitchen, maid's room, and storeroom are in the garden alcove.

The facades are plain and overgrown with climbing plants. A shingled roof is indicated; the street alcove has a balcony on the second floor.

*The inscription "Hoffmann's house" on the design is not in Hoffmann's handwriting.

Bibl.: Drawings: Estate; *Magnum*, no. 32, October 1960, 46.

Cat. 418 undated

Design for a single-family house with reflecting pool

This two-story country house with a basement and flat roof is distinguished by a three-bay loggia with two rows of pillars at the left corner. It is connected to the house by a kind of bridge, below which are steps to the entrance. Next to a vestibule with cloakroom and toilet on the street side are the pantry and kitchen. On the garden side the living room and dining room adjoin a veranda and large terrace. A reflecting

Cat. 417. Design for a small single-family house with two round alcoves, plan and street facade

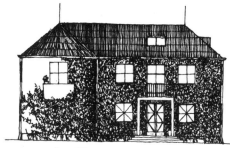

451

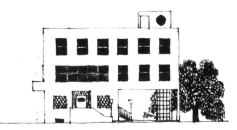

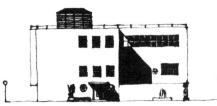

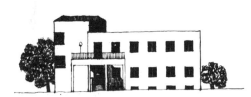

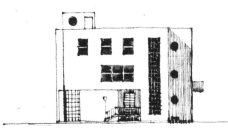

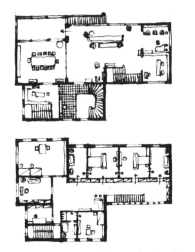

Cat. 419. Design for a three-story house with spiral stair

Cat. 420/I, II. Design for single-family house with caryatids, plans of ground floor, upper floor, and facade

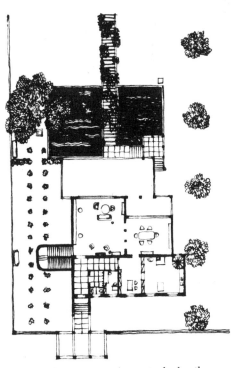

Cat. 418/I, II. Design for a single-family house with reflecting pool; plan, street and garden facades

pool with a corner pavilion extends from the terrace; a bridge with pergola leads to the garden. The main staircase is in a rounded projecting element on the left side. On the right a spiral stair with a tall strip window connects the kitchen and second floor. All facades are plain with flush windows.

Bibl.: Drawings: Estate.

Cat. 419 undated

Design for a three-story house with spiral stair

A three-story house with basement and flat roof. The ground floor houses only a lobby with main staircase and minor rooms, and a freestanding cylindrical glazed spiral stair. The remainder of the ground floor is open between the pillars supporting the upper floors. The second floor has the large living room with balcony and adjoining dining room, accessible from the main staircase, and the kitchen, pantry, and maid's room on the spiral stair at the other end. The third floor contains bedrooms and four baths.

Dining room and hall have horizontal windows, the other rooms have vertical windows. The main staircase has a vertical strip window. The secondary stair leads to a small, flat-roofed superstructure.

Bibl.: Drawings: Estate.

Cat. 420 undated

Design for single-family house with caryatids

The ground plan of this three-story house with roof terrace is L-shaped. The longer arm of the L is enclosed only on the upper story but open on the ground floor; the "hovering" upper part of half of the building is supported by two caryatids at the outer corners. The second floor houses the entrance hall with subsidiary rooms, kitchen, and servants' rooms. Assuming the entrance on the north, the main stair is at the northeast corner; a second stair from the second to the third floor is at the northwest corner.

The function rooms are on the second floor; the entrance hall and staircase are contiguous with a transparent, unified group of spaces which

almost convey the effect of a single large room. They include a large living hall with fireplace and open stair, a music room, a dining room, and a winter garden with steps down to the garden. On the third floor the hall stair ends in a spacious lobby lighted by a band of windows, with access to bedrooms and baths. The main staircase leads to a small glazed superstructure with a low hipped roof. The facades are plain with flush windows. Living hall and winter garden have very large horizontal windows.

Bibl.: Drawings: Estate.

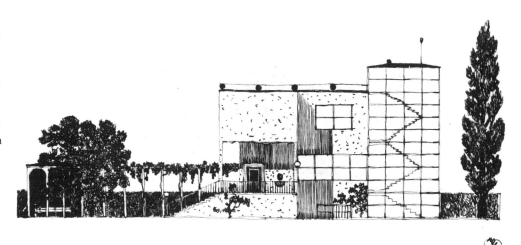

Cat. 421 undated

Design for a single-family house with glazed staircase

A two-story house with basement and roof terrace on a lot with 20m frontage, set back 5m from the street. The ground plan resembles a U with uneven arms, the shorter arm on the street side and the longer on the garden side. The shorter arm contains a glazed staircase hall, lobby, cloakroom with toilet, and servant's room with bath; an interior corridor leads to the kitchen on the garden side; next to it are pantry and dining room. The living hall in the connection between the garden and street wings is centered on a fireplace.

Next to the dining room is a terrace with steps leading down to the garden and reflecting pool. The terrace is covered by the second story of the garden wing. This story runs all the way to the left lot line where it is supported by a wall. Its overhang on the garden side forms a loggia with terrace. A pergola leads along the right lot line to a garden house with three arched openings. The facades achieve strong contrast between glazed and unglazed surfaces and the staircase glazing is carried around the corner and in places merges with the horizontal windows of the street facade; the window of the living hall similarly merges with the staircase glazing. A handrail supported by round elements borders the flat roof.

Bibl.: Drawings: Estate.

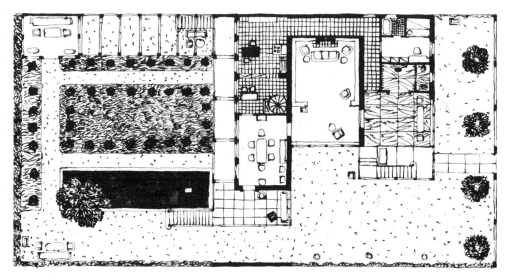

Cat. 421. Design for single-family house with glazed staircase, plan of ground floor and main facade

Cat. 422 (cf. Cat. 336) undated (1931)

Design sketch for a two-story single family house with glazed penthouse for Dr. Kuno Grohmann

Assuming the street on the north, the entrance with lobby, stair, and minor rooms is at the northeast corner. On the south is a large

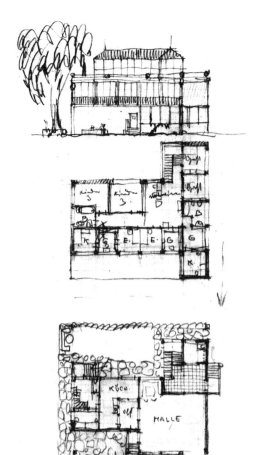

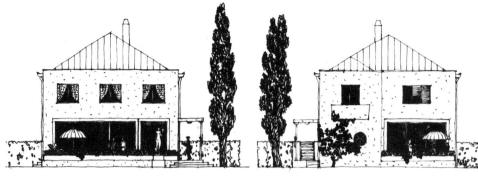

Cat. 423/I, II. Project for single-family house with spiral stair and two terraces, facades

Cat. 422. Design sketch for two-story single-family house with glazed penthouse, plan of ground floor, upper floor, and south facade

plan with a projection on the garden side. Large terraces are on the garden and street sides. The vestibule leads to the living room with adjoining dining room, or to the pantry connected to kitchen, maid's room and bath. A spiral stair in the living room leads to a second-floor living room, a small bedroom with bath, and a bedroom on the garden side next to a large dressing room and spacious bath with balcony. The windows are undivided; the facades are plain. The roof is recessed behind the facade coping.

Bibl.: Drawings: Estate.

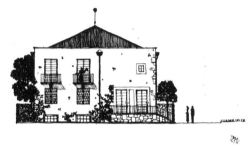

Cat. 424/I, II. Project for house with two apartments and two entrances, plan of ground floor and street facade

hall with alcove and dining nook, next to the kitchen and service entrance. An open loggia is on the garden side. On the second story there are bedrooms with dressing rooms and a hall. The south facade and the penthouse are largely glazed.

Bibl.: Drawing: Estate.

Cat. 423 undated

Project for a single-family house with spiral stair and two terraces

The two-story house with sheet metal pyramidal roof has an approximately square ground

Cat. 424 undated

Project for a house with two apartments and two entrances

The two-story house with basement and hipped roof is planned in such a manner that the north-south direction corresponds to a diagonal of the rectangle (13m x 16m) of the plan. The street facade faces northeast. It is striking that, reached by a flight of steps and a podium, there are two entrances side by side at a corner of the street facade. The first door opens onto the staircase, the second onto a long vestibule. At the end is the living hall with dining nook. On the right are an interior corridor, kitchen, cook's room, and toilet, on the left two bedrooms with dressing room and closets, and a bath. On the garden side is a study with loggia and open terrace. The basement houses service rooms and a porter's apartment. The layout of the second story is unknown but was probably similar to the ground floor.

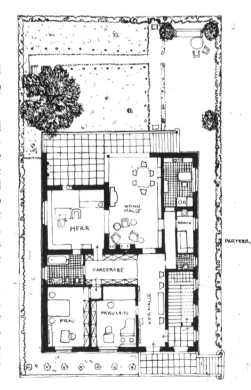

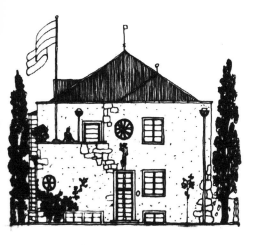

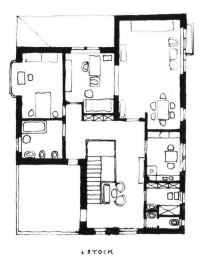

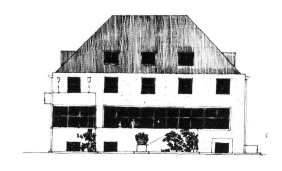

Cat. 425/I, II. Project for house with two apartments, entrance facade and plan of upper story

The roof is recessed behind the facades. The facades are stuccoed, with some random ashlar masonry at the corners; occasional stucco decorations are indicated. The two entrance doors, sharing one surround, form a unit; the adjoining windows have latticed grillwork. Above are two shallow balconies while a terrace with solid parapet is above the loggia on the garden side. The windows are divided into small horizontal panes.

Bibl.: Drawings: Estate.

Cat. 425 undated

Project for a house with two apartments

This two-story house with basement on an area of about 215 sq m accommodates two elegant apartments reached by a center stair in the axis of the entrance. Assuming the street side on the north, both stories have a maid's room, kitchen and living room with dining nook along the west facade, while bedrooms with glazed alcove and bath are along the east facade; at the south are a living room and bedroom separated by a study. On the northeast corner of the first floor is a music room with a terrace above. A loggia with terrace and reflecting pool complete the layout.

The roof is recessed behind the facade. The windows have small horizontal panes and are framed; above the entrance door with transom window is a sculpture. Random ashlar masonry projects from the stucco in several places. The

roof of the loggia is supported by a central tapering column. A clock is in a panel on the second story of the garden facade. The plan is based on the same program as Cat. 424.

Bibl.: Drawings: Estate.

Cat. 426 undated

Ground plan for a two-story single-family house

The ground plan is approximately square (10.5m x 11.5m) with steps to the entrance on the street side and a terrace on the garden side. Between the vestibule on the street side, and the pantry, which is on the garden side, a staircase leads to the kitchen in the basement. The pantry adjoins the dining room; off the vestibule is the living hall with stair to the second-story bedrooms and subsidiary rooms.

Bibl.: Drawings: Estate.

Cat. 427 undated

Facade studies for a two-story house with high hipped roof

Drawings for the entrance and garden facades of a two-story house with basement and high, finished hipped roof. Each facade has five axes and is almost symmetrical. The center entrance is reached by a short flight of steps with solid parapet beginning with a sculpture. Sculptural

decoration is also indicated above the door lintel. The vertical ground-floor windows are somewhat larger than those on the second floor. Box dormers provide light for the attic. The horizontal basement windows have wide surrounds. A band of windows dominates the ground floor of the garden facade, while the second-floor windows match those of the entrance facade. A balcony with solid parapet projects on the left, and a terrace is at the center of the ground floor.

Bibl.: Drawings: Estate.

Cat. 428 undated

Facade sketch for a house with fieldstone masonry

Basement and ground floor of this two-story house with low hipped roof are of large fieldstones; the upper story has wood siding up to parapet height. There is a large corner veranda on each floor.

Bibl.: Drawing: Estate.

Cat. 428. Facade sketch, house with fieldstone masonry

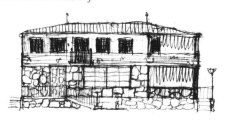

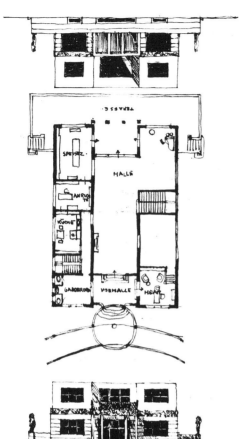

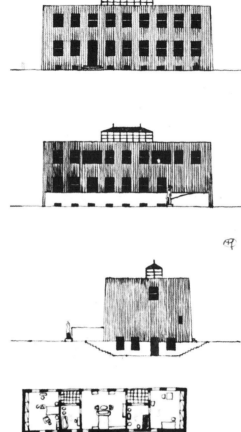

Cat. 431. Design for a large house with horizontal windows and frets, facade

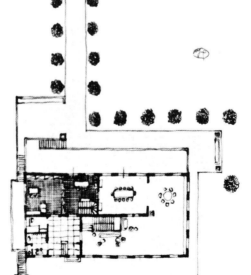

Cat. 429. Design for single-family house with round, pillared loggia, plan and facades of short sides

Cat. 430/I, II. Design for house with fluted(?) facades; plan of ground floor, upper floor, and facades

Cat. 429 undated

Design for a single-family house with round, pillared loggia

This two-story house with basement has a spacious ground plan in three sections. Entrance, lobby, hall, and garden loggia occupy the center. Cloakroom, service stairs, kitchen, pantry, and dining room are at the left; a large study, main staircase, and annex to the hall are on the right. The cubical building which conveys an impression of closure, has a flat roof without cornice. It is divided on the exterior into two zones by a richly decorated band of stucco in lieu of a string course. The lower zone is horizontally grooved. All windows are horizontal. A circular loggia in front of the entrance has a flat roof which serves as a terrace. A second straight loggia at the rear facade opens to a large terrace with access to the garden.

Bibl.: Drawing: Estate.

Cat. 430 undated

Design for a house with fluted(?) facades

The two-story house with basement and flat roof has a rectangular ground plan. The street facade has nine axes; the entrance is in the third axis from the left and opens onto a vestibule. On the left are a cloakroom, toilet, and servant's room, on the right a door gives access to the large hall with stairs to the upper story. Opposite the entrance, doors lead to kitchen and pantry. The basement stair starts in the pantry; the adjacent dining room connects to the hall by a large opening. A terrace runs along the entire garden front.

The second floor is entirely symmetrical with a three-bay bedroom in the center of the garden side. On each side of it is a bathroom with loggia and a corner-bedroom. The street side contains two smaller bedrooms with baths in each corner. The remainder of the second floor consists of a large hall with the stairs to a glazed penthouse that has a hipped roof. Vertical windows are flush with the facades. The fluted(?) outer walls are slightly battered.

Bibl.: Drawings: Estate.

Cats. 431-437

Large villas and country residences

Cat. 431 undated

Design for a large house with horizontal windows and frets

A two-story house with basement and flat roof; the basement is so deep that its windows are barely visible. The building consists of a main wing on a rectangular ground plan with projections and recesses, and a shorter wing at a right angle. Only the second-floor plan is known and indicates a solution with large hall, two balconies, and two stairs. The garden facade is dominated by horizontal windows which together with the considerable length of the facade give the building an effect of being broadly extended. The covered balcony is decoratively framed by the same fret pattern as the top of the facade.

Bibl.: Drawings: Estate.

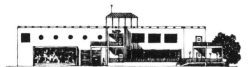

Cat. 432. Facade study for a large two-story
house(?) with flat roof, garden facade

Cat. 432 undated

*Facade studies for large two-story houses(?) with
flat roofs*

One study shows a garden facade with a large
winter garden window and numerous terraces.
The other shows two related facades, one with
a small glazed stair tower. The facade treatments
are similar in both, from the proportions of the
windows to the railings with round supports on
the flat roof.

Bibl.: Drawings: Estate.

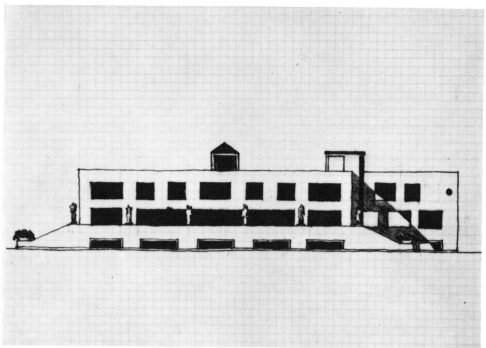

Cat. 433 undated

*Design for a large house with sculpture terrace
and reflecting pool*

The two-story building with basement and flat
roof consists of two parallel but laterally shifted
wings connected by a third at right angles. On
the street side the smaller, front, wing for guests
and servants contains the main entrance on the
right. This opens to a vestibule with minor rooms
and steps to the raised first floor containing a
large bedroom and bath. The second floor of this
wing houses three bedrooms. In the connecting
wing are the pantry and a secondary stair with
a semicircular enclosure wall which projects be-
yond the facade. The main stair is in the large
living hall, which occupies most of the main
wing. A study, dining room with bar, and cor-
ridor to the study are also in this section. The
upper story contains a stair hall, three bedrooms,
three baths, and two dressing rooms.

A terrace with lateral flights of steps runs along
the entire garden front. It has a solid parapet
and sculptured figures placed at intervals. There
is a rectangular reflecting pool behind the front
tract.

Facades are plain. Windows are flush without
surrounds except for those in the basement. The
wall between the living hall and terrace is en-
tirely glazed. The half-round projecting staircase
has a vertical strip window. Horizontal windows
alternate with square ones, but the effect of hor-
izontality predominates.

Bibl.: Drawings: Estate.

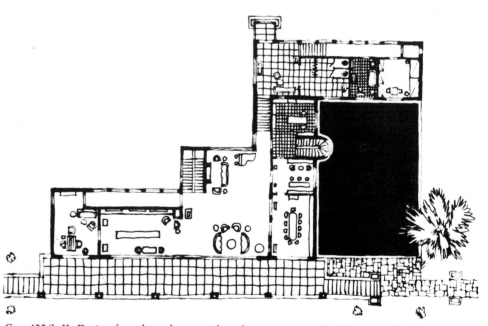

Cat. 433/I, II. Design for a large house with sculpture terrace and reflecting pool; plan of
ground floor, and garden front

Design for a large country house with L-shaped ground plan

A two-story house with basement has an L-shaped ground plan. At the center of the larger wing a six-bay pillared loggia with open stairs at the rear forms a porch over the driveway. The entrance leads to a vestibule with cloakroom and subsidiary rooms; on the right a two-leaf door opens on the large living hall with fireplace. The living hall and the adjoining dining room are entirely glazed on the garden side. A wide terrace fronts both rooms; it has a two-story pergola at one end and a reflecting pool at the other. A pantry connects the dining room and kitchen. At the juncture of the two wings a stair rises from the basement to a small penthouse. The main wing upstairs houses a large hall on the street side together with bedrooms and dressing rooms, a large bath, and a study. The first floor of the secondary wing contains several bedrooms, a bath, and the garage; above are a playroom, children's room, and governess' room.

The facades are plain, and the windows are flush with the walls. The wide windows of the upper hall have rounded corners; the stair landing has a small balcony with an unusually high narrow glass door and transom window on the street side.

Bibl.: Photographs of drawings: Estate.

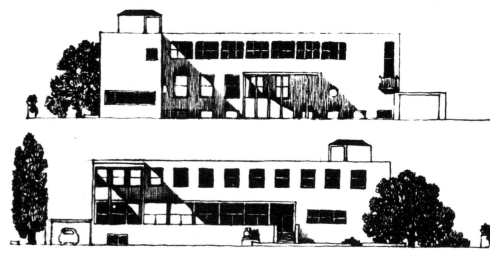

Cat. 434/I, II. Design for a large country house with L-shaped plan; plan of ground floor, facade with pillared loggia, and garden facade

Design for a large country house with three wings

This strikingly large building has three wings: an east-west two-story guest wing, a parallel and laterally shifted three-story main wing, and a two-story north-south service wing that forms the western termination of the complex. All, except for the connecting element between the main wing and guest wing, have pitched roofs. The roofs are hipped except at the east end of the guest wing, which has a gable with sculptural decoration. The roofs are set back behind the facade. There are no cornices.

The main wing is raised like a bridge; its function rooms consequently are on the level of the second floor in the other wings. The large living hall and adjoining dining room with terrace can either be reached by garden stairs to the terrace or from the main entrance, which opens to a large vestibule with glazed connecting wing and stair hall. The guest wing has a spiral stair. The

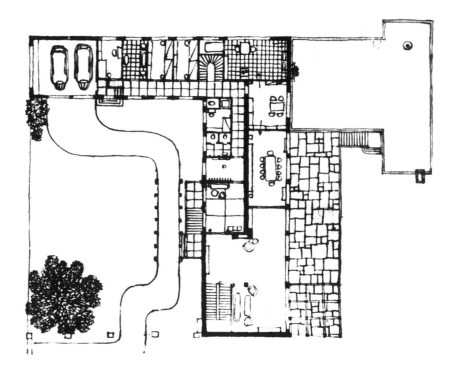

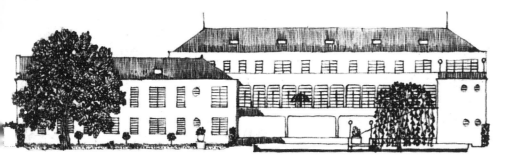

service wing ends in a straight stair and hall. The garages are in the service wing.

A gardener's house is in the southeast corner of the site. A reflecting pool at the front has a bridge leading to a loggia or pergola. Another loggia with pillars and sculptures is at the main entrance. The facades are otherwise simple. The upper corners of the openings in the central wing and connecting wing are rounded.

Bibl.: Photograph of drawing, and drawings: Estate.

Cat. 435/I, II. Design for a large country house with three wings; plan and garden facade

Cat. 436 undated

Design for a large country house with facade tower

A strongly articulated three-story house with an approximately U-shaped ground plan. A driveway runs south-north from the front to a rear yard with flanking wings. The west wing houses the garage, kitchen, laundry, and servants' rooms.

On the upper story of the south main wing is the large hall with bar and a projecting dining room which seats twenty people. The east wing contains pantry, service stair, cloakroom with two toilets, and an anteroom with exit to the yard. Steps lead in a quadrant from the anteroom to the large hall with its adjoining two-bay loggia. The west wing across from the loggia has a comfortable spiral stair and a long gallery lighted mainly by a large north window.

On the third floor the spiral stair opens to a large hall with access to the south and east wings. A short corridor leads to the west wing. On this level are bedrooms and baths. A large dressing room is next to the lady's bedroom, a study next to the gentleman's. These bedrooms share a spacious terrace; a veranda is below.

The only extant facade drawing shows a striking building with horizontal windows, triple-arched French windows, and a towerlike projection with some visible random ashlar masonry.

Bibl.: Photographs of drawings: Estate.

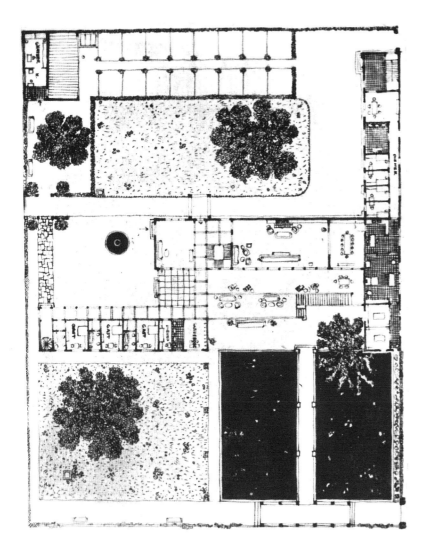

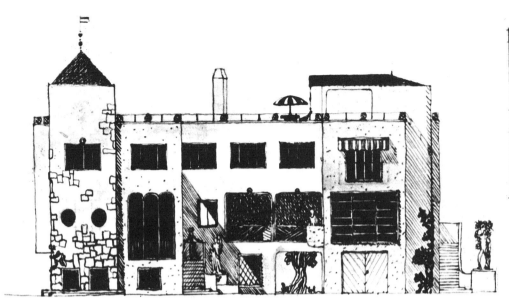

Cat. 437. Building with small court of honor, facade study

Cat. 436/I, II. Design for a large country house with facade tower; plan of upper story and courtyard facade

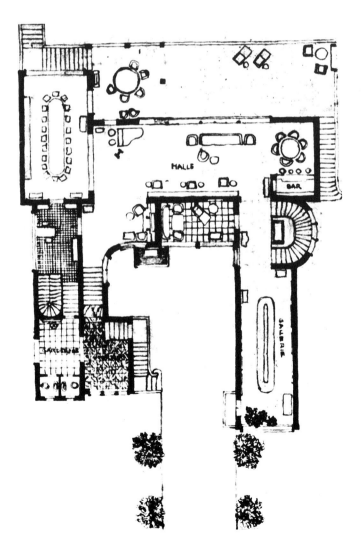

Cat. 437 undated

Facade study for building with a small court of honor

A three-story building, apparently on a U-shaped ground plan. The irregular four-bay main wing has a narrow two-story wing with a roof terrace and solid parapet at the left. On the right the projecting wing is the same height as the main wing but somewhat narrower; it ends in a gable with a round window and string course. Four buttresses end in tapered tops. Between the two central buttresses is a two-leaf door with shiplap siding, topped by a decorative balcony and coat of arms. The wings are connected by a terrace with low balustrade and two sculptured figures flanking three steps. The main entrance is on the second floor, approached by an open stair. The ground floor windows are horizontal; those on the upper stories are vertical. At the left wing is a door with a lantern(?).

Bibl.: Drawing: Estate.

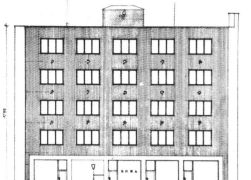

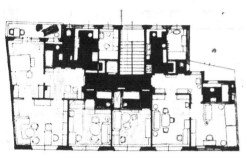

Cat. 438/I, II. Project for apartment house "Zora" with shops, ground floor plan and street facade

Cat. 439. City house for single family, about 8.5m wide, facade study

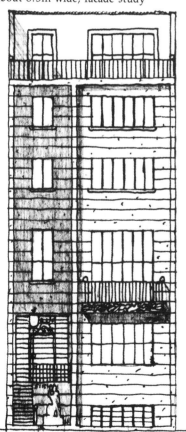

Cats. 438-445

Urban one-family houses and apartment houses

Cat. 438 undated

Project for an apartment house "Zora" with shops

A five-story apartment house with flat roof on an irregular lot. The ground floor houses four shops, each of the upper stories has two bachelor apartments and two larger apartments. These consist of vestibule, living room, bedroom, servant's room, kitchen, bath, and toilet. A construction study showing the reinforced concrete supports and a complete study for the furnishings are extant. A study for the courtyard elevation shows that the court is below street level and covered by a building. For the street front an architect's design sketch and a drawing with measurements exist. The five-bay fluted stucco facade has horizontal windows with three panes and stucco decorations above. The shop fronts and house entrance are unified by a dark stone surround; each shop consists of an entrance with transom and a large show window.

Bibl.: Drawings and prints: Estate.

Cat. 439 undated

Facade study for a single-family city house, with about 8.5m frontage

The ground plan of this project is not known. The facade drawing shows a four-story house with basement and set-back attic. The horizontally striated facade is divided vertically into a wider and narrower strip, each unified by a frame. In the narrow strip the wall is set back to form a tall niche containing the entrance with open access stairs and, on each upper floor, one window. The second-floor window is higher than those of the upper stories. The wider facade strip has a wide French window with balcony on the second floor. Horizontal windows are above and below. Next to the entrance are a sculptured figure and the beginning letters of an inscription SIR. This could be completed to read "Sirius," the name of a large match factory whose director was Hoffmann's client in the 1930s.

Bibl.: Drawing: Estate.

Cat. 440 undated

Project for a single-family city house with 9m frontage

The five-story house with basement stands on a narrow lot, built over to a depth of 20m. Entry is by an open stair in a niche at the left of the symmetrical facade, to an entrance hall with elevator. At the rear of the house is a spiral staircase. With the exception of the large entrance hall, the ground floor plan is repeated on the second floor: a small lobby with cloakroom, toilet, and washroom is next to the elevator. On the street side are a small salon and a living hall; on the courtyard side is the dining room with a terrace. Pantry and spiral staircase are between dining room and hall. The kitchen is probably in the attic as in Cat. 441. The topmost story is set back from the facade forming a terrace with decorative railing. The two upper stories have horizontal windows that project somewhat beyond the facade like the large French windows

Cat. 440. City house for single family, 9m wide, facade study

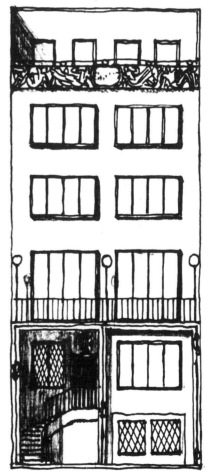

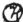

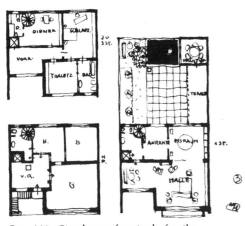

Cat. 441. City house for single family, 13m wide, plans and facade

Cat. 442. Four-story apartment building with shops, facade study

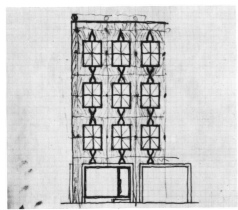

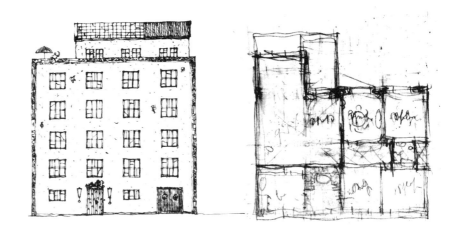

Cat. 443. Design sketch, five-story apartment building with penthouse, facade and plan

of the second floor. The entrance niche, ground floor, and basement windows are doubly framed with stucco decoration. On the balcony are three lamps.

Bibl.: Drawings: Estate.

Cat. 441 undated

Project for a single-family city residence with 13m frontage

A building, 20m high, with basement, four stories, and a set-back attic. On the left is a recess containing an open stair to the entrance and elevator lobby; at the rear of the house is a spiral staircase. The lobby gives access to a large front office and two smaller ones on the courtyard side.

The second floor has a large living hall, dining room, small anteroom, and pantry, and at the rear a breakfast room with terrace and view on a landscaped courtyard with reflecting pool. The third and fourth stories each have a bedroom with bath and dressing room, anteroom, and servant's room. The attic contains a kitchen, pantry, and laundry; it has a facade with five balcony doors. The other stories have a triaxial facade. Windows in the recess are horizontal; on the other portion of the facade window shapes vary and on the second floor a wide French window with a shallow balcony fills the entire surface. Barred windows above the pavement light the basement. The entire facade below the attic is unified by a frame.

Bibl.: Drawings: Estate.

Cat. 442 undated

Facade studies for a four-story apartment building with shops

Several solutions are studied for a facade in which two windows on each floor correspond to one ground-floor shop window. In one case the facade design is based on the reinforced concrete skeleton. In another, windows with rectangular and diagonal bars are in a stuccoed facade with small decorative elements. A third solution suggests execution in ceramics. The windows have surrounds and are vertically connected by X-shaped elements. The shop fronts have projecting surrounds.

Bibl.: Drawings: Estate.

Cat. 443 undated

Design sketch for a five-story apartment building with penthouse

The ground plan is lightly indicated while the four-bay facade is shown in some detail. It shows a decorative frame, stucco ornaments between horizontal windows and irregular decorative glazing bars(?) in the windows. A penthouse, glazed like a studio is set back on the roof terrace.

Bibl.: Drawing: Estate.

Cat. 444 undated

Project for a six-story apartment building with 20m frontage and restaurant on the ground floor

Two variations in plan and elevation for an apartment house with six stories and fully glazed attic studio. Both show a rear right wing with a staircase at the point of juncture with the front wing. Another wing is at the rear left and houses the restaurant rooms. The kitchen is in the basement. The upper stories have three apartments on each floor.

In one variation the facade is framed by a decorative garland, and has horizontal windows on the upper stories and a strip window in the restaurant. In the other, the frame is more delicate and treated decoratively only in the cornice zone. One facade has seven rows of vertical windows with small stucco decorations below each window; the alternate has such decorations between the windows. The two facades are quite different in their emphasis: one is predominantly horizontal, the other predominantly vertical.

Bibl.: Drawings: Estate.

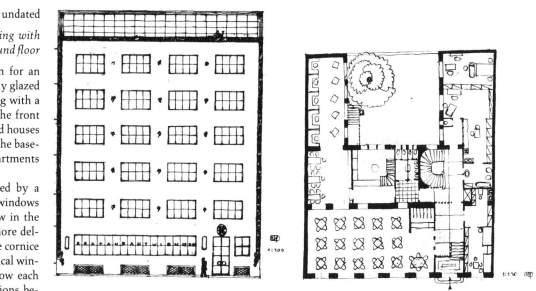

Cat. 444/I, II. Six-story apartment building, 20m wide, with restaurant on ground floor, facade and plan

Cat. 445/I, II. Seven-story apartment house, street facade and plan of ground floor

Cat. 445 undated

Project for a seven-story apartment building

The ground plan on a 11.5m wide lot is divided into two sections. On the right are the entrance hall (on the upper stories, a small room), staircase, and elevator. The wider left section has a large living room, small bedroom, kitchen, and bath. The facade expresses this division into unequal sections. On the left are the strip windows of the living rooms, on the right, small balconies. The surfaces between the plain low base and the stuccoed cornice are striking: they are treated with a decorative pattern of leaves and blossoms which give the facade the effect of a carpet or wallpaper.

Bibl.: Drawings: Estate; Mang 170.

Cats. 446-452

Special types of residential buildings

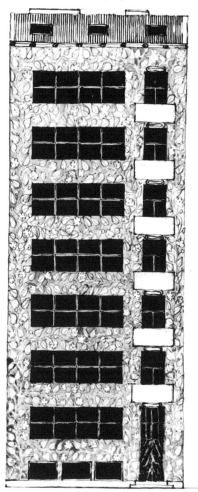

463

Cat. 446. Five-story hotel, facade study

Cat. 446 undated (1950?)

Facade study for a five-story hotel(?)

The four upper stories are rhythmically articulated with portholes or small rectangular windows alternating with French windows that are in framed segments projecting above the roofline. The ground floor projects and forms a terrace on the second floor. Candelabra with spherical lights are on its parapet. The ground floor has approximately square openings. The composition of the facade resembles Hoffmann's preliminary project for a hotel of about 1950, as shown by sketches in the Kalbac estate.

Bibl.: Drawing: Estate.

Cat. 447 undated

Design for a multistory apartment building with gardens on the upper stories

Two drawings are variations of the same project: above the walled ground floor, the upper stories with a central spiral staircase have alternating open landscaped and closed largely glazed sections. Each of the apartments has its own garden plus living rooms, bedrooms, subsidiary rooms, and an enclosed pantry behind the stairs. The load-bearing parts of the cantilevered structure are of reinforced concrete; the glazing has metal bars. Only the ground floor with its horizontally grooved facade and four small corner obelisks has solid walls. A flagpole on the flat roof tops this light, transparent building.

Two ground plan drawings show that there was a third variation with a central garden on each floor and the staircase at the side. The ground floor houses kitchen, restaurant, office, and service rooms.

Bibl.: Drawings: Estate.

Cat. 447. Design for a multistory apartment building with gardens on the upper stories, plan and facade

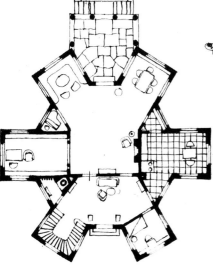

Cat. 448. Design sketch for polygonal house with regular projections, plan and entrance facade

Cat. 449. Project for cylindrical house with workroom, plan and facade

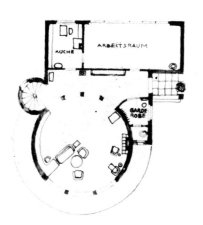

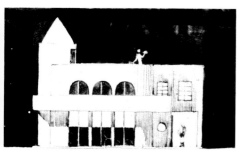

| Cat. 448 | undated |

Design sketch for a polygonal house with regular projections

The unusual ground plan of this two-story building with flat roof is a twelve-sided polygon. Open and closed sides alternate; the open sides have a rectangular projection which functions as a room. On the ground floor, the library and kitchen are longer rooms on the transverse axis. Two other projections form a seating niche and a dining nook in the central living hall. The remaining two projections house the staircase and a bedroom. A covered terrace or loggia with open stairs to the garden is in front of the living hall. The windows on the first floor are taller than those on the second floor, which are topped by small decorated lunettes. The entrance and latticed transom window have a frame crowned by an escutcheon and sculptural decoration.

Bibl.: Drawing: Estate.

| Cat. 449 | undated |

Project for a cylindrical house with workroom

This project deals with the combination of cylindrical and prismatic volumes. The rear, straight, part of the house on the ground floor contains the entrance, workroom, and kitchen. A small rectilinear projection with cloakroom and toilet makes the transition to the round part. On the other side of the house this transition is made through a second smaller cylinder with conical roof that houses a spiral stair to the roof terrace. The second story of the main cylinder has a balcony with solid parapet and inside, a large room with pillared openings to the rear.

Bibl.: Drawing: Estate.

| Cat. 450 | undated |

Design sketch for a small cylindrical house

The ground plan of this two-story house with flat roof is inscribed in a circle of about 6.5m in diameter. About half the circle is taken up by the living room with dining nook. It is divided by an S-shaped wall from the kitchen, larder, entrance hall, staircase, cloakroom, and toilet. The living room wall opens in a large strip window. The other rooms have vertical windows. The facade is plain and intended for climbing plants.

Bibl.: Drawing: Estate.

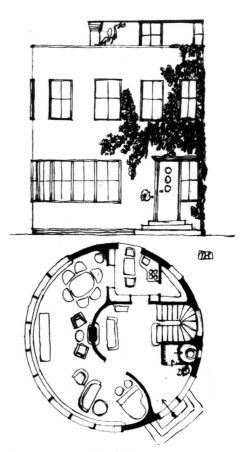

Cat. 450. Design sketch for small cylindrical house, plan and facade

| Cat. 451 | undated |

Design sketch for a small cylindrical house with battlements

A small two-story house with flat roof and a kind of battlemented top instead of a cornice. A circle of about 8m diameter houses a central stair and, on the ground floor, two bedrooms, bath, and kitchen. The small house has front and rear entrances and symmetrical windows on both stories.

Bibl.: Drawing: Estate.

| Cat. 452 | undated |

Studies for small houses in unusual forms

These designs attempt to combine the functions of a house with given geometrical forms; a pyramid, steep ridge roof, and semispherical igloo.

Bibl.: Drawings: Estate.

Cat. 452. Studies for small houses in unusual forms

Cat. 454. Exhibition building with caryatids, facade design

Cats. 453-463

Exhibition buildings and rooms

Cat. 453 undated

Facade study for a pavilion with shingled onion-shaped roof

An outline sketch and a detailed sketch depict a pavilion with a strongly curved onion-shaped roof. The rough sketch shows the roof resting on short vertical supports. The other version shows a bulging shingled form above the base and various convex and concave transitions to the onion dome, topped by a lantern with a curved peaked roof. The round building has projections with flat roofs and glazed fronts. At each side of the entrance are oval windows.

The plan and elevation of a long rectangular building are drawn on the verso. The ground plan indicates three sections, perhaps with entry, three central rooms, and a large rear room. The elevation shows a one-story building with hipped roof; it has a square projection with three tall windows, and small, slender corner pyramids. This would be unsuitable for a house or farm and suggests an exhibition building.

Bibl.: Drawing: Albertina.

Cat. 453. Pavilion with shingled onion-shaped roof, facade study

Cat. 455. Exhibition building with sloping side walls, facade design

466

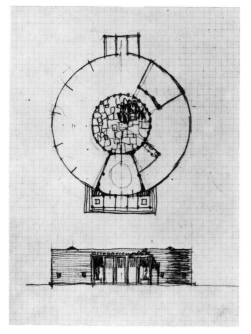

Cat. 456. Design for circular exhibition pavilion, plan and facade with pillared loggia

Cat. 458. Design for Austrian exhibition pavilion with two pillared porticoes, plan, facade, and perspective

Cat. 454	undated

Facade design for an exhibition building with caryatids

The building stands on a slightly sloping site. The entry is flanked by two masonry parapets, at the ends of which are sculptures and two flagpoles. The parapet merges with the walls of the basement under part of the exhibition hall. The other part is raised off the ground and supported at the end by two caryatids, recalling Hoffmann's design for a house with caryatids (Cat. 420). A third of the building, next to the entry, is glazed; the rest shows small windows and some sculptured wall decorations.

Bibl.: Drawing: Estate.

Cat. 455	undated

Facade design for an exhibition building with sloping sides

From a small entrance building with a sculptured figure on a high pedestal a ramp(?) leads to a bridgelike building which rests on the entrance building and on a broad support at the other side. This building is almost five times as high as the entrance pavilion. It has the form of a steep, inverted, truncated pyramid with pictorial representations on its sides. A pavilion, resembling a loggia or pergola, is on the roof

terrace. Tables and seats under umbrellas are placed next to the building, and a flag flies from a tall pole.

This study could have been made for the same project as Cat. 454.

Bibl.: Drawing: Estate.

Cat. 456	undated

Design for circular exhibition pavilion

A cylindrical, horizontally striated building 6m high and 24m in diameter has an interior court and small front and rear projections. The front has a five-bay loggia with pillars and double frames. Monumental sculptures stand in the two outer bays of the loggia. On the roof, letters form the word "Österreich" (Austria).

Bibl.: Drawing: Estate.

Cat. 457	undated

Design sketch for a circular exhibition pavilion

A circular pavilion with flat roof and small glazed rectangular annexes at both sides. A stepped superstructure with crowning sculpture is above the tall framed entrance. Two sculptures on high pedestals flank the entry.

Bibl.: Drawing: Estate.

Cat. 458	undated (1934?)

Facade design for an Austrian exhibition pavilion with two pillared porticoes

This symmetrical pavilion with low hipped roof and low front terrace has two galleries at the right and left of an entrance hall.

The entrance hall is two steps above the galleries. The main entrance has a surround and a canopy with sculptural decoration; the side entrances to the galleries are in three-bay pillared porticoes which project from the facade.

This could be a preliminary study for the 1934 Biennale Pavilion (Cat. 361), which has a related ground plan.

Bibl.: Drawing: Estate.

Cat. 459	undated (1934?)

Facade design for an Austrian exhibition pavilion with open center

A symmetrical one-story building on a low terrace. Pilasters divide the front into framed vertical panels. The three center bays are open and give access to the rear of the building where two trees are planted. Sculptures stand in front of the pavilion.

This could be a preliminary study for the 1934 Biennale Pavilion (Cat. 361).

Bibl.: Drawing: Estate.

Cat. 459. Austrian exhibition pavilion with open center, facade design

Cat. 460 undated

Design for a three-story glazed hall

The building with a low hipped roof and long glazed sides is flanked by two flagpoles. The long side has closed projections with low hipped roofs flanking a glazed three-bay entrance porch with terrace roof. Next to the projections are three-bay loggias with slender posts, covered by extensions of the main roof.

Bibl.: Drawing: Estate.

Cat. 461 undated (1929?)

Design sketch for an exhibition pavilion with ogival cross section

A tall, largely glazed pavilion, the vertical sides of which curve at the top to form a pointed arch.

Cat. 461. Design sketch for exhibition pavilion with ogival cross-section

At the entrance are flagpoles bearing banners with the dates 1898 and 1929.

Bibl.: Drawing: Estate.

Cat. 462 undated (about 1929?)

Design for an exhibition room of the firm Anton Pospischil in the Austrian Museum for Art and Industry

Two elevation sketches show an entrance wall with built-in showcases and a showcase wall with decorative glazing bars. A spherical light hangs from the center of the tentlike ceiling.

Bibl.: Drawing: Estate.

Cat. 463 undated

Studies for the forecourt at an exhibition of the Austrian Werkbund

These indicate several possibilities of arranging a decorative "Werkbund Pillar," a flagpole, and several other elements in front of an old building. The site drops off behind a parapet and could be at the bank of the river Wien next to the Austrian Museum for Applied Art.

These studies could be related to the 1930 Werkbund Exhibition (Cat. 342).

Bibl.: Drawings: Estate.

Cats. 464-466

Interiors

Cat. 464 undated

Project for a shop interior of the Viennese Dairy (WIMO)

An extant drawing shows a wall with built-in refrigerated units and shelves for milk bottles. Another drawing shows a small desk with chairs of sled construction. The desk has an extension top, drawer, and compartment.

Bibl.: Drawings: Estate.

Cat. 465 undated (about 1952)

Furnishings of Stern apartment
Langenzersdorf, Lower Austria

A vestibule, living room, and study with veneered paneling and, in one corner, book shelves above a black marble fireplace. In the plain veneered door is a small curved opening with a floral decoration. The vestibule door is framed with stucco decorations; the living room also has

Cat. 465. Stern apartment furnishings, wall elevation with fireplace, design sketch

stucco decorations on the cornice and fireplace. There is also a striking buffet with carved openwork top and a tiled stove with a top in the shape of a truncated pyramid (cf. Cat. 466).

Bibl.: Drawings: Estate.

Cat. 466 undated (about 1952)

Furnishings with seating corner and tiled stove

A living room with an imitation beamed ceiling and a wainscoting of vertical boards 1.2m high. In a corner is a seating group with built-in benches, higher wainscoting, and a wooden grid ceiling with hanging lamp. The tiled stove has a pyramidal top with figures (Bacchus with thyrsus staff?) and a surrounding bench. The room was part of the Stern apartment.*

* Information courtesy of the architect Anton Eigner, Vienna, who worked on this project.

Bibl.: Drawings: Estate.

Cats. 467-469

Memorials and tombs

Cat. 467 undated

Design sketches for a tomb

An exploration of several possibilities for a tomb design. In one case the precinct is enclosed by walls on three sides but not roofed. The other solutions call for a small forecourt or flight of steps and a three-bay tomb chapel with pedimented front or flat roof (cf. Cat. 99).

Bibl.: Drawings: Estate.

Cat. 468 undated

Four designs for tombs

1. The precinct is paved with stone slabs and enclosed by a railing of rhythmically grouped iron bars. At the head is a stone stele with a widening top. The front bears an inscription and sculptured branch. Hoffmann used a similar form on the Ast grave of 1923 (Cat. 253).

2. The precinct is like the above but the stele is different. Its top resembles a letter W except that the two outer arms of the W are significantly shortened; an edging follows the outline.

3. Here the precinct is covered with six rectangular stone slabs, and the railing consists of equal bars except for the corner posts. At the head is a slightly tapering column; its capital shows a restrained chalice form with leaves and a Star of David.

4. The rectangular precinct paved with four slabs is given a curved front. It is bordered by ranges of pillars with two openings at each side and three at the rear. The architrave has an attenuated cyma profile. A stone panel with inscription is set between the central pillars.

Bibl.: Drawings: Estate.

Cat. 467. Design sketches for a tomb (detail)

Cat. 468. Four designs for tombs

Cat. 469 undated

Design for a war memorial in the form of a pillar

The memorial is about 6m high and consists of a low base and masonry pillar which bears a tablet with inscription. At the top is a cornice profiled with a molding repeated five times; above it is a steep polygonal pyramid ending in a spiky knob.

Bibl.: Drawing: Estate (cf. Cat. 238).

Cats. 470-493

Various designs and sketches

Cat. 470 undated (before 1918)

Facade design for the palace of the Archduke Max (1895-1952)
Vienna II, Augarten

A 17-bay symmetrical building with a 9-bay center, high hipped roof, and two narrower re-

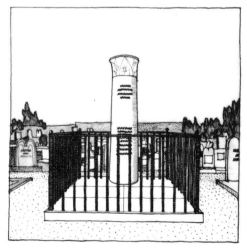
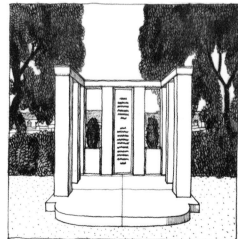

cessed side wings with 2-bay end pavilions. In the center is a glazed pedimented portico with four pillars or pilasters. A frontal flight of steps is flanked by tall bases and ramps. The upper story windows are rectangular; on the ground floor there are arched French windows in the center and pedimented rectangular windows in the end pavilions.

Bibl.: Drawing: ÖMAK.

Cat. 470. Facade design of palace for Archduke Max

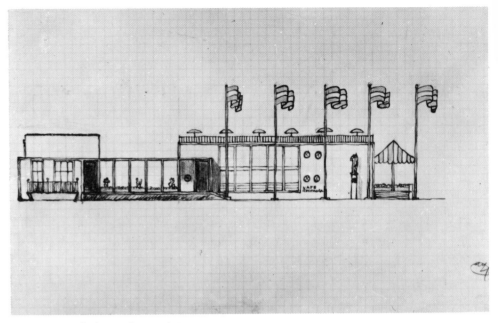

Cat. 472. Facade design for a café/restaurant

Cat. 471 undated

Facade design for a two-story building with brick piers between the windows

The drawing does not show the entire building with basement and hipped roof, but the left part with the framed entrance door and small open stair. In the first bay are small round windows, then follow large horizontal windows. The narrow piers between the windows are brick; all windows form a long horizontal band. This could be a school building.

Bibl.: Drawing: Estate.

Cat. 471. Facade design for a two-story building

Cat. 472 undated

Facade design for a café/restaurant

Two buildings with flat roofs are linked by a lower loggia with pillars which permits a view into the garden with sculptures. The smaller wing has two openings onto a balcony. The larger building has a large glazed opening of five bays next to four small round windows, and a roof terrace. At the front is a terrace shaded by a large marquee. The larger building is flanked by five flagpoles and a sculpture on a high pedestal.

Bibl.: Drawings: Estate.

Cat. 473 undated

Design for a clubhouse

Assuming north at the top, the two-story building has a west inner courtyard and an east courtyard with reflecting pool open to the north. Offices are in the west wing of the west courtyard; the kitchen is in the north wing; a cloakroom with toilet in the south wing; the lobby with drive-in porch and café-restaurant with bar are in the east wing, which is longer. A two-story hall with stairs and gallery adjoins the lobby. Reading room, game room, salon, and long gallery form the east wing of the east courtyard. A second gallery and a tall pillared loggia adjoin the long gallery. A lower loggia with a terrace above it is also in the east wing. A paved terrace is in front of the loggias and hall, and a few steps lead to a reflecting pool. The pool forms a right angle at the north and ends in a fountain jet. The facades are largely opened with windows or pillared loggias.

Bibl.: Drawings: Estate.

Cat. 474 undated

Design for the facade of a five-story building with glazed upper stories

The ground floor of regular ashlar masonry has windows with latticed grillwork and a wide central entrance; above are four recessed, largely glazed, upper stories. The second floor has a terrace with small obelisks at the corners. On the third, fourth, and fifth floors balconies with solid parapets project from the side facade. A flagpole and sculptured figure are on the somewhat recessed flat roof.

The ground floor resembles that of Cat. 447.

Bibl.: Drawing: Estate.

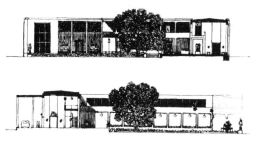

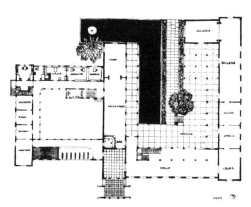

Cat. 473. Design for a clubhouse, plan and facades

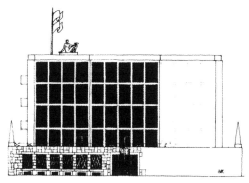

Cat. 474. Five-story building with glazed upper stories, facade design

Cat. 475 undated

Facade study of a monumental entrance to a building complex

The ground floor has five open driveways in the central bays with a sculpture above the center. There are two largely glazed upper stories with flat roof. The building ends in glazed staircases at the right and left. The glazing of the upper stories is interrupted by two wall strips with small windows, crowned by sculptured figures (see Cat. 370).

Bibl.: Drawing: Estate.

Cat. 476 undated

Perspective sketch for a two-wing building with glazed staircase

The front wing of two offset two-story wings ends in a towerlike glazed staircase; the rear wing has a prominent wide ground-floor loggia(?). The flat roofs have a railing with a handrail supported by spherical elements (see Cat. 421).

Bibl.: Drawing: Estate.

Cat. 477 undated

Studies of a funeral hall and chapel for Stockerau, Lower Austria(?)

A long building with low hipped roofs has four funeral spaces and subsidiary rooms along a corridor. An open pillared loggia leads to a taller more steeply roofed chapel. The front of the chapel has a tall window crowned with a cross.

Bibl.: Drawings: Estate. In an undated letter to J. Kalbac, Hoffmann wrote: "I have worked out the funeral hall . . ." (Kalbac Estate).

Cat. 478 undated

Ground plan sketch of a large theater

The auditorium is shown as the segment of a circle, with indication of sight lines into the depth of the stage. Extensive subsidiary rooms are in wings at the sides of the stage house.

Bibl.: Drawing: Estate.

Cat. 479 undated

Design for a festive tent or a pavilion

Four pillars or pylons with pyramidal tops and decorative metal finials are connected to about half of their height by walls. The entrance is at the center. The walls are constructed in tentlike manner and, like the pillars, have decorative patterns.

Bibl.: Drawings: Estate.

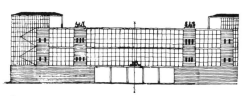

Cat. 475. Facade study, monumental entrance to a building complex

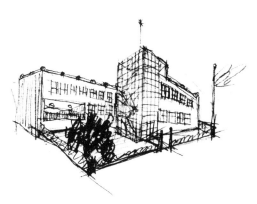

Cat. 476. Perspective design sketch for a building with two wings

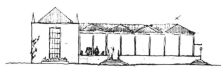

Cat. 477. Study of a funeral hall and chapel for Stockerau, Lower Austria(?)

Cat. 479. Design for a festive tent or pavilion

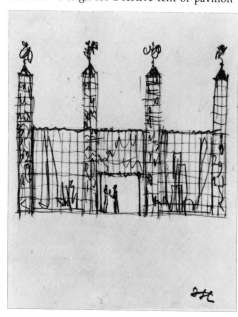

Cat. 480 1927-1928(?)

Project for a panoramic terrace with large clock for Kapfenberg, Styria(?)

Two alternative designs for a panoramic terrace on a steep slope—perhaps near a summit—with a huge clock (4m-4.5m square) topped by a sculptured figure, perhaps an angel. Another sketch shows a spherical clock mounted on a tall support with sculptures, with numbers on the equator.

Bibl.: Drawings: Estate; Report on the School Year 1927/1928, School of Arts and Crafts, Vienna.

Cat. 481 undated

Project for garden entrance with bench, inscribed New York

A simple rectilinear wrought iron gate in an ashlar garden wall. A stone sphere rests at each end of the wall. Next to the gate is a black, roughly square inset mailbox. In plan the wall runs parallel to the gate only for a short distance; it is bent at an obtuse angle on one side, at a right angle on the other. A low bench stands in front of the right-angled wall (perhaps related to Cat. 343).

Bibl.: Drawing: Estate.

Cat. 482 undated

Design for small garden house with upper story

A base with an arched opening forms a terrace which supports a towerlike two-story building with a hipped roof and one room in each story. A spiral stair, enclosed in a cylindrical structure, leads to the top. The ground floor can also be entered from the terrace by two arched openings. A ceramic model was made from this drawing.

Bibl.: Drawing: Estate.

Cat. 482/I. Project for a small garden house with upper story, plan and facades

Cat. 482/II. Ceramic model of the small garden house

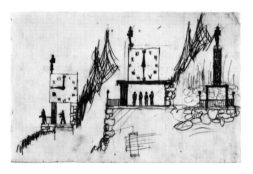

Cat. 480/I, II. Project for panoramic terrace with large clock in Kapfenberg, Styria(?)

Cat. 483. Sketch of a gazebo in the Rosenbaum Garden, facades and perspective

Cat. 485. Sketch of a small octagonal garden house, plan and perspective

Cat. 483	undated

Sketch of a gazebo in the Rosenbaum Garden in the Wieden district
Vienna IV

Hoffmann sketched this wooden two-story Biedermeier gazebo from an illustration. The ground floor has vertical siding; the barrel-vaulted upper story has horizontal siding. The roof is topped by a small railed terrace; above the ground floor loggia with four posts is a second-floor terrace.

Bibl.: Drawing: Estate; Information courtesy Dr. W. G. Rizzi.

Cat. 484. Design sketch for a garden pavilion

Cat. 484	undated

Design sketch for a garden pavilion

A round(?) pavilion with bell-shaped roof stands on a low platform. The roof is topped by two metal flowers on a curved stem. The walls could be metal grillwork or painted stucco relief. The entrance has a flat arch. The pavilion appears to be somewhat narrower at the base than at the roof.

Bibl.: Drawing: Estate. Mang, 111.

Cat. 485	undated

Sketch of a small octagonal wooden garden house
Vienna XIX, Grinzing

An octagonal garden house with vertical siding has a door, window, and slightly curved pyramidal roof. A stair leads to a terrace with access to the upper story. This is a view rather than a design sketch.

Bibl.: Drawing: Estate; Information courtesy Prof. J. Spalt. M.Gerlach, ed., *Volkstümliche Kunst*, I, Vienna (n.d.), 51.

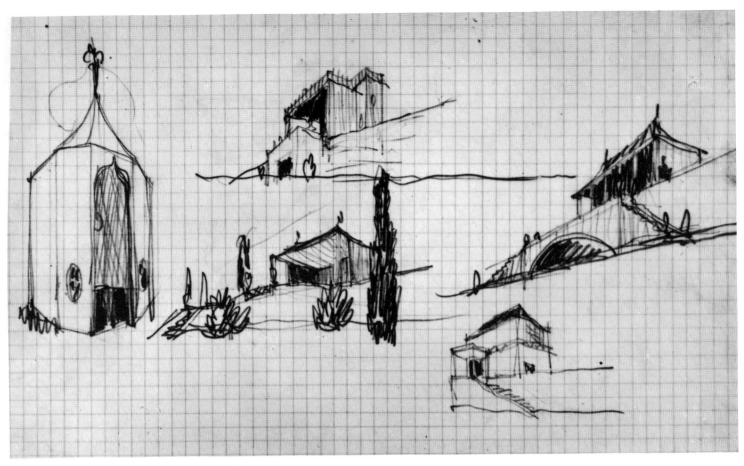

Cat. 486. Perspective sketches of various pavilions

Cat. 487. Design sketch for pavilion with fountain jet

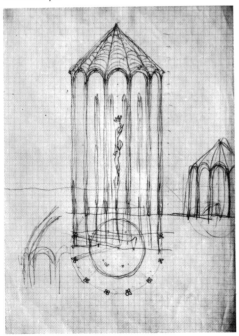

Cat. 486 undated

Perspective sketches of various pavilions

A sheet shows three pavilions on slopes, seen foreshortened from below; one stairway recalls the Primavesi House in Winkelsdorf (Cat. 179). There are also sketches of a small polygonal pavilion with ogee-arched entrance, and a small house with an open stair and loggia. On the verso is a perspective sketch of two chairs.

Bibl.: Drawing: Estate.

Cat. 487 undated

Design sketch for pavilion with fountain jet

A canopy on twelve slender supports rises from a circular basin with six jets; in the center is a sculpture. The form recalls Late Antique or Byzantine umbrella or melon vaults and roofs.

Bibl.: Drawing: Estate.

Cat. 489. Decorative sketch of fantastic architecture

Cat. 490. Sketch of an imaginary building on the water

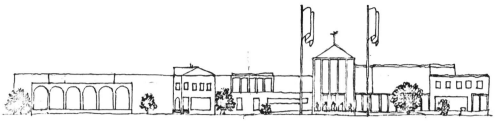

Cat. 493. Architectural composition (wallpaper pattern?)

Cat. 488 undated

Design sketch for a niche with statue

Ground plan and elevation of an exedra with eleven niches in its rear wall. The niche motif is repeated on the flat ceiling ornamented with potent crosses(?); a statue is in the center. The rear wall has vertical bands with inscriptions between the niches.

Bibl.: Drawing: Estate.

Cat. 489 undated

Decorative sketch of fantastic architecture

A tower with several overhanging stories and a penthouse with steep roof is connected to a three-bay building with steep pyramidal roof.

Cat. 491. Design sketch, room with curved walls, plan and view

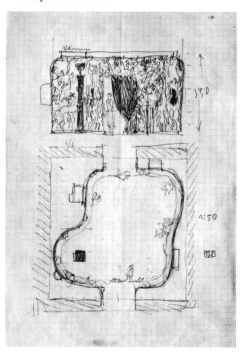

Pointed arcades play an important role on the facades.

Bibl.: Reproduction from an unidentified publication: Estate.

Cat. 490 undated

Sketch of an imaginary tall building (hotel?) on the water

A building complex with several recessed stories and a tower with pyramidal roof is on an embankment. A mountain range is indicated in the background.

Bibl.: Drawing: Estate.

Cat. 491 undated

Design sketch of a decoratively treated space with curved walls

Within a square room, 6m wide and 3.5m high, light walls are built in so as to shape freely curved spatial boundaries. A translucent velum forms the ceiling. The walls are entirely covered with decorative paintings or plants; a female bust stands on a high pedestal.

Bibl.: Drawing: Estate.

Cat. 492 undated

Sketches of imaginary, strongly modeled buildings

Quick studies of buildings strongly modeled in three dimensions. One is round with an undulating exterior; another is a U-shaped complex with strongly curved center and wings.

Bibl.: Drawings: Estate.

Cat. 493 undated

Small-scale outline drawing of architectural composition with monumental building

A monumental building flanked by two tall flagpoles and a row of buildings with flat and steep roofs, loggias and arcades, form a decorative whole. This could be a design for wallpaper.

Bibl.: Drawing: Estate.

Cat. 494-501

Works from the period of collaboration with Josef Kalbac

Cat. 494

Project for a residence in a housing estate with corner entrance

A one-story house with hipped roof. The ground plan has a circular vestibule at a corner; a part of the vestibule wall, set off from the adjacent wall surface, appears as a convex element at the corner of the facade.

Bibl.: Kalbac Estate.

Cat. 495

Project for an octagonal house in a housing estate

The following rooms are inscribed in the regular octagon of this one-story house: living room with small adjoining kitchen, bedroom with bath, anteroom with cloakroom and toilet.

Bibl.: Kalbac Estate.

Cat. 496

Project for a municipal apartment building in Hainburg, Lower Austria

A two-story, four-bay house with finished hipped roof designed as a semidetached building.

Bibl.: Kalbac Estate.

Cat. 497

Project for a physician's house in Stockerau, Lower Austria(?)

A two-story house with roof terrace. Small obelisks are at the corners as in the project for Dr. Heller (Cat. 252). A caduceus is indicated above the door.

Bibl.: Kalbac, Estate. In an undated letter to J. Kalbac, Hoffmann mentioned among other projects a physician's house for Stockerau.

Cat. 498

Project for Zartmann House

A spacious three-story house with garage on a rather steep street; two solutions were studied for the street facade.

Bibl.: Kalbac Estate.

Cat. 499

Project for a bath and sauna building

Two solutions for a one-story building. One shows masonry construction and hipped roof, the other wood construction(?) and a saddle roof.

Bibl.: Kalbac Estate.

Cat. 500

Project: Park design for Deutsch Wagram, Lower Austria

Two variations for a park design on an irregular trapezoid site; benches are arranged around a small green area.

Bibl.: Kalbac Estate.

Cat. 501 1951

Elementary school for girls, Stockerau, Lower Austria
Building permit: 8 February 1951
Certificate of occupancy: 23 October 1951
In collaboration with Josef Kalbac

Hoffmann designed a two-story schoolhouse with hipped roof and a U-shaped ground plan with short arms. On each side of a central hall with staircase are three classrooms on a wide corridor. The school was built according to Hoffmann's concept but with changes in detail.

Bibl.: Plans: ABBH; Drawings: Kalbac Estate.

Cats. 502ff.

Various projects

After completing the Catalogue I found the following projects mentioned in the annual reports of the School of Arts and Crafts:* 1913/1914, Interior in the Salon Triennal, Brussels; Interior in the Exhibition of the German-Moravian Arts and Crafts Association in Znaim; 1917/1918, Project: Urban residence on the Modena Grounds; 1921/1922, Project: Steel products factory in Budapest (in connection with Cat. 244); Project: House in Teschen; 1928/1929, Exhibition room for Marshall Field & Co. (cf. Cat. 293); Projects for Moulin Rouge, Figaro Music Publishers and Soffer Fur Shop, Vienna; 1929/1930, Interiors for Dr. Goldhammer and Lilly Bernatzik.

In addition, the following came to my attention: about 1913(?), Design of furnishings for apartment of Ing. Norbert (?), Stern, Vienna II, Untere Augartenstraße 22 (anteroom, kitchen, dining room, drawing room, study, bedroom); 1916 or later, furnishings for apartment of Dr. Dietrich Moldauer, Vienna I, Opernring 19; April 1935, Exhibition "Wirtschaft im Aufbau" (building up the economy), Vienna; 1956, Municipal apartment house, Vienna IX, Nußdorferstraße 13, jointly with R. Horner who finished the small building (13 apartments) after Hoffmann's death. Hoffmann is also reputed to have designed workers' housing for the Böhler Works, Kapfenberg.**

* I owe the reference to these reports to the courtesy of Professor Johannes Spalt, Vienna.
** Information courtesy Dr. W. G. Rizzi and Dr. C. Witt-Dörring, Vienna.

Bibl.: School of Arts and Crafts of the Austrian Museum, Annual Reports.

APPENDICES

All texts are translated from the German.

AUSTRITTS-ZEUGNIS.

VON DER KAISERLICH KÖNIGLICHEN

AKADEMIE DER BILDENDEN KÜNSTE

IN WIEN

wird hiemit bestätigt, dass Herr _Josef Hoffmann_

aus _Pirnitz in Mähren_ gebürtig, die vom gefertigten

Professor geleitete **Specialschule für Architektur** dieser k. k. Akademie

während der Schuljahre 18_92/3_ bis 18_94/95_, u. zw. vom _October_ 18_92_

bis _Juli_ 18_95_, also _sechs_ (_6_) Semester hindurch besucht hat.

_Derselbe hat zwei Jahre bei meinem Vorgänger
Carl Freiherrn von Hasenauer und ein Jahr unter meiner
Leitung die Architektur-Schule besucht. Es gereicht
mir zur besonderen Befriedigung zu constatiren,
dass bei ausgezeichnetem Talente und Fleisse dieser
Schüler bei der Concurrenz um das Reisestipendium
ein Project lieferte, welches als Meisterwerk zu be-
zeichnen ist._

Sein Betragen war den akademischen Gesetzen _vollkommen_ entsprechend.

WIEN, _23. Juli_ 189_5_.

Steinwald

d. z. Rector.

Otto Wagner

k. k. Professor.

1. Graduation certificate from the Academy of Fine Arts, 1895

1.
GRADUATION CERTIFICATE
(TRANSLATION)

By the Imperial Royal Academy of Fine Arts in Vienna it is certified herewith that Mr. Josef Hoffmann, born in Pirnitz in Moravia, has attended the Special School for Architecture of this k.k. Academy under the directorship of the undersigned professor during the academic years 1892/93 through 1894/95, i.e. from October 1892 until July 1895, for six (6) semesters. The student has attended the school of architecture for two years under my predecessor Carl Baron von Hasenauer and for one year under my direction. It gives me special satisfaction to state that in the competition for the traveling scholarship this pupil with excellent talent and diligence prepared a project that must be termed a masterwork.

His behavior was completely in accord with the academic laws.

Vienna, 23 July 1895
Otto Wagner, k.k. Professor
Trenkwald, at present Rector

2.
"ARCHITECTURAL MATTERS FROM THE ISLAND OF CAPRI"
Der Architekt III, 1897

A Contribution for Picturesque Architectural Sentiments
By Architect Josef Hoffmann

The Isle of Capri has become dear to the heart of all travelers in Italy. Its splendid location, caressed by the sea, opposite the Gulf of Naples, its complete natural beauty in mountains and grottos, the remarkable friendliness and contented serenity of its inhabitants and, what particularly charmed me, the still almost entirely pure, vernacular manner of building, render it dear and unforgettable to everyone.

There the picturesquely changeful and lively concept of building with its simplicity, free from artificial overloading with bad decoration, still fits refreshingly into the glowing landscape and speaks a language open and understandable to everyone.

The brilliantly white walls, with their windows small and deep because of the excessive light, enclose the room (almost always only one). It is covered by a flat masonry dome or barrel vault.

A spacious flight of steps with a landing and a pergola of vines lead to it through the courtyard, and all around are larger and smaller outbuildings providing much shadow in picturesque groupings and always forming a complete, unified picture; its light color and simple silhouette stand out clearly from the blue sky or dark mountain background.

Thank God, building speculation has not yet penetrated here, and the villas of newer origin, as for example that of the painter Allers, retain these excellent characteristics and fit gratifyingly into the charming whole.

The example of folk art, as it actually exists here in these simple country houses, exerts a great effect on every unprejudiced mind and lets us feel more and more how much we miss this at home.

In my opinion, despite the excessive number of newer villa developments, we certainly have not yet succeeded in creating even a single really suitable type of modern country house for our conditions, our climate, our environment. The example of Capri and of some other places I may describe later, however, should not lead to the imitation of this way of building, but should only serve to awaken in us a homely concept of housing, which consists not in decorating over the bad skeleton of a building with ridiculous ornaments of cast cement produced in the factory, nor in forced-on architecture of the Swiss or gable house type, but in a simple grouping, suited to the individual, full of understanding and sentiment, of uniform natural color and, where wealth permits it, with some sculpture—preferably less, but from the hand of a real artist.

Nature, especially ours, is in any case rich in articulation—variety in tree species, in color and forms—so that the simple, straight, or reticently curved lines of our buildings will make a felicitous contrast. Never, however, can we call those multispired, multigabled architectural fakes fitting in our landscape.

One should rather seek the silhouette in the right use of terrain and site and in tasteful surroundings of the gardens and streets of villas. Where the landscape appears colorless and bare, painting may play an important part; otherwise it should be limited preferably to interior spaces where enough unsolved tasks are waiting for it.

It is to be hoped that with us, too, sometime the hour will strike when the wallpaper, the ceiling painting, as well as furniture and utensils will be ordered not from the dealer but from the artist.

England in this is far ahead of us, but its taste, mostly indebted to medieval forms, ought not to be equally guiding for us; rather we ought to recognize England's interest in arts and crafts, and thus in the arts in general, and try to awaken it in our own context, but [we ought] to attempt time and again to search in our own being for our art forms and finally to cast away forcefully the obstructive barriers of outdated style-mongering.

3.
BRIEF AUTOBIOGRAPHY
(TRANSLATION)

The respectfully undersigned was born on 15 December 1870 in Pirnitz near Iglau in Moravia, the son of the local mayor and estate owner. There he attended the German elementary school, then the high school [*gymnasium*] in Iglau but only to the fourth [eighth, in United States system] grade, passing the latter only with difficulty.

A long-existing predilection finally brought him to the right career, first at the State Technical High School in Brünn where he attended the Building Department with success and passed the final examination. Then the undersigned desired to practice what he had learned and went to Germany for one year. In Würzburg, employed on Bavarian military buildings, he found enough time to take delight in the splendid buildings all around and to prepare himself for the planned academic studies.

Then followed three years at the Academy, first under Hasenauer, then under *Oberbaurat* [Senior Architectural Councillor] Wagner. Of the then announced prizes, all were won. In the second year even three at once.

The Gundel Prize, the golden Fügel [*sic*, for Füger] Medal, the Rosenbaum Prize, the Special School Prize, and finally the Rome Traveling Scholarship. In possession of the latter the undersigned traveled all through Italy and Sicily and carried on his studies diligently in all places. He was particularly

Kurze Lebensbeschreibung.

Der unterzeichnete Gefertigte wurde am 15.
Dezember 1870 in Chemnitz bei
Teplitz in Böhmen als Sohn des
dortigen Bürgermeisters und
Ökonomiebesitzers geboren. —
Er besuchte dort die deutsche Volks-
schule, dann das Gymnasium
in Teplitz, das er aber nur bis
zur vierten Classe, letztere nur
mit Mühe absolvierte.
Eine schon längst bestehende
Vorliebe brachte ihn endlich in
die richtige Laufbahn ein, indem
er nunmehr auf die höhere Markt-
gärtnerschule in Leimen, in
welcher er die Lehrabtheilung
mit gutem Erfolg absolvierte
u. die Reifeprüfung ablegte.
Hierauf wollte der Gefertigte
das Erlernte in der Praxis ver-
werten und ging noch ein
Jahr nach Deutschland.
Da nun inzwischen bei böhmischen
Militärbehörden beschäftigt, fand
er noch genug Zeit, sich in
den heimischen Landwerten wieder
um zu bereichern und sich

für die geplanten astronomischen Studien vorzubereiten.

Hierauf kamen die drei Jahre Akademie, zuerst unter Professor Huber, dann unter Oberbaurath Wagner.

Um das damals viel geschriebene Thema wurden viele gewonnen. Im zweiten Jahrgang sogar drei auf einmal.

Den Händelpreis, die goldene Flügelmedaille, der Rosenbaum Preis, der Schweisselschul Preis und endlich das Romreisestipendium.

Im Besitze des letzteren bereiste der Unterzeichnete ganz Italien und Sicilien und betrieb vollen, als eifriger Studien. Es interessirten ihn ganz besonders die Bücher der Hersfeld, Neapel, Palermo u. Venedig, in denen die Kleinere Gebäude gegenständ der Alten so zahlreich zu finden sind.

Nach Wien zurückgekehrt wurde er in das Atelier der Herrn Ober, baurath Wagner aufgenommen u. hatte in demselben Herbst. Hauptsächlich die großen Themen u. Architektur verlangen, mit den Themas ebenlichen die Station

Wien, den 21. März 1899

Josef Hoffmann
Architekt.

3. Handwritten "Brief Autobiography" on the occasion
 of Hoffmann's appointment as Professor, 1899

interested in the museums of Naples, Pompeii, Palermo, and Syracuse where small utensils of the Ancients are found in great numbers. Returned to Vienna, he was accepted into the studio of *Oberbaurat* Wagner and worked there principally on the great Gumpendorfer Bridge complex with the granite obelisks, the Lobkowitz Bridge Station, and various other stations.

In a competition for the City Theater in Pilsen, he meanwhile received a first prize and since began to practice his profession independently. Various furnishings, furniture, arts and crafts objects, also illustrative works (Herzig's "Viribus Unitis," the Book of the Emperor) belong to that time. Then followed smaller study trips, competitions, and finally the co-founding of the Vereinigung bildender Künstler Österreichs, which made it possible for him to solve larger decorative tasks, to furnish modern rooms, and to occupy himself with the application of ornament everywhere.

Vienna, 21 March 1899
Josef Hoffmann
Architect.

4.
"SIMPLE FURNITURE"

Das Interieur II, 1901

The present sketches, done about a year ago, are studies on the notorious slogan "Simple Furniture."
It is perhaps superfluous to publish them. They show nothing new. However, what doesn't get printed in these difficult times, and what doesn't one have to tolerate!

I shall therefore not apologize but speak about certain subjects that, although discussed often enough before, should be recalled to memory time and again.

It seems curious to all of us that those who do not themselves create, but wish only to exert their influence, now raise the battle cry "Old Art" again. Even if we need not take them seriously, we nevertheless want to pursue their ideas, to recognize whether they are directed only by idle caprice, by bottomless egotistical conceit, or by weighty reason.

Is our art not true? Is there more of the bad than of the good?

Have we not kept our word, when we promised, to give a fitting shape to our modern feeling and thinking?

How does it happen that people who make an effort to be dressed according to the latest pattern, act at home as if they were living in the 15th or 16th century?

Is that again the disgusting mania of the *parvenu* to seem more than he is, or is it a resigned retreat after deep disappointment?

I am afraid that the core of the whole counter-movement is to be found in the fact that for once the artists tried to speak up themselves and to deliberately oppose bossism and the desire to play a role with the achievements of others.

Let us see what the praised style-mongering has already brought us.

Did they perhaps want the good old handicraft tradition? God forbid! The old styles were conjured up again.

Not perhaps one. All, all! And we were again to be seized by the giddiness of the masquerade with its spurious, false knickknacks, with its lack of style despite all the styles of all times and countries.

We had already come to the point that we had to hurry through our streets blind with open eyes, or we would die for pain and shame over the insensitivity and barbarism of our buildings and monuments. What has been done to us in this respect will vastly amaze later times; someday when our soul awakens we will avoid our cities with disgust and have to erect new ones in untouched regions.

We do in fact long for that already, and it will be realized in the not too distant future. As if it were not enough that badly understood aping torments us, our old architectural monuments that we beheld with pleasure and that still here and there gave us infinite enjoyment, vanished in this time under the hand of the merciless restorers.

How could it be believed that a stone carved by an artist could be replaced by some new one?

As if the time were the same! They dared with infamous hands to replace piece by piece without realizing that the choice of stone, its structure, and its working are also significant. They forget that even the best copy will only be just a copy, and that nothing can bring back the old value. Who would dare to lift off Raphael's Madonna part by part, and to paint it anew, or who would be so crude and stupid as to complete a picture begun by Michelangelo? In architecture, this has all been accomplished by the praised period of stylistic imitations, and it thus proved most strikingly how badly it understood everything and how dangerous it was.

It is obviously clear that only the damages should be repaired, if only with bricks, that we should only support and tie together, but that we must never replace.

Someday a better time will also deplore and condemn this mischief.

In these poorest of all times, where then shall we—if [we do] not [want] imitation—at least find tradition?

The linking up would only be possible there where with us autonomous creativity has ceased. Should we have missed this moment? Have there been no forerunners here just as in England?

Thank the museums that they show you everything but this. And how much they have not shown us at all! With the exception of the ethnographic departments that have oddly been put into natural history collections despite their highly artistic content, museums seem to completely forget their duties today. Or have you ever seen a beautiful machine in a museum of arts and crafts? Has any such [museum] ever tried to search out the traces of the "Moderne" in this and other infallible things and to support you honestly in this way? Or have you not found that they wanted to train you as apes, imitators, let us say it openly, as fakers, that they showed you not the essence of things, but only the manner of some independent [individual].

Today how many want to influence and hinder without right and conscience, and how many want to be artists and misuse the name!

One sees that it would be our first duty to fight with iron tongues against all half-truths and lies, to rage against the brood of apes, and to light a holy cleansing fire, brightly flaming to the sky. We will someday be reproached that we watched when the sacred grove was desecrated and vast misery was spread because everything was allowed to grow but the creative. We shall have lost, perhaps forever, the enjoyment of art once, God forbid, they would have

succeeded in breaking the chain that linked us with those last good times.

Where shall we begin in order to help? In the school? In whose hands has it fallen? Nothing but regulations and fixed marching routes. They have stifled every individual pedagogical talent and known how to strangle everything in stereotypes. As in all subjects, few instructors in drawing think of awakening mental, creative talent, but they start right away with copying ridiculously bad models. Yet, it is man's greatest gift to will something himself and to create something new and personal.

It has been rightly claimed that art should be the expression of highest culture. But where is our culture? Look at your miserable schoolrooms, your school benches, and everything around you prescribed by regulation. Talk with your parents who have grown up in the false tradition, and listen to their views. One must be amazed by their loveless thinking, and how they try to stifle everything that could make you a better human being. Where is the splendid garden where our feelings like flowers blossomed and where the most beautiful things grew by themselves.

And yet, when it dawns within us, not here and there, but far and wide, as far as our eye can see, when we begin again to surround ourselves everywhere with beauty—with self-confident beauty, not with a borrowed lying mask—must we not be inspired by hope again? Though I fear that the fight will be unequal, that it will no longer be possible at all to convert the masses. But, then it is all the more our duty to bring happiness to the few who turn to us. They must not be betrayed at any price. They must feel that we have devoted our lives to pleasing them; they must sense our priesthood and believe in our sincere enthusiasm. Unfortunately, their still untrained eyes will again and again be fooled by the hypocrites and jugglers among us. It drives us to despair. Someday perhaps they will say about our time that its greatest skill was to put the wrong man in the wrong place; therefore we have to defend ourselves and battle ceaselessly for the good cause of today's art. We must get to the point of settling the matters of our profession ourselves, and to protect ourselves. No party shall divide us, and in all camps where they create honestly we want to be brothers!

Now, a few words about the sketches printed here. The art of interior design is not doing better than the other arts. The "Moderne" also suffers from intolerable faults; we must strive with all our might to get rid of them. On the one hand, the individual artists (without [my] wanting to criticize their true talent) often believe they have to establish a precedent, i.e., insofar as they consider worthy of imitation their personal manner of expression, and not the eternal laws of beauty inherent in every work of art. On the other hand, most of them are intent on squeezing themselves into some trend. I think we must above all consider the respective function and the material. The sense for good relationships and the inborn tact in choosing the means will by themselves create value. Faults are unavoidable, and we shall already be pleased if we have become accustomed to thinking absolutely honestly. We also want to avoid the many technical faults. One does not respect the straight fibers of the wood and makes curves on top of curves, which rarely can be joined to the necessary straight surfaces of furniture; we forget that for every curved constructive part we would have to go into the forest to look for the correctly curved branch, like the peasant who builds his plow or sled. It is, of course, something else with the so-called bentwood where the fiber is artificially bent, and the curve is therefore justified.

A great disadvantage is the undemanding public, who often bear the guilt when nothing good is created. [The public] is too inert to search out the right way and the right artist, and unaware that it should specify exactly its precise wishes. If we had a well-schooled public whose eyes could distinguish clearly between good and bad, a public not relying on articles and hearsay when ordering, consciously demanding comfort and rejecting all useless junk, then we would soon see nothing bad; for most designing artists do not lack talent so much as character and the necessary firmness. By this I mean indulgence toward the whims and false sentiments of himself and of his client, the creation of mood in rooms for daily life, and false pathos in places where we should long for naturalness. The perpetual exhibition business also has spoiled much because we have begun to take things into our houses that were intended for a thousand eyes. Therefore the insufferable changes in style and color. I believe a house should stand as a perfect whole and that the exterior should reveal the interior. While I concede a heightening of means, I plead for unity among the rooms. Equally essential is style in every piece of furniture. I mean that it must make a principle apparent, so that we can distinguish clearly between a board, a pillar, and a case piece. Such perceptions alone and many others are valid, such as painting and staining; the latter only in tones that imitate no other wood, the former where another color is out of the question, for example, pure white. Probably consideration should also be given to the fact that, as often happened, furniture in contact with the wall should be colored differently from free-standing pieces. In inlaid furniture it is probably not correct to have the inlays only on panels; I think in this case the constructional parts in particular should receive appropriate ornament. The designing of things whose only value lies in artistic handicraft should be absolutely avoided. How could we have been so deluded to overlook that simplest of all truths! I mean that one should be especially careful to request only mechanical work such as sawing, planing, polishing: perhaps inlays and stenciling can still be justified because drawings for them can be provided as precise means [of indication]; that, with the necessary experience, one may equally succeed in carrying out a glass window or a very flat carving which is precisely defined by borders and cuts, such as a kind of chip carving. It is however quite impossible and improper to have workmen freely execute embossing or carving or painting. Here we should either do without, take a hand ourselves, or entrust both design and execution to one artist. At this point it should also be said that we, too, should finally consider ensuring the workman's share in profit and name credit. The absolutely essential signing has already been discussed here.

The sketches printed here shall not, God forbid, serve as models but, since they exist,

they shall illustrate these words and eventually show how I try to search out various needs and to design accordingly. They shall perhaps also prove that we ourselves can solve all problems when we have the honesty to proffer only what we can master. Without trying to anticipate the great genius who will someday again overturn all our experience, we should avoid pomp in everything and ever strive for better material and more perfect execution since, our life also, if it is to be taken seriously, receives its dignity through simplicity, honesty, and integrity.

We will, however, always be thankful to all those who by word and deed have helped us for decades to reach this insight.

5.

SPEECH ABOUT OTTO WAGNER

(1909)

Gentlemen:

The first action of the newly founded parliament in 1848 was the dissolution of the famous imperial porcelain manufactory in Vienna. They had no sense and no time for the arts. Architecture had sunk to the absolute minimum, the other arts almost disappeared, no one cared about Waldmüller, Pettenkofen, Alt, and the few others who nevertheless could not cease to create. Politics dominated public life, the theater perhaps also, for the sake of amusement. Slowly, prosperity grows, and after the fall of the narrow borders comes a great impetus for the city of Vienna. It is remarkable that even two artists of building arise, Van der Nüll and Siccardsburg. They build the Opera, still the most beautiful theater building in the world, and yet they are persecuted, tormented, and hounded to death.

Foreigners, Hansen and Schmidt, have to be called in to determine the architectural image of Vienna.

The period has become romantic. The study of various styles, the nostalgia for the greatness of past art periods, and the momentary great demand force the artists to copy old buildings in the deceptive hope of conjuring up in this manner vanished ages. The parliament building, the city hall, are created. Here the temples of Greece with the eternally shining sun, two steps away

the likeness of the somber, dignified town halls of Flanders. . . . One searches in vain for a link to the old Viennese tradition. The science of art rises powerfully and unrolls the styles of all periods on our facades. Not one seems to be missing, otherwise it would have to be added for the sake of [good] order. America develops freely; there, building regulations do not exist. An imposing architecture is being born. Colossal tower buildings are erected that contain a number of extremely usable rooms that could replace a series of office buildings, while our city hall tower only serves the purpose of supporting the iron man. It is a period of unclear striving and struggling in which an indifferent public stands aloof. The main point is to utilize other economical achievements. The steam engine, electricity, and a thousand other inventions agitate all minds; the most incredible mental and technical revolutions occur and mankind has no time to heed art. Dreamers, collectors, cranks, appropriate it.

The science of art begins to come into being and quickly has cast its spell over the naïve era. It errs, for though it rightly draws attention to the beauty of past art periods, uncovers their sources, and expresses sincere admiration for them, it suddenly attempts to influence living art, to make rules for it, to give recipes, and to preach stylistic purity for the works. The consequences are devastating. Those who know it better defeat those who can do it better, i.e., the science of past art periods wins over the naïve, emotional manner of expression of the real artist.

The world is repaired and patched. The most worthy buildings are destroyed in order to redo them in stylistic purity. The copy is accepted for the genuine. For the splendid stove of the sacristy at St. Stefan, e.g., a fortune was paid at an auction recently, while then it had been thrown into the yard. And that period boasted of its colossal artistic connoisseurship.

Thus the city comes into being, and today everyone is amazed that it does not offer a unified, harmonious image.

It is clear that a time that has lost itself, that does not believe in itself, that delights in utopias and forgeries, that today imagines itself to feel Greek, tomorrow Gothic, the day after tomorrow Romanesque, per-

haps everything at once, such a time cannot achieve anything harmonious, anything genuine. It must be said that this whole time, despite colossal studies never before equaled, achieved nothing that could display the captivating charm of past eras. A picture, a piece of furniture, can be copied if need be. But a building serves a definite function. The smallest alteration may require the copying of different parts and may make the whole ridiculous.

Yet, the time forbids individual invention, even denies this possibility. Imagine that science and technology were forbidden to invent, to discover, and to work creatively—that actually happened centuries ago. That would be terrible, the stakes would never stop burning. But to general acclaim they dared to set limits for art.

Among us Wagner is one of the few and the first who began to break the barriers and believe in himself. This is his great merit, his first deed.

At first everything went quite well because the exterior decor of his buildings corresponded, though not blindly, with the taste of past eras. He could even dream of success. The old Association of Artists counted him among its best men.

He created the architectural setting of the Makart pageant. Today as we survey that period impartially, we must say that this work and the city decorations, also created by him, for the entry of the Crown Princess Stefanie, have far surpassed all later festive decorations. In its initiative at least, it was the only artistic [decoration] Vienna has seen since then. You see, gentlemen, that the Court then already approved of Wagner's works, and the gracious reception of Wagner after his appointment as Professor at the Academy by His Majesty, testifies to the good taste and noble intentions of the Crown.

Of course, these successes as well as the general esteem and attention Wagner enjoyed at that time—one should remember, it was the Association of Artists that soon afterward delegated Wagner to the planning of the city and the construction of the metropolitan Railroad—did not let his enemies rest. In the nineties begins an actual campaign against Wagner. All his artistic enterprises are countered, and his influence is everywhere undermined. His joining the

Secession, then newly founded and still strongly opposed, appears as the outward cause.

His best friends change into his bitterest enemies, and those who recently praised him as outstanding now do not hesitate to drag his work through the mud.—He is regularly boycotted and isolated from all important authorities.

Michelangelo says in one of his most beautiful sonnets: "I walk lonely on untrodden paths." This is evidently the lot of all innovators and pathfinders.

But it is Wagner's way to take up the fight cheerfully and gladly. A delightful optimism, his genuinely Viennese, cheerful disposition and his independent position strengthen his back.

Wagner abandons pure formalism, i.e., he does not think of his buildings as a combination of traditional forms but tries first to explain, i.e., to crystallize the construction and the purpose of the building by the usual means of expression. Up to that time, window openings were almost always framed, provided with architectural features. With him the pier between the windows as the true bearing member, as well as the wall surfaces, are important and carry emphasis. The buildings from these years will clearly prove his intentions to you.

You will also note that at first Wagner [is] one of the best connoisseurs of old styles, and that he consciously recognized the essential charm of their ratios and formal language.

Yet his development is not abrupt but consistent. His interest in the buildings of the Italian High Renaissance and its after-effects has endured until today; no escapades into alien periods of style are to be found. Yet he feels instinctively that the value of a building is not determined by the use of the old traditional formal language but only by the distinctive and original inherent character. Character takes the place of style that cannot alone distinguish the building. Indeed, Wagner's buildings always bear a distinctive stamp; they definitely remain in our memory.

Soon the old forms no longer suffice for Wagner to express his architectural ideas.

Modern building with concrete, iron construction, the countless modern technolo-gies, imperiously demand new means of expression. Now begins the phase of the great struggle with the new way, of achieving new tasks such as the iron bridge buildings, the Nussdorf watergate, etc., etc.

Wagner is above all an organizational talent who aims for the great. With a sure eye and rare acuteness, he perceives his task, and he fully commits himself with complete seriousness. He has an unusually strong gift for searching out needs, for recognizing the requirements, for sacrificing nothing to form, a gift for ordering while never disregarding the architectural image. In this respect he is certainly numbered among the foremost architects of the world. . . . His countless unfortunately unexecuted projects will someday tell us the painful story of how much we have lost through the malice of his enemies. What have we, for example, lost because the white city on the Steinhof was not built entirely according to his plans! What good is it to us that one imitates his way of building and does not let him execute the whole.

He was able to really complete only a few buildings after troublesome, disgusting struggles. Here belong the buildings for the Metropolitan Railroad, the only one of its kind that has not disfigured a city but has created a series of charming urban vistas, the buildings for the regulation of the Danube, the Nussdorf watergate with the office buildings, the church on the Steinhof, and the Postal Savings Bank, the first real office building. You see, gentlemen, that we cannot reproach Wagner for anything. He has spoiled nothing for us in Vienna.

While old Vienna, on whose dear image we gaze with the greatest respect because it houses something genuine for us, was spoiled and demolished by the style imitators and pseudo art experts, while countless millions were spent to flatten and obscure our natural setting and beauty, Wagner has increased our artistic prosperity by creating distinctive and genuine works.

In conclusion, I therefore ask you, what do we still have to hope for from a city we have loved above everything; if it should be possible that an artist, aged almost seventy, might not succeed despite the achievement of all outward distinctions that could not be denied to him, honored and recog-nized by honorary memberships in the foremost architectural associations of the whole world, after all the living proofs of his genius and the uncompromising integrity of his artistic intentions, after the confidence offered by that truly severe judge, the entire younger generation of artists?

It cannot and must not happen, at least not without the utmost resistance by all of us.

Wagner must build the museum on the Karlsplatz, it is a debt of honor for Vienna to fulfill this dearest wish of the aged artist, all the more as it means the last chance to rescue this otherwise miscarried city square.

If we are defeated, we are defeated by the intrigues of influential persons who today play the protectors of old art although their attitude toward living art proves their total and desolate incompetence. True patrons further living art; that is how the old art was created, too, and, thank God, it cannot be killed anymore.

6.
HANDWRITTEN DEDICATION IN THE BOOK BY PETER ALTENBERG, *BILDERBÖGEN DES KLEINEN LEBENS,* 1909
(TRANSLATION)

Dearest Josef Hoffmann,
I place trustingly my new book in your hands [as those] of a friend.
Your Peter Altenberg
November 1909
"*Accounting*
————and then I remember those who were mild to me, because *for some light* they forgave me my *darknesses*—." PA

7.
"MY WORK"

Lecture, given on 22 February 1911; excerpts transcribed from the lecture manuscript

Ladies and gentlemen, when I permit myself to ask you to concern yourselves with me, I do it because I am convinced that we must deal only with the subject matter and not with my person. I am certain that the things we try to design today had to be done, and I ask you to ascribe all our deeds

and mistakes to the strange development through which we were forced to go. Above all, do not believe that one can do anything on purpose. It is impossible.

In our field there are certainly two kinds of people. The one kind is happy because they can please the world by making what the public secretly seems to desire.

It does not bother them to design in the 20th century a house, an apartment, in the style of a past era. They are always ready, all styles are at their disposal. They can smilingly accept praise for past deeds and are not only popular but respected and everywhere valued. How many brains are at their disposal, and how easily they can make their choice unless they are quite Godforsaken in their lack of taste.

The others follow a dark urge not to do all that. It is their fate to believe that they must give something of their own. They force themselves relentlessly, without pleasing anybody and without thanks. They are uncomfortable and mostly awkward.

They shake everything up and are restless and dangerous. While they are unconscious tools of future developments, they believe they are giving something of their own, and yet they can only perform their small contribution of work for the future.

They are forced to walk unconsciously on their way; it would be foolish to persecute them for it and to prevent them from following their inspiration. Today or tomorrow the goal must be reached one way or another.

Their work should not annoy us but instead interest us. It is a cultural issue not to rage at the new but to make the effort to bring it to development and to understand it. There is no doubt that the incomplete, immature, undeveloped, affects us in an unpleasant manner but there is no other way.

We live in a time that tries to connect with a broken [continuity of] culture, that therefore begins its work without experience and without years of tradition.

It is unclear but determined in its intention to create a modern setting for our modern life.

This appears to us as important and as difficult as the solution of the social questions. I speak of these things to characterize the period of our development.

6. Handwritten dedication in the book by Peter Altenberg, *Bilderbögen des kleinen Lebens*, Berlin-Westend (Erich Reiss Verlag), 1909

We studied at the Academy around 1890, and you may be interested how this was done.

In the first year we designed a villa and then a princely castle.

In the second year an apartment house, then some larger project like a school or a savings bank. In the third year a government building or a theater.

One had the project and was permitted to work. There was no question of guidance or an instruction in any relevant manner. One studied the projects of one's predecessors and made something similar.

The atmosphere was entirely uninteresting and inartistic. All we had [to go on] was the study in the library which we did on our own initiative. Consider, at that time we did not learn anything about Ruskin and Moris [sic], nothing of all that which across

the Channel guided the direction [of developments] with enormous impetus. We knew nothing of Beardslei [*sic*], nothing of Oscar Wilde.

We had seen no *Studio* and had not heard anything about modern French painting, nor about the efforts of the modern Belgians. We lived on, uninformed and untutored. And yet that period also had something curious. We were seized with an endless longing to want and to attempt something other than what we saw every day.

I had just met Olbrich and Moser. Olbrich, a man full of sparkling ideas and perhaps a romanticism that was too great, was a colossal worker and indefatigable doer.

He was obsessed by Wagner's music and would have loved to build Walhalla. Fantasizing with him was too beautiful. No task was too great for him, and [there was] nothing he did not at least try to draw.

We loved his eminent capability and enjoyed his company as the first fully and totally artistic presence.

His merry laughter at all philistinism and his powerful conviction, combined with a truly charming personality, refreshed us and spurred us on to advance. His influence was absolute, although each of us at that time already was striving for something else.

Beside him appeared the painter Moser, who, thanks to his activity as an illustrator, already knew more of the outside [art world] and henceforth gained the greatest influence over us. His talent for two-dimensional artistic design and for every kind of arts and crafts invention appeared fabulous to us. He knew how to promote and stimulate everywhere. He excelled not only by his great imagination but equally by his practical and organizational abilities.

On a journey with him through Germany I first encountered the writings of Lichtwark and experienced them like a divine revelation. I believe what we read was Flowers and Wild Flowers [*sic*]. They contained viewpoints so new and surprising for us that we felt enormously stimulated.

Now there was no more halting. Meanwhile Otto Wagner had been appointed at the Academy, and with him a new life entered. He understood how to strengthen us in our intentions and ideas, and to stimulate us with sparkling spirit to all sorts of things.

His ideas stressing purpose and material

had meanwhile become known to us; and while we had to recognize them as something absolutely right, they could not eradicate a certain romanticism [that] unfortunately at that time was within us. Unfortunately, I was only briefly under his influence, then went to Italy, beginning my official Roman journey.

At first I was desperate. All official, art-scholarly architecture failed to interest me. I was looking for new impulses at any price. Library studies and the perpetual learning of certain styles and architectural forms had spoiled me, had robbed me of the entire delight of seeing for the first time, and had dulled me to the true beauties of this divine land.

Finally I fled into the Campagn [*sic*] and refreshed myself at the simple peasant buildings, that without pomp and without stylistic architecture nevertheless give the land its special character. There, for the first time, it became clear to me what matters in architecture; henceforth I studied all the little places on my way with fiery zeal. At last I came also to Pompeii and Paestum. I saw the Doric temple, and suddenly it fell from my eyes like scales why I did not like the stuff learned at school. There we learned only the proportions of the average of fifty temples and their columns and their entablatures. Here I saw columns with capitals almost as wide as the height of the column, and I was simply transfixed with admiration. Now I knew that what mattered above all was the proportion [?] and that even the most accurate application of the individual forms of architecture meant nothing at all. In Vienna, where I returned, much had changed greatly in the meantime. The Secession was founded, the whole modern progress suddenly became known to us, and we stood on the threshold of those events that gave Vienna for a time the character of a true city of art. We worked with great enthusiasm.

First [we were] confused by the pressure of so many new ideas, groping here and there, trying everything, throwing most of it away again. It is characteristic of this era that almost all artists from Wagner to Van de Velde saw the exact fulfillment of construction as the only right thing but that the expression, i.e., the formal fulfillment of this idea, was tried in incredibly varied

ways. One would hardly believe that one is facing works of one and the same time.

From this can be seen how much this time strove for new forms.

Yet, certain things nevertheless became slowly clear, and were recognized, and determined as unshakable truths.

On the one hand, a strong opposition demanded blind imitation of old styles, those in the English taste at least, and found its home at the Austrian Museum under Skala; on the other hand it saw salvation in fighting every individual touch and even in the denial of all artistic intentions. This educated us in strict self-criticism and only after long inner struggles led again to a free and fearless unfolding of our efforts.

I would like to ask you to let me read to you some occasional notes from that restless time to illustrate what our thoughts and struggles were then. It is certainly not superfluous to explain now and then the progress of our modern efforts. Many events in the field of applied art give us the opportunity to take a stand and to determine that our movement is developing steadily, despite appearances to the contrary! The exhibition at the Austrian Museum (around 1905) seemed to prove the contrary.

This is an error; just this exhibition was perhaps necessary to instruct and reassure all discerning people.

What did they want to show at the Museum? They prove that Viennese firms are more and more able to copy old styles in their way, and that they more and more give up being modern. We are extremely grateful to them for that, because nothing has been more damaging for the modern movement than the opinion of industry that it can also promptly imitate modern interiors.

It is quite a different matter to imitate a dead style, whose forms have been scientifically investigated and therefore can be easily reconstructed and used as a source, and to attempt something that is just developing.

The final version is naturally lacking, and no man knows where the designing will lead.

Industry had to realize that it had to let the apples ripen first.

It is therefore fortunate that the two still modern rooms in the exhibition were not

by an experienced firm but by a designing artist and by a cabinetmaker working with him; this is the core of the matter. We do not care for a firm that—as [has happened] in recent years—exhibits Modern and simultaneously thinks and works in a reactionary manner at home, that praises or blames entirely according to the customer's demands, but we want to be sure that specific people positively will deliver only modern work. Fortunately, we now have in Vienna four or five such enterprises, and we can therefore claim that our efforts seem to advance and develop.

Major industry in our field also above all has to produce a good return on capital; it works mostly for the pocketbook of other people than the intellectual or manual workers. It therefore does not have the right to experiment. Because it has great resources at its disposal, it can, for its own ends, unnoticeably guide and utilize the taste of the public.

The ways and means are only too well known to the initiated; it is useless to complain about that because, as we know, there is only one measure against capital—to mobilize a still greater capital.

But this [capital] will be available for our ideas only when we have become a safe and ample source of income.

Back, however, to the old styles. It might seem that initially we have conceded the justification of using them again. But this is not the case.

When we meet the real connoisseurs of objects in old styles and look around in their homes, we certainly do not find them as patrons of those firms, but we admire them as collectors and owners of genuine, wonderful works.

Their suppliers therefore are not manufacturers but antique dealers and their agents. A connoisseur will reject with indignation any copy, his esthetic sense will guard him from the tastelessness of showing himself in the period room of some firm. Isn't it ridiculous in Vienna to own a room costumed as a Tryolean peasant's chamber when its painted furniture betrays at first glance the citified master painter. It would really be interesting to see the behavior of the famous studios if they were asked for the style of Queen Semiramis, the Normans, or the Fiji Islanders. We are almost certain

that they would be able to deliver even such things promptly due to their colossal knowledge and first-class employees; we know after all of the priceless case of a recently ordered and delivered Moorish billiard table. We hear from the antique dealers that they are always doing more business. This is a gain for our efforts; for, once the public has acquired a taste for only genuine things, they will logically also have to encounter us along the way.

The public should, however, be careful even so; for as soon as the demand for genuine things becomes great, industries capable of doing anything will begin to serve in this respect too. . . .

After all we have said, the industrialist will rightly look at us with reproach and ask us what he should do to avoid falling between two stools.

It is our duty not to withhold our ideas from him and to attempt to give him the assurance and moral support he, as a businessman, absolutely needs to have our complete respect and admiration.

It is the realm of technology that indicates the sure path industry would have to follow—we cite again the fabrication of luggage articles and linen goods, carriage building, our cannons and sport articles, locomotives and machines.

It is, for example, absolutely necessary that our carpet manufacturers should create patterns similar to those of necktie fabrics; they should seek value in distinctive weave, originality of color, quality of material and its use, instead of weaving only bad patterns whose use becomes a torment for all and leads to complete dullness.

The modern possibilities are very great and known only to the technician. Industry could suddenly face fruitful and indisputable, therefore economically enormously important, tasks. Just as it does not occur to anyone to have Renaissance ornaments applied to his automobile, so it would not occur to anyone to use such designs in his home, provided the elevated and conscious interest of the manufacturer. What, however, is then the state of the modern designs?

Naturally they would only be demanded rarely by quite specific people; they would then be ordered from an artist who in his very own field of handicraft would be in a

position to meet this rare demand of a perhaps vanishing artistic sensibility. The false struggle between handicraft and industry would then have ended, and the limits of each would be determined and naturally protected. For this, however, we need a work of modern education on a large scale.

This will have to consist above all in recognizing the value of technology and creative work. It will have to emphasize the absolute fulfillment of the demand for genuine material and the limitation of the available means. There is still a long way to go.

In a textbook of vocational education I recently read the following: Staining woods serves to give inferior kinds of wood the appearance of costlier and better woods! Instead it should say that staining serves to achieve colors that do not occur in natural wood, and therefore do not copy any [natural wood]. Thus gray, blue, and green above all are proper. Of course, one can also use other tones, but one should try to show the material itself, perhaps through an emphasis on the veining, by rubbing a lighter color into the graining.

We have to present everything the way it really is.

Therefore we shall, for example, use opaque glass only when it is not commercially marbled; we shall use only tiles, not sheet metal formed and enameled like tiles.

In our architectural plasterwork we will not use wire netting for corbels and vaulting but will display the surface plane; if need be, we shall ornament it with free decoration but not stick on pressed plaster.

In our gas heaters we will not put seemingly glowing wooden logs of asbestos but we will show the flame and the reflector; we will design our electric lighting not as candle but as hanging lightbulb. Then only shall we recognize again the charm of candlelight and use it on festive occasions instead of spoiling our old chandeliers forever by ridiculous adaptation.

Our doors shall no longer have to be so high because it does not happen that guards carrying halberds march through them, but they will be all the wider because our social rooms are too small anyhow and will serve our needs better when they are linked by wide openings. All our doors, narrow or wide, should have the same height through-

out because by this their relationships become properly apparent and a pleasant restfulness is achieved. We shall, for example, orient our rooms by the sun and not by the facade, and we shall establish the fulfillment of all reasonable needs, of comfort, as the supreme principle. We shall set great value by the design of our gardens, for gardens are magic, wonder, and delight for our life. They, however, are not plant collections of botanically well-grouped beings. Gardens must be rooms, festive halls, and cosy corners. Then they are . . . [?] and playgrounds. Gardens must always have closure. A gate of perforated decoration shall open them. Public gardens too are not passages and deserts or collections of herbs. They shall be invented not only by the competent gardener but by the artist. In them our youth dreams its first dreams. They are important like schools and churches. Their instruction is gentle and unconscious, considerate of every temper.

They teach us all that the soul needs to rise above the workaday. Modern education shall set us the task to bring to our elementary schools also the sense for reality and work instead of a world of purely abstract concepts. More important than hairsplitting instruction in grammar is manual dexterity, the awakening of the creative forces; these are almost paralyzed and atrophied by a purely literary education. It is high time that we awaken them again. These are our thoughts of six, seven years ago. Meanwhile we had been called to the School of Arts and Crafts as a teacher and had to try and lead the young people in our care on a productive path. Many of our intentions were hindered by the lack of workshops of our own. It is therefore clear that we were anxious to establish them. For this we required the necessary capital or a generous Maecenas. We had the good fortune to find one in the person of Fritz Wärndorfer. After a long stay in London, Wärndorfer had returned to Vienna, and he was immediately interested in the then new movement.

I recall that we met him one fine day on the scaffolding of the Secession building.

He came to us out of pure interest with his young wife, and he has since helped and supported us with great understanding in every respect.

The idea of workshops was not alien to him. There already had been beginnings in England and Germany; he needed no explanation; he plunged head over heels into this work with ardent zeal. We wanted to start out gently but he had no desire to do a halfway job and dared to realize the ideas fully with all his means. If this enterprise had met with full understanding, we would today have a model institute, the envy of the world. But in Vienna it is not easy to prevail. It takes much, much patience.

To show what we wanted, we then wrote to our friends:

"We want to establish intimate contact between public, designer, and craftsman and to produce good simple household utensils. We start from purpose, utility is our first condition."

[Then follows citation of the well-known work program of the Wiener Werkstätte to the penultimate sentence which reads: "We shall try to fulfill what is in our powers. We can only take a step forward through the cooperation of all our friends."] Our program is approximately defined in this. We did not lack opponents; we were accused of presumption in imagining we could master so many crafts at once.

We thought that all human work can be learned; what an apprentice often learns easily under the most adverse conditions, we could perhaps also grasp. Much no longer existed; we had to start at the beginning with our helpers and masters; in any case we could only profit by constant contact with the workers, and by becoming familiar with all their tools and methods. In due time, sensible cooperation and consideration of designer and executants would surely produce results. At first, we naturally used only the simplest motifs to be safe. We also knew that steady labor at the worktable with intensive physical efforts had to result in a certain one-sidedness. We knew that there were designers at all times despite deliberate denials of this fact, and that even today we can still observe in Japanese art how painters and draftsmen make designs for objects of arts and crafts. Famous architects dictated the taste of past centuries, and it is nothing new that we undertake to intervene in all arts and crafts.

But we also owed the happiest hours to this enterprise. Each of you will have ex-perienced often in life what a pleasure it is . . . talking to a good cabinetmaker or other craftsman, and to get to know a world that stands on its two feet, and knows and fulfills its function.

Now we have the good fortune to dwell every day in a circle of such people and to enjoy with sincere admiration their devoted, heartfelt perseverance, deep understanding, and manly strength. We see with pride that they stand at the worktable with pleasure and without distaste, and that they gladly help us to realize ideas they apparently sense as made for their dexterity. But we feel how for us the forces grow, through them, and how we must not lose respect for the sanctity of work. Our art-craftsmen are an elite of the first rank. They are not slaves of a machine but creators and shapers, makers of form and masters. Their labors are not loveless patchwork by various hands but the work of one man. Therefore they are all signed with the signet, that is, with the name of the craftsman. We know that we do not work for individual profit but for the cause, and that makes us free. We know no differences in rank; we recognize only an order of work and the higher quality of performance.

We are also inspired by the same idea in our commercial management; this is proof to us that we strive for and attempt a unified cause. Of course, we are still limited in space and other possibilities, but thanks to the growing confidence of the public we hope to achieve better results.

Since we have it at heart to work with almost all artists in this field and also to welcome the young generation of artists, we dream perhaps not without justification, hope to achieve something similar to style. It is possible that the scope of these efforts will ever grow, and that we will have the good fortune to cultivate ever more fields. . . .

Stimulus is needed everywhere and at least is not harmful. We want to uphold one principle only, that of entirely free, unhindered development. Everyone can observe in our properly educated youth that there is still a strong movement toward art and invention among our people. We fight not only for the comfort and the healthy happiness of our fellow human beings but also for the monuments of our time.

It is our task to find expression for the

8. Handwritten page from the lecture manuscript "My Work"

more positive forces of our nations and to create lasting value for them. It would be a dangerous symptom for the decadence of the present if we could not succeed in overcoming all atavism and to help art break through to new and strong development.

We hope for and dream again of garden-rich, beautiful, bright cities, without oppressive ugliness; we dream of handsome, healthy people in handsome rooms and of the open cheer of positive work.

This work of the hands guided by healthy creative force shall not degrade but elevate and lead to highest perfection through the correct appreciation of its worth.

Our time should at last recall that art alone preserves the value of its colossal epoch-making works as an inspiration for the future, and that we will vanish from the earth with all the things of our civilization if a vigorous art will not transmit them by its inner value.

9.

"VIENNA'S FUTURE"

Der Merker, December 1919

We have become poor and small. We cannot see where great misery will yet lead us. Chasms are open before us, yet do we dare hope for a better future? This poor, intimidated Vienna, can it ever rise again, can it hope to experience a better, a great time? If we gather all our strength and use what little cannot be taken from us, if we create order with iron energy and go to work, if we will not be hindered and pursue our goal, we must yet succeed in doing many a thing.

The best of Vienna is certainly its people. Its marked talent, dexterity, and peaceable character are its heritage. Even in misfortune it has not lost grace.

Whoever is in a position to see countless skilled hands at work and to experience this work, done with pleasure and interest, cannot lose hope. There can be no doubt that in Vienna, as nowhere else, we can produce everything that makes life pleasant and enhances it. This beautiful and good work reflects on these people and gives them that cheerful temper which rightly delights everyone. One need only try to introduce

some kind of new work, to attempt something never done; it will not take long, and the needed staff is available. It is true, through the method of working in the last decades, which tolerated a great gap between workers and employers, through the machine and industrialization much has dried up, much has been forgotten, and worse—much has been squandered; yet the old forces still work within these people and can always be awakened.

Handicraft cooperation with the goal: Invention and execution in one person would again create enthusiastic and cheerful work. I know of a downright great talent who made a meager living for years by bronzing false palm fronds for wreaths; finally discovered, he was able to do the finest sculptural work.

We hope that the high cost of labor will of necessity lead to greater quality; it will no longer be possible to make bazaar merchandise here. We also know that our school was more or less misguided, that it ignored real life, no longer knew quality, and served reality only through abstractions and dead scholarship.

But we also know that we are about to demand from the school what alone is valuable, I mean what is awakening and stimulating and creative.

A teacher is not one who has passed the prescribed examination for a teaching post but one who has the above gift.

Everything stereotyped, prescribed, every preconceived method, is a presumption in the face of a human material that grows like a multicolored bed of varied flowers and demands especially loving and understanding care. Nowhere are the students as different and as talented for everything possible as in Vienna. So let's not have the same pattern for all.

Equally one must not kill the imagination of the teacher, who naturally has the most talent, by regulations, but one should spur him on to proceed individually and distinctively, for his own benefit and for the school's. There must be only one joy for the teacher, to have created great and able people.

We must again have the courage to believe in the infinite influence of a great man, and to recognize his value for the community.

In the last decades we were anxiously striving to equalize, flatten, or silence everything.

May our time above all break with this method and assist and support everything of genius and individuality.

Away with all jurisdictions, all lifeless deliberative bodies and commissions. Let us become accustomed again to put the right best man in every post and then hands off his work.

Everything that happens should be immediate action, not bureaucratic machine work, but the work in itself. It should be like the work of a true sculptor who immediately begins his work in stone or some other material but does not lose all originality and freshness over studies and models. Let our forces act intensively, and an undreamed flowering is assured.

Concentrated, conscious work was the cause of the superiority the German Empire was able to achieve over us in many respects.

Unshakable will, creative force, inventiveness and the ability for enthusiasm are the sources of true life.

Nothing dead any more, nothing hindering, nothing delaying, or we are lost beyond saving. In the interest of everybody we must follow the inspirations of genius in all fields. Genius, no matter of what persuasion, is the greatest treasure for the totality of a people. Every people must believe in its ability to bring forth talent, and the state has the duty to let them act.

The army of officials is often badly used capital, wasted force, nothing positive, not direct work.

All these people are first dissatisfied, then unhappy, finally harmful. It cannot be otherwise. What inhibitions, what obstacles up to now in every expression of life. This eternal applying, commissioning, conferring, investigating! For God's sake, rather a primeval forest than to begin anything on this soil. This is one reason, among others, why our city has not become more beautiful or better in the past hundred years.

Everything was so measured, prescribed, and documented that every creative expression had to dry up.

Can we no longer get used to believe at all that there simply are people who understand their business?

Things get better through peace, but not through interference.

We have lost firm judgment. We grope in the dark, and yet there is in every period one who would be the right one, if we would choose him.

Vienna lies on a splendid river. Have you seen what happened to its banks? We have turned our back on it, avoid it, barely use its gigantic powers, and hardly suspect what it could be for us in our present misery.

There is no clear plan for our development. The commission studying our water power has let the best time pass uselessly, though it has been meeting for many years and has large offices.

As we are poor and yet need all manner of things, we must make everything well so that we do not have to make it twice; however, we must also make it beautiful to provide a basis for the happiness of our life.

Our electric streetcars, for example, must be made better and more beautiful. Away with this ugly light yellow and red. We need good clean colors—blue, yellow, red, green, gray, black—according to the route to be taken. We must bring order to our streets, create real squares where there are only deserts, and improve everything so that it becomes useful.

Instead of ugly park fences we should build arcades. The costs could be covered by installing small shops, cafés, bars, etc.

In the winter these colonnades could be glazed and heated. In this area the best architects should build great new quarters appropriately adapted to their residents, but if possible not separated by classes, but for the most varied people who will always be in the city, with the needed schools, recreation facilities, baths, hospitals, sports fields, etc.

On the Burgplatz the delayed building should be finally begun.

Since we cannot afford luxury, there—integrated into the architectural setting, i.e., fitting into the main massing—one should finally erect the Vienna Hotel that invites the stranger to the best place, as befits a civilized city.

This hotel should have no equal in the world; it should truly represent us.

All our institutes must come to life again.

Our mint must not only produce the best coins and most splendid medals but it should stand at the top in the area of metal art.

Our state printing office must be the first publisher of the country, under modern management, it must compete with the best German publishers.

As we are poor, our museums could often make room in the most noble style for all works of art that are coming on the market.

They could share in the great profit and thus be in a position to acquire the most valuable [pieces] for themselves.

In this way they could also promote living art without causing expense to the state. All this would work with the right men who can be found among us, who were always with us; but they have to be left free to act. Not institutions, not statutes, tip the scales but always only the people employed for a purpose; their dexterity and quality are decisive, nothing else.

As the chosen workers so their work.

In Vienna we had an excellent garden technician at the head of the municipal gardens. Technically, the gardens were excellent also. But as he was not a landscape artist, the parks lacked all artistic charm. By the same token, Schönbrunn and Belvedere, while wonderfully designed, were poorly kept most of the time.

How comparatively backward is our theater because we failed to win the best talent living today. By contrast, Berlin has definitely taken over the leadership.

So it goes with us in many fields, and we cannot deplore it enough that subjective causes often have cost us the best.

Buildings like the Konzerthaus rightly must make us appear ridiculous in the eyes of the world.

A city with the renown of the first city of music in the world cannot build such inferior accommodations.

Nothing but the outstanding, outstanding above all else, can bring us to the top again, and therefore we should rather produce nothing than something not entirely good. Our ambition should be to strive only for the best and to seek perfection.

But what good is it to us if we have, for example, the good luck of possessing the perhaps greatest sculptor of our time if we want nothing of him, and worse, we know nothing of him?

This is the cause of our declining significance in many fields, visible to all the world.

We must seek the truly great and genuinely care for it.

Our time, the time of great social progress, only apparently seems to lack the means.

It possesses an army of workers of best quality. With the necessary enthusiasm these, by their own power, could create a work of such gigantic greatness that the world would have to be amazed. It is time to replace the work of destruction by the great work of construction and to begin the great cultural initiative.

We have this power and therefore also the hope for real life in the future.

10.

"THE SCHOOL OF THE ARCHITECT"

Das Kunstblatt, April 1924

In the Middle Ages there was the masons' lodge; it was certainly the most ideal form of school for builders. A sure path to the acquisition of the most perfect [practical] mastery, not perfect [theoretical] knowledge, could be found in this circle of builders and other artists with the same orientation. Here could be found all the artists and craftsmen needed to erect a building. This very community was the guarantee of a shared feeling for art, that is, for style.

One could stand out only by greater talent and achievement, which ultimately had to benefit the lodge, similar to the manner in which today's outstanding member benefits a theater company.

Fully knowing each other guaranteed the right employment; and the equal appreciation of achievement in every field resulted in the enthusiastic devotion of every individual for the great cause.

An art metal worker was no less than a painter or sculptor, a stonecutter no less than a carpenter, the goldsmith was as much respected as the creator of the vestments, and the weaver of tapestries no less than the painter of miniatures.

The time was fresh and healthy, it grasped the real sense of artistic work and revered it in all creations.

Only quality, not a narrow-minded division in ranks, was decisive.

This state essentially continued, though

with noticeable differences, into the Baroque; we hear that the great castles were mostly created by Italian builders, more rarely by builders of other nationalities, in closed groups comprising almost all crafts.

In the cities the guilds took the place of the masons' lodges. They isolate themselves increasingly from each other but uphold discipline and quality within their own group. They attend to the training of the young within their workshops in the most thorough manner.

Their isolation eventually leads to ignorance of the world and in the age of enlightenment could not fail to be destroyed by the amazing knowledge of the enlightened. Knowledge took the place of practice; one began to learn everything in schools.

Every field was now dogmatically divided and evaluated. Some could be learned only in higher schools, some in lower schools.

This circumstance already shows the extremely one-sided conception and finally the complete lack of orientation about the essential meaning of the creative achievement.

It went so far that there were higher and lower arts, as if this were at all possible. So much knowledge splintered the unified development and destroyed all naiveté.

One proof of this is in the division of the architectural school at the Academy into a classical and a medieval section.

Old material was mostly investigated in a superficial manner without seeking the cause of all these phenomena.

The natural connection between the cultural expressions of all human races was not grasped. Individual details from here and there were compiled, never with deeper understanding, which eventually led to the architecture of the eighties and nineties, a low point that made it possible to conceive the idea of the decline of the West.

Talents also err in this terrible time and find no satisfaction. The scholar of art who was in intimate contact with genuine works of past periods, turned with contempt from the achievements of the living, and as adviser to educated clients he was finally forced to suggest the purchase of old buildings and to recommend their furnishing with old furniture and crafts objects.

Thus it occurred that a modern gathering in tailcoat and uniform with ladies in modern dresses had to have a disturbing effect in such a room.

They did not know then that collecting and preserving old art, though meritorious, could not replace the creation of genuine contemporary forms.

Meanwhile something new had originated in an undreamed of development—modern technology.

Built on a purely scientific, mostly mathematical, basis, it knew nothing of art. Art seemed superfluous play, lacking all seriousness. [Technology's] achievements were on a giant scale and are absolutely that which in our time means real progress, without satisfying us completely, at least as far as the formal side is concerned. Where it was a matter of constructing machinery, where accordingly all tradition was lacking, everything went well.

Creativity lay in idea and invention; the execution in most cases required a thorough scientific knowledge.

However, to achieve a really valuable result—and this has been little noted up to now—a cultivated feeling for form was still necessary, even when it was entirely unconscious. It impresses its stamp on every good machine.

Where, for some reason, ornamental form was necessary, everything went wrong, of course.

Those branches of industry which produce only quality materials, for example unpatterned fabrics, loden cloth, or papers, manufactured exemplary products. Everything else, striving to imitate handmade artistic products, wasted material and labor and most sorely damaged culture.

Every inferior product made a hundred thousand times damages that many times; paid advertising takes the place of real evaluation. These phenomena led to a reaction that created the Werkbund; its intentions and activity were paralyzed by the World War.

In the war the value of technology was proved most impressively. This [technology], in the hands of leaders of genius is, after all, the essence of success.

Yet, so far capitalism wins as the supreme power.—

The modern school for building must consider all these phenomena and must be arranged accordingly.

We know today that, without using decorative forms, we can arrive at a new design that aims only for the causative.

But we also know that the best calculated form of construction does not achieve a satisfying product, that in addition to a command of the technical requirements, one must have a cultivated taste, a feeling for relationships and the rhythm of the visual, as well as that secret sensitivity which only artistically oriented people possess, in order to bring satisfying results.

Familiarity with all branches of modern art and sincere study of nature in all its manifestations are absolutely necessary.

Success is unthinkable without thorough knowledge of all available materials and their appropriate utilization. The modern school for building should therefore not be separated from the various kinds of applied art; only the combination of all results in the building.

The grasping of the spirit of the times in all its important manifestations is also necessary from the economic viewpoint.

In Austria building technology has been taught up to now in the state technical high schools with *Matura*, and at the Technical University. Yet a technical high school graduate, although obviously more qualified, was not accepted by the Technical University; only high school [*Realschule*] graduates were admitted. The artistic instruction was to be carried on at the Academy of Fine Arts. There, technical high school graduates were admitted. At the schools of art and crafts the architectural studies were extended from house construction to the detail and the entire interior.

At this institution architects, painters, and sculptors were working simultaneously in the preparatory classes; this is of particular significance. In this way, the properly guided student can grasp and judge the essence and equality of creative work in all fields. The pleasure in building and construction, but also in building beautifully, must be stimulated till it reaches enthusiasm. The constant presentation of the best works of all people, including the so-called savage tribes, through photographs and [vicarious] travel [by means of film] in the movie theater will replace the study of books.

A clear understanding of the building program, anticipation, preferably by a nose,

of every kind of need, knowledge of eternal laws; in a word, true building culture must be exercised.

A sense for true comfort is equally necessary.

It should also be considered whether actual participation in building under qualified direction will be possible at the end of the course.

The abundance of state building needs and other community buildings provide appropriate material.

Only when all arts and crafts are oriented in the same sense can the architect limit himself to the solution of the great guiding lines; today he must still perform the enormous work to the last detail himself.

In accordance with the poverty of the time, decorative form in itself will gradually disappear, but where sentiment still demands it, it must be new.

To reiterate, the old has no value.

The most modern directions in painting and sculpture show feeling for structure and construction.

The paintings of the new Russians remind us of beautiful old working drawings with their sections, dimension lines and hatching.

It is a sign that the sense for the spatial is growing. Modern sculpture no longer has merely the figurative in its program; it begins to feel architecturally and to construct. We can almost speak of a unified style already, and this hope gives us support.

The merging of the three existing schools into an appropriate unit would not only lead to the right result but would also put the necessary rooms and means at the disposal of the state.

It makes no sense to do the same thing three times inadequately instead of doing it once in a grand and proper way. One will realize that the potential for doing it is present without having to make excessively great changes. Both the necessary rooms and people are here; it is now only a matter of once again thoroughly checking these fifty- to one-hundred-year-old institutions and of ordering them anew, so that, above all, all roads are open to the student to reach his goal in any case, and there are no other conditions but talent.

11.
MEMORIAL ADDRESS AT OTTO WAGNER'S GRAVE

Delivered 11 April 1928

Honored relatives
Friends and dear colleagues

Deeply moved, we observe today the tenth anniversary of Otto Wagner's death.

What is Otto Wagner to us today, in a time thoroughly changed again?

Not that he was a teacher, what is a teacher? Not that he was an architect, what is an architect? Countless people have passed by us, without our being grateful for it; no, what makes him daily more valuable and significant to us is that he was a truly creative spirit of prophetic and rare greatness with wide-ranging impact.

He was a real building artist, rooted in his time and seeking and shaping all its forces. In this sense he was a philosopher and a thinker. Fanatical in his love for the task without considering petty advantage, building up and perfecting step by step.

One will know how to appreciate the work of Otto Wagner once the confusion of our time, the petty enmities are forgotten, and when the true freedom for which he hoped fills the world.

He was the first to begin many things, of some he had a presentiment; experiments like those made in Stuttgart last year strongly recall his ideas and intentions. The stair railing in his own house in the Döblergasse in the 7th District could be in Stuttgart.

The force of his ideas was strong; the echo that his pure intentions toward material and functional appropriateness have found in the world is a sure sign of the greatness of his truly creative humanity.

Otto Wagner as an architect of revolutionary guiding genius must be finally recognized, and even our ungrateful city will learn to value and love him.

We who had the good fortune to stand by his side, who appreciated him as the revered master and guide, frequently also friend, we thank him above all for all the stimulating and awakening forces.

He understood how to encourage us and to support our hope.

He had the gift of gladly bringing out all dormant abilities, of promoting and lead-ing. He was truly a great and important teacher. We, his disciples, collaborators, and closer friends remember him with reverence and bow before his immortal greatness.

12.
PETER BEHRENS: JOSEF HOFFMANN

Die Wiener Werkstätte 1903-1928, Vienna, 1929

When today the art of Vienna is spoken of, in Germany or any foreign country, thought instantly turns to the name of Josef Hoffmann. Since Otto Wagner, the stimulating and ordering spirit of Vienna's artistic life in the nineties, is no longer living, it is Hoffmann to whom the impulses and expressions of Austrian artistic life are linked. As Wagner was the urbanistic genius of his time, so Hoffmann too is a building artist of the truest vocation. Despite—or perhaps because of that—he, like Wagner, exerts influence on the entire artistic activity of his country. Josef Hoffmann was Otto Wagner's pupil but this is not the cause and reason for their equally wide range of interest, but because a great and real art is conceivable only in the community of all arts. Hoffmann early went his own, different ways. In his twenties he left the Academy and united a group of young artists: Olbrich, Kolo Moser, the painters Klimt and Andri, and others who shortly afterward founded the Secession. It was a period full of storm and stress, a period more of seeking than finding. It is past, and as everywhere and in other countries too, we recall it only with a smile because today's goals are of greater significance, above all more serious, and because all creation is linked to modern life. But without it the foundation of the Wiener Werkstätte would never have come about, and Josef Hoffmann is to be regarded as its true creator. As the thought of Austrian taste is associated with the name Josef Hoffmann, it is also closely linked with the Wiener Werkstätte. The products of the Wiener Werkstätte are known, disseminated, and valued beyond Austria's borders. The distinctiveness of this art is unmistakable; in addition to its high quality it has its own special character. Abroad it particularly stands out by being Viennese, in the

good and best sense. Josef Hoffmann, born in Moravia, came to Vienna at an early age and grew up from childhood in the Austrian spirit. It was therefore inevitable that this finely sensitive artist should understand and love the Austrian character so well, and wholly absorb the Viennese tradition; tradition not in the sense of the obsolete but of the Viennese that has remained alive in our century, in the city of Haydn, Mozart, Beethoven, Schubert, Brahms, and Mahler. The musicality of this city vibrates also in all works of Hoffmann. The musical and the poetical. When we see and enter any house by him, it is not the mightiness that amazes, but the fine relationships of forms and spaces, the simplicity that conveys an effect of comfort, that invites one to stay, promising contemplative calm and happiness. Such houses stand not only in Vienna and Austria, we find them also in Berlin, East Prussia, Croatia, Bohemia, and Belgium. And especially in Brussels, to be specific, stands the house of Mr. Stoclet, which gives the best example of Hoffmann's building art. Here the means were not limited, here the artistic inclination could roam, imagination could soar. But it is significant that just this house has remained simple despite the high value of the materials and the most sophisticated demands of the owner; the admirable effect was not produced by an overload of architectural forms but by harmony of all arts. Thus, it became not only a comfortable house for cultured people but at the same time a place of devotion for chosen works of art. This moment of artistic order and disposition which Vitruvius called *distributio*, where everything is in its necessary place, where one is related to the other as both to the whole, this is the reason why all details are also perfect and exemplary. This is also the reason why exhibitions built or arranged by Hoffmann, in Vienna, Cologne, Paris, or wherever, always made an outstanding impression, and that the entire contents and all displays became highly valued. Josef Hoffmann, in his importance, is an architect of the first rank, not only among Austrian artists but in his whole generation. This glory will never be contested. If it is admirable that, despite his own disposition, from him and under his direction, be it in his school or in the Wiener Werkstätte, there originate so many objects

of harmonious charm for a life ordered toward beauty, the explanation can again be found in the fact that all his ideas originate in relation to architecture. His designs, even for the simplest utensils, are always conceived as parts of an architectural idea. And this is the secret why they carry value. Today it is impossible to invent so-called arts and crafts as a thing in itself. Everything beyond the playful and superfluous is linked, dependent, and connected with a higher totality. And it is for this that our time owes thanks to Josef Hoffmann: the universality of his artistry.

13.
LE CORBUSIER: THE WIENER WERKSTÄTTE

Die Wiener Werkstätte 1903-1928, Vienna, 1929

I got to know the Wiener Werkstätte (actually the work of Professor Hoffmann) from art magazines when I was still a young fellow attending the school of my native city; that was in the years 1903-1906. The works of Hoffmann were for me the most luminous expression of the architectural development. By comparison, the creations that had originated from the Paris movement of decorative art (1900) had not yet matured to architectural expression. In 1907 (I was 19 years old), on return from my first art journey in Italy, I went to Vienna, and I was very proud to be received and encouraged by Professor Hoffmann. Afterward I went to Paris where the "constructors" (architect Perret) attracted me. Since then I have not been able to follow the development of the Wiener Werkstätte. But I always experienced a true artistic pleasure when I saw here and there the architectural work of Professor Hoffmann: because in it there was always a refined, spirited, cheerful, and sublime expression. And among the ordinary productions, often devoted to narrowly circumscribed utilitarian tasks, the works of Hoffmann left a deep impression because he, like myself, starts from the conviction that architectural work must possess a spiritual content, provided of course that it completely fulfills the demands of appropriateness. Today, when the new generations, without looking back (and without

saying "thank you") appropriate the fruits of the labor of the steadfast seekers, the true pioneers, today when the situation is comparatively clear, and the obstacles have been removed and the *great directives* are given, today it is only just—and what a pleasant task—to express our gratitude to men like Professor Hoffmann and to enterprises that were as daring as the Wiener Werkstätte. Finally, what remains is the "indispensable superfluous," *art* (a word today kicked around like a football). *And in the history of contemporary architecture, on the way to a timely aesthetic, Professor Hoffmann holds one of the most brilliant places.*

14.
SELECTED MESSAGES ON THE OCCASION OF HOFFMANN'S 60TH BIRTHDAY

Josef Hoffmann zum sechzigsten Geburtstage, Vienna, 1930

Architect Professor Dr. Josef Frank, Vienna

What modern architecture owes to Hoffmann is not only the turning away from historical, no longer living, forms whose weight hindered the new development, but also the simultaneous winning of that lightness and transparency which now appear to us as its most important characteristic.

What Austria owes to Hoffmann is that, on the basis of Austrian tradition in the sense of its living works, he founded and gave new value to this new development; it has now exerted its determining influence on the whole world beyond the borders of this country.

Professor Walter Gropius, Berlin

Dear, honored Josef Hoffmann!

Since my earliest years of study in architecture your great name, your significant and pure work has been close to me, and when I had the privilege of meeting you, my reverence for you grew because behind your great ability stands such a strong humanity which gives its lasting meaning to your life's work!

Today I congratulate you from my heart on your day of honor.

C. R. Richards, Director of the Metropolitan Museum of Art, New York

It is a special privilege to be able to say a few words of appreciation about the work and influence of Josef Hoffmann. It is his outstanding merit to have been one of the first to grasp the significance of the modern movement. Over many years he has created with extraordinary talent designs which gave direction not only to the development of his immediate homeland but to many who were far distant from personal contact. As an architect, Josef Hoffmann has made outstanding contributions of such high personal quality to modern development that one rightly wishes there were more of them.

Interior design and arts and crafts are the fields with which I am personally most familiar; there his creations are not only outstanding examples of the contemporary spirit, but they served also as a bulwark against tendencies of extreme radicalism. He has never been content to interpret the "Moderne" as a potential expression of rigid Functionalism, but he possessed the gift to unite charm with utmost simplicity. The abundance and wide variety of his designs have almost never been equaled, comprising the monumental as well as the most intimate objects of the home. In my opinion the Stoclet House is still the greatest achievement of the Modern school in the field of architecture. Then again, I see a showcase, a small wine glass by Hoffmann, things that are in purity of line the most precious I have ever seen.

For us outsiders who fervently believe in the significance of the "Moderne" the leading and inspiring influence of Josef Hoffmann on the younger Viennese generation has always been one of the most encouraging activities on the world stage. We all wish that this may long endure.

P. Morton Shand, M. A. Cantab., London

The 60th birthday of Josef Hoffmann is a jubilee of international significance. English architects, designers, and writers on art are proud to be allowed, with their Austrian colleagues, to honor a great and modest man. We Englishmen are often reproached for indubitably being bad Europeans, naively ignorant of even the names of those men who are changing the intellectual profile of the Continent. Granted that this reproach is all too often justified, there are also notable exceptions. The name Josef Hoffmann was already before the war "a name to conjure with." Today this name is more highly valued in England than ever. Even in its beginnings Hoffmann's work quite spontaneously gained our sympathy and undivided admiration—it is not always entirely easy to excite the sympathy and admiration of Englishmen.

We see in Hoffmann not only the greatest architect now living, but also a gifted master of design in every area. We wish that his birthday might return many, many times and bring him many more years of fruitful work. It is our sincere wish that the Royal Institute of British Architects may honor itself by honoring the doyen of its profession, the man who once did more than any other, when architecture threatened to be choked by an overgrowth of ornament, to lead the art back to dignity, proportion, and superior simplicity.

The works of designers such as Ernest Gimson and Robert Wear testify to the productive and refining influence of Hoffmann, as do the villas by significant English architects such as Ernest Newton, Voysey, Thackeray Turner, and George P. Bankart. Hoffmann's influence on modern English design is most evident in Heal's store in Tottenham Court Road, built by Smith and Brewer, and in the many large apartment houses built in the last prewar decade in various districts of London by the firm of William Willet. . . .

Though we owe Hoffmann so infinitely much today, we like to console ourselves in England with the awareness that our tradition in building houses has given him something in his youth. Be that as it may, today Young England in its search for inspiration turns more and more to those countries to which it is linked by a natural affinity in taste and character—Sweden and Austria. And to us Austria means Hoffmann and the tradition Hoffmann has created there. Later, once the English contribution to the "Moderne" will have become a reality, I believe that Hoffmann's influence will be evident as the outstanding influence from abroad. Recently one of our architects of the old school attacked the modern direction in my presence. He concluded: "If the modern direction were equivalent to buildings Hoffmann could design, then I would have no objections. On the contrary, I would welcome it wholeheartedly. Hoffmann, what a man!" I will always consider it a milestone of my career that it was granted to me this summer to meet the man I have so passionately admired through his works for so many years. So I consider it also as no small distinction to have been asked by the Austrian Werkbund to join my country's admiration, reverence, and gratitude with that of other nations.—As a Scot I shall never forget that Josef Hoffmann believed in the remarkable but misunderstood genius C. Rennie Mackintosh and helped him loyally in his need.

Professor Dr. Oskar Strnad, Vienna

Dear Josef Hoffmann!

What amazes me so much in you is your unshakable faith in everything new. You are ever young. Your creativity is enormous. You never falter. In your sphere of influence everything becomes simple and easy. You help all in whom you believe. You have smoothed my way. By words and examples you have freed me from academic work. You have given me the understanding of the relationships of life and form. Today I thank you for it. I congratulate you on your 60th birthday; may you celebrate it in your unshakable faith and in full strength.

Director General Architect Ivar Tengbom, Stockholm

On Josef Hoffmann's 60th birthday!

I am glad that I once really quarreled with Josef Hoffmann because thereby I learned to understand him and became his friend. I understand that he has had many passions in life but that there is only one thing he cannot bear, namely routine or stereotype, be it in life or architecture. He abhors every standstill (even sitting still can become hard for him!), only independent growth is life and development to him. Such a man is always ahead of his time and goes his own way. Long ago, about the turn of the century, Hoffmann was already admired in this country by the stormers of heaven of that time. And our Modernists of today must find that he was modern before them and

still is. The goal was and is the same: Liberation from the constraint of tradition, or rather of routine, and a new consideration of the possibilities of building materials and of the justification of forms. We must remember Hoffmann's significance for modern architecture on his festive day!

15.
TRANSCRIPT OF A LETTER WRITTEN IN MARCH 1933 ON THE OCCASION OF EVENTS IN THE AUSTRIAN WERKBUND; ITS FACSIMILE WAS SENT BY MAX WELZ TO THE MEMBERS OF THE WERKBUND

What really matters to us is to feel what can be done in the interest of enriching the image of the world within our more narrow borders. Every soil bears its special fruits and without doubt contains certain forces that can develop and unfold only there.

Everyone who possesses an outspoken feeling for his homeland will, given talent, create something remarkable and distinctive.

The German-Austrian possesses not only a charming, almost harmonious character, but he also possesses a sense for creative will.

He has to bring forth works in which one can sense the homeland and the experience of time. For us it is, therefore, important to recognize all these impulses, whether they are dormant or awake, and to bring them to unfolding.

This appears to us the most necessary within a cultural movement and compels the duty of responsibility.

In France, at the end of the last century, modern painting was able to prevail completely, and it still has an effect in the entire cultivated world, spreading pleasure and happiness.

In Austria, the fresh beginnings of modern arts and crafts could awaken the justified hope that it is given to us, at least in this field, to achieve something stimulating and capable of development for the whole of humanity.

But as in England a beginning movement around Makintosh [sic] died away without interest, and made such a leading country fall behind in this field, so it could also happen with us that distinctive talents could be stifled or pushed aside to the greatest detriment of the entire development.

They unfortunately are to be sacrificed to a purely speculative intelligence which only has the gift of criticizing and frivolously condemning everything.

Names like Peche, Zimpl, Snischek, Flögel [sic], Rix, Singer, and all the many others who created something distinctive, could be brought to unfolding despite all opposition, and are not only eloquent testimony of sincere advancement but also proof of the abilities always present on our soil.

What mattered to us were never names or profit or other advantages but only to provide opportunities for the undisturbed unfolding of those remarkable talents who originated or settled in our homeland.

Therefore, we do not want to hear even the most brilliant remarks about untimeliness or unsalability or lack of usefulness.

We daily experience these conditions anyway; they arise by themselves, and it seems to us entirely superfluous to emphasize them.

Under all circumstances, as long as there is still a homeland for us, we do not want our creative forces to perish even in the worst times.

Daily we see traces of distinctive development at work among the young, too, and we must protect and foster them.

Let others philosophize, display their vehement knowledge, let them misguidedly or deliberately spew poison and gall over such developments; we must detach ourselves and learn to bear it.

We want to keep the respect for every creative work and seek nothing else. We must time and again seek to strengthen faith in that [which] through its true distinctiveness [is] novel and creates value, and in its striving for its own means of expression. It is healthy, not degenerate, humanity in the best sense.

Naturally, it is good when others revive and continue to develop what once originated from creative work, when discoveries and experiences are utilized and if possible completed.

Yet, we also want to produce an atmosphere wherein creative work is never opposed by sophistries and malicious remarks that weaken and discourage time and again, but where every attempt is viewed with encouragement and gratitude.

Today scientific, economic, and every kind of professional work is absolutely in the lead and able to prevail completely. Yet, with excessively great arrogance it can perhaps be damaging and hindering.

Even distinctive inventors and artists have no bed of roses and, to their detriment, are quite exposed to these forces. It is time to accomplish a free and unbiased attitude everywhere.

Concerning our own artistic work, and not only the all too eagerly attacked arts and crafts, but the entire field of artistic expression and will to form, we must be on guard. We must know that all is endangered by these unexpected enemies and we must act accordingly.

Incidentally, concerning my person, my work certainly counts for nothing compared with my constant intention to serve every talent. Despite certain mistakes, I am happy to have fostered much genuine and great work.

Cischek says: Everything in flux is alive, and only stagnation means the end.

We therefore need not be ashamed to adapt ourselves daily to the demands of the time, but we do not want to get stuck in a merely speculative attitude.

Unfortunately, in the Werkbund everything has become personal today, we hardly seem to deal with the matter at hand anymore but with the power status of various groups.

This is also the most important reason to create a different forum.

Adolf Loos too, who must be considered the model for some methods of today's actions, did not choose to understand the essence of our intention.

Yet he was in some respects a fellow traveler in another form. He was at least original in his method, although he often did not shrink from imputing what was untrue and false to others, and to exploit it for his perhaps pathological ambition.

We cannot thank him and his hangers-on for his activity in foreign cultural centers, which was extremely damaging to Vienna. We will of course pay attention to everything he really created or stimulated, and will know how to appreciate it.

We must foster and desire to foster every

16. A page from the letter of March 1933

achievement but want equal understanding and opportunities for development for our experiments and attempts. . . . We have no thought of disturbing any circles, but we are fed up with being negatively criticized in a schoolmasterly manner again and again, even before a malevolent forum.

Even the young people begin to learn these methods of power play, and will later again cause damage when other forces are long since at work.

If this danger should prevail, it will certainly bring about the demise of all distinctive striving, which means the end of a nation.

Those spirits who feel themselves high above everything indigenous will have to hover in the air and will not find their way back.

Think of the decline of all ancient cultures of the Orient, China, and Europe, and beware of being forced by alien influences to approach a premature end.

Everyone who means well must attempt everything, and as a sage strive to grasp and admire only the positive.

Malicious criticism, no matter how brilliant, is always the achievement of a transient, feeble age.

Let us leave that to journalism.

We do not want friends and collaborators harassed by that. What good is it to compromise us before the world, when this causes a general demoralization that does not build up but only destroys.

In March 1933

Jos [sic] *Hoffmann*

17.
"VIENNESE IN THE YEAR 2000"

Neues Wiener Journal, 17 February 1935

City and people without kitsch.

We are in the year 2000. . . . There are still people who knew Vienna half a century ago and have now returned to their native city, driven by nostalgia. They think they are dreaming. Vienna can hardly be recognized. It has not become larger but it is full of orderly beauty. The returnee thinks: "There must have been a man to whom the

power and ability was given to make Vienna the most beautiful city in the world."

How could he have achieved that? Once called, he instantly went to work. First he noted that the Ringstraße, despite the unique opportunity, was not built in the round but divided into straight segments which formed desperate holes instead of plazas at the points of contact. The buildings themselves stood there inharmoniously articulated, one disturbing and hindering the other. He instantly saw that these buildings did not date from the times before 1830. He therefore had the rubbish razed and closed a regular Ring in one line up to the Quay. The fronts were closed by wonderful buildings following the arc, the radical streets could only be reached through openings on the ground floor.

The new metropolitan street

He further ordered the abolishment of all avenues of trees, walkways, and riding paths, and the provision of excellent paving. He regulated traffic solely by electric autos and buses; all crossings were located underground. He had the lamp posts sold to another state, and had the city lighted indirectly instead, at not very great cost. Electricity powered all machinery in the safest and most sanitary manner. This unique, half-round street around the Inner City was lined with the most beautiful modern hotels, restaurants, and cafés where the public was able to enjoy the fresh air on terraces. A small number of shops were disposed in between, creating a beautiful variety. They were organically integrated with the whole, and were of course not permitted to disturb the effect of the closed metropolitan street by loud advertising. In the center of the street wonderful sculptures were placed, and an individual great tree was left with a place of rest for the viewer.

The old Viennese vainly looked for the well-known monumental buildings which, for the sake of borrowed style, were lined up in an inharmonious and ugly manner and seemed to represent a mendacious history of style. Now he found all as cast in a single mold and yet so varied in detail that there could be no boredom. Through a broad, beautiful, arched entrance he suddenly reached the Kärntnerstraße. It was cleansed of all turrets and inferior architecture and formed a unified shopping street, reserved

for the best quality of shops. Protected by glass roofing, the shop windows could be admired in all weather.

In the heart of future Vienna

On arriving at the Stephansplatz, our old Viennese guest is quite amazed to find the venerable cathedral without all later additions. The square around the cathedral still displays the splendid old buildings and palaces, joined and harmoniously complemented by sensitive new buildings. The access to the Rotenturmstraße too, was closed by a transverse building with passages on the ground floor. On the opposite side he sees a wonderful building, devoted to Gothic and Romanesque works of art, open also for the greater part of the night. It houses a collection of incomparable quality and is always a rallying point for an educated public.

Through the descending, more commercial Rotenturmstraße our old Viennese reaches the Quay. He is astonished by the appearance of this area, once so much treated like a former stepchild. He thinks he is almost standing at a mighty river already with beautiful port installations, lively with countless motor boats. Passing pretty country houses, the vehicle takes him to the Danube area proper, to the foot of the Kahlenberg; it pleases him much more in its elegant, cosmopolitan form than it used to. By car he is soon on the height, and his view encompasses a city radiant with cleanliness and care. He sees no smoking chimneys; no cloud of fog and haze hides the image of his home city with its wonderful naturally given contours.

Immortal Schönbrunn

The returnee wants to know whether Schönbrunn and all the palaces with their splendid parks still exist. He finds them without spoiling additions in well-kept beauty, and he is happy to recognize the spirit of their parks in modern form in Vienna's gardens. He soon notices that neighbors respect and never disturb each other. The people he meets are dressed simply but well. Good material and good taste are striking. Working people are glad to wear their extremely functional work clothes and are not disturbing in the once repellent raggedness of their appearance. Airships circle above Vienna, and he would like to see the

great airport of which he has already heard. Past a large, clean central railroad station he rides to the airport and marvels at the frictionless process of worldwide traffic. Next to the great place and its giant installations of unified design, he discovers small surrounding towns with the most varied nationalities and races, with all their distinctive arrangements. They form a unique wreath around old Vienna which finally fulfills its mission of uniting nations in the heart of Europe.

18.
"THOUGHTS ON VIENNA'S RECONSTRUCTION" I

Wiener Zeitung, 23 December 1945

We still live miserably in ruins and houses by chance not quite destroyed.

We try to patch with makeshift surrogates; in the great city there stalks the spirit of allotment gardens to fix only the worst damages.

This is not yet the beginning of the reconstruction that must come sometime.

This [reconstruction], however, should be able to unfold in as fast and well-prepared a manner as conceivable, and it will be urgently necessary to apply the correct methods and proposals to finally put our cityscape, which has unfortunately been badly mistreated for a century, in order.

We must realize that the former projects were done only from the technical standpoint, mostly by the indiscriminate use of unqualified people, and above all with the unfortunate mistakes of imitating past period styles.

The announcement of competitions, however, will again not work.

Competitions are announced when the controlling authorities are quite uninformed about available people and their capacities.

If one does not know our architects or expects discoveries from the younger generation, then one ought to ask that all present themselves with their executed or projected works and proposals at the proper department, and make their ideas and intentions known.

Only in this way will we succeed in clearly getting to know all artistically able and distinctive personalities.

It can also happen that laymen come up with good ideas. They ought to be harnessed together with the appropriate professional people.

Architects compete for a definite assignment only at great trouble and often exorbitant expense.

Able people, from experience, after all, and for various obvious reasons, cannot participate in such competitions; moreover it rarely ends without disappointment, precisely because even the prize-winning projects are not usable as they are.

The artist himself must know what is especially congenial to him; he must try to make his ideas known and push them through. It will never work without enthusiasm and the necessary forcefulness.

Everyone who feels the call should be permitted on the basis of his previous achievements to make his intentions known to the public and to the proper authorities.

Often it will be a question whether, depending on the impact of destruction, we can restore even historically and artistically important works in the same manner, which surely would be the most desirable, or whether, when replacing independent parts, we should after all also think of being permitted to proceed in a tactful but timely manner, as was a matter of course in healthy periods of art. Naturally one would not proceed as brutally as formerly.

Above all, for this an extremely sensitive personality is needed who will be guided by respect for the existing artistic achievement and by extreme tact.

In the first case an art historically aware personality will usually be the right one.

Unattractive features could be removed or corrected as, for example, from our Opera House the useless structure with the imperial inscription, which was surely demanded by certain authorities, the ugly lucarnes [dormers], the inharmonious solutions at the corner roofs, as well as the too-high pedestals of the figures in the loggia.

We will probably not want to reconstruct the pressed sheet metal details simulating stucco in the auditorium. In any case, they offered no protection against the danger of fire.

Things that disturb time and again might be altered, and their omission or improvement can be justified in the sense of the former master builders. As a contemporary, one has many such wishes and great worries about what now happens, what should happen, and what could happen in the interest of the now feasible beautification of our cityscape.

For these reasons we would like to make the following suggestions to indicate what might be considered before work begins in detail.

For instance, it is rare for a large city to have an almost completely preserved, artistically valuable center as in Vienna.

All the quiet narrow side streets of the Kärntnerstraße have not yet become complete victims of the irresponsible demolition frenzy of the last decades.

How would it be if one were to evacuate and clear out this inner city quarter completely? The few new buildings, which just here unfortunately turned out to be particularly ugly and disturbing, above all should be either remodeled or removed.

The many wonderful buildings of Baroque splendor, such as Prince Eugene's Winter Palace, the churches, and monasteries, ought to be put in the most beautiful order and opened to view and to use.

Only artists, scholars, friends of art, and especially original people should live in this part of the city. On the ground floors only small, quality shops ought to be accommodated in the fashion typical of old Vienna.

In between, places of amusement as they occur already, but in impeccable, special form; small original restaurants and wine taverns, fruit restaurants, confectioners, tearooms and cafés, fish restaurants for Danube fish, lake fish, crayfish, and the like, with every finesse in the Viennese manner, could be housed here.

These must all be open in the evening and at the disposal of residents and strangers. They would be a cultivated delight and constant attraction for all.

Here Viennese clubs, art groups, cabarets, music and dance halls should also arise.

Inside the often charming courtyards the decent, unrambunctious 'Heurigen' setting of earlier times, with the arch-Viennese 'Heurigen' music, could also find its place.

Such a unique, stimulating, genuinely Viennese place of amusement could be found in Europe only here, and would be an asset of the first rank.

It must be possible to find everything here that fits into the framework of our old Vienna. Thus, for example, antiquarian bookshops, art dealers, exhibitions of old and new art, small collections which here could be preserved as entities, and much else that would soon result.

Driving in these quarters should be prohibited during certain hours; transportation possibly could be even by sedan chairs.

It is of course most important that all facilities must be under the general direction of an experienced man, an extraordinary film director would be best; he would call on our ablest artists for the many varied tasks.

One should keep in mind that with the means of a single film the most important costs would almost be [covered] as the individual entrepreneurs would take care of furnishing their own places.

For our city, which will have to rely on cultivated tourism, no better publicity can be made, and the revenues—perhaps one might also think of a small gambling casino—would be of substantial help.

Once all dirt, all unauthorized advertising, ugly show windows and everything disturbing have disappeared, one can go to work with enthusiasm.

It goes without saying that any shallow kitsch must disappear, everything must reach the highest level of quality.

Another worry is our Stadtpark which should undergo many thoroughgoing changes.

The enclosure of the Ringstraβe, today almost a trash dump behind the iron fences, should give way to a great gallery, a covered promenade which would end the complete lack of protection in bad weather.

We know that in a storm everyone must flee with bag and baggage because there is not a single covered place in the entire park. The small but appealing iron kiosk from the forties by the pond oddly enough was recently removed and not replaced.

The antiquated Kursalon [casino] should also give way to a perhaps hotellike building which could house a number of restaurants, cafés, etc., facing the park, within a water basin with loggias, galleries, and similar architectural features.

The exceedingly beautiful pond should be enlarged, . . . with the island and a rustic bridge, and open to small boats that would give special pleasure to our young people.

The outlet should be still a little wider and designed somewhat like a brook. All seating, evening lighting of various surprises, playgounds, bowers, and tree-lined ways could find a place in the neglected part above the Vienna river.

Another principal care is the design of the Prater and the Augarten where many wonderful things could still arise that shall be discussed another time.

The most important matter should yet be mentioned here: the opportunity to finally relocate a district of the city directly on the Danube.

The place for that is behind the Rotunda where a monumental facility for Danube steamship passenger traffic should be created.

The railroad along the Danube and the commercial quay should be covered over. A monumental, broad flight of steps should lead from the dock to a large square, flanked by large, beautiful hotel buildings; they could extend to the Hauptallee.

Toward the Wurstelprater, and making the transition to it, there could be, for example, the arrangement of an international settlement dedicated to the peoples of the Danube region; it would have to be designed similar to various fishing villages.

The Wurstelprater and its access must rise again after its destruction. For that there is already an appropriate plan by a capable hand; we hope that it will be realized without concessions.

In the rest of the Prater area many more attractions should be created; once started, they will gradually grow by themselves.

Vienna, in December 1945.

19.
"THOUGHTS ON VIENNA'S RECONSTRUCTION" II

Wiener Zeitung, 21 April 1946

The anxious worries about Vienna's reconstruction must always admonish us to serious concern. At the risk of wishful dreams, it is essential to discuss every idea that could stimulate reconstruction in the spiritual sense too, even if only to return to it at a given time.

The Theseus Temple

From a favorite idea of the recently deceased painter Karl *Moll* stems the project to devote the *Theseus Temple* in the Volksgarten to the memory of our native musical heroes and to redesign it for that sublime purpose. It was planned to shape the great hall for the glorification of our musical mission by the placement of a monumental group that would create a solemn mood. A stair in the background would lead in appropriate form to an existing large vaulted room in the lower story. This room, with a marble altar at the wall opposite the stair, leads right and left to three large niches on each side, in which twelve monumental sarcophagi cast in bronze or lead are to be placed. The large room with the annexes for the niches, closed off by especially precious wrought iron grilles, is visualized in shimmering gold mosaic only and lighted by torchlike fixtures on the piers between the niches. Moll thought that precisely this solemn building by Peter von *Nobile*, which now has no real function, built in the time of most of the music heroes, would be the most dignified and certainly the emotionally most appealing setting for Vienna's long overdue homage. The garden around the temple would have to be specially designed; the sculptural decoration there would have to symbolize above all what Vienna means in the world as a musical metropolis.

Augarten—Hanak (Museum)

For a similar reason attention must again be directed to the project of a World Concert Hall that for years has been proposed by Professor *Meurer* [sic] and should form the setting for music festivals and special performances of great works destined for all the world.

This building would be planned above all as a uniquely important and accordingly large concert hall with the necessary vestibules and subsidiary rooms, restaurants, lecture halls, and all ensuing necessities. The rightly felt surroundings, a museum of music, pavilions for special functions and space for great outdoor performances, would have to comprise much that has not been built any-

where and would be of the greatest importance for Vienna and its significance as a city of music. As the site the otherwise little-noted *Augarten* should be designated. Here, in the Augarten I also once projected the building of a *Hanak Museum*. Hanak, one of our most important sculptors of modern times, has hardly had the impact in Vienna he deserves. His greatest work stands in Ankara, symbolizing the strength of the revived Turkish empire. The excellent monumental bust of Viktor Adler stood only briefly near the parliament, though not placed in the best way, and it was removed again for reasons of party politics. The memorial building was roughly planned so that the various works could be placed indoors or outdoors, according to their character. Linked to the garden by a short bridge, within a large water basin to be newly created, an appropriate lobby would lead to a hall with niches for the most outstanding sculptures. Next door would be a room for his especially interesting drawings, small sculptures, and writings. A connecting gallery leads to a high, solemn, round room devoted to one of his principal works.

Around these rooms, covered pergolalike buildings open to the garden are erected to house works intended for outdoors, for example, fountains. All these works, placed at the proper distance, separated by water, would be clearly visible from the banks, and by this atmospheric, poetic placement could surely awaken the interest of the passing Viennese. Hanak carved most of his works in stone himself; works destined for bronze would yet have to be cast. Works in other materials would of course stand in the enclosed, well-lighted rooms. Such placement of sculpture would be a unique solution, it would certainly be a credit to Vienna's art life.

The Prater as architectural task

Another architectural project, intended for the Prater area, would be devoted to the fine and applied arts of the living present. It is strange that the Prater, with its splendid groups of trees, meadows and brooks, hills and alleys, was never utilized for a specific architectural task. It is planned to create a building complex to promote our vitally essential artistic handicrafts and all their various branches and arts. The individual parts of this complex would be designed and built, according to their various functions, by outstanding architects of special talent, and in this way would be a living testimony to our present artistic creativity. It is evident that, for example, the residence of the director would differ from the main building, and yet would have to be distinctive and notable for the present and the future as testimony to our present, qualitatively best conception of this task.

Museums, clublike facilities, libraries, lecture halls, collections of the best artifacts at any given moment should offer welcome tasks for architects and in their treatment be a source of constant stimulation. A residential wing (for researchers, lecturers and foreign guests, artists and scholars) would again be a special task. In addition to suitable grounds for periodic exhibitions, also of foreign art, there would be provisions for the longer stay of enthusiastic visitors in this artistic environment, and an especially distinguished restaurant with all the specialties of Viennese cuisine would be established. A separate building would have to be created for the sale of valuable and distinctive works by local artists. Pertinent books, magazines, and reproductions of works of art would also be available there. All these buildings should be linked by arcades and appear located on an island amidst a large basin of water, their effect enhanced by modern garden design.

We should remember that there were no museums in our sense in earlier times. The wonderful châteaux, monasteries, castles, imperial palaces, city halls, churches, and their builders were the ever new stimulators of genuine folk art which also, as is known, constantly changed according to the style of the times. The artists, often called here from Italy, came in close contact with the population, and joined with local creative artists to maintain a living experience of art. Of such exemplary things, although they provided a background for the whole existence, there is now a complete lack. It is therefore important to create them for enjoyment and experience, and also as models for the common man.

Thus, this project represents a last attempt—by creating in living, timely form—to provide suggestions.

Therefore, everything needed for the determined purpose will be seen in use. In the dining rooms of this complex, the table, the silverware and tableware, the linen, lighting and service, will be exemplary and distinctive. For the receptive person the opportunity shall be offered to spend leisure hours in a cultivated environment with every beauty the living present can provide, to develop taste and to find true enjoyment of the arts.

Only a living, truly applied art, in all its forms of appearance from the simplest use to monumental grandeur, will achieve such success; only then will we view with real interest and enjoyment the immense treasures that often only slumber in our museums.

20.
"UTOPIAN PROPOSALS FOR THE DESIGN OF THE STEPHANSPLATZ"

20 April 1950

The following lines were written to save later generations the anxious question whether there was ever anyone who could give a correct answer in the curious discussions about the purely artistic question of the square around St. Stephen's Cathedral.

The Gothic in a masterly manner knew how to create surprising effects in the smallest space by piling up high-rising architectural details.

It was not a matter of long-distance views but of the sudden dynamic experience of grotesque tower architecture in closest proximity; every detail had individual power and appeared in overflowing fullness.

The square around St. Stephen's Cathedral was originally closed on all sides, and despite its small size it was also bordered by a church building and the Rotenturm gate.

Entering through this gate or from the little lane opposite to it, one suddenly stood amazed and moved before this mysterious splendor.

Even today—please don't be shocked—we enjoy the most beautiful view when we climb the steep stairs from the installation underneath the Stephansplatz and suddenly experience the gigantic apparition of the cathedral tower.

The narrower the surroundings, the greater the effect.

Complete enclosure, including across Graben, Kärntnerstraße, and Rotenturmstraße, even only at the upper stories, should make this valuable effect possible.

Above all, the rounding off at the Graben—an irretrievable mistake—should be avoided at all cost in order not to rip open brutally the square that is to be created, and not to create a completely confusing effect plus an untenable traffic situation. The houses opposite the cathedral should demonstrate the necessary respect for the miraculous creation which they face by their outstanding artistic design; they should be as original and varied as possible, perhaps with airy, well-lighted arcades, and an architecture as rich as conceivable.

One is adorned when one goes to a feast, and knows what artistic tact requires.

A truly artistic design, no matter how surprising, will be a wonderful wreath around the venerable cathedral and enhance its dignity.

Traffic problems at worst can be solved underground; *for once* artistic design would have to be the supreme duty in our city and overrule all other questions if future generations are to inherit anything significant at all from our times.

All previous proposals, no matter how talented they seem, suffer from the constraint of missing relationships and misunderstood requirements. Supported by a mighty movement of all guiding forces and a people longing for beauty, something significant could originate.

When we think how the splendid pagodas of Chinese and Indian culture arose thousands of years ago, we must assume a mighty movement that generated the strength to create many thousands of sculptural works without once violating the intended creative form. We experience the memorable appearance of a people that consisted of collaborating artists throughout.

Today's sculptural movement perhaps contains the germ of similar possibilities; an inner calling to form anew all shapes, and strong architectural talent are clear in its vocation and yet unconscious intentions.

Will we once have the courage to open the way in this our time for its artistic dreams, as in past centuries similar artistic problems of the Romanesque and Gothic period, giving up the artistic conception of Antiquity, grew into new, almost unconsciously completed creations of gigantic force?

In a healthy era, open to special achievements, artistic forces will also arise suddenly and find the right paths.

Due to the political aberrations and their waste of energy in all spiritual fields, our era has lost almost all relation to the things of art; we must again start at the beginning to finally grasp the value of higher spiritual and artistic creations.

Nothing in the world can displace the work of art, and nothing can be of lasting value if there is a lack of striving for perfection and eternal beauty.

The design of the Stephansplatz is a purely artistic task that cannot be solved by regulations and innumerable hesitations. Our task, however, would be to create for the cathedral—as the manifestation of the strength of an artistically enthusiastic and self-confident age and as the fulfillment of ideas and longings of mystical greatness—an environment that complements it with true empathy and honors it through artistic form.

Vienna, April 20th, 1950
Josef Hoffmann

SOURCES AND BIBLIOGRAPHY

SOURCES IN PUBLIC COLLECTIONS

I. Architectural Drawings

Academy of the Fine Arts (Print Collection), Vienna
Albertina, Vienna
Austrian Museum for Applied Art, Vienna
Bauhaus Archive, Berlin
Historical Museum of the City of Vienna
Museum of the 20th Century, Vienna
National Gallery of Art, Washington, D.C.
Netherlands Documentation Center for Architecture, Amsterdam

II. Writings, News Clippings, Photographs

Allgemeines Verwaltungsarchiv (Kultus and Unterricht) (General Administrative Archive) (Public Worship and Education), Vienna
Archive of the Academy of Fine Arts, Vienna
Archives of the Building Authorities in the places where Hoffmann was active
Archive of the Academy for Applied Art, Vienna
Archive of the Association of Austrian Artists Secession, Vienna
Archive of the Wiener Werkstätte, Austrian Museum for Applied Art, Vienna
Austrian Gallery, Upper Belvedere (Estate Ankwicz-Kleehoven), Vienna
Picture Archive of the Austrian National Library, Vienna
Manuscript Collection of the Vienna City Library

BIBLIOGRAPHY

Books, catalogues, and selected articles on Hoffmann's architecture, published before 1983, in chronological order. Literature on individual buildings is given in the Catalogue of Works.

I. Books and Catalogues

Kleiner, Leopold, *Josef Hoffmann*, Berlin, Leipzig, and Vienna, 1927
Weiser, Armand, *Josef Hoffmann*, Geneva, 1930
Werkbund, Österreichischer, ed., *Josef Hoffmann zum 60. Geburtstag*, Vienna (Almanach der Dame), 1930
Rochowanski, Leopold W., *Josef Hoffmann*, Vienna, 1950
Veronesi, Giulia, *Josef Hoffmann*, Milan, 1956
Mostra di disegni di Josef Hoffmann (Catalogue, Libreria Einaudi), Rome, 1964
Josef Hoffmann 1870-1956, Architect and Designer (Catalogue, Fischer Fine Art Ltd.), London, 1977
Fagiolo, Maurizio, ed., *I mobili semplici etc.* (Catalogue, Emporio Floreale), Rome, n.d. (1977)
Josef Hoffmann (Catalogue, Galerie Ambiente), Vienna, 1978
Josef Hoffmann, *Architect and Designer 1870-1956* (Catalogue, Galerie Metropol), Vienna, 1981
Baroni, Daniele, and d'Auria, Antonio, *Josef Hoffmann e la Wiener Werkstätte*, Milan, 1981
Fanelli, Giovanni, and Godoli, Ezio, *La Vienna di Hoffmann architetto della qualità*, Bari, 1981
Gresleri, Giuliano, *Josef Hoffmann*, Bologna, 1981
Borsi, Franco, and Perizzi, Alessandro, *Josef Hoffmann—tempo e geometria*, Rome, 1982
Gebhard, David, *Josef Hoffmann, Design Classics* (Catalogue, Fort Worth Art Museum), Fort Worth, 1982

II. Articles

Khnopff, Fernand, "Josef Hoffmann, Architect and Decorator," *Studio* XXII, May 1901, 261-267
Lux, Joseph A., "Innenkunst von Prof. Joseph Hoffmann—Wien," *ID* XIII, May 1902, 129-152
Zuckerkandl, Berta, "Josef Hoffmann," *Die Kunst* X (*DK* VII), 1904, 1-31
Tesar, L. E., "Josef Hoffmann," *Kunst-Revue*, November 1908, 177-184
Tietze, Hans, "Josef Hoffmann zum 50. Geburtstag am 15. Dezember," *Kunstchronik* XXXII, 1920/1921, 201-205
Frey, Dagobert, "Josef Hoffmann zu seinem 50. Geburtstag," *Architekt* XXIII, 1920, 65-80
Eisler, Max, "Josef Hoffmann: 1870-1920," *Wendingen* III, August/September 1920, 4 ff. (Special Josef Hoffmann issue)
Kleiner, Leopold, "Wien," *Wasmuths Monatshefte für Baukunst* VI, 1921/1922, 165-175
Eisler, Max, "Hoffmann, Josef," in Thieme-Becker, *Allgemeines Lexikon der bildenden Künstler* XVII (1924), 267-270
Behrens, Peter, "The Work of Josef Hoffmann," *Society of Architects Journal* II, 1924, 589-599
Behrens, Peter, "The Work of Josef Hoffmann," *Journal of the American Institute of Architects* XII, October 1924, 421-426
Kleiner, Leopold, "Joseph Hoffmann et 'l'Atelier Viennois,' " *Art et Décoration* XLVI, July-December 1924, 55-64
Ankwicz-Kleehoven, Hans, "Neuere Bauten Prof. Josef Hoffmanns," *ÖBWK* II, 1925/1926, 41-53
Vogelgesang, Shepard, "The Work of Josef Hoffmann," *The Architectural Forum* XLIX, November 1928, 697-712
Behrens, Peter, "Josef Hoffmann," in *Die Wiener Werkstätte 1903-1928*, Vienna, 1929
K[och], A[lexander], "Professor Dr. Ing. E. h. Josef Hoffmann, Wien, 60 Jahre," *DKuD* LXVII, 1930/1931, 279-283
Eisler, Max, "Josef Hoffmann," *Almanach der Dame*, Vienna, 1931, 12.

M[eyer], P[eter], "Josef Hoffmann," *Das Werk* XVIII, 1931, no. 7, 222-224

P[onti], G[io], "Il gusto di Hoffmann," *Domus* VIII, no. 93, September 1935, 3-33

Vollmer, Hans, "Josef Hoffmann," in *Allgemeines Lexikon der bildenden Künste des XX. Jahrhunderts* II, Leipzig (1955), 466

Hofmann, Werner, "Josef Hoffmann, ein Formschöpfer unserer Zeit," *Forum* III, January 1956, 36, 37

Girardi, Vittoria, "Josef Hoffmann maestro dimenticato," *L'architettura* II, no. 12, October 1956, 432-441

Ankwicz-Kleehoven, Hans, "Josef Hoffmann (1870-1956)," in *Große Österreicher, Neue Österreichische Biographie ab 1815*, X, Vienna, 1957, 171-179

Feuerstein, Günther, "Josef Hoffmann und die Wiener Werkstätte," *Der Aufbau* XIX, 1964, no. 4/5, 177-187

Dimitriou, Sokratis, "Josef Hoffmann," *Christliche Kunstblätter* CIV, 1966, no. 4, 85-89

Birkner, Othmar, "Josef Hoffmann 1938-1945, etc.," *Das Werk* LIV, 1967, no. 10, 671-673

Sekler, Eduard F., "Hoffmann, Josef," in *Neue Deutsche Biographie*, Berlin, 1970

Loos-Hoffmann, special issue *AUMK* XV, November/December 1970, no. 113

Thurner, H., "Zum 100. Geburtstag Josef Hoffmanns," *Bau* XXV, 1970, no. 1, 21

Roth, Alfred, "Josef Hoffmann," in *Begegnung mit Pionieren*, Basel, 1973, 211-216

Feuerstein, Günther, "Josef Hoffmann," in W. Pollak, ed., *Tausend Jahre Österreich*, Vienna, 1976, 153ff.

Sekler, Eduard F., "Josef Hoffmann," in M. Emanuel, ed., *Contemporary Architects*, London, 1980, 364-366

Sekler, Eduard F., "Josef Hoffmann," in A. K. Placzek, ed., *Macmillan Encyclopedia of Architects*, New York, 1982, II, 397-402.

NOTES

I. YEARS OF UPBRINGING AND EDUCATION (pp. 9-24)

1. Josef Hoffmann, "Selbstbiographie" (edited by O. Breicha), *Ver Sacrum*, 1972, 104ff.
2. Undated letter, ADV.
3. "Die Familie Hoffmann und ihr Haus," Ms., 1930 (Estate).
4. Rochowanski, 35, suggests that Hoffmann's later predilection for black and white square patterns was influenced by the arms of the princely Collalto family. I consider this unlikely.
5. Information courtesy of the late Aloys Ludwig, Munich, who worked in the Wagner studio from 1897 to 1900.
6. On the social and economic conditions, compare H. Bobek and E. Lichtenberger, *Wien, Bauliche Gestalt und Entwicklung etc.*, Graz, 1966; F. Baltzarek et al., *Wirtschaft und Gesellschaft der Wiener Stadterweiterung*, Wiesbaden, 1975. Hoffmann had drastic personal experience of how unpleasant housing conditions could be in Vienna. He found that the room he had rented just after his arrival had a bed completely infested with vermin. He then spent the night sitting on his trunk. (Information courtesy of Hoffmann's student Christa Ehrlich, The Hague, 14 September 1969.)
7. *Die K. K. Akademie der Bildenden Künste in Wien 1892-1917*, Vienna, 1917, 25ff.
8. Undated Ms., "Die Schule des Architekten"; Ms. of the lecture, "Meine Arbeit," 22 February 1911 (see Appendix, "The School of the Architect" and "My Work"). (Estate Ro.)
9. G. Semper, *Kleine Schriften*, Berlin, 1884, 217, "Art knows only *one* master, necessity."
10. J. A. Lux, *Otto Wagner*, Munich, 1914, 138; Lux also mentions several of Hoffmann's remarks about Wagner, 156.
11. Lux, op. cit., 141.
12. O. Wagner, *Einige Skizzen, Projekte und ausgeführte Bauten*, Vienna, 1892, pls. 14ff., pls. 30ff.; a second project for a peace palace was worked out in 1900 by Alfred Fenzl.
13. *Jahrbuch der Gesellschaft österreichischer Architekten 1909*, Vienna, 1909, 55ff. (Compare Appendix, "Speech about Otto Wagner.")
14. Hdschr. I.Nr. 172.568.
15. R. Oerley, "Otto Wagners Persönlichkeit," *Architekt* XII, 1919, 24.
16. Information courtesy of Aloys Ludwig (see note 5). He recalls how Otto Wagner excitedly came into the studio during a Klimt exhibition and shouted: ". . . let everything be and come and look at Klimt in the Secession! I tell you, compared with him Michelangelo is just an urchin!"
17. Letter from Rome 21 January 1894, Firestone Library, Princeton University (information courtesy Prof. Robert J. Clark).
18. M. Pozzetto, *Max Fabiani Architetto*, Gorizia, 1964, 33. On the Club of Seven, see H. Ankwicz-Kleehofen, "Die Anfänge der Wiener Secession," *AUMK* V, 1960 (6/7), June/July, 6.
19. Postcard (Estate Ro.) with following text: "We live on a high alp. Wild storms rage here and badly tousle us; and the rains come down and splash on the door of this quiet hut, and there is no afternoon beer; (The cat stops mousing here—I am not fooling you!). We eat only 'mush and milk.' This might well horrify you!"
20. "Selbstbiographie," 109 (see n. 1), and lecture of 22 February 1911 (see n. 8).
21. Letter of 22 December 1895, Hdschr. I.Nr. 172.581.
22. J.D.W.E. Engelhard, *Instruction für junge Architekten zu Reisen in Italien*, Berlin, 1838, 3.
23. ". . . nel mio spirito c'e sempre un viaggio in Italia. . . . Un viaggio di questo genere e forse una 'conditio sine qua non' per il mio lavoro d'architetto." Alvar Aalto, "Italian Journey," *Casabella* 200, February/March 1954, 4.
24. See n. 5.
25. Letter from Olbrich published by K. Moser, cited in R. J. Clark, "Olbrich and Vienna," *Kunst in Hessen und am Mittelrhein* VII, 1967, 31.
26. "Trinkt, daß Euch die Nase glänzt, Hell wie ein Karfunkel. Habet gleich ein Leuchten dann in des Daseins Dunkel." ("Drink to have your nose aglow, bright as a carbuncle, Instantly you then will have light in the darkness of existence.") Hdschr. I.Nr. 172.567.
27. This is evident from Olbrich's letter of 22 December 1895 (see n. 21).
28. Le Corbusier, *Creation Is a Patient Search*, translated by J. Palmes, New York, 1960, 37.
29. F. Weinbrenner, *Denkwürdigkeiten* (edited by A. von Schneider), Karlsruhe, 1958, 116.
30. A. Freiherr von Wolzogen, *Aus Schinkels Nachlaß*, Berlin, 1862-1864, vol. I., 294, vol. II, 464; K. F. Schinkel, *Briefe, Tagebücher, Gedanken* (edited by H. Mackowsky), Berlin, 1922, 58.
31. G. Semper, *Kleine Schriften*, Berlin, 1884, 371; J. Rykwert, *On Adam's House in Paradise*, New York, 1972, 29ff.
32. C. Meeks, "The Italian Villa, etc.," *Art Bulletin* XXX, 1948, 148; G. Meason, *The Landscape Architecture of the Great Painters of Italy*, London, 1828, gives a selection of buildings in the landscape supposedly suitable for England, all from famous works of painting.
33. E. Kaufmann, *Architecture in the Age of Reason*, Cambridge, Mass., 1955, 201.
34. J. Ruskin, *The Poetry of Architecture*, New York, 1873, originally published as a series of articles in 1837 and 1838.
35. William Morris, *Selected Writings* (edited by A. Briggs), Harmondsworth, 1962, 106.
36. R. von Eitelberger, *Gesammelte kunsthistorische Schriften* II, Vienna, 1879, 267.
37. G. R. Collins, *Camillo Sitte and the Birth of Modern City Planning*, New York, 1965, 10ff.; R. J. Clark, op. cit. (see. n. 25), 28; C. E. Schorske, *Fin-de-Siècle Vienna*, New York, 1980, 66-70.
38. Postcard of 12 April 1894 from Capri, Firestone Library, Princeton University (information courtesy of Prof. Robert J. Clark).
39. *Joseph M. Olbrich* (exhibition catalogue), Darmstadt, 1967, 11.
40. *Architekt* I, 1895, 37; III, 1897, 13 (see Appendix, "Architectural Matters from the Island of Capri").
41. A. G. Baculo, "Gli studi architettonici di Emil Hoppe," *L'Architettura* XV, December 1969, 552ff.; O. A. Graf, *Die vergessene Wagnerschule*, Vienna, 1969, 13, 59.
42. Data in curriculum vitae of 21 March 1899 written by Hoffmann on the occasion of his appointment as professor, A.Z. 10293, Imperial Royal Ministry for Religion and Education (General Administration Archive) (see Appendix "Brief Autobiography").

II. ARTISTIC BEGINNINGS AND MODELS (pp. 24-40)

1. Richard Neutra, foreword to H. Geretsegger and M. Peintner, *Otto Wagner, etc.*, London, 1970.

2. Oral information from the late Ernst Lichtblau to the author in 1954.

3. R. J. Clark, "Olbrich and Vienna," *Kunst in Hessen und am Mittelrhein* VII, 1967, 38ff.; K. H. Schreyl, *Joseph Maria Olbrich, etc.*, Berlin, 1972, 25ff.

4. *DK* II, 1898, 258ff.

5. *Otto Wagner* (exhibition catalogue, Hessisches Landesmuseum), Darmstadt, 1964, no. 25.

6. Schreyl, op. cit., 36, 37.

7. Le Corbusier, *Creation Is a Patient Search*, New York, 1960, 22.

8. *Studio* IV, 1894, 197; IX, 1897, 51; XIII, 1898, 244; XVI, 1899, 197, shows the Whitechapel Art Gallery with stylized trees on the facade. Baillie Scott used comparable stylized tree tops, e.g., *Studio* VI, 1906, 105; J. D. Kornwolf, *M. H. Baillie Scott and the Arts and Crafts Movement*, Baltimore, 1972; G. Naylor, *The Arts and Crafts Movement*, Cambridge, Mass., 1971; H.-W. Kruft, "Die Arts und Crafts Bewegung und der deutsche Jugendstil" in (edited by G. Bott) *Von Morris zum Bauhaus*, Darmstadt, 1977, 25ff.

9. In addition to the *Studio*, German-language magazines above all were important for the Viennese artists: *Dekorative Kunst, Deutsche Kunst und Dekoration, Zeitschrift für Innendekoration, Moderne Bauformen*.

10. O. Wagner, *Einige Skizzen, Projekte und ausgeführte Bauten*, Vienna, 1892, pl. 54.

11. Schreyl, op. cit., 19.

12. H.-C. Hoffmann, *Die Theaterbauten von Fellner und Helmer*, Munich, 1966, 81.

13. M. Pozzetto, *Die Schule Otto Wagners*, Vienna, 1980, 235, 236, with erroneous attribution of the Pilsen Theater to Kotěra.

14. Letter from Alfred Roller to Josef Hoffmann, 22 July 1897 (Estate). On the founding of the Secession, see R. Waissenberger, *Die Wiener Secession*, Vienna, 1971, 23ff.

15. Schreyl, op. cit., 32.

16. *DK* I, 1898, 29.

17. *DK* II, 1898, 227.

18. "Als ich vor fünfzehn jahren an professor Josef Hoffmann die bitte richtete, das sitzungszimmer der Secession . . . einrichten zu dürfen, wurde mir da rundweg abgeschlagen." ("Fifteen years ago when I addressed to professor Hoffmann the request to let me furnish the meeting room of the Secession . . . this was flatly denied.") A. Loos, *Sämtliche Schriften* (edited by F. Glück), Vienna, 1962, 322.

19. The competition for the entrances to the Paris Metro was announced only in 1899. Guimard's designs are dated around 1900, that is, at a time when the Apollo portal was long completed. *Hector Guimard* (exhibition catalogue, Museum Villa Stuck), Munich, 1975, 75ff.

20. *VS* II, 1899, nos. 4, 5; contributions to the publication *Die Fläche*.

21. H. Bahr, *Secession*, Vienna, 1900, 33ff.

22. A catalogue of the firm Morris & Co. is preserved in the archive of the Secession.

23. *Studio* XXI, 1900, 114.

24. *Studio* XXII, 1901, 261.

25. Draft letter by Hoffmann in the archive of the Secession, Vienna; the surmise that the criticism was directed against Van de Velde is reinforced by a remark of Hevesi in the review of the 8th Exhibition (*KuKhw* III, 1900, 469): "Strict material men reproach him that his wood is not sufficiently woodlike." Van de Velde's criticism in *ID* XIII, 1902, 207.

26. H. Bahr, op. cit., 169ff.

27. H. Bahr, op. cit., 36.

28. This development is discussed in the extensive literature on the Jugendstil; a good summary in S. Muthesius, *Das englische Vorbild*, Munich, 1974, 156ff.

29. This letter from the estate of Dr. Hans Ankwicz-Kleehofen is now in the ÖMAK and was discussed by Dr. Wilhelm Mrazek, *Wiener Werkstätte* (exhibition catalogue), Vienna, 1967, 12.

30. Hevesi, *Acht Jahre*, 289.

31. A. Cornaro, "Englische Einflüsse, etc.," in O. Hietsche (ed.), *Österreich und die angelsächsische Welt* II, Vienna, 1968, 372ff.; H. Bahr, op. cit., 182ff.; W. Schölermann, "Modern Fine and Applied Art in Vienna," *Studio* XVI, 1899, 30ff.; S. Muthesius, op. cit., 52ff.; Karl Kraus (*Die Fackel*, no. 29, 1900, 18ff.) takes the view that the revolution in arts and crafts "was started from above. Our aristocrats, who traveled every year to England for racing and cross country hunting, there took a liking to residential interiors and decorative objects. Furnishing, like dressing, in the English manner became the fashion in the Austrian aristocracy." On the "Scala Revolution," see E. Leisching, *Ein Leben für Kunst und Volksbildung*, Vienna, 1978, 122ff.

32. T. Howarth, *Charles Rennie Mackintosh and the Modern Movement* (2nd ed.), London, 1977; E. F. Sekler, *C. R. Mackintosh und Wien* (exhibition catalogue), Vienna (Museum des 20. Jahrhunderts), 1969, 12ff.; R. Billcliffe and P. Vergo, "Charles Rennie Mackintosh and the Austrian Art Revival," *Burlington Magazine* CXIX, 1977, 739ff.; R. Billcliffe, *C. R. Mackintosh: The Complete Furniture, etc.*, London, 1979.

33. P. Vergo, "Fritz Wärndorfer as Collector," *AUMK* XXVI, 1981, no. 77, 33ff.

34. Undated letter from Eduard Wimmer to Josef Hoffmann, Hdschr. I.Nr. 162.137.

35. Howarth, op. cit., 153.

36. "Macksh [*sic*] writes that he is furious because you were only 2 days in Glasgow. . . ." Letter from Wärndorfer to Hoffmann of 23 December 1902, Estate.

37. R. Billcliffe and P. Vergo, op. cit. 740: "There can be no doubt that, at the time of the 1900 exhibition, it was Mackintosh and the Scots who were the leaders, Hoffmann, Moser, and the Viennese artists the admiring followers." The two authors especially stress the priority of Mackintosh in the invention or use of a motif of four small squares which Mackintosh used for the first time at the end of 1898 in a design for a bedroom in Westdel, Glasgow (Billcliffe, op. cit., 59). Westdel was published only in 1902, but the same motif occurs in the August 1898 issue of *Ver Sacrum* in the death notice for Burne-Jones. Hoffmann and Moser were long familiar with decorative configurations of squares before they saw such examples by Mackintosh. Apart from the fact that their entire way of working and teaching had to lead them in this direction (see p. 58), there were graphic designs with square patterns from Holland of much earlier date than corresponding work by Mackintosh. See M. Bisanz-Prakken, "Das Quadrat in der Flächenkunst der Secession," *AUMK* XXVII, January 1982, nos. 180/181, 37ff.

38. L. Hevesi, *KuKhw* III, 1900, 469ff., stresses in his discussion of the 8th Exhibition not only the relation of Ashbee to the square but also the similarity of certain features of the Mackintosh room to modern Viennese interiors: "A white room in our 'board style' with single, scattered, colorful, decorative squares. . . . The capricious element, called *Gschnas* in Vienna, plays an influential part."

39. Bill of 9 January 1901, Archive of the Secession.

40. Undated Ms. on Viennese art of furniture (Estate).

41. Howarth, op. cit., 268.

42. Billcliffe, op. cit., 81.

43. Hevesi, *Altkunst*, 220.

III. BRITISH MODELS AND THE PATH TOWARD SIMPLICITY AND UNITY (pp. 41-72)

1. Oral information from the late Prof. Michel Engelhart from the reminiscences of his father Josef Engelhart.

2. H. Bahr, *Bildung*, Berlin, 1900, 45; *VS* IV, 1901, 277.

3. Hdschr. I.Nr. 154.770.

4. Nebehay, *VS*, 18.

5. K. H. Schreyl, *Joseph Maria Olbrich, etc.*, Berlin, 1972, 72.

6. *Architekt* V, 1899, 10.

7. *DK* III, 1900, 97.

8. D. Gebhard, *Charles F. A. Voysey*, Los Angeles, 1975.

9. *Interieur* II, 1901, 203 (see Appendix, "Simple Furniture").

10. Schreyl, op. cit., 86.

11. P. Davey, *The Architecture of the Arts and Crafts Movement*, London, 1980, 154ff.

12. Hevesi, *Altkunst*, 219.

13. F. Windisch-Graetz, *AUMK* XII, 1967, no. 92, 32, pointed to the novel design of Hoffmann's cubical furniture and compared its "weight of almost archaic effect" with the architecture of revolutionary Classicism in France.

14. Hevesi, *Altkunst*, 218.

15. St. T. Madsen, *Sources of Art Nouveau*, Oslo, 1956, 401.

16. M. Bisanz-Prakken, *Gustav Klimt, Der Beethovenfries*, Salzburg, 1977, 17ff.

17. Hevesi, *Acht Jahre*, 383.

18. *Die Fackel* 117, September 1902, 27. The negative judgment of Kraus is countered by that of Josef Strzygowski, *Die bildende Kunst der Gegenwart*, Leipzig, 1907; he found in "the way the . . . Secession paid homage to Klinger's Beethoven . . . something appeared that was the start of something new, like Wagner's Festival House . . . Bayreuth."

19. *Die Kunst* II, 1900, 178, cited in P. Turner, *The Education of Le Corbusier*, New York, 1977, fig. 4.

20. *KuKhw* II, 1899, 407.

21. Illustrated: Le Corbusier, *Creation Is a Patient Search*, New York, 1960, 22, 23.

22. P. Turner, "The Beginnings of Le Corbusier's Education," *Art Bulletin* LIII, June 1971, 217.

23. J. Leshko, "Klimt, Kokoschka und die mykenischen Funde," *Mitteilungen der Österreichischen Galerie* XIII, 1969, 16ff.

24. I owe the reference to this magazine to Dr. Marian Bisanz-Prakken.

25. On 23 December 1902, Wärndorfer wrote to Hoffmann enthusiastically about the new dining room: "Well friend, yesterday we tried the lighting (without the lanterns) for the first time, and I was simply amazed: the whole room is as bathed in a sunny *golden* light. I had probably expected any other effect but this one. Whether the light of the bulbs is reflected so golden because everything is white and silver, I do not know—I only know that the light has the effect of sunlight,—which is everywhere even, without one knowing where it comes from. If you intended *that*, then you have achieved it simply brilliantly. . . . The table—brilliant!! Really, to fall in love with. . . . Everybody is stunned how well one sits in the chairs—I think you will stay with this type a long time. . . . You know that I am grateful to you from my whole heart for all that you have conceived and done for us, at least you should know it, and to repeat it, as we would like, *you* spoil because you always make such faces at every praise." (Letter: Estate)

26. In a letter to Hoffmann of 23 December 1902 (Estate), Wärndorfer writes: "You, when I sometimes look at my things, I feel as if the whole Secession had been founded only for me. My two friends, respectively Viennese pals, I have through the Sec. You have sent me to Glasgow,—of Minne I wouldn't have the haziest notion without you—in short, I feel like a pig fattened with your fat. But it doesn't matter." The "two friends" refer to Hoffmann and Moser (see Appendix, "My Work").

27. Hdschr. I.Nr. 151.370.

28. See VI/n. 61.

29. K. Moser, "Mein Werdegang," *Velhagen & Klasing's Monatshefte* XXXI, 1916/1917, 254, reprinted in catalogue, *Koloman Moser*, HFAK, Vienna, 1979.

30. H. Muthesius, "Die Guild and School of Handicraft," *DK* II, 1898, 41; P. Davey, op. cit., 139ff.

31. *KuKhw* III, 1900, 167ff., and V, 1901, 461ff.

32. H. Ankwicz-Kleehofen, "Felician Freiherr von Myrbach," in *Neue Österreichische Biographie*, XIII, Vienna, 1959, 141.

33. Letter of 12 December 1902, Estate.

34. *Marie Lang Gedenkblatt des Settlement*, Vienna, published by the author, 1933. I owe the reference to this publication to Dr. Christian Witt-Dörring.

35. *Interieur* I, 1900, 65ff.

36. W. R. Lethaby, *Philip Webb and His Work*, Oxford, 1935, 94, cited in P. Davey, op. cit., 27.

37. Letter of 13 February 1903 (Estate).

38. Letter of 29 April 1902 (Estate).

39. Letter from Peter Behrens to Hoffmann (Estate) of 27 May 1903, in which he mentions a visit to Vienna and the planned journey.

40. Hdschr. I.Nr. 162.136-137.

41. Letter of 17 March 1903 (Estate). The letter is written in German.

42. C. Moll, *Mein Leben*, unpublished Ms. (Archive Ida Wagner), 127.

43. See n. 29.

44. Hevesi, *Altkunst*, 226, "The Hoffmann style has today such international importance as Ashbee's style and Baillie Scott's."

45. Compare the Amiet House by Otto Ingold, O. Birkner, *Bauen und Wohnen in der Schweiz, 1850 bis 1920*, Zurich, 1975, 73.

46. *Peter Behrens und Nürnberg* (catalogue), Nuremberg (Germanisches Nationalmuseum), 1980, cat. nos. 157-160.

47. *Kunst* VII, 1902, 385.

48. *Kunst* X, 1904, 1ff.

49. Hevesi, *Altkunst*, 216.

50. Hevesi, *Altkunst*, 214.

IV. RICHNESS AS ARTISTIC POSSIBILITY (pp. 75-100)

1. *Die Fackel*, 68, 1 February 1901, 6; 71, March 1901, 12.

2. Letter from Wärndorfer to Hoffmann of 17 July 1906 (Estate), excerpts cited in F. Windisch-Graetz, *AUMK* XII, 1967, no. 92, 30.

3. Hevesi, *Altkunst*, 220.

4. *AUMK* VI, 1961, no. 42, 7.

5. P. Vergo has pointed out this connection in *Art in Vienna 1898-1918*, London, 1975, 144.

6. Actual rope moldings as window frames were not unknown in Belgium, as a house on the marketplace of Louvain proves. In this connection it is also interesting to observe in what way Otto Wagner carries a classical molding around a window on the house at Stadiongasse 6-8, Vienna.

7. E. F. Sekler, "Structure, Construction, Tectonics," in G. Kepes (ed.), *Structure in Art and in Science*, New York 1965, 89ff.

8. In Wright's early work there are several striking parallels with Hoffmann; see *Der Aufbau* XIV, 1959, 299; according to Bruce Goff (n. 19), Wright knew the Purkersdorf Sanatorium from its publication in the special issue of the *Studio, The Art Revival in Austria*, 1906.

9. Cited after C. E. Schorske, "Schnitzler und Hofmannsthal," *Wort und Wahrheit* XVII, May 1962, 378.

10. O. Wagner, *Die Baukunst unserer Zeit*, 4th ed., Vienna, 1914, 136.

11. Letter of 12 April 1912, Hdschr. I.Nr. 162.133.

12. C. E. Schorske, *Fin-de-Siècle Vienna*, New York, 1980, 279ff.

13. Emil Kaufmann, in *Architecture in the Age of Reason*, Cambridge, Mass., 1955, 59, was the first to point out a relation between Soane's and Hoffmann's buildings.

14. Letter of 24 June 1910, Estate COC. I owe the reference to this letter to Mrs. Senta Siller, Berlin.

15. The penciled instructions for the execution in the cartoons of the mosaics show what importance Klimt assigned to the nature of the material: F. Novotny/J. Dobai, *Gustav Klimt*, Salzburg, 1967, 341, with further references to literature; Nebehay, *Klimt*, 381ff.; H.-H. Kossatz, "The Vienna Secession, etc.," in *Studio International*, no. 929, January 1971, 18. Photographs from the time of building (Estate) seem to show that for a time working drawings of the frieze were attached to the walls of the dining room. B. Zuckerkandl, *WAZ*, 23 October 1911, 2, gives the following details: "The tripartite frieze consists of fifteen marble slabs. . . . Klimt's original . . . was executed in the material by the metal and goldsmith workshop of the Wiener Werkstätte, by the enamel school of the School of Arts and Crafts (Miss Starck, Miss König), the Wiener Keramik (Prof. B. Löffler, Prof. Powolny), the mosaic workshop (Leopold Forstner), and the marble works Oreste A. Bastreri." (I owe the reference to this passage to Dr. Alice Strobl, Vienna.)

16. Novotny/Dobai, op. cit., 389, 391.

17. W. Hofmann, *Gustav Klimt und die Wiener Jahrhundertwende*, Salzburg, 1970, 28.

18. See I/n. 16.

19. Personal information from Bruce Goff, 10 October 1976. When Goff asked Wright whether Klimt had influenced him, he replied: "Yes . . . he refreshed me." Wright also owned the portfolio *Das Werk Gustav Klimts*.

20. R. Brownlee, cited in A. Comini, *Gustav Klimt*, London, 1975, 15.

21. *DKuD* XIX, 1906-1907, 45.

22. Novotny/Dobai, op. cit., 30, 31.

23. Nebehay, *Klimt*, 389, 390; F. Servaes, "Ein Streifzug durch die Wiener Malerei," *Kunst und Künstler* VIII, 1909-1910, 589: ". . . to finally understand the newest Klimt completely, one must know about his close relation to the Moser-Hoffmann 'Wiener Werkstätten.' "

24. Carl Otto Czeschka, Leopold Forstner, Ludwig Heinrich Jungnickel, Gustav Klimt, Berthold Löffler, Richard Luksch and Elena Luksch-Makowsky, Franz Metzner, Kolo Moser, Michael Powolny, Emilie Schleiss-Simandl (according to H. Ankwicz-Kleehoven and A. S. Levetus); Egon Schiele was also to be engaged for the decoration but this proved unfeasible (Nebehay, *Schiele*, 119).

25. G. S. Salles, in his foreword to *Adolphe Stoclet Collection*, Brussels, 1956, XV.

26. These and other personal details were most cordially given to the author by M. Jacques Stoclet, the late son of the original owner.

27. E. de Bruyn, "Adieu à Monsieur Adolphe Stoclet," offprint from *Le Flambeau*, 1949, no. 6, 2; translation: ". . . the lady of the house in gold lamé by Poiret and with heron's feathers in the coiffure, at the side of Adolphe Stoclet, straight in his symmetrical, lustrous beard of Assurbanipal."

28. Salles, op. cit., IX.

29. De Bruyn, op. cit., 3: translation: "The flowers on the table—always only in one tone—and M. Stoclet's tie harmonized with the toilette of Madame. The building proved incompatible with anything banal, provisional, or mediocre."

30. A. Graf Strachwitz, "Ein Wiener Haus in Brüssel," *AUMK* VII, 1962, no. 60, 22ff.

31. L. W. Rochowanski, *Ein Führer durch das Österreichische Kunstgewerbe*, Vienna, 1930, 150; Osthaus had written enthusiastically about Hoffmann in 1906 on the occasion of the exhibition of Viennese artists at the Folkwang-Museum, and wanted to write a monograph on him; he also repeatedly expressed the intention of having Hoffmann design a building. H. Hesse-Frielinghaus et al., *Karl Ernst Osthaus*, Recklinghausen, 1971, 440ff.

32. *MBF* XIII, 1914, no. 1, 1ff.

33. H.-R. Hitchcock, *Modern Architecture, Romanticism and Reintegration*, New York, 1929, 132; H. S. Goodhart-Rendel, *How Architecture Is Made*, London, 1947, 57; B. Zevi, *Storia dell'architettura moderna*, Turin, 1950, 97; H.-R. Hitchcock, *Architecture, 19th and 20th Centuries*, Baltimore, 1958, 351.

34. *Architectural Review* LXXVI, October 1934, no. 455, 132.

35. Novotny/Dobai, op. cit., 391.

36. *Journal of the American Institute of Architects* XII, October 1924, 422.

37. R. Neutra, *Auftrag für Morgen*, Hamburg, 1962, 294.

38. *Journal of the Society of Architectural Historians* XXI, 1962, no. 2, 58.

39. E. Mendelsohn, *Briefe eines Architekten*, Munich, 1961, 27.

40. L. Benevolo, *History of Modern Architecture*, London, 1971, I, 366.

41. Undated Ms. about the artistic intentions of the Wiener Werkstätte (Estate).

V. THE TURN TO CLASSICISM (pp. 101-120)

1. The Hohe Warte dairy had a veranda painted white and blue, blue-white tableware and blue-white tablecloths: see J. A. Lux, *Wenn du vom Kahlenberg*, Vienna, 1907, 23.

2 L. E. Tesar, "Josef Hoffmann," *Kunst-Revue*, November 1909, 177.

3. Hevesi, *Altkunst*, 218.

4. Letter to Czeschka of 25 November 1907 (Estate COC.).

5. *HW* II, 1905-1906, 133ff.

6. P. Davey, *The Architecture of the Arts and Crafts Movement*, London, 1980, 205.

7. Compare III/n. 42.

8. Letter to the author of 8 April 1967. Among the guests who frequented the house were Peter Altenberg, Raoul Aslan, Shalom Asch, Hermann Bahr, Hedwig Bleibtreu, Tina Blau, Otto Brahm, Martin Buber, Richard Dehmel, Ernst Deutsch, Hugo von Hofmannsthal, Ernst Lothar, Emil Ludwig, Thomas Mann, Fritz Mauthner, Max Mell, Alexander Moissi, Emil Orlik, Georg Reimers, Max Reinhardt, Rainer Maria Rilke, Alfred Roller, Lou Andreas-Salomé, Arthur Schnitzler, Richard Strauss, Oskar Strnad, Helene Thimig, Jakob Wassermann, Franz Werfel, Anton Wildgans, Stefan and Arnold Zweig, Berta Zuckerkandl.

9. Hevesi, *Altkunst*, 188ff.

10. *Interieur* II, 1901, 193ff. (see Appendix, "Simple Furniture").

11. *Interieur* IV, 1903, 1.

12. *DK* VII, 1904, 12; see also B. Zuckerkandl, *Zeitkunst, Wien 1901-1907*, Vienna, 1908, 2ff.

13. *KuKhw* X, 1907, 24ff.

14. F. Ahlers-Hestermann, *Stilwende*, 2nd ed., Berlin, 1956, 85.

15. K. Widmer, *MBF* IV, 1905, 81.

16. *Architektur des XX. Jahrhunderts*, 7th special issue, Berlin, 1910, introduction.

17. P. G. Conody, *KuKhw* IX, 1906, 173.

18. P. Davey, op. cit., 154.

19. *DK* VII, 1904, 6.

20. A. Loos, *Sämtliche Schriften* (edited by Franz Glück), Vienna, 1962, 323.

21. *HW* I, 1904-1905, 2; the horizontal stripes on the walls used here with reference to Biedermeier style models could be the distant source of inspiration for Hoffmann's horizontal wallpaper in the Marx apartment (Cat. 145).

22. Reprint in *Moderne Vergangenheit, Wien 1800-1900*, catalogue, Vienna (Künstlerhaus), 1981.

23. Compare Voysey's hall in "Norney," Shackleford, *Studio* XXI, no. 94, January 1901, 243.

24. Hevesi, *Altkunst*, 236; Cat. nos. 109, 110, 148a, 163, 169, 176, 177, 219-223, 229, 230, 283, 365, 366, 391; formally faultless design of the last resting place also belonged to an environment conforming to Hoffmann's artistic ideals. This does not signify that the

formalities connected with death and burial meant especially much to him. When bows for wreaths were imprinted in the School for Arts and Crafts at the death of Otto Wagner, he remarked: "This is disgusting. We ought to vanish in the air" (information from Leopold Kleiner, 26 March 1981).

25. *Jugend in Wien*, catalogue no. 24 of the Schiller Nationalmuseum, Marbach am Neckar, 1974, 291.

26. K. Moser, "Mein Werdegang" (see III/n. 29). Signs of Moser's dissatisfaction with the Wiener Werkstätte became manifest early, as a letter of 25 July 1904 proves (*Jugend in Wien*, 391); serious disagreements with Wärndorfer led to the actual break (letters of 3 and 20 February 1907, Estate) where he writes: "I hold the firm conviction that it can never ever get on a sound basis the way it has been going up to now. . . . Now there are designers who don't understand anything [about business] and an enthusiastic friend of art who is also far from being a businessman—I find that hopeless. The W.W. has gradually become a nightmare for me."

27. Letter from Wärndorfer to Czeschka of 7 September 1908 (Estate COC.): "Zeyner was supposed to do the decorations . . . he left us in the lurch and finally Peppo did the job famously. Hoff also did smart posters . . . now he is just dipping something as a demonstration for the Rossi. He has drawn a Greek costume for the Flora for her . . . which is a real show-stopper."

28. E. Friedell (ed.), *Das Altenberg-Buch*, Leipzig/Vienna, 1922, 303ff., P. Altenberg, *Märchen des Lebens*, Vienna, 1908, 194.

29. *Die Fackel* IX, no. 236, 18 November 1907.

30. M. P. May Sekler, *The Early Drawings of Charles-Edouard Jeanneret (Le Corbusier) 1902 to 1908*, New York, 1977, chap. 7, gives a thorough account of Jeanneret's Viennese sojourn. In addition, Le Corbusier gave me personal information on 13 November 1959 about his memories of Hoffmann and Loos. During his second stay in Vienna in 1911 he sketched the shop of the Wiener Werkstätte.

31. Letter from Wärndorfer to Czeschka of 25 November 1907 (Estate COC.): "Saturday we open the place on the Graben." Hevesi, *Altkunst*, 242.

32. May Sekler, op. cit., 250, 266.

33. May Sekler, op. cit., 269: "Above all the lighting is absolutely remarkable."

34. Ibid., 244, 247 (". . . ugly, uncomfortable, barbaric and childish. . . . How cold, brittle, and stiff that is, and how the devil is it built?").

35. The Jaquemet and Stotzer houses most nearly recall works by the Viennese architects Freiherr von Krauß and J. Tölk, for example, the villa in Grinzing which was published in 1908: *Architekt* XIV, 1908, 159. Hoffmannesque traits appear on later houses by Jeanneret (VI/nn. 35, 39). Amédée Ozenfant once comments on the "somewhat Viennese" character of certain earlier pictures by Le Corbusier; S. von Moos, *Le Corbusier, Elements of a Synthesis*, Cambridge, Mass., 1979, 287. The possible influence of Hoffmann on Jeanneret's pupils is discussed in *La Chaux-de-Fonds et Jeanneret* (catalogue), Musée des Beaux-Arts, La Chaux-de-Fonds, 1983, 52.

36. Letter from Wärndorfer to Czeschka of 11 June 1908 (Estate COC.): "The committee is absolutely incapable, egregious riff-raff. You probably know that Peppo has withdrawn after they made his grandstand decoration impossible for him." Hoffmann and Moser had originally been entrusted jointly with the ornamentation of the Ringstraße (*Neue Freie Presse*, 15 March 1908).

37. Nebehay, *Klimt*, 394.

38. *DK* XI, 1908, 513.

39. D. Frey, "Wesensbestimmung der Architektur," in *Kunstwissenschaftliche Grundfragen*, Vienna, 1946, 93ff.

40. *DKuD* XXIII, 1908-1909, 33.

41. *MBF* VII, 1908, 361; *DKuD* XXIII, 1908-1909, 34.

42. *Wiener Sonn- und Montagszeitung*, 17 May 1909.

43. *Neues Wiener Tagblatt*, 7 June 1908.

44. Compare III/n. 23; Sir Arthur Evans began his publications about the Palace of Knossos in the *Annals of the British School at Athens* for 1899-1905; a report also appeared in the *Journal of the Royal Institute of British Architects* X, 1902-1903. Two scholars who could have contributed to Hoffmann's familiarity with pre-classic decorative forms are Alois Riegl, for many years curator at the Austrian Museum, and the archeologist Georg Niemann, Hoffmann's former teacher at the Academy.

45. D. Klein, *Martin Dülfer*, Munich, 1981, 86, believes he recognizes in the decorations of the green hall in the Lübeck City Theater a resemblance to Hoffmann's wall treatment in the room of the Wiener Werkstätte (Cat. 122). The "Kunstschau" opened on 1 June while the theater only opened its doors on 1 October; the priority would therefore be with Hoffmann. However, the stylistic attitude of the two rooms seems too different to believe in any influence, no matter in which direction.

46. B. Zuckerkandl, "Die Kunstschau," *WAZ*, 19 May 1909, 4; letter from Wärndorfer to Czeschka of 4 February 1908 (Estate COC.).

47. J. Posener, *Anfänge des Funktionalismus*, Berlin, 1964, 20ff.; *HW* III, 1906-1907, 243ff.

48. Exchange of letters between Hoffmann and Cornelius Gurlitt, respectively, Martin Dülfer, Hdschr. I.Nrs. 158.768, 159.112.

49. Ian Latham, *J. M. Olbrich*, Stuttgart, 1981, 137.

50. *MBF* VII, 1908, 265ff.

51. M. P. May Sekler, op. cit., 248.

52. *DKuD* XXIII, 1908-1909, 36.

53. F. von Feldegg, "Die Einheit der Architektur," *Architekt* XIV, 1908, 173.

54. *Die Zeit*, 6 June 1908.

55. *DKuD* XXII, 1908, 338.

56. Cited by L. W. Rochowanski in catalogue of the Kunstschau Vienna, 1927, ÖMKI, 12.

57. *DKuD* XXIII, 1908-1909, 74.

VI. INSPIRATION FROM THE VERNACULAR AND THE CLIMAX OF THE CLASSICIST PHASE (pp. 121-164)

1. *Architekt* XIV, 1908, 174; a thorough, richly illustrated article "Die bodenständige Architektur" is also in the same volume, pp. 65ff. A Ms. with the title *Kultur und Baukunst* (Hdschr. I.Nr. 154.234) is characteristic of Hoffmann's admiration for Kornhäusel. It says: "Compared with Schinkel, he [Kornhäusel] sometimes surpasses . . . , by depth of feeling, charm, still greater simplicity, and well-thought-out consistency."

2. Paul Schultze-Naumburg, *Kulturarbeiten*, vol. I: *Hausbau*, Munich, n.d.; further volumes dealt with gardens, villages, townscape; later Schultze-Naumburg became a leading ideologue of National Socialist cultural policies with books like *Kunst aus Blut und Boden*, Leipzig, 1934.

3. *HW* II, 1905-1906, 70.

4. *HW* III, 1906-1907, 247ff.; J. Posener, *Anfänge des Funktionalismus*, Berlin, 1964, 20ff.

5. Letter from Wärndorfer to Czeschka of 24 June 1908 (Estate COC.).

6. A. W. Pugin, *Contrasts, etc.*, London, 1836.

7. P. Schultze-Naumburg, *Kulturarbeiten* I, foreword.

8. H. Muthesius, *Stilarchitektur und Baukunst*, Mülheim, 1902, 62.

9. *Interieur* XIII, 1912, 71.

10. *Interieur* XIV, 1913, 18.

11. J. Petsch, "Der Deutsche Werkbund 1907 bis 1933, etc.," in L. Burckhardt (ed.), *Der Werkbund*, Stuttgart, 1978; R. Hamann, J. Hermand, *Stilkunst um 1900*, Munich, 1973.

12. L. Bauer, *Verschiedene Skizzen, Entwürfe und Studien*, Vienna, 1899, 26; Bauer writes

about "the applicability of some of Darwin's principles to our arts and trades" and ends by saying: "The lasting element of a concept of beauty is always the inherent element of functionality."

13. *DKuD* XVIII, 1905-1906, 164.
14. H. Muthesius, "Wo stehen wir?" in J. Posener, *Anfänge*, 190.
15. *HW* IV, 1908, 254.
16. Ibid., 369.
17. *Neues Wiener Tagblatt*, 7 June 1908, 3ff.
18. M. Eisler, "Josef Hoffmann," in *Almanach der Dame*, Vienna, 1931, 12.
19. Hevesi, *Altkunst*, 231ff.; designs by Lebisch: *HW* II, 1905-1906, 186ff.; *DKuD* XIX, 1906-1907, 161ff.; *Studio* XXXIX, 1907, 323ff.; *MBF* VII, 1908, 402ff.; *Jung Wien*, Darmstadt, n.d., 14-19. Hoffmann could have received suggestions for garden design from A. Lichtwark's writings (*Makartbouquet und Blumenstrauß*, Munich, 1894, and *Blumenkultus*, Berlin, 1902), as he hinted in a lecture of 22 February 1911 (see Appendix, "My Work").
20. *HW* III, 1906-1907, 8, 47.
21. B. Zuckerkandl, *Zeitkunst*, Vienna, 1908, 62.
22. *HW* I, 1904-1905, 253.
23. See I/n. 1, 118.
24. Hoffmann tried to induce Tessenow to return to Vienna: *Heinrich Tessenow*, catalogue of HFAK, 1976, 29.
25. *Profil* III, 1935, 238.
26. For information kindly provided about Dr. Koller I owe thanks to Mr. Helmut Frais, Oberwaltersdorf.
27. F. Novotny, J. Dobai, *Gustav Klimt*, Salzburg, 1967, 354, 359.
28. See VI/n. 1.
29. *Architekt* III, 1897, p. 47; VIII, 1902, 44.
30. The following data are partly based on information kindly provided by Mrs. Mäda Primavesi, Montreal.
31. See I/n. 1, 119.
32. *DK* XVIII, 8 May 1915, 233ff.; *DKuD* XXXVIII, 1916, 199ff.
33. Undated letter (between 1915 and 1918) (Estate).
34. *HW* I, 1904-1905, 223.
35. In his Schwob Villa (1916), Le Corbusier has a triangular niche above a door which, like the built-in shelves next to the doorway, are very reminiscent of Hoffmann. Illus., *L'Esprit Nouveau*, no. 6, 701.
36. Letter of 11 September 1913, Hdschr. I.Nr. 172.569.
37. *Döblinger Bezirksblatt*, II, 1914, no. 25 (15 May), 1ff.
38. A letter of 19 April 1901 from Bernatzik to Hoffmann (Estate) contains thanks for a cordial letter and mentions some embarrassing affair: "There is just no excuse for having provoked such a scene in a public place."
39. Le Corbusier's Favre Jacot Villa (1912) and the villa for his father (1912) are houses which are strongly indebted to the same ideal image and probably also to direct models by Hoffmann. In connection with his journey to the Orient, Le Corbusier was once more in Vienna in 1911.
40. Kleiner, Appendix.
41. P. Portoghesi, *L'Eclettismo a Roma 1870-1922*, Rome, n.d., 169; G. Accasto et al., *L'Architettura di Roma Capitale 1870-1970*, Rome, n.d., 363ff.; *Steine sprechen*, nr. 70/71, December 1982, 20ff.
42. *DKuD* XXIX, 1911-1912, 397.
43. H. Fischl in *DK* XX, 1912, 261.
44. Kleiner, XXIX.
45. A new volume of the plan journal of Hoffmann's studio begins in October 1913 with the entries no. 3457, Main Cornice 1:1, Skywa House, and 3458, perspective for Cologne, drawn by Max Fellerer. The preceding volume has unfortunately not been found. The two extant plan journals which go to 1939 are in the Haerdtl Estate.
46. Unpublished reminiscences by Mäda Primavesi, Montreal, cited by kind permission of the author.
47. *DKuD* XXXVII, 1915-1916, 343.
48. *DK* XIX, 1915-1916, 15.
49. *DK* XVII, 1914, 530.
50. Ibid., 544.
51. R. Breuer, *Deutschland's Raumkunst, etc., zu Brüssel 1910*, Stuttgart 1910. Emanuel von Seidl built a machinery hall with columnar orders, mansard roof, and dormers for this exhibition, and Muthesius reported: "The regressive tendencies which have recently cast their spell over some of our interior designers are especially incomprehensible to foreigners" (*DKuD* XXVII, 1910-1911, 35).
52. *DK* XVII, 1914, 29ff.
53. *Journal of the American Institute of Architects* II, 1914, 420ff.
54. A. Heilmeyer in *Kunst und Handwerk*, LXIV, 1913-1914, 275.
55. *Architekt* XX, 1914-1915, 18.
56. Nebehay, *Schiele*, 306.
57. *DK* XVII, 1914, 470; W. C. Behrendt, *Kunst und Künstler* XII, 1914, 620, viewed these things less positively: "The special character of this very elegant and tastefully designed house, its strength, but also its weakness, rests on the fact . . . that it is felt as an expression of the same spirit . . . which fills the arts and crafts shown in its interiors."—"And thus the formal unity of these arts and crafts products also does not appear as style . . . but as the result of a precocity prematurely created in a hothouse atmosphere."
58. *Berliner Architekturwelt* VIII, 1905-1906, 29ff., 110, 224; J. Posener, *Berlin etc.*, Munich, 1979, 103ff.; letter of Wärndorfer to Czeschka of 20 November 1910 (Estate COC.): ". . . Paul sticks strictly with Peppo,—does simply everything,—that Hoffmann does."
59. *Architekt* XVII, 1911, 76; XX, 1914-1915, 38, 39, pl. 67; additional examples showing Hoffmann's influence, in D. Deshoulières, H. Janneau, *Rob Mallet-Stevens, Architecte*, Brussels [1980], 163-189. According to R. Becherer, corroborated by Rachel Wischnitzer, Mallet-Stevens worked in Hoffmann's office in Vienna. *Journal of the Society of Architectural Historians*, XXXIX: 1, March 1981, 44ff. and XLII: 3, October 1983, 312.
60. H. Bobek, E. Lichtenberger, *Wien, Bauliche Gestalt, etc.*, Graz, 1966, 103.
61. Wärndorfer's description of the events is found in letters of 23 February and 7 April 1914 to Czeschka (Estate COC.): ". . . after I had put my last penny into the WW and could not go on, moneymen were found who got behind Hoffmann and Wimmer (mainly), who took over the WW and—pushed me out. The director is a Mr. Kurz (former exporter, then in the iron business) who on his first day of activity . . . announced that he was introducing piecework. . . . Peppo is a child! With a spark of energy he could have patched up everything" (see also III/n. 28).

"Hoff has found a millionaire-sucker in Primavesi and has then thrown me out. . . . The financial people have begun with 800,000 crowns and today have already subscribed another 200,000 crowns. They are losing and will lose everything (unfortunately also my last share) because one cannot make money with the WW. . . . But Hoff now has his entertainment, buys masses from his students. . . . I have a program to earn the lost money again for my family. . . . Were you in Cologne? Peppo's house is said to be brilliant."

VII. THE CLIMAX OF THE DECORATIVE PHASE AND THE INSPIRATION FROM CUBISM AND EXPRESSIONISM (pp. 165-193)

1. *DKuD* LIV, 1924, 161ff.
2. *ID* XXVIII, 1917, 84; on Peche, see H. Ank-

wicz-Kleehofen, "Dagobert Peche," in *Ausstellung von Arbeiten des modernen Österreichischen Kunsthandwerks*, Dagobert Peche Memorial Exhibition (catalogue), Vienna, ÖMKI, 1923; M. Eisler, *Dagobert Peche*, Vienna, 1925.

3. W. Frank, "Neue Arbeiten von Dagobert Peche," *DKuD* XLV, 1919-1920, 78.

4. *L'Amour de l'Art* IV, 1923, 652 (translation by the author).

5. Letter of 10 February 1912 in which Lendecke, among other things, asks Hoffmann to help him by an on-account payment from the Wiener Werkstätte (Estate).

6. B. Zuckerkandl, *Neues Wiener Journal*, 25 November 1923, and *Österreich intim*, Frankfurt, 1970, 100ff.; M. Battersby, *The Decorative Twenties*, New York, 1969, 122ff. Poiret organized a fancy dress ball on 8 March 1923 in the Vienna Konzerthaus.

7. P. Poiret, *En habillant l'Epoque*, Paris, 1930, 114ff. It is not surprising that Poiret in his memoirs writes rather negatively about what he saw in Vienna, as the memoirs were published after the First World War, and furthermore had the purpose of stressing Poiret's originality, not to point out influences on his work. He even used a fabric of the Wiener Werkstätte for an evening gown for his wife. R. Rosenthal and H. L. Ratzka, *The Story of Modern Applied Art*, New York, 1948, 42.

8. In a letter of 1925, Camilla Birke reports to Hoffmann from Paris about the exhibition and mentions expressly: ". . . Léger who always has a good laugh when he sees me in my voluptuous Austrian plumpness and sends you his cordial regards" (Estate Ro.).

9. *L'Amour de l'Art* VI, 1925, 289: ". . . toute la production moderne dans la domaine des arts décoratifs évolue sous le signe du cubisme."

10. *ÖBWK* I, 1924/1925, 338; the inventory of the library of the Wiener Werkstätte (now in James May Collection, New York) reveals other sources of influence; in addition to technical books it includes works about Chinese, Indian, Islamic, Hittite, ancient Mexican, African, and prehistoric art.

11. Letter to Karla Hoffmann of July 1971, ADV.

12. Advertisements and news items in *Architekt* XXIII, 1920, XVIIIff., cast a significant light on the distress of the time. Here a cost-of-living increase of 145 percent for the month of September is fixed for building trade employees; the opportunity of participation in a communal kitchen for architects is announced; an appeal is made and payment offered for a surplus drafting set. . . . Hoffmann himself had the advantage of direct connections with agriculture through members of his family in Pirnitz.

13. *Die Waage*, 2 October 1920; H. Tietze in *Der Neue Tag*, 1 February 1920; *Kunstchronik*, 13 August 1920. At that time Hoffmann founded a Vienna chapter of the German Werkbund; Oerley continued to lead the Austrian Werkbund.

14. *Mitteilungen der Festspielgemeinde Salzburg* III, 1920, no. 3, 1; in a letter of 21 December 1921, Joseph Urban informed Hoffmann that he had spoken with Richard Strauss about the Festival House and Hoffmann (Hdschr. I.Nr. 162.090).

15. R. Corwegh, Emanuel Margold, *Wasmuth's Monatshefte für Baukunst* VI, 1921-1922, 241ff.; D. Frey, "Gegen Taut und Margold," *Architekt* XXIV, 1921-1922, 33ff.

16. K. H. Schreyl, *Joseph Maria Olbrich, etc.*, Berlin, 1972, 49ff.; K. Kraus, *Die Fackel*, no. 59, November 1900, 19, mentions: "It is well known that Mr. Moll is art agent for the . . . coal profiteer Berl"; this confirms the interest in art of the Berl family which also benefited Hoffmann.

17. R. Arnheim, *Art and Visual Perception*, Berkeley, 1974, 239ff.

18. F. Novotny, J. Dobai, *Gustav Klimt*, Salzburg, 1967, pl. 111.

19. Ibid., pl. 2 illustrates the portrait of young Sonja Knips.

20. M. Battersby, op. cit., 47.

21. *L'Amour de l'Art* VI, 1925, 321: ". . . la chambre de repos pour une dame et qui semblerait destinée à un but spécial si, près de la porte d'entrée, n'était un petit panier contenant des pelotons de laine évoquant l'ombre de la sage et fidèle Pénélope."

22. Y. Brunhammer, *1925*, Paris, 1976.

23. "Mr. Loos is a native of Brünn and has opted for Czechoslovakia. He told me this at the time when I looked him up to invite him to collaborate at the Paris Exhibition . . . which he unfortunately declined as he did not want to have anything to do with Vienna and Austria ever again" (*Neues Wiener Journal*, 2 July 1927).

24. It had been discussed in the Hoffmann studio what could be done to avoid these colored panes. Hoffmann solved the problem at a meeting with Behrens whom he often met in a café. He suddenly asked him: "Say, do you really still like the horrible colored pieces of glass?" (information courtesy of Prof. Herbert Thurner).

25. *Art et Décoration* XLVII, 1925, 121: "Hoffmann . . . sensible artiste qui s'enthousiasme pour une ligne et pendant des mois en cherche amoureusement les multiples applications, au point qu'elle permet de dater les oeuvres du maître d'année en année." ("Hoffmann . . . the sensitive artist who is enthusiastic about a line and lovingly searches for months for its various applications, to the point that it permits dating of the master's works from year to year.")

26. Rochowanski, 43, whose formulation resembles that of Paul Clemenceau: "The Austrian Pavilion, this precious jewel box, offers us more than art. It is the *Weltanschauung* of a people of genius" (*Neues Wiener Journal*, 12 May 1925).

27. Letter to the author of 25 March 1959.

28. Painlevé said: "La formule que vous, cher Monsieur Hoffmann, avez trouvé pour mettre en valeur le génie du peuple autrichien, est une des plus belles et des plus veridiques révelations d'art, que je connais." ("The formula you, dear M. Hoffmann, have found to present the genius of the Austrian people, is one of the most beautiful and most truthful revelations of art I know.") The Secretary General, Yvanhoé Rambosson, wrote in the special exhibition issue of *l'Illustration*: "L'impression est fort agréable. . . . Hoffmann . . . a créé là un lieu d'accueil et de repos aux lignes aimables, à la fois familières et aristocratiques."

29. P. Léon, *Rapport Général*, Paris, 1928, vol. II, 59: ". . . qu'il n'est pas l'homme d'une formule et qu'en lui, la raison pratique s'accorde avec le fantaisie propre à l'art autrichien . . . les surfaces ondulées . . . paraient d'une grâce singulière des galeries éphémères."

30. *L'Architecte*, n.s., 1925, 102: "l'élégance discrète, un peu précieuse du Leopoldinischer Trakt," ". . . peut-être un peu trop traité en décorateur éfféminé."

31. *L'Amour de L'Art* VI, 1925, 309: "L'on peut aimer cela ou ne pas l'aimer; l'on ne saurait nier que cela offre une incontestable séduction, un peu dangereuse, un peu perverse peut-être, mais où s'exprime bien le goût composite autrichien."

32. Ibid., 338: "l'Autriche, ce vieux pays, montre la sensibilité d'avant-garde d'une jeune nation. La présentation des objets innombrables réunis au Pavillon d'exterieur sévère qui borde la Seine, est une des plus originales, des plus gaies malgré le parti pris d'un encadrement noir et blanc autour des vitrines de la grande salle."

33. Information courtesy of Prof. Herbert Thurner.

34. G. Veronesi, *Into the Twenties*, London, 1968, 230; Brunhammer, op. cit., 117ff.

35. Ch.-E. Jeanneret, *Étude sur le mouvement d'art décoratif en Allemagne*, La Chaux-de-Fonds, 1912, 15; *ID* XXVII, 1916, 234; H. van

de Velde, "Die Orientierung des Geschmacks in der Innenarchitektur," *Prager Presse*, 10 July 1925.

36. C. A. Glassgold in *The Arts*, XIII, no. 4, April 1928, 221. Some examples of Hoffmann's influence in the fields of architecture and interior design, without claiming completeness, are: the use of multiple framing on the Pavilion Studium-Louvre; the chairs by Jean Dunand in the smoking room of the French embassy (compare the interior by Dunand in M. Battersby, *The Decorative Thirties*, London, 1969, 39); the chalice form of the table base in the ladies' salon of the same embassy which recalls the table Otto Prutscher showed in Cologne in 1914; works by Poiret's Atelier Martine and by Francis Jourdain (*Art et Décoration* XLVII, 1925, 135; Veronesi, op. cit., illus. 188). In the field of arts and crafts, there are numerous further examples in works by Raoul Dufy, Sonja Delaunay, Jean Puiforcat, and others.

37. VII/n. 28: ". . . Hoffmann, le plus célèbre architecte de l'Europe centrale, directeur intellectuel des art appliqués autrichiens depuis vingt-cinq ans."

38. S. Cheney, *The New World Architecture*, London, 1930, 283; E. A. Plischke, *Vom Menschlichen im neuen Bauen*, Vienna, 1969, 19; *Ely Jacques Kahn (Contemporary American Architects)*, New York, 1931, illustrates several examples which recall Hoffmann. The resemblance between Kahn's Léron shop front (1931) and Hoffmann's branch of the Wiener Werkstätte in Berlin (1929, Cat. 317) is especially striking.

39. R. Rosenthal and H. L. Ratzka, *The Story of Modern Applied Art*, New York, 1948, 169, 173; for the reference to the relationship I owe thanks to Prof. Edgar Kaufmann, Jr.

40. Letter from Wärndorfer to Hoffmann of 28 February (without year) (Estate).

41. C. A. Glassgold in *The Arts* XIII, no. 3, March 1928, 160: ". . . the most venerable, stimulating and fertile figure of the Austrian architects."

42. Ascherman writes in a letter of 10 December 1907 to Hoffmann (Estate): "I would so much like to have some of your students here. It would be so much easier . . . to work with someone . . . who has the same direction." (Ascherman's name also occurs in the Americanized form Asherman.) *Arts and Decoration* IV, June 1914, 300.

43. R. Rosenthal, op. cit., 158; *The Arts* XIII, no. 4, April 1928, 233. Schoen's display room for the L. C. Smith & Corona Typewriter Co. on Fifth Avenue (1926), which was termed "the first really modern office interior in America," strongly recalls interiors by Hoffmann. The latter illustrated his article in the *Encyclopaedia Britannica* with an interior by Schoen.

44. D. Frey, "Arbeiten eines österreichischen Architekten in Amerika, etc.," *Die bildenden Künste* I, 1916-1918, 137ff.; P. T. Frankl, *New Dimensions, etc.*, New York, 1928; information courtesy of Prof. Edgar Kaufmann, Jr.

45. Letter, 11 July 1909, to H. Bahr, Theater Collection, Austrian National Library.

46. In 1913, Robert Rosenthal arranged acceptance of a fabric collection of the Wiener Werkstätte by John Wanamaker's department store; he was able to buy back the patterned silks below the sales price (D. Frey, op. cit., 142). In October 1928, Kuno Grohmann was in New York where he rented a suite in the Waldorf Hotel for display of his collection of samples and also got in touch with Urban. In 1929, Vally Wieselthier herself came to the United States where she became, among other things, a collaborator in the arts and crafts firm "Contempora," organized by Paul L. Wiener (*DKuD* LXIII, 1929, 39ff.). Marianne Wallisch, the Secretary of the Austrian Werkbund, who later settled in Chicago, was also active with propaganda for Austrian arts and crafts in the years 1928 and 1934.

47. L. V. Solon, "The Viennese Method of Artistic Display," *Architectural Record* LIII, 1923, 266.

48. Letters by Wimmer to Hoffmann (31 May, 1 June 1923, Estate Ro.) reveal that there were disagreements between Urban, Häusler, and Wimmer.

49. W. Creese, *American Architecture 1918-1933, etc.* (Harvard Univ., Ph.D. thesis), 1950, pt. II, 8; Hoffmann had used the color scheme black-gold in 1907 on the exterior of a building, namely at the salesrooms of the State Printing Office (Cat. 116).

50. R. Rosenthal, op. cit., 173.

51. Through the activity of the Austrian Werkbund in the United States (see VII/n. 46), through Wärndorfer and in connection with Cat. 343.

52. P. Bonta, *An Anatomy of Architectural Interpretation*, Barcelona, 1975.

53. Brunhammer, op. cit., 108; "Si son architecture n'apporte plus grand chose à une oeuvre essentielle, il faut lui savoir gré d'avoir fait appel à . . . Peter Behrens pour édifier . . . une serre suprématiste de toute beauté." ("If his architecture contributed no more to an essential work, we owe to him that he called Peter Behrens to erect . . . a suprematist glasshouse of complete beauty.")

54. The architect J. Hiriart wrote: "Austria, where the Rococo is peppered with barbaric naiveté," in *Les arts décoratifs modernes 1925*, special issue of *Vient de Paraître*, Paris, 1925, 155; W. George discussed most of the foreign pavilions, but not the Austrian, in *L'Amour de l'Art*, VI, 1925, 290ff.

55. *Art et Décoration* XLVII, 1925, 176: ". . . pas de remplacer un système décoratif périmé par un autre système . . . mais bien de réviser les programmes fondamentaux."

56. W. George, op. cit., 283ff.: ". . . l'art dit décoratif n'est q'une recherche arbitraire du nouveau . . . l'art décoratif moderne . . . est anti-social, antidémocratique . . . le faux luxe est la note dominante de toute l'exposition . . . au point de vue social l'Exposition de 1925 est une faillite totale . . . avec le théâtre de Perret, les deux pavillons de Robert Mallet-Stevens et le Pavillon de l'U.R.S.S., la Villa de 'L'Esprit Nouveau' est le seul édifice de toute l'exposition qui puisse être qualifié de moderne."

57. Haerdtl, 22.

58. F. Kiesler (ed.), *Katalog Programm Almanach, Internationale Ausstellung neuer Theatertechnik*, Vienna, 1924; some of the artists represented by works were Léger, Schlemmer, Moholy Nagy, Schwitters, El Lissitzky, Schreyer, Chagall, Vesnin, Exter, Braque. In the same year, Theo van Doesburg gave a lecture in Vienna.

59. Letter of 19 October 1926, ADV.

60. Letter of October 1927, ADV.

61. In addition to numerous positive press reports, there also appeared attacks against Hoffmann which began with a review in the *Neue Freie Presse*, 11 July 1925; this contribution and another attack in the *Neues Wiener Journal*, 25 July 1925, were not signed with names. B. Zuckerkandl defended Hoffmann in the same paper, 19 July and 1 August 1925, 21 February 1926. It was blamed that the showcases had been too high, the corridors too narrow, and that cronyism had prevailed in the selection of exhibits. Leopold Bauer, *Sonn- und Montagszeitung*, 15 February 1926, even speaks of intolerable "despotism." Furthermore, it was deplored that the exhibition had been a financial failure. Relevant newspaper clippings: WWA.

62. On 20 February 1927, Loos gave a lecture against the Viennese cuisine, and on 20 April one against the Wiener Werkstätte; this prompted Hoffmann to close his reply (*Neues Wiener Journal*, 2 July 1927) with the words: "But if our work is at least remotely as good as the apricot dumplings so attacked by Mr. Loos, then I am quite content." The lecture in April was discussed by many Viennese

newspapers; newspaper clippings: WWA.
63. *DKuD* LXI, 1927-1928, 69ff.
64. *Neues Wiener Journal*, 20 May 1928, 20.

VIII. THE COMING TO TERMS WITH THE MODERN MOVEMENT AND NEW ARCHITECTURAL SOLUTIONS IN HOUSING (pp. 194-218)

1. Postcard from Ivar Tengbom to Hoffmann of 26 December 1927 (Estate Ro.): "Dear Hoffmann, I admire the simplicity of your solutions and the elegance of your drawings. . . . But in Geneva it has just gone to the devil. Lemaresquier laughs and little Johnny nods. And we look stupid. I find it outrageous. As I always said, it would have been better if the minority had made a definite proposal without compromising and had then departed." Hdschr. I.Nr. 158.394, H. P. Berlage to Hoffmann on 11 January 1928: "We are all outraged over the sad outcome of Geneva; unfortunately that was to be expected."
2. S. Daria, *Le Corbusier*, Paris, 1964, 66: "Le Corbusier a, de la manière si sérieuse qu'on lui connaît, admirablement reconnu les bases du programme et en trouvé la plus poignante expression . . . il apporte une solution parfaite, claire et simple, représentant un gros pas en avant."
3. Typed account, dated by another hand: 21 June 1927, ADV; *Die Stunde*, 15 February 1928; Hoffmann also took part in the preparation of the competition announcement.
4. Information of 29 September 1981, courtesy of Architect Philipp Ginther, Innsbruck, who as a student of Witzmann was in Paris at that time.
5. Information of 14 September 1969, courtesy of Miss Christa Ehrlich, The Hague, who traveled with Hoffmann from Leipzig to Stuttgart.
6. He traveled in company with A. Vetter; information courtesy of the late Prof. Hans Vetter, Pittsburgh.
7. Letters of 29 September and 21 October 1924 from Walter Gropius to Hoffmann (Estate).
8. M. Steinmann (ed.), *CIAM Dokumente 1928 bis 1939*, Basel, 1979, 33 n. 1.
9. Typed account (Estate Ank.).
10. O. Niedermoser, *Oskar Strnad*, Vienna, 1965, illus. 29.
11. Hoffmann said: ". . . experiments like those made in Stuttgart last year strongly recall his ideas and intentions. The stair railing in his own house in the Döblergasse . . . could be in Stuttgart." (See Appendix, "Memorial Address at Otto Wagner's Grave.")

12. *Menorah* VII, 1929, 95.
13. D. Deshoulières, H. Jeanneau, *Rob Mallet-Stevens, Architecte*, Bruxelles, n.d. (1980), 239.
14. Robert Breuer, in *DKuD* LXVI, 1930, 322.
15. Letter of 15 August (1936) from Carl Moll to Hoffmann (Estate): ". . . the idea will now certainly be supported from above as it is in the spirit of the time."
16. *ID* XLIII, 1932, 419.
17. *Die Form* V, 1930, 86.
18. See VIII/n. 14.
19. *Die Form* IV, 1929, after 618.
20. *Arbeiter-Zeitung*, 9 August 1925; *Neues Wiener Journal*, 21 February 1926.
21. *Der Tag*, 19 July 1925, 8; 12 August 1925, 5; 26 August 1925, 7; surprisingly, Ermers later wrote a veritable hymn of praise about Hoffmann, which begins: "Hoffmann has always been the best teacher" and ends with an appeal to the City of Vienna to employ Hoffmann because he had "still much to say." *Der Tag*, 18 December 1927.
22. Two handwritten accounts (Estate Ro.).
23. J. Spalt, H. Czech, *Josef Frank*, Vienna (HFAK), 1981, 141.
24. L. Foltýn, *Geschichte der Architektur in der Slowakei 1918-1938* (unpublished Ms.), information courtesy of Arch. Ing. Ján Bahna., Bratislava.
25. Letter from Leopold Kleiner of 27 April 1964 to the author.
26. Letter from Josef Frank of 7 April 1964 to the author.
27. Letter of 26 March 1933 to Max Welz. (See Appendix 15.)
28. *Architekt* XXIV, 1921/1922, 38.
29. *Der Aufbau* I, 1926, 166.
30. *Die Form* V, 1930, 400.
31. E. Plischke, "Josef Frank wie ich ihn kannte," in J. Spalt, H. Czech, op. cit., 8.
32. J. Frank, *Architektur als Symbol*, Vienna, 1931, 27.
33. *Die Form* VII, 1932, "Mitteilungen des Österreichischen Werkbundes," supplement to no. 4.
34. Letter of 14 July 1932 from Max Welz to Hermann Neubacher (Estate).
35. For providing valuable information (*Werkbund-Mitteilungen*, leaflets, invitations, and the like), I owe thanks to Prof. Karl A. Bieber. I also have to thank Prof. Ernst Plischke for valuable references.
36. Hdschr. I.Nr. 172.570, dated 1 March 1934.
37. Undated draft of letter (Estate Ro.).
38. Haerdtl, 32, 34.
39. *Kunstgewerbeausstellung, Das befreite Handwerk*, exhibition catalogue, Vienna, ÖMAK, 1934.

40. *Architectural Association Quarterly*, VIII, 1976, no. 3, 37.
41. (Estate Ank.); typed copy dated July 1936.
42. Information courtesy of Mrs. Carmela Haerdtl of 6 November 1977.
43. Letter from Wiener of 10 August 1935 to Hoffmann: (Estate). Copy of an undated letter from Pirnitz of Hoffmann to Wiener: ADV.
44. C. Holzmeister, *Architekt in der Zeitenwende, Sakralbau, Profanbau Theater*, Salzburg, 1978, 178ff., where the competition projects of some other participants are also illustrated.
45. Le Corbusier, P. Jeanneret, *Oeuvre Complète 1929-1934*, Zurich, 1935, 123ff.

IX. THE LATE WORK (pp. 219-229)

1. Letter of 19 October 1926, ADV.
2. A Jewish colleague wanted to keep out of Hoffmann's way in the last days before emigration in order not to embarrass him. He testified that Hoffmann called loudly from his accustomed coffeehouse garden on the Ringstraße: "Come on, don't leave! This won't last." (Information courtesy of the architect Ernst Schwadron, New York, 5 April 1966.)
3. *Richtlinien für Neueinrichtung unserer Kunstschulen*, Ms. dated March 1938 (Estate Ro.); *Vorschläge zur Reorganisation des Kunstunterrichts*, Ms. dated April 1938 (Estate Ank.).
4. Information courtesy of Prof. Ernst Plischke.
5. *Völkischer Beobachter*, 17 December 1940, 8 June 1941.
6. *Die Pause* VII, 1941-1942, 12ff.
7. *Völkischer Beobachter*, 19 February 1944.
8. Manuscript of an undated account, Hdschr. I.Nr. 151.369.
9. Undated copies (Estate Ank.).
10. Compare the works by Breuhaus in *ID* XLIII, 1932, 123ff., XLIV, 1933, 280, with those in *ID* L, 1939, 1ff., LI, 1940, 19ff.
11. *Neues Wiener Journal*, 17 July 1936, undated Ms., *Vorschläge zur Mode*, ADV, in which Hoffmann declares among other things: "We must be . . . modern, i.e., we must not refer back too much to old dead things. It is impossible to imagine the chauffeur of an auto in the Old Viennese costume of a coachman. . . . Our eternal inspiration will always be Antiquity and the Orient, especially Chinese Art. . . . We must advance to a unified form . . . England . . . instinctively knows only the city cut, and avoids every attempt at country folk costume which often leads to costume ball-like

aberrations of taste. . . . Respect for the frequent genius of the design of such folk costumes should force us not to masquerade frivolously in them."

12. *Die Pause* V, 1939-1940, 50ff.

13. Letter of 20 October 1952 from London (Estate).

14. *Wiener Zeitung*, 23 December 1945, 21 April 1946 (see Appendix, "Thoughts on Vienna's Reconstruction").

15. In a letter to a newspaper of 23 April 1931 (Estate Ank.), Hoffmann, for example, protests vehemently against the result of the restoration of the Palace of Justice: "Now when the last coverings fall . . . we must despair of everything, and it would be best to emigrate." In the *Neues Wiener Journal* of 17 February 1935, he gave a Utopian description of how he imagined Vienna in the year 2000 (see Appendix 17).

16. Undated writings (Estate Ank., Estate Ro.).

17. He referred either to the project by Ceno Kosak or to that by Alfred Kunz and Eduard Sekler.

18. Written copy (Estate Ank.).

19. Lecture notes (Estate); notes taken by the author at the lecture on 14 December 1951.

20. Information courtesy of the architect Anton Eigner who worked for Hoffmann and Kalbac at the time; several original sketches are extant (Estate Ka.).

21. The design for the pergola by Hoffmann's own hand is extant (Estate Ka.).

22. *Die Pause* I, 1936, 66ff.

23. See IX/n. 14.

24. Letters from Hermann Neubacher, Adviser and Administrative Commissioner of the Municipality of Addis Ababa, to Josef Hoffmann, beginning with the date 12 August 1954 and ending with 30 December 1955 (Estate). H. Neubacher, *Die Festung des Löwen etc.*, Olten 1959, 253.

25. Between the luxurious volume *Viribus Unitis* (Cat. 15) of 1898 and the binding for L. W. Rochowanski's Hoffmann book of 1950 there is a long series of bindings or title pages, among others for books by L. Hevesi, B. Zuckerkandl, R. Muther, and L. W. Rochowanski. In addition there are luxurious bindings in leather with gold stamping which were made in the Wiener Werkstätte after designs by Hoffmann, and the *Almanach* of the WW. Compare *Art Revival*, D 14; *DKuD* XIX, 1906/1907, 77; XXII, 1908/1909, 110, 111; LI, 1922-1923, 375; LXVIII, 1931, 120.

26. *Kunst im Volk*, 1949, no. 3/4, 175; W. Riemerschmid, *Wir fingen einfach an*, Munich, 1953, 10; Rochowanski, 16ff.

27. M. Eisler, *Dagobert Peche*, Vienna, 1925, 70, 98.

28. Le Corbusier, P. Jeanneret, *Oeuvre Complète, 1929-1934*, Zurich, 1935, 132.

29. *Interieur* II, 1901, 5, 15; *Jung Wien, Ergebnisse aus der Wiener Kunstgewerbe-Schule*, Darmstadt, n.d., 50ff.; Le Corbusier, *Creation Is a Patient Search*, New York, 1960, 24, 25.

30. Henri Matisse, who chose this quotation as the title of one of his most famous pictures, is an exact contemporary of Hoffmann's generation; his dates are 1869-1954.

X. HOFFMANN, THE MAN, THE ARTIST, AND THE TEACHER (pp. 231-246)

1. For oral and written information about Josef Hoffmann, I owe thanks to the following persons (the dates of the respective interviews or letters are given after the names): Karl Augustinus Bieber, 10 January 1979; Camilla Birke, 6 November 1977; Rohtraut Brauneis, 14 November 1979; Max Bude, 8 September 1966; Christa Ehrlich, 14 September 1969; Philipp Ginther, 17 April 1980; Gabriel Guevrekian, 25 March 1959; Carmela Haerdtl, née Prati, 11 September 1970, and on several other occasions; Karla Hoffmann on many occasions during more than twenty years; Wolfgang Hoffmann, 25 March 1967; Viktoria Kalbac, 20 November 1981; Leopold Kleiner, 27 April 1964, and on several other occasions; Aloys Ludwig, 9 and 10 June 1967; Mäda Primavesi, 24 June 1981; Ernst Schwadron, 5 April 1966; Pola Stout, 23 April 1973; Professor Alfred Soulek, 23 September 1981; Anton Tedesko 1 April 1975; Herbert Thurner on many occasions during more than twenty years; Rudolf Wesecky, 10 September 1980; Katharina (Kitty) Winkler, née Speyer, 24 May 1972; Viktor Winkler, privately duplicated Ms. of lecture, 1970, and 23 September 1971.

2. Winkler, op. cit., 2.

3. Rohtraut Brauneis.

4. Ernst Schwadron.

5. Winkler, op. cit., 1.

6. Carmela Haerdtl.

7. Leopold Kleiner, 26 March 1981.

8. Kleiner, Schwadron.

9. As a student, Hoffmann lived in Vienna VI, Engelgasse (now Girardigasse), until 1901, Vienna VI, Magdalenenstraße 12, then in the Margaretenstraße 5, in the Münzgasse 5 and Neulinggasse 24; 1920-1939 Vienna IV, Schleifmühlgasse 3/Paulanergasse 12, and finally Vienna III, Salesianergasse 33, where there is now a memorial plaque.

10. "You know, we were never very close." Interview of 25 March 1967.

11. Aloys Ludwig (see I/n. 5).

12. Announcement of the ball in *Architekt* III, 1897, 4.

13. Handwritten dedication dated November 1909, in a volume of *Bilderbögen des kleinen Lebens*, ADV (see Appendix 6).

14. Copy of an undated Ms. from the 1920s, ADV; Guevrekian: "His comments on his contemporary colleagues were, even for his principal enemy Adolf Loos, always fair and moderate." Winkler, op. cit., 2, reports how Hoffmann reproached his students for not having gone to a lecture by Loos, because "when such an important man has something to say, we are absolutely obligated to listen." According to his own testimony he invited Loos to participate in the Paris Exhibition of 1925 but Loos declined; *Neues Wiener Journal*, 2 July 1927.

15. Hevesi, *Altkunst*, 310; H. Malmberg, *Widerhall des Herzens*, Munich, 1961, 28.

16. An undated draft of a letter (Estate Ro.) for a written apology to the President of Austria reveals that Hoffmann declined to accept an Austrian decoration of lower rank after he had received the commander's cross of the French Legion of Honor, in order to demonstrate "against the old . . . custom to distribute decorations not for actual merit but in consideration of some extraneous circumstances." Since this refusal Hoffmann was not popular in the ministry involved. The conduct of the Austrian authority did indeed conform to the usual customs.

17. Undated ms. (Estate Ro.).

18. Thurner.

19. Undated letter (1927?), ADV; plus additional information from Christian M. Nebehay.

20. Thurner.

21. Kitty Speyer.

22. Letter of 25 March 1959.

23. Carmela Haerdtl, Rohtraut Brauneis; in this respect Hoffmann was strongly influenced by Mrs. Primavesi.

24. Letters of 19 October 1926, 16 March 1927, and 18 December 1927, ADV; letter from Wärndorfer of 23 June 1923, Hdschr. I.Nr. 151.382: ". . . why are you angry that you forget what you read?"

25. Haerdtl, 14.

26. Undated letter from Czeschka (Estate) with warning to Hoffmann not to go to Darmstadt; exchange of letters with Cornelius Gurlitt and Martin Dülfer about a call to Dresden: Hdschr. I.Nrs. 158.768, 159.112-113; information from Pola Stout about Hoffmann being invited to come to New York in the 1920s.

27. Report about the reasons for the separation

of the Architectural Office from the Wiener Werkstätte (Estate).

28. Thurner; F. L. Wright, *An Autobiography*, New York, 1977, 571.

29. C. Birke and data from an official interview of Hoffmann of 20 July 1942 (Archive Prof. Johannes Spalt); these also reveal that he was interested in Chinese literature, and that he considered "the Wiener Werkstätte, its origin, its life and work, and its collapse" as his greatest experience.

30. *Festschrift*, 10.

31. Le Corbusier, P. Jeanneret, *Oeuvre Complète 1910-1929*, 7th ed., Zurich, 1960, 128.

32. Winkler, op. cit., 2.

33. Karla Hoffmann, 24 August 1976.

34. L. Kleiner, 23 March 1981.

35. Letter of 1 March 1934, Hdschr. I.Nr. 172.570.

36. *Interieur* II, 1901. 203 (see Appendix, "Simple Furniture").

37. Winkler, op. cit., 9.

38. Interview of 24 June 1981.

39. *KuKhw* XXIII, 1920, 275; about the effect of the Hoffmann school in Germany, see W. von Wymetal, "Wien's Einfluss auf das kunstgewerbliche Schaffen unserer Zeit," *Kultur Deutsche Zeitschrift*, I, 1924, 38ff.

40. Exchange of letters between Max Fellerer, Max Welz, and Josef Hoffmann, August and September 1936 (Estate). In a letter of 22 August 1937 (Estate Max Welz), Hoffmann complains not only about the "dark forces" which prevented his further appointment but also about "the addition . . . undertaken by Mr. Kramreiter" in Venice which should disappear.

41. *KuKhw* II, 1899, 405ff.

42. *Interieur* II, 1901, 1ff.; IV, 1903, 97ff.

43. *KuKhw* IX, 1906, 508.

44. *Studio* XXXIX, 1907, no. 166, 323ff.

45. *KuKhw* XV, 1912, 64.

46. Haerdtl, 22.

47. *DKuD* LIV, 1924, 161.

48. Birke, Ginther, Haerdtl (Prati), Speyer, Thurner, Winkler.

49. Hdschr. I.Nr. 158.919.

50. See Chapter V.

51. Nebehay, Schiele, 351.

52. J. Hoffmann, "Die Anfänge Kokoschka's," in J. P. Hodin, *Bekenntnis zu Kokoschka*, Berlin, 1965, 65ff.; see pp. 223, 224.

53. *Festschrift*, 21.

54. *Studio* XXII, 1901, 261ff. Khnopff mentions an otherwise unknown collaboration of Hoffmann with Olbrich and Auchentaller in an M. P. apartment in the Sühnhaus which probably refers to the apartment of Moritz Berl.

55. *ID* XIII, 1902, 129ff.

56. *DK* VII, 1904, 1ff.

57. *Kunst-Revue*, November 1909, 177ff.

58. *Art et Décoration*, XVI, 1904, 61ff.

59. *Kunstchronik* XXXII, 1920-1921, 201ff.

60. *Architekt* XXIII, 1920, 65ff.

61. *Wendingen* III, 1920, August/September, 4ff.

62. Dr. *honoris causa* of the Technical University, Dresden, Foreign Member of the Academy of Fine Arts Berlin, Commander of the French Legion of Honor, Corresponding Honorary Member of the American Institute of Architects.

63. *Art et Décoration*, XLIV, 1924, 55ff.

64. *Journal of the American Institute of Architects* XII, 1924, 421ff.

65. *Architectural Forum* XLIX, 1928, 697ff. Two years later Sheldon Cheney was equally enthusiastic in *The New World Architecture*, London, 1930, 183: "No one had ever before brought out of his magic hat so many rooms 'with just the right touch'; no one . . . so charmingly feminized architecture; no one . . . so richly colored buildings without breaking up wall sense."

66. Thurner.

67. *L'Architettura*, 12 October 1956.

68. G. Veronesi, *Josef Hoffmann*, Milan, 1956.

69. H. Tietze, *Die Methodik der Kunstgeschichte*, Leipzig, 1913, 175.

70. Above all, the exhibition about the Wiener Werkstätte at the ÖMAK in 1967, organized by Dr. Wilhelm Mrazek, has contributed much to the rise of interest in Hoffmann.

LIST OF ILLUSTRATIONS

CATALOGUE OF WORKS

20m wide, with restaurant on ground floor, facade and plan

Cat. 445/I, II. Seven-story apartment house, street facade and plan of ground floor

Cat. 446. Five-story hotel, facade study

Cat. 447. Design for a multistory apartment building with gardens on the upper stories, plan and facade

Cat. 448. Design sketch for polygonal house with regular projections, plan and entrance facade

Cat. 449. Project for cylindrical house with workroom, plan and facade

Cat. 450. Design sketch for small cylindrical house, plan and facade

Cat. 452. Studies for small houses in unusual forms

Cat. 453. Pavilion with shingled onion-shaped roof, facade study

Cat. 454. Exhibition building with caryatids, facade design

Cat. 455. Exhibition building with sloping side walls, facade design

Cat. 456. Design for circular exhibition pavilion, plan and facade with pillared loggia

Cat. 458. Design for Austrian exhibition pavilion with two pillared porticos, plan, facade, and perspective

Cat. 459. Austrian exhibition pavilion with open center, facade design

Cat. 461. Design sketch for exhibition pavilion with ogival cross-section

Cat. 465. Stern apartment furnishings, wall elevation with fireplace, design sketch

Cat. 467. Design sketches for a tomb

Cat. 468. Four designs for tombs

Cat. 470. Facade design of palace for Archduke Max

Cat. 471. Facade design for a two-story building

Cat. 472. Facade design for a café/restaurant

Cat. 473. Design for a clubhouse, plan and facades

Cat. 474. Five-story building with glazed upper stories, facade design

Cat. 475. Facade study, monumental entrance to a building complex

Cat. 476. Perspective design sketch for a building with two wings

Cat. 477. Study of a funeral hall and chapel for Stockerau, Lower Austria(?)

Cat. 479. Design for a festive tent or pavilion

Cat. 480/I, II. Project for panoramic terrace with large clock in Kapfenberg, Styria(?)

Cat. 482/I. Project for a small garden house with upper story, plan and facades

Cat. 482/II. Ceramic model of the small garden house

Cat. 483. Sketch of a gazebo in the Rosenbaum Garden, facades and perspective

Cat. 484. Design sketch for a garden pavilion

Cat. 485. Sketch of a small octagonal garden house, plan and perspective

Cat. 486. Perspective sketches of various pavilions

Cat. 487. Design sketch for pavilion with fountain jet

Cat. 489. Decorative sketch of fantastic architecture

Cat. 490. Sketch of an imaginary building on the water

Cat. 491. Design sketch, room with curved walls, plan and view

Cat. 493. Architectural composition (wallpaper pattern?)

APPENDIX

1. Graduation certificate from the Academy of Fine Arts, 1895

3. Handwritten "Brief Autobiography" on the occasion of Hoffmann's appointment as Professor, 1899

6. Handwritten dedication in the book by Peter Altenberg, *Bilderbögen des kleinen Lebens*, Berlin-Westend (Erich Reiss Verlag), 1909

8. Handwritten page from the lecture manuscript "My Work"

16. A page from the letter of March 1933

Endpapers are based on a design by Josef Hoffmann. Vignettes are from *Ver Sacrum* or ADV

ILLUSTRATION CREDITS

NOTE: The illustrations, except those made especially for this book or reproduced from old periodicals, are largely from two sources: the Estate of the architect and the former Archive of the Wiener Werkstätte, now in the Austrian Museum for Applied Arts. Parts of the Estate were acquired by other public collections; the author was able to photograph the rest largely, though not completely, during the lifetime of Hoffmann's widow. In the meantime, the Estate has gone into various private collections and the art trade.

ABBH: 50, 151; Cat. 52/I, III, 53/I, VI, 63/I, 95/II, 101/III, 102,II, 111/I, 128, 134/I, 168/III, 178/I, II, 244/I, 264/II, 307/I, II, 395/I, II, 400/I, III

ADV: 142, 144

Akademie: 10, 258, 259, 285; Cat. 157/III, 308, 340, 364, 365, 373, 374, 382/I, II, 395/I, II, 400/I, III

Albertina: 185, 186; Cat. 157/I, II, 453

Ankwicz Archive: 92

Architectural Forum XLIX, 1928: 254

Architekt I, 1895: 39 (p. 1); Cat. 2, 4

Architekt II, 1896: Cat. 7/1a, 1b, 9/I, II

Architekt III, 1897: 21 (Pl. 42), 22 (Pl. 17); Cat. 7/II, 8/I, II/10

Architekt VI, 1900: Cat. 11

Architekt VII, 1901: 42

Architekt IX, 1903 (p. 85): 40; Cat. 49, 51, 54/I

Architekt XIV, 1908 (p. 122): 130; Cat. 110b, 121/II

Architekt XV, 1909: Cat. 102/II

Architekt XVII, 1911: 181 (Pl. 1); Cat. 112/I, 118, 138, 139/I, II, 141/III, 142/I, II

Architekt XVIII, 1912: Cat. 139/III, IV, 153, 158/I, 160, 162

Architekt XIX, 1913: Cat. 167/II, 171

Architekt XX, 1914/1915: 183 (Pl. 2), 208 (Pl. 82), 210 (Pl. 50), 211 (p. 38); Cat. 179/I, 182/I

Architekt XXI, 1916-1918: Cat. 193

Architekt XXIII, 1920: Cat. 206/II

Ausgeführte Kunstschmiedearbeiten der Modernen Stilrichtung, 6th Series, Vienna: Cat. 31

Author: 1, 59, 94, 98, 99, 101, 224, 227, 249, 267; Cat. 32/II, 52/V, 53/IV, 63/II, 74/II, 77/II, 78/I, II, 84/II, 92, 95/III, 101/I, 102/II, 103/II, 104/I, II, III, 109, 111/III, 112/II, 133/II, 134/II, 142/IV, V, 144/II, 167/IV, 168/II, 176, 185/II, VII, 195/II, 219, 226/II, VI, 229, 231/II, III, 253, 254/III, IV, 264/I, 265/II, IV, 305/III, 400/II

Basil, Mrs. Christine (Photo: Ing. Hans Küpper): 181, Cat. 167/III

Bauhaus Archive: Cat. 104/IV, 264/III

BAV: 62, 65, 248, 262, 299; WV 56, 64/I, 75, 76, 114/I, 242, 247/II

Berliner Architekturwelt VIII, 1906: Cat. 110a

Cheney, Sheldon, The New World Architecture, London, 1930: 250, 251

DK I, 1898: Cat. 13, 15

DK II, 1899: 19; Cat. 16, 22

DK III, 1900: 38 (p. 97)

DK IV, 1901: Cat. 28, 29, 34

DK VI, 1902/1903: 66 (p. 25); Cat. 65

DK VII, 1903/1904: 52 (p. 5), 54 (p. 8), 56 (p. 23); Cat. 63/III, 77/I, III

DK VIII, 1905: Cat. 86

DK XI, 1908: Cat. 123/II, III

DK XVIII, May 1915: 157 (p. 233), 158 (p. 239)

DK XIX, Oct. 1915: 195 (p. 1), 199 (p. 5), 216 (p. 15)

DKuD VII: 47 (p. 19)

DKuD X: 63 (p. 486)

DKuD XV: 71 (p. 203); Cat. 83, 87, 88

DKuD XVI: Cat. 89/II

DKuD XVIII: 76 (p. 424), 77 (p. 246); Cat. 84/I, VI, 98, 106/I

DKuD XIX: 69 (p. 37), 125 (p. 50)

DKuD XX: Cat. 113

DKuD XXI: Cat. 127

DKuD XXII: 138 (p. 78); Cat. 120/I

DKuD XXIII: 145 (p. 38), 146 (p. 75); Cat. 114/II

DKuD XXIV: 129 (p. 210), 131 (p. 202), 132 (p. 207), 143 (p. 212); Cat. 115/II, 129/II

DKuD XXV: 179 (p. 309); Cat. 100/XII, 106/III, 131/I

DKuD XXXIII: Cat. 131/II, 151

DKuD XXXIV: Cat. 166, 182/II

DKuD XXXV: 183, 191 (p. 307)

DKuD XXXVII: 16 (p. 212); Cat. 174/II, 185/IV, V, 191/IV-IX

DKuD LIII: Cat. 252

DKuD LXI: Cat. 278/I, III

DKuD LXII: Cat. 289

DKuD LXV: Cat. 287/I, II, 315

DKuD LXVI: Cat. 288

DKuD LXVIII: 271; Cat. 314

Dörnhöfer, F., Rome 1911, *Internationale Kunstausstellung,* etc.: Cat. 141/I

Eisler: Cat. 179/III, 182/V, 183

Festschrift: Cat. 255/I, II, 304, 326, 327

Fiegl, Johanna, photograph: 27, 28, 35, 36, 37, 70, 78, 80, 81, 82, 83, 134, 137, 152, 167, 170, 172, 173, 175, 176, 177, 180, 182, 197, 198, 202, 203, 205, 206, 228, 232, 233, 234, 237, 266; Cat. 32/I, 45/I, 46/III, 53/III, 74/III, 103/I, 132/I, 134/III, IV, VII, 137/II, 149/II, 168/I, IV, 172/II, 185/III, 265/III

Frais, Helmut, Archive: Cat. 172/I

Frank, Josef, Die Internationale Werkbundsiedlung, Vienna, 1932: Cat. 333/IV

Fries, de, H., Moderne Villen und Landhäuser, Berlin, 1924: 221

Gerlach, Photo: Cat. 307/III

Gesellschaft der österr. Architekten, Annual, 1908: 119; Cat. 100/13

Glasgow University: 32

Glück, Hilde: 301

Grohmann, Josef, Archive: 136; Cat. 238a/I, II, 246, 253a, 259/I, 336/I, II

Haerdtl, Carmela, photograph: 270; Cat. 305/I, II

Haerdtl Estate: 155, 159, 241, 242; Cat. 107, 370/II, III, IV

HFAK Archive: 263; Cat. 120/II

HMSW: 20, 44 (Loan of the Austrian Gallery, Vienna), 313

Hoffmann Estate: 3, 4, 5, 6, 8, 9, 11, 12, 13, 14, 15, 16, 17, 18, 57, 58, 72, 73, 84, 86, 89, 91, 93, 97, 103, 104, 106, 116, 117, 126, 127, 128, 133, 135, 139, 141, 149, 150, 161, 166, 178, 190, 196, 200, 201, 207, 212, 213, 215, 218, 220, 222, 223, 236, 239, 243, 244, 245 (Reifenstein photograph), 246, 247 (Reifenstein photograph), 252, 255, 256, 257, 268, 269, 272, 273, 277, 279, 280, 281, 282, 283, 284, 286, 287, 288, 291, 292, 293, 294, 296, 297, 302, 304, 305, 309, 310, 311; Cat. 1, 6, 18/V, 52/II, 78/III, IV, V, 84/III, 89/I, 95/I, 104/VII, XI, XV, XVI, 112/I, 117, 123/I, 135, 137/I, 142/III, 144/I, 149/I, 152, 158/II, 167/I, V, 170, 179/II, IV, 182/IV, 185/I, 188, 196, 197, 203, 204, 206/I, 208/I, 212, 217, 218, 226/I, III, IV, V, VII, VIII, 231/I, 236, 240, 243, 258/III, 265/V, 266/IV, 269, 279/I, 320/I, 342, 343/I, 346, 350, 351/I, II, 352/I, 359, 363/I, II, 367, 370/I, V, VI, 371, 375/I, II, III, 384/I, II, 385/I, II, III, 387/I, 388/II, III, IV, 390, 393/II, III, 397, 398/I, II, 403/I, II, 408, 409, 410, 411, 416/I, 417, 418/I, II, 419, 420/I, II, 421, 422, 423/I, II, 424/I, II, 425/I, II, 427, 428, 429, 430/I, II, 431, 432, 433/I, 434/I, II, 435/I, II, 436/I, II, 437, 438/I, II, 439, 440, 441, 442, 443, 444/I, II, 446, 447, 448, 449, 450, 452, 454, 455, 456, 458, 459, 461, 465, 467, 468, 471, 472, 473, 474, 475, 476, 477, 479, 480, 482/I, II, 483, 484, 485, 486, 487, 489, 490, 491, 493

Hoffmann, Wolfgang, Estate: 306, 307

SOURCES OF APPENDICES

1 Estate; 2 *Architekt* III, 1897, 13; 3 Austrian State Archive, General Administrative Archive, Education, A.Z. 10293; 4 *Interieur* II, 1901, 193ff.; 5 *Annual of the Society of Austrian Architects* 1909, 55ff.; 6 in: P. Altenberg, *Bilderbögen*, 1909; 7 Estate; 8 Estate; 9 *Der Merker*, 15 Dec. 1919, 784ff.; 10 *Das Kunstblatt*, April 1924, 101ff.; 11 Estate; 12 *Die Wiener Werkstätte 1903-1928*, Vienna, 1929; 13 *Die Wiener Werkstätte 1903-1928*, Vienna, 1929; 14 *Festschrift*; 15 ADV; 16 ADV; 17 *Neues Wiener Journal*, 17 Feb. 1935; 18 *Wiener Zeitung*, 23 Dec. 1945; 19 *Wiener Zeitung*, 21 April 1946; 20 Ankwicz Estate

LIST OF ABBREVIATIONS

ABBH	Archive of the Building Authority	ID	*Zeitschrift für Innendekoration*, later *Innendekoration*
Academy	Print collection of the Library of the Academy of Fine Arts, Vienna	I. Nr.	Inventory number
ADV	Archive of the Author	Interieur	*Das Interieur*
Architekt	*Der Architekt*	Jhrb.	Jahrbuch (Yearbook)
Art-Revival	C. Holme, ed., *The Art-Revival in Austria*, London, 1906	Kleiner	Leopold Kleiner, *Josef Hoffmann*, Berlin, 1927
AUMK	*Alte und Moderne Kunst*	KuKhw	*Kunst und Kunsthandwerk*
BAV	Picture Archive of the Austrian National Library	Mang	Karl and Eva Mang, *Wiener Architektur 1860-1930 in Zeichnungen*, Stuttgart, 1979
BUWK	*Die Bau- und Werkkunst*	MBF	*Moderne Bauformen*
Columbia	Columbia University, New York, Avery Library, Microfilm documentation of Hoffmann Exhibition, 1956	Muther, Studien	Richard Muther, *Studien und Kritiken*, Vienna, 1900
DK	*Dekorative Kunst*	Nebehay, Klimt	Christian M. Nebehay, *Klimtdokumentation*, Vienna, 1969
DKuD	*Deutsche Kunst und Dekoration*	Nebehay, Schiele	Christian M. Nebehay, *Egon Schiele 1890-1918*, Salzburg, 1979
Eisler	Max Eisler, *Österreichische Werkkultur*, Vienna, 1916	Nebehay, VS	Christian M. Nebehay, *Ver Sacrum* (paperback edition), Munich, 1979
Estate	Estate Josef Hoffmann	OG	Upper story
Estate Ank.	Estate Ankwicz-Kleehoven	ÖBWK	*Österreichs Bau- und Werkkunst*
Estate COC.	Estate Carl Otto Czeschka	ÖK	*Österreichische Kunst*
Estate Haerdtl	Estate Oswald Haerdtl	ÖMKI	Austrian Museum for Art and Industry
Estate Ka.	Estate Josef Kalbac	ÖMAK	Austrian Museum for Applied Art
Estate Ro.	Estate L. W. Rochowanski	Planbuch	Book of plans, Josef Hoffmann Office, 1913-1939 (Estate Haerdtl)
Festschrift	Werkbund, Österreichischer, ed., *Josef Hoffmann zum 60. Geburtstag*, Vienna, 1930	Platz	Gustav Platz, *Die Baukunst der neuesten Zeit*, Berlin, 1927
Finale	O. Breicha and G. Fritsch, eds., *Finale und Auftakt Wien 1898-1914*, Salzburg, 1964	Rochowanski	L. W. Rochowanski, *Josef Hoffmann*, Vienna, 1950
Fries	H. de Fries, *Moderne Villen und Landhäuser*, Berlin, 1924	Studio	*The Studio*
Haerdtl	*Oswald Haerdtl 1899-1959* (Catalogue), Vienna, 1978	Veronesi	Giulia Veronesi, *Josef Hoffmann*, Milan, 1956
Hdschr.	Manuscript Collection of the City Library, Vienna	VBKÖ	*Vereinigung bildender Künstler Österreichs* (Association of Austrian Artists, Secession)
HFAK	School for Applied Arts, Vienna	VS	*Ver Sacrum*
HMSW	Historical Museum of the City of Vienna	Waissenberger	Robert Waissenberger, *Die Wiener Secession*, Vienna (1971)
Hevesi, Acht Jahre	Ludwig Hevesi, *Acht Jahre Secession*, Vienna, 1906	Wasmuths MFBK	*Wasmuths Monatshefte für Baukunst*
Hevesi, Altkunst	Ludwig Hevesi, *Altkunst-Neukunst*, Vienna, 1909	Weiser,	Armand Weiser, *Josef Hoffmann*, Geneva, 1930
HW	*Hohe Warte*	WAZ	*Wiener Allgemeine Zeitung*
		WW	*Wiener Werkstätte*
		WWA	Archive of the Wiener Werkstätte, ÖMAK

ABBREVIATIONS FOR ROOMS USED IN GROUND PLANS

A	Dressing room	H	Hall	O	Pantry	WC	Toilet
B	Bath	HZ	Smoking room, study	PE	Servant's room	WG	Winter garden
BI	Library	KA	Small room	S	Salon, drawing room	WK	Laundry room
ERZ	Governess' room	KSPZ	Children's playroom	SK	Pantry, larder	WZ	Living room
EZ	Dining room	KSZ	Children's bedroom	SPZ	Game room, card room	Z	Room
FZ	Breakfast room	KU	Kitchen	SZ	Bedroom		
G	Garage	L	Loggia	V	Vestibule, anteroom		
GD	Cloakroom	MZ	Music room	VE	Veranda		

INDEX

Library of Congress Cataloging in Publication Data

Sekler, Eduard F. (Eduard Franz)
Josef Hoffmann : the architectural work.

Translation of: Josef Hoffmann.
Bibliography: p.
Includes index.
1. Hoffmann, Josef Franz Maria, 1870-1956. 2. Architecture,
Modern—20th century—Austria. 3. Wiener Werkstätte. I. Hoffmann,
Josef Franz Maria, 1870-1956. II. Title.
NA1011.5.H593S4513 1985 720'.92'4 83-42576
ISBN 0-691-06572-1 (alk. paper)